Contents

Acknowledgements

This book has had a gestation period of nearly a quarter of a century, during which time there have been many changes in the approach to the subject. These changes are reflected in the rather personal story of how the book came to accompany an exhibition at the British Museum, and the debts of gratitude that I have incurred along the way.

In 1976, inspired by a short course on watercolours taught by Lee Johnson at the University of Toronto and half a year as a volunteer in the Department of Prints and Drawings at the British Museum under the kindly eye of Reg Williams, I approached David Bindman at Westfield College to supervise my graduate degree. He has been a source of constant encouragement ever since, and I owe to him the initial suggestion that the teaching of drawing might be a rewarding field. Ilaria Bignamini was researching the growth of artists' academies in England at the time, and I therefore concentrated on the introduction of drawing to the curricula of a cross-sample of non-artistic sites of learning. A small grant from the University of London enabled me to travel to county record offices all over Britain and to the Hermitage in (then) Leningrad. That and a month's fellowship at the Yale Center for British Art provided me with a wealth of material, friends and memories.

Michael McCarthy gave me the opportunity to present and publish my first paper on the subject. Two exhibition catalogues, a child and then two new jobs all precluded any further time to spend on the revision of the thesis for publication, in spite of the generous encouragement of my external examiner, the late and very sadly missed Michael Kitson, and a most detailed and helpful reader's report from Michael Rosenthal. By that time the study of British art had changed so much that revision was no longer possible. New issues required new approaches and I began to explore these in 1993 in a paper Brian Allen kindly invited me to contribute to a Royal Academy symposium on British Watercolours.

Antony Griffiths, Keeper of the Department of Prints and Drawings, agreed to a small exhibition, but two further exhibitions intervened and it was 1998 before I could begin work. When the collection proved to be even richer than I had anticipated, he generously agreed to double the size of the exhibition and has also patiently read through a text that was also double the expected length. At the British Museum Press Emma Way and my long-suffering editor Teresa Francis have been unfailing in their support of the resulting book. The Paul Mellon Centre for Studies in British Art most generously provided a very large grant towards the publication, which enabled us to widen its audience. The copy-editor Susan Haskins and designer James Shurmer have worked hard with a text supplied in awkward pieces to produce what I am certain will be up to their usual very high standards. Any errors that remain are entirely my own.

Ann Bermingham and Greg Smith, writing on related aspects, have most kindly let me use unedited typescripts of their publications, which will appear this year and next.

All those mentioned above have been unfailingly supportive, but over twenty-five years I have met and incurred debts of gratitude to countless others, now friends and fellow enthusiasts. I can only thank a handful of them here, and hope they will forgive me for including them in a list; I extend my sincere apologies to those I have inadvertently left out. John Abbott, Philip Athill, Frances Carey, Deborah Cherry, Michael Clarke, James Collett-White, Aileen Dawson, Diana Dethloff, Judy Egerton, Elizabeth Einberg, Elisabeth Fairman, Ann French, Carol Gibson-Wood, Colin Harrison, Asya Kantor-Gukovskaya, John Ingamells, Francina Irwin, Dian Kriz, Katharine Lochnan, Anne Lyles, Jane Munro, John Murdoch, Charles Nugent, Sheila O'Connell, Lucy Peltz, Bruce Robertson, Michael Rosenthal, Rose Marie San Juan, Jacob Simon, David Solkin, Lindsay Stainton, Henry Wemyss, Scott Wilcox, Nicholas Williams, Andrew Wilton and the late Baroness Lucas, Denys Oppé, Ann Pullan, Dudley Snelgrove and Ian Fleming-Williams have all shared and fired my enthusiasm. Cyril and Shirley Fry and Felicity Owen have recently donated many works of which, sadly, I could include only a few, but the Museum's collection has been greatly enriched by their generosity and that of Luke Herrmann. Henrietta Ryan and, most especially, Jane Roberts of the Print Room in the Royal Library at Windsor Castle have been the most patient of curators, sharing their own vast knowledge of the work of amateurs and, with Theresa-Mary Morton, immeasurably facilitating a large loan, as have Katherine Coombs and Clare Browne in whose care are the miniatures and textiles borrowed from the Victoria and Albert Museum. We are grateful to the Trustees of the latter and to the National Portrait Gallery, the Visitors of the Ashmolean Museum, Oxford, and to Her Majesty The Queen for their generous loans to the exhibition.

I should like to thank all my colleagues in the Department of Prints and Drawings for providing me with opportunities to work at home while they were under tremendous pressure from many changes in the Museum. Janice Reading has undertaken the loans with characteristic efficiency and the Museum's conservators and mounters have transformed some very neglected works. Lucy Dixon expedited my seemingly endless requests for conservation and photography and Lisa Baylis was responsible for nearly all of the photographs. Carol Blackett-Ord has for four years acted as a voluntary research assistant on her one free day a week and provided much-needed moral support and friendship. My husband Paul Chaffe and daughter Morwenna have borne and foregone much this past year with remarkable patience, constant support and understanding. Finally, there is a nice symmetry in the fact that my mother creates intricate pictures in needlework and my father, who has always drawn for pleasure and now paints wonderful water-colours for family and friends, was formerly a professor of art education. They have waited for this book as long as I have, and it is to them that I dedicate it.

'A Noble Art'

Amateur Artists
and Drawing Masters
*c.*1600–1800

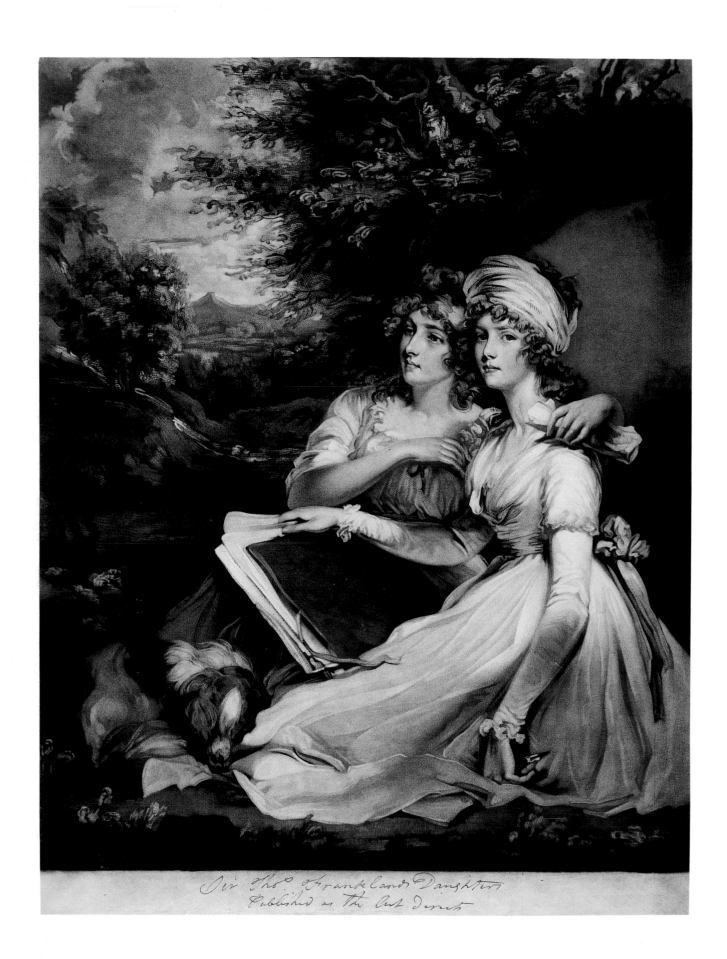

Sir Thos. Frankland Daughters
Published as the Act directs

'A Noble Art'

Amateur Artists
and Drawing Masters
c.1600–1800

Kim Sloan

Published for The Trustees of

The British Museum by

BRITISH MUSEUM ⫿ PRESS

For my parents, Joan and Bill Sloan

This publication was generously assisted
by a grant from the Paul Mellon Centre
for Studies in British Art

Photographic Acknowledgements

Photographic reproductions are courtesy of the
following: Photographic Survey of Private
Collections, Courtauld Institute of Art (fig. 1);
Admiral Blake Museum, Bridgwater, Somerset
and J. N. Chubb (fig. 2); The Paul Mellon Centre
for Studies in British Art (fig. 3); Sotheby's (fig. 7);
The Ashmolean Museum, Oxford (cat. 52);
The Trustees of the National Portrait Gallery,
London (cat. 169); V&A Picture Library (cats 25–8,
30, 37); The Royal Collection © 2000. Her Majesty
Queen Elizabeth II (cats 24, 45–8, 51, 67–8, 100–1,
155, 170, 172); All other photographs are © 2000
The British Museum.

© 2000 The Trustees of the British Museum
Published by British Museum Press
A division of The British Museum Company Ltd
46 Bloomsbury Street, London WC1B 3QQ

First published 2000

A catalogue record for this book is available from
the British Library

ISBN 0-7141-2624-1

Designed and typeset in Monotype Baskerville
by James Shurmer

Printed in Italy
by Grafiche Milani

Frontispiece:
William Ward (1768–1826) after John Hoppner
(1758–1810), *Daughters of Sir Thomas Frankland Bart.*,
mezzotint, 1797 (cat. 187).

Introduction
Drawing: 'that Most Noble and Ingenious Art' or a 'Polite Recreation'

It is always difficult to decide upon a title for a book not yet written, but even more so when it is for an exhibition as well. The title must accurately reflect the contents, indicate the main theme, and be immediately comprehensible and of interest to a broad section of the population. Both phrases above were regularly used in the titles of drawing manuals for professional and amateur artists in the seventeenth and eighteenth centuries. Their meanings are clear within the context of their full titles: *Cosens Revived or the French Academy. Containing Examples of the Fundamental Rules of Drawing, and Directions for the Assistants of Young Practitioners in that Most Noble and Ingenious Art* (1686) and *Bowles's Polite Recreation in Drawing* (1779).[1] However, the words 'ingenious' and 'polite' have slightly different meanings to a modern audience, and when removed from these historical contexts might be misleading or misunderstood. 'Noble', however, is less ambiguous and as an adjective still means 'of lofty character or ideals'.[2] Employed as a noun it indicates a person 'illustrious by rank, title, or birth, belonging to the nobility', and indeed by far the greatest number of amateurs represented in this book were nobles. Thus *A Noble Art* seemed the most appropriate title.

Subtle changes in the use and meaning of words are of fundamental importance to many of the themes of this book, and although an attempt has been made to be faithful to their seventeenth- and eighteenth-century usages, this has proved impossible with the word 'amateur'. During the period under discussion, amateurs were lovers of the arts, the word taken from the French where the root was the Latin word *amare*, to love. 'Amateur' did not appear in the titles of drawing manuals or advertisements for drawing lessons, and it was not until around 1780 that it came to mean not only someone who loved and understood, but who also practised the arts, without regard for pecuniary advantage. Thus in the seventeenth and eighteenth centuries it was possible for a professional artist to be an amateur of the arts, although in general the term was applied to those who were not of the professional classes. It has since acquired an additional pejorative definition as someone whose approach is the opposite of professional, that is, not up to a professional standard. As we hope will become clear, this is the complete antithesis of the attitudes towards professionals (often described as 'mere artificers') and non-professionals ('gentlemen' or 'ladies') during the period covered. Consequently, whenever the term 'amateur artist' appears in this book, it is intended to describe a person who loved and practised one or more of the arts, without expectation of payment.

This book accompanies the first exhibition to be devoted to the work of amateurs. The fact that it has no precedent is due to a large extent to modern prioritizing of professional over amateur. Drawing masters, too, have suffered from modern prejudices and an insistence upon ranking and expressing a preference for what is considered the best – admiring only the work of 'great' artists, and virtually ignoring 'minor' ones, to whose ranks drawing masters are perceived to belong. In the late 1970s two British Museum curators submitted a proposal for an exhibition on amateurs to several venues, only to be turned down because of the presumed lack of visual quality of the contents and perceived lack of public interest.[3] Studies of British art have changed remarkably in the intervening years and new ways of seeing have revealed that both amateurs and drawing masters hold a vital place in our understanding, not only of the history of art, but in the life and culture of seventeenth- and eighteenth-century Britain.

As long ago as 1931, Edgar Wind, the first of the Warburg scholars to turn his attention to British art, complained that 'an over-timid division of labour in modern historical studies has led scholars to examine artistic and philosophical documents in isolation from each other, instead of studying them in their interaction'.[4] For nearly fifty years after his statement, few English-speaking art historians, apart from those at the Warburg Institute, heeded his complaint, continuing to focus on the artists themselves and those documents relating to their works. They all but ignored his call to place art within the context of the philosophy of the time, only occasionally supplying background information about the politics and literature of the period. They constructed a history of British art that was chronological and focused on the achievements of those perceived to have contributed to a progressive history of art – one that traced those periods, artists and schools of western art that were regarded as having led to the 'successes' of the modern schools of the twentieth century, notably Impressionism and Abstraction, and almost entirely ignored artists, styles and genres that had not 'contributed' to this progress of the arts.

In *The Pursuit of Happiness*, the inaugural exhibition at the Yale Center for British Art in 1977, J. H. Plumb demonstrated how not only the philosophy, politics and literature of the period could help us to understand its artistic productions, but that the social, economical, scientific and wider cultural aspects could revolutionize the way British art and culture are perceived. There had been little room for minor artists and none at all for amateurs in the earlier history of British art, but the new interdisciplinary approaches of the past twenty years have highlighted these and other lacunae; by the time this book is published, another devoted to addressing the issues associated with learning to draw will have appeared and two more related studies will follow shortly.[5]

The approaches and foci of the above-mentioned studies will differ: the present one is based on an earlier examination of

various types of educational establishment where drawing was taught from c.1650 to 1780,[6] and on a selection of works taken from the rich and still largely unexplored collection of over 35,000 British drawings and watercolours in the Department of Prints and Drawings in the British Museum. The result is both chronological and thematic, although it follows neither category strictly and is largely overlaid by biographies that provide a fascinating variety of approaches to drawing and a spider's web of family, social, philosophical, aesthetic and artistic interconnections and relations.

The main purpose in taking this approach has been to encourage non-specialists towards a new way of seeing British art of the seventeenth and eighteenth centuries through the lives, interests and achievements not of the 'great' artists of the century, but of the men and women who drew for pleasure and the men and women who taught them.

The contents of the collection in the Museum dictated many of the issues that might be addressed in this study. The choice of works was guided by several factors, primarily whether the makers could be described as either amateurs (that they did not make works for payment) or as drawing masters (that at some point in their careers they were known to have taught non-professionals or to have written a drawing manual). Secondary considerations included an attempt to represent all types of amateur activity, including drawing in all media, pencil, ink, chalk and wash, watercolour, bodycolour, as well as etchings, miniatures and paper cutting, in addition to all the types of subject they depicted – portraits, figures and landscapes (invented and real), animals, birds and flowers. A handful of drawing manuals, albums and sketchbooks stands for the hundreds in the collection. The works' conditions and aesthetic values were also taken into consideration, but were tertiary deciding factors. Attribution of works the authorship of which was in doubt was also taken into account, but only if it meant that the work was unlikely to be by an amateur – there was no prejudice against anonymous works provided that they were clearly not by professionals. The Museum has few relevant miniatures, examples of needlework or works by royal amateurs from this period, and as these were vital aspects of amateur activity, it was decided to borrow representative examples. Many amateurs throughout the period painted in oils, but the Museum's collection is of works on paper: thus one small landscape (cat. 52) and one portrait in oil (not by but of an amateur, cat. 169) must represent this significant aspect of their activities and drawing in pastel as well.

Finally, although we received many generous offers of loans from private and public collections, there was room for only 200 objects in the book and exhibition. One of the primary aims has been to indicate the unexplored wealth and depth of the Museum's collection of British art – its publications and exhibitions can only reveal the tip of the iceberg. For every five works selected initially, four were returned to the collection, along with nearly all the works from the first half of the nineteenth century, which had been included in the original plans.

In spite of the number of works included and the length of this book, many relatively well-known amateurs and drawing masters are not represented within it. Considering that the numbers of amateurs were legion and that nearly every professional artist at one time gave lessons, 200 works cannot provide an entirely representative sample. In addition, some issues remain addressed only briefly and others not at all. Most significant amongst these are the exhibitions and prizes of the Society of Artists and the Society for the Encouragement of Arts, Manufacture and Commerce, which are mentioned only briefly. In some cases this is because the issues have been or will soon be addressed by others, but in most cases it was simply because the Museum had no examples of relevant work and the decision was taken not to borrow except for the two groups of works described above. Alternatively, the issues raised or the work produced did not fall within the period covered, which ends in 1804 with the foundation of the Society of Painters in Water Colours and the exclusion of the work of amateurs from its exhibitions. This marked a substantial break with the earlier close association of amateurs and professionals, and coincided with so many other cultural shifts, especially changes in perception of the identity of amateurs and the type of work they produced, that it provided an appropriate date with which to end the study of a 'noble art'.[7]

Although the word 'British' does not appear in the title, it is implicit in that all the works included are by people who lived or worked in Britain. The present writer is conscious of the fact that most of these people were centred around London or their country houses, and that the amateurs and drawing masters from the rest of England, and from Scotland, Wales and Ireland are poorly represented. The proportions that are included are by no means equal to their activities, especially in the second half of the eighteenth century. Once again, however, the limit of works available and the pressure of space were determining factors. The ratio of males to females is, however, to the best of our knowledge, fairly accurate, in spite of the traditional vague perception that most amateurs were women.

All of the men and women in this book who were not professional artists were members of the aristocracy, landed gentry or upper middle classes. Other levels of society received educations that included drawing, notably the boys at Christ's Hospital, and the children of the middle and merchant classes who attended private academies and Non-conformist schools in the eighteenth century: their works, however, rarely survive. On the whole, in the seventeenth century 'the Noble and Useful Art of Drawing' was described as 'the Gentleman's Accomplishment', the 'Ingenious, Pleasant and Antient Recreation of the Noble',[8] an activity limited to court circles in the first half of the seventeenth century which remained popular with those connected with the court throughout the rest of the period under discussion. But factors relating to birth and family connections, and the influence of the court, were not the only ones in operation; the examples that follow will indicate that developments in philosophy, education, politics, attitudes to the natural sciences, gardening, leisure, consumption, travel, patronage and collecting were all relevant to amateur activity.

Of course, changes in artistic technique and style as practised by professional artists also influenced the work of amateurs,

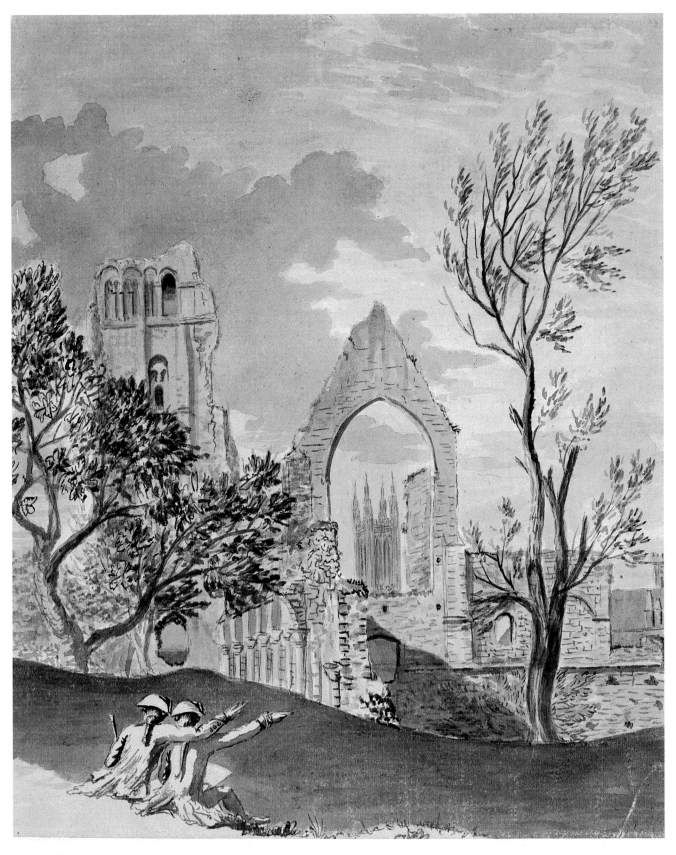

Detail of *View of St Augustine's Monastery at Canterbury* by Gabriel Bray (cat. 86).

particularly, for example, the movement away from limning to drawing with washes and watercolours. Definitions of non-familiar terms such as 'limning' will be provided as they arise in the text. On the whole, however, influences and styles, and connoisseurship in the form of modern-day changes of attribution, have not been predicated here as they usually are in art-historical studies. A new subject demands a new way of studying it and to place quality and style at the forefront as is necessary when considering attributions is to make the other aspects of the work, those most relevant to the amateur, take a secondary place. To put a name to a work in this exhibition that remains problematic, purely on the basis of style, as such attributions usually are, might be to remove the work from its context and place it where it reveals the least. Many of the Museum's works have come from collections formed by Leonard Duke and Iolo Williams who were interested in increasing the depth of our knowledge about British art; but the provenances of many have become lost as their attributions changed, and the information they might provide has become more difficult to read (see, for example, cat. 9).

The connoisseurship and collecting of these works by their contemporaries are far more fascinating and revealing. Richard Payne Knight, for example, was on the whole not interested in the British school of watercolour painting, but many of the works in this book came from the collection he bequeathed to the nation. He belonged to the generation that appreciated tinted topographical drawings and imaginary compositions, such as those by Gainsborough, which were reminiscent of old master drawings, and which in turn were consistent with his concern with the picturesque.[9] Some of these drawings were purchased, but others were gifts from friends. Richardson, Howard, Thoresby, Cracherode and Bull are only a few of the names of great collectors of their times whose names appear in the provenances of the works that follow.

Collecting patterns of the present day should also be taken into account when considering the work of amateurs. Until recently the collections of works on paper from the British Museum and the British Library were under one roof, and originally in one institution. Ideally, at least half of this book should have included works from both the Department of Manuscripts and Department of Maps in the Library, as the traditional divisions meant that works of 'fine art' were in the Department of Prints and Drawings, maps and coastal prospects and George III's topographical collection were in the Department of Maps, and illustrated writings, letters, diaries, travel books and other topographical and antiquarian views were in the Manuscripts department.[10] Throughout Britain, the richest public holdings of the works of amateurs remain in national libraries rather than in national galleries, and in the county record offices rather than in city museums. Of course, the greatest number by far is still in private collections, in the hands of the descendants of the artists who made them, in a context where they hold more meaning than in a gallery.

Where the original mounts and frames have survived, every effort has been made to include them in the reproductions that follow, as they were an integral part of how these works were intended to be viewed.

It should be noted that the literature quoted in the entries is selective rather than comprehensive and that one source in particular has been left out consistently as it would have occurred in every entry: this is Huon Mallalieu's indispensable *Dictionary of British Watercolour Artists up to 1920* (2 vols, Woodbridge 1976; second edn 1986, third vol. 1990), still the only source of information on many amateurs.

For consistency, spellings of names in the following text are according to the *Oxford Companion to Art*, except for many foreign artists working in England, where their names acquired local spellings: for these the form used in the Croft-Murray and Hulton catalogue has been retained. In the literature and footnotes, references given more than once are by surname only; full information can be found in the Bibliography.

Those expecting a book consisting mainly of watercolour landscapes and flower drawings will be disappointed, but it is to be hoped that they will discover instead knowledge and respect for both the artists who taught and for those men and women who drew and painted to please themselves and their friends or even for the benefit of their country, and had no intention or desire to compete with professional artists. Hopefully with it will come a new insight into their lives and the period in which they lived. 'The real voyage of discovery consists not in seeing new landscapes but in having new eyes' (Marcel Proust, *Remembrance of Things Past*, 1913–25).

NOTES

1 Ogden 1947, 197, and Friedman, 262.

2 Definitions throughout this book have been taken from the *Shorter Oxford English Dictionary*.

3 Michael Clarke (1984) nevertheless produced one the most useful predecessors to the present work, and Lindsay Stainton included the work of amateurs in her exhibition of 1987.

4 Wind, 1.

5 Bermingham 2000; Smith 2001 and Francina Irwin, forthcoming; before this year, studies on amateurs and drawing masters have been limited to appendices by Iolo Williams and Ian Fleming-Williams, and articles and theses, mainly by the same authors, which can be found in the Bibliography under their names, as well as Jordan and Pullan; for education, see Carline and Macdonald; see Bignamini for academies. There have recently been several important monographs on drawing masters, most notably Harrison on Malchair.

6 Sloan 1986, 'Non-professionals', which included an examination of private teaching and contained appendices listing drawing masters and their schools, as well as lists of the pupils of two drawing masters, William Austin and Alexander Cozens.

7 The work of nineteenth-century amateurs has already prompted a number of studies: see especially Bermingham 2000, Kriz, Pullan, Smith 2001; and for drawing manuals, see Bicknell and Munro.

8 Quoted from the full title of Anon., *Academia Italica, the Publick School of Drawing* ... (1666), listed in Ogden 1947, 196.

9 Clarke and Penny, 97.

10 See Ann Payne, *Views of the Past: Topographical Drawings in the British Library*, exh. British Library, 1987.

1
Virtue, *Virtuosi* and Views

In the reigns of Elizabeth I and her Stuart successors, the royal court was the primary seat of power and it was emulated in all aspects of education and culture by the leading members of society. Court life followed the humanist ideals of the Italian Renaissance as codified in Baldassare Castiglione's *Il Cortegiano*, a book on conduct and education for courtiers, which had been published in Venice in 1528 but reinterpreted for an English court by Sir Thomas Elyot in his *Boke Named the Governour* in 1531. The change in title from 'courtier' to 'governor' reflected the shift in emphasis from the Italian humanist interpretation of a gentleman as a courtier to the Protestant English ideal of public service, or the gentleman as 'governor', of use to society. English courtesy or etiquette books that followed eventually fused the two traditions, encouraging the accomplishments of the courtier alongside the gentleman's pursuit of useful knowledge.[1]

At the end of the sixteenth century, by emulating the court and following these codes of conduct, a growing number of landowning gentry had become an accepted part of this society. Their sons, well-educated in the new humanist tradition at Oxford and Cambridge and the Inns of Court, served the court as 'civil servants', but their numbers increased more rapidly than the positions available to them. By the time of the Civil War, these 'professional gentlemen', mainly younger sons who had no hopes of inheriting property, found themselves without a royal court that could use their services. Many immured themselves in the philosophical circles around Oxford, kept quietly to their families' estates or travelled abroad.

After the Interregnum, these young men, better experienced, educated and more widely travelled than their predecessors, returned to a royal court itself without money and soon without the moral prerogative to earn their services, and they therefore sought other causes than king and court to serve. Trained in the civic humanist tradition, it seemed to them far more virtuous to serve the nation as a whole. Their educations had taught them that the best method to achieve this was through dissemination of knowledge and to lead by example, through a moral and virtuous life. Courtesy books also began to reflect this philosophy by rejecting the Horatian notion that a brave and virtuous father cannot produce anything but a brave and virtuous son, in favour of Juvenal's precept: 'Nobilitas sola est et unicum virtus' (virtue is the one and only nobility).[2]

During the first half of the seventeenth century only royalty and those closest to them, aristocratic courtiers such as Sir Nathaniel Bacon (cat. 52), learned and practised drawing and painting. This followed a Renaissance tradition, expounded by Castiglione and his English followers, which considered that princes, especially, needed to study perspective in order to understand the art of fortification, so essential to war; a knowledge of painting was thought to better inform the activity of collecting paintings. By the middle of the century, however, the practice of drawing and limning (see cat. 6) had begun to be taken up not only by princes and aristocrats, but by members of the landed gentry or the sons and daughters[3] of the first generation of the 'professional' civil servants who had acquired titles, land or wealth by serving at court.

Gentlemen *virtuosi*

In this study, Prince Rupert, John Evelyn and Francis Place represent the substantial number of men from a broad spectrum of society in the seventeenth century who viewed the ability to draw as an enjoyable and useful activity. John Aubrey, William Courten, Robert Hooke and a number of others, many of whom were members of the Royal Society, took prospects while on their travels on the Continent, illustrated their own experiments and drew plans for their gardens or views of their estates. None of these men would have described himself, as we would today, Aubrey as a writer, Courten a collector or Hooke a scientist; rather these activities, like their drawing, were only a part of their varied lives – they referred to themselves as gentlemen, and hoped to merit the appellation *virtuosi*.

Henry Peacham (1578–c.1643) was the first to use the Italian term *virtuoso* in an English publication. The third edition of his courtesy book *The Compleat Gentleman*, published in 1634, was a compilation of his earlier treatises on drawing and other gentlemanly exercises to which he had added a new section on collecting classical antiquities, statues, inscriptions and coins. Because of the rarity and cost of these objects, he noted that they 'properly belonged to Princes, or rather to princely minds ... Such as are skilled in them, are by the *Italians* termed *Virtuosi*.'[4] When he had originally recommended that gentlemen should learn to draw, in his treatise of c.1609 (see Chapter 2), it was because of its usefulness to military men and travellers, and in order to communicate ideas and things they had seen. When he later additionally recommended collecting objects of *vertu*, however, Peacham was addressing a different audience. These British collectors were not mere 'gentlemen', but 'Princes, or rather princely minds', like his patron the Earl of Arundel, the Duke of Buckingham and Prince Henry, who before his death had begun a collection that his brother, Charles I, had successfully built upon. Peacham's British *virtuosi* were worthy inheritors of the Italian title and had formed three of the greatest such collections the country would ever see.[5]

Through the century, however, the term *virtuosi* underwent a remarkable evolution. By the mid-century, from being a

complimentary appellation suited only to princely collectors, it had come to mean someone who collected not just objects but knowledge for its own sake. By the end of the century, the character of a *virtuoso* had deteriorated so far that he could be criticized as one who 'Trafficks to all places, and has his Correspondents in every part of the World; yet his Merchandizes serve not to promote our Luxury, nor encrease our Trade, and neither enrich the Nation nor himself'.[6]

The word 'amateur' in modern usage, someone who cultivates an activity he or she enjoys purely as a pastime or, more familiarly, who practises 'art for art's sake', has evolved ultimately from the seventeenth-century term *virtuosi*, who were seen, incorrectly, as men who accumulated knowledge for knowledge's sake. These men have been treated with the same neglect accorded to the amateur by our age of specialists. Houghton, the first student of this subject, defined an English *virtuoso* as an antiquary and collector, a student of politics, geography, history, science and natural philosophy. The main prerequisite was that he should possess both money and leisure, and the resulting character was a combination of two English traditions – the courtier and the scholar, the 'gentleman-scholar'.[7] What then are we trying to say about the activity of amateur drawing by starting with an examination of a group of men titled *virtuosi*, represented by Prince Rupert and John Evelyn in the middle of the century and the work of the circle active in York at its end? By placing their activities as draughtsmen within the context of their lives as *virtuosi*, we shall be better placed to understand how they themselves viewed that activity – whether as a useful accomplishment or a polite recreation.

Prince Rupert is an ideal figure with whom to begin our examination of a true *virtuoso* whose multifarious activities included drawing. Through his mother Elizabeth, the cultured 'Winter Queen' of Bohemia, Rupert was a grandson of James I, the nephew of Charles I and uncle of Charles II. Born during his father Frederick V's brief reign in Bohemia, he held a prince's title and was given a princely education, but since his parents had no throne, he was to spend his life as a courtier at other kings' courts. Just as Elizabeth's brothers in England, the princes Henry and Charles, had received lessons in perspective and fortification for military reasons, and may also have had some lessons in painting, so the 'Winter Queen', exiled in the Prince of Orange's court at The Hague, ensured that her sons and daughters shared her own lessons in painting and drawing with Gerard van Honthorst. Rupert apparently showed an early aptitude for drawing and sketching, and his sisters shared his ability. His elder sister, Princess Louisa Hollandina (1622–1709), went on from limning to painting portraits in oil, and was described as 'rarely accomplisht' by John Evelyn when he visited the court in 1641.[8] Her sister Sophia, later mother of George I, also painted in oils, and turned her talent for drawing towards designing her own remarkable pieces of needlework. At the University of Leiden, Rupert studied mathematics, natural science, chemistry, perspective and fortification, and apparently himself chose to abandon the classics for modern languages. The university was one of the greatest seats of learning of the age and his sisters benefited enormously from the tuition they received from professors there, particularly in classics and philosophy.[9]

Rupert spent a brief period at Oxford in 1636, the year he produced his first etchings (cat. 2). His military career began shortly afterwards and included a spell in the company of the Sienese artist Giuliano Periccioli (*c*.1600–46), whom he had brought from England where he had designed scenery for English court masques and had been drawing master to Prince Charles. Periccioli probably taught Rupert topographical drawing while acting as a military draughtsman.[10] During three years' incarceration as a prisoner-of-war from 1638, Rupert put the time to good use practising his drawing and etching and perfecting an instrument for drawing in perspective, which he claimed Dürer had devised but been unable to make practical.[11]

Rupert's biographers have all concentrated on his military activities during the Civil War, so we know little of his contact with the many English artists who fought on the same side, including Inigo Jones and William Dobson, whose portrait made of him in Oxford was later engraved by William Faithorne (cat. 70). After the war, Rupert was constantly travelling from one European court to another, in a diplomatic or military capacity, and apparently insatiably acquired new mechanical, scientific, medicinal and artistic skills wherever he found them. During these travels he developed the potential of the new art of mezzotint engraving (see cat. 2), refined a more powerful gunpowder, discovered the properties of glass drops that could not be broken with a sledgehammer unless hit on the tail (still known as 'Rupert's drops') and refined a quadrant for measuring altitude at sea. On his return to England in 1660, he found an eager audience for his inventions in the newly established Royal Society.

After seeing action against the Dutch in the mid-1660s, Rupert was made governor of Windsor Castle in 1668 and was able to set up a forge and laboratory where he could continue his experiments, particularly in ordnance, which included the development of new metal alloys, a prototype revolver and a new method of boring with hydraulic power. The historian George Vertue noted that Rupert was patron of Valentine Lefèvre (b. Brussels, d. 1677, London), who had a 'Particular Excellence in Staining Marble', and that Rupert himself painted and stained a piece of marble with a composition of *The Woman taken in Adultery*, which was included in a sale after his daughter's death.[12] John Evelyn toured Rupert's keep at Windsor, which he had repaired and decorated

with furniture of arms, which were very singular, by so disposing the pikes, muskets, pistols, bandeliers, holsters, drums, back, breast and head pieces, as was very extraordinary … all new and bright, so disposing … as to represent festoons, and that without any confusion, trophy like. From the hall we went into his bed-chamber, and ample rooms hung with tapisserie, curious and effeminate pictures; so extreamly different from the other, which presented nothing but war and horror.[13]

With his laboratory, forge and mechanical and military inventions, and his decorative display of the means of war in close conjuction with the products of peace, Prince Rupert was

indeed the embodiment of Houghton's 'gentleman-scholar'. It was, however, his constant experimentation and attempts to improve the inventions of others that brought him closest to men such as John Evelyn and the *virtuosi* of the Royal Society.

One year younger than Prince Rupert, John Evelyn was born at Wotton in Surrey, the younger son of a gentleman whose family's fortunes had been based on the manufacture of gunpowder. At the age of four, to avoid the plague, he was sent to live with his maternal grandparents near Lewes, in Sussex, where he attended various day schools and 'tooke [an] extraordinary … fansy to drawing and designing', which his father did his best to discourage as a waste of his 'precious tyme'.[14] After Evelyn was sent to Balliol College, Oxford, in 1637, his tutor joined his father in deprecating drawing and painting as appropriate only 'as his recreation, not as his busniss'.[15] A lovely pen and ink washed landscape of the family home at Wotton, drawn in 1640 when he was twenty, shows a skilled amateur hand with a good eye for a prospect, but encountering difficulties with perspective and figures, evidence that he had complied with his father's wishes and confined drawing to his spare time.[16] The family no longer ran the gunpowder mills, and Evelyn was educated in the Christian humanist tradition of expecting to be of service to the state. Unfortunately, in 1641, when his education at Oxford had ended and he had begun his studies at the Middle Temple, the state was in disarray. His father died that year, leaving him £4,000, and he decided to make a brief tour of the Netherlands. After returning to his brother's estate at Wotton, he made his first alterations to the garden there, the beginning of what was later to become one of his leading passions.

Towards the end of 1643, Evelyn left the turmoil in England to complete his studies abroad, visiting the European courts and universities, taking notes and picking up useful pieces of information to fill his insatiable curiosity and desire for knowledge. After a year in Paris and the south of France, he moved on to Italy. Like many travellers who were to follow him, he found a use for his ability to draw by taking prospects that he wished to remember along the way (cat. 3), but he also employed his skill for his studies, and in the Vatican made a pen and ink sketch, the *Ezekiel receiving the word of God*, from a miniature in a twelfth-century manuscript on the Prophets.[17] He recognized nascent artistic talents in others and commissioned drawings of the relief on the Arch of Titus and other classical antiquities from the young Carlo Maratta (1625–1713).[18] These were not only evidence of his interest in drawing, but indications of the seriousness and depth of his studies abroad. He returned to England via Padua, where he studied anatomy, and Paris, where he took careful notes through a course of chemistry, intending them for publication.[19] Back in England in 1649, he etched his views of Italy and had them published for the benefit of those who had never been there (cat. 4) and planned another series of views along the Thames in order to celebrate London's beauty at home and abroad. The project was abandoned when Charles I was executed, and Evelyn spent his years in Paris from 1649 to 1651 collecting and commissioning prints rather than making them.[20]

After his marriage and return to England he settled at his wife's family's estate, Sayes Court in Deptford, and began to make improvements both to it and to his own family's home at Wotton. He recorded the latter in a privately printed etching titled *Wotton in Surrey The house of Geo: Evelyn Esqr. taken in perspective from the top of the Grotto by Jo: Evelyn 1653*, an image that included most of the estate, focusing on his newly laid-out garden and fountain in the foreground and newly planted walled orchard and walk on the right.[21]

This list of what appear to be various attempts to find a calling could be continued by tracing Evelyn's plans and various publications for colleges, gardens, libraries, histories and even hospitals: in fact, his entire life reads like a litany of earnest interests and studies, and his endeavours to turn them to use. But it has been well studied elsewhere and the recent acquisition of his manuscripts by the British Library provides a treasure-trove of material still to be mined. The focus here is on one particular facet of his life that situates his activities as an amateur draughtsman within those as a *virtuoso*: his involvement with the Royal Society.

The Royal Society as 'Solomon's House'

The charter granted to the Society by Charles II on its public incorporation in 1662 stated that 'its studies are to be imployed for the promoting of the knowledge of natural things, and useful Arts by Experiments. To the glory of God, and the good of mankind.'[22] The Society had been founded two years earlier by a group of men, some of whom had first met in Oxford in the late 1640s. When Christopher Wren joined them to study mathematics and physics in 1650, the group was led by John Wilkins (1614–72), the main popularizer of the new natural philosophy, and included the mathematician John Wallis (1616–1703) and the multi-talented architect and later curator of the Society, Robert Hooke (1635–1703), all of whom conducted experiments to further knowledge through the accumulation of empirical data and observation. John Evelyn was already convinced by the need for more empirical knowledge when he met Wilkins and his circle in Oxford in 1654, and heard of the first attempts to create a 'college' in which to institutionalize the new science.

The crucial difference between this college and the existing type at Oxford and Cambridge was that rather than being a teaching institution, it was to be purely for research. Its main aim was to help to provide a focus that would enhance the new philosophy and assist in the attempt to make it an accepted part of the establishment. Evelyn contributed his own ideas for the college and even drew up a perspective plan showing the buildings, Baroque in style and Renaissance in plan, laid out symmetrically around a central fountain and including a laboratory, a conservatory of rare plants and a pavilion repository for an archive and collection.[23] Not enough money was forthcoming for the Society to establish its own buildings, but Evelyn's ideas provided one of the main roots for the foundation of the Royal Society two years later in 1660.

Evelyn made drawings of alternative coats-of-arms and

mottoes for the Society, and in 1667 when Thomas Sprat's *History of the Royal Society* was published, he provided the design for the frontispiece engraved by Hollar.[24] With regard to his activities as a draughtsman, however, these are minor contributions in comparison to the enormous one he was to make to the Royal Society and to the arts in Britain through his involvement in the history of trades. This was a project for describing technical practices, which had first been advocated by Francis Bacon and then taken up by many of Evelyn's contemporaries and, institutionally, to a large extent thanks to Evelyn, by the Royal Society.

Early in the 1650s Evelyn had begun to keep a manuscript volume titled '*Trades*. Seacrets & Receipts Mechanical' in which he noted such information as it came to hand according to a table. The table consisted mainly of an alphabetical series of a comprehensive range of skills from baking to bell-founding, but was followed by further categories: 'Meane & Frippery Trades', 'Servil Trades', 'Polite Arts & Trades', 'Exotick Arts & Trades', 'Trades, more Liberall', 'Femal Trades & Arts' and 'Occupations in & about the Country'.[25] Evelyn worked on it from 1652 to 1656 and in 1661 presented it to the Royal Society with slightly different headings as a contribution to its own technological programme.

Evelyn only managed to describe a few of the secrets and trades in detail, but they show a commitment to knowledge that would be of particular use to British trade, economics and the navy.[26] The most interesting descriptions appear under the 'Polite' and 'Exotick' categories, and include skills that relate to his interest in the pictorial and decorative arts: mixing and applying colours in painting with special reference to miniatures; a recipe for varnish; enamelling; mosaic; the use of shells for grottoes; making casts of statues; an improved way of making marbled paper and a recipe for gilt varnish. The last two items were presented as papers to the Royal Society in 1661.[27]

Evelyn found, however, that he did not have the ability to converse with 'mechanical capricious persons', and the magnitude of his design overwhelmed him. He abandoned his 'general' history of trades and instead concentrated his efforts on the '*virtuoso* trades', which interested him more and which included etching and engraving, hoping eventually to publish them 'for the benefit of the ingenious', and 'as a specimen of what might be further done in the rest'. However, writing in 1657, during the political turmoil of the Interregnum, he found even this too much:

I have since been put off from that design, not knowing whether I should do so well to gratify so barbarous an age (as I fear is approaching) with curiosities of that nature, delivered with so much integrity as I intended them; and lest by it I should disoblige some, who made those professions their living; or, at least, debase much of their esteem by prostituting them to the vulgar. Rather, I conceived that a true and ingenious discovery of these and the like arts, would, to better purpose, be compiled for the use of that Mathematico-Chymico-Mechanical School designed by our noble friend Dr Wilkinson [sic], where they might (not without an oath of secresy) be taught to those that either affected or desired any of them: and from thence, as from another Solomon's house, so

much of them only made public, as should from time to time be judged convenient by the superintendent of that School, for the reputation of learning and benefit of the nation.[28]

This passage is important for two reasons. Evelyn clearly felt that to divulge these secrets under Cromwell and parliament's rule would be to cast pearls before swine, and that the nation would not benefit as it should: such technical secrets would be better filtered through something equivalent to the 'college' proposed in 1654. This problem was answered when Charles II returned and the Royal Society was able to fulfil its function as a 'Solomon's house' through its meetings and publications. And indeed, Evelyn did begin to achieve his intentions by revealing some of these 'secrets' to the Society's meetings in 1661 and by publishing a 'specimen of what might further be done in the rest' in *Sculptura*, his history of engraving, published by the Society in 1662. But his letter is also important for revealing his reservations as to his own status as an amateur, in relation to the work of skilled craftsmen who were professionals. When writing it, he had already encountered the problems involved: in one instance he had given a 'secret' for gilding frames, which had been passed to another *virtuoso* who had taken out a patent on it; he had given a similar recipe to a craftsman and was reprimanded by another *virtuoso* who was using it himself and had been 'passionately troubled' to find a tradesman in possession of it.[29]

This problem of amateur versus professional raised its head again when Evelyn published *Sculptura*. He had intended to include an appendix that translated Abraham Bosse's account of etching and printing with a rolling press, but deferred to William Faithorne on learning of the engraver's forthcoming publication of Bosse's treatise. Another and even more important 'secret' with relation to engraving had been imparted to him through Prince Rupert's demonstrations to the Royal Society of the technique of mezzotinting, and it therefore became immediately clear to him that the benefits of this technique to the art of engraving, and particularly to the practice of this art in England, far outweighed any compunction he might have had about 'prostituting' such secrets by exposing them to the vulgar. By arranging for Rupert to provide him with an example to use as a frontispiece and obtaining his permission to publish the secret in a deliberately obscure way so that the actual method could only be imparted personally to 'any curious and worthy person', he found a way of at least signalling to the artisans that this technique could be available to them through the *virtuosi* for the improvement of the art in England.

Both Evelyn and Rupert realized that the technique was capable of revolutionizing printmaking, but felt that it needed to be refined by men who had the money and leisure to devote to and develop it properly before it was taken up and diffused in a cheap and unworthy manner by those whose need was more to make a living than to further the art. This would seem to be what Evelyn meant by his statement in *Sculptura* that he did not wish the technique to be 'prostituted at so cheap a rate as the more naked describing of it here would too soon have expos'd it to'. It is confirmed by his own earlier reservations on abandoning the publication of the history of trades, when he wrote to

Robert Boyle (1627–91) that whereas currently such pursuits were the preserve of 'persons of a mean condition', whose 'necessity renders them industrious', if 'men of quality made it their delight also, arts could not but receive infinite advantages, because they have both means and leisure to improve and cultivate them'.[30] Evelyn firmly believed in the role of an élite but was disappointed in it, and much of his later intellectual effort was aimed 'to incite an affection in the Nobles of this nation' towards *virtuoso* knowledge. To this end, he was prepared 'to open to them so many of the interior secrets, and most precious rules of this mysterious art, without imposture, or invidious reserve'.[31]

Evelyn's activities in connection with the suppression of the technique of mezzotinting reveals, however, a fundamental flaw in his reasoning. How many similar discoveries or practical ideas remained 'secret', awaiting refinements that the *virtuosi* who 'discovered' them neither had the time nor qualifications to make? Samuel Pepys (1633–1703) had the process demonstrated to him purely to satisfy his intellectual curiosity, and we are not aware of his ever making any prints or even drawings himself, although his wife was taught by Alexander Browne (cat. 34). Evelyn himself, even though he made several etchings and drew constantly throughout his life, never attempted to make, let alone refine, a mezzotint. Gentlemen such as Francis Place learned the technique and used it for a handful of prints privately distributed among their friends (cat. 21). Artists like Edward Luttrell were reduced to obtaining an imperfect idea of the process through deceit, and the Dutch rather than the English were the first to develop it commercially.[32] The whole process of engraving by mezzotint, in which English engravers were to excel above all others, was held up for decades by the public-minded ideals of the *virtuosi*, rather than being promoted and refined by them.

Virtuosi were, by definition, involved in acquiring knowledge in too many areas to make them the masters of any one. In addition, as soon as they applied themselves to the refinement and exploration of one artistic technique, they were in danger of losing their status as gentlemen and of acquiring the reputation of 'mere mechanical capricious person[s]'. As Evelyn's father and tutor, and many advisers to similar young gentlemen had warned, these activities were appropriate only as a recreation, not as a business. Artists trained for years to imitate nature with facility and to disguise the art and skill involved. If amateurs imitated nature too faithfully, they would indicate that they too had laboured long and hard to acquire this skill. By drawing badly, they emphasized their amateur status. Their ability in the practice of any art could not be allowed to approach that of a professional who practised that art as a trade for profit.

One further point might be made about the connection between *virtuosi* and the development of mezzotints in Britain. As a process kept for some time the exclusive preserve of amateur printmakers, it is not surprising that the first collectors were from the same group of curious *virtuosi*. Privately printed mezzotints produced by well-known *virtuosi* such as Prince Rupert or Francis Place, who had been introduced to the secret before the professionals, were eminently collectable and held a significant place in the cabinets of Evelyn, Pepys, Robert Hooke, Ralph Thoresby (see below) and Hugh Howard. A gentleman forced by economic necessity to turn professional artist, Howard had studied in Italy, but also used his time there to acquire the reputation of a *virtuoso*, and was eventually able to abandon painting for money and began to collect (cat. 13). One of the earliest collectors of mezzotints and rare artists' etchings,[33] he also owned drawings by Prince Rupert (cat. 80).

The Education of a *Virtuoso*

The *virtuosi* discussed so far demonstrate that the ability to draw was an activity that proved to be useful as well as pleasant throughout their lives. Evelyn not only drew prospects of his home and views in Europe, but he used drawing more practically to demonstrate plans for the proposed college, for the gardens he planned at Wotton and Sayes Court, and to illustrate details of processes in such projects as the book of trades. His library contained 'A portfeuile of rede draughts of landscapes, bildings, surveys, & other papers drawne by J. Evelyn casualy'.[34] Prince Rupert continued to use drawing for his various projects (cat. 80) and Hugh Howard, even after he gave up painting professionally, recorded landscapes that held personal connotations, in a non-professional style to underline his amateur status. Drawing had been introduced into their educations not because they showed an inclination and ability for it, but because it was a useful accomplishment, for utilitarian purposes. But like gentlemen who studied natural history, astronomy, chemistry and mathematics, they had to wear their knowledge lightly or it would compromise their status as gentlemen. Just as amateur artists could not show too much skill in their drawings or prints, men of leisure had time to acquire some understanding of these subjects, which men who had to earn a living did not, but a deep academic knowledge of any of them was the preserve of the professional scholar, not a gentleman.

But there were additional, less obvious, underlying moral reasons for studying these subjects and for learning to draw: if men of leisure did not fill their time this way, they were prone to boredom and 'melancholy', a malady greatly feared in the seventeenth century.[35] Even before Peacham advocated these subjects in his *Compleat Gentleman*, Robert Burton could recommend no better remedy than their study in his *Anatomy of Melancholy* (1621).[36] They had the additional benefit of being a way to strengthen religion – by studying God's works closely in this way and seeking to discern the meanings behind the miracles of Nature, these gentlemen were conducting a form of religious pursuit. Finally, and perhaps more important, was the ancient theme of 'Idle Hands – Devil's Work': as the century went on and more well-educated young gentlemen had trouble finding suitable employment, if time was spent on these innocent and sometimes useful diversions, they would not devote it to other less innocent pursuits. These underlying motives are reflected most clearly in the prospectus and published lectures that are all that remain of Balthazar Gerbier's short-lived academy at Bethnal Green.

An artist and courtier, Gerbier (cat. 5) had acted as an agent, then diplomat, collecting paintings and information in Europe for the Duke of Buckingham and then Charles I. A great friend of Rubens, who had painted Gerbier's family at the height of his career as a diplomat, and the king's 'Master of Ceremonies', Gerbier had fallen on hard times when he attempted to set up his academy in Bethnal Green in 1649.

Gerbier's prospectus offered to teach those young gentlemen 'intending to travel or merely avid for learning' all 'the Languages, Arts, Sciences, and Noble Exercises'. The list of subjects proposed was truly impressive, especially considering that Gerbier undertook to teach them all himself. Including nearly all the modern European languages, it also proffered ancient, modern and constitutional history, experimental natural philosophy, arithmetic, book-keeping, geometry, cosmography, geography, perspective and architecture – all the subjects referred to above as proper for a gentleman's education, but impossible for a mere tradesman to acquire. In addition, drawing on his experience at court masques, Gerbier offered to teach 'building as for magnificent Shewes, and secret motions of Scenes & the like', fortification, fireworks, music, dancing, fencing, and riding:

And if there be any lovers of Vertue, who have an inclination to Drawing, Painting, Limning and Carving, either for their curiosity, or to attain unto a greater excellency in severall of the forementioned Sciences (*viz* Architecture, Fortifications, etc.) they may have them as exactly taught as any of the other Sciences.[37]

Uniquely qualified by his many earlier travels and occupations, Gerbier lectured on most of the subjects himself, but he invited any person to speak or read at the public lectures on Wednesdays. His academy was not aimed exclusively at wealthy young men: he offered to lend part of the fees without interest to those who wished to attend while continuing to earn livings with their trades. Gentlemen of more mature age were welcome to attend for shorter periods to 'satisfy their curiosity in any kind, whether for enriching their mind or for honorable profit'.[38] There would also be an open hall for some poor children of the parish or those received by the authorities to learn gratis such sciences as were seen to be fit for them.[39] Fathers and mothers ('mutually interested in the good educations of their Sonnes') were also invited to attend the Wednesday lectures:

As I thought it not strange, that Sundry Ladies of Honour, and other Gentlewomen (though their vocation is not the maintaining of Arguments, and Theses in any Universities, Academies, or Free-Scholes) would be satisfied by their own hearing of this Academicall institution … as you will soon perceive; that it doth not only concerne the glory, and good of the Nation in generall, but particularly of this great and famous City, which ought not to yeeld to any other in the World, and therefore not to be seeke leeke in the possession of one Academy, when Paris maintains twelve, besides a number of Universities, and famous Free Schooles, and that there should not be any more cause or ground for Paris to pretend unto the dignity of a second Athens then London. [He wished] to attract Italians from Padua, Spaniards

and French to this academy to learn what have hitherto wanted in theirs: to turn unto God and live in righteousness.[40]

Shortly after a grand opening on 19 July 1649, the public lectures had to be abandoned because of the 'extraordinary concourse of unruly people who robbed him and treated with savage rudeness his extraordinary services'.[41] When Londoners seemed reluctant to travel as far as Bethnal Green in the winter, he removed the academy to Whitefriars. In a final great effort to publicize it and to make some money from the venture, at the end of 1649 Gerbier published a two-volume work, printed in French and English, containing the texts of all his lectures, which could be used as a pattern for instruction. Entitled *The Interpreter of the Academie for Forrain Languages; and all Noble Sciences and Exercises*, and addressed to 'all fathers of Families and Lovers of Vertue', the second volume was devoted to military architecture or fortifications, and was illustrated and intended for use as a vade-mecum. But the first volume, consisting of 203 pages, included lessons on all the other arts, including a large section on 'Perspective, Picture Drawing & Painting, Carving, Sculpture and Architecture' (pp. 152–85). Walpole and other eighteenth-century writers, knowing only Gerbier's reputation for treasonous diplomacy and numerous other failed ventures, and knowing his academy only through the published lectures, dismissed his attempt to set up the academy as the folly of a dilettante who knew too little of too much. They misunderstood his 'superficial' approach through being unaware of its intellectual context and the need for gentlemen of this date to wear their learning broadly and lightly.

As a result, Gerbier's well-informed examination of the styles and merits of various Renaissance and contemporary masters has been ignored in modern discussions of connoisseurship and courtesy books. It reflects what Gerbier thought to be the current state of a typical travelled gentleman's knowledge of the history of various arts, their merits and uses. At the end of the volume, the tutor, who has been instructing a page, states: 'I have mixt my discourses with diverse things, which will give you occasion to speake in good company, a custome yourselfe to vertue, its pleasiour, its profit, and the honour thereof will remaine with you, and you will forget the labour of the study.'[42]

Views and the York *Virtuosi*

One of the main aims of Gerbier's academy was to prepare young gentlemen for study and travel abroad. The Grand Tour and its influence on British culture, taste and art has been most familiarly associated with the eighteenth century.[43] But in the previous century attendance at the great courts, universities and religious colleges of Europe was among the expected experiences of vast numbers of British courtiers, gentlemen and scholars. Extensive studies have been made of the British abroad in the seventeenth century and the effect of their travels on the taste, education and politics of their time.[44] The prospects taken, views drawn and studies made by amateurs on these travels provide some of the most fascinating, as well as visually attractive, drawings and watercolours throughout the two

centuries covered by the present study. But they also provide a welcome insight into the ways and means of drawing for those who did not travel, as professional artists did, for the express purpose of studying and improving their art. Since previous attempts to examine the effect of travelling abroad on British landscape paintings and drawings have been concerned with the work produced by artists, landscapes produced by amateurs should provide a revealing wider context.

Prince Rupert's portrait by Van Dyck, painted around 1632–6, incorporates a landscape background based on a drawing sketched out of doors by the artist, whose watercolour landscapes are amongst the most beautiful works in that medium produced in the seventeenth century.[45] If any amateur had the potential to make a significant contribution to British landscape through his or her experience, it should have been Rupert. But his own landscapes seem to have been imaginary and his amateur artistic activities abroad were more concerned with collecting empirical information and mechanical processes, and he utilized his ability to draw to this end.

Too few works by non-professional travellers survive before the last quarter of the century to provide much more than speculation. Even in the last quarter there are little more than a few hints, provided mainly by a handful of drawings by Thomas Manby, John Talman, Francis Place and some etchings by William Lodge (cats 7, 9, 14–23).

From the little information available about Thomas Manby before his death in 1695, he had been several times to Italy, painted landscapes in the Italian manner and brought back paintings, which he sold in London at one of the first sales of this type (see cat. 7). Not a single work in oil attributed to him is known,[46] which would seem to indicate that he did not rely solely on his art for a living. Professional or amateur, he was one of the first native-born landscape painters in Britain, but only eleven drawings by him survive.[47]

In the context of what had appeared in English art previously, Manby's drawings are a revelation, for which the only precedents are in drawings by Italians, northern artists working in Italy or the work of other English amateurs who had themselves been abroad. Amateurs like John Evelyn did not study such works when they began to draw a landscape – they merely attempted to record what they saw in front of them. They drew from nature: the view may have attracted them through personal association, or because it reminded them of an idealized painting they had seen. On tour, the reason would most likely have been because it was a famous or striking view. Rather than trying to reinterpret it through imagination as a professional artist might, the amateur would set out to record what he saw with whatever skill he already possessed. Manby's approach to the Colosseum, Castel Sant' Angelo or the ruins of Hadrian's villa was more akin to that of an amateur, with a directness seemingly drawn from nature. But because he must have seen drawings by Dutch artists working in Italy, such as Bartholomeus Breenbergh (1598–1657) or Jan Asselyn (1610–52), he was aware of how to draw with the brush and wash, with light and shade, rather than trying to tackle nature directly with a pencil or pen outline.

Landscape drawing in Britain therefore fell into three categories: views of real places, especially of great houses or estates, but more usually the strictly topographical approach best exemplified by Wenceslaus Hollar and by Talman and Place who drew in his manner; the imaginary ideal landscape, reserved mainly for oils at this time, but gradually used in drawings that were influenced by prints after them, like Prince Rupert's landscape; and the natural landscape, either drawings or watercolours of a detail of nature, an object like a ruin or a small part of a larger composition, drawn or painted entirely on the spot as Van Dyck had done in the first half of the century, or sketched *in situ* and worked up later, but allowing the natural impression to dominate.

Drawings of the first two types had a more public purpose, as a record of a view or an ideal landscape, both of which might be distributed through an engraving or display in an album. Drawings of the third type, however, were more private: seldom 'finished' in the traditional sense, they were similar in use to a sketch and could either be used for a larger composition – rarely the case in the work of an amateur – or kept as a personal record. Manby's drawings fall into this last category, as do those by Howard and some by Francis Place, who never visited Italy himself but toured Britain and took prospects, providing an unmatched detailed record of cities and coasts of the time. Place used this topographical style for works he intended to be engraved, but in the 1680s he adopted the looser personal type of landscape for some of his drawings of the area around York, confirming that the style was employed for more private rather than public purposes. He also collected works by Hollar, Francis Barlow, Thomas Wyck and Jan Lievens, and owned all Manby's known drawings, but because his collection and own drawings remained in his family's hands until 1931,[48] they directly influenced only a few of his contemporaries – his fellow *virtuosi* at York and their circle of acquaintances in London (see cats 14–23).[49] To modern eyes, these natural and comparatively unfinished works are the most attractive; that they survive at all seems to be due to the fact that they were made by men who considered themselves *virtuosi*, and their drawings had a value not in the marketplace, but only for themselves or for other *virtuosi*.

Educated as a lawyer, but with sufficient financial independence not to have to practise law, Place was able to follow all the directions in which his interests and inclinations led him. His engagement with printmaking, painting, drawing and collecting not only works of art but also, like his fellow York *virtuoso* Ralph Thoresby,[50] natural and artificial rarities, his experiments with pottery and glazes,[51] and his passion for angling and travelling throughout Britain, all typify a *virtuoso* of the end of the seventeenth century, who gathered knowledge for its own sake and to satisfy his curiosity and that of his circle, but with little concern for its benefits to the nation or society in general. The civic humanism, which had formed the underlying motives of earlier *virtuosi* such as Evelyn, had not been entirely smothered, however, and found a different means of expression in the 'ingenious pursuits' and 'polite recreations' of men and women of the eighteenth century.

NOTES

1 See Bermingham 2000, ch. 1 for the most recent discussion and an extensive bibliography on Castiglione, Elyot and the role of drawing at court in the sixteenth century. I have drawn most heavily in the following account of the growth of the gentleman-scholar and *virtuoso* on the two 1942 pioneering articles by Houghton.

2 Pears, 10.

3 This chapter is mainly concerned with examples of drawing by male *virtuosi*; for the earliest limning, see Bacon (cat. 52) and for examples by women, see cats 24, 29–30 in Chapter 2.

4 Houghton, 52.

5 See MacGregor 1989, *passim*.

6 Mary Astell, *An Essay in Defence of the Female Sex* (2nd edn, 1696), quoted in Houghton, 53.

7 Houghton, 51–9.

8 Many of Louisa's portraits are now in various English collections. See Roberts 1987, 43–7, for her self-portrait, and further details on all these royal pupils.

9 Rupert's third sister, Elizabeth, studied Greek and Latin, attended the lectures of Anna Maria von Schurman, and was a disciple and correspondent of Descartes. See Elizabeth Godfrey, *A Sister of Prince Rupert. Elizabeth Princess Palatine and Abbess of Herford*, 1909, 51–112.

10 ECM & PH, 473–4; and Vertue I, 114.

11 Kitson 1994, 67; Prince Rupert's 'perspective' machine was a mechanical tracing device, demonstrated at the Royal Society in November 1663 and improved by Hooke (see Latham and Matthews VII, 51 n. 4). See also Kemp, 172–84.

12 Vertue II, 147; V, 7. Sir Hans Sloane's collection of 'Pictures and Drawings in Frames' (BM P&D) included as no. 196 'A picture made on white marble which is stain'd with red'.

13 De Beer III, letter 28 August 1670, 349, quoted in Kitson 1998, 244.

14 Hofmann *et al.*, 13.

15 Hunter 1995, 71.

16 Hofmann *et al.*, reproduced 46.

17 ECM & PH 1.

18 Nicholas Turner, *Roman Baroque Drawings c.1620–c.1720 in the British Museum*, 1999, no. 168.

19 Hofmann *et al.*, 26.

20 Griffiths 1998, nos 80–1.

21 P&D Reg. no. 1838-5-30-7 (c.190*.a1).

22 Thomas Sprat, *History of the Royal Society*, 1667, 134.

23 Hunter 1989, 181–4.

24 Ibid., 41–3, pls 1, 2.

25 Hunter 1995, 75, where spelling is taken from Evelyn's original MS 65. Most of the following information about Evelyn's project is taken from his discussion (75–82). See also Walter Houghton, 'The history of trades: its relation to seventeenth-century thought as seen in Bacon, Petty, Evelyn, and Boyle', *Journal of the History of Ideas* II (1941), 46–8, 52–6. For its relationship to William Aglionby and, later, Jonathan Richardson's attempts to write a history of painting, see Gibson-Wood 1989, 181–6.

26 In some ways this prefigures his work on the benefits to the nation evident in his most famous work *Sylva, or a Discourse of Forest-Trees*, published by the Royal Society in 1664. See Hunter 1995, 78–9.

27 Ibid.

28 Quoted from de Beer III, 92, in ibid., 80.

29 From the Evelyn MSS, in ibid., 81.

30 Quoted from de Beer III, 84, in ibid., 83.

31 Quoted from Evelyn's *Miscellaneous Writings*, 433 n. 13, in ibid., 83.

32 Griffiths 1998, 218, 254.

33 For mezzotints in his collection, see Sheila O'Connell's essay, 'William Second Baron Cheylesmore and the taste for mezzotints', in Griffiths 1996, 143 n. 10, 148, and Griffiths, 1998, no. 178,9; for artists' own etchings, see ibid., no. 66 by Peter Oliver, no. 113 by Isaac Fuller.

34 Griffiths 1993, 66 n. 7.

35 Although melancholy and the 'divine pleasure of solitary meditation' had been cultivated in the late Elizabethan period, it came to be feared as evidence of idleness and dissipation in the seventeenth century (see Roy Strong, 'The Elizabethan malady', *Apollo* LXXIX, (1964), 264–9). Evelyn's portrait by Robert Walker of 1648 (NPG), originally portrayed him in a melancholic pose, missing his young wife, and in 1655 was altered to reflect a new preoccupation with the consolations of a Christian death (see Malcolm Rogers, *FMR* 66, XIV (February 1994), 15–18).

36 Houghton, 63–4.

37 Balthazar Gerbier, *To All Fathers of Noble Families, and Lovers of Vertue*, (advertisement for his academy), 22 July 1649.

38 Ibid.

39 Id., *The Interpreter of the Academie for Forrain Languages; and all Noble Sciences and Exercises*, 1649, 6.

40 Id., *Publique Lecture on all the Languages, Sciences and Noble Exercises, which are taught in Sir Balthazar Gerbier's Academy*, 1649, 1–2.

41 Quoted from Lyson's *Environs of London* in H. R. Williamson, *Four Stuart Portraits*, 1949, 27, which is the fullest account of Gerbier's life to date.

42 Gerbier, *The Interpreter ...*, I, 185.

43 See Ingamells, and Bignamini and Wilton.

44 See J. Stoye, *English Travellers Abroad 1604–1667*, 1952, and Yale new edn, 1989; Edward Chaney, *The Grand Tour and the Great Rebellion: Richard Lassels and 'The Voyage of Italy' in the Seventeenth Century*, Geneva and Turin 1985, and *The Evolution of the Grand Tour*, 1996.

45 The painting is in the Kunsthistorisches Museum, Vienna; see Royalton-Kisch 1999, 96–7. Van Dyck's landscape drawing may depict a Sussex landscape, and later belonged to Jonathan Richardson and Payne Knight, who bequeathed it to the BM (Oo.9-49).

46 Barber, no. 43, where she notes that the landscape background Manby was thought to have painted in Mary Beale's portrait of the Countess of Clare at Welbeck was an incorrect identification, and the location of the portrait he worked on is not known.

47 Because they survived as a group and could not be compared with any other works by Manby, there remains a small element of doubt about their attribution to him, which is based on the inscriptions. See literature for cat. 7.

48 A group of drawings by Place came to the BM through his descendants in 1850, and the rest of his collection remained with the family until the Patrick Allan-Fraser sale, Sotheby's, 19 June 1931. See Tyler, 38–9. For the attributions of the drawings in Place's collection, see Williams, 6,9.

49 For the York *virtuosi*, see Hugh Honour, 'York Virtuosi', *Apollo* 71 (1957), 143–5; Tyler, *passim*; Alberic Stacpoole, ed., *The Noble City of York*, York, 1972, 856–9; for their correspondence, see Hake, 59–68.

50 For Ralph Thoresby and his collection, see *Musaeum Thoresbyanum*, 1715, J. Hunter, ed., *The Diary of Ralph Thoresby*, 2 vols, 1830, and two articles by P. C. D. Brears and by D. P. Connell and M. J. Boyd in *Journal of the History of Collections* 1, no. 2 (1989), 213–24 and 10, no. 1 (1998), 31–40.

51 Tyler, 41–4.

1

PRINCE RUPERT (1619–82), Prince Palatine of the Rhine

1

Landscape

Graphite, with brown wash, 70 × 139 mm, on an old mount, 148 × 213 mm

Inscribed: on left tree *Rp* below a coronet; and on old mount by Jonathan Richardson the Elder, *Prince Rupert*; inventory marks inscribed on verso of old mount by same

ECM & PH 3; Stainton and White 99

Provenance: J. Richardson sen. (L. 2184); sale Cock's, 10 February 1746/7, lot 44 (one of five drawings), bt £1.11s.6d. [General?] Campbell; unknown until acquired by Sir Edward Marsh, by whom bequeathed through the National Art Collections Fund

1953-5-9-1

Today, Prince Rupert is a romantic figure, best known as Charles I's nephew, the dashing general of the King's Horse, the epitome of a cavalier. Forced to live abroad during the Interregnum, he returned to England after the Restoration, when he enjoyed some success as a naval commander against the Dutch fleet during the Anglo-Dutch wars. As a child he had grown up at the Dutch court in The Hague where his parents, Frederick V, King of Bohemia (cat. 5), and Elizabeth, 'The Winter Queen', had found a refuge after losing their throne in 1620. Their third son, Rupert was registered with his two brothers in 1628 at the University of Leiden, and was trained for a military career, in artillery, fortification and engineering, with a thorough grounding in mathematics and perspective. His mother shared her brother Charles I's cultural and artistic inclinations and, after lessons with Gerard van Honthorst, Rupert showed an early aptitude for drawing and sketching. On a visit to his uncle's court in 1636, his portrait was painted by Van Dyck and he was entered in the books of St John's College, Oxford.

It is not surprising, therefore, that although Rupert had to make his living as a soldier, once he settled permanently in England he became one of the *virtuosi* who dominated the cultural life of England at this time, and he was an early member of the Royal Society, founded in 1660.

Previous cataloguers have suggested that this drawing might be a study for an etching in the manner of Jacques Callot, but etchings were rarely prepared with shaded washed drawings. Neither Callot nor Stefano della Bella, whose etchings Rupert copied around this time (Hollstein 10,11), would seem to be the stylistic source for this drawing. Considering Rupert's knowledge of the work of Dutch landscapists and particularly Van Dyck, paintings by whom he owned, and who was sketching from nature in England when Rupert had his portrait painted by him, it seems more likely that the 1658 etching (cat. 2) and this drawing are imaginary landscapes for his own amusement.

Jonathan Richardson (1665–1745), whose collector's stamp appears in the lower right corner of this drawing and who was responsible for the mount, was, along with Van Dyck's pupil Peter Lely (1618–80), one of the most important early collectors of drawings in England. That this drawing found a place in his collection of works intended to illustrate the progress of art is an indication of the value Richardson placed upon it.

Literature: Roberts, 47–9.

2

(a) *'The Little Executioner'*, 1662

Mezzotint, with traces of burin, 130 × 164 mm

Signed upper right: *Rpf* surmounted by a crown

Hollstein 15

Provenance: H. W. Diamond; Messrs Smith, from whom purchased

1838-4-20-9

(b) *Landscape with a man driving a waggon*, 1658

Etching, 97 × 123 mm

Signed and dated: *Rp* surmounted by a crown

Hollstein 9

Provenance: H. W. Diamond; Messrs Smith, from whom purchased

1838-4-20-22

A great number of amateur draughtsmen made etchings, as the technique merely required the artist to draw on copper with a needle rather than on paper with a pen. An assistant could take on the washing of the plate in acid. Rupert's first etchings date from 1636, the year he first visited his uncle Charles I's court as a seventeen-year-old and was registered briefly at Oxford. He returned to The Hague to begin his military career later that year so it is not certain whether his earliest etchings were made in England or on the Continent. He is said to have etched during his imprisonment two years later, but it was not until the early 1650s that he took a more serious interest in various printmaking techniques, and produced his next dated prints.

During his peripatetic career in the courts of Europe with other royalists after the Civil War, Rupert developed his interests in various mechanical and artistic skills. In the 1640s a military officer, Ludwig von Siegen (1609–?80), had been experimenting with a technique that treated a plate for engraving so that it produced a grained black surface that could be scraped

to create an engraving with a previously unknown depth of light and shade. He appears to have shown the technique to Rupert in Brussels in 1654, who refined the tools used to grind the plate, making it easier to produce a finer, more evenly grained surface capable of creating a deeper velvety tone. A professional artist, Wallerant Vaillant (1623–77), collaborated with Rupert in scraping the plates, and the prince's first mezzotints of 1657–8 were remarkably accomplished reproductions of old master paintings thought at the time to be by Ribera and Giorgione.

The amateur von Siegen abandoned the process, but Rupert brought it to England where it was introduced through his fellow Royal Society member John Evelyn, an amateur and *virtuoso* who shared his fascination with printmaking. He first demonstrated the process to Evelyn early in 1661, when the latter was finishing *Sculptura*, his treatise on engraving. Evelyn persuaded Rupert to provide a detail from one of his first plates, *The Executioner*, as a frontispiece and gained permission to relate the process in the text, but in a deliberately enigmatic way. Rupert produced few further mezzotints in England, but the process remained in the hands of a few 'curious' amateurs in England for over a decade, until the work of Dutch printmakers began to make an impact on the English market and its potential became clear to professional painters and print publishers in this country.

Literature: Hollstein; O. Pissarro, 'Prince Rupert and the invention of mezzotint', *Walpole Society* XXXVI (1956–8), 1–9; G. Wuestman, 'The mezzotint in Holland', *Simiolus* XXIII (1995), 63–72; Griffiths 1996, 145–8; Griffiths 1998, 193–4, 212–14.

JOHN EVELYN (1620–1706)

3

Naples from Mount Vesuvius, 1645

Black lead, partly strengthened with red chalk, 104 × 141 mm

Inscribed: *Prospect from...*

ECM & PH 2

Provenance: H. J. Hosper, from whom purchased

1911-10-18-2

The younger son of a gentleman whose family's fortunes had been based on the manufacture of gunpowder, John Evelyn

was one of the first English amateurs known to have drawn landscape. By 1645, when he made the present drawing, he had already taken several prospects, both in England and *en route* to Italy, but apart from this drawing only a few sketches of his family's estate at Wotton survive. His diary relates his various delighted and astonished responses to the landscapes he and Thomas Henshaw, his travelling companion, encountered as they travelled through Europe, and the many occasions when he 'tooke a Landskip'. On 31 September 1644, on seeing the castle at Tournon, he wrote: 'the prospect was so tempting, that I could not forbeare to

designe it with my Crayon'. At the beginning of November, they climbed through the clouds to the travellers' inn at Radicofani and on reaching the top they came into a

most serene heaven … for we could perceive nothing but a Sea of thick Clowds rowling under our feete like huge Waves, every now & then suffering the top of some other mountains to peep through … This was I must acknowledge one of the most pleasant, new and altogether surprising objects that in my life I had ever beheld … Here we din'd, and I with my blacklead pen took the Prospect.

2(a)

2(b)

3

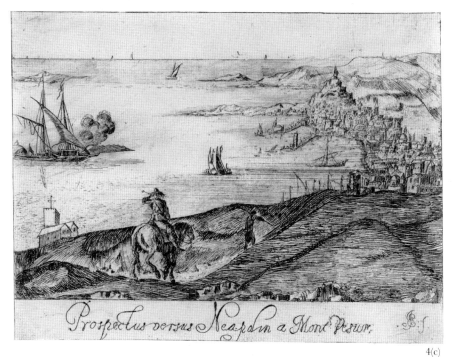

Prospectus versus Neapolin a Mont Vesur.

4(c)

Evelyn continued to draw in Rome where he wintered, and it is from there that the first evidence of his skill survives in a set of six etchings that he made from the drawings four years later (cat. 4). They were the souvenir of a memorable fortnight's journey to Naples and the surrounding area, for which he set out on 28 January 1645, with Henshaw, to whom the etchings were dedicated.

The British Museum's drawing of the view of the Bay of Naples from Vesuvius is the only drawing to survive from all the prospects and views Evelyn took on his travels. He and Henshaw made the climb on 7 February and when they reached the summit and turned their faces towards Naples, they were presented with 'one of the goodliest prospects in the World; & truely, I do not think there is a greater & more noble; all the Baiae, Cuma, Elysian fields, Capra, Ischi, Prochita, Messina … offer themselves to your view at once, & at so sweet & agreeable a distance, as nothing can be more greate & delightful'.

The wear of those travels and three and a half centuries, as well as the use of this drawing as the basis for an etching, have not been kind to it, and on its evidence, Evelyn was not a great draughtsman and had much difficulty with perspective. Of greater significance for us, however, is that regardless of his skill, he was so moved by this sight that he felt compelled to record it. His motives were not purely personal, however: his drawings recorded views never seen by most of his fellow countrymen and it was for their benefit that he etched them in 1649.

Literature: de Beer 11; John E. Bowle, *John Evelyn and his World*, London 1981; and see Hofmann *et al.*, for several reproductions of his other drawings.

4

Three etchings from the series
Six Small Views between Rome and Naples, 1649

(a) *Title-plate, dedicated to Thomas Henshaw, with a view in the Roman Forum*

(b) *Landscape with the twin peaks of Mount Vesuvius*

(c) *View of Naples from Mount Vesuvius*

Etchings, published by Richard Hoare,
110 × 145 mm, 98 × 140 mm (trimmed),
105 × 141 mm (trimmed)

Provenance: Purchased from William Upcott
in an album of drawings, etchings and other
material by Evelyn

1838-5-30-1,2,3

The six prints from this series, etched by
Evelyn himself in Paris in the second half of
1649, along with a set of five etchings of
imaginary landscapes published in London
earlier that year, form a remarkable group
for many reasons. Although etching had
been well established for a century on the
Continent, where royal amateurs like
Prince Rupert and Marie de' Medici
produced examples for private distribution
amongst their friends, it was almost
unknown in England before 1640. Evelyn's
etchings were thus amongst the earliest
produced in this country, and were cer-
tainly the first by an amateur. He had begun
to collect prints on his continental travels
and was already familiar with the work of
Stefano della Bella and Abraham Bosse, to
whose work his own set of imaginary land-
scape etchings owe a great deal. Thomas
Rowlett, their publisher, had recently pro-
duced a series of etchings of the gardens at
Wilton by Isaac de Caus (Griffiths 1998, 75)
and several of Evelyn's later drawings of
plans for his own gardens owed much to
these bird's-eye views.

Evelyn particularly admired the etched
topographical views along the Thames by
Wenceslaus Hollar, who had been brought
to England by Evelyn's friend and neigh-
bour the Earl of Arundel (see cats 10, 11).
They were his immediate inspiration when
on 20 June 1649 he wrote in his Diary:
'I went to Puttny and other places on the
Thames to take prospects in crayon, to
carry into France, where I thought to have
them engraved.' Sadly, neither the Thames
drawings nor the one recorded etching after
them survives, but later remarks in *Sculptura*
(pp. 100–1), his 1662 treatise on prints and
printmaking, make it clear that Evelyn
felt topographical views had more public
interest and utility than his earlier imagi-
nary series, which he had dedicated for
personal and political reasons to the royalist
Lady Isabella Thynne. With both of these
sets of etchings, the first landscape prints
ever made by an Englishman, Evelyn was
setting his own public agenda by example.
Amateurs usually only ran off a few copies
of their prints for private distribution to

friends; but Evelyn had his published and
distributed not only to make exotic foreign
views readily available 'to the immense
refreshment of the curious', but in order to
promote British printmaking.

Literature: Griffiths 1993, 51–67; Griffiths
1998, 129–32.

SIR BALTHAZAR GERBIER
(1591/2–1667)

5

Frederick V, Elector Palatine and King of Bohemia, after Mierevelt

Pen and brown ink, on vellum, 150 × 127 mm

Inscribed: *Gerbier fc.*, and on verso: *fr:v:-*

LB 1(b); ECM & PH 1

Provenance: Joseph Gulston (L. 2986; his
number 'N 1286' is written on the verso);
Samuel Woodburn's sale, Christie's, 27 June
1854, lot 2383, where purchased

1854-6-28-77

This extraordinarily fine drawing was based
on a portrait painted by Michiel van
Mierevelt (now Mauritshuis, The Hague) in
1613, the year Frederick V (1596–1620),
Elector Palatine, married Elizabeth
(1596–1662), the daughter of James I. After
six years in Heidelberg, Frederick was
offered the crown of Bohemia, but his
acceptance marked the opening of the
Thirty Years' War. Within a year, Frederick
and Elizabeth had lost their kingdom and
the Palatinate. Prince Rupert, their third
son, was born during their brief reign in
Prague, shortly before they fled to The
Hague and the protection of Frederick's
uncle Maurice, Prince of Orange.

Balthazar Gerbier was born in Middel-
burg, the son of a Huguenot emigré. He
may have trained with Hendrik Goltzius,
but it was his knowledge of military forti-
fication and armaments that brought him to
the attention of the Prince of Orange. The
prince in turn recommended Gerbier to the
Dutch ambassador in London with whom
he had come to England in 1616. Another
drawing on vellum in the Museum's collec-
tion, of Prince Maurice, is dated to that
year. The ornate auricular frames with
which Gerbier's drawings are embellished
imply a possible connection with the
engraver Simon de Passe, who came to
England the same year and introduced this
form of decoration, originally invented by

Paul van Vianen, a silversmith, to his
portrait engravings.

A calligrapher, miniaturist, portrait
painter and architect, Gerbier seems to
have been able to turn his hand to almost
any medium. A few years after his arrival
in England, he married the daughter of
the Dutch immigrant goldsmith and
engraver, William Kip. Gerbier designed
and produced masques, as well as painting
in miniature and oils for the Duke of
Buckingham, who appointed him 'Keeper
of York House' in 1620 and sent him to
Italy and France to purchase paintings on
his behalf. It was in his capacity as
Buckingham's agent, and later when he also
made purchases for the king, that Gerbier
made his greatest contribution to the arts in
Britain, amassing collections for them that
introduced the country and its connoisseurs
to the work not only of contemporary artists
like Rubens and Van Dyck, but especially to
the works of the Italian High Renaissance,
particularly the Venetian school, and
Caravaggio and his followers. Gerbier
negotiated with Rubens on diplomatic
and artistic matters, and entertained and
accommodated the artist during his stay in
London in 1629–30.

After Buckingham's assassination in
1628, Gerbier entered Charles I's employ as
an artist, agent and diplomat and spent
most of the 1630s as the king's resident in
Brussels. He was knighted in 1638 and on
his return to London in 1641 Charles
appointed him master of ceremonies.
Gerbier had maintained his contacts with
the exiled Bohemian court at The Hague,
and his son was serving with Prince Rupert
when the latter was captured in 1637.
Gerbier, who claimed descent from a Baron
D'Ouvilly, was a courtier and diplomat
forced to turn his hand to various schemes
in order to survive when he joined other
royalist refugees in Paris in the 1640s. He
returned to London in 1649 after the failure
of a banking scheme, and the execution of
the king. Forced to abandon any courtly
credentials, he relied on his skills as a diplo-
mat and soldier and opened an academy
at his house in Bethnal Green, where draw-
ing, painting, limning and carving were
included amongst the subjects he offered to
teach (see p. 16).

Literature: MacGregor 1989, 207–8, 229
n. 20; Murdoch, 5–12; Griffiths 1998, 56–8.

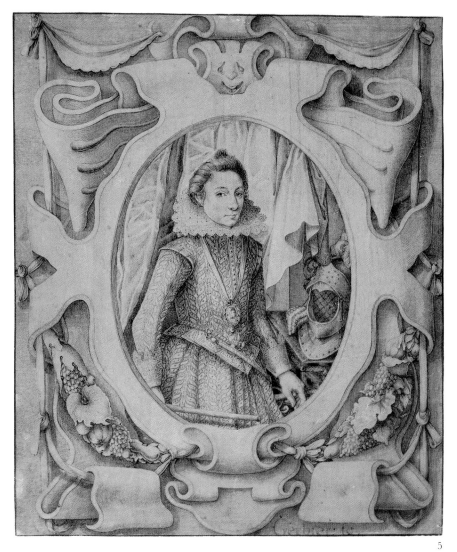

5

JOHN DUNSTALL (d. 1693)

6

A pollard oak near Westhampnett Place, Chichester

Watercolour over black lead touched with white, on vellum, 134 × 160 mm

Signed: *John Dunstall fecit*

ECM & PH 2; Stainton and White 86

Provenance: Sir Erasmus Philipps, 5th Bt; Richard Philipps, 1st B. Milford (L. 2687); Richard Grant Philipps, 1st B. Milford, 2nd creation; by descent in Philipps family; H. M. Calmann, from whom acquired by Museum in exchange for duplicate prints

1943-4-10-1

Probably a native of West Sussex, Dunstall etched five views in the region of Chichester around 1660. Three of the other views

depicted an ancient circular temple and a ruin, and a fourth was of the city from the north-west. The fifth view was based on the present watercolour, in which the mill on the right, possibly the mill at Pott, appears as prominently as Westhampnett Place; the city is just visible on the horizon and a great ancient oak dominates the foreground. The Elizabethan manor house and its tithed mill lay on the road to Arundel, just off Stane Street, the old Roman road to London. It was rebuilt in the eighteenth century and later owned by the Duke of Richmond at Goodwood, but burned down in 1899.

Only one other drawing in this medium by Dunstall is known, the north façade of *Bethlem Hospital*, the second 'Bedlam', erected to the designs of Robert Hooke, FRS, in Moorfields in 1675–6 (ECM & PH 1). Dunstall's use of opaque watercolour on vellum corresponds exactly with Sir William Sanderson's description of limning a landscape in *Graphice* (1658, 70) – a technical description Sanderson had borrowed from Edward Norgate's manuscript *Miniatura*. It is a technique that goes back to medieval illumination and was used mainly in the seventeenth century for heraldry, maps, bird's-eye views, miniature portraits and copies of old master paintings. It is precisely the type of painting that Peacham and Norgate recommended for gentlemen, along with drawing in pen and ink or with silver-point on prepared paper or vellum (see pp. 40–1). Peacham, Norgate, Browne and Gerbier all taught this type of painting in some form to amateurs, but Dunstall is the first who seems to have consistently made the attempt to earn a living as a schoolmaster who 'Teacheth the Art of Drawing'. In his will he described himself as a schoolmaster and his library, the sale of which was advertised in September 1693, contained not only his tools and stock, but also mathematical instruments, books on divinity, history, architecture, perspective, English and Latin and a 'Curious Collection of Prints and Drawings by the best Masters'. In November that year his widow Margaret sold his watercolours and prints (*London Gazette*, 2 November 1693).

Dunstall seems to have planned a publication along the lines of William Salmon's *Polygraphice, or the Arts of Drawing Limning painting &c.* (1672), a manuscript for which survives: *The Art of Delineation, or Drawing. In 6 Books: 1. Geometry 2. Faces 3. Trees 4. Houses 5. Flowers 6. Fruits, with Particular Directions For Every Book. Drawn by John Dunstall School-*

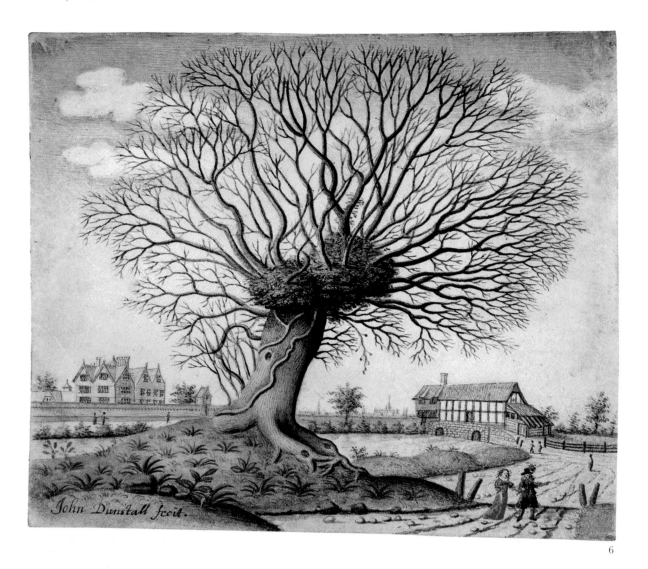

6

Master, and Teacher of the Art of Drawing. In Black-friers, London (BL Add. MS 5244). It consisted of a treatise on the 'Usefulness of this Art of Drawing', which he intended to publish along with six sets of plates, several of which had already been issued separately as copybooks (see cat. 35). Dunstall's three surviving drawings were used as the basis for three of the prints he issued on geometry (*Bethlem Hospital*), trees (the present drawing) and fruits (a pen and ink drawing, *Walnuts*, of 1666, in the Yale Center for British Art, New Haven (Conn.)).

Dunstall's text was interspersed with quotations from the Old Testament and moral reflections, the first of his four main uses of drawing being its spiritual use. The second was the 'innocent employment it provides Ladies and Gentlewomen of Quality'; the third, its use for young 'Gentlewomen's [needle] works'; the last, its use for various professions, not only

painters. It ended with a discussion of the types of object worthy of depiction: man, beasts, birds, fish, insects, plants and trees, objects of God's creation he had illustrated in his engravings. Finally, he concluded with 'A Prospect in verse being a phantasie which came into my minde' as an illustration of the close affinity between drawing, which may be called a 'Silent Poem', and poetry a 'Speaking Picture', his own version of *ut pictura poesis*. It is interesting that he did not attempt to give instructions for limning in his treatise, but rather concluded with a list of 'Necessary Instruments and Materials or things usefull in or for Practice in the Art of Drawing in Black and White', which included 'good prints to draw by', especially those of Bloemaert.

Literature: *Victoria County History of the Counties of England: Sussex* IV, 1953, 175–7; Griffiths 1998, 133, 138–40; Fleming-Williams, in Hardie III, 213

THOMAS MANBY (?1633–95)

7

Ruins of Hadrian's villa

Pen and ink with grey wash, 287 × 213 mm

Inscribed on verso: *The Ruens of Adrians / Villa*

ECM & PH 4

Provenance: Francis Place; by descent to Elizabeth Fraser (d. 1873); passed to her second husband, Patrick Allan-Fraser; his sale, Sotheby's, 10 June 1931, lot 149 (11 drawings, several inscribed *Manby*), bt Bernard Squire; bt Iolo Williams by whom presented (with three others)

1956-4-14-4

In his 1704 *Essay towards an English School of Painters*, B. Buckeridge recorded that Manby was 'a good *English* Landskip-Painter, who had been several times in Italy, and consequently painted much after the

Italian manner … he was famous for bringing over [from Italy] a good Collection of pictures, which were sold at the *banqueting-house* about the latter end of King Charles IId's Reign' (*c.*1685). John Cocks advertised the sale on 4 February 1695/6 of 'Mr Pearce, carver [Edward Pierce, sculptor, d. 1695], and Mr Manby, painter, their curious Collection of Books, Drawings, Prints, Models & Plaster Figures'.

Manby's social status remains unclear. The only contemporary references to him are found in Charles Beale's notebooks, where he records that in 1672 Manby informed his family of the death of Isaac Fuller (see cat. 33). Four years later he

painted the landscape background in a copy Mary Beale had made after a portrait by Lely, for which Charles Beale gave him some lake and pink pigments. Beale lent Manby two treatises on painting in 1676 and 1681, by Antonio Doni and Leonardo da Vinci.

The purpose and dates of Manby's visits to Italy are unknown, but while there he seems to have become familiar with a style of landscape drawing not yet practised by English artists – the Dutch-Italianate tradition demonstrated in the work of artists such as Bartholomeus Breenbergh and Jan Asselyn. Their closest precedents made in England are the works on paper of a few

Dutch and Flemish artists who had studied in Italy and worked in England – Thomas Wyck (1616–77), who was only in England briefly in the 1660s, Hendrik Danckerts (cat. 12) and Jan van der Vaart (cat. 53) who arrived in 1674.

In his own work and presumably the drawings he brought back from Italy, Manby transmitted their style to fellow amateurs and antiquarians, such as John Talman and Francis Place (cats 9, 16–19). Place owned Manby's eleven surviving drawings, which all show a specific interest in Roman ruins and ancient monuments (the Baths of Caracalla, the Colosseum and the Tomb of Plautius at Tivoli), and demonstrate little interest in a topographical panoramic approach. They also give the impression of having been sketched on the spot. This early evidence of 'sketching' from nature rather than 'delineating' it topographically is of great significance to the later tradition of English landscape drawings. It seems doubtful that Manby practised professionally, since no other works, in oil, etching or pen and ink survive. These drawings demonstrate the approach of an amateur *virtuoso*, who had learned something of the styles being used by artists around him, was not constrained by having to use the currently popular styles, and applied them to the subjects in which he had a particular interest.

Literature: Vertue IV, 105, 173–5; Iolo Williams, 'Thomas Manby, a 17th-century landscape painter', *Apollo* XXIII (1936), 276–7; Williams 1952, 6; Stainton and White, 163–4.

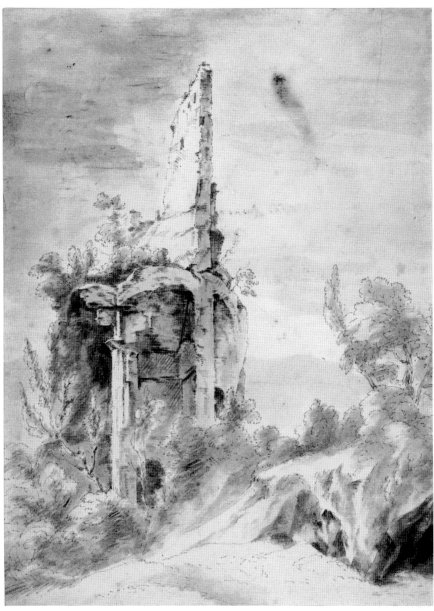

7

JOHN TALMAN (1677–1726)

8

View on the Rijn, near Rijnsburg and Katwijk, 1699

Pen and brown ink, with pen and ink border, 94 × 191 mm

Inscribed: below border *May.12.1699. I.T.*, in river *Rhÿn*, and above spires *Reinsburg* and *Katwÿck op Rhÿn*; and on separate slip of paper cut from old mount: *Talman*

ECM II, 1

Provenance: not identifiable in Talman sale, Cock's, 1 April 1728; ?Francis Place; by descent to Patrick Allan-Fraser, sale Sotheby's, 10 June 1931, lot 150; Iolo Williams, by whom bequeathed
1962-7-14-58

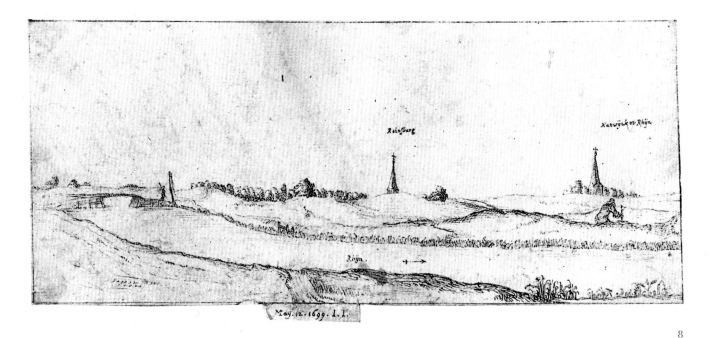

8

The architect and comptroller of the King's Works, William Talman (1650–1719), sent his eldest son John abroad to improve his knowledge of the arts and build up a repertoire of ideas for buildings, gardens and interior decorations. This drawing was made on John Talman's first journey to Holland in 1697, when he was enrolled at the University of Leiden and whence he made various excursions in the Low Countries. The resemblance of this minutely detailed topographical drawing to Hollar's work is not surprising: Talman owned several of his works (Talman sale, Cock's, 19 April 1728, section 2, lot 3: 'Twenty four [original drawings] by Hollar and Savery'). There are similar drawings by Talman in the Royal Institute of British Architects and the Ashmolean Museum, all made in the Low Countries and Germany between August 1698 and May 1699.

The recently identified journal of Talman's travels in Holland in 1697–9 is in the Harvey manuscripts deposited in the Bedfordshire Record Office (HY 940/1-3). Much of it is written in fair hand, with illustrations in the margins, and the survival of a number of finished drawings of the type exhibited here implies that Talman intended to publish his journal. In it he paid particular attention to the buildings, gardens and landscapes he had seen. On an excursion from Leiden to Katwijk, he described the view beyond the Hague ferry, a vital junction point for river traffic in the area: 'a fine house and the city Leyden

both at a distance from the Rhine afforded a pleasing aspect on the right. These were no sooner out of sight but Oestgeest, Reinsburg and Katwijck op Rhijn appeared on the right at a distance' (kindly communicated by C. D. van Strien).

In 1699 Talman went on to Italy and his presence in Rome is recorded on the back of two drawings dated 1701 and 1702, the year of his return to England.

Literature: C. D. van Strien, 'John Talman en Andere Britse Toeristen in Leiden en Omstrken Rond 1700', *Leids Jaarboekje*, 1990; Parry, *passim*.

Attributed to JOHN TALMAN (1677–1726)

9

Remains of the Temple of Saturn (or Concord), Rome

Brush drawing in grey and brown ink, with grey wash, 313 × 217 mm

Inscribed: *ye Remains of ye Temple of Concord behind ye Campidaglio*; and on verso: *N* and *Mr Diodoro* and *No. 11*

ECM II, 2

Provenance: John Talman (not identifiable in his sale, Cock's, 1 April 1728); J. Richardson the Elder's stamp (L. 2184) (not identifiable in sale Cock's, 22 January 1746/7, or in his son's sale, 5 February 1772); Iolo Williams, by whom bequeathed

1962-7-14-57

After his initial stay in Rome at the turn of century, Talman travelled there again in 1709, with William Kent and the gentle-man-architect Daniel Lock. He remained in Italy until 1717, staying mainly in Rome but with excursions to Naples, Florence, Padua, Ravenna and Venice. His letter-book documents his visit. His original purpose was to obtain designs for a new royal palace at Whitehall, but another activity soon superseded this, described by his father as forming 'the most valuable Collection of Books, Prints, Drawings &c., as in any one persons hands in Europe' (Parry, 12). During the seven years he had spent in London, Talman seems to have found a vocation as a church antiquary, moving in a circle of *virtuosi* with similar interests, many with connections with the circle in York, with the Virtuosi of St Luke in London, and with a group of Oxford friends involved in the decoration of a new hall at All Souls. In 1707, with Humphrey Wanley, who was to become Robert Harley's librarian, and John Bagford, the shoemaker-collector who planned to compile a history of printing, John Talman had formed a tavern club of antiquarians, which was to be reformed as the Society of Antiquaries ten years later. They hoped eventually to send persons to travel abroad equipped to inspect books and manuscripts and draw ancient fortifications, castles, churches, tombs, inscriptions, etc., to form a repository and library.

Talman himself was to be one of the first

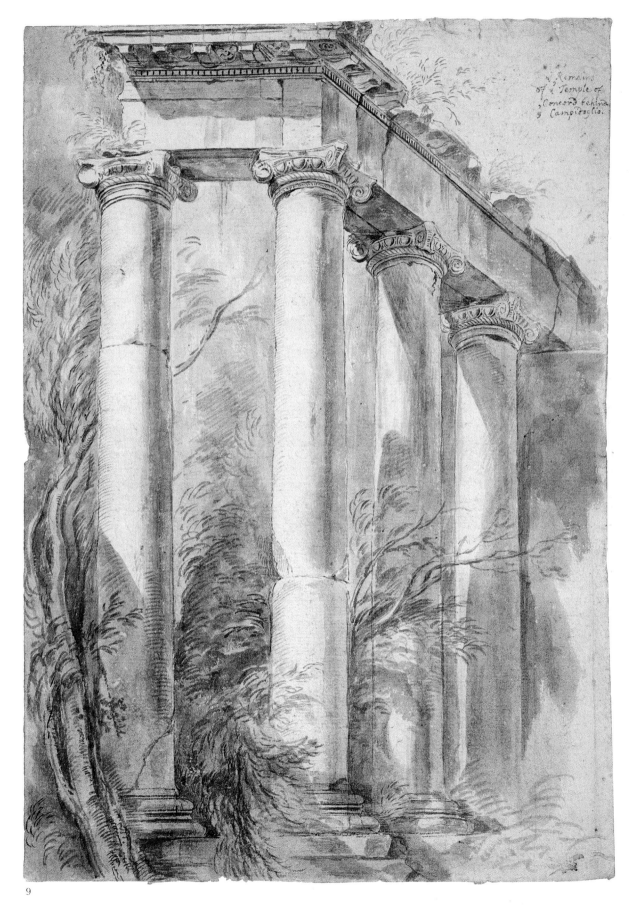

y.º Remains
of y.º Temple of
Concord behind
y.º Campidoglio.

9

'fit persons' to attempt to carry out these aims, although he was not funded by the Society but by his father, who by then was in financial difficulties. During Talman's long sojourn (he did not return until 1717), he made dozens of drawings himself and commissioned hundreds of others from artists in cities all over Italy. He was a secret convert to the Catholic Church and had a particular interest in ecclesiastical ornaments and church decorations, obtaining special permission from the pope and other important church dignitaries to make drawings and watercolours of reliquaries, ceremonial objects and jewels, which no other foreigners had even been allowed to view. He also drew items of antiquarian interest and purchased drawings, prints, architectural and antiquarian objects and sculpture, which he sent back to his father to further their ambitious plans to form a 'Musaeum Talmanicum' (see Parry, 42, 52).

The earliest provenance of this delicate and freely drawn view of the temple, which stood at the north end of the Forum in Rome, has unfortunately been lost, along with its original mount. It has become unclear whether Iolo Williams purchased it with the Manby drawings at the Allan Fraser sale of Francis Place's collection, as Croft-Murray claimed. That it was once in Talman's collection is certain from his *N* inscribed on the verso, but it is no longer clear who made the attribution to Talman, or why. It was anonymous in William's 1952 book but came to the Museum as by Talman. It is certainly not like Talman's early Dutch topographical views, but neither does it resemble the work of the many Dutch or Italian artists whose drawings he collected in great numbers for the 'Musaeum Talmanicum'.

Literature: Williams, 6; Parry, *passim*

WENCESLAUS HOLLAR (1607–77)

10

Wageningen from the south-west

Pen and ink with watercolour,
110 × 276 mm

Inscribed: *Wageningen* and *Rhenus fluvius*

LB 28; ECM & PH 26

Engraved: Pennington 898

Provenance: Thomas Dimsdale (L. 2426); W. and G. Smith, from whom purchased

1850-2-23-192

Hollar's mother was a member of the minor nobility of the emperor Rudolph's Bohemian court at Prague, and his father was knighted for his service as registrar of the law court. Hollar was educated to follow his father's profession, and his social rank and nationality were of importance to him throughout his life. John Aubrey, with whom he and the others discussed in this section shared a similar rank and ambition, wrote that as a schoolboy, Hollar 'tooke a delight in draweing of mapps; which draughts he kept, and they were pretty … so that what he did for his delight and recreation only when a boy, proved to be his livelyhood when a man' (Godfrey, 2). His father opposed his artistic inclinations and continued to train him for the court, but in a few months in 1619–20, the new King and Queen of Bohemia, to whom Hollar seems to have had some loyalty (his juvenile etched portrait of Prince Rupert's father Frederick V is in the Fitzwilliam Museum, Cambridge), had lost their throne and the positions of Protestant families such as Hollar's at the Bohemian court became increasingly difficult.

The abolition of the ancient Bohemian constitution in 1627 seems to have precipitated Hollar's decision to abandon his father's wishes and leave the country to follow his own artistic ambitions. He studied briefly in Stuttgart before seriously beginning to train as a draughtsman and engraver in Strasbourg and then in Frankfurt and Cologne. On excursions up the Rhine as far as Holland in 1634–5, when he made the present drawing, Hollar perfected his topographical skills and, in 1636, he was invited to join the entourage of the Earl of Arundel's embassy to Emperor Ferdinand II in Vienna. Travelling through war-torn Europe, he made over 100 drawings for Arundel, which illustrate most clearly his working procedure. He drew quickly on the spot with lead-point or quill pen and slight ink washes, often making several views from one point, and created more finished works later, carefully composed with the addition of a *repoussoir*, the lines clearly defined and with the addition of coloured washes. In their delicate accuracy they show no hint of the ravages that must have been apparent around him. Although officially Hollar only ever had one known pupil, through the later engravings he produced from these drawings he provided a template for centuries of amateur and professional artists' views of Europe.

Literature: F. Sprinzels, *Hollar and his Drawings*, Vienna 1938, 49–51, no. 156; R. Pennington, *A Descriptive Catalogue of the Etched Work of Wenceslaus Hollar*, Cambridge 1982, no. 898; Godfrey, *passim*.

11

London; Whitehall Palace

Pen and ink with watercolour, 98 × 293 mm

Inscribed: *White Hall Palatium Regis* and *Thamesis fluvius*

LB 10; ECM & PH 7

Provenance: Colnaghi's, from whom purchased

1859-8-6-390

Charles I's new Banqueting House in Whitehall, designed for him by Inigo Jones and decorated by Rubens – the most visual and public of all the artistic achievements of the Caroline court and ultimately the site of Charles's execution – dominates Hollar's drawing of this part of the Thames, just as it provides the focal point for Danckert's large panorama seen from the opposite direction (cat 12(b)). Hollar arrived in London in the Earl of Arundel's train in December 1636 and on 1 January the earl celebrated the opening of a new room to house his vast collection of prints and drawings, which joined the antique sculpture lining the long gallery and the paintings adorning the walls throughout Arundel House. One of England's first and greatest *virtuosi*, Arundel also had a remarkable collection of *objets de vertu*, which Hollar seems to have been partly employed to draw and etch. It was as much for his skill in the latter as for his draughtsmanship that he had originally been brought into the earl's entourage, as England was singularly lacking in engravers at this period, and his arrival heralded a new era for English printmaking.

Hollar found other outlets for his talents than his work for Arundel and, with the latter's contacts at court, had soon issued a panoramic etching of the new Queen's House at Greenwich, which he dedicated to Henrietta Maria. He became friendly with another Arundel employee, Henry Peacham, who provided him with verses to replace the dedication to the queen in this plate when her popularity waned in the early 1640s. The artist never forgot his noble or Bohemian origins and in 1639 he etched and dedicated to the king one of Charles's most recent acquisitions, the *Wilton Diptych*, showing Richard II and his

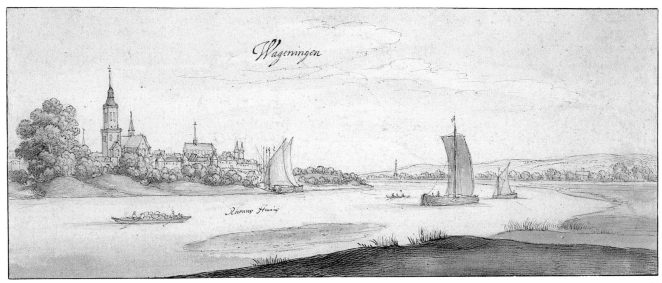

10

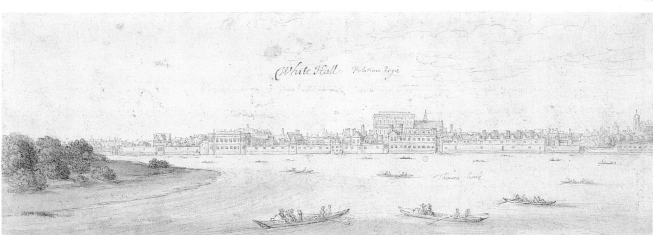

11

queen, Anne, drawing attention to her Bohemian nationality in the text. The following year Hollar married a lady-in-waiting to the Countess of Arundel, received an appointment as *serviteur domestique* to the Duke of York, and was also made drawing master to the Prince of Wales, the future Charles II.

Arundel's patronage and that of the royal family meant Hollar did not have to earn a living by engraving, and he spent most of his time sketching the people and the city itself, most characteristically from the river, the central artery of London. The middle portion of the present drawing was elaborated in the etching *Palatio Regis prope. Londinum vulgo Whitehall*. Hollar produced hundreds of sketches, which he took with him to Antwerp when he was forced to leave England two years after Arundel, in 1644. It was during his eight years abroad that he

began to produce the etchings for which he is now best known, of muffs, shells and costumes. When he returned to London in 1652, he continued to make his living by providing plates for the city's book- and printsellers.

It was Hollar's etchings of the palaces along the Thames that inspired Evelyn to make his own etchings in the late 1640s (see cat. 4), and it was the diarist, as well as Aubrey and other Fellows of the Royal Society such as Robert Hooke, or fellow *virtuosi* like Francis Place, who provided the most sympathetic associates for the engraver during the last decade of his life when his refined skills became submerged in sheer toil. His delicate topographical tinted drawings were, however, distributed widely through his etchings and their influence was felt not only on contemporaries like Talman, Place and other York *virtuosi*,

but on generations of professional and amateur draughtsmen and antiquarians. The eighteenth-century engraver and art historian George Vertue (1689–1768) so greatly admired Hollar's work that he compiled a catalogue of his prints, the first such catalogue ever published in Britain (1745). Some of Hollar's most magnificent topographical drawings were produced when he accompanied Arundel's grandson's embassy to Tangiers in an official capacity as 'Scenographer to His Majesty'; many of these are now in the British Museum – breathtaking views of the forts and settlements along the Moroccan coast that are some of the first, and in breadth, detail and colour, some of the finest works in the British tradition of panoramas.

Literature: Godfrey, 11, 64–6, 157–60; Griffiths 1998, nos 45–53, 126, 131.

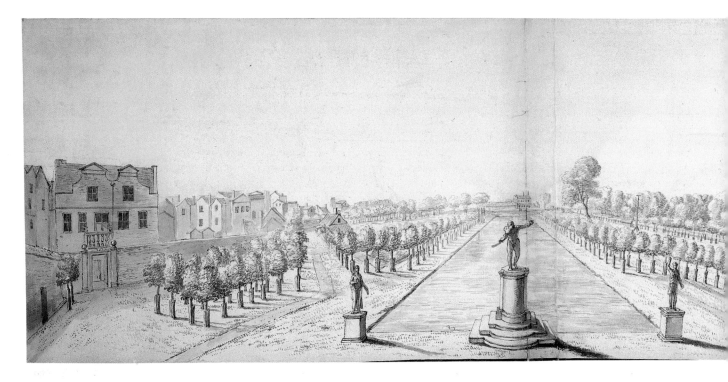

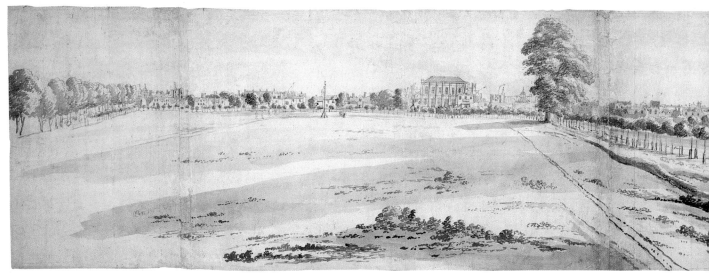

HENDRIK DANCKERTS
(*c*.1630–post 1679)

12

(a) *View of St James's Park from the north-east, c.*1661

Pen and brown ink over black lead, with grey, brown and blue-green washes, on two conjoined sheets, 282 × 900 mm

LB 7 (as by Hugh Howard); ECM & PH 2

Provenance: Hugh Howard; his brother

Robert, Bishop of Elphin; his son Ralph Howard, later 1st Earl of Wicklow; by descent to Charles Howard, 5th Earl, from whom purchased

1874-8-8-106

(b) *Whitehall and Westminster from St James's Park, c.*1661

Pen and brown ink, with grey and some coloured wash, on three conjoined sheets with two additional strips, 265 × 1048 mm

Inscribed: with abbreviated colour notes

above the buildings; and on verso: *Het Paerck* and *2592 Hampton Koert 16 gulder Reygaet*[?] *Kinston*.

ECM & PH 1

Engraved: by S. Rawle in John Thomas Smith, *The Antiquities of Westminster* IV, 1807, p. 24.

Provenance: Jonathan Richardson the Elder (L. 2184); William Stevenson; Colnaghi's, from whom purchased

1853-4-9-78

12(a)

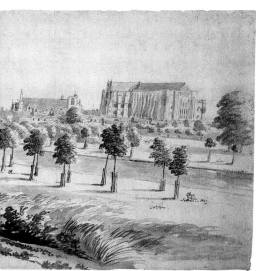

12(b)

Most of the Dutch artists painting in Britain in the late seventeenth century, including Danckerts and Jan Siberechts, were brought over to provide 'country-house portraits' or topographical drawings for reference collections and atlases.

Danckerts was trained as an engraver in The Hague, but travelled to Italy in 1653 to study painting. In London from at least 1664, he worked mainly for the court, painting large classical landscapes as well as all the sea-ports in England and Wales and all the royal palaces for Charles II.

Danckerts's finished oils have been described as stiff, but the drawings that survive have an immediacy that indicates they were done from the motif and fall into two main types, those drawn on the spot for country-house scenes and the looser landscapes somewhat in the style of Talman and Manby. The present two views in particular demonstrate all the characteristics of works done with a camera obscura. They have a panoramic approach with a vast empty expanse of grass in the foreground, leading to a distant central vanishing-point. Little has been written on the use of the camera obscura in England at this time, but it was in common use in Holland and many members of the Royal Society were engaged in refining perspective and optical drawing machines, including Robert Hooke who was working on a new more portable and effective camera obscura of his own invention in the 1680s.

Danckerts's drawings are included here not as examples by an amateur or drawing master, but to illustrate the type of work that amateur *virtuosi* knew, admired and collected. The view of St James's belonged to one such *virtuoso*, Hugh Howard, and indeed was thought to be by him when it was acquired by the British Museum. The attribution to Howard was placed in doubt when the Museum acquired the second drawing with which it obviously forms a pair. They appear to have been drawn to show the improvements made to the park shortly after the Restoration, as they show the newly planted trees and Le Sueur's statue of a gladiator, erected in 1661. The park is seen from the eastern end of the canal looking towards an unidentified distant building, with the tree-lined Mall running along the right side and other unidentified buildings on the left. *Whitehall from St James's Park* also shows the trees lining Pall Mall on the left, and the Banqueting House in Whitehall in the centre directly ahead, with the canal, St Margaret's Church and Westminster Abbey to the right. These drawings are probably studies for one of the many royal commissions Danckerts received, and this seems confirmed by their ownership by Howard, who was at one time Keeper of the State Papers.

Literature: Waterhouse, 117; Stainton and White, 160–1; Kemp, 188–90.

HUGH HOWARD (1675–1737)

13

Hampton Court from below Hampton, 1722

Pen and brown ink, with grey wash, 204 × 325 mm

Inscribed on verso: *Hampton Court from Hampton 1722*

LB 6; ECM II, 25

Provenance: Hugh Howard; his brother Robert, Bishop of Elphin; his son Ralph, later 1st Earl of Wicklow; by descent to Charles Howard, 5th Earl, from whom purchased 1874-8-8-105

On 23 February 1732 Viscount Percival, afterwards 1st Earl of Egmont, visited Hugh Howard and noted in his diary:

He is of Ireland, and of good family, but was obliged to paint in order to support himself like a gentleman, for which purpose he travelled to Italy and studied under Carlo Marat, who was peculiarly fond of him, and not only directed what pieces he should copy, but corrected his works and finished them sometimes with his own pencil. From thence Mr. Howard brought home what the Italians call *la virtu*, and we a taste and insight into building, statuary, music, medals, and ancient history, which recommending him to the acquaintance of the late Duke of Devonshire, he soon left the mechanical, though genteel, art of painting, and was made … Keeper of the Paper Office at a salary of 200*l.* a year. He showed me a small, but well chosen study of books, chiefly relating to history and genteel learning, and has a collection of medals, some busts, etc. He showed me likewise some good pieces of painting, as of Salvator Rosa, Antonio More, Guercino, Bourginone, etc.

To Percival's account, we can add that Hugh Howard's father was an eminent Dublin physician who brought his family to London in 1688 during the Rebellion. In 1697 a place was found for Hugh in the suite of the diplomat Thomas Herbert, 8th Earl of Pembroke, and he travelled with him to Holland and Italy where he studied with Carlo Maratta, returning through France to London in October 1700. Some drawings made by Howard after Maratta and Guercino are in the British Museum, but his collection of drawings, to which he continued to add throughout his life, was probably one of the finest formed in England in the eighteenth century.

After his return to England in 1700,

13

to be one of the most important landscapists of the previous century, with paintings by him hanging in all the royal palaces. Although it is on a different scale, the panoramic approach, sketchy pen and ink with wash, and the feeling of having been done on the spot, are revealing parallels in their work.

Literature: Historical Manuscripts Commission, *Diary of Viscount Percival afterwards First Earl of Egmont* I, 1920, 224–5; Vertue III, 83; M. Wynne, 'Hugh Howard, Irish portrait painter', *Apollo* XC, (September 1969), 314–17; N. Turner, *Catalogue of the Roman Baroque Drawings c.1620–c.1700 in the British Museum*, 1999, 140–5.

FRANCIS PLACE (1647–1728)

14

Richmond Castle from the south-east, 1674

Pen and ink with grey, brown, blue and green wash, 177 × 293 mm

Inscribed: *The South east side of Richmond Castle wth: part of the Toune in 1674*; on verso, in later hand: *An elegant View of Richmond Castle and Part of the Town*

LB 9; ECM & PH 23; Tyler 7

Provenance: Frances Wyndham *née* Place, m. Wadham Wyndham who in 1762 gave a group (?) to a member of the Parrott (Perrott) family (Ann Place, daughter of the artist, m. Stonier Parrott); W. and G. Smith, from whom purchased as part of a group of thirty-seven drawings by the artist

1850-2-23-828

Howard practised as a portraitist in London and Dublin. He was steward of the Virtuosi of St Luke in 1707, his name appearing in Vertue's list of members as 'Mr Hugh Howard Painter (now Esqr)' (BL Add. MSS 39167b). His style was similar to that of Kneller, who was a close friend and sketched Howard writing at his desk (1991-7-20-150). Vertue noted that the Earl of Pembroke, Duke of Devonshire, Dr Mead and several other *virtuosi* described him as their 'Oracle, his judgement being in such cases, of criticism, in drawing, &c. pictures &c. their standard' (Vertue III, 83). Howard ceased to paint in 1714, the year of his marriage, when the Duke of Devonshire obtained for him the post of keeper of the Records; and in 1726 he also became paymaster of the Royal Works and was able to bequeath £40,000, as well as his large collection of drawings, to his brother on his death. He numbered several important collectors among his close friends and etched a portrait of one of the greatest collectors of the time, Padre Resta (1635–1714), after a drawing by Carlo Maratta then in the collection of the Duke of Devonshire. The duke had acquired most of Resta's collection, as well as Van Dyck's Italian sketchbook (now 1957-12-14-207), apparently through the offices of Howard, who may have owned it previously and certainly made copies from it (1874-8-8-23 to 27).

This drawing of the river at Hampton Court is the only work known by Howard made after 1714. He probably chose the location for personal reasons, as his wife's estate was at nearby Richmond. Even more interesting is that its style is very different from any of his other earlier surviving landscape drawings: it is a fascinating instance of a professional artist who has turned 'amateur', employing an almost deliberately naïve style that reflects not only that he is drawing from nature but also that he is drawing for his own pleasure and not as a professional artist. One further point to note is that the drawing was acquired by the Museum with another landscape then also thought to be by Howard, the large panorama of *St James's Park* by Danckerts (cat. 12(a)). Howard had added examples by earlier British artists to his collection of drawings and Danckerts was considered

14

A younger son of landed gentry in Durham, Place was articled to a lawyer at Gray's Inn in 1665, and, like several other amateurs, 'did not like the practice of the Law [and] had a great inclination to drawing' (Vertue VI, 71). Unlike other amateurs, however, he actually left the law and practised professionally for a time as an etcher, and although he was never apprenticed to Hollar or any other artist, which he regretted, he knew Hollar well and worked with him copying plates for illustrated books.

Place did not depend entirely upon his income as an engraver for his living, since he made frequent, lengthy sketching trips from at least 1677 when he toured the Isle of Wight and France. The following year he visited the West Country and South Wales with William Lodge (cat. 23). This was before his father's death in 1681 when he inherited £500 and an annual income of £30. Place had family in York and in the mid-1670s he executed a number of drawings in a topographical style close to that of Hollar while on sketching tours with Lodge in the area around the city. He probably lived near the family estate in Dinsdale but travelled frequently to York, where he lodged with Henry Gyles (cat. 20) in Micklegate until he was to lease part of King's Manor in 1692 and settle permanently in the city.

The British Museum's large collection of drawings by Place indicates that initially he made a wide panoramic sketch of a view on the spot, using pen and ink in a loose sketchy manner, with quickly brushed-in washes, often on two or three sheets pasted together. From these, he would make a more carefully finished drawing, again on two or three sheets, laying in washes first, usually in brown or grey but occasionally using watercolour as in this case. Fine pen and ink work picked out details of buildings and foliage, as well as adding figures, boats and horses appropriate to the site.

The view of Richmond departs from Place's usual practice in many ways and, as a consequence, looks less like Hollar than most of his own drawings of this type. The drawing lacks the black border that outlines most of Place's surviving works, and appears to be the centre portion of a larger, more panoramic view that has been cut down. It is an anomaly not only for this period, but for Place's work as a whole, indicating that he had been looking at the work of other artists – perhaps prints after Italian landscape compositions – and also shows an

15

awareness of the traditional use of foreground in a composition that is not as apparent in his panoramic and usual topographical drawings. The figure of a man by his horse with two hooves overlapping the picture plane indicates an artist who is willing to play with pictorial conventions and is perhaps not taking himself as an artist too seriously – i.e. an amateur. This seems to be confirmed by Vertue who, when the two met in 1727, commented that Place 'had means enough to live on' and 'passed his time at ease, being a sociable & pleasant Companion much beloved' (Vertue II, 54). This drawing remained in the artist's hands from which one can infer that it was neither commissioned nor intended as a gift.

Literature: Richard Tyler, *Francis Place 1647–1723*, exh. York City Art Gallery, 1971, no. 7 and *passim*.

15
Part of Richmond Castle, 1689

Pen and brown ink and grey wash, with black border, 144 × 224 mm

Inscribed: *pt. of Richmond Castle 1689* and *part of Richmond Castle*; on verso: *F. Place delin.* and *34*

LB 11; ECM & PH 22

Provenance: as for 14

1850-2-23-827

It would be tempting on the evidence of this wash drawing and the view of Easby (cat. 17), to believe that Place 'graduated' from 'mere' topography to drawing more creatively, focusing his previously panoramic approach and making better use of light and shade with wash and brush, progressing his art by abandoning topography for this more creative, imaginative style of drawing landscape. This, however, would not be entirely true. The two manners of drawing existed side by side in his art from the beginning, just as they would do in the work of so many British landscapists to come. Like Hollar, Place made sketchy pencil and wash drawings with touches of pen and ink on the spot, and produced more finished detailed worked-up versions later, but a different element does appear in his work in the 1680s.

In that decade Place began to paint in oils, showing the influence of Francis Barlow. He was in fact etching Barlow's drawings during this period, but must also have known his genre paintings in the Dutch manner and paintings of birds, fish and flowers. Place also painted bird and hunting genre scenes, as well as portraits, although a self-portrait is the only oil that survives. The London printseller and publisher Pierce Tempest, a fellow Yorkshireman, sold several of Place's portraits in mezzotint, commissioning from him sets of prints of animals and birds after Barlow's drawings.

Place had begun playing with the elements in his landscapes, adding towers and ruins (although few of these imaginary landscapes survive), and making features of a building the focus of a composition.

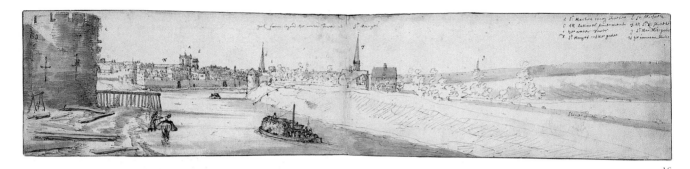

16

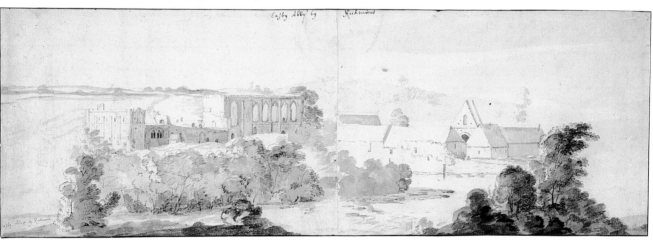

17

This may have been the result of his acquiring a group of drawings by Thomas Manby, which demonstrated what could be achieved by focusing on a single subject, particularly a ruin, rather than taking a panoramic approach. The main difference between this approach and the earlier ones of Place and Hollar is that in these the artist draws with the brush and adds a few pen and ink details, instead of drawing with the pen, thus emphasizing light and shade, composition and texture, rather than the details of forms.

16

York, from St Mary's Tower, looking south-east

Pen and brown ink with grey and brown wash, on two conjoined sheets, with black border, 100 × 449 mm

Inscribed: *York from beyond the water Tower at St. Maryes*, with letters above buildings referring to legend top right

LB 3; ECM & PH 30

Provenance: as for 14

1850-2-23-834

In 1678, the year Place toured Wales with William Lodge, the younger artist etched two views of York (cat 23(a)). Their compositions were similar to sketches by Place that were probably made the same year. It has been suggested that Place's sketches were based on Lodge's etchings, but the viewpoints are slightly different and it would seem more likely that the spot was a popular one from which to draw.

Place's drawing shows the Lendal Tower, on the left bank beyond St Mary's Tower, before it was repaired and an additional storey added in 1682. The water tower is the substantial round building on the far left of the drawing. In 1692 Place sublet part of King's Manor in York, and he married the following year. His travels did not cease – in 1698 he spent a year travelling and sketching in Ireland and in 1701 he visited Scotland. But after that, the year his second daughter was born, he confined his sketching trips to Yorkshire. It was while concentrating on themes of local interest in this decade that he returned to this subject for a group of four prints and a finished drawing, similar in style and medium to the view of Richmond of 1674. The plates passed to Francis Drake (1696–1771), and

were later issued with Lodge's as illustrations to Drake's history of York, *Eboracum* (1736). The later drawings, too, probably belonged to Drake and this may explain why they were so different in style and finish from his other works of this period which remained in the artist's own hands.

Literature: Hake, 46–7; Richard Tyler, 'Drawings by Francis Place in Leeds', *Leeds Art Calendar* 62 (1968), 12–19; Tyler, 86.

17

Easby Abbey

Brush drawing in brown wash over graphite, on two conjoined sheets, with black border, 145 × 434 mm

Inscribed: *Easby Abby. by* [gap] *Richmond*, and lower left, *Easby Abie by Richmond*

LB 21; ECM & PH 11

Provenance: as for 14

1850-2-23-814

This drawing and two closer views of the ruins themselves were probably made on the same visit to Richmond in 1689 that produced *Richmond Castle* (cat. 15). It is a good example of the artist sketching on the

spot with the brush rather than the pen over a very slight pencil sketch. In his earliest drawings from nature, Place had sketched roughly with pen and ink first, but by 1689 he no longer needed the heavy lines: light and shade rather than forms provided guidance for any later use he might have for the drawing.

By changing to this technique, Place was moving from a topographical recording approach to a more natural interpretation of landscape, reflecting a type brought to Britain in the work of Van Dyck and Thomas Wyck, some of whose drawings he owned, and of Danckerts, an artist practising in England in his own lifetime. The drawing presents more an idea of an abbey and its site than a topographical detailed depiction and was, like most of his drawings that remained with his family, drawn for personal satisfaction, and not to be worked up into an etching or detailed view.

Literature: Williams, 9; Tyler, 25, 56; Wark, 38–9.

18

18

Knaresborough Castle, the Keep, 1703

Pen and brown ink with brown wash over slight graphite sketch, with black border, 321 × 413 mm

Inscribed: *Part of the ruines of / Knaisborough Castle / 1703 / F:P:*; on verso: *F. Place delin*

LB 15; ECM & PH 17

Provenance: as for 14

1850-2-23-821

This drawing of 1703 and the one of 1711 exhibited with it, along with three others done on the same later sketching trip, represent a sea change not only in Place's work, but in British landscape. From the turn of the century, when after a final trip to Scotland, Place finally settled himself to sketching in Yorkshire, he produced fewer wide panoramic drawings and focused instead on central parts or even central features in a view, allowing them to dominate the composition and fill the surface of the paper. Danckerts was the only earlier artist to work in Britain who did this with large sheets of paper (ECM & PH 3,6), but Thomas Wyck and Dutch Italianate artists such as Breenburgh had allowed ruins to fill their sheets in much the same manner. Place was the first British artist to focus on ruins in this way, and he went on to use this

approach in this series of large sheets in the British Museum. They are a small group in his *oeuvre*, however; the rest of his works of the final two decades of his life are smaller in size, still being panoramic, topographical and many of them detailed in approach.

19

The Dropping Well, Knaresborough, 1711

Grey wash over pen and brown ink and slight graphite sketch, with black border, 324 × 408 mm

Inscribed: *The Droping well Knaisborough F:P:*; on verso: *F. Place delin.* and *92 Perrott*

Verso: slight graphite sketch of trees and rocks

LB 16; ECM & PH 18; Stainton and White 150

Provenance: as for 14

1850-2-23-822

In 1699 Pierce Tempest published a large print after Place's carefully detailed drawing of *St Winifred's Well*, widely famous as 'Noble Fountain of great Antiquity' and a popular place of pilgrimage in North Wales. In the 1710s Place made carefully detailed drawings of York Minster for engraving. All of these, as well as the present work, are in the spirit of the amateur *virtuoso*, who by the

end of the seventeenth century was not just interested in natural philosophy, natural history, animals and classical antiquities but particularly in the sites and rites of ancient Britain. It was the period of the exploration of and attempts to understand the construction of Stonehenge and Avebury and a growing fascination with ancient natural curiosities such as St Winifred's Well, Wookey Hole and the petrifying well at Knaresborough.

Place's own previous works and those of other artists focused on the ruins themselves or the activities and scientific experiments and results at the sites, such as the lack of oxygen in the caves or the objects being petrified by the well. But Place was now interested almost purely in the landscape without figures or objects much as his other larger drawings had focused on parts of ruins. To devote a drawing of this size to a landscape with no obvious antiquarian interest and to make it aesthetically pleasing was a radical departure from an exact topographical depiction. Its influence on other artists was negligible, however, since Place's drawings at this date seem to have been for his personal use and remained with his family.

19

20

Henry Gyles

Red and black chalks, with watercolour, on
buff paper, 313 × 227 mm

Inscribed by Ralph Thoresby: *ye effigies of Mr
Hen: Gyles the celebrated Glass-Painter at Yorke*

LB 1; ECM & PH 1; Stainton and White 137,
attributed to Henry Gyles

Provenance: Ralph Thoresby; George Vertue
(not identified in his sales); Horace Walpole,
sale, Robins, 28 June 1842, lot 1270;
A. E. Evans & Sons, from whom purchased
1852-2-14-372

Henry Gyles was the third generation of his
family to follow the art of glass painting and
his surviving works date from 1670 to 1707.
They include windows in public buildings,
chapels and a sundial at Tong, near

Bradford. His friend Ralph Thoresby, who
owned this drawing and the following
mezzotint, described him as 'the famousest
painter of glass perhaps in the world'. Gyles
assisted Thoresby in his own collecting, not
only of glass but of other objects as well, and
although he never earned a substantial
living from his trade, he was a congenial
host to his fellow York *virtuosi*. By 1679 he
owned a manuscript copy of Norgate's
Miniatura, to which he added recipes for his
own profession (BL Harleian MSS 6276,
1–83).

Drawings for Gyles's glass designs are in
the City Art Gallery, York, but few other
drawings survive and no portraits. This type
of 'crayon' portrait was practised by several
artists who were also early mezzotinters
such as Edward Luttrell and Francis Place.
Although it has been called a self-portrait

ever since it was first catalogued by Horace
Walpole, who may have been basing his
attribution on an earlier inscription, it
seems more likely that this portrait of Gyles
was drawn by Place, who mezzotinted
Gyles's portrait (cat. 21) and several after
crayons by the artist John Greenhill; he is
also known to have drawn portraits in chalk
himself, although the few that survive are
usually signed. According to Thoresby,
their friend John Lambert (d. 1701), was also
a 'most exact limner'.

Literature: Tyler, 19; J. T. Brighton,
'Cartoons for York glass – Henry Gyles',
City of York Art Gallery Quarterly XXI (October
1968), 772–5.

21

Henry Gyles

Mezzotint, 117 × 82 mm; on contemporary
mount with wash border, 147 × 110 mm

Inscribed on print: *Mr. Hen. Gyles Glass Painter,*
let his Art Dye with him at York; and on label on
mount: *This Print of Mr. Gyles belong'd to Mr.*
Thoresby who has mention'd it amongst his curiosities
p. 492. He said it was wrought in Mezzo-Tinto by
the celebrated Mr. Fran-Place, when that art was
known to few others. I bought it (inter alia) of the
Executor of the late Mr. Wilson of Leedes The
Antiquary, who had bought it of the Exors. of Mr.
Thoresby. John Watson. Mr Thoresby bought it of
the exors. of Mr. Gyles

Challoner Smith 5; Hake 207 I

Provenance: Henry Gyles; Ralph Thoresby of
Leeds; Wilson of Leeds; John Watson;
H. W. Diamond; Messrs Smith, from whom
purchased

1838-4-20-123

In 1683, on one of his frequent stays in
London, Francis Place wrote to his friend
Henry Gyles in York, reporting on the state
of glass painting in London and the prices
charged, informing him that there were

four glass painters in town, but not enough
work to employ one. Place lodged with
Gyles when in York, and sought business for
him while in London, but it is not clear
when he mezzotinted this portrait, which
was intended as a trade card. This is a proof,
but later states bore the letterpress: 'Glass
painting for windows, as Armes, Sundyals,
History, Landskipt, &c. Done by Henry
Gyles of the City of York.' It may date from
shortly after 1676, when Gyles's father died
and he had set up on his own.

Although Place executed over a hundred
etchings, Hake recorded only twenty-three
mezzotints by him, both portraits and genre
pieces. Others have been identified since,
including *A Tavern Scene* after Brouwer
(Tyler 117) which seems to have been issued
in 1666–7, making it the earliest English
mezzotint after that by Prince Rupert
(cat. 2(a)). This was one or two years after
Place had been articled to a lawyer in
Gray's Inn, a period when little is known
about his activities, but interest in and
contacts with the print world in London at
the time, as well as his amateur standing,
may have gained him entrance to the

exclusive circle who shared the secret of
the medium. Years later, he passed on his
knowledge to fellow *virtuosi* in York, includ-
ing Thoresby's brother-in-law George
Lumley, to whom he eventually gave his
equipment.

Literature: Hake, 64–5; Tyler, 71, 79–82;
Griffiths 1998, 251; the collector Dr Richard
Mead also had a copy of this print, see
Wal.Corr., XL, 231.

22

Studies of waterfowl, 1709

Pen and brown ink and grey wash, tinted with
watercolour, 202 × 319 mm

Inscribed: *The head of a Mallard, The head of a*
fishing fowle, The black diver or Scoter wce. is
discrib'd in Mr: Willoghbys booke this was Kild upon
Ous 1708/9 the whole body is black feete and all
and *F. Place*

LB 36; ECM & PH 38

Provenance: William Wells, his sale
Christie's, 22 January 1857, lot 361, where
purchased with another study of a mallard

1857-1-10-27

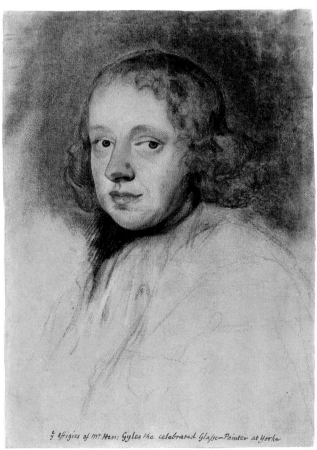

y effigies of mr. Hen: Gyles the celebrated Glasse-Painter at Yorke

20

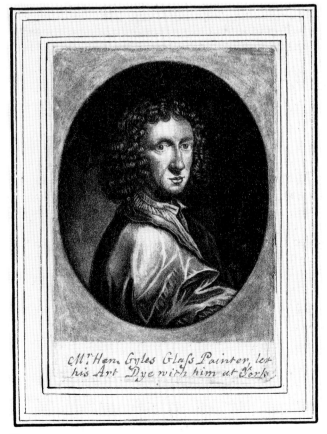

Mr. Hen. Gyles Glass Painter, let
his Art Dye with him at York

21

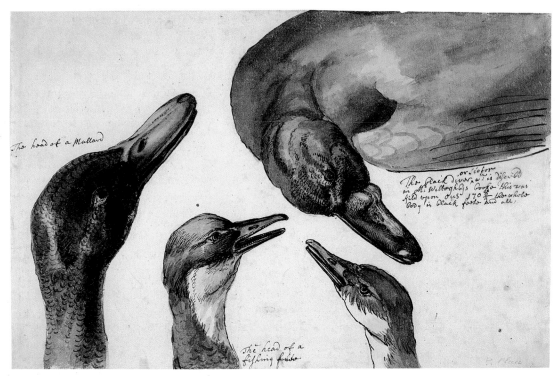

The head of a Mallard

The Black diver ... or Scoter ...

The head of a fishing fowle

22

In the mid-1680s Place was engaged in etching prints after drawings by Francis Barlow for publication in a series of prints by the London printseller Pierce Tempest. The subjects were mainly birds – one or two species, sometimes with dogs chasing them and, on one occasion, in their natural habitat off the coast of Scotland with Bass Island in the distance. Place kept some of Barlow's drawings for his own collection, and Tempest deducted their cost from his fee for the prints.

In his inscription, Place cites Willoughby's book on birds, *Ornithologiae Libri Tres*, which had appeared in 1678, when Place was engraving plates after Barlow, at the height of his own interest in painting oils of this genre. As a keen angler, Place had plenty of opportunity to study 'fishing fowle' but this drawing, another careful multiple study of the female common mallard in the British Museum, and a cockerel and plover of the same date in a large sketchbook in the Victoria and Albert Museum, are curiously almost the only survivors of this genre in his work. However, as the engraver of the plates for his friend Martin Lister's translation of Johannes Godartius's book on insects (1682), and several other plates for Royal Society publications, he undoubtedly shared his fellow York *virtuosi*'s interest in natural philosophy and classification, which

is evident in the carefully detailed notes and replication of the colour of the birds in the present work.

Place's own collection of natural and artificial rarities was donated by him to Ralph Thoresby and included pottery, prints and drawings by himself, letters, medals, an Indian arrow and armour, an old horn punch ladle, bones of a duck, swan and whale, a shark's fin, shellfish, a reed from Virginia, a coconut shell, fossils, rock salt, iron ore and a porphyry bowl in which Place ground his colours. Dismissively described by a modern author as a 'motley collection of items', they are instead exactly the kind of items treasured by *virtuosi* of the period.

Literature: *Ornithologiae Libri Tres*, 1676 (English edn, 1678) (the Scoter is pl. LXXIV, and described p. 281); Tyler, 33–6, 64, 75–7, 84–5; Griffiths 1998, 267, 277–9.

WILLIAM LODGE (1649–89)

23 (a)

York from St Marie's Tower Ao: 1678

Etching, 152 × 230 mm

Provenance: Messrs Colnaghi, from whom purchased

1870-10-8-2946

23 (b)

Etching from *A Book of Divers Prospects Done after the Life by Will Lodge: A View of the Circaen Promontory*

Etching, 83 × 165 mm

Provenance: In collection, with Hollar prints attributed to Hollar, by 1837

Ii.1–21.

FRANCIS PLACE (1647–1728)

23 (c)

Etching from *Johannes Godartius of Insects*, 1682

Etching, 135 × 262 mm

Hake 77

Provenance: As above

Ee.2.75

From a family of prosperous cloth merchants in Leeds, Lodge had an annual income of £300 from an early age and although he studied law at Lincoln's Inn, he did not find it necessary to practise. He had learned to draw, limn and etch while still at Cambridge in 1667, possibly taking lessons from the amateur artist John Lambert

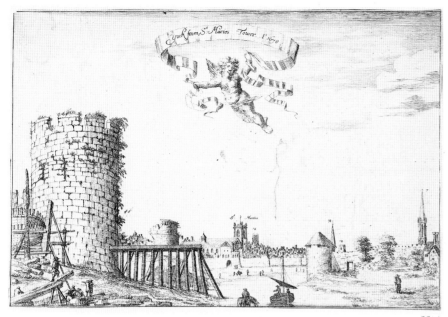

23(a)

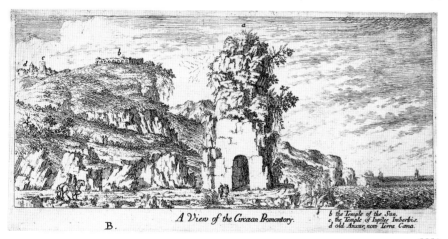

A View of the Circæan Promontory.

b the Temple of the Sun.
c the Temple of Jupiter Imberbis.
d old Anxur, now Terra Cœna.

B.

23(b)

23(c)

(*c.*1640–1701), who was a friend of Place. That year, when promising to send his mother 'the best efforts of my limning', he took care to reassure her: 'I make painting only a recreation an hour after dinner or so, no hindrance in it but rather a furtherance to things of greater concernment' (Hake, 60). In 1669 he accompanied Thomas Belasyse, 2nd Viscount Fauconberg, on his embassy to Venice, where he remained until 1671. Giacomo Barri's *Viaggio Pittoresco d'Italia* was published that year and in 1679 Lodge published the English translation, accompanied by his own etched map of Italy and portraits of the artists mentioned in the text. He also etched a series of views in Italy and France, as well as of monuments and buildings of antiquarian interest around London, York and Leeds.

During that decade Lodge had been drawn into the circle of York *virtuosi*, particularly to Dr Martin Lister, whose shells, fossils, snails and spiders he drew and etched to accompany the doctor's papers for the Royal Society. His greatest friend among the York circle was Francis Place, who also illustrated Lister's articles, and shared with him a passion for topographical views, antiquities and angling. The pair frequently travelled together on sketching tours that lasted three to four months. Sketching tours were not yet as popular as they were to become in the eighteenth century, and in 1678, during the Popish Plot, they were arrested as Jesuit spies. Place produced a mezzotint portrait of Lodge, and on the latter's death, inherited his portrait in oils by Alexander Cromer.

Vertue recorded that Lodge 'painted some few pictures from the life in Oil, but was no mighty labourer in Art, having enough to live on without it. being all his life single'. His oils 'from the life' may well have been landscapes, the subject preferred by Lambert, but none survives. His topographical drawings and drawings of monuments are in the collections in Leeds and York, and the British Museum has three views of monuments and ancient buildings in London, intended for engraving (ECM & PH 1–3), which came from the collection of another of the circle of York *virtuosi*, Ralph Thoresby.

Literature: Vertue I, 26, 74–5, 83, 119–21; Hake, 60; Norah Gillow, 'A portrait of William Lodge by Comer', *Preview: City of York Art Gallery Quarterly* XXXV (April 1972), 883–7; Griffiths 1998, 245, 253–4.

2
Learning to Limn

John Chubb (1746–1818) (fig. 2) was the son of a prosperous merchant of Bridgwater in Somerset. Well-educated, at the age of thirteen he was sent to London to stay with an uncle who had a shop in Cheapside. He wrote to his father that he would like to settle in London, and follow a career as a merchant, doctor, cornet in the dragoons or 'above all a limner' because 'it is a very genteel business … the painting is pleasant to the painter … and because one has the pleasure of looking at pretty ladies'. His father replied that painting was 'generally regarded as an ungenteel or mean business … The pleasure of composition greatly abates when we labour at it for bread … The looking *properly* at one pretty lady is better than a thousand.'[1] The younger Chubb returned home where his father seems to have continued to run the business, leaving his son to live the life of a gentleman who had leisure to amuse himself with painting, poetry, music and composition. His watercolours included 'pretty ladies' wearing ribboned hats and looking coyly from behind fans, but he was also a great friend of Charles James Fox, becoming deeply involved in local politics, and drawing caricatures of locals, as well as the occasional satirical print. He appears to have been self-taught and all his watercolours are slightly awkward in perspective and proportion. His self-portrait shows him standing casually, hands in pocket, in front of his easel, a small cast of a classical figure and a palette and brush on the table.[2]

Chubb's charmingly naïve self-portrait makes a telling contrast to Sir Nathaniel Bacon's (1585–1627) of 150 years earlier (fig. 1). Painted six years before he was made a knight of the Order of the Bath, Bacon's sword indicates his gentlemanly status, his clothes and furnishings his wealth, and the pile of books, one open to a map showing East Anglia in relation to the Low Countries, demonstrate his learning and his hereditary as well as cultural ties. His palette includes a yellow pigment of his own invention, known as Bacon's 'Pinke', and the drawing he holds, the perspective diagram on the table and the miniature painting on the wall all attest to his skills as an artist.[3] In his *Compleat Gentleman*, Henry Peacham lauded him as the primary example of the type of *virtuoso* who numbered painting amongst his attributes: in his judgement, Bacon was 'not inferiour … to our skillfullest Masters'.[4] His accomplishments in painting included at least two other self-portraits, ten large oil paintings of 'fish and fowl', one of which, *Cookmaid with Still Life of Vegetables and Fruit*, is now in the Tate Gallery, and a miniature landscape on copper (cat. 52) once owned by the Tradescants and now in the Ashmolean Museum, Oxford.

Bacon's connection with John Tradescant is a significant one. Like many other amateur limners to be described in this chapter, Bacon was a keen horticulturalist: melons grown on his estate appeared in the large painting mentioned above and his monument records him as 'well skilled in the history of plants, and in delineating them with his pencil'.[5] However, it is as a gentleman 'limner' of the seventeenth century, in contrast to John Chubb of the late eighteenth, that Bacon most concerns us here. His oval self-portrait (National Portrait Gallery), the small painting of Minerva visible in his larger self-portrait, and the miniature landscape, thought to be the earliest pure landscape painting by an English-born artist, are all early products of the polite recreation of 'limning', which would continue to be practised in varying forms by amateurs over the next 150 years.

'Limning, a thing apart … which excelleth all other painting whatsoever'

Thus Nicholas Hilliard introduced his treatise of c.1598 on *The Art of Limning*. The word 'miniature' as we employ it today to mean a small portrait or something very tiny is a fairly recent usage. It actually comes from the Latin *miniare* meaning to colour with red lead, and like the words 'illumination' and 'limning', it refers to the decoration of manuscript books before the invention of printing; all three words derive from the medieval Latin word *luminare* – to give light. Edward Norgate (1581–1650) was the first to use the Italian word for illumination, *miniatura*, to describe the art of limning in his manuscript treatise of that title in 1627.[6]

The newer meaning of the word 'miniature', like the word 'amateur', has perhaps led in some way to its marginalization in the consideration of British art. Ellis Waterhouse exemplified this attitude in his 1953 history of British painting, writing: 'Painters in miniature are normally a byway which the historian need hardly consider in a general account of a school of painting.' He was mistaken to see Hilliard's art as an orchestration of the 'purely decorative elements' of Elizabethan style, but correct to note that limners inhabited 'an Italianate world, whose presuppositions about art, the theory of art and the artist's title to distinction are derived from Lomazzo and Alberti and from Baldassare Castiglione's idea of a "Gentleman"'. The 'more popular Flemings', on the other hand, 'were craftsmen and did not aspire to be anything else'.[7]

The private nature of miniature portraits, their traditional connection with goldsmiths and jewellery and the relative simplicity of the tools used have also helped to marginalize miniatures and almost eliminate the word 'limning' from our vocabulary. It was precisely these aspects as well as its neatness and cleanliness that made limning the perfect activity for the

English 'gentleman' courtier and his wife. Like Evelyn and Prince Rupert and the secret of mezzotinting, Hilliard and Norgate after him did not publish their treatises on limning but circulated them selectively in manuscript: they did not want their art demeaned by becoming the practice of mere craftsmen or artisans and argued that 'none should meddle with limning but gentlemen alone'.[8]

Sir Nathaniel Bacon may have learned the secret of limning from Hilliard or from Edward Norgate, whose treatise recommended the use of Bacon's 'Pinke'.[9] Balthazar Gerbier (cat. 5) painted a miniature of Charles, Prince of Wales, shortly after he arrived at court and Sir James Palmer (1584–1657) painted one of James I (both miniatures now in the Victoria and Albert Museum).[10] An important collector of paintings, Palmer was a gentleman of the bedchamber to James I as well as the court herald, responsible for limning coats-of-arms, a practice that like manuscript illumination had preceded the use of limning for portraits or small paintings. These courtiers not only advised the king on his collection of paintings but they also made small limned copies of them. These were treasured and displayed in glazed cases with locks in King Charles I's new Cabinet Room at Whitehall, along with his illuminated books, engraved gems, ivory, bronzes, coins and medals. The miniature copies included one selected by the king from a group of five painted by Lady Killigrew.[11] In 1661 it was joined in the cabinet by a limned copy of Peter Oliver's copy of a painting by Raphael, painted and presented to Charles II by John Evelyn's wife Mary.[12] The Evelyns' daughter Susannah was also an accomplished amateur and scholar of Greek, Latin and French.[13] Most famously, in 1665, Samuel Pepys wrote in his diary on 7 May: 'Yesterday begun my wife to learn to Limb [*sic*] of one Browne … And by her beginning, upon some eyes, I think she will [do] very fine things – and I shall take great delight in it.'[14]

In the *Courtier*, Castiglione had argued that a woman at court

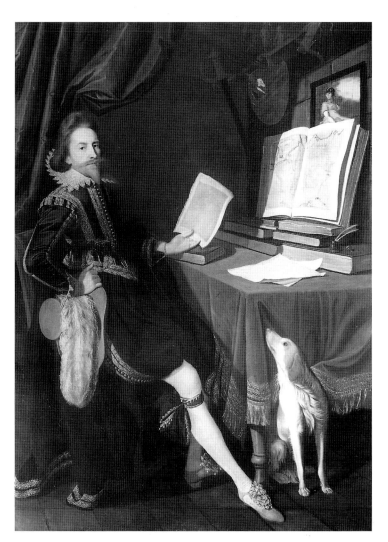

Fig. 1 Sir Nathaniel Bacon, *Self-Portrait*, oil on canvas, 206.4 × 153.7 cm (Private collection)

Fig. 2 John Chubb, *Self-portrait with artist's paraphernalia*, watercolour, 215 × 135 mm (J.N.Chubb, on loan to the Admiral Blake Museum, Bridgwater, Somerset)

should be the feminine counterpart of the courtier: she should be well-educated in order to share with him the same 'virtues of the mind', be able to converse intelligently and understand such arts and graces as might be in keeping with her femininity.[15] English courtesy books of the seventeenth century continued to encourage women in their complementary roles and to demonstrate their virtue and learning through the gentle arts. Needlework was historically the most common and most acceptable (see cat. 37), being a sedentary, clean and quiet occupation, which employed rich materials and resulted in decorative works. The introduction of limning to England in the late sixteenth century added a new art that satisfied these criteria. Since limners in the first half of the century were, like those listed above, gentlemen usually with positions at court, a lady learning from them would not have to associate with common artisans. Her first lessons might be in drawing, but she would soon proceed not to drawing portraits from life, but to copying – from prints, miniatures, paintings and, like Mary Evelyn, from copies by others. The word 'copy' and the idea it conveys to a modern reader once again leads us away from its seventeenth-century connotations. The words 'copy' and 'copious' have the same root, the Latin *copia*, meaning abundance.[16] When one thus associates copies with richness and plenitude, the making of limned copies, jewel-like both in appearance and the expensive materials with which they are made, becomes an appropriate gentle art and its products worthy of a king's cabinet.

Although this essay is followed by several further examples of ladies and gentlemen who limned, there are few contemporary written references to indicate how they learned or what their families thought of their work. Samuel Pepys's wife, Elizabeth St Michel (1640–69), was French, and her lessons in limning began in the year of her marriage at the age of fifteen. Although none of her work survives, Pepys provides the only contemporary clues to this practice and his comments in his diary are therefore worth transcribing in full:[17]

29th July 1665: Up betimes. And after viewing some of my wife's pictures, which now she is come to do very finely, to my great satisfaction, beyond what I could ever look for – I went away.

[VI, 174]

5 Aug. 1665: In the morning up, and my wife showed me several things of her doeing, especially one fine woman's persian head mighty finely done, beyond what I could expect of her.

[VI, 183]

21 Aug. 1665: I to my wife; and having first viewed her last piece of drawing since I saw her (which is seven or eight days), which pleases me beyond anything in the world, I to bed, with great content. [VI, 200]

22nd Aug. 1665: being opportuned by my wife … for me to buy a necklace of pearl for her, and I promising to give her one of 60*l* in two years at furthest, and less if she pleases me in her painting. [She bought one for £80 on 30 April 1666.] [VI, 200–1]

3rd Sept. 1665: I took my Lady Pen home, and her daughter Peg, … and after dinner, I made my wife show them her pictures, which did mad pegg Pen, who learns of the same man – and cannot do so well. [VI, 210]

27th Sept. 1665: Up, and saw and admired my wife's picture of Our Saviour, now finished, which is very pretty … had most excellent discourse with Mr. Eveling touching all manner of learning; wherein, I find him a very fine gentleman, and perticularly of Paynting, in which he tells me the beautiful Mrs. Middleton is rare, and his own wife doth brave things.

[VI, 242–3]

3–4th May 1666: [told my wife] would not have Browne to think to dine at my table with me always, being desirous to have my house to myself, without a stranger and a Mechanique to be privy to all my concernments … [next day] then to dinner – and had a great fray with my wife again about Brown's coming to teach her to paint and sitting with me at table, which I will not yield to. I do thoroughly believe she means no hurt in it, but very angry we were; and I resolved all into my having my will done, …

[VI, 116–17]

7 Nov. 1666: called at Faythornes to buy some prints for my wife to draw by this winter; and here did see my Lady Castlemaynes picture, done by him from Lillys, in red chalke and other colours, by which he hath cut it in copper to be printed.[see cat. 70] The picture in chalke is the finest thing I ever saw in my life I think, and I did desire to buy it. [VII, 359]

Pepys's wife also received lessons in dancing, arithmetic and singing and he himself taught her astronomy, the use of the globes, arithmetic and experiments with a microscope, a clear indication that he hoped to endow her with all the attributes of a courtier's lady. But her limning should also be viewed in the context of Pepys's own artistic activities.

In November 1665 Pepys had visited Evelyn at Deptford and was shown 'most excellent painting in little – in distemper, Indian Incke – water colours – graving; and above all, the whole secret of Mezzo Tinto and the manner of it, which is very pretty, and good things done with it'.[18] He discussed 'the art of drawing pictures by Prince Rupert's rule and machine' with Hooke at the Royal Society, and was pleased to learn that Hooke felt 'nothing do like squares, or, which is the best in the world, like a dark roome [camera obscura]'.[19] Two years later his wife accompanied him to a demonstration of a parallelogram, a similar instrument for copying and enlarging drawings, which could be used by people who did not know how to draw. He ordered one for himself,[20] but his wife was never mentioned in connection with it, although she had one lesson in the rules of perspective from Henry Sheeres, a military engineer, after which Pepys noted: 'I think, upon trial, [he] thinks it too hard to teach her, being ignorant of the principles of lines'.[21] Shortly after this, Alexander Browne presented Pepys with 'a book of drawings by him, lately printed, which cost me 20*s* to him' (see cat. 34).[22]

At first it might appear from these transcriptions and from the activities of the other limners discussed in the entries that follow that although limning was considered a suitable activity for gentlemen and ladies in the first half of the seventeenth century, by the time of the Restoration a polarization was beginning to occur in the types of drawing being practised by men and women. Pepys danced and sang with his wife, but his own

participation in the visual arts was limited to connoisseurship, collecting (especially prints),[23] an interest in mechanical devices for drawing, and engraving techniques. John Evelyn drew, painted in watercolours and etched, but it was his wife who limned.

Thomas Flatman (cat. 25) was perhaps the last flowering of Hilliard, Peacham and Norgate's gentleman limner. As a landowner, barrister and poet (he published many poems and songs and contributed to an important translation of Ovid's *Epistles* in 1680), he has always been considered an amateur. He was well acquainted with the artist Mary Beale and her husband Charles who prepared her colours; he may even have been paid for lessons to their son in 1677.[24] Nevertheless, in the light of his various other activities, as well as the fact that he was self-taught and retained an old-fashioned, rather individual approach to style that seems to have reflected a personal philosophy towards simplicity and naturalness, he should be placed firmly within the tradition established by earlier gentlemen limners such as Sir Nathaniel Bacon and Sir Balthazar Gerbier. His poetry, art and practice as a barrister and self-description as a 'gentleman' constituted an attitude towards life that reflected that of his fellow *virtuosi* in the Royal Society who devoted their lives to a natural philosophy that studied the various ways in which God and His power were manifested through science and art. For Flatman painting was not a separate activity but rather was like a thread that ran through life: 'Thus (like the Soul o' th' world) our subtle Art, / Insinuates itself through every part.'[25]

By the beginning of the eighteenth century not only the daughters of peers, but also the daughters of late seventeenth-century *virtuosi* such as Sir Hans Sloane (1660–1753) were learning to limn flowers and portraits from life and to copy oil paintings. By this date the copies were also being painted in watercolour on paper, more often than on vellum or card, and 'to limn' was coming to mean merely to paint small copies or portraits. John Chubb's use of the term in 1750 was clearly no longer the same as that of Sir Nathaniel Bacon; Johnson's *Dictionary* of 1755 defined limning as 'To draw; to paint any thing' and a limner was any 'painter; a picture-maker'. But it would be a mistake to generalize about the polarization of the activity of painting miniatures and to see 'limning' confined to female amateurs for the rest of the eighteenth century. In her *Dictionary of Miniature Painters* Daphne Foskett lists several examples of gentlemen such as the Hon. John Perceval (1711–70) who painted his own portrait in miniature in 1730, the Hon. Algernon Percy (1779–1833) who painted miniatures of himself and his mother around 1805, and 'Beau' Brummell (1778–1840) who painted a miniature of the Countess of Essex, which he presented to her. What seems more likely is that the general history of art and the histories of individual men have ignored or glossed over these personal and private accomplishments rather than dwelling on them as one would their public activities, whereas for women, whose spheres of activity tended to be more domestic, such accomplishments have been considered more important.

This attitude was signalled by earlier writers, including John Aubrey in his manuscript thoughts on education: 'limning is too effeminate, Painting is more masculine and useful'.[26] Through-

out his life, Aubrey himself drew antiquities and landscapes, but his comments indicate that already in the seventeenth century limning was seen to be a decorative rather than useful art, and therefore not appropriate for men. Other commentators on the place of limning in British art in general have regarded it as a forerunner to watercolours – another type of painting that has sometimes been marginalized and, at the beginning of the nineteenth century, when it was inundated by amateur practitioners, had to reinvent itself to be considered a serious profession.[27]

From *The Compleat Gentleman* to *The Compleat Drawing Master*

This change of focus, from the 'noble and gentle art' of limning as a refined 'accomplement' of a gentleman to being merely one of many accomplishments practised mainly by women, is reflected in the drawing manuals produced through these centuries. The earliest recommended drawing and limning under the instruction of a master, but in the eighteenth century the sections on limning were gradually dropped and replaced by instructions on watercolour washes, with texts relying on a combination of earlier English and French treatises by Gerard Lairesse and Charles-Alphonse Dufresnoy. Manuals such as *The Compleat Drawing Master* and *The Compleat Drawing Book* (see cat. 38) were compiled by printsellers rather than artists and issued in several varying editions during the eighteenth century, and provided a variety of skills that could be learned without the aid of a master.

Most of the earliest drawing manuals published in English were translations of, or relied heavily on, the text or plates of manuals or treatises already published by G. P. Lomazzo or Odoardo Fialetti (cat. 32) in Italy or Abraham Bloemaert (cat. 91) in the Netherlands; very few were entirely the work of the English authors or publishers.[28] The earliest was Richard Haydocke's *A Tracte containing the Artes of curious Paintinge, Carvinge & Buildinge* of 1598, a translation of Lomazzo's manual, *Il Trattato dell'arte*, published in Milan fifteen years earlier. Unlike Lomazzo's original, Haydocke's was illustrated with thirteen plates based in part on those by Dürer in his treatise on human proportions, *Vier Bücher von menschlicher Proporzion* (1527). Haydocke was a physician but, according to his preface, had, for his own recreation, '7 years dilligent and painfull practice in the Arte' of engraving and painting, and had himself studied fine examples of painting, carving and building in order to provide his translation, which was more than a literal one.[29] It was a highly influential text: Hilliard's manuscript on the art of limning was shaped by it and Hogarth found confirmation there for his 'line of beauty'.[30] Other publishers issued editions of drawing manuals that pirated plates and portions of translated texts: Thomas Jenner's *Book of Drawing, Limning, Washing Or Colouring of Maps and Prints: and the Art of Painting* was subtitled *The Young-mans Time well Spent* (1647), and appeared again in the following two centuries as *Albert Dürer Revived*.

One of the earliest and best-known manuals was published in

1612, and it is significant in the context of this study that it was written by an amateur, for amateurs. Henry Peacham's *Gentlemans Exercise* (1612, expanded from his 1606 *Art of Drawing with a Pen, and Limming in Water colours*)[31] had a long and self-explanatory subtitle: *Or An exquisite practise, as well for drawing all manner of Beasts in their true Portraitures: as also the making of all kinds of colours, to be used in Lymning, Painting, Tricking, and Blason of Coates, and Armes, with divers others most delightfull and pleasurable observations, for all young Gentlemen and others. As also Serving for the necessarie use and generall benefite of divers Trades-men and Artificers…* The note 'To the Reader' indicated that Peacham had first published his earlier short discourse on the art of drawing for the benefit of the young men who were his Latin and Greek scholars, that he had written it himself, based on his own experience, and that he was entirely self-taught. Drawing was not his profession and although he hoped it would be useful for professional artists as well, the main purpose of his text was to introduce the art of drawing to other gentlemen who would allow it 'the place *inter splendidas nugas*, and those things of accomplement required in a Scholler or Gentleman'. He did not propose that they should devote themselves to it exclusively, and cited the examples of ancient philosophers who gave some time to music or the arts but did not allow these to divert them from their true professions. Finally, to further explain his title, he noted that Aristotle had designed four principal exercises 'wherein he would have all children in a well governed Citie or Commonwealth, brought up and taught' grammar, gymnastics, 'Graphice or use of the Pen in writing faire, drawings, painting, and the like' and, finally, music. Peacham's text began, as many subsequent ones would, with the reasons for studying drawing, then with a list of the tools required. Practice in drawing geometrical forms was followed by drawing simple objects, such as a cherry or a rose. He recommended that an object be drawn not from life but from an idea of it, and that the drawing should be set aside and corrected again later. But the most important subject to draw was man, and one should begin with the features of the face, proceeding to the entire head, then parts of the body, followed by the whole. The book was illustrated with examples after his own drawings inserted into spaces in the text.

Peacham's drawing manual *The Gentleman's Exercise* was followed by his courtesy book *The Compleat Gentleman* (1622), which contained a long section devoted to the visual arts, and was expanded in 1634 to include the section on collecting and the first English use of the term *virtuoso*. Both books went through several editions, before being combined as *The Compleat Gentleman* of 1661.[32]

Peacham was at one time tutor to the sons of the Earl of Arundel. It is not surprising that the author of the first manual in English to include a discussion 'concerning the proper method of becoming a connoisseur' was Francis Junius, the Earl of Arundel's librarian and a friend of Edward Norgate. Junius's *Painting of the Ancients* (1638) was relied upon heavily by later authors of drawing manuals such as William Sanderson in his *Graphice* (1658), and ideas expressed by Junius, Peacham and Norgate were to be repeated in drawing and painting manuals right through the seventeenth and eighteenth centuries.

Edward Norgate's *Miniatura, or the Art of Limning* was first written in 1627–8 and revised for presentation to the 3rd Earl of Arundel in 1648. Never published by the author, it circulated in many manuscript versions amongst the *virtuosi* and a handful of professional limners in court circles, and was the basis for a number of drawing manuals published in the second half of the century. It treated not only limning and its materials, but also landscape, history painting and drawing, the last only added to the revised version because the earlier one had been addressed to a gentleman amateur artist and chemist, Sir Theodore de Mayerne (1573–1655), who was already a 'good and sufficient designer'.[33]

Norgate followed his discussion of limning landscape and historical paintings with the following statement:

For my part I can but hope and wish that what I have written in this short discourse of excellent men, and excellent things may have that influence upon some of the Gentry of this Kingdome (for whose sake and service it was principally intended) that they may become the one, and make the other. In the Practize whereof … there is gotten an honest harmles, and innocent expence of time in a sweet and contented retirement from the *Tintamarra* … and ill Company, the bane and ruine of many a rare wit and ingenious spirit … Yet never was it my meaning that the time spent in this Art, should become a hindrance to better studies, but rather to a discreete Artist may serve as a witty commendable recreation, and perhaps become an improvement to better.[34]

Norgate did not want to see English artists or gentlemen confining themselves to limning portraits or landscapes: he felt that the English were much better at limning 'histories' than any contemporary Italian artist, and to demonstrate English superiority, it was incumbent upon amateurs to set an example and build a foundation for a national school in the distinctive national 'language' of limning.[35] The best way to learn was to copy carefully chosen paintings by acknowledged masters.[36] The honoured place accorded such copies by professional limners and gentlemen and women amateurs, in glazed and locked cases in the king's cabinet, ensured their status.

John Evelyn included the publication of Norgate's treatise in his plans for 'a history of trades' dating from 1657, but when the larger plan was dropped, he included only portions of it in his *Sculptura* of 1662. Excerpts from Norgate's treatise had already made their first appearance in print in William Sanderson's *Graphice* in 1658, and were repeated in most of the other drawing manuals of the seventeenth century, including that by Alexander Browne (cat. 34) and William Salmon's *Polygraphice, or The Arts of Drawing Limning painting &c.* (1672). Salmon's extensive text of over 400 pages covered not only drawing, painting, limning and etching, but also the manufacture of cosmetics and perfumes, fake gems and alchemy.[37] On the whole, these published versions of Norgate's treatise were full of errors, so manuscript copies continued to be made, circulated and treasured. It was during the time that Evelyn had access to a copy of the treatise that his wife made her copy of Isaac Oliver's copy of Raphael's *Madonna*, which she presented to Charles II in 1661, and it was shortly after this that Pepys's wife began to learn

to limn from Alexander Browne. Fellows of the Royal Society had access to Arundel's copy, which came to the Society in 1678 with his library, and later Ralph Thoresby, George Vertue and Horace Walpole all owned copies.[38]

Although flawed, the various publications of Norgate's *Miniatura* made the treatise and the practice of limning available to a much wider audience than the circle of courtiers and gentlemen *virtuosi* who had access to the manuscript. Sanderson wrote that his intention was to reach 'the ordinary artizan' in order to help him achieve a new excellence. His and the other published interpretations of Norgate's treatise made it widely available to all professional artists, the 'mere' craftsmen that Norgate's original circle, the Royal Society and fellow *virtuosi* had been so keen to exclude from knowledge of such 'curiosities', lest they debased or 'prostituted' them. At the same time it had a further significant effect.

In theory the secret of limning was now also available to anyone who could afford to purchase or borrow one of these manuals, to all gentlemen and female amateurs, as well as their children and their tutors. But in the seventeenth century, in spite of the proliferation of drawing manuals, there is very little evidence of anyone outside this circle achieving this end 'without a master', by learning from a manual alone. Reading and writing were still on the whole confined to a certain level of society, and the 'polite recreations' of drawing and limning seem to have been confined to even further upper reaches, those with not only the resources to provide the required finances and time, but with the wide cultural interests displayed by the *virtuosi* of the previous chapter.

Flora, Fauna and Florilegia

Two gentlemen whose work appears in this chapter made individual contributions to the English art of limning that typify its status as a 'polite' art as much as a professional one. John Dunstall (cats 6, 35) and Alexander Marshal (cats 45–8) both probably learned to limn from copying and from other *virtuosi*, as well as by taking lessons from professional artists. Both were exceptionally skilled at and interested in depicting plants and animals from nature, rather than figural subjects. Both had classical educations and close ties with the church. Neither described himself as a professional artist, yet neither seems to have been sufficiently wealthy to paint purely for pleasure: Dunstall described himself as a schoolmaster and provided drawings for engravers, while Marshal, at one time a merchant, lived with a number of patrons whose plants and treasures he painted, not as an artist employee but rather as a resident gentleman expert on horticulture and entomology who also happened to be an excellent limner. It was, no doubt, from someone like these that the members of the families of such patrons as Lady Carnarvon (cat. 24) learned to limn flowers.

Horticulture was as much a field for gentlemen and lady amateurs as limning, and demanded a similar specialist knowledge acquired like other *virtuosi* pursuits through books and association with experts as well as fellow enthusiasts. In a similar manner to limning and collecting, horticulture was considered a study suitable for kings and connoisseurs, and plants were to be studied more for themselves, for their beauty and rarity, than for their healing properties alone. The Duchess of Portland, Mary Delany, Lady Anne Monson and Anna Blackburne are just four of the hundreds of gentlewomen who studied, collected, classified and drew plants in the later eighteenth century whose history is just beginning to be examined.[39]

Women were considered to be particularly skilled in botanical drawing, and it is not surprising to find more female professional artists in this field than in any other. From Maria Sibylla Merian in Holland in the seventeenth century, to Margaret Meen, Mary Lawrence and Mary Moser in England in the eighteenth, women found a source of income in flower painting when their families or financial situations made it suitable or necessary.[40] Some were daughters who followed their fathers' trades, while others were amateurs who turned professional when they lost other means of support. Why women should be particularly suited to this subject is in some ways obvious: flowers are beautiful and delicate, traditional female attributes and adornments, directly associated with another accomplishment that was most certainly a female pursuit – needlework (see cat. 37). What is surprising, however, is that so few examples of flower paintings by amateurs, male or female, from the seventeenth or early eighteenth century, appear to survive.

Most of these women did not, however, paint flowers alone, and it is slightly misleading to consider their activity as amateur artists as a peculiarly feminine pursuit because of its association with this particular subject matter, just as it was misleading to think of limning as a feminine pursuit because of its medium and association with jewellery and adornment. Exceptions can be found as soon as such assumptions begin to be made, and it is often more revealing to study actual cases like Sarah Stanley (cats 29–30), whose limnings altered in subject and media as her skill and the decades progressed, or Helena Percival (cat. 44) whose only surviving work is an ambitious landscape done under the tutelage of the same drawing master, Bernard Lens. Lens also taught one of the most famous, active and varied of all eighteenth-century women amateurs, Mary Delany, whose work spanned the century not only in years but also in the various forms that a polite recreation might take.

The Reward of Industry

Amateur activity in the first half of the eighteenth century seems to have centred around lessons in drawing in crayons provided by the artist/dealer Arthur Pond (cat. 169) and by 'two of our best miniature painters and worthy of any cabinet',[41] Bernard Lens (cats 27ff) and Joseph Goupy (1689–1769), who continued the seventeenth-century tradition of limning and gave lessons to members of the court and the smaller circles that emanated from them. Goupy taught Frederick, Prince of Wales, to draw, and the Princess of Wales lined her closet with his limnings after old masters 'in curious carved frames

and glasses'.[42] He and his uncle Louis (*c.*1674–1747) also had several private pupils.[43]

Mary Delany's engagement in a wide array of activities is perhaps the best documented of them all, in her vast correspondence, wide acquaintance and large body of surviving work, including her drawings of landscapes in public collections and her paper mosaics now in the British Museum (cat. 40).[44] Classically educated and groomed from childhood for a position at court, she already practised cutting paper and needlework before taking lessons in japanning, drawing and painting in the 1720s with several other women in her circle, which included Mrs Montagu, Lady Harriet Harley and her daughter Margaret, later the Duchess of Portland. After her marriage to Dr Patrick Delany of Trinity College, Dublin, in 1743, she spent most of the next twenty-five years in Ireland, creating a garden at Delville and putting to use the landscape skills she had learned from Bernard Lens,[45] as well as drawing portraits, copying paintings in oil and designing her own needlework.

Mrs Delany had a special closet built for her painting, carving and gilding tools, prints, drawings and collection of fossils and minerals, but felt guilty about the purpose of her closet when comparing it to her sister's more philanthropic activities:

Mine fits only an idle mind that wants amusement; yours serves either to supply your hospitable table, or gives cordial and healing medicines to the poor and sick. Your mind is ever turned to help, relieve, and bless ... whilst mine is *too much filled* with amusements of no real estimation; and when people commend any of my performances I feel a consciousness that my time might have been better employed.[46]

She clearly worried that her 'amusements' were tied to the courtly *virtuoso* arts of the previous century, and were not of sufficient public and moral benefit to take pride in them. They were shared by a surprisingly limited number of women who, like her, had been unusually well educated, were closely connected to the court and were encouraged by their liberally minded fathers and husbands. There was an element of virtue and morality in their accomplishments, in that they were setting an example by occupying their time innocently and industriously and displaying that they were of liberal 'taste'. But their correspondence indicates that they were aware that their attitudes were not shared by society in general: indeed, Lady Mary Wortley Montagu warned Lady Bute that her daughter should be indulged in her desire for serious study but 'conceal whatever Learning she attains, with as much solicitude as she would hide crookedness or lameness'.[47]

Mary Delany's artistic 'amusements' continued to evolve. She had cut paper throughout her life, making not only landscape and figural silhouettes, but also three-dimensional pictures of birds, cut from vellum. The labels identifying the birds and where they originated indicate that she copied them from natural history prints, which proliferated along with botanical prints at this time. She had collected shells from childhood and used the 'more common sort' as imitation stucco to decorate the chapel at Delville, while the 'serious' collection was carefully arranged in cabinets.

Widowed for the second time in 1768, Mary Delany was invited by Margaret Harley Bentinck, the dowager Duchess of Portland, to visit her at Bulstrode, which she did for six months every year for the next seventeen years. During an earlier visit in 1756, she rearranged the great Bulstrode collection of miniatures, formed by the Cavendish and Holles families, and added to by subsequent members of the Harley family, the earls of Oxford.[48] Mrs Delany was in her early eighties with failing eyesight when Mary Hamilton (1756–1816, m. John Dickenson, 1785), a young Bluestocking (see p. 214), who held a minor position at court, was adopted as a companion by the two elder ladies. Like Mrs Delany, she was the mistress of several accomplishments, and when only thirteen received a letter from an older friend advising:

I hope you will not grow tired of your drawing, 'tis a pretty Amusement, & I am certain you will arrive at Perfection, if you persevere ... But you attempt a Hundred things at a Time, you scorn the beaten Track prescribed to the rest of your Sex, & would soar to the skies at once. 'By slow degrees the liberal Arts were won, & Hercules grew strong.' You are so young that you may have a knowledge of every useful science, before the time that most women know how to read English.[49]

In 1784 Mary Hamilton arranged Mrs Delany's collection of prints and Mrs Delany presented her with a small mother-of-pearl locket, enclosing some of her hair. On the cover that enclosed the locket, she had written: 'The reward of Industry'.[50]

Mary Hamilton helped her uncle Sir William Hamilton to negotiate the sale of his Barberini Vase to the Duchess of Portland, and his admiration for the qualities of the old *virtuosi* that the duchess and Mrs Delany embodied led him to remark: 'Vive la vieille court, they are worth a million of the new-fangled ladies.'[51]

It is easy to see why Sir William should have admired these women in particular – their outlooks on their purposes in life and roles in society were the same that motivated all the inheritors of Shaftesbury's 'civic humanism', who sought to lead through example by living morally virtuous and useful lives. Mrs Delany declared in 1780 that one of the greatest blessings to be enjoyed was 'the reflection of *doing our duty*',[52] echoed by Sir William just over a decade later in a letter to Horace Walpole: 'But in this world one must do one's duty and fulfill every obligation in the best manner one can – without which no thinking man can be happy.'[53] Writing to Joseph Banks of his own new-found passion for gardening when he was given responsibility for the creation of the English Garden at Caserta, Sir William noted: 'As one passion begins to fail, it is necessary to form another; for the whole art of going through life tollerably in my opinion is to keep oneself eager about anything. The moment one is indifferent *on s'ennuie*, and that is a misery to which I perceive even Kings are often subject.'[54] It was a sentiment that echoed that of the seventeenth-century *virtuosi*, a desire to avoid the most dangerous and evil of all maladies, 'melancholia', which they perceived as being brought on by *ennui*, what we now describe as boredom. It was one's duty to society to keep oneself always employed, but above all employed usefully.

NOTES

1 Mark Girouard, 'Country-town Portfolio', *Country Life* (7 December 1989), 155

2 Ibid., 154–9; most of his watercolours (private collection) are on loan to the Admiral Blake Museum, Bridgwater, Somerset.

3 Hearn, no. 149.

4 Quoted in Whinney and Millar, 82, from *The Compleat Gentleman*.

5 MacGregor 1983, 28.

6 For Norgate's treatise *Miniatura*, see Muller and Murrell. K. Coombs, *The Portrait Miniature in England*, 1998, is the best general guide to the subject. I am indebted to her Introduction for the following section, and for clarifying terms, and her kind patience and generosity in introducing me to the entirely new (to me) world of English miniatures.

7 Ellis K. Waterhouse, *Painting in Britain 1530–1790*, Harmondsworth 1953, 1978 edn, 38–9.

8 Hilliard, quoted in Coombs, 1998, 54; see also Norgate, in Muller and Murrell, 95–6.

9 Muller and Murrell, 63–4, 99, 120 n. 23, 191 n. 241; one of Hilliard's most important patrons, Robert Cecil, was related to Sir Nathaniel Bacon.

10 Foskett, 434–5; Murdoch 13–15; Griffiths 1998, 92.

11 Murdoch, Murrell and Noon, 82–4; presumably the mother of Henry and grandmother of Anne Killigrew.

12 De Beer III, 287; she also designed the frontispiece to his essay on the first book of Lucretius, ibid., 173 n. 2.

13 John Bowle, *John Evelyn and his World: A Biography*, 1981, 213.

14 Latham and Matthews VI, 98.

15 Bermingham 2000, 10.

16 Ibid., 52–3.

17 The entries are followed by the volume and page references from Latham and Matthews.

18 Latham and Matthews VI, 289.

19 Ibid., VII, 51.

20 Ibid., IX, 390.

21 Ibid., IX, 535; in May 1669 Sheeres left for Tangiers where he was employed as an engineer. He was knighted in 1685. The lessons in perspective may have ceased because Pepys thought his wife was over fond of Sheere: see IX, 532, 541.

22 Ibid., IX, 561.

23 See Jan van der Waals, 'The Print Collection of Samuel Pepys', *Print Quarterly* I, no. 4 (December 1984), 236–57.

24 George Vertue's transcriptions of Charles Beale's accounts also record that he paid Flatman for his portrait (V&A P13–1941) and others (Vertue IV, 173–5). Flatman's wife, Suzanna, about whom very little is known, gave the elder Charles Beale a copy of Leonardo's *Trattato della Pittura*, which he in turn lent to Thomas Manby in 1681 (see cat. 7).

25 'On the noble Art of Painting', affixed to Sanderson's *Graphice*, 1658, quoted in Murdoch 1997, 206.

26 Quoted in Richard Wendorf, *Elements of Life in Stuart and Georgian England*, 1990, 122.

27 See Clarke, 19–20, and Coombs, 12, where she notes that by establishing itself as a focus for the national collection of miniature painting, at which the British were considered to excel, the Victoria and Albert Museum situated miniature painting as an 'English watercolour art, precursor and integral part of the "English tradition" of watercolour painting'; and see Smith (forthcoming 2001).

28 The history of seventeenth- and eighteenth-century English draw-ing manuals is a complicated one and still awaits proper study, but see Ogden 1947, Dobai I, II, *passim*, and Bermingham 2000, chap. 2.

29 See Eileen Harris, *British Architectural Books 1556–1785*, Cambridge 1990, 297.

30 Robert Harley, 1st Earl of Oxford's copy was with Quaritch in 1995 (cat. 1204, no. 50).

31 Bermingham 2000, 33, 49ff..

32 The evolution of the various editions and titles is explained in ibid.; see pp. 47–50 for his illustrations in the text and two or three draw-ings that have been attributed to him. See also Bermingham's earlier article on Peacham and later drawing manuals, 1995, 47–55. But see also F. J. Levy, 'Henry Peacham and the Art of Drawing', *Journal of the Warburg and Courtauld Institute* XXXVII (1974), 174–90. There is some question about the dates of publication. Some copies of *The Art of Drawing with a Pen* are dated 1606 and 1607 (Levy, 179). In 1612 the *Art of Drawing* was expanded and published as *Graphice* – reissued later that year as *The Gentleman's Exercise*. The BM has a landscape with figures initialled *H.P.*, formerly attributed to Peacham but now kept with the seventeenth-century Dutch and Flemish drawings.

33 Sir Theodore (1573–1655) was the Huguenot physician to Charles I, see Muller and Murrell, 58, 114 n. 7, and H. Trevor-Roper in Howarth, 264–93.

34 Muller and Murrell, 95–6.

35 Ibid., 173 n. 183.

36 Ibid., 89–90.

37 The third edition of 1675 incorporated a dozen plates, engraved by William Sherwin, who issued them as his own copybook in 1684.

38 Muller and Murrell, App. I.

39 See Shteir, 1–57, and the forthcoming exhibition at the NPG, *Women and Gardens* (September 2000).

40 See the entries on these women in Gaze; see also Shteir, 41–6, and for Moser, Pointon, 131–71.

41 Walpole, *Anecdotes* III, 32.

42 Whitley II, 135.

43 See C. Reginald Grundy, 'Documents relating to an action brought against Joseph Goupy in 1738', *Walpole Society* IX (1921), 77–88, esp. 81–2; Robertson 1988; and Jacob Simon, 'New Light on Joseph Goupy (1689–1769)', *Apollo* (February 1994), 15–18.

44 See Lady Llanover, ed., *The Autobiography and correspondence of Mary Granville, Mrs Delany*, 6 vols, 1st series, 1861, 2nd series, 1862, and Ruth Hayden's monograph.

45 Most of her pen and ink and wash landscapes of Ireland are in the National Gallery of Ireland, Dublin.

46 Quoted in Hayden, 95.

47 Quoted in Sloan 1997, 294. See this article and pp. 213–15 below for further information about this circle, their education, and how both the type of artistic activities women engaged in and the way they were received changed around the middle of the century.

48 Llanover, series I, vol. 3, 1861, 439; for the Bulstrode collection, see Goulding.

49 E. and H. Anson, eds, *Mary Hamilton: afterwards Mrs John Dickenson at Court and at Home – from Letters and Diaries, 1756 to 1816*, 1925, 7.

50 Ibid., 250.

51 Hayden, 129.

52 Ibid., 171. For Shaftesbury's 'civic humanism', see below, pp. 103–4.

53 *Wal. Corr.*, XXXV, 441.

54 Quoted by C. Knight in Jenkins and Sloan, 18.

ELIZABETH, COUNTESS OF CARNARVON (1633–78), *née* CAPEL

24

Flowers in a vase, 1662

Bodycolour on paper, mounted on panel, 410 × 308 mm

Signed and dated: *E Carnarvon: 1662:*

Millar 318

Lent by Her Majesty The Queen (RCIN 402988)

In 1654 Lely painted a double portrait of the daughters of Arthur, 1st Baron Capel, for their brother (Metropolitan Museum of Art, New York). Mary (1630–1715), later the Duchess of Beaufort, is seated on the left, holding a wreath of ivy, possibly an allusion to Poetry, while her sister Elizabeth, who married the 2nd Earl of Carnarvon in 1653, holds a small framed drawing of a single flower, possibly a 'broken' tulip, clearly inscribed *E. Carnarvon/fecit*. A charming earlier family portrait by Cornelius Johnson

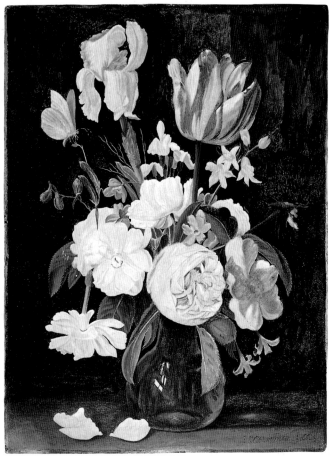

(National Portrait Gallery) depicted them with their parents and brothers Arthur and Henry holding flowers and standing before their garden at Little Hadham.

The entire family were keen botanists and gardeners. The 1st Baron Capel and his eldest son Arthur, later Earl of Essex, built up the gardens at Cassiobury, and Henry was to establish a garden at Kew that later became the site of the Royal Botanic Gardens. Both were greatly admired by John Evelyn who stated that Sir Henry's garden house at Kew contained 'the choicest fruit of any plantation in England'. The Duchess of Beaufort developed the gardens at Beaufort House and Badminton and between 1703 and 1705 commissioned a florilegium in watercolours from Everard Kickius and Daniel Frankcom of 'naturall Plants growing at Badminton and Chelsea', where her garden bordered the physic garden of her friend Sir Hans Sloane.

The drawing held by the Countess of Carnarvon in her portrait by Lely is very similar to the type found in florilegia on the Continent and in England in the seven-

teenth century. Little is known of the countess's early education, but flowers played an important role in Lely's paintings and he may have given her lessons. It is more likely, however, that she learned to limn with Richard Gibson (1615–90) around 1657, when he painted a group of miniature portraits of her and other members of the Capel family. Her husband, Lord Carnarvon, became Gibson's main patron after the death of his grandfather, the Earl of Pembroke, whom Lely had introduced to Gibson in the 1640s. After the Restoration, Gibson was employed as a copyist of paintings in the Royal Collection and as a teacher of drawing to James II's daughters. His own daughter was Susannah-Penelope Rosse (cat. 26).

One of the central flowers in the present drawing, sadly faded, is a tulip. During the height of 'Tulipmania' in the 1630s, single bulbs changed hands for as much as £80,000 at today's value. The mania was for 'broken' tulips, which produced variations now known to have been caused by a virus: in feathered tulips the colour is confined to the edges of the petals, and in flamed tulips it runs up the centre of each petal branching out to the edges. The countess seems to have been conversant with various manners of painting flowers, apparently her own contribution to the family passion; in Lely's portrait her painting was in the style of a French florilegia and in this drawing she has used the Dutch manner. It has not been established whether this was a copy or her own composition; nevertheless, it is a rare survival of a work by an English woman during a time when Alexander Marshal was the only other British artist attempting a genre so completely dominated by European artists. Lady Carnarvon's work should be seen in this context rather than that of later eighteenth- and nineteenth-century flower paintings by lady amateurs: it was a remarkable achievement on many levels and although its early provenance is not known, it may well have been a gift to the royal cabinet.

Literature: Whinney and Millar, 281; O. Millar, *Tudor, Stuart and Early Georgian Pictures in the Collection of Her Majesty the Queen*, 1963, 138; O. Millar, *Sir Peter Lely*, exh. NPG, 1978, no. 27; Gloria Cottesloe and Doris Hunt, *The Duchess of Beaufort's Flowers*, Exeter 1983, *passim*; Blunt, 129–30.

24

25

THOMAS FLATMAN (1635–88)

25

Unknown man, 1663

Watercolour on vellum, 62 × 50 mm; oval, in seventeenth-century gold locket

Signed with monogram and dated: *TF 1663*; inscribed on verso: *Begun on Shrove/Teusday 1663/TF/London/finish't Marsh 1/1663*

Murdoch 121

Provenance: Hon. F. H. A. Wallop before 1927; lent to Victoria and Albert Museum, 1927–49; ownership transferred to Alan Evans, 1933, and by him bequeathed in 1974 to National Gallery; indeterminate loan to Victoria and Albert Museum

Lent by the Victoria and Albert Museum (Evans 22)

The son of a clerk in Chancery, Flatman attended Winchester and Oxford and had an MA from Cambridge. He was called to the Bar in 1662 and elected to the Royal Society in 1668. He seems to have had sufficient income for it not to have been necessary for him to actually practise law. In addition to being an amateur limner, he was also a gifted poet and dabbled in astrology and theology. A small estate in Norfolk may have been acquired through his marriage in 1672, but he appears to have spent most of his time in London. His miniatures, mainly of his circle of friends, fellow lawyers and officials, as well as artists,

are among the finest of the seventeenth century. The earliest date from *c*.1660 and owe a debt to Samuel Cooper's early technique of building up the face with red-brown hatching, which remains part of the image rather than being blended into a smoothly finished surface. As it was by then an old-fashioned technique, it would seem to imply that he taught himself to limn from the various manuals then circulating in manuscript or published form. Flatman wrote a poem on the Power of Art as a preface to William Sanderson's *Graphice* of 1658, and valedictory verse for William Faithorne's *Art of Graveing and Etching* (1662) (see cat. 70). In the tradition of Sir Nathaniel Bacon and other earlier gentleman limners, Flatman leaves the impression of 'a very gifted man reading himself into a subject, consulting those of his acquaintance who knew something of it, and going along to watch the greatest exponents' (Murdoch, Murrell and Noon, 149).

Flatman's sitters, even when they are members of the Stuart court, are depicted without the jewellery, gilding and lace that were the trappings of power found in the works of many of his contemporaries. Their portraits are direct and honest, and their costumes and shoulders are often covered with draped cloaks. As in the present example, many are unidentified, and most are in this rather plain setting preferred by the artist. John Murdoch has seen this approach as the visual counterpart of Flatman's Pindaric odes on the Deaths of Champions, where the informality of the verse treated the illustrious subjects with respect and gratitude rather than obsequious awe.

Literature: G. Reynolds, 'A miniature self-portrait by Thomas Flatman, limner and poet', *Burlington Magazine* LXXXIX (1947), 63–7; Murdoch, Murrell and Noon, 148–53.

SUSANNAH-PENELOPE ROSSE (b. *c*.1655–d. 1700), *née* GIBSON

26

*Presumed Self-Portrait, c.*1680

Watercolour on vellum, put down on a table-book leaf, 80 × 64 mm; oval

Inscribed on verso: *Mrs Rosse*

Murdoch 138

Provenance: from 'Samuel Cooper's Pocket-Book', presumably acquired from Cooper's

estate by the Rosses; perhaps in Michael Rosse sale, 2 April 1723; acquired by Edwin [Durning] Lawrence before 1862 and sold by him to the Victoria and Albert Museum, 1892

Lent by the Victoria and Albert Museum (451-1892)

Richard Gibson was one of the most successful miniature copyists of the seventeenth century. He had originally been a page at court and returned there after the Restoration as a successful miniaturist and drawing master to the princesses Mary (1662–94) and Anne (1665–1714). From 1677 to 1688 he lived in The Hague in order to teach the Princess of Orange. Gibson had four children, whom he also presumably taught to draw. The eldest daughter, Susannah-Penelope, married Michael, the son of a successful jeweller, Christopher Rosse, who had taken over the house of Samuel Cooper, one of the finest miniaturists of the century, after his death in 1672. Gibson was a skilled copyist, but his portrait style was rather mannered, while Cooper's greatest achievement was his ability to capture likenesses in a very natural manner. He made careful sketches from life, taking several sittings, and produced finished works in his studio, often with assistants, but retaining the original sketches for further copies later.

Susannah-Penelope may not have had lessons from Cooper, but she certainly knew and studied examples of his work left in his house after his death. Cooper's widow sold most of them, but the Rosses owned a few, which were purchased in a pocket-book by the Victoria and Albert Museum in 1892.

26

The pocket-book contained fourteen miniatures in varying degrees of finish, mainly on square pieces of vellum laid on card with a prepared gesso back. At one point they were all thought to be by Cooper, but the inscriptions on the versos led to a number of them being recognized as the work of Susannah-Penelope Rosse. At least two were self-portraits, of which this, with its well-drawn face but rather roughly sketched costume, is the earliest. The other portraits in the pocket-book were of Susannah-Penelope's sister and neighbours, or copies of portraits by other artists. They not only illustrate graphically the method of creating a miniature and the skill that could be achieved by application, but also give a rare and intimate glimpse into the social and artistic circle in which at least one female amateur, who was neither a member of the aristocracy nor gentry, moved. Her father was an artist, her husband a jeweller and member of the Virtuosi of St Luke, her cousin William Gibson a picture-dealer, and her near neighbours included Nicholas Dixon (see cat. 28) and Alexander Browne (cat. 34). There are miniatures by her that are less than an inch in height; many are copies after portraits by other artists such as Kneller to whose studio she had access and with whom she shared at least one sitter, the ambassador from Morocco.

Literature: Graham Reynolds, *Samuel Cooper's Pocket Book*, Victoria and Albert Museum Brochure no. 8, 1975; Coombs, 73–6.

Bernard Lens III (1682–1740)

27

Sarah Churchill, Duchess of Marlborough (1660–1744)

Watercolour and bodycolour on ivory, 73 × 57 mm; in pearwood frame

Signed with gilt monogram; inscribed on verso of frame: *Sarah Jenning, Duchess of Marlborough*

Provenance: Bequeathed by J. Jones

Lent by the Victoria and Albert Museum (610-1882)

Bernard Lens III's first known miniature dates from 1707, the year his father began to teach Edward Harley (1689–1741, later 2nd Earl of Oxford), who in turn was to become one of the greatest collectors of miniatures, many of which are still at Welbeck Abbey. In the 1710s Harley com-

27

missioned miniature portraits of his father, wife and daughter from the younger Lens, and in 1726 purchased a book of twenty topographical drawings by him. Lens later taught Harley's daughter, the Duchess of Portland, to draw landscapes (see cat. 43). From 1708 to 1721 Bernard Lens III painted several portraits on ivory for John Hervey, 1st Earl of Bristol, of Sir Isaac Newton, and a group of artists, including Van Dyck, Rubens and Raphael, for three guineas each. He became limner to George I and George II, and is best known for his miniatures, both portraits *ad vivum*, as well as copies of old masters, such as those he made for the Duke of Marlborough from 1719 to 1721, of paintings by Rubens and Van Dyck, which had only recently arrived at Blenheim. The paintings by Rubens proved to be popular paintings for copyists: the duke's great-granddaughter, Lady Diana Beauclerk, was to copy from them a few decades later (cat. 176).

While working at Blenheim, Lens also painted a series of miniature portraits of the duke's family, some of which were miniature copies of existing portraits, such as the full-length portrait of Sarah, Duchess of Marlborough, on vellum (Victoria and Albert Museum), which although dated 1720 and inscribed *ad vivum* on the verso, cannot be from the life as the duchess was sixty at the time. For some of the family portraits Lens made miniature copies of portraits of other sitters by Van Dyck or Rubens, inserting the heads of members of the duke's family. The portrait of the duchess shown here must have been copied from an earlier portrait than the full-length one, as she appears to be even younger. With its oval format, painted on ivory with a grey wash ground in one of Lens's typical stained pearwood frames, it makes a useful comparison with the portrait by Sarah Stanley (cat. 29). The blue of the duchess's dress is a colour of which Lens was

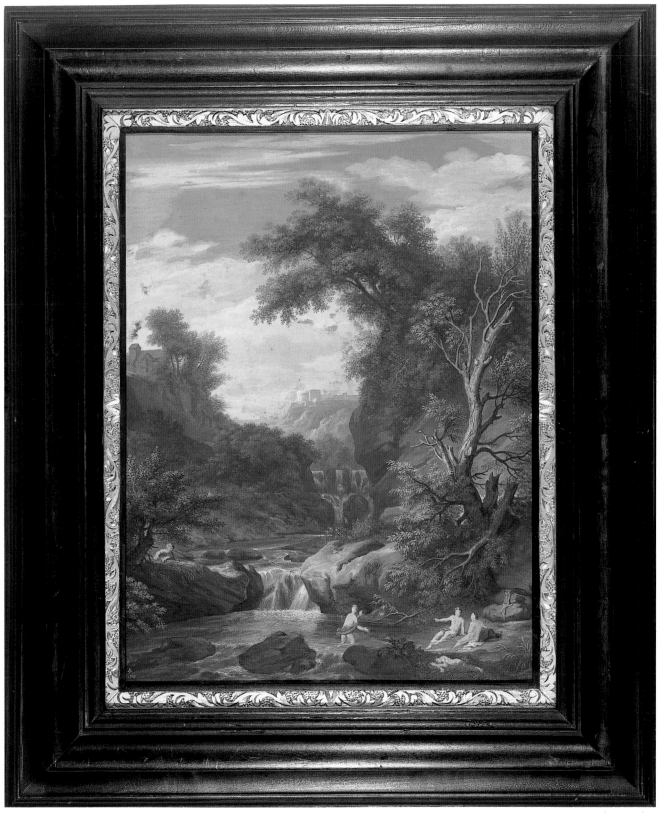

28

particularly fond and used to great effect, often in the backgrounds of his portrait miniatures, a technique that deliberately referred back to Elizabethan miniatures.

Literature: Goulding, 41–2; Anne-Marie Logan, 'Bernard Lens the Younger and the Marlborough Collection', in *Essays in Honor of Paul Mellon*, ed. John Wilmerding, National Gallery of Art, Washington 1986, 203–15.

BERNARD LENS III (1682–1740) after JAN VAN DER VAART (1647–1721)

28

Landscape with bathers, 1718

Watercolour and bodycolour on vellum, put down on wooden panel, 260 × 199 mm; in pearwood frame with gilt slip

Signed with gilt monogram and dated; inscribed on verso of panel: *John Vander Vart Invented / Bernard Lens Junr. Fecit Londini / Feb ye:8:1718*

Provenance: Lady Gosford; purchased from Levin and Mosley, with R. H. Stephenson Bequest Fund

Lent by the Victoria and Albert Museum (P.1.-1934)

One of the traditional purposes of the office of king's limner was not, as frequently supposed, merely to provide portable like-nesses, but to copy subject pictures by old and modern masters. From the time of Isaac and Peter Oliver, these copies, usually on vellum, were treasured in cabinets as precious works of art in their own right; their owners did not share the present-day view that a copy was not a 'proper' work of art. Nicholas Dixon (*c*.1645–post 1708) was a king's limner who was also keeper of the King's Picture Closet and in 1698 marketed his copies by floating a lottery. It was a commercial failure, however, and his works were mortgaged to the Duke of Newcastle at Welbeck where thirty of them remain. In the early eighteenth century this practice had become an industry and artists such as Joseph Goupy specialized in it while other miniaturists like Bernard Lens III divided their time equally between portraits *ad vivum* and copies. Vertue particularly admired Lens's copies after Rubens and Van Dyck 'whose colouring he imitated exactly'. He copied a Raphael *Madonna* at Kensington in 1711 for John Hervey, Earl of Bristol, for £7 10s.6d. and a number after Rubens and Van

Dyck at Blenheim. Only a handful survives: two are after unidentified classical land-scapes (Birmingham Museum and Art Gallery, and Sotheby's, 14 November 1991, lot 37), and are very similar in subject and size to the present work after the Dutch artist, Jan van der Vaart (cat. 53).

Vertue also recorded that one of Lens's pupils, Catharine da Costa, began to learn to limn in 1712, at about the same time that Lens gave lessons to Sarah Stanley (cat. 29). Catharine da Costa also painted portraits on ivory and copied Lens's own copies of the Blenheim paintings by Rubens and Van Dyck.

Bernard Lens used vellum as a support for some of his miniature portraits and for all his copies, some of which reached the size of small oil paintings. He employed a miniature technique for these small copies on vellum, each highlight or leaf a dot of pure colour on the surface of broader areas of colour carefully built up with layers of tiny strokes of the brush over laid-in grounds. All known copies after paintings by earlier miniaturists such as Oliver and Flatman were after figural subjects. Lens was the first to copy landscapes and this is particularly relevant when considering the technique he employed in his topographical drawings in pen and ink with wash, where the grass was invariably depicted using tiny individual strokes of the brush (cat. 43).

Literature: Goulding, 25–6; Foskett, *sub* Costa; Murdoch, Murrell and Noon, 154–6, 164.

SARAH STANLEY (1696–1764), *née* SLOANE

29

Elizabeth Cadogan, 1725

Watercolour and bodycolour on vellum, 105 × 90 mm; oval in original pearwood frame, 154 × 138 mm

Signed: *S: Stanly.Fecit / 1725* and inscribed on verso: *Mrs. Eliz..Cadogan Pictor / Mrs Sarah Stanley Fecit*

Provenance: by family descent to Major R. C. Hans Sloane Stanley of Paultons, Hants., deceased; his sale, Messrs Woolley and Wallis of Salisbury, 4th day, 13 July 1955, lot 1251, bt Colnaghi's, from whom purchased 1955-7-26-1

Very little is known of Sarah, the eldest daughter of Sir Hans Sloane and his wife

Elizabeth. She married George Stanley (d. January 1734) of Paultons, near Romsey, in 1719, and bore him a son, Hans, in 1721 and a daughter, Elizabeth, who died in 1738, aged eighteen. Both her husband and son died by their own hands. Sarah's younger sister, also Elizabeth, married Colonel Charles Cadogan, later 2nd Lord Cadogan, through whom Sir Hans Sloane's property in Knightsbridge and Chelsea passed to the Cadogan family. According to the inscription on the verso Elizabeth also painted, but there is no record of her work. Sarah's son seems to have been brought up with some knowledge of and desire to collect paintings. In 1755 he sat to Reynolds with his mother and sisters. In 1764 he asked Lord Palmerston to look out for portraits by Veronese, 'perfectly fresh and well coloured', and he made use of the services of the antiquarian and artist Gavin Hamilton on his own visit to Italy the following year. The family collection at Paultons included a typical selection of paintings that might be collected on the Grand Tour or imported from Holland.

The collection at Paultons also included 'eighteen small Gouache Paintings in colour, of classical subjects from Old Masters, in ebonized and gilt frames', all by Sarah Stanley (divided into three lots 1307–9). Six were purchased by the Victoria and Albert Museum (see cat. 30). The sale also included a miniature (lot 1252, no artist given) identified as a portrait of 'Sarah Sloane, 1696–1764, eldest daughter of Sir Hans Sloane, and Miss Stewart (Lady Robinson), sister of Mrs Berens'. Also in the sale were 'Three Miniature Drawings' by Sarah Stanley (lot 1310), and the following lots may also have been by her: 1311 'An XVIIIth c. silkwork picture of a Lady and Child in a Garden, 10 × 11, in black and gilt bordered glass and gilt frame'; 1312 'A needlework picture "Baptising an Infant", 22 × 16 in gilt frame'. John Murdoch noted two miniatures on the London market in the 1970s that may have come from lot 1310 above: a signed and dated miniature of 1716, which seems to be based on a painting by Rosalba Carriera and a copy of Sir Hans Sloane's version of Nicholas Hilliard's *Man Clutching a Hand in the Clouds* of 1588 (V&A P21-1942).

We have no documentation to indicate from whom Sarah took lessons, but it is clear from the above that she had access to important collections and was copying Rosalba Carriera (1675–1758) in her mid-

29

teens. The Italian miniaturist is credited with having been the first to paint on ivory and Bernard Lens III with having introduced the practice to England (cat. 27). In 1702 Sir Hans Sloane inherited William Courten's collection, which included some miniatures. Sloane was court physician from 1712 onwards. Bernard Lens was active in court circles himself during this decade, as a miniature painter, drawing master and copyist, and on the strength of the resemblance of Sarah's portrait of her sister to the medium and style of painting Lens employed in his miniatures, it seems most likely that she had some lessons from him.

Literature: Foskett, 529; Murdoch, Murrell and Noon, 172, 222 n. 31; Ingamells, 889.

after GUERCINO (1591–1666)

30
Joseph and Potiphar's wife, 1727

Bodycolour on vellum, 178 × 228 mm; in original gilt and pearwood frame

Signed: *Sarah Stanley: Fecit:1727*

Provenance: as for 29, lot 1307 (six items), bt Victoria and Albert Museum

Lent by the Victoria and Albert Museum (P51-1955)

From the evidence of the sale at Paulton's in 1955, Sarah Stanley painted at least eighteen small copies in bodycolour on vellum after paintings by other artists. The other five purchased by the Victoria and Albert Museum in 1955 were: *Cupid making a bow*, after Parmigianino, 1722, 178 × 127 mm (P54-1955); *The Magdalen*, after Titian, 1723,

197 × 159 mm (P53-1955); *Landscape with figures*, after Cornelius van Poelenburg, inscribed on verso *in the Collection of Thos. Broderick, Esq.* [(1654–1730) MP and privy counsellor, of Wandsworth] *Dec. 19th 1724*, 190 × 217 mm (P50-1955); *Christ and the Money Changers*, 1735, 197 × 232 mm (P52-1955); and *Christ and the Woman of Samaria*, after Ciro Ferri, 1737, 325 × 289 mm (P55-1955). It has been assumed that Sarah Stanley made her copies from prints, but it seems possible from the inscription on the van Poelenberg painting that on at least that occasion, and probably when she made the present copy of a Guercino, she made her copies directly from oil paintings.

Guercino's original painting is now in the National Gallery, Washington, and did not leave Italy until around 1830; but the artist's workshop made copies of his more successful compositions and there is a contemporary copy of the *Joseph and Potiphar's wife* in Sarasota (Fla.). Several other early copies were known in English collections from the mid-eighteenth century, including that of Sir Joshua Reynolds, but Sarah Stanley's work is the earliest indication of the presence of a copy of this subject in England. In fact, throughout the seventeenth and eighteenth centuries there are frequent references to important collectors lending their paintings to friends to be copied – whether by an amateur member of the family or by a professional artist, to scale or in miniature. There are several references, for example, in Charles Beale's accounts, to borrowing paintings for his wife to copy and to copies he commissioned himself; on one occasion, he borrowed six drawings from the king's collection for 'my sons to practise by' (in 1677: Vertue IV, p. 173). We have seen that Catharine da Costa copied Bernard Lens's own copies of paintings.

Bernard Lens used vellum as a support for some of his miniature portraits and for all of his copies. His handling tended to remain the same as in his miniatures, but Sarah confined her miniature stippling technique to the areas of flesh on the figures. Larger areas were brushed in with bodycolours, but continued to be of the depth of colour, as in the greens and blues here, used by limners such as Lens. It has been suggested, because of these broader areas and the larger size of these works, that they may have been done under the tutelage of Goupy, but Sarah's manner is quite different and the use of the stipple tech-

30

nique and the jewel-like colours seem to confirm Lens as her master.

Literature: Diane de Grazia and Eric Garberson, *Italian Paintings of the Seventeenth and Eighteenth Centuries in the National Gallery of Art*, New York and Oxford 1997, 162–9; Murdoch, Murrell and Noon, 222 n. 31.

AMELIA HUME (1772–1837), (m. 1793 Charles LONG, cr. 1826 Baron FARNBOROUGH)

31
*Madonna and Child after Raphael, c.*1792

Watercolour over graphite, 188 × 133 mm; with border 212 × 157 mm

Inscribed: *Amelia Hume*

Provenance: from the Sydney sale, Frognal, June 1915; presented by E. E. Leggatt 1915-8-25-1

Amelia Hume's father Sir Abraham Hume (1749–1838) was an amateur artist and noted collector, a friend of Reynolds who left him his choice of his works by Claude, and an authority on the works of Titian. He collected precious stones and minerals as well as paintings, and was a Fellow of the Royal Society, founder of the Geological Society and director of the British Institution. Nothing is known of his daughter's early education, but at the age of fourteen she spent nearly a year in Italy with her parents, visiting galleries with them in Milan, Florence, Venice, Naples and Rome, where her father purchased several works for his collection, including paintings by Canaletto and the Carracci.

Painted before Amelia Hume's marriage in 1793, according to Ellis Waterhouse the

subject of this watercolour was copied from a print after Raphael's *Madonna with the Fish*, now in the Prado. However, her version excludes the figures of St Jerome, the Archangel, and Tobias, who presents a fish to the Christ child. In the eighteenth century a number of prints were issued after Raphael's painting, and it may have been that some focused on the central figures or that Amelia may have selected only this part to copy. It is also possible that her source was an oil copy or version of the painting in the Prado. Later in the nineteenth century, G. F. Waagen (1868, 109) noted a version in the Wellington collection.

With its gilt and black border, Amelia's watercolour is in the tradition of the earlier 'limned' copies of old masters by Lens and Sarah Stanley, and its quality indicates that she had a precocious and well-trained talent. As Amelia Long and later Lady Farnborough, she has long been admired as one of the most talented followers of Thomas Girtin, whom she probably met through Dr Monro after her marriage (cat. 148). But her early training in water-colours appears from the present work to have taken a form that binds her firmly to earlier practitioners. This is perhaps not so surprising when her maternal family

connections are taken into account. Her grandparents, John Egerton, the Bishop of Durham, and his wife Lady Sophia, were closely related and in frequent contact with Marchioness Grey of Wrest Park and her daughters who were all noted bluestockings, amateurs and collectors (see pp. 213–14).

Literature: Tessa Sidey, *Amelia Long, Lady Farnborough*, exh. Dundee Art Gallery, 1980.

ODOARDO FIALETTI (1572–1638)

32

Il vero modo et ordine per dissegnar tutte le parti et membra del corpo humano, 1608

Etchings, published by Iu. Sadeler in Venice, open to last plate, 112 × 157 mm

Provenance: Sir Hans Sloane, with whose collection purchased for the Museum in 1753

1972.u.208 (1 to 33) (163*.a.36)

Born in Bologna, Fialetti worked mainly in Venice and was a prolific engraver as well as painter. Like many drawing books produced in Italy and the Netherlands in the seventeenth century, this one, on which he collaborated with Palma Giovane (1544–1628), had no text but was intended to instruct professional artists how to draw a figure by providing good examples to copy or follow. The book was particularly well-known in England because many English grand tourists, had met the artist in Venice. Alexander Browne copied part of it for the publisher Peter Stent. It was known to the English artist Isaac Fuller, whose own drawing book, heavily influenced by Fialetti's, was published by Stent in 1654 (see cat. 33).

This copy belonged to Sir Hans Sloane and was presumably studied by his daughters (cat. 29). It contains a second title-page with a central cartouche flanked by classical figures of a female and a male painter. In a sequence followed by most drawing books, the first three plates show how to draw eyes, in profile first, then facing front, with eyebrows, open, closed, etcetera. The next two plates are of ears, followed by two of mouths and noses, then several of different types of heads from several angles, and, finally, figures of infants and young men. The last plates provide examples of arms, hands, feet, knees, legs, busts and torsos. The final plate is of the interior of an artist's studio.

31

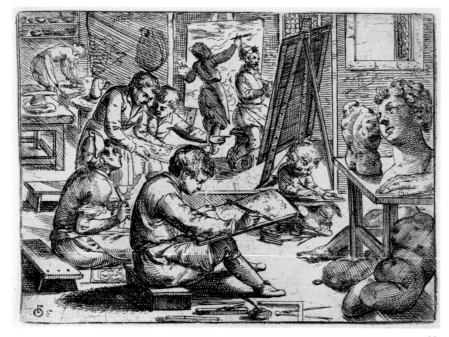

32

Edward Norgate advised that the best method for beginners learning to draw was by copying the best prints to be found. He, too, had met Fialetti in Venice and in his own manuscript treatise recommended his book by name, and followed the same order for learning the parts of the body: i.e. first the parts of the head, then the entire head, followed by the parts of the body before proceeding to the whole.

Literature: Griffiths 1998, 173–4; Muller and Murrell, 106.

Museum purchased this set in 1973. The fifteen etchings of figures were intended specifically to provide examples for amateurs to copy in order to teach themselves. Although numerous sets of etchings of flowers, insects, animals and birds issued earlier in the century were used as pattern books by various craftsmen and embroiderers, and as copy-books by amateurs, and frequently bear drawn copies on the blank pages opposite the prints, they were not issued specifically as drawing

books and did not follow a programme of instruction as Fuller and later Browne (cat. 34) and Sanderson (p. 44) were to do. Like Oduardo Fialetti, Fuller provided examples of features of the head before examples of whole heads and parts of the body, followed by illustrations of entire figures, in this case a reclining river god, seen from the back. The title-page included a full figure of a half-draped reclining female. Unlike many such books later, Fuller only copied his examples of eyes and ears from those by the earlier artist, the rest of the heads, all imaginatively drawn and arranged, were entirely his own invention. It is also perhaps significant that all Fialetti's examples, whether part or whole figures, were male, while Fuller and other English artists included female figures from the beginning.

There was, however, a long tradition of this type of drawing manual on the Continent: many were published in Amsterdam, and were already to be found in the libraries of British artists and connoisseurs. The British Museum has a study from Michelangelo's *Last Judgement* by Fuller, which shows that the artist had made a careful study of Michelangelo's works as well as those by French masters, and his knowledge of their work is evident in the selection he used as examples in this drawing book. Although he was a fine portraitist, his visual sense was a very unique one which, when combined with his comparative lack of skill in etching, resulted in some very strange images, such as the one shown here.

ISAAC FULLER (?1606–72)

33
Un Libro da Designiare, 1654

Etchings, published by Peter Stent.
Open at plate 15, *A river god lying beside his urn*, 115 × 185 mm

Griffiths 1998, 112

Provenance: Purchased from Colnaghi's 1973-2-24-1 to 14 (167* b.40)

Fuller was a flamboyant character whose unique approach to life was reflected in his art. He was said to have studied in France for many years and first appeared as a portraitist in Oxford in the 1640s. Vertue knew him to be the author of the earliest British drawing book, but no copy was known to modern scholars until the

33

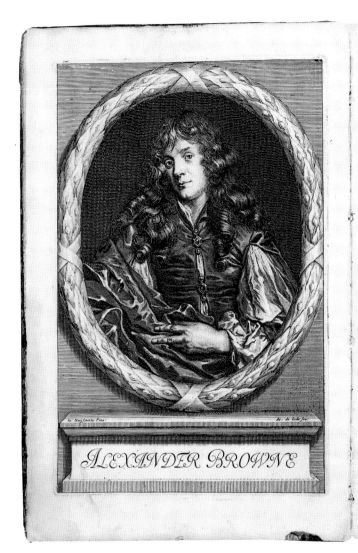

Literature: ECM & PH 1,2; Stainton and White, no. 65; Griffiths 1998, 133–40, 173–4; Jeremy Wood, 'Inigo Jones, Italian art, and the practice of drawing', *Art Bulletin* LXXIV (June 1992), 247–69.

ALEXANDER BROWNE
(*fl.* 1659–1706)

34
Ars Pictoria

Ars Pictoria, or an Academy Treating of Drawing, Painting, Limning, Etching, to which are Added XXXI Copper Plates, Expressing the Choicest, Nearest and Most Exact Grounds and Rules of Symmetry, Collected out of the Most Eminent Italian, German and Netherland Authors, London, for Arthur Tooker and William Battersby, second edn, 1675

Open at title-page and frontispiece portrait of the author, engraved by Arnold de Jode after James (?) Hüysmans, 305 × 200 mm

Griffiths 1998, 146

Provenance: Formerly in the libraries of John Disney and Edmund Turner; purchased from Messrs Evans

1857-2-14-254 (1 to 32) (167*c.1)

Although none of his miniatures survives, Alexander Browne described himself on the title-page as 'practitioner in the art of limning'. From 1665 he taught Samuel Pepys's wife Elizabeth, possibly on the recommendation of Pepys's superior, Sir William Penn, whose daughter Browne also taught. He offered his services as a colourman, 'because it is very difficult to procure the Colours for Limning rightly prepared', at his lodgings in the apothecary's shop in Long Acre, Covent Garden.

In 1660 Browne copied part of Fialetti's book for the publisher Peter Stent and this may have been the impetus for him to produce his own drawing manual of the same year, *The Whole Art of Drawing, Limning, Painting and Etching Collected out of the Choicest Italian and German Authors. To Which is Added Exact Rules of Proportion for Drawing the Heads of Men, Women … Originally Invented and Written by … Odoardo Fialetti… Published for the Benefit of all Ingenuous Gentlemen and Artists.* This contained fifty-four pages of text and only eight plates after Fialetti's book. The first edition of the *Ars Pictoria* was 1669, but it borrowed elements from the 1660 publication and was clearly related to Browne's other drawing book, *A Compendious Drawing-Book… from the Drawings of ye most celebrated Painters in Europe, Engraven … on Forty Copperplates, by Arnold de Jodes, and others…* This had no text, only plates, many of them found in

Ars Pictoria and it is not clear which was issued first.

Ars Pictoria was dedicated to another former pupil of Browne, Anne, Duchess of Monmouth (1651–1732), who had married Charles II's natural son in 1663. In the note to the reader, Browne repeated the now common refrain that Greeks and Romans made drawing part of their liberal education, along with geometry, music and other mathematical sciences. Perhaps because so many of Browne's own pupils were women, he noted in particular that the art of painting was so highly esteemed by the Romans that 'amongst the Feminine Sex it was held a great Honour if they had affected and delighted themselves in such an Honourable Exercise'. The text was fairly technical, dealing first with how to draw the elements of the head and body in proportion, followed by a discussion of painting and the effects of light, motion, the planets and the passions and how to depict them. The third part of the text was devoted to 'The Art of Miniature or Limning', which Browne stated was not to be attempted until drawing had been mastered, not only by copying prints, but also by drawing after casts and from the life. This section was based on part of Edward Norgate's earlier treatise *Miniatura, or the Art of Limning*. It was mainly devoted to preparing grounds, and to colours and where to apply them according to sittings, and included one page dealing with the colours to use in landscapes.

The fourth part of his text listed 'the Grounds and Rules of Etching', which included a final brief paragraph on 'The Manner or Way of Mezo Tinto', where it was clear that much depended upon the tool used for roughing the plate, further details of which could only be had from the author (see pp. 14–15). An Appendix formed the second half of this second edition of *Ars Pictoria*, which gave yet more directions for limning, including recipes for colours, ground colours, 'cryons' or 'pastils', and how to limn 'histories'. Although Browne claimed that this text had never been published before, it too was largely based on Norgate's treatise, which Norgate himself had not published but which had been borrowed from extensively by earlier authors of treatises. Browne ended his appendix with some brief rules for the young practitioner and with an essay on the history of the invention of drawing and painting, which included two lives of

painters from Carel van Mander, followed by a plea for patronage to complete this project.

The plates were all engraved by Arnold de Jode after earlier drawing book examples by Fialetti and Bloemaert, and compositions by Parmigianino, Guido Reni and others. They were in the usual order of parts of the head, followed by entire heads, parts of the body followed by examples of the whole, ending with compositions after the masters. In the final plate, the *Rest on the Flight into Egypt* after Reni, the figures are draped and set in a landscape.

Literature: Howard C. Levis, *A Descriptive Bibliography of the Most Important Books in the English Language Relating to the Art & History of Engraving and the Collecting of Prints*, 1912, 22–5; Griffiths 1998, 174, 216, 232–4.

ROBERT WALTON (1618–88), publisher, after JOHN DUNSTALL (d. 1693) and others

35
A View of the Creation, c.1666

(a) *Part 5: The Pleasant Garden or a Booke of Severall sorts & sizes of most rare, sweet, delightfull Flowers & Slips exactly Drawn & excellently engraven*

Engravings, open to plate 6, a sheet of twelve carnations, 165 × 248 mm

(b) *Part 7: The delightfull Orchard, or a Book of most Pleasant and Desirable Fruits*

Engravings, open to unnumbered plate, a sheet with slips of hazelnuts, plums and apples, 160 × 238 mm

Griffiths 1998, 87

Provenance: Purchased from Ben Weinreb 1983-10-1-8 (61 to 93), open at (66); (104 to 124), open at (110-11) (181 c.14)

An embroidered panel survives at Mellerstain, near Edinburgh, with an image of a woman representing the sense of smell surrounded by flowers and animals, all worked in fine tent stitch in coloured wools and silks on a blue ground canvas. It is dated 1706 and initialled by its makers, Griselle and Rachael Baillie, aged thirteen and ten, and their governess, May Menzies. All the images were traced directly on to the canvas from a book that had belonged to May

Menzies's grandmother, and is still in the library at Mellerstain: *A Booke of Beast, Birds, Flowers, Fruits, Flies and Wormes …*, published by Thomas Johnson (London 1630), with a set of the *Five Senses*, by Jenner, bound in. Johnson's plates had been purchased from another print publisher, who in turn had copied them from various plates in a number of books published on the Continent by Crispijn de Passe and others. These earlier books, known as the *Altera Pars* and *Hortus Floridus*, were reprinted, copied and pirated by various English printsellers throughout the seventeenth century, and were later collected by botanists such as Sir Hans Sloane and Sir Joseph Banks. Copies by English engravers of plates from both provided the basis for later books like that of Johnson, who added further examples of animals and insects from other sources, and for Walton's *View of the Creation*, largely made up from Johnson's plates.

The book at Mellerstain, carefully handed down through two generations, the copies treasured by later collectors, and the number and variety of this type of publication, produced through the century by other printsellers such as Peter Stent and his successor John Overton, all indicate that the market for them was huge. They were sold in large sets like this one, with over 124 plates, by dozens of different artists and engravers and of subjects that encompassed the whole of creation, as well as in smaller sets drawn and engraved by individual artists such as John Dunstall.

In spite of their popularity, the numbers that survive are minimal. This is because of the use to which they were put: they were coloured by children, used as drawing copybooks by amateurs, source books for artists, cut up and used to decorate furniture and textiles, and most of all, used as patterns for embroidery (see cat. 37). This is the only surviving copy of Walton's *View of the Creation*, and its original binding was inscribed *Embroidery Pattern Book*. The pounced and pricked images of acorns and lemons on some of the pages show how the patterns were transferred to cloth and how the prints might be destroyed in the process. In fact, one of the pricked pages bears a text along the bottom: 'Printed cullored and Sould with all other Sorts of Stories and fanceis [*sic*] for Gentlewomens worke by Rob: Walton.' Other plates in parts 5 and 7 depict bunches of flowers in vases, tiny houses with trees and gardens, and baskets and plates of fruit. Carnations, representing

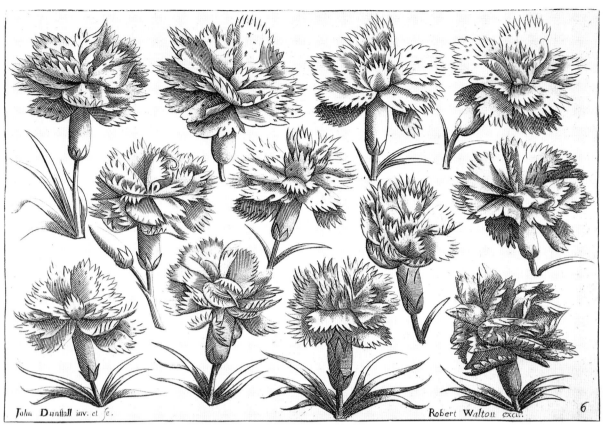

John Dunstall inv. et se. Robert Walton exci. 6

35(a)

sold by Ro.Walton at ÿ Globe and Compasses at ÿ West end of St Pauls Church at ÿ corner turning downe towards Ludgat

35(b)

purity and virginity, were especially popular motifs in embroidery (see cat. 37).

John Dunstall (cat. 6) advertised himself as a drawing master. In his manuscript treatise *The Art of Delineation* (British Library, Sloane MS 5244), like Gerbier and Norgate, Dunstall recommended drawing to persons of quality as an innocent employment for their vacant hours, and to young gentlewomen as an aid in making patterns for their stitch-work, as well as advocating its usefulness to various trades. He included geometry in his treatise, and listed the necessary instruments and materials for the art of drawing, heading that list with 'Prints for Examples to Draw by. There ought to be great care taken in the choice of Good Prints' (f. 106) His manuscript treatise included six sets of etchings after his own drawings, each with Greek, Latin and English titles followed by four plates. Two of these survive in the British Museum: *Geometria. Or Some Geometricall Figures by Way of Introduction to the Art of Pourtraicture, Delineation, or Drawing* and *Aut Liber Domorum. a Book of Houses Drawn by John Dunstall School-Master. Composed for Learners to Draw by. The Author hereof Teacheth the Art of Delineation, or Drawing* (169 b.12; 1972 U.474, 475, from Sir Hans Sloane's collection). The others were devoted to faces, trees, flowers and fruits. The treatise was never published in the form it takes in the manuscript, but the six copybooks were published in various forms. The Hunt Botanical Library in Pittsburgh has the only copy of *Vegetabilium Liber, … A Book of Flowers, Fruits, Birds, Beasts, Flys and Wormes: Drawn and composed into a new method with the addition of many things lately Invented, Etch'd, and Graven, by John Dunstall*, published by Peter Stent, 1663, with the second and third books of the same title printed in 1661.

Until 1989 only two drawings by Dunstall were known, the *Pollard Oak* and façade of *Bethlem Hospital* (see cat. 6), both in the British Museum. A third appeared at Sotheby's (9 March 1989, lot 22), *Studies of Walnuts and Hazelnuts*, which is remarkably similar to the opening shown here in part 7: like the other two it is very close to the engravings included in Dunstall's manuscript treatise and was probably drawn as an example for it.

Literature: Jane Quinby, *Catalogue of Botanical Books in the Collection of Rachel McMasters Miller Hunt*, 1, Pittsburgh 1958, 312–13; Swain 1970, 43, pl. 21; Roberts, 47–50; Swain 1990, *passim*.

Anonymous, 17th century

36

A book of Several Flowers, Fruits, Birds and Insects, open to *Peasscodes* (no. 29)

Watercolour and bodycolours over black lead, 145 × 204 mm

Inscribed on f. 1: *Min 34* [struck through] *273* and *104* [struck through] and *Bibliothecae Sloanianae. Min: 273*; and on separate slip attached to f. 2: *Min. 273 Several Flowers, Fruits, Birds, Insects painted in water colours by Mrs. Ellen Powers. It begins with the damask rose, & ends with the Robin red breast; should contain 37 leaves, but wants leave 11th. At the end is a loose leafe of figures of solid bodies from the globe to the Cube*; with identification on each sheet; and on last leaf *Ellen Power Booke*

LB 1 (1–37) as Power; ECM&PH Anon.

Provenance: Ellen Power; (?) Henry Power; Sir Hans Sloane

Sloane Old Crown (1975-U-1589(29), c.198.a.18)

Henry Power (1623–68) was, like Hans Sloane, a physician, naturalist and Fellow of the Royal Society. Sloane acquired many of his papers. These included a book of *Drawings of tulips and other flowers, in colours: by Mr. Power* (Add. MSS 5298) and *Theatrum Botanicum* (Sloane MS 1343, art 4). Either he, Ellen Power, presumably a relation, who once certainly owned this book, or another artist, was responsible for the charming coloured limnings within it. Mainly flowers that could be found in England, but also including native and exotic birds (such as a peacock highlighted with gold), strawberries, an artichoke, grapes, berries, a frog

and a fly, the drawings are all centred on the page as here, with no background, and each is identified and numbered. The drawing of a goldfinch (f. 36) has been pricked for transfer and two conjoined sheets have been inserted in the back, on which are drawn a cube, sphere, pyramid, prism and other geometrical forms in pen and brown ink heightened with white and gold. These shapes were recommended in drawing manuals as early as Henry Peacham's because 'symmetry or proportion is the very soul of the picture, it is impossible that you should be ready in the bodies, before you can draw their abstract and general forms' (quoted in Bermingham 2000, 35).

At one time the entire book was bound with a copy of Jacques Le Moyne's series of wood-engravings of 'Beastes, Birds & flowers', in *La Clef des Champs* (1586) (Sloane Min. 269, now c.162.a.25). The volume was clearly a treasured possession, which must have served as a pattern book for Ellen Power's needlework, just as the Thomas Johnson book had served the same purpose and been passed on through generations of women at Mellerstain, and Robert Walton's book, with plates after John Dunstall, had served others (cat. 35). Many women in the seventeenth century who knew how to limn must have created similar reference books of their own watercolours based on images from the printed sources or from early florilegia. This lovely book has a naïve quality to the images, and the sheet of geometrical shapes clearly indicates drawing lessons; sadly, however we cannot say for certain that it was made by Ellen or Henry Power.

36

37(a) 37(b)

ENGLISH, early 18th Century

37

(a) *Embroidered Stomacher*

White ribbed silk, embroidered with flowers
in coloured silks, and silver-gilt thread, lined
with printed linen, 324 × 241 mm

Provenance: Purchased 1902

Lent by the Victoria and Albert Museum
(702.1902)

(b) *Embroidered Stomacher*

Blue silk, embroidered with flowers in
coloured silks and silver-gilt thread, trimmed
with silver braid, with *faux* lacing, lined with
printed linen, 317 × 267 mm

Provenance: Talbot Hughes; presented by
Messrs Harrods

Lent by the Victoria and Albert Museum
(T708-B-1913)

In the seventeenth century many needle-
women copied entire prints to make
needlework pictures of historical or biblical
compositions. Others decorated mirror
surrounds or panels for work boxes, or
created embroidered 'slips', which were
pieces of embroidery the size of the slips of
branches in publications such as Le
Moyne's *La Clef des Champs* (see cat. 36) or
Altera Pars (see cat. 35). They were cut out
from the canvas and embroidered to be
used to decorate dresses or furnishings and
could later be removed and used on another
item. The designs were either transferred as
mentioned above (cat. 35), printed on the
canvas by printsellers, or a professional
draughtsman could be employed to copy
a design on to a canvas for them. A few
women composed and drew their own
designs, notably Prince Rupert's sister
Sophia (mother of George I) and the
daughters of James II, Mary and Anne,
both future queens. The opportunity for
women to invent came in the way that
they combined the different examples
provided by the pattern books into their
own needlework pictures of the Creation,
the Garden of Eden, the seasons or senses,
or historical incidents set in landscapes of
their own, often wonderfully idiosyncratic,
inventions.

In the eighteenth century embroidered
pictures, boxes and hangings gradually gave
way to smaller embroidered pictures of
vases of flowers, sometimes used on chairs
or firescreeens. In the 1750s Mary Delany
decorated a series of chairs at Llanover into
which she incorporated an image of the
Duchess of Portland's parrot from one of
her own drawings. Some of her paper
patterns and sketches for them survive
(private collection), indicating that most
of the designs were her own; but like other
women she also relied on the prints of
individual subjects, such as animals, flowers
and insects, provided in drawing and
pattern books.

In the 1740s court dresses featured
embroidered motifs of vases with flowers or
even landscapes on white or black silk, satin
or velvet. Mrs Delany designed and embroi-
dered her own in the 1760s in a style then
fashionable of flowers arranged singly or in
a meandering border on a background of
solid black silk. More popular, however,
were small panels of fine silk embroidery
that could be inserted into various parts of
dresses, such as aprons, sleeves and, most
frequently, stomachers. Women designed
their own, tending to simplify and stylize
flowers found in pattern books. The bright
unfaded green, red and white embroidered
example here is on white, the most common
background colour, as it could be worn with
any dress. The blue silk stomacher was

probably worn with a dress of the same material. The silver work in the flowers and braid is now grey through tarnish and the flowers have faded from their once bright yellows, oranges and greens.

Literature: Roberts, 37–47; Swain 1990, *passim*; Hayden, 27–34, 43–5, 88–98.

Bernard Lens II (1659–1725) and Edward Lens (d. 1750)

38
Bowles's New Preceptor in Drawing

Bowles's New Preceptor in Drawing; Consisting of Variety of Classes, viz. Whole Figures in divers Positions, And all the several Parts of the Human Body from Head to Foot; Light, airy loose Landscapes; Perspective Views of Sea-Ports, Forts, Ruins, &c. Being the close Study, for a Series of Years, Of the late Mr. Lens, Miniature-Painter, and Drawing-Master, to Christ's-Hospital. On Sixty-two Copper-Plates, engraved by Himself. Designed chiefly for young Beginners, and now published from the Author's Originals, very necessary and useful for all Drawing, Boarding Schools, &c. &c. To which is prefixed, An Introduction to Drawing; containing A Description of the Instruments and their respective Uses, and the Materials proper for Drawing; Rules for managing the Pencil, and the best Method for attaining Perfection in the Art; With Instructions by which a young Practitioner shall be enabled to form a Judgment as well of his own Performances as those of others; … Likewise, Colours for washing Landscapes, or Prints of any Kind; with plain and easy Rules for Japanning. Translated from the French of Monsieur Gerard de Lairesse, and improved with Extracts from C. A. Du Fresnoy, Salmon, &c.

Printed for and sold by Carington Bowles, open at title-page, 200 × 315 mm

Provenance: Purchased from Mr C. Eskell 1906-5-15-2 (1 to 62) (167* a.1)

The original edition of this book, titled *A New and Compleat Drawing Book*, was published in 1750 by B. Dickinson at Ludgate Hill, price 5s. The frontispiece includes a portrait of Edward Lens who was, like his brother Bernard Lens III, a miniature painter as well as drawing master. Bernard Lens III was well established as limner to the king when Edward took over from his father as drawing master to Christ's Hospital on his death in 1725; Edward no doubt inherited some of his father's drawings used to teach these particular pupils. Two of the pupils are included in the frontispiece with their distinctive long-waisted, buttoned blue coats with the Christ's Hospital 'mathemats' badge (see fig. 3). They are shown holding the type of drawing – maps and prospects – Lens was required to teach and in which they were examined by the masters of Trinity House. Tools for perspective and geometry, as well as painting, are scattered on the floor. The first half of the plates consists of the usual progression from eyes, noses and ears, etc., to faces and heads, and from parts of the body to whole bodies. They have been redrawn by Lens or his father from a variety of earlier drawing book sources including, amongst others, Giuseppe Ribera (1591–1652), Fialetti and Salmon, but also include figures drawn from the life by the Lenses themselves. The most unusual feature of this particular drawing book is the group of landscapes that makes up the rest of the plates. Most are of fortresses or walled harbours seen from the sea, and a handful is of ruins or towns set in more classical landscapes, with one or two figures. All bear the text *Lens fecit*, and one of the fortresses includes the additional etched initials *EL*.

Paul Sandby (1730–1809)

39 (a)
A New Book of Ruins

Six etchings, printed for D. Voisin, sewn together, 106 × 146 mm

Francis (1709–80) and Thomas Vivares (fl. 1758–65)

39 (b)
Second Book of Principles of Lanskips, 1765

Seven etchings, published by F. Vivares, sewn together, 105 × 87 mm

After Sebastien le Clerc (1637–1714)

39 (c)
A Drawing Book of Horses & Figures

Twelve etchings, printed for Robert Sayer, sewn together, 104 × 170 mm

Anonymous

39 (d)
A New Drawing Book of Aesop's Fables, 1776

Six etchings, printed for Robert Sayer and John Bennett, sewn together, 132 × 92 mm

Provenance: Winn family of Nostell Priory, West Yorkshire, by descent; sale, Christie's,

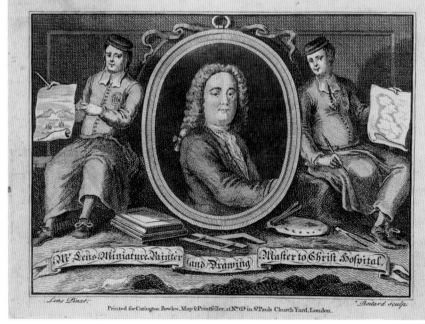

Lens Pinxt. Printed for Carington Bowles, Map & Printseller, at No 69 in St Pauls Church Yard, London. *Boitard sculp.*

38

39

Artist's Vade Mecum, The Complete Drawing Book, The Complete Drawing Master and other such titles. His *Draughtsman's Assistant; or Drawing Made Easy* was issued in several editions from 1772 into the next century, the brief text focusing on drawing (other manuals published by him were devoted, among other topics, to japanning and flower painting), and the plates made up of sets of prints of exactly the type shown here. The date on the title-page changed according to the year Sayer put the collection together, but even the manuals of the same year did not contain the same combination of plates. The edition in the British Museum includes plates after J.-B. Greuze, J. Collet, Vivares, J. June's flower prints, ornamental buildings in Richmond Park and even a 1779 mezzotint by J. Laurie of the Duchess of Devonshire after a drawing by Lady Diana Beauclerk (see cat. 177), which no longer acknowledges her as the artist.

These collections of prints, put together in the form of drawing *cum* pattern books, date back to the kind that artists such as John Dunstall and printsellers like Stent and Overton produced in the seventeenth century (cat. 35).

MARY DELANY (1700–88), *née* GRANVILLE

40

(a) *Poinciana pulcherrima (Decandria Monogynia); Barbados flowerfence*, 1778

Coloured paper with bodycolour and watercolour, on paper washed with black ink, 334 × 235 mm; with grey paper border, 398 × 295 mm, formerly in album VII, no. 83

Identified on a slip of paper and signed with cut monogram; inscribed on verso: *Decandria Monogynia* and *Bulstrode Octr 1778 Sion*

(b) *Papaver Somniferum (Polyandria Monogynia); the Opium Poppy*, 1776

Coloured paper with grey and red wash, on paper washed with black ink, 343 × 227 mm; with grey paper border, 390 × 267 mm, formerly in album VII, no. 48

Identified on a slip of paper and signed with cut monogram; inscribed on verso: *Polyandria Monogynia* and *Bulstrode 18 Octr 1776*

Nostell Priory, 1 May 1990, lot 664 [?]; bt Christopher Lennox-Boyd; Sanders of Oxford, from whom purchased

1990-7-28-48 (1 to 6); 1990-7-28-47 (1 to 7); 1990-7-28-45 (1 to 12); 1990-7-28-44 (1 to 6) (167* b.45)

These drawing books are four from a group of seven kept together in the British Museum. They are rare survivals of a type that proliferated in printsellers' catalogues throughout the eighteenth century. The other three books in this group are: six town and country views, very close to Bernard Lens's topographical drawings in style, etched by J. June and sold by Robert Sayer; six oval picturesque landscapes, etched by June and sold by D. Voisin; and a set acquired in 1871, of six figural compositions originally engraved in the 1730s but published and sold by Laurie & Whittle at 53 Fleet Street in 1800. These small sets of prints were issued in vast numbers, described in printsellers' catalogues such as Robert Sayer's in 1766 as 'new and curious Drawing Books, six Leaves in each, are sold at Six-pence each, viz… Landscape and ruins by Chatelain, two on a leaf with Out-lines and finish'd.' They were the most ephemeral type of drawing book and very rarely survive in this form. They were either separated or cut up and pasted on walls for decoration, or were used by various generations of children or amateurs until they fell apart. Some were collected together and bound for libraries, the form in which they usually survive. Printsellers would sometimes produce these bound volumes with left-over sets and provide them with a new title-page, occasionally prefaced by a borrowed text such as those of Lens or Le Clerc or one of the older texts, or even a combination of several. One of the earliest seen by the present writer was published by Thomas Bowles in 1739. Described as the third edition, *The Principles of Drawing: or . . A Compleat Drawing Book* had an introductory text translated from Lairesse with extracts from Dufresnoy with fifty plates from Hollar, Dürer, Bloemaert and others. Sometimes the authors were acknowledged, but usually the title-pages did not bear an author's name, merely the name of the printseller, with several pages of advertisements added at the back. Several such examples exist in the British Museum. The *Bowles's Artist's Assistant in Drawing, Perspective, Etching, Engraving, Mezzotinto-scraping, Painting on Glass, in Crayons, and in Water-Colours, and on Silk or Satin*, for example, was mainly text with only four fold-out plates. Published by Carington Bowles in 1787 (as a seventh edition), it was small in size and actually a reduced version of one of the larger drawing books he advertised in the back, such as *Bowles's Practice of Perspective, Bowles's Practical Geometry, Bowles's Principles of Drawing, Bowles's Complete Drawing Book, Bowles's Florist, Bowles's Drawing Book for Ladies*, and *Bowles's Polite Recreation in Drawing*. The final items listed were small booklets of the type shown here, in sets of twelve (3s. each) or six etchings (1s. 6d. large, 6d. small). Robert Sayer also published *The School of Art, The*

(c) *Passeflora Laurifolia (Gynandria Pentandria); Bay Leaved*, 1777

Coloured paper with bodycolour and watercolour, on paper washed with black ink, 352 × 242 mm; with grey paper border, 412 × 295 mm, formerly in album VII, no. 54

Identified on slip of paper and signed with cut monogram; inscribed on verso: *Gynandria Pentandria* and *Luton Augt 1777*

(d) *Physalis; Winter Cherry (Berry)*, 1772–82

Coloured paper with bodycolour and watercolour with plant fibre, on paper washed with black ink, 292 × 179 mm; with grey paper border, 335 × 245 mm, formerly in album VII, no. 71a

Identified on slip of paper and signed with cut monogram; inscribed on verso: *Bulstrode*

Provenance: By descent to Lady Llanover, by whom bequeathed

1897-5-5-684, 648, 654, 672

The newly widowed Mrs Delany spent six months at Bulstrode with the Duchess of Portland, when the botanical artist George Dionysius Ehret (1708–70) was working there in 1768. In 1771 Joseph Banks (cat. 184) and Daniel Solander, who had recently accompanied Captain Cook to the South Pacific, stayed at Bulstrode. Banks (1743–1820) had searched for new plants that would be of economic benefit to Britain, recording them in his herbarium, while the botanist Solander collected and stored them. Banks had a large private income inherited from his father and the two men were planning an illustrated published account of the natural history encountered on the voyage. Shortly afterwards the duchess and Mrs Delany visited Banks's collection in London, and the following year Mrs Delany began her cut-paper flowers.

Over the next ten years Mrs Delany created a florilegium of nearly one thousand pictures of plants, all of cut paper, occasionally with pieces of plants added, on black backgrounds, with her own borders, each carefully inscribed on the verso with its identification and where she obtained the model, as well as the date when and place where she had worked the picture. She invented the medium herself, referring to it as paper mosaic. The collection was intended as an imitation of a *hortus siccus*, a collection of dried flowers.

Mrs Delany's skill at cutting paper had been honed by a lifetime of practice and was truly remarkable: the bloom in the passion flower illustrated here includes 230 paper petals. Sometimes whole petals or leaves were cut from one piece, with additional smaller ones laid on top for shading. Individual pieces of paper were built up to form the stamens, calyx and veins of leaves. Although she took care to cut the correct number of stamens and styles and used the Linnaean system of classification, Mrs Delany did not reproduce the various stages and individual parts of a plant, and only rarely included bulbs or roots, as found in the botanical publications of the time. Her earliest works are on paper washed with a black iron gall ink, then washed with size, which produced a shiny surface; but in 1774 a newly established paper mill in Hampshire provided her with a paper that she could wash with Indian ink to give a better matt surface. The coloured papers were obtained from examples brought back from China in this period, sometimes provided by friends, as well as from paper-stainers who supplied wallpaper, and occasionally she dyed the paper herself or touched up the picture with watercolours. The flowers she used as models were provided by the gardens at Bulstrode and the Chelsea Physic Garden, as well as the gardens she encountered while staying with friends such as Lady Bute at Luton Park. Other landowners, gardeners and keen amateur botanists sent her examples, knowing her collection would record their achievements for posterity. Some of her mosaics were based on drawings by other lady amateurs like Lady Anne Monson (d. 1776) who had made studies of flowers in Madras. Eighty-four plants were provided by Sir Joseph Banks from Queen Charlotte's garden at Kew.

George III and Queen Charlotte were to pay regular visits to the Duchess of Portland and Mrs Delany at Bulstrode from 1776, when they asked to see her *hortus siccus*, then kept in the first of the ten albums in which they eventually came to the Museum. Each picture was 'signed' with a monogram cut in one piece and each album contained 100 works except for the last. The greatest number of pictures Mrs Delany executed in one month was twenty-eight. She taught her paper mosaic work to several ladies, the most accomplished of whom was a Miss Jennings who helped her to finish some of the last ones when her eyesight was fading. It had begun to fail in 1780 and two years later Mrs Delany composed a poem of farewell to her flowers, which she inserted in the front of the first album, along with a record of their creation and a particular acknowledgement of the encouragement she had received from the Duchess of Portland.

On the duchess's death in 1785, George III presented Mrs Delany with an annuity of £300 and a house in St Alban's Street, Windsor, with a garden adjoining that of the Queen's Lodge. The various members of the royal family visited regularly, dropping in at any time and frequently staying for two hours. She in turn spent the evenings with them *en famille*, sitting at a table at which the princes and princesses drew or 'worked' at needlework, silhouettes and cut paper, or the queen at her own 'Herbal' of pressed flowers on black backgrounds in imitation of those made by Mrs Delany. It was on a visit to the royal family at Kew that Mrs Delany caught a chill in March 1788 and died a month later.

Literature: Ruth Hayden, *Mrs Delany and her Flower Collages*, British Museum Press 1986, 2nd edn 1992.

ANONYMOUS, 18th century

41

(a) *Illustration to the fable 'The Fox and the Goat'*

Cut paper with cut text and pin-pricking, after a print, originally on blue ground, now mounted on black paper, 127 × 115 mm

(b) *Landscape*

Cut paper, after a print, mounted on black paper, 190 × 370 mm

(c) *Cupid with scales, in an ornamental surround*

Cut watch-paper with pen and ink and watercolour, central portion mounted on cloth, all mounted on black paper, 40 mm diameter

Provenance: Unknown, part of a group brought from the 'Old Stores' of the Museum in 1878

1878-9-14-131, 146, 123

Many women in the eighteenth century either mentioned in their correspondence that they cut paper or are known from the comments of others to have practised this art. Walpole mentioned in his list of

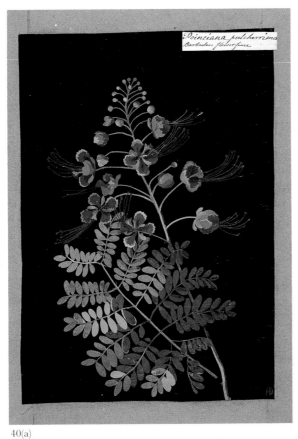

40(a)

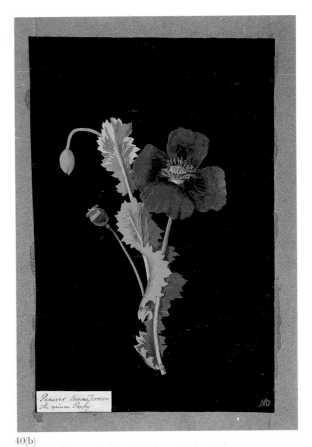

40(b)

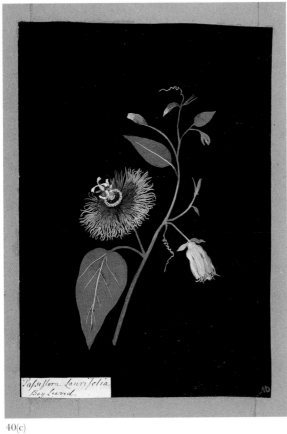

40(c)

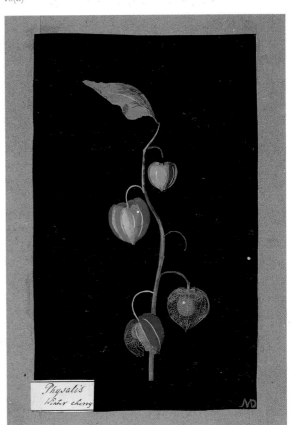

40(d)

distinguished amateurs that Sir William Hamilton's first wife 'cut figures in card excellently, in the manner of Monsr. Hubert of Geneva', and that Lady Andover was so skilled at cutting landscapes that a magnifying glass was needed to see them properly (see cat.118). Several men and women exhibited examples at the Free Society and the Society of Arts, masters advertised teaching it in Bath and London,

printsellers sold patterns for it, and Mrs Delany often spoke of her own pupils in her correspondence. Yet Mrs Delany's flowers (cat.40) and a handful of silhouettes of groups of figures by her and the princesses Charlotte and Elizabeth (cat.174) are almost the only known firmly attributable works by British amateurs. Occasionally, silhouettes of family groups are found in country houses, but most have lost any

record of who cut them or whom they depict, or are by known professional silhouettists such as Torond.

Profile silhouettes of heads or single seated figures are what most people think of today in relation to paper cutting, but these portrait silhouettes only became popular with amateurs in the nineteenth century. For 200 years before, English 'cut paper' took completely different forms, which are very little studied and relatively unfamiliar today. The examples gathered in the album in the Department of Prints and Drawings (c.35) were so incidental to the main collection that they cannot even be traced to an inventory, and it is impossible to ascertain whether they are by amateurs or professionals. They are included here to serve as a reminder of this popular 'polite recreation'. Examples have been selected to represent the four main types of cut paper that were practised.

(a) Ornamented Cut Text and Copies of Prints

Some of the earliest known examples of ornamented cut text were executed in watermarked paper by Alvaro Lourenço in late sixteenth-century Portugal. The leaves resembled pages from decorated printed books of psalms and prayers, surrounded by cut-work cartouches or decorative borders consisting of the type of strapwork and

41(a)

41(c)

41(b)

grotesques found in ornamental prints. The Doheny collection included two seventeenth-century examples (Christie's sale, 2 December 1987, lots 179–80). These early works are extremely rare: a similar example in the British Museum is undated, but the Victoria and Albert Museum has an album of prints, drawings and cut paper put together by the family of William Styles in the seventeenth century, which includes an unornamented cut-paper letter from Eliza Styles to her husband, signed and dated 28 October 1664, with a piece of black silk placed inside the folded sheet to enable the letters to be read. The letter reassures Mrs Styles's husband that she is recovering the strength of her eyes and that she awaits his return 'and commands with the assistance of your owne pretty fancy to sett my fingers on snipping'. A pair of tiny scissors in a leather case was acquired with the album. Along with a knife and a pin, these were the only tools required for this art. Some cut in paper and others in vellum – the Styles album also contains three cut-vellum landscapes no more than 25 mm across and slightly larger landscapes and seascapes in black paper, some of the figures and features no more than 1 mm in size. It also includes pen and ink outline copies on vellum after Bloemaert's drawing book, signed and dated *RS 1660*.

Cut paper containing text continued into the eighteenth century: a Mrs Seymour exhibited a frame of devices cut in vellum, containing the Lord's Prayer with her name and date within the compass of a silver threepence. This type of cut paper culminated with the work of Martha Ann Honeywell, born in 1787 in Lempster, New Hampshire, with no hands, who cut paper with her toes and teeth, working in public between 1806 and 1808. She cut watch-papers with the Lord's Prayer within a circle less than 51 mm in diameter, as well as flowers and landscapes. Her letters were cut in running script attached to bottom lines so that the paper representing the letters remained instead of each letter being cut out (possibly with a knife) as in the text here.

This example was probably copied from a print illustrating La Fontaine or Aesop's fable of the fox and the goat, with the French moral spelt out in the cut text in the arch at the top. The sprigs of oak were cut separately and attached (a note in the album records that it was originally mounted on blue paper), and the rest of the image

was cut from one piece of paper, employing a knife, scissors and pin-pricking (in the middle distance). Many of the other examples in the Museum's album are cut-paper copies of portrait and ornamental prints. Nathaniel Bermingham, a herald painter, advertised himself in Mortimer's *Universal Directory* of 1763 as an 'improver of a curious art of cutting out Portraits and Coats of Arms in vellum with the aid of a pen knife'. His image of Britannia holding a portrait of the Prince of Wales in the Victoria and Albert Museum is in vellum, employing curves to add a three-dimensional quality.

(b) Landscapes

Joanna Koerten of Amsterdam (b. 1650) achieved fame throughout the courts of Europe with her paper cuts, and Jean Huber of Geneva (1721–86) was equally renowned for his *tableaux en découpures*. Mrs Delany and the first wife of Sir William Hamilton cut similar landscapes after their own inventions, but the present example appears to be based on a Dutch print.

(c) Cut watch-papers

Some of the smallest and most intricate examples of cut paper imitated lace, and were mounted on velvet to reinforce the illusion. Lattice-work or concentric circles framed a central allegorical image, some-

times coloured as here, or an example of miniature manuscript, printed or cut text.

Literature: V&A National Art Library, file on cut paper; for Honeywell, see M. L. Blumenthal, *Antiques* XX (May 1931), 379; Basil Long, 'The ancient art of paper-cutting', *Antiques* (February 1931), 120–2; E. N. Jackson, 'Cut-work', *Apollo* 30 (1939), 161–4; and see entries on 'Papercut' and 'Silhouettes', in Turner, vol. 24, 56–7 and vol. 28, 714.

ANONYMOUS

42

*Painting, c.*1740

Painted glass print, published by Henry Overton, 253 × 355 mm; framed with gilt slip

Provenance: Grosvenor Prints, from whom purchased and presented by the British Museum Society

1998-1-18-2

Painting on glass, as this technique was known, was another popular 'polite recreation' in England from the mid-seventeenth century. A print, most commonly a mezzotint, was pasted face down with a non-soluble glue on a sheet of glass. The paper was then soaked and carefully scraped and rubbed away, leaving only the printing ink adhered to the glass. This was coloured on the same side with oil, varnish or water-

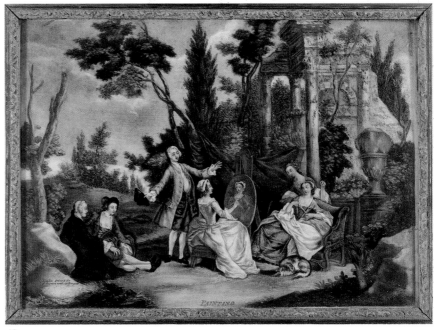

42

colour as one would wash a print, so that the lines and shaded areas of the print still showed when viewed from the recto, but with colour behind. The finished effect was intended to approximate an oil painting.

The first published explanation of the method seen by the present writer is in Alexander Browne's *Ars Pictoria* of 1675 (cat. 34), but as it is a second edition of this book, the method may have been published earlier and it was certainly already a common practice. When mezzotints began to appear in great numbers in the 1680s, they seemed to be the perfect medium for glass painting, and Edward Luttrell noted in a manuscript treatise of 1683 that it was 'in great use among all persons of quality'. The method was explained in further treatises, including a manual for painting in oil in 1687, and in John Stalker and George Parker's *Treatise of Japanning and Varnishing* the following year. They noted that by then it was looked upon as 'the womens more peculiar province, and the ladies are almost the only pretenders'. Printsellers catered to women's tastes by producing suitable subjects and even providing them already attached to the glass.

However, Stalker and Parker complained that drawing masters who were teaching ladies the technique were not teaching them correctly. Done properly, it was perceived as a means of producing something similar to an oil painting, without the necessity of first learning to draw. This would be one reason why it would appeal to amateurs in particular since it saved them from labouring long and hard to acquire a skill practised by professional craftsmen and therefore inappropriate to a gentleman or woman. Nevertheless, Stalker and Parker thought that it was particularly appropriate for women to practise because of its ability to deceive: 'Tis a pleasant insinuating Art; which, under a pretty disguise betrays us into a mistake: We think a piece of limning lies before us, ... Who can be displeased to be so innocently deluded, and enamoured at the same time: Tis female policy at once to ravish and deceive the eyes, and we not only caress the cheat, but are in love with the imposter too.'

The attraction of being able to produce 'an oil painting' in as little as three hours, without learning to draw, was echoed in painting, drawing and japanning manuals addressed to men and women for the next 200 years, and it remained a popular pastime, even attracting a market in 'fake'

glass pictures in the twentieth century. Because of their obvious fragility, surviving examples are extremely rare, but this is also due in part to the fact that more skill was actually required than the method seemed to indicate and relatively few were well done. Finally, as a feminine pastime that was not meant to require a great deal of skill or even the ability to draw and, further, as a pastime intended to deceive, glass painting was not regarded as a fine art appropriate for museum collections.

Literature: Ann Massing, 'From print to painting. The technique of glass transfer painting', *Print Quarterly* VI, no. 4 (December 1989), 383–93; Griffiths 1998, 29, 34; S. O'Connell, *Popular Prints*, exh. British Museum, 1999, 40–1.

BERNARD LENS III (1682–1740)

43

(a) *A view of Bonewell in Herefordshire*, 1722

Grey wash with pen and ink over pencil sketch with a pen and ink border, 238 × 345 mm

Inscribed: *a view of Bone-well under Richards-Castle in Herefordshire which for 3 or 4 months in ye year is full of small frog-bones. Drawn in August 1722 by Bernard Lens at ye well*

LB 1 (where attr. to Bernard Lens II); ECM II (where also attr. to Bernard Lens II)

Provenance: Sir Hans Sloane, purchased with his collection, 1753

Sloane 5214-163

(b) *A view of Sadlers Wells at Islington and the new River Water House*

Pen and ink with grey wash over pencil, 239 × 345 mm

Inscribed with title and numbered *2*

LB 3 (where attr. to Bernard Lens II); ECM II, 21

Provenance: Purchased from Colnaghi

1853-4-9-41

Bernard Lens III's father, Bernard Lens II, and his brother Edward had drawn and etched mainly landscape and coastal views for their pupils at Christ's Hospital (see cat. 38), but they also provided detailed pen and ink and grey wash topographical views of London and its environs, and other towns

and sites throughout England. Their hands are difficult to distinguish and Bernard Lens III as well as his sons made their own contributions to this group. In 1726 Bernard Lens III submitted a bill to Edward Harley, later Earl of Oxford, for a miniature painting of Queen Elizabeth set in a ring (£8.8s.) and 'a book of 20 Drawings, views of severall Places in England of my Drawing by ye life in Indion Ink, half a Giney each Drawing £10.10s'. Many of the Lenses' views of this type are of Hampton Court, Windsor and Kensington Gardens, but they drew all over England, especially around Bath and Portsmouth. The detailed nature of the buildings and figures and the distinctive manner of drawing grass are clearly indebted to their limning techniques. The present view of Islington from the south is taken from a set accompanied by a sheet with the title inscribed in a drawn cartouche, including the name of the artist, the date 1730–1, and the note 'taken by the Life'. Some of these drawings were engraved, but the Lenses mostly produced endless drawn copies of their own compositions.

The Lenses' pupils also made copies, including Bernard Lens III's royal pupils (see cat. 73); those by Princess Mary are in her library at Hesse-Cassel, and a mixed group of master and pupils' works was recently sold at Christie's, South Kensington (21 June 1998, lot 32). Priscilla Coombe's copies of drawings made by Bernard Lens III at Bath in 1727 are in the Map Library (British Library). Mary Delany and her friend Letitia Bushe took lessons from Lens in the 1730s, and the daughter of Lens's patron Edward Harley, Margaret Cavendish, later Duchess of Portland (1715–95), to whom Mrs Delany was companion, produced a pen and ink drawing of a coastal fortress 'learn't 3 months' in 1738 under Lens's tuition (ex collection Dudley Snelgrove). Lens's 1735 drawing book (cat. 73) continued to be used for early exercises in drawing by royal pupils long after his death.

On his tours to take topographical views of Britain, Bernard Lens III also drew objects of interest to antiquarians. These included not only Roman antiquities discovered during excavations at Bath (now in the Map Library, British Library, King's Topographical Collection XXXVII. 26), and the ruins and tor at Glastonbury, but also natural curiosities such as the present drawing from Hans Sloane's collection, and

A view of Bone well under Downes Castle in Herefordshire which for 3 or 4 months in a year is full which happened Down in August 1722 by Bernard Lens at 5 with

43(a)

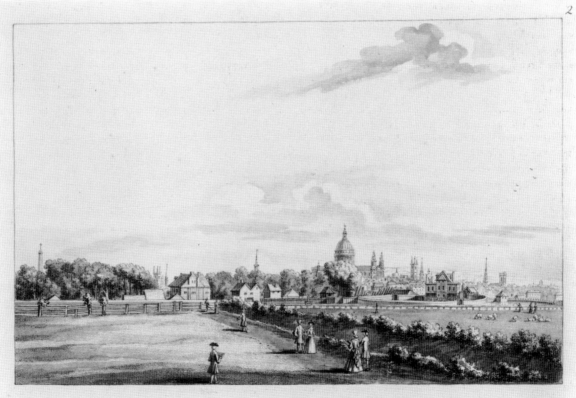

A view of Sadlers wells at Islington and the New River Water House

43(b)

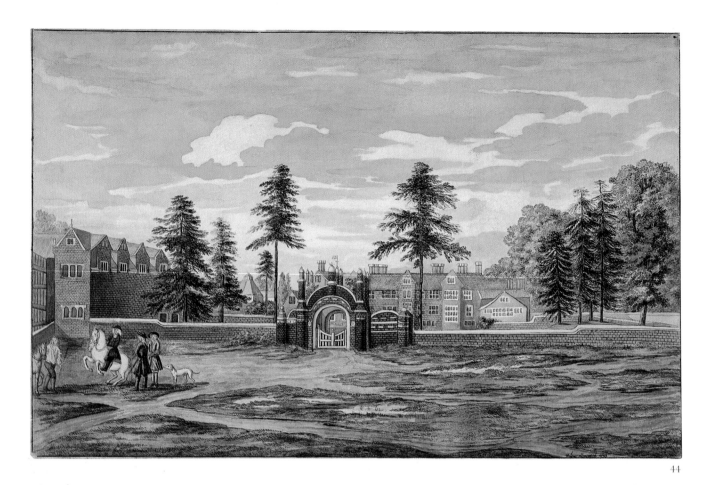

44

a series of twelve views of Wookey Hole in Somerset, which included a 'Wonderful Cistern that is always full yet never runs over'.

Literature: Goulding, 41; Vertue III, 100, VI, 112; Fleming-Williams, in Hardie III, 212–15, Sloan 1986, 'Non-professionals', Appendix C.

LADY HELENA PERCIVAL (1718–46), later Rawdon

44
Erwarton Hall, Suffolk, 1737

Watercolour with pen and ink over a graphite sketch, 334 × 523 mm

Signed: *Helena Percival 1737*

ECM II, 1

Provenance: Presented by A. R. Harvey 1946-6-24-6

This view of Erwarton was described as 'primitive' when it was acquired by the British Museum in 1946, but this was a misunderstanding of its technique, the milieu in which it was executed and the skills of its nineteen-year-old artist.

Although many topographical drawings by Bernard Lens III survive, and we know that he taught this type of drawing to many pupils, very few examples of their work are known. On 15 April 1732 John, Viscount Percival (later 1st Earl of Egmont), recorded in his diary that he 'went to see the works of Mr Lens, limner to the King, and enamel painter, who teaches my daughter Helena to draw'. In March and August 1737 Helena sat to Arthur Pond for her portrait in crayons, but between these dates visited her uncle Sir Philip Parker at Erwarton where she made this watercolour. Four years later, she married Sir John Rawdon, recently returned from his grand tour, who shared his wife's interests in music and painting. After bearing him three children, she died of consumption at Hotwells, near Bristol, in 1746.

When Lady Helena's view is compared with similar examples by her drawing master, her debt to him is clear. Although she may lack his skill in perspective, a landscape that included so many buildings and figures was an ambitious subject for an amateur to undertake from life, without the direct supervision of her drawing master. Even more remarkable is the fact that she used colours; all Lens's own extant topographical landscapes are in monochrome grey or brown wash with pen and ink. It is of course possible that Lady Helena was copying an oil painting of the house by another artist, but it is more likely that her lessons from Lens had included limning in colours, as he had taught Catharine da Costa and Sarah Stanley (cats 29, 30), and that she is here combining lessons in copying old masters in colour with depicting a view of a real place.

Literature: Royal Manuscripts Commission, *Report on the Manuscripts of the Earl of Egmont*, ed. R. A. Roberts, I, 1920, 257.

ALEXANDER MARSHAL
(*fl.* 1640s–d. 1682)

45

Figure studies after Rubens, from the Windsor *Florilegium*, f. 155

Pen and ink and wash with white bodycolour, on blue paper, 455 × 331 mm

Signed

Oppé 1950, 432; Leith-Ross 156

Provenance: By descent to the artist's nephew, William Freind; his sale, Christie and Ansell, 25 April 1777, lot 46, bt Mr Way; purchased by Ross Donnelly at Brussels, 1818, for John Mangles of Hurley, Berkshire, by whom presented to George IV

Lent by Her Majesty The Queen (RL 24422)

According to his nephew, who inherited the *Florilegium Alexandri Marshal* now in the Royal Library at Windsor, Alexander Marshal was a 'Gentleman' who 'had an independent fortune and painted merely for his Amusement. – He is said to have had a particular art of extracting colors out of the Natural Flowers' with which he painted.

Marshal is not known to have received any formal training as an artist, but probably learned by studying one of the many seventeenth-century manuscripts or published treatises on limning, or by observing a professional or another amateur at work. His known works (Leith-Ross, Appendix C) date from 1649 to 1663, many of them copies after prints or paintings by other artists, including topographical landscapes, figural subjects after Rubens, Van Dyck, Goltzius, Raphael and Parmigianino, and miniature portraits. Some of the paintings he copied may have been borrowed from friends, but like many gentlemen, he himself had a collection of prints, including at least one album of engravings after Rubens (Leith-Ross, Appendix B).

The present work is based on elements from two prints after Rubens: the figure of the man supporting the cross and the plant are from *Christ Bearing the Cross*, engraved in 1632 by Paul Pontius (Hollstein 1976, 8) and the other figure with an urn is from *Melchisedech Giving Bread and Wine to Abraham*, engraved in 1638 by Hans Witdouc (Dutuit 1885, VI, 10). Marshal painted several biblical subjects, which are indicative of the importance of learning to draw the human figure and drapery for all students of the art of limning, even if, like Marshal, their main interest was in flowers and insects.

46

(a) *Blue clematis, pink columbine and purple fritillary, tied with a crimson ribbon*

(b) *Yellow and crimson tulip, blue convolvulus and crimson gladiolus, tied with an orange ribbon*

(c) *White and crimson tulip, purple larkspur and yellow narcissus, tied with a blue ribbon*

Watercolour over metalpoint, heightened with white (oxidized to dark grey), on vellum, 179 × 114 mm (average)

LB 9 (a), (b), (c); ECM 4, 5, 6

Provenance: Purchased from Miss Cecilia Ashe

1878-12-14-62, 63, 64

Alexander Marshal was by profession a merchant who had lived for some time in France, but he was also a respected botanist and entomologist, described by the social reformer Samuel Hartlib as 'one of the greatest Florists and dealers for all manner of Roots Plants and seeds from the Indies and else where' (quoted in Leith-Ross, 7). He created at least four albums of drawings of flowers and insects: the one from which the present works are taken (possibly his earliest), 'A Book of Mr Tradescant's choicest Flowers and Plants, exquisitely limned in vellum' from the 1640s (recorded in the catalogue of the *Musaeum Tradescantianum* in 1656, now lost); the Windsor *Florilegium* (cats 45, 47, 48); and a volume of sixty-three folios of insect studies (now Philadelphia, Academy of Natural Sciences). Marshal collected and made observations on insects and the art of drawing them, and in the Bishop of London's garden at Fulham, where he lived for a time, he planted cedars of Lebanon and raised exotic plants, including a Guernsey lily sent to him in 1659 by his friend General Lambert. The bishop was Henry Compton (1632–1713), one of the most active horticulturalists of his day.

45

'A new Man of Experiments and Art' (Hartlib, in Leith-Ross, 7), Marshal experimented with colours from plants throughout his life, and the Royal Society approached him for his recipes soon after its foundation. In his reply in 1667 he gave one or two examples but apologized for not giving more, because not only were the recipes constantly changing but, echoing the reasoning of Evelyn and other gentlemen *virtuosi* in similar situations, he wrote: 'The truth is, they are pretty secrets, but known, they are nothing. Several have been at me to know, how; as if they were but trifles, and not worth secrecy. To part with them as yet I desire to be excused' (Leith-Ross, 12–13). The drawings at Windsor certainly contain unusual colours and, kept in an album (cats 47–8), they are still fresh. Unfortunately, as they are now faded, the group of thirty-three on vellum in the British Museum must have been exhibited on their removal from the album in which they came to the Museum in 1878.

At one time it was hoped that the group in the British Museum might be the missing Tradescant book, but they were not considered sufficiently exotic to correspond with the latter's known rarities. Nevertheless, a number of the flowers depicted were relatively new to northern Europe in the seventeenth century. The native columbine was dark purple-blue, but the pink varieties were brought from North America by John Tradescant by the 1630s. A large number of the flowers depicted are tulips, including 'Parrot' tulips, broken tulips with irregular edges, which came into cultivation shortly after the Restoration.

The bouquet motif, usually a random mixture of flowers intertwined or loosely tied with a ribbon, frequently appeared in floral pattern books the primary purpose of which was for use by designers or decorators of textiles and china. It also appeared in botanical books with primarily decorative intent and was therefore apt for use in florilegia. It was employed by Nicolas Robert (1614–85) and other artists in their botanical portraits on vellum painted for Louis XIII and Louis XIV. Marshal was resident for some time in France where he may have seen their work. In the eighteenth century Ehret employed the motif frequently throughout his career, having seen the French works on a visit to Paris in 1734–5. Marshal did not use it in his most famous work, the Windsor *Florilegium*, where nearly all the watercolours are on paper, but he did use it for the present series, all watercolour on vellum.

Literature: John Fisher and Jane Roberts, *Mr Marshal's Flower Album from the Royal Library at Windsor Castle*, 1985, *passim*; Leith-Ross and McBurney, 7, 12–13, 21, 24–8 and Appendix C.

47

Carnations, Love in a Mist, Bullaces, Silkworm Larva and a Cricket, from the Windsor *Florilegium*, f. 110

Watercolour and bodycolour, 470 × 355 mm

Oppé 1950, 432; Leith-Ross 110

Provenance: as for 45

Lent by Her Majesty The Queen (RL 24377)

Alexander Marshal's *Florilegium* in the Royal Library at Windsor contains 159 folios similar to the present one, bearing exquisite watercolours of over 600 different plants, birds, animals and insects. France, Germany and the Netherlands were rich in flower painters, but Alexander Marshal is the only notable English artist in this field, and he was not a professional. His watercolours were an integral part of his activity as a gentleman who studied natural history, focusing his attention particularly on flowers and insects. Bullaces, a type of wild plum, had been grown in England for several centuries, but Marshal may have drawn these from a tree known to grow in the Tradescants's Lambeth garden in 1656. James I had attempted to found a native silk industry and the 'silke worme' depicted here may have been in the royal palace at Oatlands where the elder Tradescant was keeper.

46(a)

46(b)

46(c)

47

The manner in which Marshal arranged and depicted the flowers in his florilegium indicates that he knew continental examples, but that it was very much a personal collection for his own use. Spaces were left blank in order to add examples discovered later, and small animals were sometimes inserted almost whimsically to provide a 'foreground'. Insects are shown in different stages of development, and native and exotic species of plants are mixed, but the overall arrangement of the album falls basically into the traditional seasonal arrangement for florilegia. Most of these florilegia were commissioned by owners of British gardens from continental artists. Alexander Marshal's is the only surviving seventeenth-century florilegium by a British artist. Louis XIV offered Marshal's widow £500 for it, but she refused to sell and bequeathed it to the artist's nephew, William Freind.

48

Walnuts, Oysters and a dead Yellowhammer, from the Windsor *Florilegium*, f. 159

Watercolour and bodycolour on white prepared ground, on vellum, 119 × 154, 177 × 210, 119 × 160 mm

Oppé 1950, 432; Leith-Ross 165, 163, 159

Provenance: as for 45

Lent by Her Majesty The Queen (RL 24426a,b,c)

At the end of the Windsor *Florilegium*, a number of drawings were inserted which had not originally been part of the botanical work. These included the drawing after Rubens (cat. 45) and the present group of natural history studies on vellum. Sir Hans Sloane's catalogue listed *Strange birds &c. of Mareschall* (untraced), and the Freind sale included drawings of a horse and a tiger. Drawings of monkeys, dogs, snakes and other small animals are scattered throughout the pages of the *Florilegium*, some cut out and glued to the pages.

The present life-size studies of oysters, nuts and a dead bird are reminiscent of the type of limning that recorded the contents not of a garden but of a seventeenth-century cabinet of natural curiosities. The nuts and oyster originally shared a page with an edible medlar, and the bird was mounted with a partridge and a bullfinch. As a gentleman who had travelled on the

Continent, who drew plants and insects and collected prints and also birds, it would be surprising if Marshal had not had a small collection of shells, fossils and similar curiosities himself.

ANONYMOUS, 18th century

49

A sprig of apple blossom with various insects

Bodycolour on black background,
273 × 192 mm

LB IV, 378

Provenance: Purchased from Edward Daniell
1876-7-8-2397

The artist of the present work is not known, but the painting is very close to the work of Barbara Regina Dietzsch (1706–83) and her younger sister Margareta Barbara (1726–95), from a family of Nuremberg artists. Their works are characterized by their black backgrounds which set off their use of bright colours and a sharp hard finish. Examples of their work in the Fitzwilliam Museum, Cambridge, *Iris Germanica* and *Dandelion*, include the same insects as the present work, and it seems likely that this painting can be attributed to one of them. The sisters worked in the tradition of one of the greatest flower painters of the sixteenth century, the German-born painter Maria Sibylla Merian (1647–1717), who was one of many women who earned their livings this way in Germany and the Netherlands in the seventeenth and eighteenth centuries. Only

licensed artists were allowed to paint in oil, so that most women worked mainly in watercolour and bodycolour on vellum or fabric, regarded as the most appropriate medium for amateurs. A specialist in still lifes, Merian taught unmarried women (once married their time should be filled with other more essential business), and also designed, painted and embroidered fabrics. Her first publication took the form of a needlework pattern book of flowers, *Neues Blumenbuch* (3 vols, Nuremberg 1675–80).

Insects played a large part in still-life painting and Merian had studied insect metamorphosis from the age of thirteen. She travelled with her daughter to the Dutch colony of Surinam to study insect and plant life there, producing extremely detailed and marvellously coloured body-colour drawings on vellum, used as the basis

48

49

for her publication of 1705. A large group of these was already in Sir Hans Sloane's collection by 1710 and was placed on public display in albums when the Museum opened in 1753. It was thus as an entomologist and botanical artist that she enjoyed a reputation in the first part of the eighteenth century.

However, like many of her contemporaries, Merian's art and studies in natural history, based on close observation of nature, were a reflection of her strong Protestant belief that nature could only be understood as part of God's creation. To study and record it so closely was a form of worshipful living, endorsing further its suitability as a subject for women and amateurs. Her early flower paintings were more in the decorative tradition of seventeenth-century Dutch and German flower painting, with bouquets or vases of flowers, often painted either in dark niches, like that of Lady Carnarvon (cat. 24) or with solid black backgrounds. The present work, depicting a carefully observed single branch of blossom with insects and web, is an interesting mixture of decorative and natural history elements that appears to date from the first half of the eighteenth century, before flower painting became clearly divided into botanical studies and more purely decorative pieces. Mrs Delany employed black backgrounds to produce the same effect in her embroidered court dress and paper mosaics.

Literature: Heidrun Ludwig, 'Maria Sibylla Merian', in Gaze II, 946–8; David Scrase, *Flower Drawings: Fitzwilliam Museum Handbooks*, Cambridge 1997, nos 19, 20; Kurt Wettengl, ed., *Maria Sibylla Merian. Artist and Naturalist. 1647–1717*, Frankfurt-am-Main 1998, *passim*.

50

MARY MOSER (1744–1819)

50

Study of roses, marigolds and stocks

Watercolour, 298 × 236 mm

Inscribed: *Mary Moser RA*

LB 1

Provenance: Purchased from J. Hogarth & Sons

1878-7-13-1270

Mary Moser's flower paintings are less the celebration of the wonders of God's creation and careful observation of nature that we have already encountered, and more the type of flower painting we are accustomed to associating with the work of lady amateurs. Her paintings resemble the type that could be found in prints by J. June and others. London printsellers sold countless decorative flower prints, depicting them in baskets, vases or tied in bouquets, for use as pattern books for ladies to embroider or draw after, for glass painting, japan work or even for copying on to undecorated china-in-the-white. By the later part of the eighteenth century, drawing masters specializing in teaching this type of painting were much in demand, and many women who had given up flower painting on their marriages found it a useful means of support when they became widowed.

Mary Moser was the only surviving child

of an immigrant Swiss portrait painter in enamel who taught drawing after the Antique to the Prince of Wales before he became George III. She exhibited first at the Society of Arts, winning a medal for a vase of flowers in 1759, then at the Society of Artists, before joining her father as a professional artist and founding member of the Royal Academy where she was the only other woman besides Angelica Kauffman. Like the latter, she continued to paint after her marriage, but unlike her, ceased to paint professionally and exhibited as an honorary painter under her married name of Mary Lloyd.

Individual species are usually identifiable in Mary Moser's work, but not in the detailed form of a botanical drawing, which included the bud and clearer indications of the leaf and stem. That she was capable of this type of drawing as well is clear from the studies of tulips by her in the Victoria and Albert Museum, but they are not typical of her work and were probably executed on commission. Her flower compositions in general do not give the impression of having been studied from nature, but from the work of others and, unlike botanical studies, they are overlaid with allegorical symbols and references to the seasons. This work is less typical in that the flowers are not shown in a vase or in the usual elaborate composition that normally included a background. It has something of the appearance of a study – perhaps for a larger, more elaborate composition such as the murals she executed for Queen Charlotte at Frogmore in the mid-1790s.

Farington claimed that Mary Moser was drawing mistress to the queen and her daughters for several years, and that they rose at four in the morning in eagerness to pursue their studies, creating decorations for Frogmore (9 November 1797, *Farington*

Diary III, 919). There is no evidence that she taught them drawing, however – merely that the queen admired her work and that Moser painted the six enormous canvases that now decorate the room named after her at Frogmore. Those on the walls take the form of large urns with garlands and plain blue backgrounds, but the ceiling is painted to give the appearance of a trellis with a *trompe l'oeil* sky above.

Literature: Robert Sayer, *The Ladies Amusement; or, whole Art of Japanning made easy … extremely useful to the Porcelaine*, c.1758–62; Roberts, 83; Gill Saunders, 'Mary Moser', in Gaze, 986; Pointon, 160–5; *Frogmore House and the Royal Mausoleum*, Royal Collection, 1998; A. Ledger, 'Letters to the Editor', *Derby Porcelain International Society, Newsletter* 44 (May 1999), 35–6.

PRINCESS ELIZABETH (1770–1840)

51
Flower piece with bird's nest, 1792

Watercolour and bodycolour, 710 × 510 mm; in original frame 875 × 675 mm

Lent by Her Majesty The Queen
(RCIN 452491)

George III, Queen Charlotte and their daughters were keen botanists as well as amateur artists. After meeting Mrs Delany at the Duchess of Portland's home at Bulstrode and seeing her *hortus siccus*, they regularly sent her flowers from Kew. They must have been familiar with George Ehret's botanical drawings for the duchess and for Joseph Banks, who was responsible for the Royal Botanic Gardens at Kew. From 1790 Banks employed the Austrian Francis Baur as permanent draughtsman at Kew, who gave lessons in botanical drawing

to Queen Charlotte and Princess Elizabeth. The queen and the princess royal, Princess Charlotte, had already been painting botanical watercolours of rare plants in the gardens for a number of years and, by 1790, when they began to use Amelia Lodge and then Frogmore House as a morning retreat at Windsor, there were enough paintings for the queen to keep her botanical collection there.

Princess Elizabeth was the most prolific of all the queen's daughters, and worked in many different media. There are examples of her cut-paper work (during frequent visits to Mrs Delany the princess learned to cut paper and the queen began to lay down her pressed flowers on black paper for her 'Herbal') and fan decoration later in this study (cat. 174), but she was also heavily involved in the decorations of the rooms at Frogmore. She designed a number of the garden buildings, and the long narrow room called the 'Cross Gallery' on the first-floor landing was decorated with panels that incorporated her cut-paper silhouettes and paintings of flower garlands in oil and tempera in the manner of Mary Moser and Lady Diana Beauclerk's work at Little Marble Hill.

Although the present accomplished painting is similar to some of Moser's paintings of large ornamental urns, it appears to be a copy of a still life signed by another flower painter, Margaret Meen, which may have been purchased by Queen Charlotte (now V&A). Meen was active from 1775 to 1818, but her watercolours (now in the Library at Kew) looked back to the Dutch seventeenth-century tradition, as she frequently painted on vellum, adding realistic elements such as drops of dew on leaves and mossy birds' nests with eggs.

Literature: Roberts, 74–85; Hayden, 166.

PRINCESS ELIZABETH. (1770-1840)

51

3

From 'Landskip' to Landscape

In 1955 Henry and Margaret Ogden pointed out that 'the full extent of the vogue of landscape in England in the seventeenth century has never been recognized'.[1] Yet the majority of studies of landscape painting in Britain has continued to start with examples dating from *c*.1750: beginning with John Wootton and George Lambert as forerunners, they normally proceed with Thomas Gainsborough and Richard Wilson as the first significant native practitioners in oil, and Paul Sandby and William Pars in watercolour.[2] If they are discussed at all, landscapes of the seventeenth and first half of the eighteenth centuries, mainly the work of topographers, sporting artists or foreign artists working in England, are usually despatched within the first chapter.[3] However, by focusing our attention on the 'Golden Age' of British landscape, we obtain a false impression of the activity of landscape drawing and painting in Britain. The early history cannot be rewritten here, but we can attempt to build on the Ogdens' efforts by illustrating in this chapter and the next how widespread the activity of viewing, sketching, interpreting and re-creating landscape was amongst both amateurs and professionals before the middle of the eighteenth century.

'Landskip' and Landscape

One particular development in the English language around the mid-eighteenth century indicated a significant change in attitude towards landscape painting in Britain at that time: this was the appearance and consistent use of the modern word 'landscape'. The Dutch were credited with having invented the genre, and from the first English adoption of their word, *landtschap*, around the end of the sixteenth century until the middle of the eighteenth, the most common (although not only) spelling had been 'landskip'. When 'landskip' first appeared in English art, its function was usually as the background to a history painting or portrait, and it was closely tied with the study of perspective used to indicate distance. At first the figures were merely placed in front of it, so that it acted as a backdrop, but around the beginning of the seventeenth century, they began to take a more natural place within it and at the same time an interest in topography began to reveal itself in accurate depictions of actual places.

But from the very first discussion of the genre in England, the objects common to landscape were already separated into a division that was to remain consistently essential to the understanding of, taste for, and practice of the art in England: that is, the objects within it were either *natural* or *artificial*.[4] In the late sixteenth and early seventeenth centuries, the understanding of

these two words was different from our own and more akin to the division of objects in seventeenth-century museums or collections into *natural* and *artificial rarities*. Trees, hills, rivers, people, flowers, etcetera, were *natural* objects in a landscape, while cities, castles, and other man-made objects were *artificial*. The two types of object could reside quite happily in the same painting. A subtle change took place in attitudes to landscape over the next century, however, and landscape itself, rather than the objects within it, was divided into two types – *natural* and *artificial* or, more familiarly, *real* and *imaginary*, that is landscapes that depicted an actual spot, or an invented one.

This division was already evident in the work of Prince Rupert, Evelyn and Place in Chapter 1, and the wide variety of landscape types presented there should indicate just how widespread the practice of and taste for landscape already was in Britain. However, as our focus in that chapter was on the place of drawing within their lives as seventeenth-century gentlemen and *virtuosi*, it may be useful to summarize contemporary attitudes to landscape here through three examples that have a special relevance to amateurs.

In Henry Peacham's first treatment of the subject in *The Art of Drawing* (1606), landscape held a subordinate place in art,[5] but when he returned to it in 1612, in *The Gentleman's Exercise* (and included in *The Compleat Gentleman* from 1622),[6] he indicated approval for landscape as a subject that could stand alone. The most desirable feature within landscape was variety, which could be found in imaginary landscapes or in real views, and he listed some of those he considered the most beautiful in the world, including views in the Alps, the Italian lakes and around Naples.

Even though it circulated mainly in manuscript, Edward Norgate was the author of the other most influential text on landscape in the early seventeenth century, entitled *Miniatura* (1627–8, revised 1648). Noting in the margin that it was 'An Art soe new in England, and soe Lately come a shore, as all the Language within our fower Seas cannot find it a Name, but a borrowed one', Norgate defined it as '*Landscape*, or shape of Land'. It afforded great variety, delight and pleasure, and he owed much 'to this harmless and honest Recreation, of all kinds of painting the most innocent, and which the *Divill* him selfe could never accuse of or infect with Idolatry'.[7] After establishing its provenance, he described 'Lanscape' as a '*privado* [confidant] and Cabinet Companion of Kings and Princes', thus setting royal approval on the genre.[8] He went on to a technical description of limning landscapes on vellum, recommending the use of perspective for depth, and either study from nature or imagination to complete the conjuring trick of representing nature in a painting.[9]

Norgate listed a number of landscapists whose work he admired, but curiously, although he and Peacham knew Sir Nathaniel Bacon and admired his work,[10] neither mentioned the small painting on copper attributed to Bacon that is apparently the first pure landscape by an English-born artist (cat. 52). Now in the Ashmolean Museum in Oxford, it is probably the 'small Landskip drawn by Sir Nath. Bacon' in the 1656 catalogue of the Tradescant collection.[11] Bacon may have known the gardener and collector John Tradescant the Elder (d. 1638) through his own interest in horticulture. The painting has attracted little attention in studies of the English art of landscape, but the fact that both Norgate and Peacham directed their treatises as much towards their amateur friends and patrons as to professional artists, and that this first work was executed by a courtier, is indicative of its importance for our purposes here.

The imaginary landscape is freely painted and resembles the small decorative 'fantasy' landscapes on vellum or copper painted by artists such as Lucas and Martin Valkenborgh or Roelandt Savery, which were particularly popular in the Netherlands and in the Bohemian court at Prague, and were imported into England directly from the Netherlands around this time.[12] Norgate himself and several contemporaries limned small landscapes or painted them in watercolours. It was no doubt this smaller type of landscape, whether on copper, vellum or paper, that Norgate was thinking of when he described landscape as the private cabinet companion of kings and princes.

From the time of its introduction to England, then, landscape was truly a 'noble and ingenious art',[13] whether produced by artists or amateurs. It is thus less surprising to find that Prince Rupert not only learned to draw prospects, using perspective and any technical tools available, but that he also attempted small washed landscapes such as cat. 1, the purpose of which was not utilitarian, but rather an attempt to achieve a 'landskip' as men such as Peacham and Norgate were then describing the art. Similarly, John Evelyn's earliest surviving drawings are views of his father's house and prospects he admired on his travels. His primary purpose was not merely to record what he saw but to create a souvenir of a view that he was drawn to for personal or aesthetic reasons. But for Evelyn, with his *virtuoso*'s desire to share knowledge, his small private, cabinet-type drawings of the prospects around Naples could also serve a public end. By turning them into prints, he could satisfy the curiosity of those who had not seen them in the original.

The Stuart market for views of real places was fed by the increasing importation of such prints from Holland, and even a growing native production of British topographical prints. Some were large and intended for framing, while others were to be bound in book form.[14] There was also an enormous market for Flemish 'Mannerist' landscapes, imported in vast numbers as prints – indicators of the place that landscape already held in British taste long before British artists themselves began to paint landscapes.

It is not only prints that reveal a strong inclination to landscape amongst British collectors and amateurs in the seventeenth century. Many Dutch and Flemish artists who trained in Italy, including Rubens, Van Dyck, van Poelenburg, Breenburg and numerous others, worked in England, bringing with them their various approaches to landscape painting in oil and attracting numerous patrons of their work in this genre, which entered English collections in increasing numbers through the century. Their drawings have been less well documented than the paintings, but recently a number of studies have underlined the importance of works on paper in understanding the ways landscape was approached in this country.[15] The taste for these works in oil and on paper has been documented, but it is largely ignored in any search for the roots of a native school of landscape, because it was largely superseded by a taste for and the almost wholesale importation from the end of the seventeenth century of the works of Salvator Rosa, Gaspard Dughet, Nicolas Poussin and Claude Lorrain.[16]

The result of this exposure to various forms of landscape during the seventeenth century was that towards its end men such as Talman and Place were comfortable using a variety of styles and media for different types of landscapes for various purposes: they were happy to employ Hollar's detailed mode of recording prospects and topography, but it is interesting that they adopted the Dutch-Italianate style of loose washes and enlivening pen work for their views of ruins or to capture a lovely fragment of nature that held no obvious building, town or figure. Some of Thomas Manby's landscapes were of known features combined to create an imaginary landscape capriccio,[17] but few British artists had yet attempted an ideal landscape of the type that would dominate amateur and professional productions of the first half of the eighteenth century.

From the first decades of the new century, limners such as Bernard Lens and his pupils (cat. 28) began to copy the imaginary Italianate landscapes painted in oil by van der Vaart and van Poelenburg, who were themselves influenced by an approach to landscape typified by Claude and Poussin. Artists like Joseph Goupy and Marco and Sebastiano Ricci, who were favoured at the new Hanoverian court, worked in oil and gouache, copying the works of Rosa and Dughet, as well as inventing their own compositions in their manner.[18] It was also during this period that paintings by Italian artists began to flood into British collections in a movement that has been well documented,[19] and that finally prompted native artists to imitate their work.

At the time of its introduction to England, landscape was either seen as a piece of Dutch *drollerie*, or regarded in the way it was described by Norgate, as something filled with variety, an object that was rich, rare and precious, limned by a 'cunning' painter who could beguile the viewer and magically transport him or her to another country.[20] Bernard Lens and Sarah Stanley's small detailed copies of van der Vaart and van Poelenburg continued this earlier courtly tradition of limned landscapes, but the practice died with them. By the middle of the eighteenth century ideal Italian landscapes with their classical overtones were preferred to the too 'fantastic' or too realistic imitations of nature found in Dutch art, and the English spelling of the word began to distance itself from its Dutch roots. Around 1750, 'landskip', was supplanted within a decade or two by 'landscape'.[21]

This gradual change in the English taste for landscape was not only a turning away from the Dutch school towards ideal Italianate compositions, but was also a reflection of political, cultural and social changes in Britain. In the seventeenth century ties with the Netherlands had been exceptionally strong: the Winter Queen and Charles II had been protected at the Dutch court, and the Prince of Orange became William III of England. But with the ascent of the Hanoverians and Whigs, there was a gradual turning to the cultures and philosophy of classical Greece and Rome represented by the Italian tradition in art. This is of course an oversimplification of complicated events and evolving philosophies, but is an indication of how closely related changes in politics, society and culture were and of their ultimate effects on the activities of amateur artists.

The movement away from the 'realism' or *drolleries* of Dutch 'landskip' towards the 'artificial' or imaginary *landscape* was also an indication of the beginnings of a desire to identify a British school in art. Amateurs, connoisseurs and professional artists were all involved in the creation of a British school, as it would be of benefit to the nation and was therefore a moral and civic responsibility. If landscapes reflected too close a relationship to the Dutch school, that is if they were small limned copies, too realistic, merely topographical, or full of flowers or other Dutch *drolleries*, then they were not suitable as contributions towards a national school. This type of landscape activity remained the province of antiquarians recording ruins and views, and of women whose works were intended for the cabinet and for private use (see cat. 30), and who do not seem to have attempted to produce imaginary landscapes in the first half of the century. The examples in this chapter provide evidence that imaginary, classical landscapes were suitable productions for men who wished to demonstrate that they occupied their leisure time in a publicly useful manner, which they could even place on display on the walls of their homes or in public exhibitions, while realistic sketches from nature, if produced at all, were intended for the portfolio. In addition, the gentlemen in this chapter who practised this type of drawing cannot be characterized, as the seventeenth-century *virtuosi* were, by their omnivorous interests (of which drawing was just one of many) and collecting activities, but rather by their pursuit of this one particular art, the drawing and painting of landscape.

A 'harmless and honest Recreation'

Although the technique of limning landscape had changed since Norgate's description of it in the first half of the seventeenth century, his description of landscape as the most innocent of all kinds of painting must have reinforced its aptness as a subject suitable for the gentlemen of Locke, Shaftesbury and Addison's generation, who advocated a return to the civic humanism of Augustan Rome and searched for opportunities for cultural and moral improvement (see pp. 103–4).[22]

In the decades before and after the turn of the century the British passion for portraits of themselves was matched by their desire to own portraits of their houses and estates, a public demonstration of their participation in the new nation that Britain was becoming. It was in providing such portraits that artists such as Danckerts, Peter Tillemans and George Lambert made their livings as landscape painters, the last the first native-born artist to do so. The 4th Lord Byron seems to have known Peter Tillemans from the time that the artist painted the horse and landscape background in the baron's equestrian portrait by Michael Dahl (1659–1743) (now lost). Tillemans painted at least three views of Newstead Abbey: one still hangs there but was left unfinished by the artist just before his death, and the figures, coach and courtyard were completed by Byron. Another painting of the abbey showed a figure drawing with another gentleman watching on a hill to the left of the house.[23] Byron's earliest dated drawing, of a tree struck by lightning, was drawn in 1718, when he was forty-nine, about the year that he began to receive a substantial annual pension from George I, and a time when many of the changes at Newstead were undertaken. Many of Byron's wash and watercolour drawings survive: one, a landscape with gibbets and figures, signed and dated 1728, was used as backing paper for an imaginary landscape signed by Tillemans.[24] The latter's own drawing style varied enormously according to his subject, from atmospheric wash drawings apparently drawn on the spot,[25] to sketches working out compositions, finished coloured drawings to be placed in portfolios, or imaginary landscapes like cat. 54, which Byron's (cat. 55) resembles so closely. The pupil imitated most of these styles and their relationship evidently extended over a number of decades with attributions of their drawings remaining fraught with difficulty.

Another patron of Tillemans, the Suffolk antiquary Dr Cox Macro, owned at least twenty paintings by the artist, paying a little less than the usual £20 for them, as a favoured patron; but the Earl of Derby paid £40 for 'Four little water Coloured Landskips' at Knowsley.[26] Tillemans's own collection had sketches by Flemish artists including Jan and Thomas Wyck, whose work is an important link between Tillemans and Thomas Wyck's pupil Jan van der Vaart (cat. 53); the drawings of all three bear many similar characteristics and are also significant for later developments in British landscape. Like Tillemans, Paul Sandby was an important collector of drawings, and also owned views attributed to the Wycks.[27]

It has been claimed that Tillemans's main contribution to landscape drawing in England was his ability to overlay his views, even of real places, with a sense of atmosphere, mainly through a skilful application of the medium of wash and watercolour, something not achieved by many earlier Dutch artists in their drawings.[28] If we were to argue a linear 'progressive' development of the history of British art, it would seem to follow that Tillemans thus laid the foundations for the later school of landscape watercolour painting in Britain, particularly as later artists such as William Taverner and Sandby knew and collected his work. But by examining the works of less well-known artists, instead we are trying to understand various levels on which artists, amateurs and collectors viewed and appreciated each other's works. From this we know that the atmospheric works so much appreciated by our modern eyes

were probably very private works, executed for study purposes only, and were not the type that would have been known or collected by later artists. In fact, the early history of these 'atmospheric' works is not known and their attribution to Tillemans is relatively recent and based on comparison of style with his documented drawings.[29] Tillemans and his pupil Lord Byron, as well as his patron Cox Macro, did not place a high value on atmosphere and naturalism in their landscapes as we might today. Instead they looked for 'cunning' imitations of landscapes they either knew in reality or wanted to visit in their imaginations, painted in a style that made references to and demonstrated their taste for landscape paintings that they and their contemporaries already knew and admired, whether by contemporary artists or by earlier Dutch-Italianate masters.

Poetry and Reputation

It is significant that William Taverner, unlike any of the amateurs discussed so far, was not a landowner, did not have connections at court and, although he was a collector, was not a *virtuoso* in the seventeenth-century sense. His landscapes also show a departure in medium and subject matter from any we have examined earlier. They reflect the influx of and growing taste for a type of landscape that had begun to appear in England in the last decades of the previous century, best typified by the idealized classical landscapes of Gaspard Dughet.[30]

The poet John Dryden had already celebrated this type of landscape in his poem 'To the Pious Memory of the Accomplish'd Young Lady, Mrs. Anne Killigrew, excellent in the two sister arts of Poetry and Painting' in 1686. A lady at court whose grandmother, Lady Killigrew, permitted Charles I to choose one of her works for his cabinet,[31] Anne Killigrew (1660–85) died young, and her reputation, probably largely due to her tragic early death and to Dryden's poem, far outstrips any of the few surviving works attributed to her. Although the works described by Dryden were probably small limned landscapes, his verses indicate the new direction in which taste for landscape was heading, towards a place reminiscent of ancient Greece and Rome to which one might retire in one's mind:

Her Pencil drew whate'er her soul design'd,
And oft the happy draught surpass'd the image in her mind.
The sylvan scenes of herds and flocks…
And perspectives of pleasant glades,
Where nymphs of brightest form appear,…
The ruins too of some majestic piece,
Boasting the pow'r of ancient Rome, or Greece…[32]

Poetry and reputation also played a large part in the admiration of the works of William Taverner, the son of a procurator and playwright and grandson of a portrait painter (see cat. 56). In 1733 his contemporary, George Vertue, who was collecting notes on artists for posterity, wrote that Taverner had

(besides his practice in the Law) a wonderful genius to drawing of Landskap in an excellent manner. adorned with figures in a stile above the common & paints in oil in a very commendable & masterly manner. a fine genius blending the arts of his Ancestors in

Painting & Poetry in his happy stile of Painting … living in Drs Commons and a proctor there whch business he follows besides that has such an excellent genius for drawing especially Landskips that he has done some pieces lately to the admiration of all the Curious that see them – they are said to be incomparable.[33]

Vertue's statements are revealing on a number of levels. Taverner's business was the law but he had a 'genius' for landscape – one of the earliest uses of the term in this way, which implied that he had a natural gift that he did not have to labour to acquire, underlining his status as a non-professional. Vertue also indicated that Taverner's birthright enabled him to achieve a unification of the arts of painting and poetry, exemplifying the humanist theory of painting, *Ut pictura poesis*. Norgate had found it in the limned history paintings of Isaac Oliver, who took only a few days to paint a portrait from life, but as much as two years to produce a religious historical composition in imitation of the greatest Italian masters. The requisites for history painting were shared with those of poetry: variety, learning, imitation of exemplary models, a skilled hand and an inborn talent ('your owne genius') for invention.[34] Norgate's ultimate aim in describing history painting, however, was to make a case for the establishment of an English school of history painting, although he rooted it in the special status of limning as an English art.[35] In the eighteenth century there was a similar call for an English school of history painting, to which Vertue was no doubt contributing with this commendation of Taverner's work, but Norgate's recommendation of limning small histories for cabinets was too private, too precious and too Dutch and thus no longer appropriate. The search was beginning for a more public medium and subjects more appealing to a more widespread, not merely courtly, taste. Taverner's landscapes in gouache, watercolour and in oil, and peopled with classical figures, must have seemed to his contemporaries to be a step towards achieving this goal.

Vertue also mentioned that Taverner's works were admired by all the 'curious' who saw them, signifying that a natural genius excited curiosity, which at first he was pleased to satisfy. Later, however, Taverner 'had much quaking about showing his pictures, which raised their reputations'.[36] The ultimate effect of his reputation was noted in the *Gentleman's Magazine* after his death when Taverner was described as 'one of the best landscape painters England ever produced: but as he painted only by way of amusement, his paintings are very rare and will bear a high price'.[37] Indeed, later owners of his works ensured that they recorded why these works were valuable, inscribing them 'Drawn by Mr. Taverner *of Doctors Coms*' (author's italics),[38] and his reputation remains high today. In his *Dictionary of British Watercolour Artists* Mallalieu credits Taverner's 'romantic and poetical landscapes' with founding 'one of the two streams of eighteenth-century watercolour painting, the other being exemplified by Sandby's perfect tinted topographical work'.

It is perhaps an over-simplification of too many cultural layers to credit Taverner with the 'founding' of one of two streams of watercolour painting. This type of classical landscape, so reminiscent of Claude and Dughet, who worked in gouache as well as oil, could also be found in the paintings

of Breenburg, van Poelenburg, and van der Vaart, and in eighteenth-century gouaches by Sebastiano and Marco Ricci, Joseph Goupy and Francesco Zuccarelli, whose works were collected by Tillemans, Cox Macro and by royal collectors, especially Frederick, Prince of Wales. All were diffused in copies, large and small, in oil, bodycolour, watercolour and in ink wash, and all inspired imitators in these various media. Perhaps even more significantly, they also circulated in prints, imported from abroad in the late seventeenth century, but issued by British printmakers such as George Knapton and Arthur Pond in the eighteenth.[39]

The most relevant prints for Taverner and his admirers, however, were probably the 'fancy piece' mezzotints by Robert Robinson (*fl.* 1674–d. 1706) and Bernard Lens II (1659–1725), which are now rare, but at the time were common currency amongst British collectors and amateurs. Robinson was responsible for around fifty imaginative and poetic compositions, mainly landscapes with ruins and figures, often classical, which betray his experience in stage design.[40] Two watercolour and bodycolour drawings of architectural capricci by Taverner have always been thought to be imitations of G. P. Panini,[41] but might also indicate familiarity with Robinson's mezzotints of similar subjects. Lens's output has been described as 'vast', and although it has not yet been catalogued, it included a notable group after van der Vaart, and presumably several after his own collection of 'curious Italian drawings' sold after his death.[42]

Taverner's reputation ensured the survival of large numbers of his works, which were so well advertised during his lifetime and on his death, and well documented from the sale of his collection afterwards at Langford's, 21–4 February 1774 (12 pp.). He left instructions in his will that his own works were to be sold, along with his collection of statues and medals, old master drawings by Giulio Romano, Rembrandt, Rubens and others, his large collection of old master prints, including 600 historical compositions after Rubens, and 6 studies of heads, 9 studies of dogs and 8 of plants in oil and a few pictures by contemporaries, among them a 'A small battle by Tillemans'.[43]

Just as he probably purchased works at the sale of the collections of artists such as Tillemans and Jonathan Richardson the Elder, so Taverner's own works ended up in the collections of Paul Sandby, the sculptor Joseph Nollekens (1737–1823), and connoisseurs like Cracherode and Payne Knight, whose ownership lent their own further *imprimatur* to the artist's reputation.

Like Tillemans and Byron and many of the other artists we have studied, Taverner adapted his medium to his subject, but his most individual contribution appears to be the fact that although some of the landscapes in which he placed his figures were clearly drawn on examples seen in the works of Dughet or van Poelenburg,[44] many others are based on the landscapes he observed directly himself around London. The result is that his bathing nymphs and the scene from Ovid in cats 57–9 appear to be set by the ponds or in the woods at Hampstead, rather than at Tivoli or in the Roman Campagna.

Like many other amateurs and professional artists, Taverner painted his own original compositions in oil,[45] and he was also given access to some of the most famous paintings of his time in order to copy them in oil. Both he and John Wootton made copies from the *Jonah and the Whale*, one of the best-known paintings by Gaspard Dughet in England, which was thought to have figures painted by Nicolas Poussin, and was bought by Frederick, Prince of Wales, around 1745. It was Dughet's only marine subject and was engraved by Vivares in 1748. Wootton's copy went to Blenheim and Taverner's was purchased (although probably not directly) by Henry Hoare of Stourhead who also owned one of Dughet's undoubted masterpieces, the *Landscape with Eurydice*.[46] Henry Hoare, the collection of paintings he formed at Stourhead by Dughet and similar artists, as well as by contemporary British and continental artists, and the gardens he created at Stourhead hold a central place not only in the history of British art and taste, but also in this chapter. His relationship with Taverner is unknown, but that Taverner's copy filled a vital gap in his collection is clear, and provides an additional thread of continuity between Taverner, with his roots in the earlier part of the century, and the next generation of collectors, connoisseurs, amateur artists and gardeners, represented by Hoare and his great friend Coplestone Warre Bampfylde, a pupil and friend of Taverner's exact contemporary, George Lambert.

The 'Simplicity of unadorned Nature' and 'a more noble sort of Tranquility'

Horace and Virgil had celebrated country life as morally superior to life in town, and the landscape of retirement dominated the work of poets such as James Thomson (1700–48) and Alexander Pope (1688–1744) who advocated the creation of natural gardens and encouraged the simple act of viewing scenery as a philosophically worthwhile activity. Thomson in particular contrasted the formality of French and Dutch gardens where 'Nature by presumptuous Art oppress'd,/The woodland Genius mourns' (*Liberty* v),[47] with the English garden which, by contrast, was, like the landscapes in Virgil's *Aeneid* and *Georgics*, a space of freedom where the visitor was at liberty to choose from among various paths and scenery according to his mood. In 1713 Pope wrote:

There is certainly something in the amiable Simplicity of unadorned Nature, that spreads over the Mind a more noble sort of Tranquility, and a loftier Sensation of Pleasure, than can be raised from nicer Scenes of Art. This was the Taste of the Ancients in their Gardens, as we may discover from the Descriptions are extant of them.[48]

This new passion for creating and contemplating a more natural landscape was reflected in the activities of the gentlemen who, either unable or not content with reordering the real world of their estates, sought to signal their participation by creating their own 'landscape of retirement' on paper or canvas.

In his paintings of the houses and estates of the dukes of Bedford and Richmond and the Earl of Burlington, George Lambert helped to supply canvases that reflected his patrons' attempts to reorder the landscape around them into more natural ones, but also ones that celebrated the resultant

beneficial agricultural and economical effects. He had also known Coplestone Warre Bampfylde from the 1750s, and was employed by him to paint a view of the changes he had made to the grounds at Hestercombe in Somerset.

Bampfylde's earliest watercolour dates from 1750. He spent a great deal of time in London that decade, and George Lambert's influence can be seen clearly in the oils and watercolours of this period. There is no documentary evidence that Bampfylde took lessons from Lambert, but in 1755 the latter advertised a series of five engravings of *Views of Mount Edgcumbe*, which had been painted by himself and the topographical artist Samuel Scott, but drawn for the engraver by Bampfylde.[49]

Throughout his life, Bampfylde painted enormous history paintings in oil: most were still at Hestercombe when Maynard's of Taunton sold the contents (8–11 October 1872). The drawing-room housed two landscapes depicting scenes from the opera *The Maid of the Mill* (151 by 82 ins each) and five historical landscapes painted by Bampfylde with figures by 'Thorn'. The hall boasted his life-size equestrian portrait painted by Richard Phelps, with much of the landscape painted by Bampfylde himself and another collaborative work, a copy of Van Dyck's *Charles I on Horseback*, which they painted in 1761. According to the list of contents of the house, Bampfylde was the sole artist of an oval composition of Laurence Sterne's *Maria* and several other historical landscapes as well as a coastal scene.

One of the historical landscapes, *Aeneas and Achates in the Lybian Forest* (96 by 54 ins), was on Bampfylde's easel in 1782 when he was corresponding with Christopher Anstey, the author of *An Election Ball* (1776) and other works for which Bampfylde had provided illustrations:

I am daubing of Canvas & the Trojan hero is still aiming at ye 2nd stag and is doom'd like ye painter never to hit ye mark. As to Dido [probably a companion picture] I shall leave her to enjoy her Feather Bed & will not give her an airing till ye summer advances. What cou'd a lazy fellow do in ye Country were it not for such a hobby Horse?[50]

The finished painting was exhibited at the Royal Academy the following summer. On an earlier occasion Bampfylde exercised his hobby horse at Stourhead and 'mended Gainsborough's sheep' in *Peasants Going to Market: Early Morning*, purchased by Henry Hoare in 1773 (until recently at Royal Holloway College, Egham, Surrey). Prince Hoare later had them 'restored to their original deficiencies'.[51]

Bampfylde had known Henry Hoare from a very early age. On his many visits to Stourhead he not only painted watercolours of the gardens, but copied paintings in the collection, especially Italian landscapes, and was probably involved in the design of several features in the gardens. Vivares engraved two of the most famous views of Stourhead after watercolours by Bampfylde in 1777. Bampfylde's wife did not draw, but was extremely adept at an another eighteenth-century artistic polite accomplishment for ladies – she made silk needlework pictures of still lifes of birds, one of which still hangs at Stourhead.

We know less about the gardening or collecting activities of another pupil of Lambert, Richard Beauvoir, but he too learned to discover 'the taste of the Ancients in their gardens' by painting imaginary classical landscapes in oil, which occasionally incorporated elements of English scenery or fragments of English views.[52] However, Beauvoir and his fellow pupil Jonathan Skelton did not ignore the 'amiable Simplicity of unadorned Nature', and frequently focused on those aspects of the English countryside that bore no distinguishing features or obvious allusions to the classics and instead reached back to the type of appreciation of nature found in sketches made directly from it by Claude and the Dutch-Italianate painters discussed earlier. Works such as cats 62–3 are small and personal, referring back to Norgate's 'harmless and honest recreation', and it is also significant that they employ fresh, truthful colours, rather than the darker tones that characterized their imitations of classical landscape.

In 1761 the sculptor Louis-François Roubiliac (1702–62) wrote a poem to celebrate the arrival of a national school of painting, which he considered could at last be found on the walls of the Society of Artists' exhibition:

… Les Maitres de la Grece, & ceux de l'Italie
Rendre justice egalement;
A ceux qu'a nourris ta Patrie?
Vois ce Salon, et tu perdras,
Cette prevention injuste.
Et bien etonné Conviendras
Qu'il ne faut pas qu'un Mecenas
Pour revoir Le Siecle d'Auguste.

These lines were pinned up in the exhibition itself and printed in the *St James's Chronicle*, 14 May 1761.[53] This was the second exhibition of the Society of Artists, and at the fourth, in 1763, Richard Beauvoir and Coplestone Warre Bampfylde each exhibited works as 'An Honorary Exhibitor'. Joshua Kirby's entries for 1767 and 1769 were said by Horace Walpole to have been painted by George III (see cat. 68).

In his history of the Society of Artists, the artist Edward Edwards wrote:

After the Peace of Aix-la-Chapelle, the nation appeared to be roused to a spirit of exertion and improvement in the arts, which had not been known in England before that period; and several institutions or societies were formed, whose avowed intentions were to encourage the talents of their countrymen. Such were the Antigallican and Dilettanti Societies, but especially the Society for the Encouragement of Arts, Manufactures and Commerce [The Society of Arts].

This noble institution, which was founded by the liberality of a very small number of noblemen and gentlemen in the year 1754, has fully answered the wishes of its first founders.[54]

It was alongside premium winning works in the rooms of the Society of Arts that the Society of Artists held their first exhibition in 1760. In subsequent years they rented rooms in Spring Gardens while the Free Society of Artists continued its association with the Society of Arts. It has been said that it would be easier to compile a list of eminent men of the mid-eighteenth century who were not members of the Society of Arts than to compile a list of those who were.[55]

The appearance of a British national school thus owed much to these early societies and their exhibitions which included the work of amateurs and artists alike and owed their creation neither to royal patronage nor solely to the effects of professional artists, but to public-spirited patrons and gentlemen amateurs.

NOTES

1 Ogden 1955, 1.

2 Leslie Parris, *Landscape in Britain c.1750–1850*, exh. Tate Gallery, 1973; Andrew Wilton, *British Watercolours 1750–1850*, Oxford 1977; Andrew Wilton and Anne Lyles, *The Great Age of British Watercolours 1750–1880*, exh. Royal Academy, 1993.

3 Both Luke Herrmann, *British Landscape Painting of the Eighteenth Century*, 1973, 9–36, and Rosenthal 1982, 10–43, afforded these artists more consideration than most.

4 Ogden 1955, 1–4: it is important to note that in their discussion of the terms 'natural' and 'artificial' (p. 2), the Ogdens misunderstood their seventeenth-century meaning and their statement that the attitude towards them in eighteenth-century landscape 'was usually the opposite' is thus misleading.

5 Quoted in Ogden 1955, 5.

6 Two drawings in Robert Witt's collection have been attributed to Peacham and used to illustrate his attitude to landscape, but the attributions are too insubstantial for any conclusions to be made from these drawings. One reproduced by the Ogdens, pl. 17, is initialled *HP*, which the authors thought might be by Peacham, but appears to be compiled from prints; see p. 47 n. 32 (above) and J. Hayes, 'British patrons and landscape painting', *Apollo* 82 (1965), 40 and n. 10.

7 Muller and Murrell, 82–3.

8 Ibid., 85.

9 Ibid., 85–9.

10 Ibid., 63–4.

11 Tradescant may have known Bacon through Robert Cecil, Tradescant's first patron, to whom Bacon was connected by marriage; see MacGregor 1983, 291, 298, no. 254; more recently, see Hearn, 166.

12 See, for example, A1506 and A1559 by the van Valckenborghs and A2117 by J. Savery and A1297 by R. Savery in P. and J. van Thiel, *All the Paintings in the Rijksmuseum in Amsterdam*, Amsterdam 1976.

13 Several drawing manuals in the seventeenth century bore the subtitle, 'that Noble and Ingenious Art'; see Ogden 1947, 197.

14 Griffiths 1998, 245.

15 See especially Stainton and White, and Royalton-Kisch 1999, Introduction, 10–62.

16 See Ogden 1947, 20–1; and especially Hayes (n. 6 above).

17 See, for example, Stainton and White, no. 125.

18 See Robertson 1988.

19 The standard work is Elizabeth Manwaring, *Italian Landscape in Eighteenth-Century England*, 1925, and numerous monographs, especially French 1980 on Gaspard Dughet.

20 Muller and Murrell, 82–4.

21 Royalton-Kisch quotes two of the earliest uses from the *OED* in his n. 179, p. 61. It is important to note that it entered common usage as 'landscape' in English literature (e.g. Alexander Pope, Joseph Addison) long before it was applied to the genre of painting. Exhibitors at the Society of Artists were still using using 'landschape' in 1769, and Alexander Cozens used 'landskip' in his 1759 *Essay*, but the movement was clearly towards the less Dutch-sounding emphasis on the long 'a' sound rather than the short 'i', and by the 1770s the use of 'landscape' was consistent.

22 See Rosenthal 1982, 14–16.

23 Nottingham City Museums, Guide to Newstead Abbey, 1978, and Raines, 44, 49–50.

24 Oppé collection, Tate TO8608.

25 David Brown (in *Early English Drawings from the Ashmolean*, exh. Morton Morris & Co., London, in association with the Ashmolean Museum, Oxford, 1983) suggested that these may have been done entirely for private study and pleasure (cat. no. 18).

26 Raines, 31, found this price 'inexplicable'.

27 See, for example, Stainton and White, no. 83, attributed to the elder Wyck.

28 See n. 25 above.

29 Ibid.

30 For the history of taste for his art in Britain, see French 1980, 7–11.

31 Murdoch, Murrell and Noon, 84.

32 Quoted in Ogden 1955, 102.

33 Vertue III, 68, 95, 118.

34 Muller and Murrell, 90, 175, n. 188.

35 Ibid.

36 Farington, *Diary* III, 8 February 1797, 765–6.

37 XLII, (1772), 496.

38 Drawing with Albany Gallery in 1971.

39 French 1980, 11, re: Wilton print albums now in the Metropolitan Museum, New York. See also Ogden 1955, 101–7.

40 Griffiths 1998, 256–8, and Ganz, *passim*.

41 In the collections of the Huntington Library, San Marino (Calif.), and Leeds City Art Gallery.

42 Griffiths 1998, 263–4, where he notes that van der Vaart painted Lens's portrait, mentioned in his will, and that the sale of his drawings was held in November 1725 (BL Sc 550/13).

43 ECM II.

44 See YCBA B1975.4.1854 inscribed on verso: *Nymphs bathing/ Polinburg*, in S. Wilcox, *British Watercolours: Drawings of the 18th and 19th Centuries from the Yale Center for British Art*, New York 1985, no. 4.

45 The University of Liverpool has a *Wooded Landscape with Nymphs and Satyrs*, and there are two paintings in the manner of Dughet, which are set in rococo plaster frames in the saloon at Langley Park, Norfolk. He painted at least one 'curiously worked on metal' of *Venus and Adonis in a Landscape* (ECM II, quoting John Thane's sale, Jones, 26 March 1819, lot 314).

46 Purchased with its pendant for him by Horace Mann from the Arnaldi collection in Florence in 1758, in the face of stiff competition, see French 1980, 38–41.

47 Quoted in J. D. Hunt and P. Willis, eds, *The Genius of the Place: The English Landscape Garden 1620–1820*, 1975, 191.

48 Ibid, 205, quoted from the *Guardian*, 1713.

49 See Einberg 1970, nos 43–4.

50 Somerset R O, Taunton, Graham Clarke (Hestercombe) Papers, DD/GC/103, f.

51 Quoted in White, 8.

52 See Einberg 1999, 35–7.

53 Quoted from the account of the Society of Artists from Edward Edwards, *Anecdotes of Painters*, 1808, as compiled by Graves, 297–8.

54 Ibid., 295.

55 D. G. C. Allan and John L. Abbott, eds, *The Virtuoso Tribe of Arts and Sciences: Studies in the Eighteenth-Century Work and Membership of the London Society of Arts*, Athens (Ga.) and London 1992, 38.

SIR NATHANIEL BACON
(1585–1627)

52
Landscape

Oil on unprimed copper, 70 × 110 mm (sight); in narrow black moulding, backed with oak panel, 100 × 140 mm

Signed with monogram: *NB*

MacGregor 254

Provenance: Possibly the entry 'A small Landskip drawn by Sir Nath. Bacon' in the 1656 list of the Tradescant collection; Ashmolean Museum

Lent by the Visitors, Ashmolean Museum, Oxford

If this tiny oil painting on copper is the work listed in the Tradescants's collection in 1656, it is the earliest known landscape by any Englishman, and it is not by a professional, but an amateur. Probably imaginary, the freely painted landscape includes a horseman accompanied by a figure on foot ascending the rocky tree-topped hill in the centre foreground, with the turrets of a cliff-top castle visible on the right, a group of buildings at the foot of a hilly riverbank lined by a path on the left and a village

dominated by a church spire in the distance. Although painted on copper, it does not resemble the small landscapes in this medium by Adam Elsheimer and Paul Bril, several of which were then in the collections of the Earl of Arundel and Charles I.

Instead, it is much closer to the small imaginary decorative landscapes on vellum or copper that were popular on the Continent both for hanging on walls or to insert as panels into cabinets. Miniature painting on the Continent was not as specialized as it was in England: it was not as confined to portraiture and was frequently practised by painters used to painting in oil on a larger scale such as Lucas van Valkenborgh (*c*.1535–97), whose circular *Landscape of mountain scenery* on vellum, (on loan to the Victoria and Albert Museum), is typical of the kind of work by Antwerp-trained artists to be found throughout the courts and aristocratic collections in the Netherlands and Germany in the sixteenth century. Copper was a common support for these small oils, but the varnish tends to discolour more than does watercolour on vellum.

Living in East Anglia and proud of his close contacts with the Netherlands, Bacon was undoubtedly familiar with these works

that were being imported into England in large numbers around this time. Today we are used to seeing them as decorative furnishings rather than works of art, so they are seldom considered in connection with landscape painting in England, particularly as no British artists were trained in their production. But in the sixteenth and seventeenth centuries they were treasured possessions and that Sir Nathaniel Bacon should attempt to paint on this jewel-like scale possibly before attempting to paint his own self-portrait (fig. 1) or the enormous still lifes that lined the panels of his hall, is indicative of the manner in which a seventeenth-century gentleman courtier understood, admired and participated in the noble art of limning 'landskips'. The difference between these imaginary capricci and the utilitarian topographical approach, which was also in use at this time in maps and bird's-eye views, is underlined by the map of the coastlines of the Netherlands and East Anglia Bacon points to in his self-portrait. The ability to draw both types of landscape fulfilled Peacham's qualifications for a 'compleat gentleman'.

Literature: MacGregor, 28, 298, pl. CXXIV; Hearn, no. 114.

52

JAN VAN DER VAART (1647–1727)

53

Fragment of a sketchbook, open to
f. 3v and 4r: *A rocky outcrop with a
view of walled town on a river*

Brush drawing in grey and yellow wash, over
pencil, 204 × 275 mm

Inscribed on f. 1: *Min 37* [struck through] and
*Bibliothec Sloaniana Min: 259 Several views done
with Indian Ink*

ECM & PH 2

Provenance: Sir Hans Sloane; purchased
with his collection for the nation, 1753;
formerly bound with Sloane MS 5251 in the
British Library, this portion was transferred
to the Department of Prints and Drawings in
the British Museum

1928-3-10-93 (3,4)

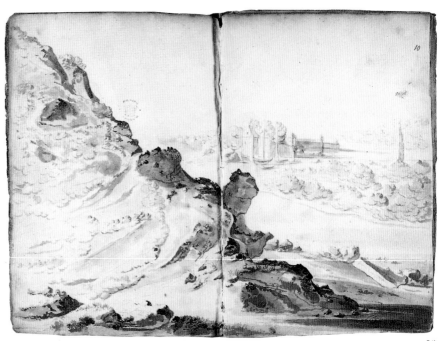

53

Sloane MS 5251 was listed in his library
catalogue as 'A Book of Designs in Crayons
begun by Mr Courten Janry 1673'. The date
was inscribed inside the book itself by
Courten, whose own drawings in red chalk
on the first five folios remain bound with the
cover and a number of blank pages in the
British Library. In 1928 this series of draw-
ings on ten folios at the back of the book
were attributed to Jan van der Vaart (or van
der Vaardt), and were removed and placed
with the sketchbooks in the Department of
Prints and Drawings. The opening illus-
trated here is typical of several landscapes
in this sketchbook; others depict fishing
villages on a river and fortified buildings.
They are reminiscent of Breenbergh's work
several decades earlier.

William Courten (1642–1702; also known
as Charleton) was a well-educated seven-
teenth-century *virtuoso* who spent a great
deal of time travelling and collecting on the
Continent between 1659 and 1684. In the
last year he took up permanent residence
in rooms above the museum he had estab-
lished in the Middle Temple. Although not
a Fellow of the Royal Society, he numbered
many members among his acquaintance,
particularly his closest friend Sir Hans
Sloane, to whom he left his entire collection
of paintings, prints, drawings, medals and
natural specimens. Most of the 'paintings'
(listed by Sloane as *miniata*, and including
the book attributed to Ellen Power (cat. 36)),
were actually what we have described as
limnings, in bodycolour or watercolour
on vellum or heavy paper, such as those
by Alexander Marshal (cats 46–8), and

included plants and animals by some of the
finest French painters of these subjects.
Many were acquired by Courten between
1666 and 1669; four years later he began to
learn to draw himself.

It is tempting to assume that van der
Vaart had begun to give lessons to Courten
in Holland in 1673 and the following
year accompanied him back to England
where the artist settled, but there is no
evidence apart from the presence of van der
Vaart's drawings at the back of the volume
containing Courten's lessons. These were
in red chalk and consisted of two pages of
pairs of images, the master's drawings and
Courten's copies, followed by two imagi-
nary landscapes and a careful drawing of a
weir in a river.

Apart from this sketchbook, there are few
drawings by van der Vaart in England. The
British Museum has one other, a *Landscape
with a quarry* (LB 1; ECM & PH 1), which is in
the same medium and also appears to have
come from a sketchbook, and once
belonged to Hugh Howard (see cat. 13). Van
der Vaart was born in Haarlem and was
said to have been trained by Thomas Wyck
before moving to England in 1674 where he
earned his living as a drapery painter. He
also painted small landscapes with figures
and still lifes, which one contemporary
stated were 'extraordinary fine', ranking the
artist 'among the great Masters of the Age'.
Vertue records that in 1713, finding that he

was losing his eyesight, van der Vaart sold
off his pictures and bought a small house in
Covent Garden, where he began a lucrative
business as a picture restorer.

Van der Vaart's work as a landscapist has
hitherto been neglected but, bearing in
mind his connection with William Courten,
and considering his affinity with the work
of Wyck who was so influential to early
British landscape painters such as Manby
and Talman, and the similarity of many
of Tillemans's drawings to his landscapes, it
seems important to re-establish van der
Vaart's reputation in this genre. His land-
scapes were well known during his lifetime;
two still hang at Squerryes Court in Kent,
and at least one was copied by Bernard
Lens III (cat. 28). Lens's father executed a
notable group of mezzotints after paintings
by van der Vaart, who in turn painted his
portrait. It is possible that some of the other
unidentified classical landscapes that the
younger Lens copied were after originals by
van der Vaart. After Lely's death, van der
Vaart was employed with Willem Wissing
and others to finish Lely's paintings, and it is
therefore significant that his landscape
sketches also show an affinity to the few
known examples by the older artist.

Literature: Carol Gibson-Wood,
'Classification and value in a seventeenth-
century museum: William Courten's
collection', *Journal of the History of Collections* 9,
no. 1 (1997), 61–77; Griffiths 1998, 264.

PETER TILLEMANS (1684–1734)

54

A wooded valley with road

Watercolour with touches of bodycolour,
179 × 226 mm

Hind IV, 5 as 'formerly attr. to Caspar van
Wittel'; ECM II, 5

Provenance: Thomas Barrett and the Revd
John Mitford, joint sale, Sotheby's, 26 July
1859, lot 520, as by 'Gaspar dell'Ochiali', bt
A. E. Evans for the Museum

1859-8-6-58

Tillemans came to England from his native
Antwerp in 1708. A signed drawing in the
Huntington Library, San Marino (Calif.), is
probably from the period before he came to
England and shows a number of similarities
to the work of Jan van der Vaart (cat. 53).
The resemblance is probably due to the
mutual influences of earlier Dutch and
Flemish landscape draughtsmen, beginning
with Van Dyck and including many of the
circle inspired by Bril who worked around
Breenbergh and van Poelenburg in Rome.
The influences of all of these artists, who
either worked in England or whose draw-
ings could be found in English collections,
as well as a number of other continental
artists working in England around the turn
of the seventeenth century, particularly van
der Vaart, Jan Wyck and Jan Siberechts,
seem to have been largely responsible for
the manner in which early English amateur
artists approached landscape drawing in
particular. Their atmospheric examples,
loosely washed in grey or brown, or more
carefully painted pastel-coloured works
such as the present one, circulated in British
collections at the same time as the detailed
topographical approach first practised by
Claude de Jongh and Hollar. Both styles
were used in parallel for the next century in
Britain, with artists choosing the most
appropriate for their purposes. For a while
the loose naturalistic style incorporating
grey or brown washes was used for views of
real sites or landscapes; it gradually came to
be associated with imaginary landscapes,
and detailed topographical drawing was
used for real views.

Tillemans himself employed both but,
uniquely, he seems to have imbued his
topographical views with atmospheric
washes. This is especially evident in the
handful of wash sketches of the Thames,
which David Brown has suggested may

54

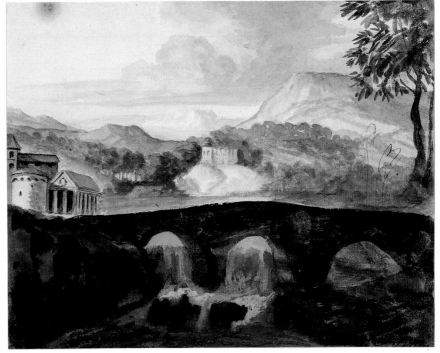

55

have been done entirely for private study and pleasure. A. P. Oppé owned several works by Tillemans and his pupil Lord Byron (cat. 55). His attribution of this work to Tillemans makes sense in the light of these connections rather than any affinity to his sporting paintings.

Better known now as a sporting artist, Tillemans was first employed mainly as a copyist of old master paintings and as a scene painter in various theatres with Joseph Goupy. Many of his paintings were the result of collaborations with other artists. He does not seem to have specialized in either figures, architecture or landscape as his contributions to the works of others included all three elements, as did the views of country seats he painted alone.

Literature: Williams, 13; *Portrait Drawings in the British Museum*, exh. 1974, no. 291; Wark, 53; Raines, *passim*; David Brown, *Early English Drawings from the Ashmolean*, exh. at Morton Morris & Co., London, in association with the Ashmolean Museum, Oxford, 1983, no. 18.

WILLIAM, 4th BARON BYRON (1670–1736)

55

Classical landscape with a bridge spanning a torrent

Watercolour and bodycolour over graphite, 176 × 224 mm

Inscribed: *Ld Byron*

LB 1; ECM II, 1

Provenance: Richard Bull, his sale, Sotheby's, 1 May 1880, lot 885, purchased by Donaldson; Bull-Donaldson sale, Sotheby's, 23 May 1881, lot 17, purchased by A. W. Thibaudeau for the Museum

1881-6-11-134

William Byron succeeded his father as 4th Lord Byron in 1695. A Tory in politics, in 1717 he was appointed chief ranger of the Purlieus, receiving an annual pension of £1,000 from George I. He married three times, to the daughters of the earls of Bridgewater and Portland and Lord Berkeley of Stratton. His younger son, the Revd Richard Byron, was also an amateur artist (cats 158–9). His eldest son, the 5th baron, was succeeded in 1798 by his ten-year-old great-nephew, George Gordon, the poet.

Peter Tillemans worked for the 4th baron over a number of years. His painting, *Going*

a *Hunting with Lord Biron's pack of Hounds* (private collection), is datable to the mid-1720s. Both artist and pupil made many drawings of the family seat, Newstead Abbey, and its grounds, and Byron evidently also learned to paint in oils, as he completed one of Tillemans's views of the abbey left unfinished at the artist's death (see p. 80). A handful of chalk views of the abbey in the collection at Newstead are also probably drawn by Byron but relate to two of Tillemans's paintings that the abbey has recently acquired from the Bute collection. A pencil and grey wash view of the abbey sold by Christie's, 25 February 1974 (168), was attributed there to Tillemans, but the style and inscription – *this View taken near Umbarella Ld Byron* – would seem to argue for an attribution to the pupil.

The present watercolour with its deep, dark washes and classical style is much like Tillemans's *A wooded valley with a road* (cat. 54). Other drawings by Lord Byron imitate Tillemans's other styles, focusing on one or two trees, and drawn with the tip of a wet brush, or imaginary landscapes drawn and washed like Tillemans's sporting scenes, dominated by trees and woods executed in the same manner as the tree on the right of the present example.

The British Museum has three etchings and two other drawings by Lord Byron. One etching is a landscape after a drawing by Guercino, and the other two are landscapes with horsemen and ruins, and peasants at a cottage door. One of the drawings was purchased with the present one: it is in pen and ink with some watercolour, and is of travellers on a road.

The second drawing is a large pen and ink portrait of a huntsman, which was also once in Richard Bull's collection along with another drawing of a huntsman by Tillemans (1881-6-11-198, 1962-7-14-17). Both are rather naïvely drawn, but apparently accurate, identified portraits, probably used by Bull as extra-illustrations to one of his grangerized books (see cat. 88). Byron's drawing was engraved in 1736 and both drawings may have been made with an illustrated local history in mind. Many artists were working on these at the time: Tillemans himself left around 200 drawings of Northamptonshire (dated from 1719 to 1721) to illustrate a county history by the antiquary John Bridges, for which he was paid a guinea a day (BL, Add. MS 32467). In the 1730s he was employed by the Suffolk antiquary Dr Cox Macro.

Literature: Hardie 1, 68; Nottingham City Museums, *Guide to Newstead Abbey*, 1978; Raines, 27, 44, 49–50 (I am very grateful to Haidee Jackson and Nicholas Williams for their kind assistance with this entry).

WILLIAM TAVERNER (1700–72)

56

A nude woman resting against a bank

Red and black chalk, 326 × 208 mm

Verso inscribed in an old hand: *Taverner*

ECM II, 9

Provenance: Colnaghi's, from whom purchased with a donation by Mr C. Cuningham

1973-1-20-26

William Taverner was baptised at St Martin's, Ludgate, on 25 November 1700, not in 1703 as is usually stated. His grandfather, Jeremiah Taverner of Hexton, Hertfordshire, was a portrait painter, and his father William (d. 1731) became a notary in the Court of Arches in 1700 and proctor/procurator in 1737 (similar to solicitors and lawyers in other courts). He was better known, however, as a playwright and a number of his plays were produced at Drury Lane between 1704 and 1721. His son William was articled to him in 1720, notarized in 1737 and made proctor in 1739.

By 1733 Vertue had already noted that the younger Taverner, besides his law practice, had a 'wonderful genius to drawing of Landskap in an excellent manner … adorned with figures in a stile above the common' (III, 68). The present drawing is the first in this exhibition of a type that was more commonly drawn by amateurs than might be supposed – an academic study from life. A brush drawing in grey wash of a male figure attributed to Francis Place is in the British Museum's collection (1982-10-2-20). Formal and informal academies and artists' studios are known to have provided the opportunity for study from casts of Antique statues and from live models throughout the seventeenth century in England, but documentary evidence of where they were held and who attended is sparse. What is known, however, is that drawings were made from live female models as well as male, and gentlemen amateurs would not have been excluded from the life classes. In the first half of the eighteenth century further opportunities

were available at various academies in London, Edinburgh and Dublin, and most artists who travelled abroad availed themselves of the opportunities presented by academies in Paris and Rome. Female models were only available at a few, but were employed at the St Martin's Lane academies from the 1720s onwards and later at the Royal Academy. Taverner's name does not appear on the incomplete lists of any of these academies, and although the head in this figure has evidently been borrowed from a classical bust, all the evidence of this drawing, particularly the awkward rendering of the waist and breast, points to it being drawn from the life. There was no bar to artists drawing from models posing for them privately in studios. This type of study was essential for any artist whose compositions, whether oil or watercolour, contained as many classical, draped and nude figures as Taverner's.

Although it is the only known work of this type to survive by Taverner, it was not alone in his *oeuvre*. His own collection, sold after his death, contained 'Statues and Medals', and he presumably made studies of the statues, although they are not listed individually in the sale. However, Paul Sandby purchased many drawings from this sale, and his own at Greenwood's on 27 May 1785, lot 49, included 'Seventeen [drawings], academy's ec. by Taverne'. Sandby's collector's stamp is not on this work, but

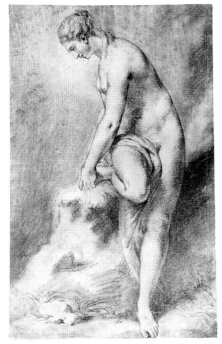

56

that does not preclude the possibility that it was one of this group. Iolo Williams owned a drawing of the head and shoulders of Diana (present location unknown) in the same medium, which may have come from the same source.

Literature: Vertue III, 68, 95, 118; Williams, 20–1; Ilaria Bignamini and Martin Postle, *The Artist's Model*, exh. Kenwood House, 1991, 8–14.

57
Wooded landscape

Watercolour over graphite, 376 × 482 mm
LB (under Paul Sandby, 124); ECM II, 3
Provenance: Bequeathed by Richard Payne Knight

Oo.5-40

This drawing was described as 'An unfinished sketch of a woodscene, slight colour. P. Sandby' in a list of the Payne Knight bequest shortly after it came to the Museum. Binyon followed this attribution but Croft-Murray gave it to Taverner on stylistic grounds. In fact, early classical or capriccio landscapes in bodycolour and watercolour by Sandby, as well as his early atmospheric topographical views such as *Leith* of 1747 (Ashmolean Museum, Oxford) are often very close to the style of some of Tillemans or Taverner's works. This is not surprising, as Sandby owned at least twenty works by Taverner, purchased at the latter's sale in 1776 – some appeared in Sandby's own sales, at Greenwood's, 27 May 1785, lot 49 (academic studies, see cat. 56) and at Christie's, 17 March 1812: lots 70 ('three large views of Greenwich and Woolwich', see cat. 60), and 81 ('Ten grand landscapes Taverner, etc.'). Many of Taverner's works thus bear Sandby's distinctive collector's stamp *PS*.

This work, however, appears to have been sketched from nature, something Sandby did not practise very much later in life but which Taverner did frequently throughout his career: another example was recently acquired by the Museum (1983-10-1-4). A similar grove of trees, with a river or path running through it, appeared numerous times in his finished compositions, two of which are in the British Museum's collection (cat. 58 and 1872-7-13-442). It was an ideal setting for Diana and her attendants, or nymphs and satyrs, and was employed in final compositions in

oil (City Art Gallery, Leeds) as well as in watercolour and bodycolour. One of the watercolours of this grove, which has no figures and also has the appearance of having been done on the spot, is inscribed as a view on Hampstead Heath (ex collection L. G. Duke, now Courtauld Gallery). Views of the Thames at Richmond, the view from Highgate, and the *Sandpit at Woolwich* (cat. 60) must have been based on sketches done from nature or built up into finished compositions from sketches begun on the spot. Such works do not survive in enough numbers from the seventeenth and early eighteenth centuries to tell us much about the practice, but examples by Van Dyck and Claude Lorrain and a handful of other artists were well-enough known and appreciated by a certain type of collector for a taste for such works to begin to emerge, and the numbers that were allowed to survive from the contents of studios or given to fellow artists as gifts began to increase. Taverner, who was not married and instructed in his will that all his works be sold after his death, may have been one of the first British artists whose works of this type were sold, collected and now survive in larger numbers than most. They have added a quality to the overall impression of his *oeuvre* that is very much to modern taste, but one that was not enjoyed by his contemporaries whose works of this nature do not survive, even though they may have produced them. In addition, amateur artists did not have to worry about posthumous reputations, whereas professional artists would, on the whole, keep unfinished works or mere sketches out of public circulation. Some of Thomas Gainsborough's watercolour landscapes have this fresh quality and absence of any topographical content, but although he studied nature carefully, and he may have known Taverner's works or shared common sources, he does not seem to have painted in watercolour directly from nature.

Literature: Stainton 1985, no. 11; Munich, *Das Aquarell 1400–1950*, exh. Haus der Kunst, 1973; for watercolour studies from nature, see Royalton-Kisch *passim*.

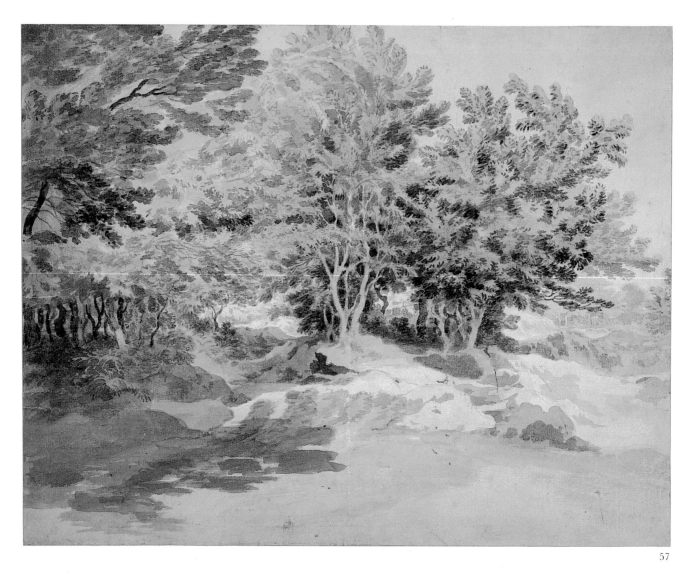

57

58
Woodland scene with women bathing

Watercolour touched with bodycolour,
253 × 386 mm

ECM II, 7

Provenance: Bequeathed by Edward Marsh
through the National Art Collections Fund

1953-5-9-4

This watercolour is very similar to a num-
ber of other works by Taverner that appear
to be copies of or inspired by paintings by
Gaspard Dughet or van Poelenburg. We
have already noted that Taverner copied at
least one oil by Dughet (see p.82), but the
artist's compositions were also known in a
small number of drawings (two in the British
Museum were in Payne Knight and
Benjamin West's collections) as well as in
the series of engravings after old masters
issued by George Knapton and Arthur
Pond in the 1740s. Generally, however,
Dughet's landscapes open up with a vista to
a distant scene of mountains, plains or
towns, while Taverner's woods tend to run
across the background and close off any
view into the distance. At the Yale Center
for British Art, a Taverner landscape
similar to the present one is inscribed on the
verso *Nymphs Bathing Polinburg*, indicating
that he either drew his inspiration from
works by this artist, or copied them.
Although the figures in the present work are
small, in most of Taverner's compositions
with nymphs bathing, the figures are larger,
more numerous and dominate the fore-
ground as they would in a history painting
(cat. 59).

The unfinished watercolour of a grove of
trees (cat. 57) is echoed in the composition
here and in many others, which may be
based on an actual grove on Hampstead
Heath where the artist is known to have
worked. It is the remarkable English char-
acter of the trees and groves in which
Taverner's classical figures disport them-
selves that gives these works and his oil
painting of the same subject (University
of Liverpool) a distinctive quality that
distances them from their Italian or Dutch
roots.

Taverner mixes bodycolour and water-
colour in this and many of his works,
indicating that the distinctions between
tinted (watercolour) drawing and body-
colour (limned) paintings were not as rigidly
observed in the eighteenth century as we
tend to assume. Because the works of Joseph
Goupy, Marco and Sebastiano Ricci and
Francesco Zuccarelli are no longer as well
known, we are inclined to forget how strong
the bodycolour tradition in Britain was in

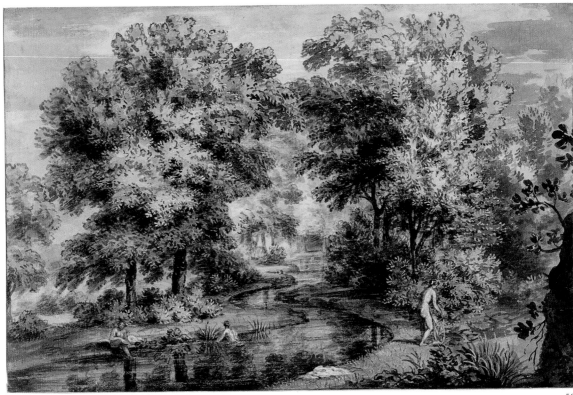

58

the first half of the eighteenth century. Gainsborough worked in both media, either separately or mixed in one piece as here, as did Sandby at the end of the century. There are also several drawings by Sandby in black chalk with brown and grey wash on paper, the washes given a chalky opacity that also invites comparison with Taverner's drawings as well as those by Gainsborough.

Literature: Lindsay Stainton, *Nature into Art*, exh. British Museum, 1991, no. 8.

59

Aglauros discovering Erichthonius from Ovid's 'Metamorphoses', II, 552

Watercolour over black ink, 478 × 376 mm

Inscribed on verso by Cracherode with his monogram, followed by the date *1789* and a Latin transcription of the passage from Ovid

LB 1; ECM II, 1

Provenance: Bequeathed by the Revd Clayton Mordaunt Cracherode

GG. 3-367

The child Erichthonius was a son of Vulcan, born without a mother and protected by Minerva who hid him in a basket that she entrusted to the three daughters of Cecrops. Pandrosus and Herse followed Minerva's strict instructions not to open the basket, but their sister Aglaurus uncovered the child who at first appeared to have a snake stretched out beside him. This is the moment depicted, but Ovid went on to recount that the child had badly malformed legs; he eventually became King of Athens but never appeared in public without his specially constructed vehicle that covered them.

Cracherode left another landscape of similar size by Taverner to the Museum. It is much less finished, and also appears to illustrate a classical tale the subject of which, however, has not been identified – a woman converses with an old man by a pool, while another man leans on a bank with travellers and classical buildings in the distance (GG. 3-368). A few other Taverner landscapes with classical figures have identifiable subjects: the *Rape of Persephone* (Maas Gallery, London, in 1963) and three versions of *Diana and her nymphs* (Oppé collection, now Tate Gallery, and two private collections). In all of these the figures are numerous and prominent as they are here but, apart from the figures of Diana and her attendants on the right of the version at the Tate, the figures tend to be nude, their poses studied from old master paintings of the subject. The careful attention to the detail in the clothes and expressions of the figures here and in the version at the Tate, as well as the existence of an apparent study for the head of Diana (see p. 89) suggest that these paintings were not intended to be merely landscapes but were history paintings, a much more ambitious genre. Cracherode's transcription of the passage from Ovid and his additional note of the date he acquired this watercolour (1789) are indications of the value he placed on it.

Many eighteenth-century professional landscape artists searched for a way to combine the two genres and the subject of Diana and her nymphs was a common solution. There were many examples by earlier Italian artists in various British collections: a large canvas by Sebastiano Ricci hung at Burlington House. A similar subject, Diana and Actaeon, also from Ovid (*Metamorphoses* III) was illustrated by Hayman in the 1760s, but more importantly was chosen by Gainsborough for his own last, and most ambitious attempt (now in the Royal Collection). This was the only occasion Gainsborough painted a classical subject and it may be significant that the first

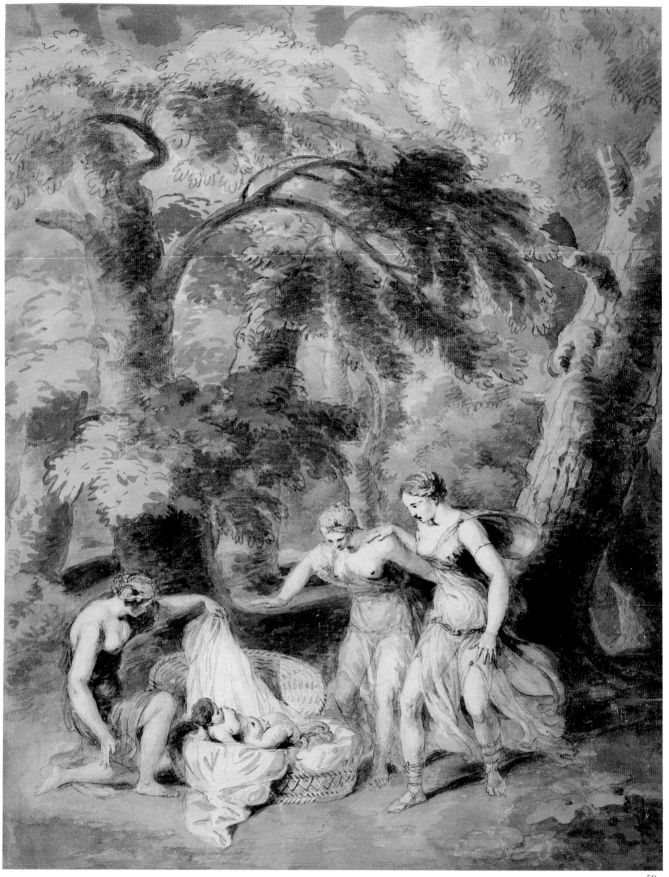

59

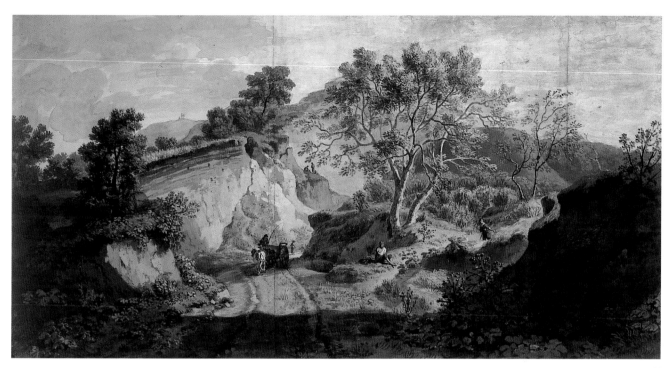

60

drawings for it, which are remarkably similar to some of those by Taverner, date from the early 1780s, only a few years after Taverner's sale in 1776.

Literature: Michael Rosenthal, 'Gainsborough's *Diana and Actaeon*', in Barrell, 168–78.

60

Sandpit at Woolwich

Bodycolour and watercolour, on three conjoined sheets, 363 × 702 mm

Verso of old mount inscribed: *Taverna Sand Pitts, Woolwich*

LB 4; ECM II, 5

Provenance: (?) Taverner's sale, Langford's, 21–5 February 1776 (L. 2242), where bt Paul Sandby; his sale, Christie's, 17 March 1812, lot 70 (one of three large views of Greenwich and Woolwich); bt F. B. Daniell from whose son purchased by Dr Percy in 1876; his sale, Christie's, 23 April 1890, lot 1227, bt for the Museum

1890-5-12-140

Although around fifty works by Taverner survive, none of these is dated and it is therefore difficult to give them a chronology. As in the case of so many other earlier amateur artists of the eighteenth century, only a few of his oil paintings survive, but those that do are imaginary compositions in the manner of Dughet or van Poelenburg. However, the existence of a number of large carefully finished watercolour and bodycolour views of real places, like the present work or the ones already noted as purchased by Sandby at the sale after Taverner's death, makes an important departure from the activities of any earlier artists, amateur or professional.

Although we have concentrated on his more imaginary landscapes, Taverner also made many topographical drawings of a variety of sizes and types. Some are not topographical in the strict sense as they are merely atmospheric evocations of a site, with inscriptions that identify that site, but without any obvious features recorded, such as the views from Camberwell and Highgate (Oppé collection, Tate Gallery) or the view of a grove in Hampstead (Courtauld Gallery). Others are recognizable views with buildings or towns such as the watercolours of Richmond Castle, Yorkshire (Sotheby's, 14 April 1994, lot 450), a group of farmhouses in Hampstead (Pierpont Morgan Library, New York), and views of Windsor and the house and estate of Montreal in Kent. Taverner's sale included watercolours of views 'behind Cavendish Square and in the environs of London' (Langford's, 21–5 February 1776).

Sandpit at Woolwich was one of three large views of Greenwich and Woolwich that belonged to Sandby and appeared in his sale in 1812 (lot 70). It has become one of the icons of early watercolour painting in Britain, but we do not actually know when it was painted. Because Taverner practised over such a long period, we must ask whether it shows the influence of Dutch landscapists, one of whose favourite motifs for sketches from nature was a sandy bank by a road, or whether it shows the influence of the work of Jonathan Skelton (cat. 63), George Lambert (cat. 61), Gainsborough or even Sandby, who all painted similar subjects in watercolour or oil, but rarely on this scale. Alternatively, their work might have been inspired by this large ambitious painting in watercolour, of a size previously reserved for strictly topographical panoramas by Hollar or Danckerts or Taverner's own view of Richmond. There is no record that Taverner ever exhibited this watercolour and it was in his collection at his death. When a professional artist produced landscapes on this scale, they were always with a purpose – either they contained an historical subject or depicted a place of some significance. But an amateur artist who painted only to please himself did not need to justify his choice of subject in this way, and if he was inspired by a scene that

attracted him in itself, he was not limited by artistic convention in either size, medium or subject matter.

Literature: Stainton 1985, no. 10.

GEORGE LAMBERT (1700–65)

61

A country lane skirting a wood

Watercolour over pencil, 145 × 221 mm

LB 1 (as Gilpin); ECM II, 1

Provenance: Edward Daniell, from whom purchased as Gilpin

1871-8-12-1715

George Lambert was the professional artist who seems to have formed such substantial links between his professional and amateur associates that they run like a connecting thread through fifty years of artistic production in the eighteenth century. His oil paintings were often executed with other painters and can sometimes be difficult to attribute. He had an apparent affection for sketching in watercolour and washes *devant le motif*, which he passed on to his professional and amateur pupils and which they shared so closely that secure attributions are almost impossible. The following watercolours by Skelton and Beauvoir and a few others by his exact contemporary, William Taverner, are a case in point. The present watercolour came into the collection as a work by William Gilpin (cat. 111), which can certainly be ruled out, but afterwards it was thought that it and another work attributed to Lambert in the collection might be by Jonathan Skelton who was supposed to have been Lambert's pupil.

The result is that only a few drawings have been attributed to Lambert with any security. These include a *Landscape with a mill-pond* (ex collection L. G. Duke), which is apparently signed, but came from the Blofeld collection, the source of all Skelton's known drawings (see cat. 63). Another signed watercolour is also a finished composition, *A Woody Landscape with a bridge* (now Yale Center for British Art, New Haven (Conn.)), and exists with slight variations in three versions in oil and in another watercolour version in the British Museum since 1958. The last, however, is inscribed *Mr Lambert pinxit*, which seems to indicate that it was a copy by a pupil, and Skelton or Beauvoir are likely candidates. The final signed drawing by Lambert is the most secure to attribute and not at all like the others. It is a pencil and watercolour drawing, the *Gazebo on a hill* (private collection) with all the appearance of having been sketched on the spot, and is signed by the artist. It is the similarity to this work that helps to identify the one being catalogued here as the work of Lambert. His drawing style, the closeness of the subject, and the manner of shading with tiny strokes of the brush all differ slightly from the securely attributed works of Skelton and Beauvoir catalogued here.

Some beliefs will linger that the present work may still prove to be by Skelton. Although the Blofelds had over eighty works by Skelton, which have mainly been accounted for, there were twenty more still in the artist's possession at the time of his

61

62

death that have not. The closeness of their association is underlined by manuscript annotations in a copy of the sale of Lambert's collection after his death: two lots (21 *A view of Charlton Wood, Kent* and 45 *A view of a wood near Dover*) described as by Lambert were struck through and given to Skelton by the author of the notes who obviously knew his work well.

Literature: Williams, 22–3; Einberg 1970, *passim*; Einberg, 'Catalogue raisonné of the work of George Lambert', *Walpole Society*, forthcoming.

RICHARD BEAUVOIR (1730–80)

62

Overgrown ruins with an artist seated on a rock

Watercolour, 138 × 223 mm

Provenance: By descent through the de Beauvoir and Benyon families; bt Michael Bryan, from whom purchased

1992-7-25-16

In 1763 Richard 'Beavoir', 'An Honorary Exhibitor', showed 'Four landskip drawings; stained from nature' (no. 212) at the Society of Artists' annual exhibition. Like most of the other honorary exhibitors to these exhibitions held by the Society of Artists and the Free Society of Artists (recorded in Algernon Graves's *Dictionary of Contributors*), Beavoir's identity remained unknown. But a descendant's sale of a handful of his signed works, which led to their appearance in Michael Bryan's annual catalogue, and the discovery of his cash book by Elizabeth Einberg while working on George Lambert, have revealed another significant figure in the circle around Lambert, and a substantial body of work in watercolour and oil that remains in the hands of his descendants.

Beauvoir was a younger son of an East India merchant, who followed his father's business and lived sometimes in London but mainly at the family seat of Downham Hall in Essex. His surviving work and the cash book mentioned above provide the only basis for our knowledge of his activities as an amateur artist. In 1755 he purchased a copy of Charles Lebrun's *Expressions of the Passions of the Soul*, a common book in the drawing manual section of printsellers' catalogues, and found in the library of most people who professed any knowledge of the arts. The first mention of Lambert is a payment of £30 in May 1758 'as a present', presumably for informal lessons and advice. The same month Lambert was paid for a painting of Cheddar Cliffs (signed and dated 1755), which may be the painting of these cliffs in Somerset (or another version of it) exhibited by the artist in 1763, the same year as Beavoir's entry. In the intervening years until Lambert's death in 1765, Beauvoir subscribed to Lambert for a number of prints, including views of Palmyra and the ruins of Greece, and he also gave the artist three more substantial payments, again presumably for lessons, although they are not itemized in the cash book. Beauvoir took his studies seriously, purchasing painting materials from a colourman, a Claude glass, an optic glass and stand, a plaster cast of an anatomical figure, and prints after Major, Vernet, Wilson and Ricci. He also subscribed to the Society of Arts from 1760.

Beauvoir's oils are mainly signed copies of known compositions by Lambert, but two are unsigned and seem to be the combined effort of both Lambert and Beauvoir. Twenty-six watercolours date from 1759 to 1778, nearly all mounted, as the present example once was, on thick cream card with pencil-outlined pink and yellow wash borders, signed on the inner pink border on the lower right, sometimes with the additional word 'Copy' to indicate they have been taken from a Lambert painting. The subjects all appear to be scenes local to Downham, Harwich and Southampton or to Englefield House, near Reading, the home of the Beauvoirs's close friends, the Benyons, from whose library the Museum acquired their copy of William Austin's 1763 publication, *A Specimen for Sketching Landscapes in a New and Easy Manner*.

The present watercolour is typical of Beauvoir's smaller works, demonstrating how close his technique was to those of Lambert and Skelton. The watercolours still in the hands of his descendants are loose and tentatively drawn at the beginning, but become more assured and ambitious in composition as his skill and confidence

increased through the 1760s. One or two views of country lanes around Downham are remarkably close to Lambert's watercolour (cat. 61) and show how unreliable earlier attributions of Lambert's watercolours could be. But Beauvoir continued to paint and draw after Lambert's death so that in 1777 he was capable of painting an ancient twisted oak overlooking a distant landscape in a distinctive style of his own.

Literature: Einberg 1999, *passim*.

JONATHAN SKELTON (d. 1759)

63

A sandpit near Croydon, Surrey, 1756

Watercolour, 191 × 322 mm

Inscribed, on a separate slip with the title, artist's signature and date

ECM II, 2; Stainton 29

Provenance: Thomas Blofeld, by descent to John C. Blofeld, from whom purchased

1909-4-6-10

Nothing is known of Skelton's birth or early years. His surviving letters from Rome

(1757–9) to William Herring, who had lent him the money to travel, indicate that he was well educated. This is at odds with an inscription on the earliest drawing attributed to him, *A garden view of the Archbishop's Palace at Croydon*, which states that it was 'taken by a Footman in his Grace's family in 1754'. William Herring was attached to the household of the archbishop, to whom he was related, and was described in Skelton's will as his 'kind and excellent friend'. All of his inscribed drawings between 1754 and 1757 were executed in the areas around the archbishops' palaces at Canterbury, Croydon and Lambeth. George Lambert owned two Kentish views by Skelton and the latter's references to the elder artist in his letters seem to indicate he had studied Lambert's technique, and he was said to work in his style when he first arrived in Rome.

In Italy Skelton drew and sketched in oils and bodycolour out of doors and painted the evening sky from his window. He hoped to copy paintings by Vernet, Poussin or Claude if he was able to obtain access to them, and studied life drawing in the Academy of St Luke. Near the end of

63

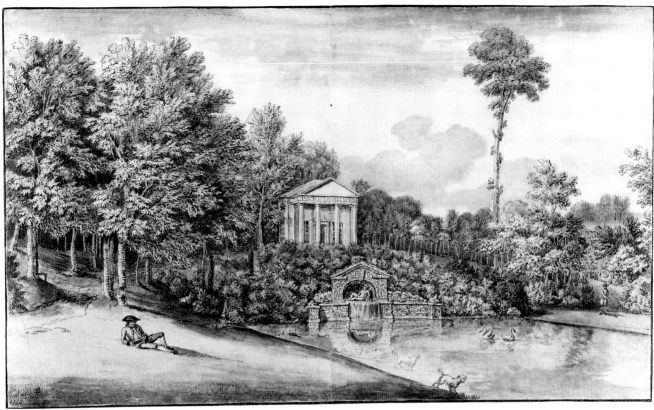

64

his visit a friend reported to Herring that Skelton's constant study from nature had 'quite got him out of his masters [Lambert's?] manner', and that he was improving in his 'taste of composition'. Before he could return home, however, he died suddenly in January 1759. His will had been drafted the previous November when he had requested that all his works be sold to pay his debts, including the 105 guineas he still owed William Herring. He left nearly 120 drawings and sketches by himself and others, a small book of sketches, 30 prints, and 15 paintings, 3 of which were unfinished. The details of the sale are not known, but over eighty later belonged to Thomas Blofeld (1753–1817) of Hoveton House, near Norwich.

There is indeed a remarkable difference between the landscapes Skelton made in England and in Rome. The earlier works, as is the case in the present watercolour of a sand-pit near Croydon, are sometimes so close to Lambert that they might be attributed to that artist, were they not signed by Skelton. His Italian landscapes, on the other hand, no longer contain the fresh colours, light touch and careful transcrip-

tion of nature that characterize the earlier works, and instead tend towards heavily worked, more monochromatic landscapes with contrived compositional features that imitate the works of Claude and Poussin. The parallels with developments in the work of Alexander Cozens (cats 75–6) have not previously been noted, perhaps because so little is known of Cozens's work before he arrived in Rome in the mid-1740s; but when they are sought, they are striking enough to suggest the possibility that Skelton and Cozens may have shared a master in Lambert, the only professional artist working in this manner in London from the 1730s to the 1750s.

Literature: S. Rowland Pierce, 'Jonathan Skelton and his water colours', and Brinsley Ford, 'The letters of Jonathan Skelton', *Walpole Society* XXXVI (1956–8), 10–82.

COPLESTONE WARRE BAMPFYLDE (1720–91)

64
The Grotto at Stourhead, 1753

Pen and ink and grey and brown wash with watercolour on joined paper with black ink border, 280 × 470 mm

Inscribed: *CWB f. 1753*

Provenance: Sotheran, as a view of Kensington Gardens, bt July 1949 by L. G. Duke, by whom presented

1970-9-19-20

Very little is known of the early life of Coplestone Warre Bampfylde of the ancient de la Warre family seat of Hestercombe in Somerset, apart from the fact that he was educated at Winchester and St John's College, Oxford. An equestrian portrait of him with a groom, with Hestercombe and the deer park in the distance, was painted by Wootton in 1740, but Bampfylde himself emerges in his first work six years later as a fully competent painter of landscapes in oil. A life-size equestrian self-portrait with the artist Richard Phelps (c.1710–85) as his

groom was painted by them both that year. The figures were by Phelps, a native of Somerset who was a pupil of Thomas Hudson with Joshua Reynolds. The extensive landscape by Bampfylde is an imaginary classical one, but shows Bampfylde's horse in front of the gates of the stable block at Hestercombe.

The earliest date we have for Bampfylde's association with the banker Henry Hoare (1705–85) of Stourhead is that on this watercolour of the gardens. They had many friends in common, particularly Bampfylde's neighbour, Sir Charles-Kemeys Tynte. In 1786 after their deaths, Bampfylde erected an urn at Hestercombe to commemorate their friendship, paraphrasing Horace's praise of Virgil in *Satires* I, 5: 'Earth has not borne such shining spirits as these, nor any with whom I have closer bonds.' The gardens at Stourhead, Hestercombe and Tynte's park at Halswell (see cat. 109) progressed along Virgilian themes with similar features and it seems clear that all three men made contributions to each others' gardens. The success of Bampfylde's cascade (cat. 65) was followed by one he helped to design at Stourhead in 1765. All three gardens were created to imitate classical landscapes as depicted in paintings by Poussin and Claude and even capricci by more recent Italian artists. In this way they were very early contributions to the growth of the appreciation of the literal 'picturesque' in England. But their allusions to Horace and to Virgil's *Aeneid* reflect a much deeper cultural and philosophical bond between the three men.

Bampfylde's relations with Hoare were not confined to the garden. Hoare had brought back hundreds of paintings from his grand tour, which Bampfylde copied and drew on for inspiration. He painted Italianate capriccio landscapes in oil in the manner of Hoare's paintings by Ricci, Panini and Locatelli, and presented an oval view of a bay to Hoare in 1766 that still hangs at Stourhead. A pen, ink and wash study for another is now in the Courtauld Gallery.

This watercolour of the Temple of Flora, drawn shortly after it was completed by the architect Henry Flitcroft, is the earliest of many views of the gardens at Stourhead by Bampfylde. The size and finished nature of the watercolour indicate that it may have been an exhibition piece intended for hanging, which would explain why it is badly discoloured. It is interesting that the

reclining position of the man reading on the bank on the left reflects the pose of the river god in the arch below the temple. It is one of the earliest known watercolours by Bampfylde: the drawing of this figure shows his debt to a drawing master who set him to copying prints; a *pentimento* of the dog has been rather unsuccessfully erased. The figure of the reclining man reading may, however, be more than a visual pun. In British art, a solitary reclining figure meditating between wood and water had always been a visual reference to the Elizabethan literary tradition of 'melancholy'. As Judy Egerton has noted in connection with Wright of Derby's *Brooke Boothby* of nearly twenty years later, it 'signified not low spirits, but the capacity to muse on subjects other than the petty preoccupations of this world; it thus had flattering implications of intellectuality' (p. 117). Here it clearly points to the intended literary and classical references that Hoare and Bampfylde were making in their gardens.

There are several sketches of various features in the garden, in pen and ink, frequently with light washes of watercolour, in an album in the Victoria and Albert Museum, which were done over a period of years and seem to have culminated in the two large finished watercolours of the gardens that still hang at Stourhead and were engraved by Vivares in 1777.

Literature: P. White, *passim*; Kenneth Woodbridge, *Landscape and Antiquity: Aspects of English Culture at Stourhead*, Oxford 1970; Graham-Clarke and Luttrell Collections, Somerset R. O., Taunton; Egerton, 117.

65

Cascade at Hestercombe

Brush drawing in brown and grey wash over black lead, 232 × 281 mm

Inscribed on verso with title, and on label from old mount: *Cascade at Hestercombe by Mr Warre Bampfylde*

Provenance: Presented by Mrs Phyllis Higgins

1960-7-8-1

In his *Tour in the West of England* (1787), Lord Palmerston visited Hestercombe, noting nothing remarkable in the house, but that behind it was a valley with a wooded stream along which Bampfylde had formed walks:

But the principle Beauty and striking Feature of the Place is a Cascade of a considerable

height which falls abruptly down a Rock in the middle of a thick Wood. It is a most romantick and beautiful object from several parts of the Ground, and is on the whole one of the best Things of the Mind I have seen in the territory of any private Person.[quoted in White, p. 7]

Records of the manor at Hestercombe, near Taunton, in Somerset, predate the Norman Conquest and it remained in the hands of the de la Warre family from 1391 until 1718 when Margaret Warre married John Bampfylde. The surrounding lands were mainly deer park until the end of the seventeenth century when Margaret's father Sir Francis Warre began to develop the combe garden, adding a pond and hedges. In the 1720s John Bampfylde rebuilt the front of the house in a Palladian style and paid various gardeners for designs.

When he inherited it in 1750, Bampfylde made his own additions to the house and combe gardens, soon acquiring a reputation, according to the poet William Shenstone (1714–63), as a man 'whose fortune, person, figure and accomplishments can hardly leave him long unnoticed in any place where he resides'. Shenstone described Bampfylde in this manner when he was pressed by Edward Knight, Bampfylde's brother-in-law, to accompany him on a visit to Hestercombe in 1758. It seems that the visit never took place, but four years later Bampfylde was inspired by a visit to the gardens and waterfall the poet had created at The Leasowes, in Worcestershire, to build his own cascade at Hestercombe.

When Edward Knight visited Hestercombe in 1761, the garden already contained a 'Witch or Root House', an octagonal summer house, terrace and chinese seat, with views down the water to Taunton Vale, and a 'Rock' with lawn and beeches before it and a Gothic seat with views into the vales. The 'Rock' was undoubtedly the cliff face down which the cascade was to fall the following year. George Lambert, who may have been one of Bampfylde's tutors in painting (cat. 64) had painted a view of 'A Rock in a Garden' at Hestercombe in the 1750s. Bampfylde probably made a series of studies of the cascade: a slightly larger vertical watercolour at the Victoria and Albert Museum shows the falls as they would look standing in the position of the man on the right of the present study in brown wash.

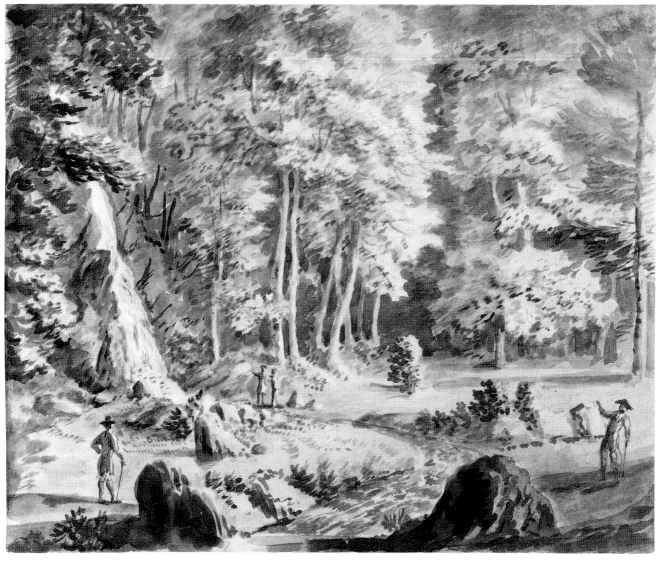

65

The agriculturist and writer Arthur Young visited in 1771, and described many of the features of the gardens, including the 'Witch or Root House', decorated with paintings of a cat, witch, snakes and an owl by Bampfylde, and ended with the following quotation:

O'er Bampfield's woods by various nature grac'd,
A witch presides! – but then that witch is TASTE.

The gardens were the subject of a popular book by Richard Graves, *Columella*, published in 1779, often mistakenly thought to refer to The Leasowes. It explored the conflict between natural and horticultural gardens and reflected the development of Bampfylde's own taste as it moved towards the natural and reflected the developments in the Picturesque, later elaborated by Uvedale Price (see cat. 117) and Bampfylde's wife's cousin, Richard Payne Knight (see cat. 126).

From 1904 to 1910, Sir Edwin Lutyens and Gertrude Jekyll laid down formal gardens and an orangery to the east of the house. The grounds were neglected for most of the twentieth century, but in 1995 the Hestercombe Gardens Project was set up to secure and restore Bampfylde's landscape gardens and reopen them to the public as they were during the eighteenth and nineteenth centuries.

Literature: White, *passim*.

66

Matlock Bath, 1780

Pen and ink with watercolour over graphite sketch, 286 × 460 mm

Inscribed on verso: *Matlock Bath Augt. 1780*

Provenance: Presented by Iolo Williams 1960-7-16-1

In addition to the classical and capriccio landscape compositions Bampfylde executed in oil as well as watercolour, he painted topographical views drawn with pen and ink and washed in the manner of Paul Sandby's work of this type. Many are views of Bath or the area around Taunton and Exeter, but several are of friends' country houses. Most of these topographical views are thinly and brightly

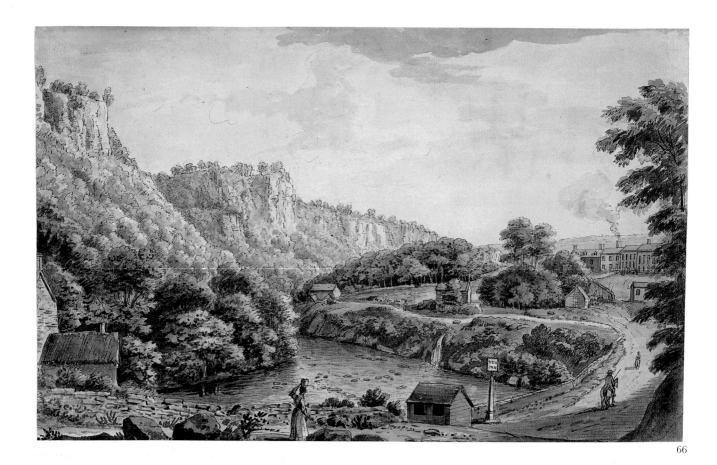

66

coloured, such as this view of Matlock in Derbyshire.

Bampfylde made regular sketching tours of parts of England and Wales. In the 1750s he was in the Somerset militia and based for a while at Plymouth and many of his earliest watercolours are views of Exeter and Exmouth *en route* from Taunton. He was a regular visitor to Bath, where Gainsborough painted his portrait as a major in 1758, which Bampfylde later over-painted after he was made a colonel in 1767. In Bath he seems to have known Alexander Cozens (cat. 106), who mentioned him in letters written in that city. There are certainly similarities in their imaginary landscapes and Bampfylde's name appears in the list of subscribers to his *Principles of Beauty* in 1776.

Bampfylde's first views of *The Derwent near the boathouse at Matlock* and *Dovedale* date from 1766 (in the album in the Victoria and Albert Museum). They were presumably done on a visit to his wife's relatives – her father Edward Knight lived at Wolverly in Hertfordshire, not far from her first cousin Richard Payne Knight at Downton.

In July 1769 Bampfylde wrote to his brother-in-law Edward Knight from Weymouth where he was staying before spending two weeks at Stourhead on the way home. A year later he wrote from Lymington that the road there from Salisbury abounded with 'delightful forest scenes, and picturesque villages, every Hamlet is a Tull'. He had made 'a trip to ye Needles, and Mrs B- took an Emetick there whilst I was drawing the rocks ... I have made above a dozen sketches already in this picturesque Country, & I verily believe might make a thousand in ye Environs of this place.' He was finding the Revd Gilpin's New Forest picturesque seven years before Gilpin became vicar of Boldre in 1777.

Later that decade Bamfylde sketched in Wales, and a number of watercolours of the Lake District and Dovedale are dated 1780. He seems to have made a tour of the North that summer at least as far as Hornby Castle on the road to Lancaster. When his health deteriorated in the 1780s, he sketched closer to home, in Cornwall and Devon.

Literature: Kidderminster Public Library, Arch. 125, 122; Wilton 1980, no. 71, 145; Sloan 1986, *Cozens*, 37–8, 93–9.

GEORGE III (1738–1820)

67
The Hermitage at Richmond

Grey wash and pencil, 238 × 291 mm on mount with wash border

Oppé 1950, 2

Inscribed: *PW*

Lent by Her Majesty The Queen
(RL K 251)

From 1751 to 1756 an unknown 'Master of Fortification and Drawing' was employed for £100 per annum to teach George, Prince of Wales, and his brother Edward. From 1756, when the prince became responsible for his own household, the unknown drawing master was replaced by Joshua Kirby, a painter from Suffolk who had come to London in 1755, the year after the publication of his treatise *Dr Brooke Taylor's Perspective Made Easy*, with its famous frontispiece by Hogarth. Work by the prince survives that indicates that he took lessons in perspective and architecture from Kirby, who settled in Kew Green in 1759 and published *Perspective of Architecture* in

67

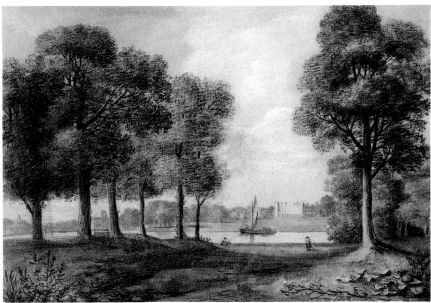

68

1761, which included a print after his royal pupil's design and another frontispiece by Hogarth. At Windsor there is a series of drawings by the Prince of Wales in a vertical format with geometric diagrams in the top half, balanced by imaginary pen and ink and grey landscape vignettes with buildings carefully drawn in perspective below. This format repeated the plates in a book on geometry by Sebastien le Clerc and seems to reinforce the close ties traditionally noted between a knowledge of geometry and perspective, which all artists and amateurs were supposed to understand and master before undertaking prospects and topographical drawing. These must have been exercises carried out under Kirby's tuition.

From 1761 Kirby and his son were employed as joint clerks of the Royal Works at Richmond and Kew under William Chambers, who had taken over Kirby's role as a teacher of perspective in order to build on the king's mastery of architecture. Kirby's own output of architectural designs was minimal, and this and the change of instructors underlines the understanding that architecture is the art of building and cannot rely on a knowledge of perspective alone. In 1757 Chambers dedicated his *Designs of Chinese Buildings* to George and shortly afterwards wrote that he was employed three mornings a week to teach the prince architecture. The rest of the time he was working on the buildings at Kew for the prince's mother, Augusta. The future king designed at least one of the buildings Chambers erected at Kew, the Temple of Victory (built 1759), and he was closely involved in all the later building works at Buckingham House and Windsor.

What remains unclear, however, is who taught the Prince of Wales to sketch and draw his two surviving series of landscapes, from which the present examples are taken. The first series is a group of eleven drawings in pencil, some with grey wash, gathered together in 1809, before the king's last illness, by Queen Charlotte in a beautiful red leather portfolio with silk flaps and gold tooling on the spine: 'Drawings by His Majesty When Prince of Wales 1760' (Oppé 1950, 2). The drawings are all mounted as here and signed *PW* (Prince of Wales), indicating that they were made sometime between 1751 and 1760. They include many sketches that appear to have been drawn on the spot, of a bridge being built, a house by a road, and the present

view, recently identified by Jane Roberts as the Hermitage in the gardens at Richmond belonging to the prince's grandparents.

Literature: See cat. 68

68

View of Syon House from Richmond

Black and white chalk on blue paper, with border, 412 × 537 mm

Oppé 1950, 1

Lent by Her Majesty The Queen (RL K 237)

The landscapes inscribed *PW* were assumed to have been made under the tutelage of Joshua Kirby, along with a group of forty-five black and white chalk landscapes, some with stump, on blue paper with a ruled black border. These are also kept in a special album tooled 'Landscapes drawn by H. M.', its leaves lined with shiny blue paper intended to reduce the amount of off-setting by the chalk (Oppé 1950, 1, RL K 200–245). The album was also put together by Queen Charlotte and has been assumed to represent work of the 1750s. The emphasis on architecture within a number of the compositions is not the only notable feature of this group. Many are of known classical buildings including the Temple of the Winds at Athens and the Baths of Caracalla. Others are reminiscent of the gardens at Stourhead, while further examples are derived from the classical compositions of Claude, Poussin or Dughet. One view of a castle ruin by the water is seen through an arch in the manner of Canaletto. Still others appear to be views of English towns or scenery, some clearly views of boats on the Thames.

Might these landscapes have all been done under the sole tutelage of Kirby? The drawing master who preceded him between 1751 and 1755 is not known and Earl Harcourt, who remained George's friend after he ceased to be his governor, was particularly fond of the work of George Knapton, who painted Harcourt's portrait with his royal charges and may have taught the earl's own children (see p. 171). With Arthur Pond, Knapton issued a series of prints after Claude's *Liber Veritatis*. The various sources of the large group of chalk drawings that appear to be from prints, as well as from nature, indicate a wider variety of artistic contacts and exposure than at first glance. Hogarth and Gainsborough were

good friends of Kirby, who was not merely a teacher of perspective. He painted several classical landscapes in oil; few survive, but one, signed and dated 1761, appears, like George's chalk drawings, to be a capriccio made up of a combination of views on the Thames with classical ruins.

Kirby submitted two landscapes to the Society of Artists' exhibitions in 1767 and 1769, which Horace Walpole and the *London Chronicle* attributed to his royal pupil. The first was *An Evening View at Kew Ferry*, possibly related in composition to the chalk view of Syon exhibited here, and the second was *A View of Ockham Mill in Surrey*, which had figures painted by George Stubbs. Kirby also knew the finished chalk landscape drawings and oil paintings of Richard Wilson, and tried to persuade the young king to buy one of Wilson's oils, which ended up in his own collection. Chambers may also have exerted some influence on George's landscape drawing as he was working with the Prince of Wales from 1757, shortly after his return from Italy where he had known the chalk landscapes of French draughtsmen such as C.-L. Clérisseau.

Literature: Roberts, 64, 214 n. 25; Jane Roberts, 'Sir William Chambers and George III', in John Harris and Michael Snodin, eds, *William Chambers*, exh. Courtauld Gallery, New Haven and London 1996, 41–3.

4
Writing Masters, 'Mathemats', Prospects and Antiquities

Drawing and 'the Common People'

The seventeenth century saw a revolution in education not matched until the twentieth century. A proliferation of free and grammar schools ensured that nearly half of the male population of London and a third in the rest of the country were literate, and even the sons of tradesmen were receiving higher educations at the universities or inns of court. The latter offered not only professional vocational training for lawyers, but mere enrolment there provided a general education for the gentry at large and an opportunity to live in London and seek a place or a patron. The landed classes had assimilated the arguments of the late sixteenth- and early seventeenth-century humanist educators such as Elyot, Peacham and even Gerbier, and ensured that their sons had higher educations in order to serve at court, in public office or to run their estates. Sixty per cent of the members of the Long Parliament had a higher education – more than any again until the nineteenth century.[1]

A society is judged by the achievements of its cultural élite. The number and range of social classes represented by the *virtuosi* discussed in the first chapter, so many of whom were conversant with, if not actual practitioners of, limning, drawing and engraving, reflect the extent of this cultural group in the seventeenth century. In addition, because culture and knowledge were esteemed by them, their wives and daughters, who were also comparatively well-educated when seen against their peers in the following century, were encouraged to participate in these activities in their own appropriate spheres.

The increasing numbers attending higher education resulted in a backlash at the end of the century when some of the gentry objected to mixing with their social inferiors at university, and their attendance declined. Their disillusionment was accompanied by a decrease in their charitable support for free and grammar schools that provided these 'social inferiors' with their educations. The landed classes considered higher education should only be available to those who could afford it, that 'all too familiar English association of educational opportunity with social status',[2] but they were also concerned that educating more men than society could usefully employ might lead to dissatisfaction, and was therefore a grave danger to established order.

The resultant changes in education were reflected in the activity of drawing by non-professional artists at all levels of society. Education for the landed gentry and aristocracy was in order to fit them to be the cultural élite among their own ranks, not only on a moral and civic level, but also as judges and arbiters of taste. The most persuasive and pervasive proponent of this type of education was John Locke. In *Some Thoughts Concerning Education* of 1693, he argued that the grammar schools were not preparing children properly, and that they were better taught privately in such a manner as to make them of benefit to society, not just to themselves. He expressed a theory of social and cultural morality that called for reason in education, and for the teaching of subjects that would promote virtue, not just pleasure, thus creating a generation of 'vertuous, useful and able Men in their distinct Callings'.[3]

Locke supervised the education of Anthony Ashley Cooper, the 3rd Earl of Shaftesbury (1671–1713), whose own *Miscellaneous Reflections* (first published in 1714) produced the century's most influential and sustained argument for providing an education in the polite arts.[4] Put very simply, he argued that the ability to recognize and respond to beauty was a crucial moral quality: thus taste became a virtue and bad taste signified a moral lapse. To be a 'man of taste' was to fulfil one's civic responsibility and moral obligation to provide a good example for society to follow.[5] To collect was one way to display taste, but to draw or paint was another public way to demonstrate knowledge of painting; however, as we have already seen, to do it too well would indicate that too much time had been spent acquiring a 'professional' skill.

Along similar lines to Shaftesbury, in 1719 Jonathan Richardson stated that the love of art had a 'Natural tendency to Reform our Manners, Refine our Pleasures, and Increase our Wealth, Power and Reputation'.[6] Thus he could claim that it was a sort of 'Illiterature, and Unpoliteness' if a gentleman could not properly read and appreciate the beauty of thought, expression, grace and greatness in painting.[7] In his reasoned demonstration of why connoisseurship was a worthy pursuit, Richardson indicated how it could help to fulfil a gentleman's moral civic responsibility: 'If Gentlemen were Lovers of Painting, and *Connoisseurs* This would help to Reform Them, as their Example, and Influence would have the like Effect upon the Common People.'[8]

The 'common people' could not become connoisseurs themselves as this was the exclusive preserve of those with knowledge of and access to the fine arts, as well as the wealth to provide the leisure time to become connoisseurs; but Richardson argued that there was a more direct way to provide instruction in art that would improve not only the moral welfare of the 'common people' but also the arts and manufactures of the country. From the late seventeenth century, lack of knowledge of painting amongst English gentlemen had been perceived as a contributing factor in England's failure to produce a national school of painting to rival that of France, Italy or Holland.[9] Richardson noted that the 'common people' had 'been exceedingly Improv'd within an Age, or two, by being Taught to Read, and Write; they have also made great Advances in Mechanicks, and

in several Other Arts, and Sciences'. If they were also taught to draw, he argued, they would be better and more easily prepared to become painters, carvers, engravers and masters of other trades dependent upon design, and 'they would thus become better Mechanicks of all kinds'.[10]

In this Richardson was echoing an argument first put forward by Gerbier, although with little actual success, in 1650, and echoed by the schoolmaster, John Dunstall, in his manuscript treatise on drawing (see cat. 35). But a few decades later, when the education of the artisan and merchant classes, and those attending charity schools like Christ's Hospital and other 'breeding grounds' of the capital's apprentices, became the concern of men such as Prince Rupert, John Evelyn, Christopher Wren and Samuel Pepys, who sat on the boards of these institutions, their education thus became of national importance. Entrusted with the creation of schools that would reflect the nation's ability at mathematics, astronomy, manufactures, navigation, exploration and even naval warfare, these men were concerned to give pupils any instruction that would improve such skills. Many, as members of the Royal Society, were familiar with the ambitions of its 'history of trades' and the benefits to be accrued from instruction in drawing, and they therefore ensured that it was incorporated into their curricula.

Thus, at a time when young gentry, nobles and even royalty were receiving private instruction in the 'polite' arts of drawing and painting for the various cultural reasons already discussed above, orphans, children of apprentices, and those attending private merchant, military and naval academies were also being instructed in perspective, prospects and the drawing of figures. It is on the instruction and products of this second group that we shall concentrate in this chapter.

Christ's Hospital: Writing Masters and 'Mathemats'

During the sixteenth and seventeenth centuries writing schools were frequently set up in connection with grammar schools to cater for those pupils whose future apprenticeships, as clerks, for example, would require a 'good hand'. For the rest, a journeyman 'scrivener', or writing master, or one of the masters would teach plain writing and special hands, or calligraphy, for a few hours a week, as an 'extra' subject. Since fluency and accuracy of hand were the goals, exercises in drawing circles, ovals and spirals with the pen and charcoal were recommended in order to train the hand. Shading and colouring were not taught, as they were the province of those who were to become professional artists. Thus drawing was included in the curriculum, not to draw figures or nature, but rather as a support for writing. Teachers and academies that advertised that they taught 'writing and drawing', often also in combination with arithmetic, were thus commonplace.[11]

In 1553 Christ's Hospital had been established as one of the royal hospitals, and it was soon provided with a writing and grammar school to prepare the orphans of city craftsmen for apprenticeship; or if they showed promise, for university. In the middle of the seventeenth century, the shortage of experienced seamen induced Prince Rupert to persuade the king to allot £1,000 for selecting forty of the ablest boys from Christ's Hospital for training as pilots and ships' masters.[12] This was followed in 1672 by a recommendation from Samuel Pepys, then clerk of the Acts of the Navy, that in the light of the successful schools of navigation in Spain and France, it would be useful to the nation if a school could be erected for children to be educated in mathematics 'for the particular Use and Service of Navigation'.[13] Shortly afterwards Charles II gave an endowment of £7,000 to establish the Royal Mathematical School at Christ's Hospital. Those children who showed promise from the writing and grammar schools at the Hospital were then sent on to the Royal Mathematical School, where the pupils were known as 'Mathemats'. There they were taught all the subjects necessary for navigation, including geometry, trigonometry, astronomy, plain sailing and the reading and making of maps and charts. They also 'prepared draughts of all kinds under the eye of their master'.[14] They were examined by the masters of Trinity House. The 1680 log-book of one pupil is illustrated with calligraphic flourishes, as well as with, among other things, ships, coastlines, harbours and their cross-sections and fortifications.[15]

In 1694 a new plan of lessons for the 'mathemats' was sent by their master to Isaac Newton, the mathematician John Wallis and the astronomer David Gregory for their comments and approval.[16] As a result, a slight change of emphasis towards a clear connection of mathematics with designing was reflected in the new plan of the school when finally adopted in 1696. Article 9 became 'The construction and use of right lined and circular Mappes, the Practice of Drawing for laying down the appearance of lands; Moles and other objects worthy of notice.'[17]

In 1692, however, John Smith (fl. 1670–96), who had been writing master at Christ's Hospital for sixteen years, proposed a three-month trial to teach drawing to the boys of the writing school, which would help to recommend them to 'such as desire to become their Masters'. William Faithorne the Younger (c.1670–1703) was hired to assist Smith in teaching them, and the results were sent to the governors and two advisers who had close connections with the Hospital, Christopher Wren and Samuel Pepys, for their opinions. Wren noted in his reply that English artists were accomplished at imitating others but wanted

education in that which is the foundation of all Mechanick Arts, a practice in designing or drawing, which everybody in Italy, France and the Low Countryes pretend to more or less … I cannot imagine that next to good writing, anything could be more usefully taught your children, especially such as will naturally take to it … it will prepare them for many trades, and they will be more usefull and profitable to their masters … No Art but will be mended and improved; By which not only ye Charity of the House will be enlarged, but the Nation advantaged, and this I am confident is obvious to any ingenious person who hathe been abroad.[18]

Samuel Pepys wrote that he agreed with the proposition, 'from my generall inclination to the advancement of arts and the

propogating of them positively among these children'. However, the children of the Hospital were bred for 'honest and plainer callings', and although the ability to draw would give them an advantage when they were apprenticed, he was worried that it might also recommend them to persons of 'the best quality' as tutors or clerks, which in turn might lead to a 'knowledge of liberty, and thoughts above their condition, and so to wantonness, and an early forgetting to provide for old age'.[19]

Drawing was therefore also introduced to the curriculum of the boys of the writing school in 1693. Various problems soon arose: the master of the 'mathemats' was supposed to teach his own boys drawing, but wanted the drawing master to take over this responsibility. Smith was discharged after one of his ushers was caught stealing, and the younger Faithorne, not as diligent in his attendance as he should have been, was also dismissed in June 1696.[20]

In the years that followed there were several complaints from the examiners at Trinity House that the 'mathemats' were not sufficiently prepared for navigation. The respected mathematician John Harris (1667–1719) was applied to for advice in June 1703 and he recommended that John 'Lentz', who taught at Major Ayres's school, be brought in to teach the boys drawing and designing.[21] Described as a 'gunner' in 1708,[22] Lens presumably assisted Thomas Ayres who taught, amongst other subjects, navigation, surveying, dialling, gauging, perspective, gunnery, algebra and geometry at Major John Ayres's school at the Hand and Pen. Writing, arithmetic and merchant's accounts were taught by the major.[23] John Lens must have been trained by his father Bernard Lens II who from 1697 ran a drawing school near the same Hand and Pen, near St Paul's, with his partner, the writing master and engraver John Sturt (1658–1730) who, like his friend the elder Faithorne, specialized in engraving writing books. Sturt's portrait was drawn on copper by Faithorne in c.1690 (cat. 70), but he was also the engraver of several writing copybooks for Ayres, and the master of the most important writing master and engraver of calligraphy in the eighteenth century, George Bickham (cat. 72).

This circle of writing, drawing and mathematics masters and engravers becomes even tighter with the appointment in 1705, not of John Lens, but of his father Bernard Lens II (see cat. 38), as drawing master to the 'Mathemats' and writing school at Christ's Hospital. Obtaining the position by passing a test devised by the almoners' committee, Lens and the other applicant were sent up to the roof to draw 'Christchurch steeple and the prospect of the steeples as far as the Guildhall'. Lens drew 'the quickest and the best and, having been a teacher of that art for severall years', was found to be the better qualified.[24] When his year's trial was up, he was teaching forty boys from the two schools, mainly by having them copy his own drawings and teaching them the use of the compass. After his death in 1725, he was succeeded by his son Edward Lens (1685–1748).[25] The masters at Trinity found no cause for complaint until 18 January 1749, when Alexander Cozens was elected drawing master 'in room of Mr Edward Lens deceased'.[26]

Practical versus 'Polite' Prospects

In January 1749 Alexander Cozens (1717–86) had placed an advertisement requesting the votes of the governors for the position of drawing master, arguing that he was the best qualified 'by reason of the many Coasting Prospects I have taken at Sea, in the Course of several Voyages, the last of which was to Rome, Where I studied Drawing and Painting for the Space of two Years'.[27] Although Cozens himself had no problems with perspective, fortifications or coasting prospects (see cats 75–6), and even planned a publication on perspective,[28] he did have problems with the examiners at Trinity House.

Cozens's duties were not described in the Hospital minutes; the last time they had been discussed was in 1706 when Bernard Lens was to teach twenty-five boys from the writing school and twenty-five 'mathemats' 'the art of drawing and designing, in order to take draughts and prospects of harbours, views of Lands, ships, etc.', from one p.m. until five p.m. three afternoons a week for £50 per annum. The 'mathemats' were examined by Trinity House on the basis of the work they produced during their final year in their manuscript exercise books titled 'Elements of Navigation'. Only a handful survives, but one was produced under Cozens's instructions and submitted in 1755 by James Slater Elly (b. 1740),[29] who had been admitted to the Hospital as a King's ward in 1751, and in 1756 was apprenticed to Sir William Burnaby, commander of HMS *Jersey*, where he served for seven years.[30] Elly's 'Plan of Navigation' makes an illuminating comparison with the 'Plan of Learning at the Naval Academy, Portsmouth' produced by Charles Steevens in 1753.[31]

In 1733 the Naval Academy was established in the Portsmouth Dockyard by the Admiralty, on George II's orders, to educate 'Young Gentlemen to the Sea Service': specifically, up to forty sons of nobles or gentlemen, not under twelve years of age or over fifteen, except for fifteen sons of sea officers aged between seven and fifteen years. They were to stay for two to five years, when they were rated out as midshipmen and expected to rise to lieutenants. Taught gunnery, navigation, fortification and other useful parts of mathematics, they were also provided with lessons in fencing, dancing, French and drawing. The masters' salaries for the last two subjects were £100 per annum. At sea, the 'young gentlemen' were expected to keep journals and 'draw the Appearances of Head-Lands, Coasts, Bays and such-like…'.[32] Jeremiah Andrews (1710–60), one of the first writing and drawing masters at the Portsmouth Academy, had been a pupil of Christ's Hospital and apprenticed to a schoolmaster in London, later going on from Portsmouth to become writing master to George III when Prince of Wales.[33]

The 'Plan of Learning' and 'Plan of Navigation' both included figures, carefully based on academic models and classically draped, and both contained depictions of ships, coastlines, castles and fortifications; but Steevens's maps, landscapes and even his figures were drawn as part of his exercises in mathematics and mensuration, with labelled lines of trajectory and other calculations, while Elly's were copies of the landscapes drawn by Cozens and copied from plates in Lens's drawing

book published in 1750 (cat. 38). Elly's drawings contain neither lines of measurement nor calculations, and bear no relationship to the written and mathematical exercises found on the facing pages. Steevens's, however, contain explanations of the calculations and illustrate the accompanying manuscript text.[34]

Pupils at Christ's Hospital were the same age as those at Portsmouth, but came from different social backgrounds. Portsmouth's plan of learning was an integrated one, where drawing lessons were carefully planned to complement the more technical ones, while at Christ's Hospital, Cozens was clearly on his own and instructed to instil in his pupils a facility for drawing alone. Just as potential officers from Portsmouth needed to be able to speak French, the language of fortification, and to display some social accomplishments, they also needed to both understand measurements and drawings, as well as instruct and supervise those carrying them out. Apprentices from Christ's Hospital, however, were merely to receive training in the basics so that they would be able to follow orders given by others.

This outlook is reflected in the complaints in July 1753 by examiners at Trinity House that some of the 'mathemats'' drawings were 'worse than heretofore'. Cozens replied that 'three of the said Children were very dull and the other Two but indifferent'.[35] The students were passed but, anticipating further complaints, Cozens resigned in May 1754.[36] His emphasis on classically composed landscapes, despite containing the required elements, was inappropriate for the students of Christ's Hospital, but found favour among the pupils he abandoned them for – private families such as the Harcourts and Greys and the young gentlemen at Eton (see cats 109–10). Nevertheless, it would not appear that Cozens's successors altered the type of drawing they taught, as indicated by the drawing held by one of Benjamin Green's pupils about fifteen years later (see fig. 3 and cat. 113).

Cozens's difficulties with his pupils at Christ's Hospital, and those of his successors, are symptomatic of significant changes around the mid-eighteenth century in the teaching of drawing for different national and cultural purposes, and to different levels of society. They are equally well illustrated by the plates in Lens's drawing book published at this time (cat. 38), which contained not only coastal views and fortifications, but also lessons in drawing figures and copies of seventeenth-century Dutch and Italian landscapes. It was around this date that William Shipley established his drawing school in London, and helped to found the Society for the Encouragement of Arts, Manufacture and Commerce, offering lessons and premiums for prospective professional artists, apprentices for other manufactures, and 'young ladies and gentlemen'.[37] It was also the date of Paul Sandby's appointments, first as draughtsman to the Survey of the Highlands and then to the Royal Military Academy at Woolwich. All these artists attempted to accommodate the more technical and mathematical aspects of drawing necessary for preparing young men for trades and naval or military careers, as well as less technical aspects of landscape appropriate to young gentlemen. The latter type of drawing

Fig. 3 Benjamin Green, *A Christ's Hospital Boy*, oil on canvas 530 × 420 mm (private collection)

tended to reflect the instructor's perceptions of their own professions, not as drawing masters, but as artists.

This division between practical drawing lessons for apprentices and polite ones for the gentry was not, however, clear cut or sudden. The issues as always were more complicated and again reflect underlying changes in education. Grammar schools, traditionally the educators of the middle and merchant classes, were bound by their statutes to provide a classical education, which was useful for becoming a gentleman and for entry to university, but little else. From the middle of the seventeenth century, increasing numbers of Dissenting academies mixed the classics with more useful modern subjects, including mathematics, accounts, perspective and drawing. Their growth was accompanied by a comparable one in small private schools and academies, which taught some of these subjects and, in particular, trained young men for careers in business or the military.

Major John Ayres, mentioned above, ran one of these private schools, while George Bickham (cat. 72) held another with an emphasis on drawing, writing and accounts. John Sturt and Bernard Lens II's drawing school at the Hand and Pen was even more specialized. Their handbill issued in 1697 stated their reasons for founding the school, and was reprinted in full in the 1720 new edition of Stow's *Survey of London*.[38] Although offering to

teach children in order 'to have a constant Nursery or Breed of Youths proper for artificers', and echoing many of the reasons given by Evelyn, Wren and Pepys before them, they also noted that it was an 'Accomplishment for Noblemen and Gentlemen, Scholars, all students in Art or Nature; Generals, Engineers, Mathematicians, Surveyors, Surgeons'. By echoing not only classical and Renaissance precedents for drawing as a noble art, as well as the argument for a national school of painting to rival that of France, Sturt and Lens were virtually arguing for 'universal' education in drawing. Their hours accommodated any potential student, and in 1700 they advertised *A New Drawing-Book Teaching the Grounds of that Art*, with fifty-two plates, for the use of their drawing school, of which no copies survive.[39] When the new edition of Stow's *London* appeared in 1720, the school was being run by Bernard Lens alone.[40]

In his writings around this time, the Earl of Shaftesbury had called for more 'Academys of Exercises' where the 'sprightly' arts and sciences were not severed from philosophy and the classics, which he felt were growing less useful to the 'real Knowledge and Practice of the World and Mankind'.[41] Some 'academies' were less formal than others. The astronomer royal John Flamsteed had supplemented his income from 1676 by taking in as pupils the sons of gentry and nobility who later entered the navy, East India Company or Ordnance Office, or stayed to assist him in his observations.[42] Thomas Weston, who, as a young man with a gift for drawing, had been one of Flamsteed's pupils, set up his own academy in Greenwich around 1715, where he taught Greek and Latin, mathematics, French, merchants' accounts, dancing and drawing, and in 1721 erected a theatre.[43] The presence of these 'polite' lessons in addition to more utilitarian subjects also reflected the fact that Greenwich had been a royal residence until 1694. But it was also the site of the Royal Observatory and Greenwich Hospital, in close proximity to the Arsenal at Woolwich and the docks at Deptford. Not surprisingly, it soon gained a reputation for preparing young men for military and naval careers. Greenwich Hospital also sent an increasing number of 'orphans of the sea' to Weston's school, where they were taught separately and prepared for binding out to service in the navy. Weston's reputation as an astronomer was established publicly when James Thornhill depicted him in the ceiling of the great hall at Greenwich Hospital as the 'ingenious Disciple' of John Flamsteed, showing him assisting with the observation of the Great Eclipse of 1715.[44] During his apprenticeship, Weston helped Flamsteed compile astronomical charts, and accompanied his master to Christ's Hospital to examine the 'mathemats'.

George Bickham the Elder engraved Weston's 1726 copybook, *Writing, Drawing and Ancient Arithmetick*, for the use of his pupils at Greenwich. His son Bickham the Younger later taught drawing at the academy. The present difficulties in attempting to establish which Bickham taught writing or drawing and where, and who published which copybooks, serve to underline the close relationship between writing, drawing and mathematics, which continued through the middle of the eighteenth century (see cat. 72).

Paul Sandby: Ordnance, Arsenal and Abroad

Because Paul Sandby has always been considered 'the father of British watercolour', his work has always been looked at in that context. However, he was by training and throughout most of his life by profession a civilian draughtsman to the military, like his brother who also remained on the payroll of the Board of Ordnance.[45] That he attempted to leave his career as a military draughtsman to build one as a professional landscape painter, there is no doubt, and he made a particular effort from 1752 to 1768, when he exhibited oil paintings and built up a clientèle of aristocratic patrons and amateur pupils, as well as becoming a founder member of the Royal Academy. Despite his skill at 'real landscapes',[46] however, he was not successful enough to be financially independent as a professional landscape artist. He turned back to the Board of Ordnance and an appointment as chief drawing master at the Military Academy at Woolwich from 1768 to 1797, relying upon his military training and skills for a regular income, teaching along similar lines to the masters at Portsmouth, and including figures, landscape, 'military embellishments' and perspective.[47] His work as an artist and a teacher, as well as the work of his pupils, take on a radically new appearance when seen in this context.[48]

The examples chosen from the Museum's collection to represent Paul Sandby's activities as a drawing master are an indication of the diversity of the methods and purposes of his teaching. They vary from private lessons to men and women such as John Clerk of Eldin and Viscount Nuneham, to whom he taught landscape and etching (cats 94, 96), William Hamilton who learned to draw landscape and possibly caricatures (see cat. 93), Colonel Gravatt who painted landscapes in bodycolour (cat. 102), and countless other military pupils at Woolwich who were taught to draw figures and prospects and imposed Sandby's approach to landscape on people and lands as far afield as Canada and India (cats 99, 104). Sandby tailored his lessons to his pupils' needs, but never forgot his own preferred profession as an artist, altering his pupils' views of their family seats (in *The Virtuosi's Museum* (1778–81)) or travels (*Views in Wales*) to reflect his own artistic approach.[49] In all of this, as in his drawings of antiquities, he continued to draw and take 'views', while others mapped, planned and drew topographical prospects. He appropriated the scenes to conform to the British national school of landscape, while others appropriated them through military mensuration and scientific enquiry.[50]

This fascinating theme of the appropriation of the landscape and cultures of other lands by British gentry (male and female) and military amateurs is vast and multi-layered. The resulting works are only represented by a few sketchbooks and drawings in the Prints and Drawings Department of the Museum, but numerous further examples are in the British Library in the Map, Manuscript and India Office libraries. Public archives and collections in several former colonies, including Australia, Canada, America and the East and West Indies, as well as East Asia, document how the British way of seeing, particularly landscape, dominated the British, European and indigenous visions of these lands.[51]

The India Office Library, once the library of the East India Company but now part of the British Library, contains over 11,000 drawings by British artists; all but around 1,000 are by amateurs, of which nearly half were drawn during their leisure time, and the rest in their official capacities as engineers, surveyors or gunners in the manner for which they were trained at Woolwich and later at the India Office Academy at Addiscombe, in Kent. Official drawings included antiquarian, archaeological and even anthropological records as the nineteenth century progressed. But in their leisure time these 'amateurs' sketched and drew the scenery or life around them.[52] The motive for amateurs such as Robert Colebrooke and Thomas Williamson (cats 104–5), who issued prints after their works, was less likely to be monetary profit than to demonstrate publicly their participation in one of the nation's most glorious ventures, as well as their desire to take part in the distribution of knowledge.

Although these amateurs' drawings and publications provide us with much of what we know of Indian life and history at this time, as well as an important archaeological record, it was an India seen through British eyes, literally, artistically and intellectually. The imposition of the British version of Italianate landscapes, Edmund Burke's definition of the sublime or Gilpin's picturesque way of seeing sit uncomfortably and misleadingly on Indian landscapes, just as it did on the rocks, lakes and forests covering one of the other most important sites of military amateur activity at this time, Canada. British ownership there was confirmed and strengthened by the taking of French-held territory in the Seven Years' War. The India Office Library holds amateur drawings, mainly military, that provide some of the earliest British records of that continent in the same way as the Hudson Bay Company holds similar collections. Others are in the Map Library of the British Library, but many more have been assiduously acquired by the Public Archives of Canada, where a quick glance through their views of Canada before 1800 indicates that nearly all were drawn by men trained at Woolwich or Portsmouth.[53]

''Tis all a matter of record'[54]

One final group of amateurs in this chapter undertook a type of drawing that was closely bound with mathematics, surveying and recording, and grew out of the seventeenth-century *virtuosi*'s desire to observe and amass knowledge – the antiquarians. John Aubrey's (1626–97) life was devoted to an empirical search for evidence of the past in order that lessons might be learned through reconstructing it rather than revering it without question. Aubrey never held an appointment at court, and stated that his role in life was to be a whetstone, which could 'make the iron sharp though itself unable to cut'. He considered that his other most worthwhile occupation was that of a recorder of curiosities and antiquities that would otherwise 'be quite forgott'.[55] Amongst the myriad records he created were drawings he made himself, or employed others to make, of ruins of abbeys soon to be demolished, and a Roman temple in Surrey

that he regretted had not been drawn while it was 'entire'.[56] He ensured the preservation of his own manuscripts by sending them to the Ashmolean Museum, Oxford, before his death.[57]

From childhood Aubrey had collected information about what we would call prehistoric monuments, such as Avebury, which he had 'discovered' in January 1649, and Stonehenge, as well as miscellaneous megaliths, barrows and hill-forts. He produced a complete 'Templa Duridum', which he hypothesized had been erected by Druids, whom he considered the most eminent priests among the ancient Britons. Earlier writers had believed that the stones had occurred naturally, having been placed by the hand of God, or deposited in the universal deluge, or 'magicked' there by Merlin.[58] Like modern archaeologists, Aubrey relied on material remains of the past to reconstruct it, and it is from this tradition that the examples of antiquarian drawings in the present study derive.

Few of Aubrey's seventeenth-century contemporaries attempted chronological histories of architectural remains, but such records soon led to this type of study in the eighteenth century. For Aubrey and William Stukeley, his eighteenth-century follower at Avebury, their knowledge of mathematics and ability to survey, which Aubrey had actually recommended be taught to young gentlemen in his manuscript plan of education, enabled them to make accurate records of a site that was being further destroyed while Stukeley wrote (see cat. 94). It is significant that modern archaeologists consider Aubrey and Stukeley's greatest contributions to the discipline to have been their initiation and development of field or 'landscape' archaeology at which the British now excel: 'pure field-work and survey carried out in the open air, with a minimum of excavation'.[59] Like military draughtsmen, their drawings and plans of the site required skills in mathematics and surveying. An ability to observe and analyse the physical makeup of the soil enabled the physician Stukeley especially to read and understand what the various layers he could see told him about the site's history. Above all, as amateur landscape draughtsmen, Aubrey and Stukeley brought a knowledge, appreciation and ability to view a landscape that enabled them to visualize the detailed parts of it before them as part of a larger whole.[60] Without the written accounts and records of these early antiquarians, their detailed plans, drawings, watercolour sketches and views, our knowledge of ancient sites such as Avebury would be so much the poorer that we would not even have the tools to argue to save them today. From the later eighteenth century, through the nineteenth and for most of the twentieth century, Aubrey and Stukeley's manuscripts and drawings lay unregarded because they were the work of gentlemen amateurs.[61]

NOTES

1 This information is based on the analysis of statistics by Lawrence Stone, 'The educational revolution in England, 1560–1640', *Past and Present* 28 (1961), 41–69.

2 Ibid., 75.

3 Quoted in M. J. M. Ezell, 'John Locke's images of childhood', *Eighteenth-Century Studies* 17, no. 2 (1963/4), 142. For a discussion of

the effect of Locke's theory of 'usefulness' on his contemporaries and later writers, see G.C. Brauer, *The Education of a Gentleman*, New York 1959.

4 The *Miscellaneous Reflections* were published in the well-known compendium of his work *Characteristicks of Men, Manners, Opinions, Times, etc.*, 3 vols, 1749.

5 See chap. 7, 'The Ethic of Feeling', in Colin Campbell's *The Romantic Ethic and the Spirit of Modern Consumerism*, Oxford 1987, esp. 151–2.

6 Jonathan Richardson, *Two Discourses* II: *An Argument in behalf of the Science of a Connoisseur*, 1719, 216.

7 Ibid., 221–2. For a good overview of 'politeness', connoisseurship, sensibility and the rhetoric of civic humanism, see the excellent article by the late Stephen Copley, 'The fine arts in the eighteenth century', in Barrell, 13–37; for a discussion of the *Two Discourses*, see Gibson-Wood 1984, 38–56.

8 Richardson, *Two Discourses* II, 44.

9 For example, William Aglionby's plea in *Painting Ilustrated in three Diallogues*, 1685, preface, noted in Gibson-Wood 1984, 39–40.

10 Richardson, *Two Discourses* II, 46.

11 Carline, 20–2.

12 Fergusson, 136.

13 Pepys MS 2612, III, Magdalene College, Cambridge, quoted in Nicholas Plumley, 'The Royal Mathematical School within Christ's Hospital', 52, in *Vistas in Astronomy* 20 (1976), 51–9.

14 E. H. Pearce, *Annals of Christ's Hospital*, 1908, 158.

15 Carline, 23, 36.

16 CH MSS, 12,811, vol. 6, 1694, f. 501; 1695, f. 600.

17 CH ibid., 1696, f. 695.

18 CH ibid., 1692, ff. 362–3; the letter was published by the *Wren Society* XI (1934), 74.

19 CH ibid., 1692, ff. 363–4.

20 CH ibid., f. 699; see also Fleming-Williams in Hardie III, 213–14, and Sloan 1986, 'Non-professionals', 36–41.

21 CH MSS 12,811, vol. 7, 1703, ff. 260, 282.

22 On the verso of a portrait of him by his brother Bernard Lens III, see Foskett, I, 379.

23 John Ayres was a writing master who ran an academy at the Sign of Hand and Pen, near St Paul's, from around 1680. He was the author of several books on arithmetic, clerking and writing. The subjects taught by him and Thomas Ayres were listed in an advertisement in one of these books in 1698. See Heal, xvii, 7–8.

24 CH MSS 12,811, vol. 7, 1705, f. 397.

25 CH MSS 12,811, vol. 9, 1726, f. 276.

26 CH MSS 12,806, vol. II, 18 January 1749, ff. 90–1.

27 *General Advertiser* II, 16–18, 1749. A copy of this advertisement with a blot on the verso sold Christie's, 14 June 1977, lot 172.

28 *A Treatise on Perspective and Rules for Shading by Invention*, 1765. No copy survives, see Sloan 1986, *Cozens*, 44.

29 Christ's Hospital, Horsham, Library Archives.

30 CH MSS 12,818, vol. 9, 1751, no. 22, 1756, f. 243.

31 National Maritime Museum STV/101; there are several there by the students of Portsmouth, the earliest dated 1746.

32 Admiralty Office, *Rules and Orders relating to the Royal Academy at Portsmouth*, 1767, Articles I, 2; XIII, 7; XXXV, 15. See also R. K. Dickson, 'The history of H. M. Navigational School, 1729–1926: A study of naval education', in *Naval Review* XIV (1926), 793–7; the orders for its foundation were in 1729, and it became the Royal Naval Academy in 1806.

33 Heal, 5. The name of the drawing master when Steevens attended is unknown.

34 For illustrations from Elly's book, see Sloan 1986, *Cozens*, figs 26, 27, and Sloan 1986, 'Non-professionals', figs 39–50, 55.

35 CH MSS 12,811, vol. II, 3 July 1753, 549.

36 CH MSS 12,806, vol. II, 22 May 1754, 209–10; 13 June 1754, 211.

37 See above, 101, and D. G. C. Allan, *William Shipley, Founder of the Royal Society of Arts*, 1979.

38 The original handbill is BL 816.m.23(3). The one quoted in John Strype's 1720 edition of Stow's *Survey of London*, 173, has a slightly different text, with new prices, a new description of the use of drawing and no mention of Sturt.

39 Ogden 1947, 199.

40 Lens 'now, or late living in Fleet Street', taught three mornings and three evenings a week, at 1 guinea entrance and 1 guinea per month.

41 *Characteristicks* I, 225, based on his earlier texts.

42 Flamsteed Notes, MSS vol. 15, Royal Observatory, quoted in Sloan 1984, 313–14. See also Francis Baily, *An Account of the Reverend John Flamsteed*, 1835, *passim*.

43 For Weston's academy, see Sloan 1984, *passim*, and Sloan 1986, 'Non-professionals', 71–91.

44 Sir James Thornhill, *An Explanation of the Painting*, 1729, 10–11.

45 Although their records for this period do not survive, we know from Jones, 60, that he received income from the board from 1768 to 1797, after which he received an annual pension of £50 until his death.

46 Herrmann, 23–4.

47 Fully detailed in Jones and Buchanan-Dunlop, *passim*.

48 For studies of this type of drawing, see O'Donahue and Christian, *passim*, and Michael Charlesworth, 'Panoramic drawing in eighteenth-century Britain', *Art History* 19, no. 2 (1996), 247–66.

49 See Robertson, 104–5 and 68–80 respectively.

50 See N. Alfrey, 'Landscape and the Ordnance Survey 1795–1820', in Alfrey and Daniels, 23–7.

51 See Rüdiger Joppien and Bernard Smith, *The Art of Captain Cook's Voyages*, 5 vols, New Haven and London 1989, and Smith's other numerous excellent publications; Caroline Jordan's Ph D. thesis on women's views of Australia; Stephen Daniels, *Fields of Vision: Landscape Imagery and National Identity in England and the United States*, Cambridge 1993, and Charlotte Klonk, *Science and the Perception of Nature*, New Haven and London 1996.

52 See Archer; and Rohatgi and Godrej.

53 They include Thomas Davies, John Hamilton (cat. 81), and James Meres; see Bell, 221–2; and Mary Sparling, *Great Expectations: the European vision in Nova Scotia 1749–1848*, Mount St Vincent University Art Gallery, Halifax 1980, which includes a discussion of Gilpin.

54 John Aubrey, in a letter of 1694, quoted in Hunter, 1975, 68.

55 Ibid., 63, 67.

56 Ibid., 68–9.

57 Now mainly in the Bodleian Library, Oxford, see ibid., 90–2.

58 Ucko, Hunter *et al.*, 8–16.

59 Piggott, 181.

60 See Alain Schnapp, *Discovery of the Past*, 1996, 212–18, especially the reproduction of Stukeley's panoramic overhead view of Avebury of 1723, 216–17.

61 Only recently have they been 'rediscovered' and produced to help marshal evidence to help to save a 'World Heritage Site' from further 'development'; see Ucko, Hunter *et al.*, 255–64.

JOHN COOKE (*fl.* 1717)

69

Writing Sheet, with Queen Anne and Prince George of Denmark

Pen and brown ink on engraved writing sheet, 402 × 315 mm

Inscribed with text: *To Write a Good Hand …* , signed and dated

O'D 58

Provenance: Presented by Sir Henry Ellis 1854-7-8-187

69

Fantastic calligraphic flourishes such as the example here are unfamiliar to us today, but childrens' exercise copybooks were filled with such images well into the eighteenth century. Cheap prints with examples of fine penmanship were issued for copying, but often the central section was left blank for the pupil to fill as an exercise and keepsake of his accomplishment in writing which, as noted in the text here, was generally considered to be 'as useful to the Gentleman and Scholar, as the Man of Business'. John Smith, who taught at Christ's Hospital, was one of the finest calligraphers of this type and he designed some of the earliest surviving writing sheets. George Shelley (*c.*1666–1736), who was educated at Christ's Hospital and also taught writing there for twenty years, adorned his first book, *Penman's Magazine* (1705), with 100 open figures and 'fancies' after originals by the seventeenth-century 'master of the quill' for these 'flourishes', Thomas Seddon.

The fact that the print depicts Queen Anne (d. 1714), and that John Cooke did not fill it with his writing exercise until 1717, indicates that calligraphic flourishes of this seventeenth-century type continued to be associated and taught as part of good penmanship into the eighteenth century. However, by the third decade, such fantastic figures had disappeared, to be replaced by more purely decorative flourishes, initial letters and small vignettes with decorative borders of the type found on similar writing sheets right through the Victorian period. By the end of the century such flourishes were rarely found on official documents and accounts as they had been earlier, but instead made an appearance in the borders of grangerized volumes (see cat. 87), or in manuscript keepsake books, usually made by women, who decorated and illuminated the texts in the margins in a manner similar to that found in Bickham's example (cat. 72). Queen Charlotte and her daughters compiled several volumes; Princess Elizabeth's example now in Hanover was made as late as the 1830s (Roberts, pl. 23).

In 1762, when William Massey was writing his history of English penmen, he wondered why women, several of whom he had taught and all of whom had showed 'a natural genius for writing', did not set up a school and teach writing and accounts to young women. He took note of many English women who had excelled at writing, most recently Mary Johns, the daughter of a cooper of Bermondsey who had a natural genius for both drawing and writing. Her performances, including the Lord's Prayer in the compass of a silver penny, were in several collections, but in 1752 she married a carpenter named Taylor and no longer had the leisure to do 'anything in that way' since 'the prudent management of a family and the carefree bringing up of children, are a *married woman's* greatest and wisest employment'. Massey further expressed disappointment that Bickham refused to include her work in his *Universal Penman* as it would have been 'not only to her honour, but to her sex in general'.

Literature: Massey, 168–72; Heal, *passim*; O'Connell, 34–5.

WILLIAM FAITHORNE (c.1620–91)

70

Portrait of John Sturt

Chalks on copper, 103 × 69 mm; in original frame 190 × 155 mm

Verso: Part of a pedimental design, probably for a title-page, not identified (not visible), engraved on copper

Inscribed by the sitter on a vellum label on back of frame: *John Sturt Engraver Born the 6 April MDCL[VIII] Drawn by the Celebrated Mr. Will:m Faithorne .. . An du Noces, MDCXCIII. J. S. scripsit 1726. Aetat 68*

ECM & PH 5

Engraved by William Humphrey, in mezzotint, and published, 1774, in reverse and with some modifications

Provenance: John Sturt; Edward Harley, 2nd Earl of Oxford, his sale, Cock's, 12 March 1741/2, lot 2, bt 'West'; James West, his sale, Langford's, 3 April 1773, lot 32, bt John Thane; Read Adams; Dr George C. Williamson, no. '280' on reverse of frame; E. Wheeler, from whom purchased

1950-10-14-3

William Faithorne trained as an engraver before the Civil War, but was captured with a number of royalists after the siege

70

of Basing House. He was permitted to continue engraving as a prisoner in London and later in Paris, returning to London in 1652. He specialized in portraits, drawing them in crayon first and then engraving and publishing them himself. He translated Abraham Bosse's treatise on engraving in 1662, providing the first technical account in English in the year John Evelyn published his historical account of the media, *Sculptura*. Faithorne's plumbago and wash portrait of John Aubrey is one of the most beautifully drawn of the century, and his engraved portraits of Prince Rupert and Elias Ashmole are powerful images with his characteristic engraved script rather than printed lettering below.

In the 1680s John Sturt (1658–1730) and Faithorne seem to have specialized in engraving writing copybooks and portraits of London's finest writing masters at a time when they were amongst the best in the world. The English hand was invented for use in trade, and in schools writing masters were second only to the headmaster in importance, and frequently also taught accounts, shorthand and arithmetic. Sturt was later famous for his 1717 edition of the *Book of Common Prayer* engraved on silver plates, but sometime in the 1690s he took

George Bickham as his apprentice, who gained a reputation equal to his master as an engraver of script (cat. 72).

Competition from newly arrived foreign engravers specializing in the portrait print field in the 1660s and 1670s had diverted Faithorne from portraits to dealing, and Pepys mentions buying prints from him for his wife to copy in 1666. But he also experimented with mezzotints once the secret of the method was better known, and this portrait seems to be the product of his later years when he evolved a method of drawing portraits in chalk on copper plates roughened with a mezzotint rocker. This method was also employed by Edward Luttrell (*fl.* 1680–1724; probably a relative of the Revd Luttrell Wynne, cat. 95), who gave up law for art and wrote a manuscript treatise on mezzotint and drawing portraits with this method.

William Faithorne the Younger specialized in mezzotint portrait prints, but apparently needed to supplement his income with teaching drawing, which he began in 1693, assisting his father's friend, the writing master John Smith, at Christ's Hospital. Sturt either misremembered the date this portrait was drawn, placing it two years after Faithorne the Elder's death, or it was actually drawn by Faithorne's son. Sturt is depicted here wearing a coat and lace cravat, and holding a sheet of paper. George Vertue (I, p. 140) recorded seeing this portrait in the collection of the Earl of Oxford in 1734, seven years after he had drawn his own portrait of Sturt (later in Walpole's collection and now in the British Museum (1852-2-14-381)).

Literature: Stainton and White, 117, 193; Griffiths 1998, 125–8, 175–6, 198–9.

BERNARD LENS II (1659–1725)

71

A medley with a sheet of music, a portrait, playing cards, title pages and an initial letter, 1704

Pen and black ink with grey wash, and watercolour, 280 × 404 mm

Signed and dated on the portrait

ECM II, I

Provenance: Sir Hans Sloane; purchased with his collection for the nation 1753

Sloane, Misc. Pic. 26 (1991-U-I)

71

Medley paintings and prints were very collectable and highly valued in the eighteenth century. Examples such as those by Edwart Collyer, a Dutch immigrant to London in around 1700, included objects as well as pamphlets and papers, but medley prints showed scattered prints and cards. Sometimes printed in red and black to imitate letterpress, a medley print was admired as a piece of *deceptio visus*, a virtuoso performance of printmaking that also served as an advertisement of the printmaker's skill and the wares he sold in his shop. Lens's associate John Sturt (cat. 70) and the latter's pupil George Bickham (cat. 72) produced some of the first medley prints in 1706 and 1707. Like medley paintings, they contained underlying moral and political messages, and were sometimes satirical. The items reproduced in Lens's image here include John Smith's mezzotint of William III after Kneller (CS 273), a leaf from Henry Playford and Thomas d'Urfrey's *Wit and Mirth; or, Pills to purge Melancholy: Being a collection of the best merry ballads and songs*

(2 parts, 1699 and 1700, 240), an engraving by Jacques LeClerc of a gentleman kneeling before a lady, published in Paris by J. Mariette and three playing-cards. A long pencil inscription on the verso in a nineteenth-century hand refers to Walpole's attribution of a similar medley to another artist, Samuel Moore. The image also serves to remind us of the popularity of *découpage* (see cats 41–2).

This drawing appears in the manuscript list of 'Pictures and Drawings in Frames' in the Sloane collection as item 26: 'King William's print, a ballad &c. done by Lens. — 2.3.0'. It is not clear whether this was what Sloane paid for it or whether it was the value placed on it at his death, but it was a high value in a list that placed ten shillings against a portrait on panel of Lord Arundel. There were well over 300 items in Sloane's list, which included oil paintings (some portraits and some of curiosities), *miniata* (illuminated manuscripts, e.g. cat. 36), cut paper (cat. 41) and natural history drawings by Mrs Merian and others, all still in the

British Museum, as well as framed natural and artificial curiosities, most of which went to the Natural History Museum, and other works that have since been reattributed and are now more difficult to find. These may include a group of portraits of Mrs Fuller, Mr Sam Langley and Mrs Anne Rose, all by Taverner (nos 92, 93 and 132 on the list, present whereabouts unknown). The collection also included a number of portraits by William Faithorne (ECM & PH 1–3).

Bernard Lens II (himself the son of an enamel painter) was a prolific mezzotinter, after his own as well as others' designs, and ran a drawing school with John Sturt at their premises at the Hand and Pen in St Paul's Churchyard from 1697 (see pp. 106–7). One of their finest joint productions was a large folio print, the *Edystone Lighthouse* (1708), engraved by Sturt after Lens's perspective drawing, complete with tables of facts and measurements (see 1862-6-14-1454 and 1282, for a first impression of the print and a contemporary drawn copy after it).

As in this print, the emphasis of Lens's teaching was on perspective, fortification and taking views, which in turn recommended him to the governors of Christ's Hospital when they sought a drawing master for their 'mathemats' and their writing-school pupils in 1705. Lens taught there until his death in 1725, when his son Edward took over his post until his own death in 1750. Bernard Lens II was probably the artist of a number of the charming grey wash and pen and ink views of London scattered throughout many public collections; but his own sons Edward and Bernard III (cat. 43) and Bernard III's sons, Peter Paul and Andrew Benjamin, also taught drawing, produced similar landscapes, and were miniature painters as well.

Literature: For Lens's prints, see Ganz, 24–35, and Griffiths 1998, 264–5; for his drawings and teaching, see Sloan 1986, 'Non-professionals', chap. 2 and entry in Turner, vol. 19, 165; for early medley prints, see Mark Hallett, *The Spectacle of Difference: Graphic Satire in the Age of Hogarth*, New Haven and London 1999, 37–55.

GEORGE BICKHAM the Elder (1683/4–1758)

72

A Poem on Writing, addressed to Six Writing Masters of London

Engraving, 505 × 385 mm

Provenance: Purchased from Mr Daniell

1866-11-14-687

This plate was originally engraved by George Bickham sometime in the late 1710s and reprinted later in the century by the printseller Robert Sayer. We have already noted how printsellers advertised dozens of drawing copybooks and manuals made up from new combinations of plates in stock (cat. 39). There was an equally lucrative trade in penmanship and writing copybooks and prints, advertised and sold in the same way. In fact, the frontispieces to some of the surviving catalogues of the printsellers John Bowles and Robert Sayers were medley prints containing overlapping sheets of maps, trade cards, penmanship and drawing.

George Bickham was a pupil of Sturt and succeeded him as the finest engraver of calligraphy in London. He drew and engraved portraits as well, but supple-

mented his living by teaching drawing and writing, privately and at academies run by others. He engraved the frontispiece portraits and writing copybooks of the writing masters celebrated in this print. He also engraved Thomas Weston's mathematics, writing and drawing copybook for his academy at Greenwich in 1726, and soon afterwards employed for the first time his unique combination of drawing and writing examples on the same sheet in his *Drawing and Writing Tutor* (n.d.). Bickham's son produced several further examples in later editions of his father's and his own drawing copybooks, and the younger Bickham also taught drawing at Greenwich. Their most fascinating achievement in

copybooks of this type, *The Museum of Arts; or the curious repository*, made up of seventy-odd medley prints, each combining overprinted counterproofs of writing and drawing examples, some in colour, survives in only two copies (Newberry Library, Chicago, and Yale Center for British Art, New Haven) and a handful of loose prints.

The *Universal Penman*, issued in fifty-two parts from 1733 to 1741, was the culmination of Bickham's career as a writing master and engraver of calligraphy. In the title and introduction he echoed the sentiment of writing as a 'Useful Accomplishment' expressed in John Cooke's copied text, and described penmanship as an art where:

72

Use and Ornament Unite in One,
To serve, or grace, the counter or the
 Throne:
Art Still improving from plain Nature's
 source;
With Judgment, Freedom; and with Freedom,
 Force.

[J. Bancks, on dedication plate]

Bickham noted that writing was the first and essential step for preparing the man of business, but significantly also pointed out that drawing was another necessary qualification. To underline and support this theory, he provided decorations or vignettes for the book that could be imitated by those 'whose Genius prompts them to the Study of that Art'; although writing was the more useful of the two and therefore given more prominence and examples. The images and the texts underlined the values and virtues of a mercantile society: industry, learning, honesty, wit, poetry and liberty.

The success of *The Musical Entertainer* published by his son George Bickham, Junior, from 1737 to 1739, as well as of the elder Bickham's last publication, *The British Monarchy* of 1748, owed much to the use of this successful formula of combining writing with drawing examples in the form of vignettes, all chosen to extol the same contemporary virtues. In fact all these writing/copybooks used the opportunity to provide moral instruction in the texts chosen. The two volumes of the last publication contained a number of maps, tables and bird's-eye views, further underlining the close connection between cartography, penmanship and drawing that we see exemplified in the works Paul Sandby submitted to the Drawing Room of the Board of Ordnance two years earlier (cat. 91).

Drawing was not, however, only a requirement for more military pupils: the continued union of writing and drawing masters in one figure who taught both subjects survived through the eighteenth century in schools and academies in less urban areas. In Perth in 1798, David Junor (1773–1835), a topographical artist with limited skills who also painted in oil, was appointed drawing master at Perth Academy in 1798, and supplemented his income by teaching writing, not only at the academy but also privately (Christie's, 24 November 1998, lot 243).

As well as drawing, mathematics were closely connected with writing: using a 'good hand' was an essential requisite for clerks who kept accounts. Writing masters therefore also often taught mathematics and accountancy: John Clark, in the centre of this image, taught both writing and 'accompts', and William Kippax's *New Book of Arithmetick* (n.d., c.1740) provides a clear demonstration of the connection between the two disciplines. The calligraphic title-page advertised that the titles, tables and notes in his book were 'curiously adorned with variety of Penmanship and command of hand', and that Kippax (1705–53), 'Writing Master and Accomptant', boarded and instructed youths 'in the various branches of Education: In Great Russel Street, near Bloomsbury Square, London' (1870-7-9-36).

Literature: Massey, 88–92; Heal, *passim*; Nancy Davison, 'Bickham's *Musical Entertainer* and other Curiosities', in Dolmetsch, 98–122; Sloan 1986, 'Non-professionals', chap. 3; also entry on the Bickhams in Turner; David P. Becker, *The Practice of Letters: The Hofer collection of writing manuals 1514–1800*, Cambridge (Mass.) 1997, 96–102; Saur *Allgemeines Künstler-Lexikon* x, Leipzig 1995, 500, continues to confuse the work of father and son.

BERNARD LENS III (1681–1740)

73

Title page of *A New Drawing Book for ye Use of His Royal Highness ye Duke of Cumberland, their Royal Highnesses the Princess Mary and Princess Louisa,* 1735

Etching, 66 × 175 mm

Provenance: One of eighteen prints (others with monogram and date 1736 in plate), purchased from Mr Daniell

1872-10-12-3659 to 3676

We have already encountered Bernard Lens III in the 1710s and 1720s as Sarah Stanley's instructor in limning miniature portraits and copies (cat. 27), and Helen Percival and Mrs Delany's drawing master for views (cat. 44). A number of pen and ink copies of old master drawings dated to the early 1700s (Victoria and Albert Museum; Sotheby's, Amsterdam, 10 November 1998, lot 6) may be the products of his own earliest lessons, probably with his father. His first miniatures also date from this period, when his brother John Lens was teaching at Ayres's academy and their father, already running his own drawing school with John Sturt, began to teach the 'mathemats' and writing-school children at Christ's Hospital. One of these miniatures was a portrait of the school's writing master, George Shelley, later engraved with a frame of calligraphic flourishes by George Bickham.

The younger Lens was thus a product of this closely knit community of masters of limning, drawing, engraving, writing, mathematics and accounts who were teaching in drawing, business and private academies for young gentlemen, as well as to the young 'mathemats' at Christ's Hospital destined for the navy. Perspective, accuracy and the correct drawing of figures were key elements of the type of drawing they taught. A drawing of the fortifications of Gibraltar in the Royal Collection is signed and dated by Bernard Lens in 1704 (Oppé 1950, no. 420). From 1707 Lens or his father was giving lessons to Edward Harley, and in 1714, the younger Lens's skill in miniature painting earned him employment as a copyist and miniature painter for Edward Harley's father, Robert, later 1st Earl of Oxford. Bernard Lens III had already executed a number of similar commissions for John Hervey, later 1st Earl of Bristol. Nevertheless, he maintained

73

74

his connections with the business academies in the city and in 1722 he attended three afternoons a week at Thomas Watt's academy in Little Tower Street. Two life drawings dated the same year (with William Drummond, *An Exhibition of Portraits and Figures*, 1988–9, nos 41–2) may indicate he was attending the life classes in one of the artists' academies in London at this time.

It is not clear when Lens became limner to George I, but he served George II in the same capacity and was drawing master to his younger children, William Augustus, Mary and Louisa from at least 1733 when they were twelve, ten and nine. William began his military training shortly afterwards as Duke of Cumberland, but the princesses received lessons in drawing for the same reason as other young women at court. Not surprisingly, the images in these plates from the drawing copybook Bernard Lens etched for his royal charges in 1735 and 1736 show that he tailored his lessons to their needs, providing simple outline views of larger buildings, cottages and gardens (see cat. 43 for a discussion of his landscape views of this type), as well as military, naval and coastal views with fortifications. He produced several watercolours of costumes and headdresses, but in 1735 he also painted a series of seventeen watercolours of the *Granadiers Exercise of the Granade* (album sold at Christie's, 19 November 1985, lot 123). They were engraved after his death by his son Andrew Benjamin in 1744, and dedicated to William, Duke of Cumberland, commander of the Grenadiers, the 1st Regiment of Foot-Guards.

Literature: S. H. A. Hervey, *The Diary and Expenses of John Hervey, 1st Earl of Bristol*, 1895, 161; Goulding, 41; Roberts, 55–7; Sloan 1986, 'Non-professionals', esp. Appendix C; and entry on the Lens family in Turner, vol. 19, 165.

ANONYMOUS NAVAL OFFICER (*fl.* 1817)

74

Appearance of an Ice-Island seen by the Queensberry packet, April 2ᵈ. 1817

Blue, grey and green washes, on two sewn sheets, 140 × 260 mm, 135 × 240 mm

Inscribed with title, measurements and calculations of height

Provenance: Transferred from British Museum, Department of Printed Books

1914-5-20-675

Unfortunately, the British Museum register does not record where this item was found in Printed Books, which might have given some indication of its original source. However, these sheets depicting an iceberg and the calculations used to estimate its height by taking bearings are the types of note that might be found in a naval officer's log-book. They provide an excellent example of the use to which he might put the training in drawing and mathematics he would have received at Christ's Hospital, Greenwich Hospital or Portsmouth Naval Academy.

ALEXANDER COZENS (1717–86)

75

(a) *Near Spezia*
(b) *Spezia*

Pen and black ink, with watercolour, 183 × 240 mm and 178 × 240 mm

One inscribed: *5* and *More Chinese & W*

LB 23(a)(b)

Provenance: From an album of fifty-one drawings, purchased from Mr Smith, a descendant of the artist

1867-10-12-21, 20

The son and grandson of English shipbuilders to Peter the Great, Alexander

Cozens was born in Russia and lived in Archangel and St Petersburg before being sent to school in London at the age of ten. By 1737 he had already learned to draw and etch, and was probably apprenticed to a painter or engraver, such as George Lambert (cat. 61) or John Pine. In 1742 Pine engraved Cozens's view of Eton College, and later became his father-in-law. In the early 1740s Alexander returned to his mother and siblings who had remained in Russia, where a pension from the czarina was dependent upon his learning his father's trade of shipbuilding, but around 1745 he sailed to Italy to study drawing and painting.

Cozens's earliest landscape drawings are clearly influenced by the popular Dutch style characterized by the etchings of Waterloo (see cat. 117) that he was later to recommend to others for learning to draw. But his artistic education clearly also included lessons in perspective and views of ships and dockyards familiar to him from the area of his family's original home of Deptford, as well as from the shipyards of Archangel and St Petersburg. As he himself noted in his application for the position of drawing master at Christ's Hospital in 1749/50, he had taken many 'Coasting Prospects' at sea on several voyages. According to C. R. Leslie, these drawings had dropped from Cozens's saddle in Germany on his return to England, and were later found in Florence by his son and returned to him. They remained with the artist's descendants until their purchase by the Museum in 1867. The date of 1746 appears on one of the Roman drawings, but the dates of his arrival and departure are unknown. The drawings include coasting prospects and views of harbours. These two drawings, with one other in the collection (LB 24(a)), form sections of a panoramic view of Spezia, an important fortified naval dockyard on the Ligurian coast north of Leghorn (Livorno) that Cozens also drew, and Porto Longona on the island of Elba to the south (see cat. 76).

Literature: C. R. Leslie, *A Hand-book for Young Painters*, 1853 (see Oppé 1952); R. and S. Redgrave, *A Century of Painters*, 1866, I, 377–8; Oppé 1952, II, 12; Sloan 1986, *Cozens*, 21–8.

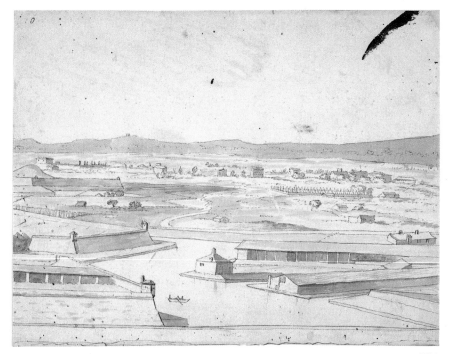

75(a)

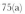

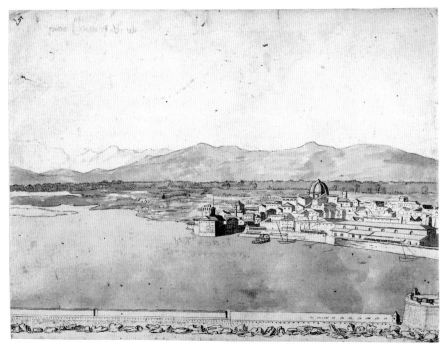

75(b)

76

(a) *Porto Longona, Isle of Elba*
(b) *A villa on a hill*

Pen and black ink, with grey wash and water-colour, 117 × 185 mm; brush drawing in grey wash with colour chalks over graphite, 112 × 191 mm

One inscribed: *Porto Longona in ye Isleand Elbe* and *2*

LB 27(a)(b)

Provenance: as cat. 75

1867-10-12-33, 30

In another Roman sketchbook now in New Haven (Yale Center for British Art), Cozens wrote that it was his intention while in Italy to 'studdy beauty of Form & injoy elegant Ideas immure [my]selff in solitude & paint ye Graces act Truth and contemplate Virtue' (quoted in Sloan 1986, *Cozens*, 1). These were the ambitions of a professional artist who intended to make his living painting landscapes with figures in oil, and in Rome he followed a programme similar to those of other artists who travelled there to study the art of the past, as well as in the studios of artists from all over Europe who worked there.

Cozens studied in the workshop and sketched from nature with the landscape painter Claude-Joseph Vernet (1714–89) and the history painter Gavin Hamilton (1723–98). The landscapes and buildings in the Roman sketchbook are interspersed with drawings of figures after the Antique and from life, but his notes indicate the importance he gave to sketching and correcting from nature. He noted that he had to develop two different ways of colouring or washing from life to reflect the two different kinds of light and shade in nature, found in clear or cloudy skies. He invented a box to transport wet inks and colours out of doors, experimenting with a variety of media and styles and methods for capturing the different kinds of landscape seen while travelling.

In Rome Cozens's work gradually moved away from the reliance on outline and topographical detail visible in his 'coasting prospects' to sketches drawn with the brush and landscapes that were based on reality but carefully composed along the lines of the works by other artists, old masters and contemporaries, that he saw in Rome. Sometimes grey wash was laid over a carefully drawn and detailed composition, which had been squared up for transfer,

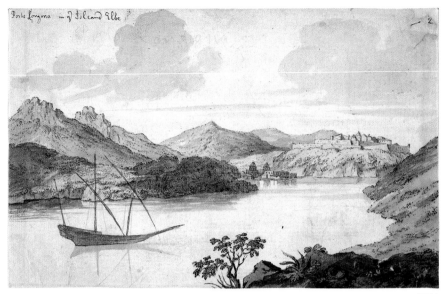

76(a)

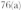

76(b)

with the foreground picked out in pen and ink, while at other times, as in the present drawing of a villa, he sketched freely with a brush, concentrating on recording light and shade in order to refer to it later for the finished composition (LB 20(a) 1867-10-12-24). The sketch for this view of Porto Longona is missing but was probably made on the spot, as the foreground, colouring and pen work were likely done later, and are comparable to the finished drawing of the villa.

On his return to England Cozens was able to employ his topographical skills in his teaching position at Christ's Hospital and for the handful of oil paintings of particular views he was commissioned to paint. He also taught private pupils such as members of the Harcourt family (cat. 96) to draw and sketch views from nature. But from the 1760s he tended to concentrate, in his teaching and in his own finished works, now mainly on paper, on imaginary landscape compositions in which he gradually eschewed figures and nature for various compositions that were intended to arouse specific responses in the viewer (see cat. 107).

Literature: Oppé 1952, 77–83; Wilton 1980, 19–23; Sloan 1986, *Cozens*, 9–20.

WILLIAM HARCOURT
(1743–1830)

77

*View of Havana, c.*1762

Pen and grey ink with watercolour,
315 × 530 mm

LB 1

Provenance: Purchased from Mr Toon
1882-12-9-766

Like his father, Simon, 1st Earl Harcourt (1714–77), and his brother, sister and wife, William Harcourt was very close to court circles and an active amateur artist. His father was wealthy, elegant and impeccably mannered, and on his return from his grand tour in 1734 helped to found the Society of Dilettanti and was made lord of the bedchamber to George II. The 1st Earl Harcourt attended the king at the battle of Dettingen against the French in 1743, becoming a colonel in 1745 and general in 1772. When Frederick, Prince of Wales, died, he was appointed governor to his sons, the princes George and Edward. In 1761 he was chosen as the new king's proxy for his marriage to Charlotte of Mecklenburg, and on his return was given further appointments in the queen's household, followed by posts as ambassador to Paris and lord lieutenant of Ireland.

The relevance of the 1st earl's history at court, and his taste in landscape and artists, will become more apparent in the discussion of the work of his elder son George and his daughter Elizabeth (cats 96, 109). Comparatively little is known of their younger brother William's early education and his connection with the artists who taught them cannot be documented as clearly, but it seems likely, particularly on the evidence of the present watercolour, that he shared their lessons in landscape with Alexander Cozens and Paul Sandby and may also have studied perspective with Joshua Kirby (see cat. 67) or copied drawing examples provided by Bernard Lens several decades earlier for other royal pupils (see cat. 73).

Unlike his elder brother, who was educated to become the 2nd earl and sent on a grand tour at the age of nineteen, in 1759 William Harcourt was given command of a troop in his father's horse regiment, two years later accompanying his father's suite to Mecklenberg. This was followed by a post in the royal household and various military appointments, including aide-de-

77

camp to Lord Albemarle at the taking of Havana in 1762. This very accomplished view of the city, presumably from a tower overlooking the main square, includes the main buildings, fortifications, harbour and details of the wooded shore opposite, and would do justice to the portfolio of any professional military topographical draughtsman. At some time prior to 1882 when it was purchased by the Museum, this watercolour was badly damaged by an auctioneer or dealer writing the word 'Watercolour' and a price or lot number on a wrapper. Nevertheless, it indicates an appreciation of atmosphere, light and shade and composition that hint at an ability in landscape watercolour that sadly cannot be documented by any other surviving examples, although his brother Viscount Nuneham etched several of William's landscapes drawn abroad, including the *Morro Castle taken from the town* of 1762. William Harcourt also learned to etch, as Richard Bull's album of etchings by amateurs includes his 1764 caricature of a washerwoman very similar to the series produced by Sandby around this time (Bull I, no. 47).

William Harcourt's successful military career included the capture of General Lee on the Delaware in 1776, and twenty years later he was made general and appointed the first governor of the Royal Military College at Great Marlow. On the advice of his friend John Fisher (see cat. 138), he approached John Constable to fill the post of drawing master, but the artist declined. The position went instead to

William Alexander, later keeper of Prints and Drawings in the British Museum. Harcourt succeeded his brother as 3rd earl in 1809, having lived at St Leonard's Hill in Windsor from 1782 where he was deputy ranger of Windsor Great Park. His wife Mary was an accomplished amateur pupil of Alexander Cozens (see cat. 108)

Literature: Edward W. Harcourt, ed., *The Harcourt Papers*, XI, Oxford 1905, 145ff.; *DNB*; Fleming-Williams, in Hardie III, 217–18.

THOMAS MITCHELL (1735–90)

78
View of Deptford with a Man-of-War under repair

Brush drawing in grey wash, with watercolour, over graphite, 211 × 454 mm

Not in LB

Provenance: Purchased from Mr Toon

1882-10-14-14

Thomas Mitchell combined service as shipwright to the Admiralty with his recreation of painting marine views in wash, watercolour and oils. He won a premium at the Society of Arts in 1766 in the category of 'Original Sea Pieces in Oils' of the artist's own composition, $4\frac{1}{2}$ by 3 ft or $5\frac{1}{2}$ by $3\frac{1}{2}$ ft in size. Dossie, who recorded the premiums in 1782, described Mitchell as a 'ship painter, Chatham, Kent', but the Admiralty records state that he was a builder's assistant at HM Dockyard, Chatham, in 1771. He also worked at Deptford, and in 1774

conducted a supplement to the survey of the harbours, eventually becoming assistant surveyor of the navy.

Mitchell exhibited large battle pieces at the Free Society of Artists and the Royal Academy from 1763 to 1789. The British Museum has a large collection of his drawings. A series in grey wash depicts the main dockyards and harbours of southern England, especially around Plymouth, but his finished works rarely have colour or the spontaneity of the present view, which retains the impression of having been sketched on the spot.

Literature: Robert Dossie, *Memoirs of Agriculture and Other Oeconomical Arts* III, 1782, 434.

CHARLES GORE (1729–1807)

79
View of Bonn, 1790

Pen and black ink and watercolour, 182 × 532 mm

Inscribed: *Vue de Bonn, Bonn, No 21* and *Bonn sur le Rhin Cs Gore 1790*

LB 26

Provenance: Bequeathed by Richard Payne Knight

Oo.5-68

The majority of Charles Gore's drawings and watercolours was of marine prospects and views although Gore did not receive his training in this type of drawing through preparation at a naval academy. Rather, he was the son of a Lincolnshire landowner, educated with the Earl of Bristol and William Hamilton (see p. 171) at Westminster, who married the heiress of a shipbuilding company and learned to draw and design ships through his close contact with them in business. He lived for a time at Southampton until 1772 when he and his family sailed to Lisbon and later to Italy in an effort to improve his wife's health.

In Rome, Gore became a close friend of the German artist Jakob Philipp Hackert (1737–1807), who was drawing master to his daughters Eliza (1754–1802) and Emily (1755–1832). Many of the surviving works by his daughters (Kunstsammlungen zu Weimar, Schlossmuseum) are easily mistaken for their teacher's bright decorative landscapes in bodycolour, but they also sketched landscapes, as did their father, in grey, blue or brown washes. Goethe

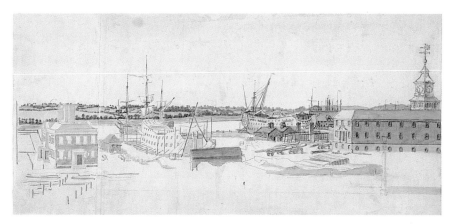

78

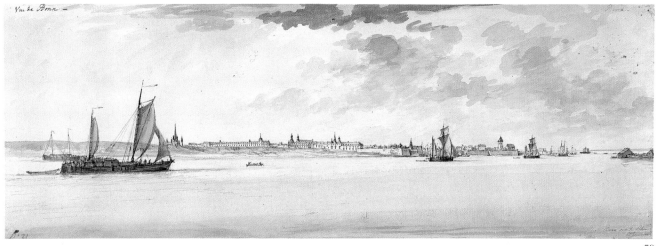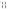

79

appended several pages on Gore to his 1811 biography of Hackert, recording that Gore spent two summers with the artist sketching from nature in the Alban Hills and in the winters spent most evenings at Hackert's house with other English and German artists. Eliza later described to Goethe how they sat around a table spread with lamps and Hackert's studies from nature, copying them and 'competing in handling the lead pencil and sepia' while an *abbé* stirred their imaginations with readings from Tasso.

Gore and Eliza may have taken lessons in watercolour from the British watercolourist William Pars who arrived in Rome the same year as the Gores. All three painted views of the interior of the Colosseum with the Martyr's Memorial. Charles Gore's was sold at Christie's, 9 April 1991, lot 27, and Eliza's on 13 November 1990, lot 96 (now Ashmolean Museum, Oxford). Eliza's is a copy of Pars's finished watercolour in the Birmingham Museum and Art Gallery. But it was his interest in classical antiquities that led Charles Gore to join Hackert

and Richard Payne Knight on their expedition to Sicily from April to June 1777 (cats 126–8). The family spent two years in Switzerland before returning to England in 1779 where Gore painted a series of loosely washed panoramic views of Sussex. They did not remain in England long, returning to the Continent in 1782, where Gore's wife died three years later. He and Eliza settled in Weimar in 1791, where he became an intimate of the Weimar court, having met Goethe and others through Hackert. On his death Gore left five great folio albums containing around a thousand drawings to Duke Karl August of Saxe-Weimar (now in Goethe-Nationalmuseum, Weimar).

The British Museum has a large collection of drawings by Gore that all came from Payne Knight's bequest – many are of Sicily, but several are shipping scenes, some in brown wash, concentrating on the waves and ships, with no landscape in sight, but others are like the present view, which must have been taken *en route* to Weimar. Another, very large panoramic watercolour

(900 mm wide) is a view of Isola Bella, dated 1795 and, like many of the marine views that are dated 1794, it must have been sent to Payne Knight by his friend. Although his drawings of ships were always accurate, in most of his marine views, Gore displayed a freedom of manner, employing especially loose washes in the sky that are reminiscent of the work of the van de Veldes, which he greatly admired. This loose manner is not always evident in his Sicilian views, which were presumably done directly under Hackert's influence and to fulfil certain topographical and other factual criteria dictated by the purpose of their expedition.

Literature: C. F. Bell, Manuscript notes on the Gore drawings at Weimar and translation of Goethe's biographical sketch of Charles Gore, 1933, in the Girtin Archive, P&D; C. F. Bell, Introduction to 'The Drawings and Sketches of John Robert Cozens', *Walpole Society* XXIII (1934–5), Oxford, 6–11; A. Wilton, 'Eliza Gore: An English girl in Rome in the 1780s', *The Ashmolean* 20 (1991), 16–17; Ingamells, 410–11.

80(a)

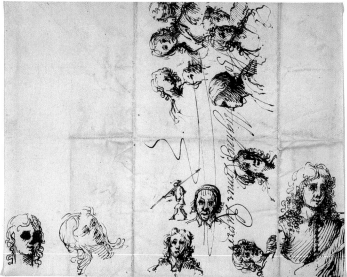

80(b)

PRINCE RUPERT (1619–82)

80

(a) *A Mortar mounted on a boat, with a cross-section above*

Pen and brown ink with wash over black lead, 171 × 186 mm

Inscribed on verso: *P. Rupert*

(b) *Studies of heads*

Pen and brown ink, 150 × 190 mm

Inscribed: *ffor his Highness, Prince Rupert*

LB 1,2; ECM & PH 1,2

Provenance: Hugh Howard; Dr Robert Howard (Bishop of Elphin); Earls of Wicklow; Charles Howard, 5th Earl, from whom purchased

1874-8-8-2273,2274

During the Civil War, Rupert assisted with the direction of the operations of the royalist ships and in 1648 he was made admiral of the fleet, a commission renewed by Charles II during the Interregnum. Although his activities at that time were perforce barely distinguishable from those of a pirate, he sailed in the Tagus, Mediterranean, Azores and West Indies and took the opportunity to experiment with herbal cures, devising one for burns and another for the bloody flux, later used by John Locke, physician to Rupert's friend the Earl of Shaftesbury. In his travels during the Interregnum, Rupert collected a number of new mechanical skills that he imparted to the Royal Society on his return and put to use against the Dutch fleet in the mid-1660s. He continued to experiment with ordnance in his forge and laboratory at Windsor, and in 1671 gained a patent to produce a high-quality cannon with his new metallurgical process, sharing the profits of the production with the co-owners of his company, including the master of the Ordnance.

The rather primitive type of 'mortar' in this drawing defied precise identification until 1993, when the late G. W. E. Farrow in a letter to the Museum pointed out that it seemed to be a sketch of a *cannone di corsia*, a type of wrought-iron bombard mounted as a centre-line gun in the bows of Mediterranean war galleys from the second half of the fifteenth century. They were tried out by the English navy for a brief period in the late seventeenth century, when they were known as Cassia guns. The Tower inventory of 1701 listed two 'Cashee Pieces' invented by Captain Richard Leake, master gunner of England between 1677 and 1696. With a slightly higher elevation than a howitzer, they were the predecessors of sea-service mortars.

The juxtaposition here with sketches of heads and figures possibly drawn from life is a fortuitous one, as it underlines the fact that even those like Prince Rupert, who were taught military drawing, with its emphasis on perspective, architecture and artillery, were first taught to draw the human figure.

Literature: Fergusson, *passim*.

JOHN HAMILTON (*fl.* 1767–85)

81

Back view of Tyburn at an execution, 1767

Pen and brown ink and watercolour; on two conjoined sheets, 121 × 359 mm

Inscribed upper left: *by J. Hamilton a back — view or Scetch of Tybourn (Taken Oc.r ye 14th – 1767 ye Day 'Greens... hanged'* [struck through] *that Guest — the Bankers Clark was hanged* and below image: *it was the Custom of Lamplighters in those days to Erect their Ladders together – for persons to mount them at 2d & 3d each to see the Executions. Some of their Partys frequently pulled down the ladders to get fresh customers to mount 3d: June 1795*

LB 1

Provenance: Purchased from Alphonse Wyatt Thibaudeau

1883-7-14-103

Many antiquarians, including John Aubrey, were as keen to record costumes and customs as they were ancient monuments or ruins, which they felt might be lost to posterity if no visual record existed. The present drawing appears to be by an amateur; that he was also an antiquarian is clear from his unusual approach to the subject, which does not dwell on the features people usually found gruesomely fascinating at Tyburn, nor on the events for which this particular hanging was renowned at the time. A note in the Museum dossier states that William Guest, a teller in the Bank of England, was convicted of filing guineas, a crime of high

treason. While praying before his death, 'his deportment was so pious, grave, manly, and solemn as to draw tears from the greatest part of the spectators'. The movable gallows in use at this time are barely visible in the centre of the drawings, and the artist is clearly more anxious to record the structures and machines provided for spectators than the spectacle itself.

This drawing has always been attributed to an artist of this name, sometimes described as an amateur, whose dates are not known but was said to have been born in Dublin and came to England shortly afterwards. He was a friend of John Astley who made him manager of his estates at Over Tabley, near Chester. He exhibited views of the house and park, and other landscapes at the Society of Artists between 1767 and 1777, where he was vice-president. He was also a friend of the amateur artist and antiquarian Captain Francis Grose (cat. 89), and etched the plates for his *Ancient Armour and Weapons* (1785). No paintings by him appear to survive and the present drawing and the etchings were all that was known of his work. The name, however, is a common one and it is possible that his history has been conflated with that of Captain John Hamilton who served in the Maritimes from 1753 to 1759 and in Montreal in 1760 during the Seven Years' War, and died in 1777.

Captain Hamilton made several topographical grey wash drawings of forts Beauséjour and Lawrence on the Bay of Fundy during a siege between them in 1755 (King's Topographical Collection, Map Library, British Library and the Public Archives of Canada). Hamilton's drawings were used as the basis for a painting for Brook Watson in 1805 to record an event during the siege (now New Brunswick Museum). It seems more likely that this present view of Tyburn is by Captain Hamilton, whose military drawings it resembles, rather than by the artist to whom it has always been attributed.

Literature: notes in P&D dossier from Alfred Mack's *History and Annals of Tyburn*, 1908, and information from Dr J. C. Webster's 1939 catalogue of his collection at New Brunswick Museum provided by Andrea Kirkpatrick (letter 30 March 1999); Bell, 30, 221.

81

82

K. COFIELD (*fl.* 1760)

82

*Cannon taken at Quebec,*1760

Graphite, 179 × 296 mm

Inscribed: *two 4 Pounders taken at Qebeck before the Governors Door in 1759 and now deposited in the Grand arsenell in the tower of London*, with scale in feet, and signed: *K. Cofield, pinxt, 1760*

LB 1

Provenance: Purchased from Mason

1873-5-10-1736

The artist of this drawing is not known, but it seems probable that he was a draughtsman in the Drawing Room of the Board of Ordnance at the Tower of London, where Thomas and Paul Sandby worked in the 1740s. The Drawing Room trained and employed both civilian and military draughtsmen who worked either in the Drawing Room itself or were attached to particular military personnel, especially engineers serving at various stations in Britain and abroad. Few of the Ordnance records survive for this period so it is not possible to identify Cofield or details of his service. But it is clear that the cannon depicted were captured from the French governor in Quebec in 1759 and deposited in the Royal Arsenal at the Tower, and it was presumably the business of the Drawing Room to record the ordnance there.

The master of the Ordnance was also responsible for and examined the cadets of the Royal Military Academy at Woolwich. To some extent the training at the Drawing Room was duplicated by the drawing masters at Woolwich. In 1750, for example, Robert Sandham, a young cadet at Woolwich, wrote to his parents that since he had been there he had 'drawn a Cannon and a Mortar-bed by a scale, and begun a Landscape after the Mezzotinto manner...'. In 1782 a warrant was signed by the master of the Ordnance to reduce the establishment of the Drawing Room at the Tower, which seemed 'ill-calculated for instruction', and to augment the complement of cadets in the Artillery at Woolwich by teaching them there (Jones, 29).

A VIEW of CHARLES FORT near KINSALE in IRELAND.

83

A few cadets' 'Course of Artillery' notebooks survive in the library of the present Royal Artillery Institution at Woolwich Arsenal. They not only contain calculations and lists of diameters of shells, recipes for grape shot and exercise and manoeuvres of guns of various weights, but the information is also illustrated with careful, measured, pen, ink and wash drawings of the artillery, carriages, bridges and ladders, and men manoeuvring them. Some of the notebooks are by Paul Sandby's drawing pupils at Woolwich, but they contain few landscapes. They indicate instead that lessons in drawing, particularly figures, elevations and perspective, which were taught by the assistant drawing master (Gabriel Massiot, 1744–82; Robert Davey, 1782–93; Joseph Barney, 1793–?), were an essential part of a cadet's training, particularly for their lessons in surveying, artillery and fortification.

Literature: Sandham quoted in Buchanan-Dunlop, 7; Jones, 29; Fleming-Williams, 'Drawing-Masters', 216–17; Parris, no. 73.

CHARLES TARRANT (fl. 1752–65)

83

A View of Charles Fort near Kinsale in Ireland, 1756

Watercolour, touched with pen and black ink, 236 × 390 mm

Inscribed: *Chas: Tarrant Delin: 1756* and *A VIEW of CHARLES FORT near KINSALE in IRELAND.*

ECM II, 1

Provenance: Presented by J. C. Lyell

1919-3-28-1

From 1720, five years after the Jacobite rising of 1715, until 1740, five years before the rebellion that ended at Culloden, General George Wade employed 500 soldiers to carry out a massive road and fortification programme to enable easier military movement by British troops in Scotland. After the '45, the programme continued but maps of the country were inadequate and in 1747, Lieutenant-Colonel David Watson began a great Military Survey of the Highlands in order to produce an accurate map. The survey, which later

also included the southern part of Scotland, took nine years to complete, and was headed by a civilian surveyor, William Roy (1726–90), who was assistant quartermaster to Watson.

Roy had been trained as a civilian draughtsman in the Ordnance Office in Edinburgh, the Scottish equivalent to the Board of Ordnance Drawing Room in the Tower of London where Thomas and Paul Sandby trained. The board's records for this period are incomplete: Paul Sandby was chief draughtsman from the beginning, responsible for the eventual presentation or 'fair copy' of the map, but the surveyors were also skilled draughtsmen and it is not clear whether the only other two draughtsmen whose names are known were military or civilian. John Pleydell's surviving work indicates that he was only employed briefly on the later part of the survey in the south of Scotland, but Charles Tarrant was posted to Scotland in 1750 as the result of a request by William Skinner, director of engineers in Scotland, for another draughtsman for the survey. According to his surviving work in the Map libraries in Edinburgh and London, where the maps passed after they

ceased to be military documents in 1761, Tarrant worked mainly on Skinner's plans for the new Fort George and little on the survey in general. Thus the similarity of this work to watercolours by Paul Sandby is due less to influence of one on the other, than to a similar training in the drawing of conventional and military landscape.

In 1755, at the beginning of the Seven Years' War, work on the survey ceased. A year later Tarrant painted a watercolour view of *Stirling Castle* (private collection) and the present view of Charles Fort in Ireland, looking west towards the fort with Kinsale Harbour to the left, a ship flying the red ensign, Kinsale in the distance and the tower of Rincurran Church to the right. Although both are of military subjects, they are drawn as conventional landscapes and seem to have been intended as traditional views, possibly forming part of a series to be engraved. The bright colouring is unusual, even for a well-preserved watercolour kept from sunlight, and is also found in Tarrant's military work. It may be the result of training in military maps, which use colours to symbolize certain features, such as blue-green for water, green for woodlands, yellow with hatching for land under cultivation, solid red for houses and red outline for formal grounds.

It is still unclear whether Tarrant had been a civilian or military draughtsman in Scotland, as army lists only record him from 5 September 1756. The following year he began working his way up from practitioner engineer and ensign, to sub-engineer and lieutenant in 1760. In 1758 he served under Admiral Keppel in the expedition to the island of Gorée, off Senegal, which he surveyed after its capture and produced an account of its fortifications, as well as designing a block-house to be erected at Cape Apollonia on the Gold Coast. A survey of the rivers around Lismore, County Waterford (Public Record Office) is signed *Captain Charles Tarrant R.E.*, which must have been from a later posting, as the last record of him is in Dublin in 1765.

Literature: O'Donoghue, 18; Christian, 19.

FRANCIS BARLOW (*fl.* 1648–1704)

84

*Kit's Coty, Kent, c.*1659

Pen and brown ink with grey wash over graphite, verso blackened for etching plate, 190 × 130 mm

Inscribed illegibly below image, containing words *Kent* and *by Hollar* on r

Provenance: ?Jonathan Richardson (faint L. 2183); Dudley F. Snelgrove, by descent to his children, their sale of his collection, Sotheby's, 19 November 1992, lot 169, bt in; purchased from P. Snelgrove and M. MacKenzie

1993-12-11-5

Francis Barlow's activities as a draughtsman of natural history might easily have been discussed in the first chapter alongside the work of Francis Place, as his drawings of birds and animals, the finest produced anywhere in Europe that century, were etched by Place and Hollar and frequently reused

in drawing manuals. His two earliest drawings in the Museum, the *David slaying the lion*, (1648), and a group of heads of various types and ages from different angles inscribed *Invention* (ECM & PH 1, 2) bear all the characteristics of works intended for a drawing book. Like Place, Barlow painted still lifes and animal paintings in oil, but his greatest achievement was his illustrations to the 1666 edition of *Aesop's Fables*, which he etched himself after his own original drawings (most now in Department of Prints and Drawings, British Museum). This first edition had English verses by Thomas Philipott engraved on the plate itself below the image.

In 1659 Philipott's *Villare Cantianum: or Kent Surveyed and Illustrated* was published with only two or three prints, including one after the present drawing, which was printed on the top half of page 49 in the text. It bore a dedication line from Philipott to Johnathan Wroth of Bexley, who had paid for it to be etched for the book. The name

84

of the engraver was not given and has been assumed to have been Hollar, but it is almost certainly by Barlow himself. Although he was modest about his ability, he was one of the best English etchers in the seventeenth century, and this print for Philipott may have led to the collaboration on *Aesop's Fables* mentioned above.

Hollar and Faithorne (see cat. 70) have been mentioned in connection with John Evelyn and Samuel Pepys, but they were well known to other Royal Society Fellows such as John Aubrey and William Dugdale who represented yet another side of the interests of seventeenth-century *virtuosi* – antiquarianism. Aubrey's notes on Hollar provide the greater part of our knowledge of his life, and he employed Faithorne to draw his portrait for the frontispiece to his intended publication *Monumenta Britannica*, which he hoped would record for posterity ancient monuments that were gradually being destroyed. Aubrey's work, which included notes on Kit's Coty, was largely based on his own examination, surveying and drawing of sites, a procedure later followed by Stukeley and others (cat. 85). Dugdale, on the other hand, sought to record equally endangered religious buildings and monuments. In 1640–1 he had toured the Midlands with William Sedgwick whose watercolour drawings illustrate Dugdale's two-volume manuscript 'Book of monuments' now in the British Library. He later commissioned other artists to make drawings to accompany his researches into their paper records, and had Hollar engrave them as plates to illustrate his publications, including *Monasticon Anglicanum* (from 1655 to 1673) and *Antiquities of Warwickshire* (1656). They quickly inspired many other county histories including Philipott's of Kent. This drawing by Hollar's friend Barlow records Kit's Coty, which Philipott (p. 48) explained took its name from its resemblance to a sheepcote. It was actually a Bronze Age megalith believed by Philipott to be the tomb of an ancient British hero, Catigern, son of Vortigern, King of South Britain. It is one of the earliest records of a megalith by a professional British artist and was an unusual subject for Barlow. No related drawings are known. It is a tantalizing glimpse of this early close involvement between artists and antiquarians, at times so close that the two interests often merged, with artists either drawing scenes for antiquarians, or interpreting the latters' own amateur drawings by turning them

into finished drawings, watercolours or prints. It may bear the collector's mark of Jonathan Richardson, but the mark, like the inscription is very faint and difficult to read.

Literature: Godfrey, no. 113; Griffiths 1998, 140–1, nos 88, 125; for Barlow in BM see ECM & PH 1–137, Stainton and White, 141–53.

WILLIAM STUKELEY (1687–1765)

85

Sketchbook open to *The Otus or eared owl*, 1728

Brush drawing in ink, 238 × 153 mm

Inscribed: *The Otus or eared owl, sent me from Grimsthorp park by the Duchess of Ancaster Nov. 1728*

ECM II, 3 (12)

Provenance: John Thane; E. H. Dring, by whom presented

1928-4-26-1(1 to 24)

William Stukeley's work on the stone circles at Avebury and Stonehenge has made him the best-known of all eighteenth-century antiquarians. For much of the nineteenth and twentieth centuries, however, his work and that of his fellow antiquarians was dismissed by archaeologists and historians

85

as the speculations of unscientific amateurs; their work was largely ignored and their manuscripts remained unexamined, often to the detriment of the monuments that they had sought to save. But he and his predecessors such as Aubrey, and his own friends like Sir John Clerk of Penicuik (see cat. 94) were serious in their intentions to record their investigations, employing their amateur abilities at surveying and mathematics, as well as drawing plans and prospects.

Stukeley knew of Aubrey's manuscript work *Monumenta Britannica* through notes taken from it by Thomas Gale, and his own first manuscript, 'The History of the Temples of the Antient Celts' (1722–3, Bodleian Library, Oxford), often makes reference to Aubrey's conjectures on specific monuments including the Devil's Coits at Stanton Harcourt and Kit's Coty in Kent, which Stukeley himself visited in October 1722 (see cats 84, 96). Most British still believed, as Inigo Jones had done, that the stone circles at Avebury and Stonehenge had been built by the Romans; two of Jones's drawings of *Stonehenge restored* have recently been discovered in the Museum (see Chippindale). But Aubrey and Stukeley were convinced that they were pre-Roman, built by ancient Britons, the Celts, and were somehow connected with their religion, which was thought to be druidic.

Stukeley's publications, especially *Stonehenge, Temple restor'd to the British Druids* (1740) and *Abury, a Temple of the British Druids* (1743), inspired not only fellow members of the Royal Society and Society of Antiquaries, such as Dr Mead and Hans Sloane, but also later antiquarians, travellers and amateur artists to make their own pilgrimages, records and drawings of similar ancient monuments. However, it was his writings on the ancient Britons, the mysterious Druids and their religion, that ignited the imagination of most later readers, and their eventual 'recognition' of the Druids as the founders of British liberty.

There are a number of portraits of Stukeley, including a well-known self-portrait in the British Museum (LB1), which came from the same collection as the present work, along with Stukeley's portrait of the artist Gerard Vandergucht. The latter was a member of Stukeley's club for the study of Roman Britain, the so-called Society of Roman Knights. He and another member, the engraver John Pine, accompanied Stukeley on his summer tour of 1722

and engraved the plates for many of his publications. Stukeley's ability to draw, however, was the result of childhood drawing lessons from his writing master in Lincolnshire, Mr Coleman, who had 'a mighty knack of drawing with the pen' (Piggott, p. 20); at Cambridge Stukeley drew landscapes and began to make drawn records of interesting antiquities. He drew many subjects other than antiquities – notably views of the gardens and interior of his house at Grantham, which survive with his manuscripts in the Bodleian Library, Oxford.

The present sketchbook only came to the Museum in 1928, thus was not recorded in Binyon and has not been mentioned in any of the literature on Stukeley, including a recent article on his house at Grantham. It is an important addition to the literature, which needs further examination than can be provided here. It contains his typical pen and ink drawings with touches of wash, and includes drawings of sculpture such as a personification of architecture labelled *Augusta Trinobantium*, a Greek bas-relief (drawn 3 November 1724), designs for his garden and orangery at Grantham (1728, 1729), Sir Michael Newton's temple at Hathor (1728), the interior of the *Best Bedchamber Barnhill. 1744* which includes the placing of portraits, notes on a *Map of Levels in Lincolns.* (1722), a view of Seven Dials (1722), Highgate Woods, studies of effigies of William Baxter and *Caruilius Magnus* (Thomas Herbert, 8th Earl of Pembroke, one of Stukeley's Roman Knights, 1723), a statue *In Cupers garden 25 Jan. 1723/4. G. V. Gucht f.* and, finally, Greek and Latin inscriptions addressed to Lord Pembroke (possibly the dedications to him in *Iter Dumnoniense*), with whom he stayed at Wilton – he drew and catalogued the earl's antiquities (Piggott, p. 68). Stukeley had drawn a view of Ancaster in July 1724 (Piggott, p. 90; engraved as a plate in *Itinerarium Curiosum* II, pl. 15), and the horned owl shown here was sent to him as a 'curiosity' by the Duchess of Ancaster (see cat. 118), but 'died and I buried it in my garden: this gave great offence to its kindred the gentlemen and Squires of Grantham, who encouraged the mob to abuse me upon it' (quoted in Scoones, 164).

Literature: Christopher Chippindale, 'Two original drawings for Inigo Jones and John Webb's "Stone-heng Restored"', *Antiquaries Journal* LXIV, pt I (1984), 106–11; Stuart Piggott, *William Stukeley: An Eighteenth-Century Antiquary*, revised edn 1985; Ucko, Hunter *et al.*, 42–53, 67–85; Francesca Scoones, 'Dr William Stukeley's house at Grantham', *Georgian Group Journal* IX (1999), 158–65.

GABRIEL BRAY (1746–1823)

86

View of St Augustine's monastery at Canterbury

Brush drawing in grey wash, with watercolour, 234 × 289 mm

Inscribed on a separate sheet: *A View of St Austins Monastry at Canterbury Drawn by Capt Gabriel Bray of Deal* [continues with anecdote about artist and provenance of drawing, then signed] *Canterbury 29th Jany:1788 Eli. Berkeley*

LB 1 (as a view of Lincoln)

Provenance: Miss Anson to George Monck Berkeley; part of a group of 'Etchings and Drawings by Amateurs, from selections from Mr. McIntosh's sale', Christie's, 20 May 1857, purchased for the Museum through Messrs Evans

1857-5-20-139

According to the long inscription attached to the original mount of this drawing, it was presented to the young writer George Monck Berkeley (1763–93) by Miss Anson as a keepsake when he was about to leave Canterbury: this must have been in 1775 when Berkeley left the King's School for Eton. Over a hundred years after Barlow's drawing of *Kit's Coty*, Bray's watercolour illustrates how the English fascination with antiquities had altered in the intervening years. Both set the objects of their views within the landscape conventions of their times, accompanied by appropriate figures; but Barlow's shepherd and his rustic companion have become young military gentlemen in Bray's watercolour. Barlow's monument represented an ancient but native religion before the Romans came to Britain, while the Roman-dominated religion, represented by the monastery in the foreground of Bray's watercolour, is in ruins, and the strong towers of Canterbury Cathedral and St Augustine's Gate, representing the unification of church and state, rise beyond the monastery's crumbling walls. By the time Bray painted his view, interest in ancient monuments had become the preserve of a handful of dedicated antiquarians whose main objective was to record them, while ruins of castles and churches were monuments of a more recent and immediately understandable past, which did not need to be measured and recorded, but could serve a double use in a landscape as symbol as well as picturesque element.

By the second half of the eighteenth century, drawing had also become a 'polite' recreation, an accepted way in which a gentleman might usefully employ his leisure, and it is not surprising to find many young officers producing 'official' views of coasts, fortifications and prospects, which now survive in map libraries and archives, as well as more picturesque landscapes drawn during their leisure time as souvenirs for themselves or gifts for others, or to be engraved as views for the armchair-traveller as intended by Charles Tarrant (cat. 83) and later military amateurs such as Williamson (cat. 105) and Colebrooke (cat. 104).

The inscription on this drawing records another by Bray of George III reviewing the fleet under the command of Sir Richard Spry at Portsmouth in 1773. Bray sketched it on the spot and sat up all night to finish it so that it might be presented to the king the following day, 'as occasioned his Majesty on seeing it to promote him'. The drawing must be the one catalogued as 'anonymous' in the Royal Collection (Oppé 1950, no. 721). Gabriel Bray was indeed promoted to lieutenant on 25 June 1773 and posted on board HMY *Augusta*. A drawing of a ruined castle in Cumberland (LB 2) and an oil painting titled *A ship hove down and burning off* (Greenwich, National Maritime Museum) were the only other known works by Bray until the sale by his godson's descendants of an album of ninety-five drawings made on a voyage to the British colonies in Africa and Jamaica from 1774 to 1775. Mainly watercolours, they include landscapes of Deal and Portsmouth, as well as figure studies of gentlemen and ladies, sailors and natives, and a self-portrait of Bray painting in his cabin. His interest was more in the customs and costumes of the inhabitants of the places he visited than in their topography, reflecting the changing attitudes of travelling amateur artists as the century progressed. Bray joined the repeat voyage in 1775–6 but after 1782 he was a captain in the Customs House Service.

Literature: Sale catalogue, Sotheby's, 11 April 1991, lot 11.

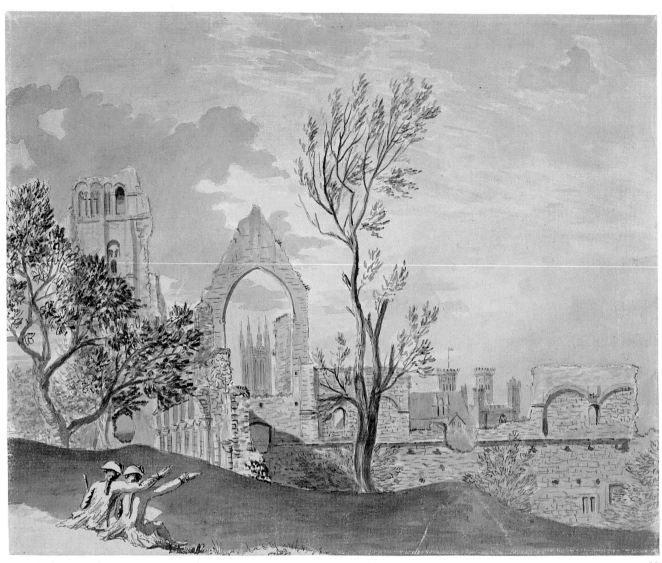

86

MOSES GRIFFITH (1747–1819)

87

Beeston Castle from the canal

Watercolour with pen and grey ink, mounted on original washed mount, 165 × 281 mm

Inscribed on mount with title

Provenance: By descent from Thomas Pennant through his granddaughter who married 7th Earl of Denbigh; by descent to Viscount Fielding, sale of his estate including nearly 2,000 drawings (mostly extra-illustrations in bound volumes) by Griffith, Christie's, 1938, portfolios of loose drawings bt Walker's Galleries, by whom exhibited for sale, February 1939, no. 1, where purchased with four others

1939-3-11-17

Thomas Pennant (1726–98) was born into an ancient Welsh family whose seat was Downing, in Flintshire. He was interested in natural history from childhood and went up to Queen's College, Oxford, at the age of eighteen, touring Cornwall two years later to study fossils and minerals. Although no accounts of his life mention it, he must have known how to draw in order to make his own visual records and an early portrait confirms this. It was probably painted by Joseph Highmore (1692–1780) while Pennant was in London before Oxford and shows him holding a volume of drawings and a *porte-crayon*. The entry in the sale catalogue (Sotheby's, 15 July 1992, lot 21) described the volume as a collection of Dutch drawings, thus demonstrating his early interest in collecting. But the drawings

are clearly his own copies after prints or a drawing manual, in the same manner as Highmore's daughter Susanna learned to draw (see p. 214), or Malchair's pupil Skippe at Oxford thirty years later (cat. 124).

A noted naturalist, Pennant published important works on British and Indian zoology from 1766, the year before he was elected a Fellow of the Royal Society. But in British art he is better known as the employer of Moses Griffith, who became his personal servant in 1769 and 'early took to the use of his pencil', accompanying Pennant on his tours around North Wales, the Isle of Wight and the Border counties. When Thomas Pennant died, Griffith attempted to set himself up as an engraver, but soon began to make Welsh views for Pennant's son.

Beestone Castle from the Canal

87

Moses Griffith was probably trained by a local portraitist in the limning tradition, as he was at his best working with brightly toned bodycolours on small portraits and copies of old master paintings, objects of natural history and individual buildings rather than landscape views and prospects. He never developed his own approach to his subjects – they and the manner in which they were depicted were dictated entirely by Pennant. In 1781 he was refused permission to undertake a commission from Richard Bull for a copy of a drawing of Valle Crucis, but three years later, 'by permission from his master', he advertised that he offered his services to the public 'at his leisure Hours' to paint landscapes (priced according to length), heads and the margins of books and coats-of-arms, confirming that his training was as a traditional limner.

Beeston Castle is in the English border county of Cheshire. Another watercolour of the castle in the National Library of Wales was engraved for Pennant's *Journey from Chester to London*, (1782). That many of Pennant's tours focused on the English-Welsh and English-Scottish borders is significant, as one of his main concerns was to mend national fences – in his own words,

in the preface to his 1771 *Tour in Scotland*, 'to conciliate the affections of the two nations, so wickedly and studiously set at variance by evil-designing people' (quoted by Colley, p. 116). Bridges dominate many of the views he chose for Griffith to depict and other evidence of an underlying national 'agenda' can be found in the selection of Welsh castles – not only those built by Edward I, including Carnarvon, which he described as 'that magnificent badge of our subjection', but also the ruins of castles built by native Welsh princes to defend themselves against the Norman invaders, and less obviously marked sites of important historic battles. Quarries, smelting works and local manufactories were also included, along with recognizable Welsh mountains and various ancient monuments of the type that dominated the work of early antiquarians, in whose views, the estate walls surrounding them, and the framing trees and picturesquely placed cows, were an important part of their depiction.

Literature: Donald Moore, *Moses Griffith*, Welsh Arts Council Touring exh., 1979.

88

The 'Noonstone', 1777

Watercolour with pen and grey ink with original washed border, 250 × 283 mm

Inscribed: *Moses Griffith delineavit June 6 1777* and *174*

Provenance: as cat. 87 (Walker no. 174)

1939-3-11-19

Moses Griffith was neither an amateur artist nor a drawing master: he was a servant, employed by an antiquarian to make drawings for him, even though like Aubrey, Stukeley and Grose, Pennant was probably able to make his own (see cat. 87). Griffith is included here to represent another side of amateur activity in the eighteenth century. Many antiquarians, such as those listed above, were happy to illustrate their manuscripts with their own drawings. Others who wished to publish their drawings for posterity employed skilled engravers to 'improve' them. Some antiquarians employed artists like Griffith to accompany them on their travels to teach them and improve their work, or to make drawings for them, to be engraved, or with which to extra-illustrate

88

FRANCIS GROSE (1731–91)

89

View of the West Gate Canterbury from the river, 1766

Pen and grey ink and watercolour,
227 × 305 mm

Inscribed on verso: *Westgate Canterbury Novr 2nd 1766*

Provenance: Presented by Miss M. H. Turner

1944-10-14-25

Like Thomas Pennant, Grose toured Britain with a draughtsman-servant, Tom Cocking, taking views of antiquities for his various publications. The son of a Richmond jeweller, Grose received a good education, including some training at Shipley's drawing school. He exhibited as an amateur, and held the post of Richmond herald for a period before joining the Hampshire, then Surrey, militias. He drew caricatures, often of fellow antiquaries, publishing a manual on the subject in 1788. Well-liked and self-mocking, he was described as a sort of antiquarian Falstaff. He also published on ancient armour and military antiquities, but his greatest achievements were his *Antiquities of England and Wales* (1773–87) and *Antiquities of Scotland* (1789–91), which were the results of tours with Pennant and Griffiths and others. When he toured Scotland in the summers of 1788 to 1790, he relied on a group of fellow antiquarians such as Robert Riddell, who lent him drawings by Sandby (see cat. 90) for Cocking to copy, and at the same time gave the Scotsman copies Cocking had made of views taken by Moses Griffith in 1772 for Pennant. Grose and Riddell toured Scotland together and Grose became a friend of Riddell's neighbour, Robert Burns. *Tam O'Shanter* was first published under the entry in Grose's *Antiquities* on Alloway Church, and he himself was celebrated in one of Burns's poems: 'A chiel's amang you takin' notes / And, faith, he'll prent it.'

Grose was said to have made most of the drawings supplied to the engravers of his *Antiquities* himself, and certainly he was a capable draughtsman, but there is some question about how much he was assisted in his drawings by Cocking who travelled with him. This view of Canterbury (Grose's wife was from the city), dates from 1766, before he employed Cocking. His figures were sometimes clumsy and, unlike other

or grangerize published and unpublished accounts.

The term 'grangerize' is named after the Revd James Granger (1723–76) who interleaved his own unillustrated book, *Biographical History of England* ... (1769), with 14,000 engraved portraits he had collected. Horace Walpole (1717–97), to whom it was dedicated, followed suit, collecting portraits of artists (now broken up into the portrait series in the British Museum), as did a number of other contemporaries, including Thomas Pennant, who similarly interleaved other types of books with collected prints, drawings and watercolours illustrating the text. Pennant's most popular work for others to grangerize was his *Antiquities of London and environs* (1791); John Crowle presented his own particularly lavish version to the Museum in 1811. Grangerizing was also a popular activity for women: the collector Richard Bull's daughters assisted him with labelling and drawing frames around the prints in volumes he put together for himself and for others, and Queen Charlotte extra-illustrated and illuminated her own manuscript transcriptions of a number of royal histories. Pennant's own library also contained manuscript tours, never published, but with watercolours and margin illuminations by Griffith.

The National Library of Wales has grangerized copies of Pennant's tours of Wales and Scotland. They contain not only Griffith's watercolours, but drawings and etchings sent by friends, amongst them watercolours by Paul Sandby and etchings by John Clerk of Eldin (cat. 94), whose work Pennant particularly admired.

Walker's Galleries were able to identify neither the site depicted in this drawing, nor the book it was intended to illustrate, although they noted that it was executed on the date inscribed on Griffith's drawings of Fountains Abbey and presumably illustrates a monument nearby.

Literature: Joyner, 1–16; Bernard Adams, 'A Regency Pastime: the extra-illustration of Thomas Pennant's "London"', *London Journal* 8 (2) (1982), 123–39; Peltz, *passim*.

89

military draughtsmen discussed in this chapter, Grose does not seem to have received lessons in perspective or surveying. However, he had a good eye for composition and used lovely fresh colours. Like Sandby, John Laporte and others, he also used bodycolour for works for exhibition.

Drawings and etchings of ancient buildings or particularly interesting views by amateurs often enjoyed a wide circulation and long afterlife. Grose himself redrew for the engravers views by other artists, including amateurs. A series of these drawings in the Society of Antiquaries includes a small pen and ink and watercolour version of Nuneham's etching of the old kitchen, Stanton Harcourt (cat. 96), and a view of Warwick Castle based on a drawing by Canaletto then in the Warwick collection. However, Nuneham's view not only appeared in Grose's *Antiquities* (III; engraved by R. B. Godfrey, 7 August 1773) but also on an oval dish that formed part of Wedgwood's Green Frog Service for Catherine the Great. In 1774 Wedgwood and his partner Bentley were running out of time and images for the decoration of this enormous service and began to comb the print shops and engravers for suitable material. The series of antiquities being produced by Grose and Pennant (cats 87–8) were both still in production, but the two authors arranged for the printers to make engravings available for the service; Grose

even provided some drawings not yet engraved.

He died suddenly while on tour in Ireland and various papers suggested the epitaph 'Here lies Francis Grose … DEATH Put an end to his Views and Prospects.' The Irish antiquities were published posthumously.

Literature: Williams, 244–5; Burns quoted in Hardie III, 43 n. 2; Errington and Holloway, 59; I. Brown, 10–11; Young, 134–48, nos 184–90, 208, 314; 'The Collection of the late Dudley Snelgrove', sale, Sotheby's, 19 November 1992 (lots 237–55).

PAUL SANDBY (1730–1809)

90

The Collegiate Church, Hamilton, Lanarkshire, 1750

Watercolour and bodycolour, with pen and black ink, 167 × 230 mm

Signed and dated: *P. Sandby Fecit 1750*; verso inscribed: *Hamilton, Scotland*

LB 1(b)

Provenance: Bequeathed by William Sandby 1904-8-19-50

Paul Sandby joined the Board of Ordnance Drawing Office at the age of sixteen (cat. 91), and his training there included drawing prospects and views, reinforcing the skills he already possessed as a draughts-

man, but preparing him for his posting the following year to the Military Survey of Scotland (1747–52). He was chief draughtsman, responsible for the presentation or fair copy of the final map (for the project, see cat. 83). Much has been made of the improvements his skills as a landscape artist brought to the end product, most notably a way of depicting mountains that combined both bird's-eye and topographical approaches with a cartographic one, enabling the military to visualize the layout of the land more clearly than with the usual type of map or plan accompanied only by measurements or profile views. However, there are many earlier examples of precisely these kinds of combination on maps and plans in the King's Topographical Collection (Map Library, British Library); Sandby's were not as innovative as has been claimed, but they were undoubtedly more beautifully executed.

The new map resulting from the survey was intended to be engraved, but the beginning of the Seven Years' War ended work on the survey. William Roy, the assistant quartermaster in charge of the survey, considered the final manuscript product to be a 'magnificent military sketch, [rather] than a very accurate map of a country', which might have been produced with the more sophisticated measuring equipment available a few years later. In fact Sandby's maps were the forerunners of the type of carefully measured and surveyed map that relied on symbols rather than drawings of mountains and other features, produced by the Ordnance Survey a few decades later and still in use today.

Surveying was done in the summer and the winters were spent in the Ordnance Drawing Room in Edinburgh Castle. It is significant that the majority of work that survives from Sandby's time in Scotland is not official drawings, but the sketches, etchings and washed views that were produced during his leisure time, when he met Robert Adam and his brother-in-law, John Clerk of Eldin, and drew picturesque views of castles, bridges and ruins that he visited in an official capacity or on private commissions for Scottish landowners. They were worked up into the finished watercolours, views, and prints used to establish his reputation and build up a private clientèle as an artist, rather than a military draughtsman, both in Scotland and on his return to London around 1751. The castles in which he was particularly interested for this

90

PAUL SANDBY (1730–1809)
after ABRAHAM BLOEMAERT
(1564–1651)

91

(a) Title-page to: *'A Book of Figures with the prospect of Edinburgh Castle by Paul Sandby'*, from title-page to part I of Bloemaert's *Recueil de Principes pour Designer* (1655)

(P&D c.156 a.2)

Pen and black ink with grey wash,
308 × 195 mm

Inscribed below with verses from Dufresnoy's *De Arte Graphica*; and at side: *Presented to the Board as a specimen of Mr. Paul Sandby's performance. Vide Minutes, 12 March 1746*

(b) *A Bandit with a halberd*, from pl. 44 of Bloemaert

Pen and black ink, 305 × 190 mm

LB 102(a)(b)

Provenance: Transferred from the Map Library, British Library

1880-9-11-1772, 1773 (not illustrated)

purpose were dramatically positioned ruins that had long lost their military use; although medieval, it was their wild settings that probably attracted his interest rather than a predilection for antiquity. Similarly, his views of church ruins, as in the present work, were indicative of a taste for the picturesque rather than a fascination for antiquity. However, many of his fellow military draughtsmen and surveyors did show a particular interest in ancient remains: William Roy also developed a fascination with Roman remains in north Britain to which he returned later, making a serious study published posthumously in 1793 by the Society of Antiquaries, to which he had been elected in 1776.

Some of Sandby's Scottish sketches were worked up immediately into three series of etchings published in 1748, 1750 and 1751 (combined edition 1765), in which topographical accuracy was not a priority, although architectural details were not compromised. In no. 6 in the 1748 series he combined the ruins of the Collegiate Church at Hamilton depicted in this water-colour with a distant view of Edinburgh Castle. His sketches of Scottish castles were later engraved for his *Virtuosi's Museum* (1778), the mountains higher and more rugged and with kilted figures introduced; others were worked up at various times into finished drawings for exhibition or sale, like the present work. This seems to have been

owned at one time by the Scottish antiquary Robert Riddell who lent a number of his works by Sandby to Grose to illustrate his *Antiquities of Scotland*. The view was copied by Grose's servant Thomas Cocking (National Library of Scotland, Edinburgh) and engraved for the *Antiquities* in 1797. Some of Sandby's sketches of Scotland were acquired at the London bookseller John Towneley's sale in 1816 by David Pennant and inserted into one of the grangerized editions of his father's *Tour in Scotland* (1769–72), which are now in the National Library of Wales; another edition was illustrated earlier with etchings by John Clerk of Eldin (cat. 94).

Literature: O'Donoghue, *passim*; Christian, in Alfrey, 19ff.; Joyner, 1–16; Errington, 33–46.

The early education in Nottingham of Paul Sandby's elder brother Thomas (1723–98) underlines the points being raised in this chapter connecting the teaching of drawing with surveying and an interest in antiquities. Thomas was probably taught by Thomas Peat, a local schoolmaster, surveyor and architect who produced a map of Nottingham for Charles Deering's book *Nottingham Old and New* (1751). Most of Thomas Sandby's earliest drawings were antiquarian, architectural and prospect views, which were engraved to illustrate it. In 1742 he began working in the Drawing Room of the Board of Ordnance, then housed in the Tower of London. A year later he accompanied an unknown military engineer to Scotland, travelling there again in 1745 as a civilian draughtsman with the British army under the command of the Duke of Cumberland, the younger son of George II. Sandby was with the duke at Culloden and also accompanied him on campaign in the Netherlands during the War of Austrian Succession, entering his household at Windsor on his return.

For the rest of his life, Thomas continued to draw three shillings a day and a half-pay allowance of £91 5s. every year from the Board of Ordnance. It is not surprising

then to find his younger brother Paul preparing drawings for submission to the same board in 1746, although almost nothing is known of his training before this date. Few records of the Drawing Room survive from this period, but its main business was connected with military engineers, both in map-making, surveying, road-building and fortifications, as well as making coastal views, plans of docks and charts for the navy. It had strong connections with the Admiralty, the astronomer royal and Christ's Hospital, and the various military and naval academies. The young men trained there were mainly used as part of surveying and reconnoitring teams, employed not only in Britain but also in conflicts and colonies abroad. Some like Paul and Thomas Sandby remained civilians, while others such as Charles Tarrant combined their drawing abilities with a professional military career.

Literature: see Tarrant (cat. 83); *The Painters' Progress: The Life and Times of Thomas and Paul Sandby*, exh. Nottingham Castle Museum, 1986, *passim*; Robertson 1985, *passim*; Johnson Ball, *Paul and Thomas Sandby. Royal Academicians*, Cheddar 1985, 135ff.; Herrmann, 11–16, 81; Alfrey, nos III.10,11

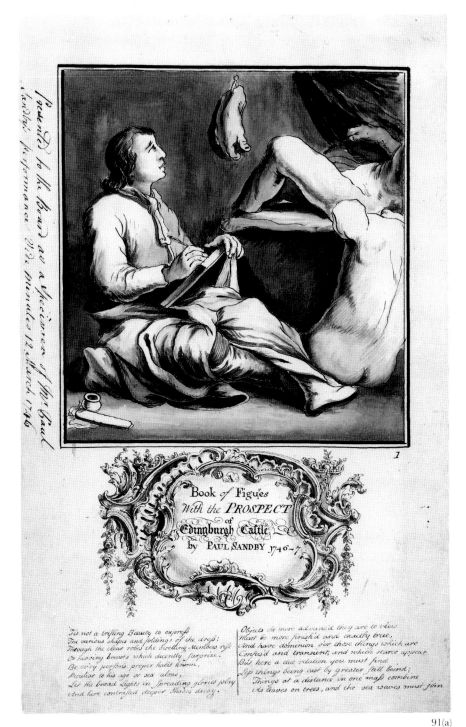

91(a)

92

East view of Edinburgh Castle, 1746–7

Pen and black ink, 192 × 307 mm

Signed and dated: *Paul Sandy delint. 1746–7* and inscribed with title, numbered *8*

LB 106

Provenance: Transferred from the Map Library, British Library

1880-9-11-1779

Most of the set of eight drawings in the British Museum, which were submitted by Sandby to the Drawing Room (see also cat. 91), are after plates of military figures from Bloemaert's drawing book (French edn, 1655: LB 102 a,b, 103, 104 a,b, 105 a,b are after title-page and pls 44, 73, 112, 72, 45 and 64 respectively). This, along with the quotations from Dufresnoy on the title-page, indicates that Sandby's training was a traditional one composed initially of copying figures from prints. The first drawing of a young man drawing from casts and a reclining figure (cat. 91) is a simplified version of Bloemaert's title-page, not a self-portrait as previously assumed. The present drawing of Edinburgh Castle, the eighth in

EAST VIEW of EDINBURGH CASTLE.

92

the set, is not from Bloemaert, but has probably been copied from a print after another artist, or even from a drawing by Sandby's brother Thomas who had returned to London from Scotland with the Duke of Cumberland in July 1746. The style of the figures owes a great deal to the work of H.-F. B. Gravelot (1699–1773), which circulated in print form as illustrations and in copybooks and drawing manuals, and influenced the staffage in similar topographical views by other artists. This topographical approach was to be echoed in Sandby's own compositions in Scotland: a very similar view of Dumbarton drawn and etched by him was included in the series of Scottish views published at Windsor in 1751.

The set of eight drawings was produced either as part of Sandby's test for admission or for submission on completion of the course at the Drawing Office. There is some confusion concerning the dates they were drawn and submitted as some are dated 1746 and others, as here, 1746–7, which indicates that it was actually drawn between 1 January and 24 March 1747. The additional note, *Vide Minutes 12 March 1746*, probably refers to 1747, as the new style calendar to which we are accustomed, beginning the new year on 1 January rather than 24 March, was not yet in consistent use. The date of Paul Sandby's arrival in Scotland to begin work on the survey is not known, but a submission date of March 1747 (new style) fits with his being in Scotland that summer when the survey commenced.

A ninth drawing in the Victoria and Albert Museum bears a similar inscription to the view of Edinburgh, but is not copied after a print; instead it is a 'Prospect' drawn on the spot, in pen, ink and grey wash, of the entrance to the Tower where the Drawing Office was housed, demonstrating Sandby's ability to sketch accurately in the field, just as Bernard Lens II had been taken to the roof of Christ's Hospital to prove his ability forty years earlier.

An additional series of drawings by Sandby, apparently executed while working in the Drawing Office, was also transferred from the Map Library in 1880, but was not all listed by Binyon or mounted until recently so that the drawings are little known (1880-9-11-1755 to 1771). They include drawings for coats-of-arms, monograms, crowns and cyphers, possibly to be inscribed on guns and cannon, a drawing of a man-of-war filled with men, and detailed drawings and sections of guns, mortars and other munitions.

Literature: as above (cat. 91); Julian Faigan, *Paul Sandby Drawings*, exh. Australian Gallery Directors' Council, Sydney, 1981, no. 1.

93

View of a castle (?Edinburgh)

Brush drawing in grey and brown wash, with watercolour, over graphite, 93 × 64 mm

Inscribed on verso: *Mr P. Sandby in Dufours Court, Broad street, Carnaby Market;* and in a later hand: *1803. Very old, found amongst Sir W. Hamilton's papers*

LB 58

Provenance: Sarah Sophia Banks, by descent to Dorothea, Lady Banks, by whom presented 1891-11-16-179 (52)

In 1751 Paul Sandby spent the summer with his brother at Windsor, working on a series of interior views at Sandpit Gate Lodge (Oppé 1947, nos 245–7) and on his etchings of Scotland. He went back to Edinburgh for the winter, returning finally to London in 1752. The following February, he and his brother issued an invitation to Theodosius Forrest (1728–84), a well-known amateur of the period who later made several sketching tours with Thomas, to join them at their home in Poultney Street for an evening of sketching. A drawing accompanied the invitation, showing a figure in an historical costume posing under a lamp on a platform in an interior with a group of men seated and standing around a table sketching. Paul Sandby is assumed to have been living with his brother in Windsor from the mid-1750s but he seems to have set up his own residence sometime between 1761 and 1763 at Mr Pow's in Dufours Court, Broad Street, near Carnaby Market. The watercolour exhibited here from the Banks collection of trade and visiting cards bears this address on the verso, and was sent to William Hamilton (1730–1803), later the British envoy to Naples, in whose papers it was found.

Sandby moved to Poland Street in 1766 and this neatly dates his contact with William Hamilton to sometime between c.1761 and 1766. By the time he came back from Windsor to London with his brother around 1761, he had already built up a small clientèle of patrons and pupils from the court circles (including Earl Harcourt and his son Lord Nuneham (cat. 96)). In that year Sandby exhibited a painting entitled *The Welsh Bard*, composed with the assistance of Lord Nuneham's friend William Mason, at the second exhibition of the Society of Artists, held in the rooms of the Society of Arts.

William Hamilton had served under the

93

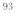

94

JOHN CLERK OF ELDIN (1728–1812)

94

Melville Castle (Midlothian)

Pen and black ink with watercolour, 105 x 166 mm

Provenance: Presented by Iolo Williams 1960-7-16-5

John Clerk of Eldin was the son of William Stukeley's old friend Sir John Clerk of Penicuik (1676–1755), a keen recorder of Roman antiquities and inscriptions. Another of Stukeley's friends, the architect/mason Andrew Jelf was sent by the Board of Ordnance to Scotland just before 1720 to 'repair and make some Forts' near the Antonine Wall, where on Stukeley's behalf he made measured drawings of 'Arthur's O'on' (oven), which had been known as an 'ancient' building since the ninth century. Circular and stone-built, it had a relief carving over the door, and Stukeley believed it to be a Roman temple or shrine. In 1743 it was pulled down by Sir Michael Bruce of Stenhouse to repair a mill-dam, on which occasion Stukeley produced an etching entitled *Syr Mitchil Bruce stonekiller*. As records like Jelf's drawings were the only evidence of such monuments, it is not surprising to find Sir John recommending 'to all the young lads of this family to lairn to draw or design as the best means for advancing their fortune' (Bertram, 6).

Instead of becoming a surgeon as his father had hoped, the younger John Clerk went into business and purchased land at Eldin where he erected a small mansion. In the 1750s he befriended the Adam family of architects and married Robert Adam's younger sister. The architect was fond of drawing imaginary landscape compositions, which are remarkably close to Clerk's of the early 1750s, and it seems that this probably resulted from them both taking lessons from Paul Sandby during his time in the Ordnance Office in Edinburgh from 1747 to 1752, although there is no secure evidence for this. Paul Sandby's son produced a memoir of his father in 1811 in which he recorded that while he was in Edinburgh he took instruction in etching from a Mr Bell, an interest he later shared with Clerk who began to etch in 1770. Clerk owned at least thirty watercolours by Sandby by 1763, and two letters from Sandby of 1775 (Victoria and Albert Museum), indicate that

Duke of Cumberland in the Netherlands when Thomas Sandby was the duke's draughtsman in 1747–8. Hamilton knew Paul Sandby before he left for Naples in 1764; he may even have taken drawing lessons from him. However, the only evidence of Sir William's drawing ability is two pencil, pen and ink and sepia wash 'Italianate' sketches of bridges and ruins that appeared at Sotheby's, Billingshurst, in 1986 (exh. *Sussex and the Grand Tour*).

Walpole also owned an etching by Hamilton after one of Rembrandt's etched self-portraits (Bartsch 19; now Lewis Walpole Library, Farmington (Conn.); see p. 216 below).

Literature: E. H. Ramsden, 'The Sandby Brothers in London', *Burlington Magazine* 89 (1947), 15–18; Robertston 1985, 68; Jenkins and Sloan, 78; Roberts 1995, 17–21.

at that time Clerk was experimenting with etching with aquatint, and they exchanged examples of work in this medium, for which Sandby had a superior method, which he could not share (see cat. 141). Nevertheless, in the second letter he provided as much detailed instruction for improving the effect as he could, without giving away the entire secret.

Clerk was largely self-taught in etching, seemingly taking it up at the encouragement of fellow antiquarians who admired his drawings and watercolours. He looked carefully at works by Rembrandt, Claude and Franz Edmund Weirotter (1733–71) first and did his own printing on a small press, selling his prints through an Edinburgh printseller to cover his costs. He was often frustrated with the results and especially with the small size of his plates, partly due to the enforced use of spectacles. Most of his watercolours were larger, but the present work is about the size of the etching to which it relates (Lumsden 73, *Melville Castle from Eldin*, 105 × 166 mm; lettered 'Melville Castle, seat belonging to Lord Advocate Dundas' and 'J.C. 1776'). Clerk's etchings are mainly views of castles and ruins and local sites, antiquarian in nature, although he took liberties with topography in order to achieve better overall effects of composition, as in the present small watercolour. He printed over a hundred, but stopped around 1778, presenting a fine set of sixty-two, washed by Robert Adam, to George III (British Library) in 1786. The prints were reissued in 1825 and 1855 before the plates were destroyed. In 1782 Clerk privately published his contribution to the war effort with France, which he had been working on through the 1770s: *An Essay on Naval Tactics – Systematical and Historical with explanatory plates* (republished 1790). In the 1780s he worked closely with Dr James Hutton on his *Theory of the Earth*, and later produced geological drawings for the plates, which were never engraved.

Literature: E. S. Lumsden, 'The etchings of John Clerk of Eldin', *Print Collectors' Quarterly* XII (1925), 14–39; Martin Hardie, 'Letters from Paul Sandby to John Clerk of Eldin', *Print Collectors' Quarterly* XX (1933), 362–4; Geoffrey Bertram, *John Clerk of Eldin: Etchings and Drawings*, exh. 6 North West Circus Place, Edinburgh 1978; A. A. Tait, 'Robert Adam and John Clerk of Eldin', *Master Drawings* XVI, no. 1 (1978), 53–7; I. Brown, 5–9, 30–3; Piggott, 59–60.

THE REVD DR LUTTRELL WYNNE (1739–1814)

95

(a) Sketchbook, open to *The Camp above Brixholme in Torbay*

Watercolour and ink wash over graphite, 175 × 280 mm

Inscribed on facing page with title and *ye 50th regiment*

(b) *Kidwelly Castle*, page from a sketchbook of 1770

Watercolour and ink wash over graphite, 215 × 315 mm

Inscribed on verso: *N. Bridge over ye R. Taaf* [describing drawing on facing page in sketchbook]; and in modern hand transcription of inscription on facing page in original sketchbook: *Kidwelly Castle – This has been copied by Mr Grose & published*

Provenance: *c.*1955, Stanley Crowe, bookseller, Bloomsbury, by whom a) sold to ?; sale Bloomsbury Book Auctions, 10 December 1998, lot 42 (five sketchbooks); bt Charles Plante, from whom purchased with the assistance of Professor Luke Herrmann

(b) removed by Crowe from 1770 sketchbook sold to Iolo Williams; Felicity Owen, by whom presented

(a) 1999-2-27-1

(b) 1997-2-22-6

Although not a skilled draughtsman, the Revd Wynne was a prolific one. At least seven surviving sketchbooks record tours in Wales (1770 and 1774), Nottinghamshire, Yorkshire, Northumberland and Scotland (1772), Ireland, Cheshire and Kent (1790s), and Devon and Cornwall, where Wynne lived in the manor and rectory at Polzne from the mid-1770s until his death. According to the *Gentleman's Magazine* (1816), he also travelled in Europe, although none of the known sketchbooks records views there.

Born in London, Wynne was the son of a serjeant-at-law, educated at Eton and Oxford where he arrived in 1758, the year before Malchair (cat. 115). He became a Fellow of All Souls and received his BCL in 1766, and DCL in 1771. Although he was 'familiar with the great, he had a mind too independent to solicit their patronage' (*Gentleman's Magazine*) and held the valuable rectory of St Erme, Cornwall, for thirty-two years before resigning it in favour of his curate. In 1784 he inherited the famous library of the seventeenth-century collector of political tracts, Narcissus Luttrell, but sold it in 1786 (parts now in the British Museum and British Library). He visited Robert Price (cat. 117) at Foxley in 1770, and was still corresponding with Malchair in 1793.

In style Wynne's drawings certainly owe much to Malchair who was probably his drawing master at Oxford, and they are thus too vague to be of antiquarian value in the same way as measured, surveyed or strictly topographical drawings with accurate perspective. Nevertheless, his drawings are reliable records of towns, castles,

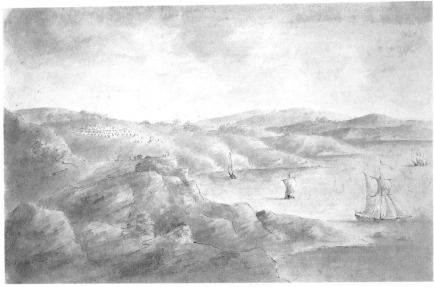

95(a)

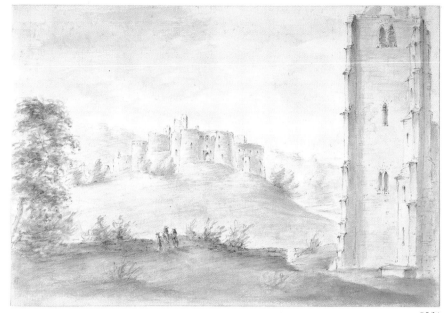

95(b)

churches and ruins, and provide examples of early 'picturesque' tours of Britain useful for placing Gilpin's well-known tours of the same period into a wider perspective. Although Wynne's drawings were 'views' like Gilpin's, and not as detailed as those commissioned by Pennant or Grose from their servants or professional artists, they clearly served in cases where no other views were to hand for their plates, and Sandby and others used several as the basis for their own publications.

Wynne's view of the Episcopal Palace at St David's was drawn the same year as Sandby made his first tour of Wales, and was the basis for the sixth plate in his first series of Welsh aquatints. Although in the end Sandby's interpretation was only loosely based on that of the amateur, Wynne was duly credited in the imprint below the image, which served, like a dedication, to publicly advertise the assistance and patronage of such men. Luttrell proudly inscribed that his view of Dumbarton with the new bridge in one of the Scottish sketchbooks was *copied and published by Mr Sandby*, and a drawing by Wynne of 1774 is credited as the basis of Sandby's 1776 aquatint of *Bridgnorth* in his series of Shropshire views.

In fact, Sandby managed to publicly acknowledge a number of important men through his engravings in various ways. His first Welsh tour was in 1770, when he spent the summer at Wynnstay, the home of Sir Watkin Williams Wynne, who may have

been a relation of Luttrell Wynne. Sandby gave drawing lessons, painted scenery for amateur theatricals and toured North Wales with Sir Watkin and his party. In the summer of 1773 he travelled around South Wales with Joseph Banks, Dr Solander and Charles Greville (all Fellows of the Royal Society) and again visited the north. *Twelve Views in South Wales*, which contained Wynne's view of St David's, was antiquarian in approach and published in 1775 with a dedication to his friend Banks and his pupil Greville. The latter, a keen mineralogist, took one or two views around Milford Haven where his uncle Sir William Hamilton had property (Sandby later engraved one in the *Virtuosi's Museum*)

Sandby's second set, *Views in North Wales*, was published 1776 with more dramatic scenery and a dedication to Sir Watkin. A final set of Welsh views published in 1786 contained two views of places Sandby had not visited, Kidwelly Castle in Carmarthenshire lettered 'Rev'd. T. Rackett Delint.' and 'Abbey on the Wye', again 'T. Rackett Delint.'. Thomas Rackett (1757–1841) was also a pupil of Malchair at Oxford, but had already learned to draw from Sandby in London. His parish was in Dorset and, like Luttrell Wynne and the Revd Cordiner, he travelled the country sketching antiquities, sharing these with fellow antiquarians and engravers. An inscription on what was the facing page of the sketchbook from which Wynne's Kidwelly view was removed indicated that Grose had engraved it. Francis

Grose died while on his tour of Ireland and Wynne's views were used to complete his publication in 1794.

Literature: Iolo Williams, 'Paul Sandby and his predecessors in Wales', *Transactions of the Hon. Society of Cymmrodorian*, 1961, pt 2, 24–8; Peter Hughes, 'Paul Sandby and Sir Watkin Williams-Wynn' and 'Paul Sandby's Tour of Wales with Joseph Banks', *Burlington Magazine* CXIV (1972), 459–66, and CXVII (1975), 452–7.

GEORGE SIMON, VISCOUNT NUNEHAM (1736–1809), after PAUL SANDBY

96

(a) *A View of the Ruins of the Chappel at Stanton-Harcourt*, 1763

Etching after a drawing by Paul Sandby of 1760, 430 × 522 mm

(b) *View of the Ruins of the Kitchen at Stanton-Harcourt*, 1763

Etching after a drawing by Paul Sandby of 1760, 390 × 525 mm

Provenance: Bequeathed by William Sandby 1904-8-19-813, 815

In 1763, employing the superlatives that were characteristic of his praise of the work of his amateur friends, Horace Walpole described these two prints as 'the richest etchings I ever saw, and masterly executed'. He noted that Lord Nuneham was planning two more, which were printed the following year, depicting slightly different views of the same subjects. Over this brief period in the early 1760s Nuneham made six etchings after Sandby's compositions and another half-dozen after drawings by his brother William (cat. 77) and paintings by Claude Lorraine. Only one of the etchings actually states in the letterpress that it is after Sandby's drawing from nature, but William Sandby's inscriptions in pencil seem to confirm that Sandby drew the original views.

In the early 1750s when his father, the 1st Earl Harcourt, was governor to the royal princes, Viscount Nuneham and his sister Lady Elizabeth Harcourt received lessons in drawing figures from Richard Dalton, and in landscape from George Knapton, Alexander Cozens and Joshua Kirby. Dalton was royal librarian and Knapton was painting a portrait of the princes with

their mother around 1752 (a chalk study of the princes with Harcourt is in the Huntington Library, San Marino (Calif.)). Little documentary evidence exists concerning who taught the royal family during this period, but their work indicates that they probably received lessons from all these artists and others (see cats 100–1). The fact that they also taught the children of other members of the royal household indicates that the close relationship observed between what was being taught to royalty and their nobles and courtiers in the seventeenth century continued right through the eighteenth.

The Harcourt family's lands at Stanton Harcourt in Oxfordshire dated back to the Norman Conquest, but Sir Simon Harcourt, lord chancellor and solicitor general to Queen Anne, had purchased Newnham Courtenay in 1712. His grandson, the 1st earl, spent the 1750s moving the family seat to the newer estate and changed its name from Newnham to Nuneham. As early as 1753 the earl had been working on plans to move the original village of Newnham Courtney and create a Claudian landscape to set off his new Palladian villa. Paul Sandby's association with the royal family and with Harcourt's eldest son George, Viscount Nuneham, and his drawings of Lady Elizabeth Harcourt (Oppé 1947, nos 268, 315) are datable to the same decade, marked at its end by the artist's paintings of the new family seat at Nuneham, which he exhibited at the Society of Artists in 1760.

Viscount Nuneham became a Fellow of the Society of Antiquaries, and presented the plates of his etchings to the society in 1785. However, his choice of the ancient manor at Stanton Harcourt as the subject of these etchings after Sandby, rather than his father's new villa, was probably not merely for antiquarian purposes. Nuneham was a confirmed francophile and, by depicting the seat granted to the de Harcourts at the Conquest, commemorated his family's French roots. He was, however, also a republican idealist and disciple of Rousseau, and for a period denounced hereditary titles, refusing to be called 'my Lord'. He omitted his title on these prints, and objected to his father's tenants being forcibly removed from their homes and their medieval church destroyed in order to provide him with a better view and more scope for developing a classical landscape and a new temple-like church. These events

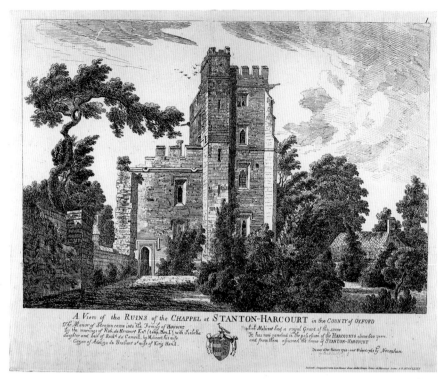

A View of the RUINS of the CHAPPEL at STANTON-HARCOURT in the COUNTY of OXFORD

96(a)

View of the Ruins of the Kitchen at STANTON-HARCOURT

96(b)

97

are thought to have inspired Goldsmith's poem 'The Deserted Village' of 1770. Nuneham provided Rousseau with a home when the philosopher was in exile in England, and when his brother William Harcourt reported his success in America in 1775, he wrote that he expected Nuneham and his sister to send their 'condolences instead of congratulations upon my taking of General Lee, *another stab* to expiring liberty'. When Nuneham inherited the title the following year, he erected a statue to Rousseau in the garden, had the coronets removed from the coaches, and his bewildered tenants were prepared for citizenship in an ideal republic by being provided with special ribbons for their hats as rewards for virtue.

In 1783, however, the 'gentle executioner', as Walpole called him, became, like his brother, an intimate of the royal family and confined his republicanism to his own estate where he bettered his tenants' lives in more practical ways and employed Capability Brown to eliminate the formal vistas. In the 1760s Rousseau had sown not only wildflower seeds at Nuneham but also his taste for a nature of 'sentiment'. In 1772

William Mason exercised 'A Poet's feeling and a Painter's eye', creating for Lord Nuneham the first informal flower garden, celebrated in his poem 'The English Garden', and acclaimed as 'a revolution in taste and sentiment'. It was recorded in a series of watercolours by Sandby, which was copied by Nuneham but never engraved. As the 2nd Earl Harcourt, he encouraged numerous other artists, including William Gilpin and Alexander Cozens, and exchanged his own drawings and paintings for similar presents from members of the royal family.

Literature: Daghlian and Hilles, 230; for Knapton, see Wark, 33; M. Baty, *Nuneham Courtenay Oxfordshire: A short history and description*, Abingdon, 1970 for Oxford University Estates; B. Barr and J. Ingamells, *A Candidate for Praise: William Mason 1725–97, Preceptor of York*, exh. York Art Gallery, 1973, 31–9; Roberts 57, 67–8.

PAUL SANDBY (1730–1809)

97
Woolwich from Powis Street

Watercolour, over graphite, 255 × 420 mm

LB 26

Provenance: Purchased at Paul Sandby's sale Christie's, 16 April 1817 (113) by Col. Gravatt; William Sandby, by whom bequeathed

1904-8-19-55

Sandby's connection with the military did not end in 1752 when he returned to London from working on the Military Survey of Scotland. His brother remained on the payroll of the Drawing Office for the rest of his life, although his duties were directly to William Augustus, Duke of Cumberland (George III's uncle). The duke ensured Sandby family connections with Windsor during the 1750s, and when he died in 1765, the new Duke of Cumberland, Henry Frederick, George III's younger brother, retained Thomas Sandby's appointment as his draughtsman, although it now took the form of deputy to the duke in his appointment as ranger of Windsor Great Park.

During this time, Windsor Castle was still defended as a military fortress, and many of its inhabitants were soldiers.

In 1768 the Sandbys were among the group of artists who finally successfully petitioned George III to found the Royal Academy. Also in that year Paul was appointed chief drawing master at the Royal Military Academy at Woolwich. It is significant, but has not previously been noted in this connection, that the Woolwich Academy was under the inspection of the Board of Ordnance. In attempts to attribute works by the Sandby brothers, the general rule has always been that if a work contained detailed architectural elements or was a wide panoramic view drawn with a camera obscura, it was probably by Thomas, who was professor of architecture at the Royal Academy; any well-drawn and substantial figures were possibly inserted by Paul. This, however, is an over-simplification of their talents, as Paul had received the same training in perspective, mathematics and surveying at the Ordnance Drawing Office as his brother and had an equally remarkable mastery of perspective. However, the fact that their skills as military topographers overlapped with their abilities as landscape artists is clear from Thomas's instructions to his students at the academy that they must be able, as he and his brother were, to 'draw after real Buildings without the use of Rules and Compasses, in the manner of Landskip Painters' (G. Worsley, quoted in Roberts 1995, 25).

This combination of draughting skills with a professional landscapist's art is precisely the type of drawing Paul Sandby was expected to teach gentlemen cadets at Woolwich in order to prepare them for examination for a commission in the Royal Corps of Artillery and Engineers. They were not expected to be able to produce maps, but they had to be able to convey the lie (or slopes) of land, harbours and fortifications in such a way that commanders could deploy troops and artillery.

In their drawing lessons with Sandby, the cadets copied his landscapes in Indian ink to learn perspective in practice and light and shade, followed by more difficult landscapes coloured from nature, civil and military architecture and perspective, and finally describe 'all the various Kinds of Ground, with its Inequalities, as necessary for the Drawing of Plans; and Drawings from Nature' (*Orders* 1776, 25). The latter drawings were views taken 'about Woolwich and other places; which teaches them at the same time to break ground, and forms the eye to the knowledge of it' (*Orders*, 33). The present view down a long road to Woolwich includes an octagonal building and figures that would provide a useful exercise in drawing accurately from nature. Another watercolour of Powis Street showing the same octagonal building was also in Gravatt's collection (LB 27). Powis

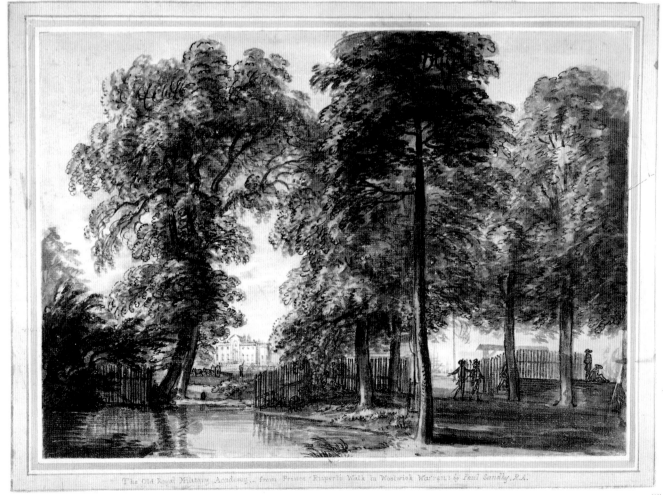

The Old Royal Military Academy from Prince Rupert's Walk in Woolwich Warren: by Paul Sandby, R.A.

98

Street was not formally laid out until 1800 and grew into the modern town's main shopping street.

Literature: George, Viscount Townshend, master general of the Ordnance, *Rules & Orders for the Royal Military Academy at Woolwich*, 1776; Jones, *passim*; Buchanan-Dunlop, *passim*: the edition of 1892 is illustrated with costumes of cadets copied from sketches by Col. William Gravatt (see cat. 102), formerly inspector, Royal Military Academy.

98

The Old Royal Military Academy, from Prince Rupert's Walk in Woolwich Warren

Pen and grey ink and grey wash, 265 × 375 mm

Inscribed on mount with title

LB 30

Provenance: Bequeathed by William Sandby (with LB 1-29)

1904-8-19-18

The military establishment at Woolwich probably arose from the location there of an important Tudor naval dockyard, the remains of which are indicated in the distance in the present work. In the late seventeenth century ordnance stores were established at Woolwich Warren, further along the river and separated from the dockyard by the long ropeyards. Prince Rupert's Walk no longer exists, but it would seem fitting that a walk that ran along the river from the docks to the ordnance should be named after him. The Royal Laboratory was built there in 1695, and the establishment of a brass gun foundry in 1716 led to the building of the Royal Arsenal, designed by Vanbrugh and completed in 1717. The Model Room, a second building by Vanbrugh in 1719, also of yellow stock brick, has a central pediment over a semi-circular arch, flanked on each side by three bays of tall arched windows with circular windows above, and a projecting apse to the north. Seen in the background here, this became the home of the Royal Military Academy when it was founded in 1741. The academy moved to a grand new home designed by Wyatt outside the Arsenal in 1805.

The town of Woolwich began to grow up the hill when the military started to build its barracks in that direction, towards Powis Street. Like many who taught or worked at the Arsenal, Sandby kept lodgings in

Charlton, which accounts for his many drawings in this area of Kent. Five views of Woolwich and Charlton, mainly from Colonel Gravatt's collection, came to the British Museum in William Sandby's bequest in 1904. A view titled the *Royal Arsenal, Woolwich Repository, from the green in front of the Cadet Barracks* (LB114) was formerly in the collection of Colonel Landmann, who also taught at Woolwich, and the Museum also has a substantial number of pencil sketches of Woolwich, Greenwich, Chatham, Blackheath and the surrounding area, which came as a group of anonymous topographical drawings from Gravatt's collection, but were not listed by Binyon (1867-12-14-88-133). Only two views of the Military Academy by Sandby were ever engraved, in the *Virtuosi's Museum*, but in 1780 he proposed to published six aquatints of Woolwich by subscription, which never appeared.

Literature: Nikolaus Pevsner, *London except the Cities of London and Westminster*, Harmondsworth 1952, 453–6; Robertson 1985, 104.

PAUL SANDBY (1730–1808) and JAMES PEAKE (*c*.1730–80) after GOVERNOR THOMAS POWNALL (1722–1805)

99

(a) *A View of the Falls on the Passaick, or second River in the Province of New Jersey*, 1761

(b) *A Design to represent the beginning and completion of an American Settlement or Farm*, 1761

from *Eight Views in North America and the West Indies, painted and engraved by Paul Sandby, from drawings made on the spot by Governor Pownall and others* (1761)

Engravings, 365 × 530 mm

Provenance: Purchased from Mr Francis and Mr Bihn, respectively

1878-5-11-946, 1873-8-9-374

A native of Lincoln and educated at Cambridge, Thomas Pownall is best known for his governorship of Massachusetts and his subsequent support of the American colonies in parliament. From 1753 to

1760 he served in New York, New Jersey and Massachusetts as private secretary, lieutenant-governor and then governor, sympathetic to the colonists and working with them, particularly with Benjamin Franklin, to help drive the French out of North America. The book he published on his return, *The Administration of the Colonies* (1764 and several subsequent editions), argued the need for a special government department to deal with American affairs, criticized the dictatorial power of the commander-in-chief, and defended the principle of 'no taxation without representation', suggesting the colonists should send MPs to Westminster. He himself became an MP from 1767 to 1780 in order to argue their cause in parliament, but became increasingly disillusioned.

Clearly well-educated and cultivated, Pownall was ridiculed by his enemies in Boston for dressing too well and enjoying a social life too freely. He may have had some military training, as he addressed a memorial on the 'wondrous means of inter-communication possessed by America through its noble rivers' to the Duke of Cumberland, and he was also a good mathematician, understood practical surveying and sketched maps and views in Boston, as well as the originals of these prints. Amongst his many publications on politics and later Roman antiquities, in 1776 he published a *Topographical Description of such parts of North America as are contained in the annexed Map of the Middle British Colonies in North America* for the support of the map-maker's children. In 1786 he wrote a *Proposal for Founding University Professorships for Architecture, Painting and Sculpture*.

It is not clear how, on Pownall's return from North America in 1760, Paul Sandby was employed to make paintings from four of Pownall's own drawings and sketches made on the spot for a series of printed views. Pownall's view of a North American settlement was clearly his own attempt to gain admiration for what the colonists had laboured hard to achieve towards fulfilling the Arcadian possibilities of the new world – from wilderness to a cultivated estate. But the engraved set included views after drawings of Havana and a view of the French settlement of Miramachi, 'destroyed by Brigadier Murray detached by General Wolfe for that purpose'. The initiative for the series probably lay with the printsellers, as they were feeding a market where interest in North America exceeded the information

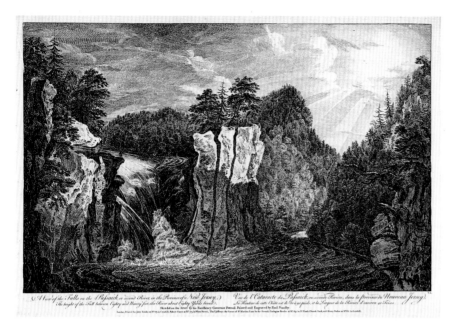

A View of the Falls on the Passaick, or second River, in the Province of New Jersey. *Vue de l'Cataracte du Passaick, ou seconde Rivière, dans la Province du Nouveau Jersey.*

99(a)

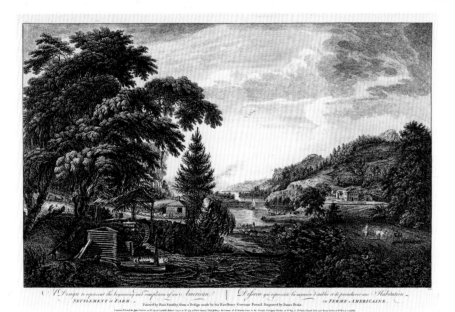

A Design to represent the beginning and completion of an American *Dessein qui représente la manière d'établir et de parachever une Habitation*
SETTLEMENT or FARM. *en FERME AMERICAINE.*

99(b)

PRINCE AUGUSTUS FREDERICK (1773–1843), later DUKE OF SUSSEX

100

View of St Leonard's Hill, Windsor (?1781)

Bodycolour on thick board, 273 × 371 mm

Inscribed on verso: *A View of St. Leonard's Hill near Windsor — His Royal Highness Prince Augustus Frederick aged 7 years and 3/4*

Oppé 1950, 16

Lent by Her Majesty The Queen (RL K 369)

Paul Sandby's relations with Windsor were so close through his brother Thomas's long residence there that it would suggest that he taught drawing to members of the royal family. However, the records of royal drawing masters are very incomplete and the facts are difficult to ascertain. It was presumably through his brother's connections at court through two successive dukes of Cumberland that Sandby came to the notice of Earl Harcourt (cat. 96). Sandby's work for the Harcourt family began in the 1750s and continued through the 1760s with the younger members of the family. William Harcourt (cat. 77) purchased the house depicted here on St Leonard's Hill from Henry Frederick, Duke of Cumberland, in 1780 (see cat. 108).

Sandby lived at Windsor with his brother from *c.*1755 to 1761 but in 1766 took over a house in Poland Street, London, from his friend William Chambers, George III's instructor in architecture (see cat. 68). But the only evidence for Sandby instructing a member of the royal family is the appearance of his name in the 1771 list of subscribers to Gandon's *Vitruvius Britannicus* IV, as 'Drawing Master to the Prince of Wales' (later George IV, 1762–1830; see cat. 175). By this date Sandby was teaching at the Royal Military Academy at Woolwich, and bearing in mind that the prince's father had been trained by Kirby and Chambers in several forms of what might be considered military drawing, as well as receiving lessons in landscape, it seems quite likely that this was precisely what Sandby was employed to teach another future king, the military commander of his country. Similarly, the prince's younger brothers, like George III's uncle and brother who were successive Dukes of Cumberland, could also expect to serve in a military capacity and received lessons in drawing landscape as well.

available and money could be made by those who could supply the images. A series of prints titled *Scenographia Americana* followed, the prints based on drawings made by naval and artillery officers, many of them trained at Portsmouth, or at Woolwich before Sandby arrived. It can be enlightening to compare some of these early prints with the interpretations of the same views issued one or two decades later. Like that of Governor Pownall, Captain Thomas Davies's early view of the Passaic Falls was topographically correct, to supply immediate information on hostile terrain; but a later view of the same falls replaced the native family in Davies's view, one of whom held a gun, with a white settler fishing for his supper, his house and fenced yard nearby – the wilderness tamed and the natives banished.

Literature: Dolmetsch, 21–4, 92–3; *DNB*; Lewis Namier and John Brooke, *House of Commons 1754–1790* III, 1964, 316–17.

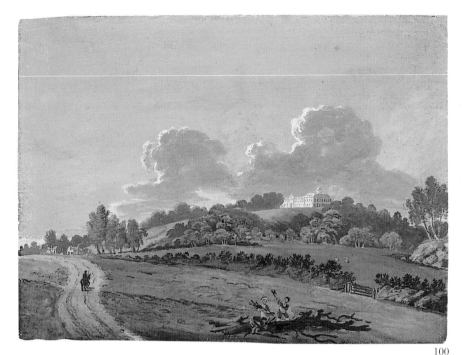

100

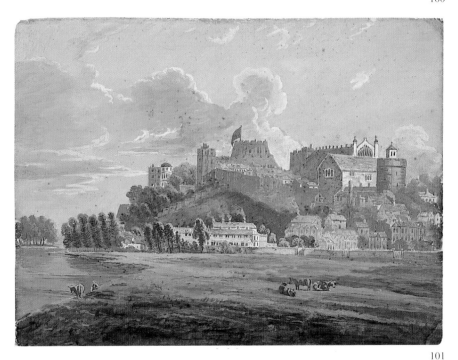

101

In 1777, 1780 and 1782 Sandby issued several etchings of views of Windsor in outline only. The most complete set was bequeathed to the British Museum by William Sandby (c.189* b.2). A note by him inside the cover, written in 1872, explains that they were issued in sets as outlines for 'tinted drawings'. The first would be done by Sandby himself to serve as an example, and the rest by his pupils as studies and exercises in the art of colouring. This was precisely the form his teaching took at Woolwich (see cat. 97).

Around 1781, when these two bodycolour landscapes were produced, the young princes would still have been learning the basics of drawing, and detailed instruction in perspective, fortification and other similar subjects would have followed. A number of artists were employed to teach different types of drawing to the royal family, and these bodycolour landscapes may be the result of lessons with an artist whose work was very close to Sandby's, John Alexander Gresse (1741–94), who received various payments for drawing lessons given to the younger princes and princesses from 1778 to 1793.

Literature: Roberts 1987, 69; Roberts 1995, 20–1, 24, 137.

PRINCE ERNEST AUGUSTUS (1771–1851), later DUKE OF CUMBERLAND

101

A view of Windsor Town and Castle from the River Thames, 1780

Bodycolour on thick board, 273 × 371 mm

Inscribed on verso: *His Royal Highness Prince Ernest Augustus aged 9 years and a ½. Dec.8 1780 – view of Windsor. Town & Castle*

Oppé 1950, 16

Lent by Her Majesty The Queen (RL K 368)

John Alexander Gresse was teaching drawing to the younger princes and princesses when these landscapes were painted. Along with similar works by two other princes, they were found in Queen Charlotte's portfolio of works by her family. The present work bears evidence of once having been framed. The landscapes are a useful reminder that watercolour (described as 'tinted' or 'stained' drawing) was not the

only medium favoured by landscape artists in the second half of the eighteenth century. Considered 'foreign' in origin and 'garish', in the early nineteenth century bodycolour or gouache was abandoned in favour of the 'natural school' of watercolour painting, and these works have been excluded from most considerations of British art.

The use of bodycolour was common in the seventeenth century for limning small works on paper, card and vellum, but in the eighteenth century it was mainly employed in landscapes, and was considered to be the result of the influence of a number of Italian artists who worked or whose work was collected in Britain throughout the century. Goupy has already been discussed as an artist who produced copies of old masters in bodycolour, and in the 1740s was in constant attendance on Frederick, Prince of Wales, at Clivedon and Kew. The work of Marco Ricci (1676–1730), who often painted in bodycolour on leather, was particularly admired after 1762, when George III acquired Consul Smith's collection of his work. Francesco Zuccarelli

(1702–88) was another favourite with royal collectors, and was one of the teachers of Gresse, the son of a Genoese with property in London.

Like Sandby, Gresse worked in both bodycolour and watercolour. Sandby employed it for what he would have considered some of his most important commissions and exhibited pieces, and it appears from the works of his pupils, both civilian and military (cat. 102), that it formed an essential element of his instruction in 'colouring' landscape.

These views of the area around Windsor are reminders of a further connection between Sandby and royal amateurs and their circle at court. Sandby painted a very similar composition in bodycolour in 1802 (Oppé 1947, no. 79), but he had also painted seventy views of Windsor and Eton for Joseph Banks just before he and Sandby visited Wales in 1773. These were kept in a folio volume. Banks's acquaintance with the royal family grew in the following decades, particularly through his activities at Kew, and sometime between c.1790 and 1818

Lady Banks lent the volume to Princess Elizabeth (cat. 51), who produced a number of tracings from them. These are preserved in the Staatliche Museum at Greiz, along with a number of watercolours and drawings by Sandby that were also in her collection.

Literature: Roberts 1987, 69, 212 n. 44; Roberts 1995, 137; Herrmann, 29–35.

WILLIAM GRAVATT
(*fl.* 1790–1867?)

102

Kingstown, St Vincent

Bodycolour and watercolour over pencil, 317 × 486 mm

LB 2

Provenance: Purchased from MacPherson 1867-12-14-76

William Gravatt was in the Royal Engineers and seems to have received his training at Woolwich where he would have been

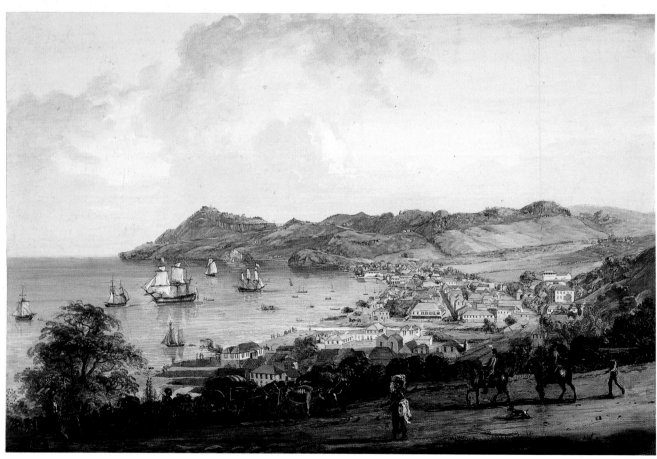

102

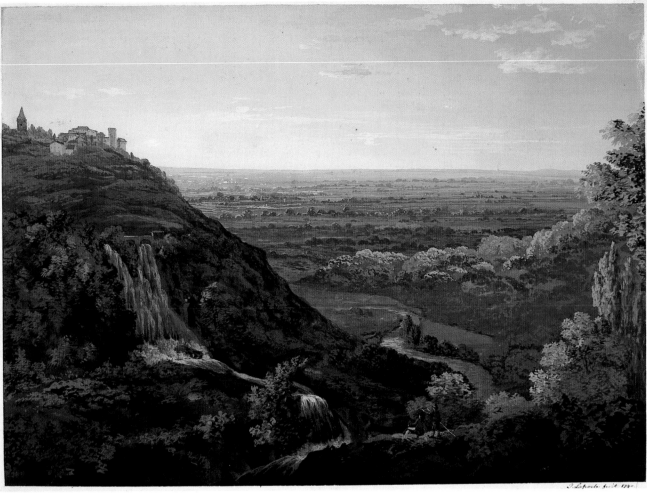

103

taught drawing by Sandby. Commissioned in 1791, he served in the West Indies and was made captain in 1799. The published records of the academy indicate that his involvement with the Military Academy continued in 1814 when as lieutenant-colonel he was appointed assistant inspector of the academy, becoming full inspector in 1828. The 1895 edition of the *Records of the Royal Military Academy* was illustrated with plates after his sketches of the uniforms of the cadets through different periods of the academy's history. By the date of this last publication, Gravatt would have been fairly widely known as a disciple of Sandby. He had formed a large collection of his works (several are now in the Victoria and Albert Museum and British Museum), and William Sandby published excerpts from Gravatt's diary in his biography of the Sandbys in 1892. These provide a full, detailed description of Sandby's method of

working in bodycolours, as he watched Sandby paint a 'picture in water colours' of Conway Castle over a three-day period in 1802, another of an oak in 1805 and an oil painting in 1807 (the whole of the first two are transcribed in Hardie).

The Museum has a watercolour view of Ludlow Castle, Shropshire, by Gravatt, which is reminiscent of the type of watercolours that Sandby used for the plates in the *Virtuosi's Museum* (1778–81). In that publication he worked up finished landscapes from drawings, watercolours and sketches sent to him by his amateur and military pupils, many of whom were younger sons of important landowners and aristocrats, including Charles Greville and the Hon. Mr Dawson. They were engraved and published with a facing text in which he was careful to acknowledge the person who had sent him the sketch, as well as the owners of houses or estates depicted. It was reissued

later as *A Collection of One Hundred and Fifty Select Views in England, Wales, Scotland and Ireland* with texts in English and French. In the preface he acknowledged that he had been given the idea for the publication by the fact that Catherine the Great had requested similar views of the country to adorn the creamware dinner service Wedgwood had created for her in the 1770s. Sandby successfully built upon its success by providing a similar project that was able to reach a much wider audience through the medium of prints.

At the same time Sandby was building on the constantly growing demand for printed views, and it is natural that his pupils, whether military or civilian and often stationed in exotic foreign lands, should wish to make their own contribution and demonstrate it publicly through the medium of prints. For military amateurs it must have been a form of self-promotion, as

nearly every example of this type of drawing, whether merely a sketch, watercolour or carefully worked bodycolour painting as here, appeared shortly afterwards in print. Gravatt is unusual in that he engraved his own prints in aquatint, the medium that Sandby had played such a large part in introducing to England.

Gravatt's view shows the town and harbour of Kingston, St Vincent, with Fort Charlotte beyond. He plays down the military aspect of the view more than he would in a drawing for military engineering purposes and provides his British audience with the details they would find most interesting – the general view, the exotic vegetation and the local inhabitants in the foreground in a cart, with two men on horses to the left representing the controlling presence of Britain. The view is one of three in the Museum of the town, harbour and British forts of Kingston, and there are also two etchings, all by Gravatt (1867-12-14-75, 77, 79, 81).

Literature: Buchanan-Dunlop, intro (n.p.); Hardie I, 106–8; Herrmann, 67.

JOHN LAPORTE (1761–1839)

103

View of Tivoli and the Roman Campagna, 1790

Bodycolour, 320 × 444 mm, on mount with wash border, 375 × 500 mm

Inscribed on mount: *J. Laporte fecit 1790*.

Provenance: Bequeathed by Iolo Williams 1962-7-14-42

Iolo Williams, who once owned this drawing, thought that it showed the strong influence of Paul Sandby because of its use of bodycolour and an Italianate composition. He remarked that high objects and diagonal lines guiding the eye were Laporte's favourite compositional motifs. Rather than Sandby's direct influence, however, this work is an example of how landscapists who were often also drawing masters, like Sandby and Laporte (who had military pupils at Addiscombe, as well as private ones), demonstrated their ability in works they painted for public exhibition. Because oil painting was still considered a superior medium by collectors and connoisseurs, even at the end of the century, landscapists employed bodycolour particu-

larly for works for exhibition because it was closer to oil in effect and colour, and had literally a stronger 'presence' on crowded exhibition walls than tinted watercolour drawings.

Such drawings are something of a shock to modern eyes used to the comparatively pale washes of watercolour drawings, but bodycolour had been popular and in constant use throughout the eighteenth century and the colours, which might seem garish today, are comparable to the bright colours of the skies in the oil paintings of Alexander Cozens, Wright of Derby and Joseph Vernet. In the last decades of the century collectors such as Sir William Hamilton and Richard Colt Hoare were bringing back from Italy similarly brightly coloured works in bodycolour by Pietro Fabris, Philipp Hackert and Xavier della Gatta.

Sandby had never been to Italy, but painted similar Italianate compositions based on the work he had seen by Goupy, Zuccarelli and Ricci, some examples of which he owned himself. Basil Long suggested that Laporte's use of bodycolour was a deliberate reminder of his continental, probably French, origin, intended to attract patrons and pupils, but Laporte was, in fact, probably taught by John Melchior Barralet, a Huguenot from Dublin who ran a drawing school there and in London with his brother in the 1770s and also exhibited in bodycolour. In the 1790s the use of this medium began to fall away after John Robert Cozens, Warwick Smith and later Turner and Girtin began to demonstrate other ways of lending 'presence' to watercolours.

At some date Laporte taught Dr Monro (to whom he sold around £500 worth of drawings) and his later works and well-known drawing books indicate that he, unlike Sandby, was attempting to keep up with developments in technique and public taste for painting in watercolour. He produced an influential series of soft-ground etchings, *A Collection of Prints illustrative of English Scenery, from the drawings and sketches of Thomas Gainsborough* (1802–4), listing on the title-page the collectors who owned the drawings that were the sources of these prints, including the Baroness Lucas (cat. 110), Dr Monro and himself. It also served as a drawing book, as did his *Characters of Trees* (1798–1801), which was remarkably close to John Robert Cozens's publication of 1789, and two successful landscape manuals, which demonstrated in

a series of progressive plates how to sketch from nature (1804) and paint in watercolours (1812).

Literature: Basil Long, 'John Laporte, landscape painter and etcher', *Walker's Quarterly* VIII (1922), 3–58; Williams, 61–2; Fleming-Williams, in Hardie III, 239–40; Bicknell and Munro, 52–3, 132.

ROBERT HYDE COLEBROOKE (1762–1808)

104

Benares, c.1794

Pen and black ink, with grey wash and watercolour, 344 × 514 mm

Provenance: Presented by Dr J. Law Adam 1909-2-11-1

Robert Colebrooke was a military surveyor like William Roy, with whom Sandby had worked in Scotland (see cat. 90). The natural son of the British envoy to Switzerland, through the influence of his uncle, a director of the East India Company, Colebrooke went to India at the age of sixteen with the Bengal Infantry and during the war in Mysore in 1781–5, proved to be an outstanding surveyor and draughtsman. Early military surveys were quickly followed by more carefully planned topographical and revenue surveys once territory had been formally ceded to the East India Company. He worked mainly in Bengal for the surveyor-general and was one of the assistants on the 1789–90 survey for possible harbours in the coast and islands of the Bay of Bengal. Copies of his watercolours, probably the earliest images of the islands and their inhabitants, illustrated the official reports of the islands, which were sent back to London.

Back in Mysore from 1791 to 1792, Colebrooke's experiences provided him with an opportunity to make his own contribution to the English fascination with the area. On his return to Calcutta he advertised for subscribers to the publication of a set of watercolours he was finishing. In December 1792 he reported to subscribers that these were 'put into the hands of Edy, an eminent engraver, under the eye and superintendence of Mr Paul Sandby'. Cadets of the East India Company were partly trained at Woolwich where he himself had probably received lessons from Sandby in the mid-1770s. An entertainment

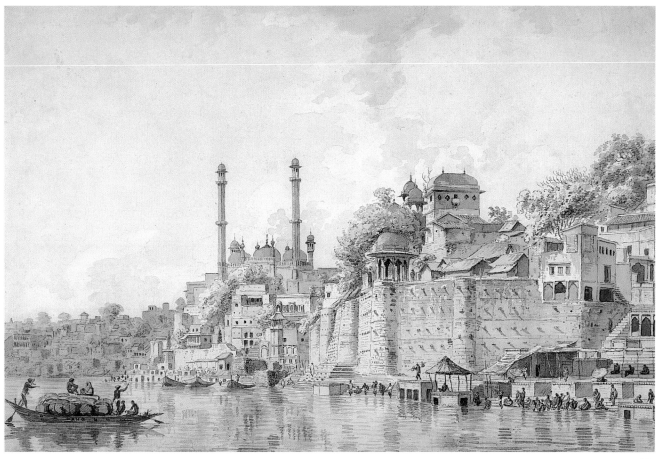

104

at the Calcutta Theatre to celebrate the victory at Seringapatam had scenery painted from his drawings in 1793, and the following year the *Twelve views of Places in the Kingdom of Mysore, the Country of Tippoo Sultan* was published. The same year he was appointed surveyor-general, the first infantry officer to hold the post. John William Edy seems to have specialized in such interpretations as two years later he made aquatints of Lieutenant George Bulteel Fisher's *Views in North America* (cat. 138).

The watercolours for two of Colebrooke's published views, *North-west view of Seringapatam* and the *Mausoleum of Hyder Aly Khan, at Laulbaug*, are in the British Museum, both inscribed *ad vivum, 1792* (LB 1, 2; 1881-11-12-30,29). The printed views do not dwell on the exotic and at first glance resemble views of the Lake District, with a few small figures of Indians and cows instead of English shepherds and sheep. However, in one or two of the plates English soldiers are seen in action and a closer look reveals that

the mountains shelter the fortresses and cruel prisons of the 'inhuman Tyrant Tippoo Sultan'. The text dwells on the gruesome details of the sultan's treatment of British prisoners and the success of British attacks, with the names of commanders and men distinguished in action. It was an exercise in British national and imperial propaganda, unlike Thomas Williamson's *Oriental Field Sports* (see cat. 105), but both overlay their subtext with the same *frisson* of horror and fear.

From 1794 to 1797 Colebrooke worked on the survey of the River Ganges and some of the watercolours made at that time (now British Library, OIOC) bear inscriptions indicating that he probably intended to publish them in a volume of 'Indian Scenery', but none appeared. The Museum was presented with two watercolours from this series in 1909: *A view of Plassey House*, dated 1794, and the present work. According to Brahmin legends, the sacred city of Benares, now Varanasi, was originally made of gold, but became stone as

a consequence of the wickedness of the inhabitants. On the northern bank of the Ganges, it was the largest city in Hindustan, a place of commerce, especially in diamonds, and pilgrimage, where sinners could be cleansed by washing in the river.

Literature: Archer 1–32, 142–3;
R. H. Phillimore, *Historical Records of the Survey of India*, Dehra Dun 1945, 326–9; Patricia Kattenhorn, 'Sketching from nature: soldier artists in India', in Rohatgi and Godrej, 20–1.

105

Captain Thomas George Williamson (1758/9–1817)

105

Exhibition of a battle between a tiger and a buffalo

LB 10 (under Howitt)

Pen and grey ink with watercolour, 283 × 417 mm

Provenance: Revd Dr Charles Sloman, LL.D, rector of Eling, near Southampton; his sale Wheatley's, 20 July 1835, part of lot 279 'Various Views Sketches etc.' (26 items), purchased for the Museum by William Young Ottley

Nn. 7-39(279/24) and 1835-7-11-206(24)

Thomas Williamson was the author of *Oriental Field Sports*, published in 1807 and illustrated with engravings after watercolours by Samuel Howitt (1756–1822), based on Williamson's own sketches made on the spot. Binyon thought that the two drawings related to this publication (one is exhibited here), acquired by the Museum in 1835, were probably Williamson's own sketches; but he listed them in his catalogue of the collection under Howitt. Iolo Williams owned two other drawings, which 'free and rough as they are, are quite characteristic of Howitt', and Hardie followed his example. However, in the coloured engraving after this drawing, the awning is moved to the right, a landscape background with cliffs, palms and other exotic elements is introduced, and even the position of the animals is changed. It seems unlikely that Howitt produced an entire series of sketches before making the watercolours on which the engravings were based; the British Museum's sketches, as well as a number scattered through various collections, would seem instead to be Williamson's own.

Williamson has remained an enigmatic footnote in books on British art, but an anonymous researcher in oriental field sports placed a note with the details of his career in the Witt Library. This new information places him firmly in this exhibition as a military amateur whose views of life and customs in the country to which he was posted provide evidence of the ways that the British saw themselves and the inhabitants. Born in London, Williamson sailed to India in the 3rd Bengal European Regiment in 1778, rising quickly through the ranks from cadet to ensign and then to lieutenant. He was transferred to the Sepoys in 1787, returning to his first regiment as captain in 1796. Two years later, when he was in the Native Infantry, he was suspended and ordered home for writing a letter that had appeared in the Calcutta *Telegraph* criticizing the government's military policy. The military review board considered 'his conduct highly criminal and of dangerous tendency', but he was permitted to retire and wrote several other books on India, including *The East India Vade-Mecum* (1810) and *The European in India* (1813).

The full title and preface to *Oriental Field Sports* indicate that it was not only intended for the sportsman, but also for the public 'as depicting the Manners, Customs, Scenes, and Costume of a territory now intimately blended with the British Empire and of such import to its welfare … [so as to provide] knowledge of whatever may hitherto have been concealed, or remains unfolded to our view'. Williamson also pointed out that his images depicted Europeans rather than Indians hunting because to hunt was a 'drugery' derogatory to Indians of higher orders. The three-page text that accompanied this particular plate (XXIV, 92–4) included a detailed description of the character, habitat and fierce nature of the buffalo, and explained that such special entertainments were given by Indian nobles.

Throughout the late eighteenth and early nineteenth centuries, many amateurs sent home sketches and watercolours to be engraved for the British market, with varying results. Sometimes their works were vastly improved, but they also suffered from mistaken interpretations and the imposition of British artistic norms on landscapes the engravers or other artists improving their work had never seen themselves. Williamson was on hand to guide Howitt's interpretation of his sketches with the result that Howitt gained a reputation for the depiction of 'exotic' animals and Williamson's own hand has been lost and can no longer be identified with certainty.

Literature: Williams, 195; Hardie I, 225, fig. 231; for amateur artists in India, see esp. Archer.

5
Creating Compositions

Blotting, splashing and sponging

In 1812–13 an unsigned author, probably the watercolourist William Henry Pyne, wrote a series of articles titled 'Observations on the Rise and Progress of Painting in Water Colours' for Rudolph Ackermann's popular periodical the *Repository of Arts*.[1] In the text he staked a claim for watercolour as Britain's own unique contribution to the history of art, and described its development from its sources in manuscript illumination (limning) through topographical tinted drawings, such as those of Sandby, to painting in watercolour as practised by Girtin and Turner. This way of seeing the 'new' art of painting in watercolours as a triumphant national school emerged from a search during the years of war with France for a truly British alternative to what reviewers saw as 'the Gallic glitter' of fashionable landscape painting.[2] In the 1790s and 1800s anything too reminiscent of Dutch or French art, or too reliant upon flashy techniques or colours, even works too obviously derivative of the old masters, were dismissed in the search for a 'natural' English school. Sandby's work was lauded as representing English nature most directly and unaffectedly.[3]

Writing under the pseudonym of Ephraim Hardcastle, Pyne took up the subject again ten years later in his own weekly, the *Somerset House Gazette*.[4] By then a shift had occurred in the definition of the 'natural' English school from tinted topographical drawings to the fully fledged painting of landscapes in watercolour, produced not for the portfolio as most earlier watercolours were, but to be framed, exhibited, purchased and hung in grand rooms in the manner previously reserved for oil paintings or works mainly in bodycolour. Foreign artists were no longer the main threat to the national school, but truth to nature and its skilful portrayal were the defining characteristics, and anything not paying homage to them was a step backwards. In addition, from 1804 watercolourists had formed their own exhibiting societies, and, insisting that their work and their profession as artists be considered with the same seriousness as painters in oil, they had distanced themselves from amateurs by banning the work of the latter from their exhibitions, eliminating any chance that their 'incorrectness' might be mistaken for the work of professional watercolour painters.

Professional artists ranked drawing masters who falsely encouraged such amateurs as the lowest of their kind,[5] and it was the work of one drawing master in particular that had instigated Pyne's invective. This was John Glover (1767–1849), whose 'split brush technique' for foliage was a trick that led to 'incorrectness' and 'fortuitous scumbling' in his own and his pupils' work. William Payne (1760–1830), with his mannered formulaic trees, was another, moving Pyne to write:

Certain professors, even of original capacity and talent, seeking profit rather than fame, lent themselves to this perversion of style, by sedulously studying how to substitute incoherency and scrawling, for correctness of drawing; and blotting and sponging, for precision of touch ... Indeed it is a fatal truth that not one amateur in fifty can now be found who will endure to copy a correct and highly finished work of art ... it is now the custom to 'begin at the ending', namely by pretending to teach them composition, light, shadow, colouring, and effect, without the previous study of drawing a correct outline, of a single lesson on perspective, or any one grammatical trait of the art. Hence, the half-accomplished sylphs play [music] like angels, and paint, or rather smudge, like Chimney sweeps.[6]

Pyne laid the blame ultimately at the door of two eighteenth-century landscape artists: Thomas Gainsborough and Alexander Cozens. In a greatly exaggerated and misleading account of Cozens's work, later repeated in Henry Angelo's *Reminiscences* (1828), Pyne wrote:

Will it be believed hereafter, that a professor of painting, should undertake to splash the surface of a china plate with yellow, red, blue, and black, and taking impressions from the promiscuous mass, on prepared paper, affect to teach his disciples; and those persons of education and elegant mind to work them into landscape compositions?[7]

The account was largely a fabrication, in part based on Cozens's experiments while teaching his pupils from Eton and in part on his own explanation in the *New Method* (see cats 106–7). Nevertheless, it was accounts such as this that led to the misunderstanding of both Cozens's technique and his intentions during the nineteenth century, and to many anachronistic claims for it as a forerunner of abstraction in the twentieth.[8]

For Cozens, as for William Gilpin, J. B. Malchair and the other artists and amateurs in this chapter, to copy nature exactly was to imitate rather than invent. In his annual *Discourses* to the Royal Academy Reynolds argued that although imitation and copying were necessary steps in acquiring skills, to exhibit imitations or copies as finished works of art was to 'operate by deception'; they also stifled real invention, the sign of true genius.[9]

Cozens, too, wrote that novelty was a sign of genius, especially when it was combined with 'strength of ideas, power of invention and ready execution' (*New Method*, p. 18). Thus, because these works do not copy nature, they seem to us to be further removed from it. Nature was, nevertheless, a constant source of inspiration for these artists, and their work was a celebration of nature and produced in homage to it. This was alluded to, if rather obscurely, on the title-page to Cozens's

New Method, where he quoted from Shakespeare: 'This is an Art/ Which does mend Nature, change it rather; but/ The Art itself is Nature.' He echoed the sentiment again later in his text (p. 31), quoting a passage by Alexander Pope as a preface to his list of the various kinds of landscape composition:

> Those Rules which are discover'd, not devis'd,
> Are Nature still, but Nature methodiz'd:
> Nature, like Monarchy, is but restrain'd
> By the same Laws which first herself ordain'd.

'Composing landscapes by invention'

The works in this chapter rely on form, light and shade rather than on drawing and colour as in the work of Sandby and his pupils. Cozens explained the difference as one of method:

> To sketch in the common way, is to transfer ideas from the mind to the paper, or canvas, in outlines, in the slightest manner. To blot, is to make varied spots and shapes with ink on paper, producing accidental forms without lines, from which ideas are presented to the mind. This is conformable to nature: for in nature, forms are not distinguished by line, but by shade and colour. To sketch is to delineate ideas; blotting suggests them

– and of purpose –

> Composing landscapes by invention, is not the art of imitating individual nature; it is more; it is forming artificial representations of landscape on the general principles of nature … ; concentring in each individual composition the beauties, which judicious imitation would select from those which are dispersed in nature
> [pp. 8, 9, 2]

Thus the precept of truth to nature underlies all of these landscapes of the eighteenth century when the divisions between topographical landscape, invented landscapes and sketching from nature are not as clear cut as they were to become in Pyne's version of the 'rise of painting in watercolour'.

During the 1750s the children of the 1st Earl Harcourt took lessons in drawing from the royal drawing masters (see cats 96, 109), and on his grand tour in 1755, his eldest son Viscount Nuneham wrote from Vienna to his sister Lady Elizabeth that he had tried his hand at

all sorts of Painting since I left England – as to watercolours I could never do anything that had the likeness of any thing that is in heaven above or the earth beneath but for Crayons I have without a Master or any instructions done some Landscapes that were more tollerable, particularly one large one of a view upon the Rhine, … Landscape in Crayons are things almost unknown & I never knew but Knapton & the D. of Weimar that did them so that I fear I shall even find difficulty in Italy to get an instructor … of all the masters I have seen & learned of Cozens was the only one that had taste or thoroughly understood the business he professed.[10]

In Rome the following February Nuneham wrote that he had not been able to find a master but had painted a large picture in crayons and was working on a companion.[11] He noted a month later that Elizabeth was studying perspective, which he thought she must find difficult, and supposed that she was studying it with Kirby, and also drawing landscapes with him or another master 'to amuse [her] a little'.[12]

In a letter several years later, Nuneham told his sister he was 'painting as if it were for my bread, my daub (which by the way) is much less of a daub than any of my former daubs, is designed as a present for the Queen',[13] evidently as wary as earlier amateurs of labouring too hard or producing something too professional. In 1787 he lent his own drawings to Queen Charlotte to copy, which she said continued to amuse 'though the King says it is the shabbiest way of drawing in the whole world',[14] apparently aware of Reynolds's strictures against copying.

Gainsborough was one of those whose 'moppings' Pyne had stated were imitated by his pupils to the detriment of the national school, and a few years later Henry Angelo repeated that the queen took lessons from Gainsborough during the 'then fashionable rage for that artist's eccentric style denominated Gainsborough's moppings'.[15] Certainly Gainsborough had a number of pupils throughout his life, and several amateurs continued to copy his work after his death when his drawings were purchased by Sir George Beaumont, Dr Monro, John Henderson and Richard Payne Knight (see cats 149–54). In 1764 he wrote to a friend that he was teaching his own daughters to paint landscape upon a scheme 'somewhat above the common Fan-mount style', and his portrait of them holding *portes-crayons* and a portfolio before his small cast of the Farnese *Flora* shows the seriousness of his scheme, which in their case certainly did not lean towards the common taste for his 'moppings'. His letters to them at school continued their instruction in drawing.[16] It is doubtful, however, that Gainsborough gave the royal family direct regular tuition in 1781 when he was painting their portraits: rather they probably studied his style by copying his portraits, redrawn and interpreted for them by their current drawing master, Alexander Gresse,[17] or by copying his watercolours. Princess Elizabeth's 1789 copy of Gainsborough's *Landscape with a boy asleep in a cart* of the 1760s (Ashmolean Museum, Oxford) indicates that the drawing may have once been in the Royal Collection.[18] Queen Charlotte's sale in 1819 had twenty-two studies by Gainsborough, presumably including ten of his much-acclaimed drawings in coloured chalks.[19] Queen Charlotte's own copies of Gainsborough drawings were presented by her to the 2nd Earl Harcourt,[20] and when the earl was succeeded by his brother William, who was married to Mary (cat. 108), the close relationship of the two families and the flow of gifts to another pair of accomplished amateurs, who would appreciate the royal efforts, continued (see cats 77, 96, 109).

In the 1760s, shortly after he moved to Bath and became acquainted with Uvedale Tomkyns Price of Foxley and his son Robert, Gainsborough studied landscapes from nature as well as composing them from imagination, just as he had done earlier in Suffolk. His study of a beech at Foxley, dated 1760, was clearly a study from nature,[21] but at the same time he began to enliven the surface of his watercolours with white bodycolour after seeing the drawings produced by Robert Price under Giovanni Battista Busiri's (1698–1757) tuition in Rome (see

cat. 117). Another drawing made at this time, of a waggon in a wooded glade,[22] is very reminiscent of a series of watercolour sketches from nature on blue paper traditionally attributed to Van Dyck.[23] At least one of these was in the collection of Uvedale Price and was inscribed on the verso: *Vandyck, thought so by Mr West. It was a very favourite drawing of Gainsborough's.*[24] Gainsborough also produced a series of landscapes in chalk (Nuneham's 'crayons') on blue paper in the 1770s, many of which were in the Spencer collection at Althorp.[25]

All these sketches from nature are reminiscent of the watercolour studies made by Taverner at some unknown date, possibly also in the 1750s and 1760s (see cats 57–9), and Gainsborough's studies for his late history painting of *Diana and Actaeon* (Royal Collection) seem to derive from the same way of studying nature. Taverner's large *Sandpit at Woolwich* (cat. 60) is illustrative of the way in which studies from nature were intended to lead to finished works that did not slavishly copy nature, but created something new out of it, through the medium of the old masters (in this case the Dutch realists), the English topographical tradition and the use of bodycolour, as seen in the Italianate works of the Goupys, Riccis and occasionally in Sandby and Gainsborough's drawings as well. Similarly, Jonathan Skelton's works before travelling to Italy were basically topographical, but those done in Rome in 1758 show the strong influence of Dughet, Claude and Poussin, even though Skelton's letters are full of the improvements he has made to his work from painting from nature as his patron William Herring had advised.[26]

'Sybil's leaves'

All Mary Harcourt's very Cozens-like brown wash landscapes, several of them once attributed to Cozens, were based on real views from nature, many of them from around her home at St Leonard's Hill (see cat. 108). But they were interpreted through Cozens's methods and techniques in order to lend them originality and remove them from being slavish copies of nature. A landscape in an almost identical style in the Victoria and Albert Museum (P.6-1928) was purchased as the work of Baroness Templetown (Elizabeth Boughton (1747–1823), m. Clotworthy Upton, 1769, cr. Baron Templetown 1777). She was already known as an amateur on her first grand tour in 1773–5, and had a reputation as a designer for Wedgwood (see cat. 176) when she returned to Italy with her three daughters in 1792, where they stayed until 1795.[27] Charlotte Aynscombe and Henry Stebbing were two other pupils who assiduously followed Cozens's technique for inventing landscapes.[28]

Two further pupils of Cozens who studied from nature, but produced brown wash drawings that bear little resemblance to it, were Lady Elizabeth Harcourt, later Lee (cat. 109) and Lady Amabel Grey, later Polwarth and Lucas (cat. 110). The portfolio of drawings by the former, now in the Buckinghamshire Record Office, once contained oval blot drawings and landscapes after them clearly done under Cozens's tuition, but it also held some of his early carefully drawn imaginary landscapes, and still

contains watercolour and brown wash landscapes in his manner, which are views of real, rather than imaginary landscapes, particularly gardens such as that of Sir Charles-Kemeys Tynte.[29] Lady Elizabeth shared her brother's passion for gardening, especially their 'equally favorite Hobby Horse, the Flower Garden'. William Mason had created a flower garden for Nuneham in the early 1770s, and Lady Elizabeth redesigned that at Hartwell after her husband's death in the 1790s.[30] But unlike other women who created watercolour florilegia, Lady Elizabeth designed garlands of flowers and made nature prints from pressed flowers from her garden to record them.[31]

Lady Amabel Polwarth's etchings are included in this study to represent the legions of amateur printmakers of the eighteenth century. Her drawings and watercolours have remained in the hands of her descendants.[32] Few are outline drawings as her etchings are: most are once again close to Cozens's method of representing nature through form, light and shade, employing grey, brown and black washes with the occasional wash of blue or green. Her correspondence with her mother, the Marchioness Grey, and sister, Lady Mary Grantham, indicate how closely they followed Cozens's various methods for inventing landscape as he published them, and all three were subscribers to his *Principles of Beauty*. Amabel followed his instructions most closely and even at the age of sixteen (in 1767), her mother was to report:

Perhaps you may now think we are really as Idle as I mention'd before, & our Leisure as much Wasted. But … employing the morning more usefully in some Respects would be less so upon the whole … My Designer [Amabel] has taken some little sketches that are like & I think pretty, but she still complains of the want of Mr. Cozens' freedom of Manner, & believes he won't be satisfied with them.[33]

Amabel had been brought up to employ her time in a useful manner, and had herself written to her governess the year previously that the extent and wide range of her ambitions had defeated her: 'A great many things did I design to do – take views and trees by the dozens, draw and paint flowers by sheetfuls, read various histories, study the globes and astronomy, try experiments with the prisms, but as the French proverb says "qui trop embrasse, mal étreint".'[34] She married in July 1772, and toured Britain visiting relations with her new husband, and in Scotland she taught one of the young women she met to blot using Cozens's method.[35]

When Wedgwood's Green Frog Service for Catherine the Great, still 150 pieces short, went on display in London in June 1774, the Marchioness Grey anticipated seeing her own estates depicted in the service, as drawn by her daughter. She wrote to Lady Amabel with a list of drawings she wanted her to send.[36] Her daughter replied the same day:

I am glad you have seen Wedgwoods service for the Czarina, & that it is not yet compleat, for to be sure, though you & I will have no great share in the honour, I shall not be displeas'd if Wrest & Wimple make some figure aux Regions de l'Ourse … And I think they are pretty enough to deserve a good place, even in a collec-

tion of the prettiest views in England. Who knows but our tower may have the inestimable glory of pleasing her Imperial Majesty, & be mounted upon some Hill at Czarsko Zelo [finished drawings and sketches and three framed works were at her mother's disposal] … Though to say the truth I rather doubt whether my drawings of that ancient ruin are very intelligible & I cannot finish them better without being upon the spot … Two more Sybil's leaves will be sent up next Thursday, one of the window, & the other of the cold bath. I shall have done a little more to the last in the meantime, though I shall not have leisure to finish it properly.[37]

These letters provide a detailed description of the approach, method, technique and purpose of a female amateur landscapist of the eighteenth century. Lady Amabel's surviving drawings do not include the drawings she describes here, but we can gauge their appearance from the seven views of Wimpole and five of Wrest, which were indeed used on the lid of a tureen and eleven dessert plates in the Green Frog Service.[38] But we can also make some estimate of her abilities, style and approach to landscape from her surviving prints (see cat. 110). Like other amateurs, she had these printed privately and presented them as gifts to friends and collectors – not only to Richard Bull, but also to the president of the Royal Academy, Benjamin West, who had cleaned one of her paintings and expressed regard for her late brother-in-law, Lord Grantham: 'it may interest him to hear that Ldy Lucas (having learnt Etching of Mr. Bretherton) executed a Set of Plates after Six Views Ld. Grantham had taken in the Neighbourhood of Aranjuez. & if Mr West would like to admit them into his collection, she will look them out, & send them to him'.[39] Her correspondence is liberally scattered with references to her own and her relatives' drawings and to exhibitions visited and artists employed by her family as well as the works they collected.

Her aunt Agneta Yorke shared Lady Amabel's passion for drawing, and through the 1780s her letters from Lymington are full of references to her own attempts. Agneta Yorke made the acquaintance there of the Revd William Gilpin, who had taught her sons when headmaster at Cheam in the 1770s, where the school's regulations had stated 'drawing too is much recommended as a useful amusement. If any hath a genius for it, it is encouraged.'[40] Shortly after meeting him again, Agneta wrote to the Marchioness Grey in October 1781:

I have wished for dear Lady Bell's presence more than once here, having been treated with the sight of a number of such beautiful and masterly sketches made by a Gentleman in his Tour thro the Highlands, the north of England & some parts of Wales, together with his observations on the picturesque beauties of those countries, has afforded me the highest entertainment … His taste and skill in design & execution, are very uncommon, and tho I am not of an covetous disposition, I own I do most sincerely wish myself possessed of his genius … I recommend the aquatinta to him as a manner most likely to preserve the spirit of his drawings. I have, myself, been dabbling a little in Indian Ink, & have attempted to take two or three views of the River here; but have not succeeded so well as I could wish, tho perhaps well enough for one who never practiced drawing from Nature. I shall desire Lady Bell to set in Judgement …[41]

Some of Agneta Yorke's views were later etched by her daughter Caroline, who in 1788 sent Gilpin a couple of etchings for his approval and offered to etch one of his drawings for his next tour. He diplomatically replied that he could not possibly use her services in this way as it would class her as a professional, but if she could interest a few of her friends who could etch as well as she, he 'would turn one of my little journeys into an exhibition-room for gentlemen, & ladies, without the intrusion of any artist'.[42] Caroline Yorke was unable to convince others to join her, but the project makes an interesting addition to collections of etchings such as those of Horace Walpole and Richard Bull (see cat. 87), and to tours later illustrated and engraved by the amateurs themselves (see cat. 132).

Apart from a few early lessons given to pupils at Cheam before his brother Sawrey arrived to assist, William Gilpin was not a drawing master. But his tours, all beginning with the words *Observations relative to Picturesque Beauty*…, were easy to use as instruction books about the proper way to view scenery and the principles for discovering the picturesque. He defined the picturesque as 'that kind of beauty which would look well in a picture'.[43] Although he did not teach, his example was before hundreds of followers in the form of prints after his drawings that illustrated his tours, and the drawings themselves, which he frequently presented as gifts. In addition, he scrupulously advised those who wrote to him with queries, and he compiled dozens of manuscript manuals as albums where he explained by example, as Cozens had done on 'the different modes of composition in landscape'.[44] The examples in these albums were usually arranged in pairs of drawings with some fault in the composition of one being corrected in the other. He also published several instructional texts, particularly various *Essays* explaining his mode of executing rough sketches and the principles on which they were composed.[45] Like Cozens, Gilpin recommended sketching loosely rather than delineating carefully, as an eye accustomed to picturesque ideas could 'take up the half-formed images … give them a new creation; and make up all that is not expressed from its own store-house' (*Three Essays*, 62). Thus the artist 'produces from the glow of his imagination, with a few bold strokes, such wonderful effusions of genius as the most sober, and correct productions of his pencil cannot equal' (ibid.). This reliance on the imagination to complete the process of creation results in constant novelty, thus fulfilling Cozens's earlier definition of genius as strength of ideas, power of invention and ready execution.

An essential difference in their work, however, is Cozens's insistence that a store of references be built up from nature, while although Gilpin taught how to see pictures in nature, when it came to creating landscapes on paper, composition and effect were essential, but truth to the details of nature were not. Gilpin was the first to identify as singularly English the obscurity caused by the vaporous atmosphere as it occurred in landscapes in nature, and he built on the link between indistinctness and its power to stimulate the imagination. Cozens took this power of imagination one step further and noted that the feelings or sentiments raised by certain compositions could be used in a way beneficial to society, by using landscape to

purposely stimulate ideas of freedom, liberty, delight, greatness and awe.

In his own way, although with no evident connection with Gilpin or Cozens, the Oxford musician and drawing master John Baptist Malchair (cat. 116) produced landscapes that paid homage to compositions familiar from pictures as well as to the atmospheric obscurity native to the English and Welsh countryside. Oppé noted that Malchair, even without 'having great success in representation, could impart to others patience and sympathy in looking at Nature and the choice of picturesque subjects in the way of classical composition and rustic interest'.[46] But Malchair's greatest achievement as a drawing master was that he did not impose a style on his pupils – many of their works are instantly recognizable as the results of his tutelage, especially annotations concerning the time and place drawings were made – but these are equally indications that he taught his pupils to paint out of doors, and to interpret nature through traditional compositions, rather than merely to transcribe literally what they saw. His pupils were not encouraged to reduce or alter what they saw to fit a more 'picturesque' composition as Gilpin had done, nor did they 'invent' compositions as Cozens had encouraged his pupils to do; instead they looked at nature and interpreted it through their own styles and approaches. Malchair had a horror of systems and formulae and encouraged working freehand from nature. Most of his better pupils did indeed manage to achieve distinctive personal styles of their own, in which their debt to him is clear, but their work could never be mistaken for his.

Even though they are nearly all based on real views in nature, the monochromatic landscapes in this chapter are strikingly different from those that precede and follow them. They fulfil all the criteria recommended for the creation of landscape drawings and watercolours in the eighteenth century, notably Reynolds's strictures concerning over-attention to detail, which dissipates attention from the general effect and power of the whole,[47] and they demonstrate a knowledge of and homage to the compositions of the old masters, as well as a fundamental understanding of the precept that one must invent and create something new and original from nature rather than copy it slavishly. Very few of these works were framed and exhibited: many changed hands as gifts, but they were intended for the album or portfolio – for domestic consumption rather than public display. They fulfilled none of Pyne or other nineteenth-century critics' criteria for watercolours representative of the great new national school, with its particular version of 'truth to nature', demonstrating instead all the features that the professional artists who founded the Society of Painters in Water Colours in 1804 associated with the work of amateurs, and excluded from their exhibitions.[48] Gainsborough's 'moppings', Cozens's 'blots', Gilpin's 'indistinct visions' of the picturesque and Malchair's 'recollections', as well as the works of countless other provincial drawing masters such as Amos Green and Joseph Barber, thus became associated almost exclusively with the productions of amateurs,[49] sharing their decline in status and their ostracism, until recently, from 'the great age of British watercolours'.

NOTES

1 8, 1812, 257–60, 324–27; 9, 1813, 23–7, 91–4, 146–9, 219–21; for the attribution of these articles to Pyne and the significant role of this periodical and Pyne's own later *Somerset House Gazette*, see Ann Pullan, 'Fashioning a Public for Art: Ideology, Gender and the Fine Arts in the English Periodical *c.*1800–25', PhD thesis, University of Cambridge, 1992.

2 See Kriz chap. 2, 'Of old masters, French glitter, and English nature', 33–56.

3 Ibid., 45; and see Wilcox, 'Looking backwards: Victorian perspectives on the romantic landscape watercolour', in Rosenthal, Payne and Wilcox, 312–13, and Smith 1999, 1, 11.

4 1, 1823, 65–7 and *passim*.

5 Fleming-Williams, 225

6 W. H. Pyne, 'The Rise and Progress of Watercolour Painting', *Somerset House Gazette* (1823) (1), 145–6.

7 *Somerset House Gazette* (1823) (1), 162; and Oppé 1952, 41.

8 For a list of these anachronistic interpretations and further explanation of Cozens's sense of abstraction, see Cramer, 113, 126.

9 Reynolds's views on copying and imitation are summarized in Bermingham 1992, 152–3, where she takes this argument a step further and equates nature with reproduction and the feminine, and invention with creation and the masculine.

10 Lee papers, Buckinghamshire Record Office, R.O.D./LE/E/2/16, quoted in Sloan 1986, *Cozens*, 29. An example of a landscape in crayons by Alexander Cozens in the British Museum is reproduced in ibid., fig. 57.

11 E/2/18.

12 E/2/19, Rome, 9 April, 1756, addressed to her at Cavendish Square in London.

13 E/2/48, n.d.

14 Whitley II, 73–4

15 Angelo and Pyne, quoted in Roberts, 70.

16 Hayes and Stainton, no. 31; his portrait of them is now in Worcester Art Museum, (Mass).

17 Roberts 71 for etched version of Gresse's interpretation of Gainsborough's portrait of Prince Octavius who died 1783.

18 See Hayes and Stainton, no. 30.

19 Oppé 1950, 11.

20 See Roberts, 64 for *God save the King*, and Hayes 865, pl. 325 for *Shepherd girl*.

21 Hayes and Stainton, no. 24.

22 BM 1899-5-16-10, Hayes and Stainton, no. 39; and Royalton-Kisch, fig. 42.

23 Royalton-Kisch, 180–1.

24 Ibid., now in British Museum as Anon. Flemish 17th century; it was no. 56 in T. Clifford, A. Griffiths and M. Royalton-Kisch, *Gainsborough and Reynolds in the British Museum*, exh. 1978 (1936-10-10-23); Price's sale Sotheby's 4 May 1854, lot 279. See also *Study of fields* (1936-10-10-22), and Popham, 'Acquisitions at the Oppenheimer sale', *BM Quarterly* XI, (1936), 128 ff.

25 Stainton and Hayes, nos 53, 60; also see BM 1910-2-12-251.

26 'I have painted a Picture here in Watercolours from Nature, and succeeded rather better than I expected (as it is the first time).... I have half-finished another in Oil from Nature, from the Window of my Bed-Chamber, I think I see my Manner altering in it; ... I have spent the greatest part of this summer in drawing and painting after Nature', Ford, 54.

27 Ingamells, 964–5, 932–3. The drawing is reproduced in Germaine Greer, *Obstacle Race*, 1979, 286, where it is incorrectly identified as the work of 'Viscountess Templeton – *neé* Lady Mary Montague', who was Lady Templetown's daughter-in-law.

28 Sloan 1985, pt II, 355–6, fig. 21, Sloan 1986, *Cozens*, 44, 170 n. 23; and Sloan 1986, 'Non-professionals', 196–206, 226–81.

29 Buckinghamshire Record Office AR 121/79, D/LE/169/81. Another view may be of Stourhead, see Sloan 1985, pt I, 74–5, and Sloan 1986, 'Non-professionals', 226–9, fig. 100.

30 Mark Laird, '"Our equally favorite Hobby Horse": The flower gardens of Lady Elizabeth Lee at Hartwell and the 2nd Earl Harcourt at Nuneham Courtenay', *Garden History* 18, no. I (Spring 1990), 103–42. I am very grateful to Jane Roberts for informing me of the existence of Harcourt's copies of Sandby's views of the garden, and of this article which reproduces the Sandby 1777 views (figs 4a,b). See also Mark Laird's *The Flowering of the Landscape Garden: English Pleasure Grounds 1720–1800*, Philadelphia 1999, 350–80 and his note 1, for a list of other articles on the flower gardens at Nuneham and their symbolism.

31 Ibid., 138, 142, in D/LE/E4/19.

32 Discussed in detail and some reproduced in Sloan 1986, 'Non-professionals', 213–23, figs 72–91.

33 Bedfordshire Record Office, Lucas (Wrest Park) Papers, L30/9a/9/2–5.

34 Quoted in Joyce Godber, 'The Marchioness Grey of Wrest Park', *Bedfordshire Historical Record Society* XLVII (1969), 80.

35 See Sloan 1986, 'Non-professionals', 215: 1772: L30/9/63.

36 19 June 1774, Jemima, Marchioness Grey, to her daughter Lady Amabel Polwarth from Richmond (Bedfordshire Record Office L30/11/122/60).

37 19 June 1774, L30/9/60/35.

38 Green Frog Service, nos 113, 1196–1201, 1204, 1207–11, as listed in George Charles Williamson, *The Imperial Russian Dinner Service*, 1909.

39 Letter, with R. G. Watkins July 1998: n.d., but after 1796 when she became Baroness Lucas.

40 William Gilpin, *Regulations of a private school at Cheam in Surrey*, 1752, 4; for Gilpin's teaching at Cheam, see Barbier, 27–38; and Sloan 1986, 'Non-professionals', chap. 4.

41 L30/9/97/77. Her son Charles had attended Cheam from 1771 (L30/9/97/15). There are etchings after her drawings by her daughter Caroline in the Bull album of etchings by women (BM). In 1789 she wrote from Sydney Farm that she longed to show 'Lady Bell some of the *Blots* I made in Devonshire. I have been very industrious this summer' (L30/9/97/119).

42 Quoted in Barbier, 156.

43 Standring, in Baetjer, 74; and see his notes for a recent extensive bibliography on drawing manuals for watercolour landscape and the picturesque.

44 Listed in Barbier, 93–4, and letters to his publisher and the text accompanying one of these albums recently acquired by Gainsborough's House from Sotheby's, 26 November 1998, lot 31.

45 *Three Essays*, 1792, and *Two Essays* published 1802, 2nd edn 1804.

46 Oppé 1924, 266.

47 Robert Wark, *Sir Joshua Reynolds: Discourses on Art*, New Haven and London 1975, Discourse XI (1782), 192.

48 For their reasons for wishing to distance their work from that of amateurs, see chap. 3 'Dangerous Associations', in Greg Smith, forthcoming (2001).

49 See Kriz, 62.

106(a)

106(b)

ALEXANDER COZENS (1717–86)

106

(a) *'Blot' landscape with large tree*

Brush drawing in grey wash, 159 × 194 mm

(b) *Landscape from a 'blot' drawing*

Pen and black ink with brown wash, 161 × 199 mm

Provenance: Purchased from Patricia, Lady Hake

1951-7-14-66, 67

In the 1750s, while he was teaching a number of private pupils, including the children of the 1st Earl Harcourt (cats 96, 109), Alexander Cozens began to build on some of the lessons he himself had learned in Italy. Most of the drawings he made in Rome are detailed outline drawings of real places, carefully shaded in pen and ink or in grey wash and sometimes in colour, but a few are sketches drawn swiftly with a brush and ink, in the manner employed by many seventeenth-century artists working in that city, including Claude Lorrain and a few imitators from France and the Netherlands. The tradition of sketching in this manner out of doors continued through the eighteenth century, most notably in the work of Claude-Joseph Vernet (1714–89), with whom Cozens studied in Rome.

The finished drawings by Cozens acquired by his pupils in the 1750s are finely drawn detailed landscapes, mostly imaginary and filled with the type of Italianate round towers and ruins found in a series of small outline etchings produced for him by William Austin (1721–1820) also during this decade. Austin, as well as being an engraver, was a drawing master in great demand, boasting as many as 300 pupils in an advertisement of 1768. Around 1755 he had published a manual titled *A Specimen of Sketching Landscapes in a Free and Masterly Manner* (British Museum, n.d., 2nd edn 1757), prefaced by an explanation of the 'seeming rudeness' of the designs for those not conversant with the art of drawing who expected a high degree of finish. Austin noted that sketching was the best way to capture the thoughts, and 'one of its greatest beauties is the freedom which appears through the Whole and by the unknowing is mistaken for negligence'.

It was during this decade that Cozens developed the ideas behind, and a group of examples to illustrate, his first published 'system', *An Essay to Facilitate the Inventing of Landskips, Intended for Students in the Art*, which was printed and sold for him by Austin. The only copy is in The Hermitage, St Petersburg, and is prefaced by two pages of text explaining how he had developed the idea from an observation of Leonardo da Vinci that by looking at an old wall covered with dirt or streaked stones or clouds, it might be possible to imagine seeing, amongst other things, landscapes and faces, thus furnishing the mind with an abundance of new ideas. Cozens's improvement upon Leonardo's idea was to make these accidental forms on purpose, with some degree of design, particularly in disposing

the objects according to his eight styles of composition based on the old masters. The rude black sketch or 'blot' thus achieved was then placed under a sheet of thin paper and used as the basis for a finished composition, employing the imagination and nature when drawing in the details. Cozens supplied eight pairs of blots and finished outline drawings after them according to his eight styles of composition, which included 'a sea coast or the banks of a river', 'an avenue by land, water, etc.' and 'an extensive country with high trees, etc. in the foreground'. The blots conform more with our ideas of a sketch than a blot, and to duplicate them Cozens employed an experimental and innovative type of printmaking, possibly an early form of aquatint. He ended his text with a notice that examples could be seen at the premises of two printsellers, Boydell and Austin, and that he intended to publish further examples with figures and 'shaded upon two different Principles'.

There are several surviving sets of examples such as the blot of a tree and drawing after it here, but because the compositions are too simple to conform to even his first style of landscape, they probably served as first lessons of how to create 'rude sketches' or 'blots' with the most basic design in mind.

Literature: Sloan 1985, pt II reproduces the 1759 *Essay* in full; Sloan 1986, *Cozens*, 9–11, 30–5, 41, 44.

107

107

Landscape with oaks

Brush drawing in grey wash,
231 mm × 307 mm

Provenance: Purchased from Max De Beer
and presented by the National Art Collections
Fund

1941-12-13-717

In the 1760s and 1770s Cozens continued to
teach and to work on his systems for invent-
ing compositions of landscape, exhibiting
examples at the Society of Artists from 1760
and the Royal Academy from 1772. Occa-
sionally he advertised forthcoming publica-
tions, including *A Treatise on Perspective and
Shading by Invention* (1765; no copy survives)
and *The Shape, Skeleton and Foliage of Thirty-two
Species of Trees* (1771); a few small outline
etchings by William Austin after his land-
scapes may be the remains of another

system. That his ultimate intentions were
much more serious and wide-reaching than
these usual subjects for drawing manuals is
indicated by a 1772 manuscript plan for
'A Great Work: Morality, Illustrated by
representations of Human Nature in Poetry
and Painting, in Two Parts', involving the
participation of a university and an
academy, which were to illustrate human
virtues and vices through an epic-length
poem and a series of large paintings.

Enough of Cozens's *Various Species of
Composition of Landscape in Nature* survives to
enable us to piece together the components
of this publication, which was probably
never completed. The eight original styles
of landscape composition of his 1759 *Essay*
doubled to sixteen, which were issued as
outline engravings and listed on a printed
sheet that also included fourteen objects
(woods, gardens, Europe, America, etc.)
and twenty-seven circumstances (times of

day, weather, seasons, etc.), which affect the
colour, tone and atmosphere of a landscape.
John Constable made notes from Sir
George Beaumont's copy of this publication
that indicate that there were also sixteen
sentiments that might be aroused by the
various compositions, once again suggest-
ing that Cozens was aware of the theory of
association employed by writers such as
Edmund Burke and Archibald Alison.
Educated with a belief in the ideals of civic
humanism as propounded by Shaftesbury
and Locke, Cozens felt that landscape was
endowed with the same potential for public
moral improvement as music, literature or
the art of history painting, which relied
more directly upon narrative and influence
through obvious moral examples.

In 1778 Cozens published his explanation
of *The Principles of Beauty relative to the Human
Head* where different expressions and hair-
styles signifying sixteen characters of beauty

added to the breadth of his ambitions and research. In the 1780s he began his final project, issuing examples of skies that might lend different characters to landscapes, and returning to his method of inventing sixteen kinds of landscape composition by blots: *A New Method of Assisting the Invention in Drawing Original Compositions of Landscape*. There is no date on the title-page, but the plates include aquatinted and mezzotinted blots as well as finished examples based on them, some mezzotinted by William Pether and dated 1785 (Cozens died in April 1786). The thirty-three pages of text explained Cozens's history of the development of the technique, his definition of genius in landscape and added a number of refinements to the original method described in 1759. A group of finished watercolours, including the present *Landscape with oaks*, closely related to the examples provided in the book, were probably intended to be displayed as an explanation of the system.

Literature: Oppé 1952, 56–71, 165–87 (*New Method* reproduced); Wilton 1980, 31–5; Sloan 1986, *Cozens*, 49–85; J. C. Lebensztejn, *L'art de la tache*, Paris 1990; Cramer, *passim*.

After MARY HARCOURT (1749–1833)

108

(a) *View of the road by Saorgio to the Passage of the Col de Tende*

Etching and aquatint by J. Hibbert Junr., Bath, 362 × 475 mm

Provenance: Purchased from Mr Daniell

1870-5-14-1626

(b) *A View of the Town of Nice taken from the Villa near the Road to the Var*

Etching and aquatint by Maria Catherine Prestel (1747–94), 395 × 570 mm (trimmed)

Provenance: Wrest Park collection, by descent; presented by the Baroness Lucas and Dingwall in memory of her brother, Lord Lucas (d. 1916)

1917-12-8-4166

Mary Danby was the daughter of William Danby of Swinton Park, in Yorkshire. Nothing is known of her early education, but her father was constantly employed in improving his house and estate and her

brother, who inherited in 1781, was an avid collector who built his own museum. He attended Eton from 1763 to 1770, and may have received drawing lessons from Alexander Cozens. Mary, his elder sister, married Thomas Lockhart in 1772 and was a widow when she married William Harcourt (cat. 77) in 1778. The following year John Downman drew her portrait, showing her pointing to a spot on a globe, and a companion portrait of her sister, Miss Danby; he drew Mary Harcourt again in 1781, leaning against a column, holding a *porte-crayon* and a drawing of a tree (reproduced in colour in Williamson, *Downman*, 1907, pl. 41).

In September of that year Mary Danby wrote to Cozens's pupil and patron William Beckford:

I rejoice that Cozens is with you. I hope that you will restore him to such health by good air and the pleasure he will enjoy in being with you, that I shall have his society some hours of every week in London for many years to come. Tell him I am six hours of every day following his instructions. I would give him half I am worth if he could give me his genius also.

[quoted in Oppé 1952, 34]

In 1778 the royal family had moved from Richmond to Windsor and in 1782 Major-General William Harcourt purchased Gloucester Lodge in St Leonard's Hill, in Windsor Forest (see cat. 100).

In September 1783 Horace Walpole, who was a great friend of the 2nd Earl Harcourt, wrote to Lord Strafford from Strawberry Hill (*Wal. Corr.*, XXXV, 374–6) reporting that he had just been to Nuneham, where there had been many improvements to the garden and house, and where he found William Mason who:

as he shines in every art, was assisting Mrs Harcourt with his new discoveries in painting, by which he will unite miniature and oil. Indeed, she is a very apt and extraordinary scholar. Since our professors seem to have lost the art of colouring, I am glad at least that they have ungraduated assessors.

When Sophie von La Roche visited the Harcourts in 1786, she was impressed by

the number of large and excellent drawings [Mary Harcourt] has executed, for she has drawn all the districts visible from Leonard's Hill, and in addition, those from which this noble country house can be seen. They are half a royal folio in size, so masterly in execution that I was unjust enough to marvel how a lady could attain such a high degree of finish and so selective a vision.

[*Sophie in London 1786*, Clare Williams trans., 1933, 274]

Several of these drawings are now in public collections, at Yale, Leeds and in the Tate Gallery, where they are now recognized as her work, but for many years some were thought to be by Alexander Cozens because they were so close in style and compositional approach. The Harcourts continued to admire Cozens's work for several years: William Harcourt purchased a number of works at the sale at Christie's after Cozens's death, and the Harcourts contributed to the fund for his son in the 1790s.

The present print of Nice is one of a pair of views of the town and its environs by Mary Harcourt, and the view of Saorgio one of three in Piedmont. There was always a large circle of English residents at Nice, a convenient stopping point on the Grand Tour. In February 1783 Lady Elizabeth Foster was there at the same time as a Miss Danby, presumably Mary Harcourt's sister, who may have provided Mary with drawings that she in turn worked up into the compositions that were the basis of these prints. Mary Harcourt is not known to have travelled to the Continent herself. Printed privately for distribution to friends such as Lady Amabel Polwarth, later Baroness Lucas of Wrest Park (cat. 110), these prints bear no publication line or date, but her name as given indicates that they must have been etched after her marriage to William Harcourt in 1777 and before she became Countess Harcourt, when William succeeded his brother as 3rd earl in 1809.

Other copies of these prints appeared in the Stanton-Harcourt sale at Sotheby's on 10 June 1993, in lot 910, a large miscellaneous group including portrait mezzotints and Lord Nuneham's etchings after Sandby. It also included three signed characteristic brown monochrome landscapes by Mary Harcourt: an imaginary oval composition related to two blots in the Oppé collection, *Near Selve on the road from Geneva to Chamouny*, and a similar mountain view, untitled. The lot also included a scrap of paper inscribed: *To The Honourable Anne Seymour Damer* [cat. 184], *These Etchings are respectfully presented, Her affectionately attached friend Harcourt. 1798*.

Literature: *Anglais sur la Riviera*, exh. Musée Masséna, Nice, 1934, nos 181–8, 203–4; Oppé 1952, 34–5, 119; Wilton 1980, nos 156–9; Sloan 1986, 'Non-Professionals', 226–8; Vere Foster, ed., *Two Duchesses*, 1898, 88–9.

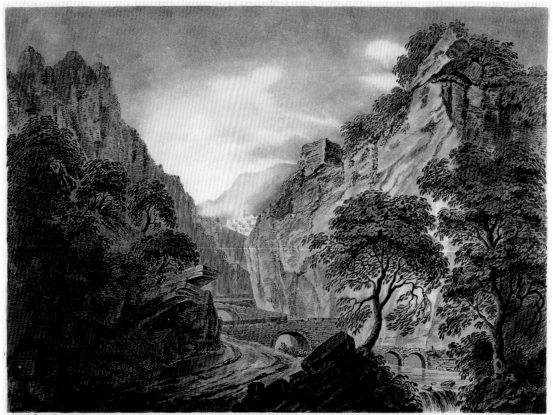

VIEW OF THE ROAD BY SAORGIO TO THE PASSAGE OF THE COL DE TENDE

108(a)

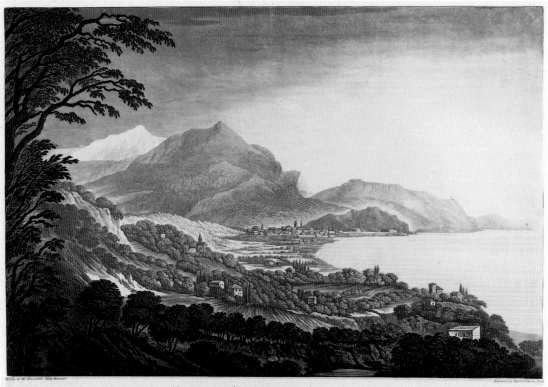

A VIEW OF NICE TAKEN FROM A VILLA NEAR THE ROAD TO THE VAR.

108(b)

109

LADY ELIZABETH HARCOURT
(1739–1811)

109

View in Sir Charles Tynte's Wood at Halswell

Pen and grey, black and brown ink, with wash, 275 × 172 mm

Inscribed on verso: *a View in Sr. Char. Tyntes wood at Halswell Somersetshire*, and in another hand: *This was found in a portfolio of Lady Elizabeth Lee at Hartwell 1828 J. Lee. – the above is her writing*

Provenance: Portfolio of drawings by Lady Elizabeth Lee; Christie's, South Kensington, 1994; bt Alexandra Williams Pictures, from whom purchased

1995-9-29-1

Lady Elizabeth Harcourt was the daughter of the 1st Earl Harcourt and sister of George Simon, Viscount Nuneham (cat. 96), and William Harcourt (cat. 77) and the sister-in-law of Mary Harcourt (cat. 108). In 1763 she married Sir William Lee of Hartwell (1726–99), whose uncles held positions alongside her father in Princess Augusta's court. Like the rest of her family, Lady Elizabeth had close connections at court, attending Queen Charlotte at her wedding, and also like them, she was a pupil of Alexander Cozens and several other artists who taught the royal family, including Richard Dalton, Joshua Kirby and presumably Paul Sandby, who drew her portrait twice in the 1750s (Oppé 1947, nos 268, 315).

Over the past few decades several oval pairs of blot drawings with compositions after them and one or two early detailed drawings by Alexander Cozens have appeared in different sales inscribed *found at Hartwell among some papers of Lady Elizabeth Lee. There are several similar at Hartwell framed*. The reference is to a portfolio now in the Buckinghamshire Record Office, which still contains a number of Lady Elizabeth's works. They include copies of figures from drawing manuals, rubbings and pressed flowers and outline floral designs, and imaginary landscapes in the manner of Alexander Cozens which, like those of Mary Harcourt and Lady Amabel Polwarth, are drawn in black and brown ink over varnished paper. Other drawings in the portfolio are views of English gardens similar to the drawing of Halswell, and include a watercolour of Stourhead dated 1779 (her brother's letters of the 1750s are full of references to 'Mr Hoare'). The oval drawings once in the portfolio are a clear indication that her lessons with Cozens continued after her marriage in 1763: one is a blot and the other an imaginary composition based on it (Museum of Fine Arts, Boston). A second pair is in the Oppé collection now in the Tate. A similar oval composition by Mary Harcourt, clearly also based on a blot, was in the Stanton Harcourt sale at Sotheby's (10 June 1993, part of lot 910).

Lady Elizabeth's earliest works were pen and ink and wash drawings in the manner of Alexander Cozens's early drawings of the 1750s when he began to teach her brother. She apparently shared his 'republican' views, and made a washed sketch from nature of the old *Nuneham Church* (1876-5-10-924), recording the village before it was pulled down by her father (see cat. 96). The idea of drawing sketches on the spot may have been the result of lessons from Cozens or Paul Sandby, who began his paintings of the new Nuneham around 1758, and whose influence is clearly seen in the large panoramic *River landscape with boats and castle on a hill*, in pen and brown ink with watercolour on two joined sheets, signed and dated *Eliz: Harcourt fecit 1761*, which appeared in the Stanton Harcourt sale (lot 889). It was one of a pair that used to hang at Nuneham (photographs of both are in the Witt Library).

Sir Charles-Kemeys Tynte of Cefn Mably and Halswell was a neighbour and friend of C. W. Bampfylde and Henry Hoare of Stourhead and, like them and the Harcourts, was an innovative gardener. Hogarth depicted him pointing to a plan and group of drawing instruments on a table, his landscaped garden viewed through the window beyond (present whereabouts unknown).

Literature: Sloan 1985, pt I, 74–5; Sloan 1986, 'Non-professionals', 226–7.

LADY AMABEL POLWARTH
(1751–1833)

110

(a) *Four landscapes mounted on a page in Richard Bull's album of Etchings and Engravings, by the Nobility and Gentry of England; or, by Persons not exercising the Art as a Trade*

(189.* b. 23)

Etchings, two after Alexander Cozens, 88 × 114 mm each; one after James Bretherton, 115 × 145 mm; one after her own composition, 104 × 143 mm; all trimmed and mounted on album page, each framed by a red pen and ink border

Lower etching inscribed in border by Bull: *By Lady Amab'l Polwarth from a drawing of her Ladyships*

Provenance: Richard Bull; P. & D. Colnaghi, from whom purchased

1931-4-13-323 to 326

(b) *View in Studley Park* and *View in Ld. Granthams Park at Newby*

Etchings, 150 × 210 mm and 148 × 203 mm

Provenance: Wrest Park collection, by descent; presented by the Baroness Lucas and Dingwall in memory of her brother, Lord Lucas (d. 1916)

1917-12-8-2630, 2627

Lady Amabel Grey was the eldest daughter of Philip Yorke, 2nd Earl of Hardwick and the Marchioness Grey, of Wimpole Hall and Wrest Park. With her younger sister Mary, she was given a classical education by Catherine Talbot, who had edited *Athenian Letters* with Amabel's father and Daniel Wray in 1736. Both Catherine and the marchioness were amateurs, and from an

early age Amabel was encouraged to draw, first by copying prints and drawings in the collections of her parents and their friends, and later by sketching out of doors at Wrest and Wimpole and on visits to family in the north. She was taken to exhibitions in London from an early age, and received lessons from Alexander Cozens and other artists from at least 1767 and probably much earlier. In 1772 she married Alexander Hume-Campbell, Viscount Polwarth, but was widowed before the end of the decade.

Lady Amabel serves here as a representative example of the legions of young men and women who learned to etch in the eighteenth century. Their numbers are hinted at by the list of 400 'Nobility , Gentry &c.' that the engraver and drawing master William Austin appended to his advertisements in the late 1760s. Etching was only a short step from drawing and many drawing masters taught both – by the evidence of the present works, Lady Amabel had lessons from Cozens, but also from James Bretherton (fl. 1770–90), a drawing master/engraver with an address in New Bond Street who seems to have had the Cambridge clientèle much as Cozens took pupils from Eton and Windsor, and J. B. Malchair from Oxford.

Richard Bull filled two albums with similar works by men and women from whom he solicited examples or by whom he was presented with prints, but he was only one of several who formed such collections: Horace Walpole, James Chelsum and many of the amateur artists themselves, including the Yorke and Grey families, created albums of etchings and circulated them amongst their friends and acquaintances. The Museum was very fortunate to acquire the collection from Wrest Park in 1917, including proofs of all of Lady Amabel's efforts from her earliest to the accomplished views of Studley and her brother-in-law's park at Newby illustrated here. Bull's album contained ten further etchings by her, some of which were already mounted when he lent the albums to her. Her reply is bound into the volume:

Ldy A. Polwarth presents her compts to Mr Bull & thanks him for the Opportunity of looking over his Volumes of Honorary Etchings. She has not lately taken up the Needle again, but has ventur'd to send him a few Trifles of her former Performances, & two Duplicates she happen'd to have by her of Etchings that perhaps Mr Bull never heard of, Landscapes by Mrs Parker, the late Ld Grantham's Sister, the same Lady of whom there is a Whole-Length Print after Reynolds.– She hopes the Books are return'd perfectly safe.–

Lady Amabel's etchings included a group based on drawings made by her sister's husband, Lord Grantham, of views on the Tagus taken in Aranjuez in 1777. The etchings by his own sister are not in the album, but other members of the Yorke family are represented, including Caroline Yorke, after drawings by her mother Agneta Yorke and William Gilpin (see p. 150). The album also boasts a large group of etchings by Lady Louisa Greville, sister of Charles Greville (cat. 141), and Lord Warwick (cat. 140), including an early, very accomplished view of *The Priory at Warwick* after her own drawing (1757) and several copies of drawings by Guercino, Rosa and Sandby, amongst others. Lady Louisa used her monogram to sign her works from 1757 to 1770, but seems to have stopped etching after her marriage to William Churchill. Richard Byron (cat. 159) and his sister Isabella are repre-sented by their etchings after Rembrandt. A pair of decorative circular stipple engravings by Hodgson at the end of the album, is based on drawings by 'Miss Georgiana Keate Daughter of the Poet', 1787 (see cat. 123).

Literature: Sloan 1985, pt II, 356; Sloan 1986, *Cozens*, 213–22.

110(a)

VIEW IN STUDLEY PARK

110(b)

VIEW IN L.ᴰ GRANTHAMS PARK AT NEWBY

110(b)

THE REVD WILLIAM GILPIN
(1724–1804)

111

(a) *Sunset view on a river*

Brush drawing in grey wash, over graphite, on paper washed with yellow, 275 × 351 mm

LB 5

Provenance: Purchased from Edward Daniell

1877-10-13-957

(b) *A lake scene*

Pen and black ink and grey wash, over graphite, on paper washed with yellow, 244 × 329 (oval)

LB 4; Stainton 16

Provenance: Purchased from Edward Daniell

1871-8-12-1718

William Gilpin's grandfather, the recorder of Carlisle, and his father Captain John Bernard Gilpin, were both gentlemen painters (in oil and watercolour) who 'discovered' and were patrons of several local artists, including Robert Smirke, Guy Head and John 'Warwick' Smith. Captain Gilpin employed his friend Dr John Brown, the apologist of Shaftesbury, as tutor to his children and their lessons and correspondence were full of references to the latter's concepts of Beauty, Truth and Virtue, and reflections on the relations between the sister arts of poetry, painting and music. Captain Gilpin was later a correspondent of several antiquarians who toured the north and borrowed his drawings, a large number of which survive. He advised his son in his drawing, encouraging him to copy, especially figures, and to sketch out of doors, but William was reluctant to move on to large finished drawings from nature and continued to copy oils and study them. He developed an interest in prints and learned to etch; his publication *An Essay on Prints* (1768) was the most important English contribution to the subject since Evelyn's *Sculptura* of a century earlier.

William Gilpin's first publications were sermons and dialogues on gardens he had visited; these were not guidebooks, but attempts to awaken aesthetic pleasure in the contemplation of landscape through associations with other natural and painted landscapes, and with those described by classical authors such as Horace and Virgil. The thread that ran through all these publications was Shaftesbury's equation of

beauty with truth and virtue. Gilpin took over the preparatory school at Cheam in 1752 where he successfully implemented civic humanist ideas in the education of a generation of young men, with whom he remained in contact throughout the rest of his life.

Gilpin was unable return to landscape drawing until the 1760s, a decade when his brother, the artist Sawrey Gilpin, was frequently in contact with Alexander Cozens. The landscapes he produced during this decade are combinations of the type found in etchings after Salvator Rosa and the invented types of composition listed in Cozens's publications and used by him in his own work of that decade. Gilpin's compositions gradually moved away from the sublimity of Rosa, although he always retained his figures to enliven his landscapes, unlike Cozens who gradually abandoned figures altogether.

Every summer from 1768 Gilpin set out on excursions to different parts of Britain, recording his impressions in notebooks, later written up as manuscript tours that served not as guidebooks, but as picturesque tours, 'in which writing and illustrations complement one another to sing the praises of nature' (Barbier, 41). Gilpin's drawings were illustrations, in an aesthetic sense rather than a topographical one: they were generalized ideas of specific views, illustrating the quest after picturesque beauty. Freedom and spirited execution were what he searched for in the paintings of others, and these qualities are the most obvious in his own drawings, although finished drawings such as the present examples are based on original sketches that recorded what he saw in a shorthand form of drawing very close to Cozens's early 'rough sketches' or blots (see cat. 106).

Gilpin circulated the manuscripts amongst friends who encouraged him to publish them, but the publication of the first tour, of the Wye, in 1772, was held up until 1783 (although the title-page states 1782) while he searched for a suitable method of reproducing his drawings in print form. He settled on aquatint, but had difficulty obtaining the secret until, with the assistance of the Duchess of Portland, Horace Walpole and Lord Harcourt, he finally secured it. The 800 copies sold quickly, but their purpose was misunderstood, as readers took them on their own tours of the Wye, searching for the exact views he illustrated. Gilpin later explained that the

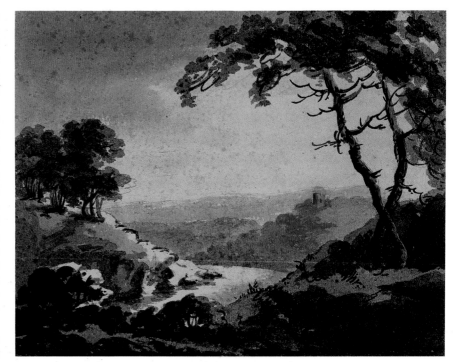

111(a)

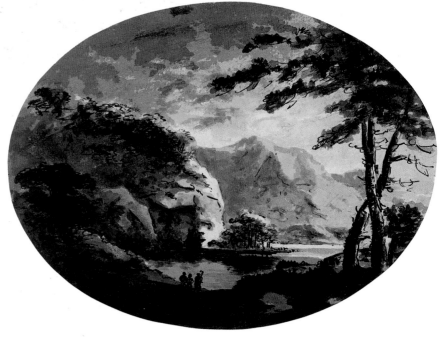

111(b)

illustrations were of 'general ideas' and not exact portraits, for 'I am so attached to my picturesque rules, that if nature gets wrong, I cannot help putting her right' (Gilpin in a letter to the Revd William Mason, February 1784, quoted in Barbier, 72).

Gilpin not only drew on tour, but invented picturesque compositions based on combinations of his favourite elements, which resulted in works illustrating his theory of harmony in landscape as represented in the examples here. They also carry important ideas of association or responses to various types of landscape that form a remarkable parallel to what Alexander Cozens was attempting in his own invented landscape compositions.

Literature: Barbier, *passim*, and Andrews, *passim*; and Stephen Copley, 'Gilpin on the Wye: Tourists, Tintern Abbey, and the Picturesque', in Rosenthal, Payne and Wilcox, 133–55.

MARY HARTLEY
(*fl.* 1757–d. 1803)

112

The refectory and the great kitchen chimney at Fountains Abbey

Brush and black, grey and brown ink and wash, over pencil, 145 × 221 mm; mounted on larger brown paper, with pen and ink border and inscription, 250 × 254 mm

Signed on mount lower left and lengthy inscription with title and explanation of ruins on mount below image; also inscribed in later hand in graphite: *Mrs M Hartley Ex RSA 1775*

Provenance: Presented by Felicity Owen 1998-3-14-9

Mary Hartley was the daughter of the philosopher David Hartley (1705–57) and his second wife (m. 1735) who had settled in Bath in 1742. Her half-brother, also David (1732–1813), was an MP who, like Lord Nuneham, was a 'champion of liberty', opposed to the war with America and the slave trade. Through her father's friends, the Lister family, she seems to have moved in a circle of amateurs with northern connections, particularly Lord Hardwicke and his family (see cat. 110) and Lord Rockingham's family at Wentworth Park. A view of the latter 'Painted by Mrs M Hartley' was engraved in 1789 for an unidentified series of family seats and described in the accompanying text

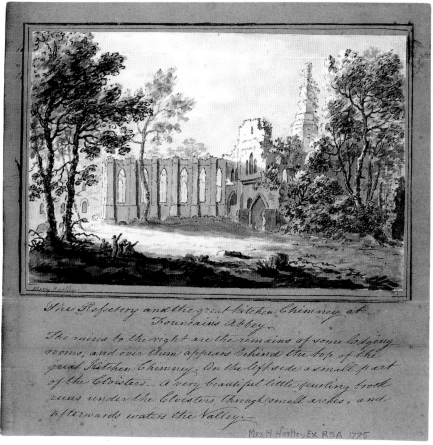

The Refectory and the great kitchen Chimney at Fountains Abbey
The ruins to the right are the remains of some lodging rooms, and over them appears behind the top of the great Kitchen Chimney. On the left side a small part of the Cloisters. A very beautiful little purling brook runs under the Cloisters through small arches, and afterwards waters the Valley.
Mrs M Hartley Ex RSA 1775

112

as 'by a lady whose freedom of pencil, and principle of light and shade, cannot be excelled' (Witt Library). Lady Anne Wentworth was herself an amateur who painted in oils and crayons, including copies of Van Dyck full-length portraits. Her own portrait by Philip Mercier (1740) showed her seated with palette and brushes, before a large canvas, but Walpole felt she was better at copying fruit and flowers in needlework than in oils. Her portrait of one of her servants was engraved by John Pine, and Walpole included a copy of this print, along with two by Mary Hartley, in his album *A Collection of Prints Engraved by Various Persons of Quality* (Lewis Walpole Library, Farmington (Conn.)). In his 'Books of Materials' Walpole wrote that Miss Hartley 'etches, and draws landscapes in very good taste'.

Nothing is known of Mary Hartley's drawing masters or her work that was not etched. Five imaginary landscapes exhibited by 'Miss Hartley', an honorary exhibitor at the Society of Artists in 1775, were preceded in the catalogue by three

identified landscapes by 'Mrs Hartley', also an honorary exhibitor. Either the latter was a relation or there was some confusion about her title, as unmarried women were sometimes titled 'Mrs' as a courtesy. Along with a number of her other acquaintances, she was a subscriber to Cozens's *Principles of Beauty* (1778), and she seems to have met Gilpin through their mutual acquaintances, Daniel Wray and the Revd Mason, who were also Cozens subscribers and correspondents of Walpole and of Lord Hardwicke's family.

Mary Hartley's interest in the present view seems to be picturesque rather than antiquary, which might date it to after 1780, the year she learned through Mason of his friend William Gilpin's manuscripts, *Essay on Picturesque Beauty* and *Tour of the Lakes*. She borrowed them, copied Gilpin's drawings and began a twenty-year correspondence with him. She admired his effects of light and shade and particularly his 'tuning', and originally asked him for tuition. They met once for a half an hour in 1781, and she enlisted the help of her brother to find

113

Gilpin a brown ink that would not blur; but otherwise he could only oblige through letters, offering his written opinions and advice on her work as he did with many other disciples. He wrote to William Lock, who also knew her, that she was a lady of 'great taste & genius; & ... as enthusiastic in the art she loves, as any of us ... I have seldom seen more agreable landscape; more pleasing forms, and composition ... seizing the most beautiful resemblances'. He felt she worked best with nature before her and he from imagination. In 1782 she suffered a stroke, which affected her hand, and it is not clear that she managed to continue drawing. They wrote constantly about specific points of picturesque theory, and she kept him informed of artistic life in Bath, telling him of the latest work of Warwick Smith, Bampfylde (cats 65–7), Amos Green (cat. 113) and the young Thomas Lawrence.

Literature: Hilles and Daghlian, 231, 236; Barbier, 88, 150 ff.; Alexander 1983, no. 17; Munro and Bicknell, no. D6.

AMOS GREEN (1735–1807)

113

A waterfall

Watercolour with pen and brown ink, 247 × 320 mm

LB 1 (as William Green)

Provenance: Sir Walter Calverley Trevelyan, by whom presented

1871-12-9-6277

Amos Green was one of a family of artists from Halesowen, near Birmingham, most of whom taught drawing. His brother James (1729–59) was an engraver of antiquities and

views in Oxford, and Benjamin (1738–98) at first succeeded him before going to London in 1762 as assistant to Thomas Bisse, the drawing master to Christ's Hospital, whom he succeeded on the latter's death in 1766, a balloted appointment earning £50 per annum, having won all the votes except two in a field of four candidates, which included George Bickham (see cat. 72). Amos Green's eldest brother, Charles, was a clerk at the Hospital. The British Museum has two large watercolours by Benjamin and a small view of the Hospital where he taught until 1796. Benjamin Green exhibited at the Society of Artists and supplemented his income with print-making. He was the author and engraver of several drawing books including *Drawing and Painting in Watercolour* (1755) and *A Drawing Book of Landscapes* (1786). From 1769 he published mezzotint portraits and a series

114

after paintings by George Stubbs, and he also taught his daughter Sarah to engrave in order to assist him. He has been credited some of the earliest (1771) English experiments in the soft-ground technique, which was used for reproducing the effect of chalk drawings and employed in his *A Drawing Book in Chalks* (1775). This publication contained fifty-one plates after old masters, including portraits in the manner of Rembrandt after Thomas Worlidge, and his experiments were to inspire Sandby and Gainsborough to try the medium.

In 1779 Benjamin engraved six bouquets by his brother Amos in mezzotint, which were printed in green ink and coloured by hand. Amos Green had been apprenticed to a printer in Birmingham, but his potential as a painter of still lifes, especially flowers and fruit, was noticed by a neighbour, the poet William Shenstone, who provided

him with letters of introduction to several families around Birmingham. He lived with the Deanes of Hagley, whose gardens he laid out and to whom he gave drawing lessons from 1766, in Suffolk and finally in Bath until his marriage to one of his pupils, Harriet Lister, in 1796.

Harriet and her wealthy widowed mother were from York and had met Alexander Cozens in 1775 and subscribed to his *Principles of Beauty*. She had made several sketching tours of England when she met Gilpin in 1792 and, through their mutual friend Mary Hartley, met Amos Green in Bath in 1793. Mary Hartley had earlier encouraged Amos to take up landscape painting in watercolours, lending him some of Gilpin's published tours, and knowledge of the latter is clearly evident in the present work. In 1789 Mary Hartley wrote to Gilpin: 'Mr. Green ... draws &

paints better than any gentleman that I know; & he is so enthusiastic about all these effects that you speak of, from mists, clouds, streams of light, & other accidental causes of light & shade, that I wish you cou'd have some conversation together' (Barbier, 165 n. 5). The present work, although it was once attributed to the lakeland artist William Green (no relation), has the bright yellows and greens and distinctive reeds and grasses in the foreground that were typical of his landscape style before he met Harriet. She is said to have taken lessons from him, but there is no proof and she was already an accomplished landscapist with a distinctive style of her own. From their marriage until his death, they toured and sketched constantly all over England, Scotland and Wales, producing several albums of hundreds of drawings in grey wash. In spite of initials on some of the

drawings, it is very difficult to distinguish their work from each other's. Many of the albums have been broken up, but their style is very distinctive and quite different from the present watercolour, indicating that Harriet had a stronger influence on his style than he on hers.

Literature: Johnson Ball, *1951 Festival Exhibition of Pictures by the Halesowen Artists James, Amos and Benjamin Green*, exh. Council House, Halesowen, 1951; Barbier, 164–5; Clayton, 176, 193, 245.

JOSEPH BARBER (1757–1811)

114

Llangollen Bridge, North Wales

Watercolour, 261 × 338 mm

LB IV, p. 379 (as Anon)

Provenance: Purchased from Edward Daniell

1872-10-12-3332

Joseph Barber advertised himself as a painter and drawing master of Charles Street, Birmingham in the *Universal British Directory* of 1795, but an earlier advertisement (watercolour, now in Birmingham City Museum and Art Gallery) stated that he also taught painting in oil, water, crayons and grey wash. The present, more ambitious, work and an almost identical one in the Victoria and Albert Museum, dated 1802 (129–1885), were the result of a sketching tour in Wales in the 1790s. Similar works were collected by local families such as that of the Earl of Warwick, from whom Barber may have drawn pupils. It is perhaps significant that the composition in the present work is a motif that first appeared in England in several versions of *London seen through an arch of Westminster Bridge* (engraved 1747) by Canaletto. The motif was a favourite one with Canaletto and later British artists such as Samuel Scott and Turner, who painted Warwick Castle seen through Castle Bridge in a watercolour of 1794 (Whitworth Art Gallery, University of Manchester). Several of Barber's pupils went on to become professional artists, most notably David Cox, whose main income also came from providing drawing lessons.

Literature: Williams, 95.

115

JOHN BAPTIST MALCHAIR (1730–1812)

115

A Tree in a Clearing

Brush drawing in grey wash, over pencil, 481 × 347 mm

Provenance: Presented anonymously

1959-3-7-7

John Malchair was born in Cologne. The son of a watchmaker, he practised as a musician and emigrated to England around 1754. He could also draw landscapes from nature, and taught both music and drawing at private academies in London before meeting William Hamilton and Robert Price through a friend of his father. Nothing more is known of his connection with William Hamilton, who was still Captain Hamilton at this time. Hamilton was also a keen violinist and his family may have employed Malchair as a teacher, as Price was to do at Foxley (cat. 117). Malchair worked for two years at Bristol before settling in Oxford at the end of 1759, where he was employed in the band in the Music Room, and offered lessons in drawing.

As a teacher, Malchair avoided systems and formulae, encouraging his pupils to draw from nature, and his own drawing

style evolved through the years. An early reliance on pencil and chalk underdrawing and shading with brushed washes was thought by Oppé to be a debt to Gainsborough, but it was more likely the influence of Robert Price's earlier lessons from Busiri in Rome, and certainly Malchair's earliest extant drawings are very close to Price in style. He later modified them until they were pencil drawings worked up with washes, adding pencil on top to bring definition to the foreground. He was also fond of repeating earlier views, although not as exact copies, and in his later years he delighted in 'improving' his old sketches, which he described as 'reforming old sinners'. He placed a great deal of emphasis on the study of trees in his teaching, but rarely drew individual examples. The present drawing seems to relate to a grove of elms behind Magdalen College, which he first drew in 1785. It has the appearance of an old composition, which had been revisited after his later tours in Wales in the 1790s when he also began to use larger sheets of paper. He had visited the country several times earlier with Luttrell Wynne (cat. 95) and Lord Aylesford, but his final tours in the 1790s,

accompanied by a geologist, seem to have produced a burst of activity and a new way of looking at the mountains, cliffs and valleys.

Literature: Harrison, *passim.*

JOHN BAPTIST MALCHAIR (1730–1812) and HENEAGE FINCH (1751–1812), VISCOUNT GUERNSEY, 4TH EARL OF AYLESFORD from 1777

116

An album of drawings, open to f. 21: *A wooded landscape with hunter and dogs*

Watercolour, grey wash and pencil, 320 × 460 mm

Provenance: Elizabeth Carlyon, 1831 (inscribed inside cover); C. W. Trayler, from whom purchased

1942-7-11-17 (1 to 54), c.200*.b.1

This album contains examples of all of Malchair's different styles, but some of the most interesting are his homages to the ideal

compositions of the old masters in the form of drawings made from memory of works he had seen by Claude (at Buckingham House), by Wilson (at Oldfield Bowles's) and a drawing by Annibale Carracci (whose work he had set Skippe to copy, see cat. 124), as well as imaginary landscapes inspired by them. Other drawings after old masters may have had their sources in the Christ Church collection, Oxford. A lost album mentioned in his diary contained reduced versions of Earlom's prints after Claude, which he had put together for the use of his students. In some of the drawings in this album, the well-preserved colours, inspired by the tone of the original paintings, appear shockingly bright, particularly the pinks, oranges and purples, when compared to Malchair's usual more monochromatic drawings or those that have lost their colour through exposure over the years. The rest of the drawings in this album are in various media, usually black chalk and watercolour or grey wash; many are original views inscribed with the location, date and time the drawing was made, while others repeat drawings made earlier in Oxford and on various tours, dating from the 1770s to the 1790s. Malchair's knowledge of the work of

116

Cozens, Gainsborough and Gilpin is also evident throughout the album.

Five of the drawings at the back of the album have been attributed to Lord Aylesford (cat. 120); others are not obviously attributable to either Malchair or Aylesford and may be by other pupils who presented Malchair with examples of their work – the drawing on f. 37 is probably by Luttrell Wynne. Another, inscribed *for Miss M. H.*, may have been intended for a pupil or possibly Mary Hartley (cat. 112).

The Museum also has a beautiful signed and dated (1782) watercolour of ruined arches in a landscape, possibly a Welsh abbey, which uses lovely bright greens, blues, pinks and yellows, and was owned by Cracherode when it was painted (Gg.3–401).

Literature: A. P. Oppé, 'John Baptist Malchair of Oxford', *Burlington Magazine* (August 1943), 193.

ROBERT PRICE (1717–61), after ANTONIE WATERLOO (1609–90)

117

Woodland landscape

Brush drawing in brown wash, over pencil, 201 × 250 mm (sight measurement); inserted in a mount with contemporary wash border, 340 × 390 mm

Inscribed on verso: *after an Etching of Waterlow*

Provenance: N. W. Lott and H. J. Gerrish Ltd, from whom purchased through the H. L. Florence Fund

1983-5-21-35

Gainsborough moved to Bath in 1759 and soon afterwards became acquainted with the Price family of Foxley, Herefordshire. Robert predeceased his father, Uvedale Tompkyns Price (1685–1764), but Gainsborough painted both their portraits about a year before Robert's death. Uvedale is portrayed as a distinguished elderly man seated on a chair the back of which is carefully depicted by the artist to show it has been covered with a large needlework flower (Neue Pinakothek, Munich). He sits before a large framed drawing by Gainsborough on the wall, with portfolios on a table beside his right hand, which holds a *porte-crayon*; in his left hand is a half-finished chalk drawing of a landscape with trees. It is disappointing that the whereabouts of Robert's portrait is not known, as

he, too, was an accomplished amateur. Father and son probably took lessons from Gainsborough, who at the time was in the process of 'discovering' the landscapes of Van Dyck and Rubens, as he was already familiar with the etchings of Dutch artists such as Anthonie Waterloo and Jacob Ruisdael. Many of Gainsborough's early Suffolk sketches in their manner were in a sketchbook purchased by Payne Knight at the artist's sale in 1799 (now British Museum), and from his time in Bath onwards, Gainsborough never sold drawings, but retained them for his own use or gave them away as presents. It was during his time in Bath that he studied Van Dyck, as well as drawings by Giovanni Battista Busiri and Marco Ricci in the collection at Foxley, where he also sketched on the estate. The Prices, father and son, had collected on their grand tours, but from 1735 had also regularly purchased old master drawings from Arthur Pond.

From 1738 to 1740 Robert Price travelled through Italy with William Windham of Felbrigg Hall in Norfolk and his tutor Benjamin Stillingfleet. Windham was a keen student of natural history, but also intended to form a collection while abroad, and in Rome he began to collect works by Busiri from whom Price was taking lessons,

learning to sketch directly from nature in pen and ink. Windham bought a series of twenty-six gouaches and six oils for Felbrigg, while Stillingfleet admired Price's landscapes in pen. Price wrote to his father that he would not give the 'worst of my Busiris watercolours' for four of John Wootton's best paintings. In Paris he showed his Busiris to French and Swiss artists who recommended that he etch them. Smuggling them into England in a fiddle case to avoid customs, in 1746 he purchased etching tools and materials from Pond. Instead of etching, however, he began sketching in chalks and reported that his father looked upon him 'as a great dab at it, & tells me I draw much better than he does'.

The three younger men had studied natural history and botany in Geneva, and in 1744 Windham published an account of their exploration of the glaciers in Savoy, illustrated with an engraving after a drawing by Price, apparently the first ever made of the Mer de Glâce. Stillingfleet, a great classical scholar, who lived at Foxley from 1746, wrote a musical treatise with Price, translated Linnaeus and published a treatise on husbandry with observations on grasses, which was later republished with illustrations by Price (*Miscellaneous Tracts*, 1762).

117

118

They toured the Wye river valley, which ran through the estate and into Wales, and also explored the mountains of North Wales, keeping journals, sketching and studying. They passed on their way of looking at nature to the Swiss artist Malchair who first began to visit Foxley in 1757, as a musician. He picked up useful hints about drawing from his host and continued to visit long after Price's death. At the time the Museum acquired the present interpretation of Waterloo's etching of *Two boys and their dog at the waterside* (Bartsch 36), in which Price left out the figures, one of his Roman drawings and a view on the Wye were also purchased. His somewhat 'woolly' style is similar in all three and clearly influenced Malchair's own approach, in which composition and effect took precedence over topographical detail.

Price's most important legacy was the improvements he made to the estate at Foxley. He always took into account the present use and quality of the existing landscape, and his sympathetic alterations had an important effect on the picturesque theories of his son Uvedale Price (1747–1829), who, with Payne Knight and Gilpin, was one of its most important exponents later in the century.

Literature: Fleming-Williams, in Hardie III, 259–60; Andrew Moore, *Norfolk and the Grand Tour*, exh. Norwich, 1985, 43–4, 123–31; Peter Morse, *The Illustrated Bartsch* II, pt 1, 1992, xi–xiii, no. 36; Beryl Hartley, 'Naturalism and sketching: Robert Price at Foxley and on tour', in S. Daniels and D. Watkins, *The Picturesque Landscape*, exh. University of Nottingham, 1994, 34–9.

FRANCES HOWARD (m. 1783)

118

Landscape with a river and woods, 1790

Brush drawing in grey wash, with watercolour, over pencil, 229 × 290 mm

Inscribed verso: *Frances Howard 1790* and *27*

Provenance: Alexander Yakovleff, by whom presented

1949-9-5-4

The Hon. Frances Howard was the daughter of Mary Finch (1716–1803) and William Howard, Viscount Andover (1714–56), who had married in 1736. As Viscountess Andover, her mother was known as an accomplished amateur. Her portrait painted by Thomas Hudson (1701–79) in

1746 now hangs at the Ranger's House, Blackheath, and shows her as a 'Muse of Art' holding a *porte-crayon* and a drawing. In 1747 Vertue recorded that she was a 'most ingenious lovely and agreeable lady. a great Lover of curious works and drawing. some her Ladyship shewd me views taken by herself: drawn in ink & pencil – mighty well' (v, 154). She was later a member of the Bluestocking circle around Mrs Montagu, where she frequently met Mrs Delany, who noted Lady Andover was so skilled at cutting landscapes in paper that a magnifying glass was needed to see her work.

Viscountess Andover was the aunt of the 4th Earl of Aylesford (cat. 120), and ties between the Howard and Finch family remained close. Frances's brother became the 12th Earl of Suffolk and later married his cousin, Lord Aylesford's sister. Frances herself married Richard Bagot (1733–1813) in 1783, and he took her maiden name.

All of the Andovers' children and many of their friends and relatives were amateurs, and they collected examples of each other's works together in two albums. These contained 560 drawings dated between 1735 and 1778, as well as embroidery, fan and clothes patterns. Fortunately, most were acquired to add to the Suffolk collection at the Ranger's House, Blackheath, after they were sold in 1987 (Sotheby's, 16 July, lot 22). They included works not only by members of the Howard, Finch and Bagot families, but also by William Courtney of Powderham, in Devon, and his sisters, by the Dashwood and Conyer sisters, and by Mrs Delany and her friend Letitia Bushe. A watercolour by Viscountess Andover, dated 1758, was a copy of of a view in Kerry after a painting by Letitia Bushe dated 1752. There were also examples by a handful of artists, including Thomas Hudson and possibly Alexander Cozens. One unsigned blot and a very accomplished varnished landscape drawing based on it, as well as another very similar landscape view of Charlton Park, the Jacobean seat of the earls of Suffolk, indicate that Cozens certainly taught the Howard family in the late 1750s or early 1760s when Frances Howard probably began her own drawing lessons. Many of the compositions of pen and ink and sepia and grey washed drawings on mounts with washed borders, signed by *M. Andover* and *F. Howard*, are very similar to works produced by Lady Polwarth (cat. 110) under Cozens's tutelage.

The following lot in the same sale was a folio of eighteen views on eight mounts removed from the above two albums. The views were all by Frances Howard and her mother, taken between 1764 and 1770 around Leven Hall, Westmorland, the home of Frances Howard's grandmother. Many were grey wash, but some were watercolours like the present work, which is one of four presented to the British Museum and three to the Victoria and Albert Museum by the same donor in 1949. An inscription on the verso of one in the Victoria and Albert Museum identifies it as Hawes Bridge, near Kendal, in Westmorland, and several of this lovely group with their delicate modelling and colours depict scenes of rocks, cliffs and trees along what appears to be the same river bank. Frances Howard and her mother also seem to have toured in Wales as two views in the British Museum are inscribed on the verso: *Vale Crucis*.

Literature: Hayden, 125, 134; Bennett, 58–9.

SIR WILLIAM ELFORD, Bt (1749–1837)

119

Abbey ruins in a landscape

Pen and brown ink and grey and brown wash, over graphite, 315 × 450 mm

LB 2

Provenance: Bequeathed by Richard Payne Knight

Oo.5-58

Sir William Elford was born in Devon. A partner in a Plymouth bank, in 1797 he became the city's mayor and served as its member of parliament from 1796 to 1806. A lieutenant-colonel in the South Devon militia, he served in Ireland in 1798 and was created a baronet in 1800. Coplestone Warre Bampfylde had close associations with the Somerset militia in Plymouth in the 1770s, and although he died in 1791, it would be surprising if the two men had not known each other.

Sir William exhibited at the Royal Academy from 1774 until his death, and presented many examples of his works to his university (now in the Ashmolean Museum, Oxford) and to friends, including the prince regent and Richard Payne Knight, whose bequest included the present work and a similar one in an upright format. Elford

lived the later part of his life at the Priory, Totnes. The British Museum was recently given a large, loosely washed pencil sketch of Pendennis Castle at Falmouth, taken from the shore and dated 1811 (1998-3-14-23). Nothing is known of Elford's drawing masters, but his style is very similar to that of Aylesford and, ultimately, of Malchair, whom he may have known at Oxford. His landscapes are mannered, with little attention to detail, and an emphasis similar to those of Malchair and Gilpin on light and shade and composition. The present work may be an identifiable site, perhaps Valle Crucis in Wales, but the identity was not as important to the artist as creating a strong and memorable image. In the one oil painting by Elford that has been reproduced (in Grant; it was with Spink in 1975), he depicts an artist, presumably himself, seated with a companion at the foot of a path through an old quarry, sketching a view from nature of a rocky outcrop crowned by a pair of trees. This painting in oil dated 1802 is quite different from Elford's watercolours and gives the impression of having been largely painted from oil sketches made out of doors, a practice of Wright of Derby and Thomas Jones a few decades earlier, and also of Lady Balcarres (see cat. 136), Thomas Kerrich (cat. 156) and Philip Reinagle (1749–1833) and his son Ramsay Richard (1795–1862).

Literature: Col. Maurice Harold Grant, *Old English Landscape Painters in Oil* I, 1933, 126–7, pl. 81.

HENEAGE FINCH (1751–1812), VISCOUNT GUERNSEY, 4TH EARL OF AYLESFORD from 1777

120

Tenby

Pen and grey ink and watercolour, 211 × 280 mm; on artist's own mount with wash border, 352 × 450 mm

Inscribed on mount: *Tenby*

Provenance: Purchased from P. & D. Colnaghi

1956-2-11-14

Viscount Guernsey may have met Malchair at Oxford in 1767 through his friend Uvedale Price, who had known the musician and drawing master since his visits to his father, Robert Price, at Foxley from the mid-1750s (cat. 117). Guernsey probably had

119

a number of drawing masters: he had been at Westminster before going to Oxford, and in the 1780s employed Joseph Bonomi to teach him architectural drawing, an accomplishment and master he shared with a number of contemporaries. At Oxford he absorbed Malchair's technique and advice to study old masters: his drawings even at this early date show a particular fondness for old cottages, barns and outbuildings, indicating a debt to Dutch and Flemish masters, especially Rembrandt. In the 1780s Aylesford, as he was now, abandoned Malchair's reliance on pencil and turned to brown ink not merely for outline, but to bring a liveliness to his drawings, effectively set off by his cream paper, brown and pale red washes, and mounted by the artist on his own mount, with a carefully chosen wash border. He is said to have made a tour of Italy in the late 1770s, which would account for a change in style, but the evidence is based only on a small group of drawings of Italian subjects and two prints by him of Greek temples in Henry Swinburne's *Travels in the Two Sicilies* (see cat. 131). There is no documentary evidence to place him in Italy and no other travellers mention him, so it seems possible that the drawings were copied or inspired by the works of another

artist. They are the first to employ the pen and ink lines that were to become his hallmark, but without any letters or other proof, the source of these drawings and this new manner must remain unknown.

Aylesford toured Britain, accompanying Malchair to Wales in the 1780s. An album of over fifty views from 1784 remains with most of the rest of his drawings in the hands of his descendants at Packington. These views of Tenby are part of a group in the British Museum, and one in the Oppé collection in the Tate Gallery. They would seem to date from around 1790, but Aylesford visited Wales several times and another drawing in the collection, of Margaret Davies (aged seventy-five), a bathing woman at Tenby, is dated 1803. Attribution of his work can still be confused by the existence of similar works by his brothers and sisters, including General Edward Finch and the Revd Daniel Finch (also a pupil of Malchair at Oxford), and his children who were also amateurs.

Literature: Ian Fleming-Williams, 'The Finches of Packington' *Country Life* (15, 22 July 1971), 170–2, 229–31.

121

Tenby

Pen and brown ink and watercolour, over black chalk, 212 × 291; on artist's own mount with wash border, 357 × 435 mm

Inscribed on mount: *Tenby*

Provenance: Purchased from P. & D. Colnaghi

1956-2-11-16

Around 1830 William Young Ottley began to write *Notices of Engravers and their Works*, although he only completed the first volume (*A-Baldung*). His very high praise of Aylesford (he described nineteen of his plates in detail) has ensured that the latter's name and reputation as an etcher has been picked up by every subsequent authority who relied on Ottley's unfinished work. However, he is best known to modern print collectors for having formed a fine collection of Rembrandt etchings. He produced his own first landscape etchings in 1770–1 and a few others in the 1780s, but between 1794 and 1797 he etched and printed, with constant revisions of the plates, fifty-one of his own compositions in Rembrandt's manner. They have been credited with providing an important link between

Rembrandt's sensibility for light and natural features of landscape and the British etching tradition of the nineteenth century. According to Sir George Beaumont (cat. 149), however, by that date Aylesford's admiration for Rembrandt precluded a taste for any other artists, and the style overlay even his drawings from nature.

Many of Lord Aylesford's albums of drawings have been split up and scattered, often losing the name of their producer in the process, and gaining attributions to Henry Edridge and Patrick Nasmyth, but his style is so distinctive that by now they should be easily recognizable. The present examples demonstrate his singular approach to drawing from nature, presenting real landscapes in the manner of Rembrandt's landscapes painted in oil. The Yale Center for British Art has two drawings from the 1790s that are quite different in style from the present examples: in pen and brown ink with brown and grey wash, they are successful translations of Rembrandt's own drawing style.

Both the etchings and the drawings, which date mainly from around 1784 (Aylesford exhibited at the Royal Academy in 1786, 1789 and 1790), were based on sketching tours around Oxford, Kent, Scotland and Wales, and especially around his seat at Packington, Warwickshire. An MP from 1772 to 1777, after his succession to the earldom he became a trustee of the British Museum. He held a series of court appointments and, like the Harcourt family, became very close to Queen Charlotte, sharing her and her children's enthusiasm for drawings and presenting her with an album of fourteen mounted views of the Medway, near Rochester, in 1809. Like most amateurs, he presented many drawings to friends, and there were examples of his work in Lord Warwick's collection (sale Sotheby's, 1936). His eldest son, the 5th Earl of Aylesford, married the 2nd Earl of Warwick's (cat. 140) daughter, Augusta Sophia Greville.

Literature: Oppé 1924, *passim*; Fleming-Williams 1971, *passim*; D'Oench, Alexander and White, 73, 86–7.

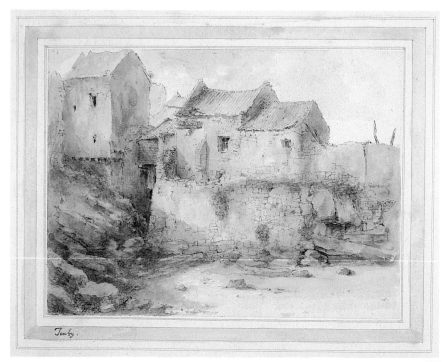

120

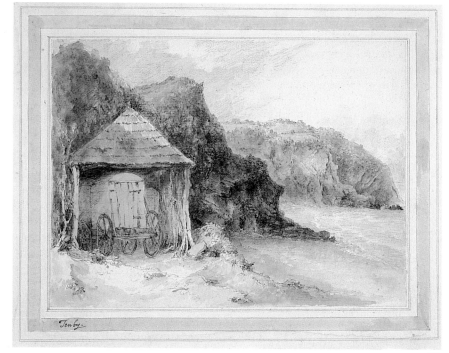

121

6

Amateurs at Home and Abroad

George, Viscount Nuneham, later 2nd Earl Harcourt (cat. 96), attended Westminster School in the 1740s with his contemporary Edward Gibbon (cats 180–2); only a few years earlier Charles Gore (cat. 79), William Hamilton (cat. 93) and Frederick Augustus Hervey, later Bishop of Derry and 4th Earl of Bristol (1730–1803), had also been educated there. All are names to conjure with in the history of the English on the Grand Tour, and all undoubtedly owed a large part of their expectations of and responses to Italy to their educations at Westminster, where virtue, social responsibility and a taste for beauty were nurtured along with the classics. Lord Nuneham is a particularly apposite example of the product of such an education and of the type of amateur we have come to expect to encounter on the Grand Tour in Italy in the eighteenth century, whose later life in England was informed and guided by these earlier experiences and precepts.[1]

In 1755, after 'twelve horrid months' in Germany, Nuneham wrote to his sister Lady Elizabeth Harcourt (cat. 109) from Vienna:

I am in high spirits at the thought of seeing Italy in so short a time, ever since I can remember I have been wishing to go into a Countrey, where my fondness for Painting and Antiquities will be so indulged, I expect every day a letter from Mr Knapton with a Catalogue of all the finest Galleries & his remarks on them, for I intend not only to improve my taste, but my judgement, by the fine originals I expect to see there.[2]

He continued with a description of his failure to paint landscapes in watercolours and his more successful attempts at drawing landscapes in crayons (pastels). Later letters describe visiting galleries and antiquities and his search for a drawing master to assist him in new drawing techniques he hoped to learn from masters there that he could not learn at home.

The grand tourist/amateur that Nuneham typifies did not end with his generation, but continued during the second half of the century. Charles Parker (1755–95), born the year Nuneham was in Italy, was the nephew and expected heir of Sir Roger Newdigate (1719–1806) of Arbury Hall, Warwickshire, who had been the first to measure and survey the ruins of the Roman city of Aosta on his own grand tour in 1739.[3] Like Newdigate and Nuneham, Parker was also an amateur, but unlike Nuneham, was interested in minerals, geology and the history of the earth, and his drawing skills were put to use in his studies of the disastrous earthquake at Messina, as well as in his search for the sites of classical history, an equally great passion he had inherited from his uncle.[4] When Parker made his first tour with Sir Roger and his sister-in-law Mary Conyers (see cat. 166) in 1774–5, Mary had taken lessons from 'little Fabrini' in Rome,

and on Parker's return in 1783 he employed the same master and another whose name is not known. The Scottish artist Allan Ramsay (1713–84) had been conducting research into the site of Horace's Sabine villa for several years, and when Parker met him in Naples he consulted with him on the possible location of various sites described in classical sources. Parker wrote to Newdigate that before leaving Rome he planned an excursion of eight or nine days to explore some of these, describing the planned route with the classical rather than contemporary names of the sites:

First to see the Town of Rome & Campagna from the Top of Mt. Aelgidus now the Monte Cavo: which in fine Weather is a noble sight, from thence to Palestrina, then up into the Mountainous Country to the Lake Fucinas, which the Romans tried to drain as well as that of Albano … – then to see what remains of Cicero's Villa at Arsinum, from thence by Anague, & Norba into the Pontine Marshes to the old Port of Astura, where Cicero was murder'd. There is a Temple now remaining. Hence to Antium [Anzio], Ostia &c to Rome – I mean to go this Jaunt on Horseback en Peintre having prevailed upon my Drawing Master to go with me, (who is one of the [fine]st fellows in Rome). We shall take our Cartelle & draw as we like. This single Week, with Nature before me & a Master to open my Eyes & teach me how to imitate her, will I am confident do more than half a years practise within doors … – I feel my desire to see Elba as strong as ever …[5]

Clearly Parker's intention was to search out, discover and record for himself the sites described by Horace and Virgil, Italy's 'Classic Ground',[6] at the same time as indulging his amateur interests in geology and mineralogy and collecting antiquities, paintings, coins and medals for Sir Roger. Similarly, Henry Swinburne wrote from Naples in 1777 that the excursions he and his wife made were 'delightfully amusing and interesting: for, except in taking views, my wife has the same propensities as myself for antiquities, and our mode of life is so pleasant in this delicious climate, where no impediment of weather prevents our daily journeys of discovery, that it is impossible for me to express how agreeably time passes'.[7] It is misleading, however, to perceive amateurs on their grand tours undertaking such studies in a superficial manner; as well-educated, well-connected and if not already, soon to be part of Britain's ruling and social establishment (most were peers or landed gentry and many became MPs on their return), they were aware of their moral, civic and cultural responsibilities. Their private pursuits abroad were often intended to fulfil more public purposes at home.

Ancient History and Modern Manners

The published sources for providing information about the intentions of individuals on the Grand Tour and on tour in Britain in the eighteenth century have increased enormously over the last decade,[8] but the process of analysing this information has barely begun.[9] The examples by tourists in this chapter provide opportunities for examining their public achievements, in the form of published books, finished drawings and paintings for exhibition or prints after them, as well as the more personal sketches they made while on tour that served a more private purpose. A frequently encountered third category, which might be described as semi-private, is represented by the carefully compiled albums of drawings by Cordiner, Keate and Skippe (cats 122–4), attractively mounted and expensively bound, intended to be shown to visitors and circulated amongst friends and aquaintances. Many of these albums have now been broken up and dispersed.[10]

The circulation of such albums was occasionally a form of preparation for publication, by way of having the contents proof-read for errors, garnering interest for potential subscribers and securing the approval of those who were acknowledged as pre-eminent in that field. Edward Swinburne's (cat.131) uncle Henry published a letter from Sir William Hamilton in the preface to the second edition of his *Travels in the Two Sicilies* (1790), which stated that the envoy had been requested to send his remarks on Swinburne's manuscript tour of Puglia, but that he could add nothing to what Swinburne had already written and indeed he had referred the Duke of Leeds and Joseph Banks to the text.

William Young Ottley's uncle Sir William Young visited the southern parts of Italy with Charles Townley, going on to Sicily and Malta in 1772, and was also accompanied by the artist John Brown, who later taught Young's nephew (see cat.133). As it was a part of Italy 'visited by few and described by none', Young thought it 'incumbent on me to take such notes as might thereafter give an adequate idea of the state and face of the country',[11] and illustrated his account with his own sketches and watercolours. His descriptions of scenery and antiquities were interspersed with quotations from classical authors and ended with a lament on the corruption and disorder of contemporary Sicilian society.[12] It may have been that his own attempts to find encouragement for his publication were less successful than those of Swinburne, or that his intentions were less public-spirited since he had only twenty copies printed privately for distribution to his friends in 1774. Ten years later, Young's mother sent one of these to Sir William Hamilton, who claimed it to be 'the most faithfull and best account of Sicily he had ever read'.[13]

Other tourists were not satisfied with such modest 'semi-private' attempts at public virtue and sought a wider distribution than their circles of aquaintances. Sir William Hamilton sent his own sketches and observations on antiquities and Vesuvius to the Society of Antiquaries and the Royal Society for publication in their transactions, and he later commissioned artists to produce watercolours and drawings to be engraved as illustrations to these reports and to his own publications.[14] Richard Payne Knight took Charles Gore (cats 126–8), a fellow amateur adept at using a camera obscura, and a professional artist, Jakob Philipp Hackert (1737–1807), on his 'expedition' to Sicily in 1777 to investigate the island's ancient remains and to make a study of modern manners. Gore and Hackert produced finished watercolours to be engraved and Payne Knight wrote up his notes into a more polished account, employing two more professional artists, John Robert Cozens and Thomas Hearne, to work up other sketches into additional finished watercolours for publication.[15] Their motives have been described as financial,[16] but both Payne Knight and Gore were wealthy gentlemen whose money came from business rather than inherited ancestral lands and titles. Rather than income, they were concerned with establishing in a public and respectable manner reputations as commentators on antiquity and modern society, deserving of appellations as men of taste and learning.

Although the strong criticism of Christianity and advocacy of revolution in Payne Knight's text evidently led him to reconsider publication on his return, as he perceived it might do his reputation more harm than good, his intentions were nevertheless comparable to those of Henry Swinburne and Cornelia Knight in their respective published examinations of the ancient history and modern manners and customs of Italy, illustrated with prints based on their own drawings. In her *Description of Latium* (1805) Cornelia Knight argued, for example, that it was important to cast a retrospective glance on the first advances of the civilization of a 'People to whose arms and arts the most polished nations of modern Europe, and this Island in particular are indebted for the chief advantages and blessings of their society and political existence' (Preface, p. xi). She punctuated her study with descriptions of the people and customs of Latium, and concluded with an account of how the inhabitants had reacted to the French invasion in 1793 when they joined the Papal Standard against the French, eventually being freed in 1799 'by English valour and English disinterestedness' (p. 261).

All these accounts, whether illustrated by their authors' own drawings or not, shared a common purpose, which was not only, as we might assume, one of self-interest in publicly establishing their authors' own reputations, but the education and moral and cultural improvement of the British nation.

Pre-Raphaelites and Pre-history

The amateurs' search for evidence in classical texts and antiquities that might provide not only historical validation for ancient history, but also sources for contemporary manners and even politics, extended to a search for material to provide a history of art and architecture. Evidence for a history of architecture was relatively easy to find, measure and document, but sources for the history of painting were more scarce and appeared to be limited to recently discovered wall paintings at Herculaneum and Pompeii. In 1767, however, Baron d'Hancarville elaborated his theory of the origin and development of painting in

antiquity by basing it on the images found on Sir William Hamilton's collection of vases, and published it in the first volume on the collection in 1767.[17] At about this time other amateurs, familiar with the masters of the Italian Renaissance through copying and collecting their works, began to search for an explanation of the transition from these sources from classical antiquity to the paintings of the old masters. Skippe, Greville and Ottley made the first attempts to understand this history in their own studies, which were informed, directed and ultimately transmitted through their abilities as amateurs and the collections they put together. All three made careful studies, copying, or employing others to copy for them, the prints, drawings, paintings and frescoes of the so-called 'primitive' artists of the Trecento and Quattrocento, whose works provided a 'pre-history' of art before Raphael.

John Skippe (cat. 124) recorded such works in drawings and monochrome copies, and arranged his old master drawings in albums so that they might illustrate the history of art. He also explored 'archaic' printmaking techniques with his chiaroscuro woodcuts after them. In 1781 Charles Greville (cat. 141) wrote to his uncle Sir William Hamilton of his intention to collect paintings 'in order to have a little series of the progress of the art'.[18] On inheriting his uncle's paintings in 1802, he invited Charles Townley to visit his recently renovated house at Paddington Green, where he hoped 'the ar[r]angement of my specimens of the art & of its progress, may be more than heretofore satisfactory'.[19] The sale in 1810 after Greville's death included works attributed to Cimabue, Giotto and Masaccio, and advertised that these 'Rare Specimens of the Restoration of the Art of Painting in Italy, and its subsequent Progress to Perfection: ... had been collected with a design to illustrate the progress of Painting, displaying a Rare and Curious series from Cimabue to Raphael and ... were selected by the late intelligent Proprietor from authentic Situations, and they may therefore be deemed Invaluable'.[20]

In the 1790s William Young Ottley (cats 162–3) found himself in Italy at a time when the finest collections were being dispersed and even destroyed. Provided by his family's wealth with the means to acquire and thus save them, he purchased paintings and drawings from the Colonna, Borghese and Corsini palaces, and from the Uffizi, publishing them in a chronological sequence after his return to England.[21] A contemporary visitor described a small gallery in his house hung from floor to ceiling with 'pictures by the Old Pre-Raphaelite artists, ... collected in Italy during the occupation by the French soldiery, [which] but for his intervention, might have been destroyed'.[22] The collection included works by Botticelli (including the *Nativity* now in the National Gallery) and others then attributed to Fra Angelico and Gentile da Fabriano, as well as paintings by Masaccio and Ghirlandaio that Ottley may have acquired at Greville's sale.[23] In 1826 he published them in a volume of plates dedicated to his friend John Flaxman whose interest in Greek sources for Roman art paralleled his own researches.[24] Like Skippe, he was also interested in the history of printmaking, forming an enormous collection and publishing two enquiries into its origin and history.[25]

It was not only amateurs who had travelled abroad who participated in this attempt to reveal the past, and thus shed light on the present through the antiquities, architecture or works of art that they drew and copied. They found their parallel at home in the activities of men such as the Revd Cordiner (cat. 122) who followed John Aubrey and William Stukeley's belief that the Druids had brought the seeds of civilization to the Celtic Britons who had been the inhabitants of a pre-Roman Britain. For such men, the Druids came to represent the leaders of the rebellion against Roman 'oppression' in Britain, a concept of great significance to the British in the eighteenth century who were keen to establish native roots for British culture, religion and the origins of British liberty.[26]

A kind of 'Druid-mania' took hold of many enlightened figures and amateurs throughout the century, in the form of poetry and books celebrating the ancient bards, including James MacPherson's famous histories of Ossian and Fingal, as well as secret societies, and even the erection of 'Druidic temples'.[27] William Kent had designed a 'Merlin's Cave' for Queen Caroline in Richmond Park in 1735, a 'primitive' beehive-like structure with a thatched roof, which spawned a host of imitations that acquired Druidic connotations in the 1750s, including a thatched Druid's Temple in Sir Charles-Kemeys Tynte's gardens at Halswell.[28] Although that temple has since been destroyed, Lady Elizabeth Harcourt who, we have noted, shared her brother's leanings towards liberty and republicanism, visited the garden and recorded a 'gothic' ruin set within it (cat. 109). In the 1750s, when a hoard of early axes and tools was discovered in the process of landscaping the Princess of Wales's gardens at Kew, Stukeley was called in to advise and explain, and found Princess Augusta well-versed in his accounts of Druid Celts: a 'Druid's Temple' was constructed shortly afterwards.[29] A small stone circle monument was discovered in Jersey and presented to the governor of the island, General Conway (the father of Mrs Damer (cat. 184)), who erected it in his grounds at Park Place, near Henley, while Walpole had a model made of it for Strawberry Hill.[30] Another elaborate temple was built by Mary Harcourt's brother William Danby in the grounds of the family seat at Swinton.[31]

Earlier antiquarians and their counterparts in Italy took careful measurements of monuments and recorded them as accurately as possible, frequently using a camera obscura, as Gore and Dodwell had done (cats 127, 134), and employing earlier training in perspective and surveying. Their fascination with recording not only the monuments of the past, but especially its ruins and even its rubbish, led to a mocking and satirical attitude towards a certain type of late eighteenth-century antiquary, which paralleled the misconception of the *virtuoso* of the end of the seventeenth century. The 'dull, unanimated pursuits of certain Antiquaries' were criticized for bringing to light 'the blunders of past ages without aiming at one useful end'.[32] Other antiquarians such as Cordiner paid less attention to exact detail or topography, and took a more picturesque, almost 'Claude glass' approach to the monuments they depicted, hinting at other agendas. Their accompanying texts

echoed this in their reliance less on historical facts and more on anecdotes and descriptions of the location, as their underlying aims were frequently nationalistic, illustrating national (i.e. Scottish, Welsh or Irish) customs and foibles and recording 'improvements' made by the English.

Records and Reflections: the Camera Obscura and Claude Glass

Drawing aids such as the camera obscura and the Claude glass have often been associated with amateurs,[33] and are often seen today as confirmation that these amateurs needed mechanical assistance to approach the skill that professionals could display without it. One of Sandby's best-known watercolours depicts Lady Frances Scott employing a camera obscura, a box with a lens that produces a reflection via a mirror on to a sheet of thin paper placed over a glass screen, to draw a view of Roslin Castle.[34] The use of camera obscuras by professional artists for reference or as foundations for detailed or panoramic works is occasionally acknowledged, but discussion of the use of a darkened convex mirror called a Claude glass (see below) has consistently been restricted to the work of amateurs and tourists. Since, however, it has been shown that amateurs had no intention of competing with professionals in matters of skill, it is worth briefly re-examining their use of these aids in the context of the drawings they made abroad and at home.

Because modern art historians have tended to see any reliance on mechanical aids as evidence of a lack of 'originality' or skill, they have been reluctant to acknowledge and examine the evidence, or to make any attempt to see these aids in the context of eighteenth-century attitudes towards their use by professional artists. We have already noted the probable use of a camera obscura by Danckerts and Hollar, and it would therefore be surprising if Francis Place had not been familiar with his friend Robert Hooke's invention of a more easily portable model.[35] The camera obscura was used to a far greater extent by amateurs and professionals throughout the eighteenth century than is usually recognized or acknowledged. Josiah Wedgwood provided his artists working on the Green Frog Service with such instruments, and it is now well-known that Canaletto, the Sandbys, Reynolds (whose camera when closed was disguised as a folio of *Ancient History*) and Thomas Girtin (1775–1802) all used them.[36] Jonathan Skelton (cat. 63) referred to making 'studies with the camera' while in Italy in the 1750s,[37] and in 1769 John Brown (see cat. 133) ordered a camera obscura in London, which he described as 'useful and necessary to a landscape painter', before going to Italy; John Downman also used one for several of his studies from nature.[38] They were also used regularly by a number of Italian and German artists working for the English in Italy. Giovanni Battista Lusieri found its use essential for his meticulously detailed panoramic views in watercolour such as the painting of the Bay of Naples from the window of Sir William Hamilton's Palazzo Sessa (Getty Museum, Malibu).[39] Louis Ducros and Philipp Hackert painted equally detailed and panoramic views, in bodycolour, oil, and

hand-coloured outline etchings, and it seems unlikely that they could have been produced without the aid of such a device.

For professionals and amateurs alike, recent inventions and refinements had provided them with a number of useful instruments that assisted them in their study of nature and the objects within it: the camera obscura, by no means a new instrument, was a tool to be used in the same way as a telescope for viewing volcanoes, an electrical machine for studying lightning or a ruler and mathematics for drawing in perspective. Whether drawing architecture, panoramic landscapes, classical remains – where proportion and detail were of paramount importance – or the vast expanse of coastline and horizon seen from on board ship, a camera obscura was as essential a tool as a sufficient supply of paper. For Gore this was particularly important in his views of the Lipari Islands (cat. 126) where he was recording natural history as much as he was taking views. The use of a camera obscura in such a 'scientific' context, or by military draughtsmen and surveyors would seem more appropriate to modern viewers. But Gore's purpose in employing one for his views of ancient ruins in Sicily is less obvious, although easily explained by his desire, rather than need, for accuracy. Unlike Hackert, he was not employed professionally on this trip to produce views that might later illustrate Payne Knight's publication; his interest in classical ruins was, however, like that of many educated visitors to Italy at the time, not a superficial one, and

Fig. 4 Thomas Gainsborough, *Study of a man sketching with a Claude glass*, c.1750. Pencil, 184 × 138 mm (British Museum, Oo.2-27)

a mere sketch or view would not sufficiently reflect the serious-ness he intended to display in his visual records of their study tour.

From the mid-seventeenth century professional artists had recorded the use of a convex mirror for reducing large views to a more manageable compass and, at the same time, for composing the view. An early drawing by Gainsborough shows how such mirrors were used (fig. 4), and Alexander Cozens included 'study with ye Glass &c at Capitoll' in his list of activities in Rome in c.1746.[40] In 1772 the recently married Lady Amabel Polwarth (cat. 110), touring Britain to visit relatives, at Taymouth found herself 'very much taken … with a very common thing, the effect of a concave mirror, which I had never seen applied to a prospect before, & made the most perfect picture I had ever beheld'.[41] We have already encountered her as a pupil of Cozens who composed landscapes from blots, and whose interpretations of real landscapes were not merely topographical records, but carefully composed and concerned with effect.

The Claude glass, named after the artist whose works it imitated, was a further refinement whereby the darkened con-cave surface reflected a landscape in which the details were reduced to dark shapes and the image was already composed and framed – the foreground sharp and the distance fading away.[42] One of its earliest recorded uses was by the poet Thomas Gray (1716–71) who took one bound like a pocket-book on his tour of the Lakes in 1769.[43] Not surprisingly, the Claude glass was a useful tool on picturesque tours undertaken in the spirit of the Revd William Gilpin's *Observations* (see cat. 111), especially as the colours and shapes produced so closely resembled the aquatints that illustrated them. Gilpin appreciated their ability to achieve what the human eye could not, to focus and generalize at the same time, and to provide harmony in colour and effect. Different coloured glasses enabled the tourist to control nature to an astonishing degree without any previous knowledge of composition. Gilpin warned, however, that 'In general, I am apt to believe, that the merit of this kind of modified vision consists chiefly in its novelty; and that nature has given us a better apparatus, for viewing objects in a picturesque light; than any, the optician can furnish.'[44]

Drawing Masters, Mistresses and Ministers

In 1965 Benedict Nicolson wrote: 'It was the habit in the last decades of the eighteenth century for clergymen to practise drawing from nature.'[45] There has certainly been a tendency, when discussing the work of a late eighteenth-century amateur such as Gilpin or his friend the Revd Thomas Gisborne (cat. 139), to regard their practice of making watercolours as a pleasant way for a country curate with no financial respon-sibilities to fill his unoccupied time. Several other clergymen who were amateur artists have also been mentioned in this category – William Bree, William Henry Barnard, Daniel Finch, James Bourne and John Gardnor.[46] In most of these cases, however, what might at first seem to justify discussing

them as a particular category of amateur could be found to be an erroneous way of regarding them, their work and why they practised it. The examinations of William Mason and William Gilpin (cats 96 and 111) have already indicated how these two clergymen/amateurs do not fit into such a categorization, and Thomas Gisborne is another case in point.

The following description of Gisborne's own study suggests that drawing was merely one of the many activities in which he engaged, and that 'recreation' and 'pastime' are not really the appropriate words to describe them:

a chamber…where books and manuscripts, plants and pallets, tools and philosophical instruments, birds perched on the shoulder, or nestling in the bosom of the student, or birds curiously stuffed by his own hands, usurped the places usually assigned to the works of the upholsterer.[47]

Although he did not hold public office or a position at court like the seventeenth-century *virtuosi*, Gisborne was one of the last of this type of English gentleman, content to live quietly on an inherited income and to pursue a wide range of interests, all of them of potential benefit to his country. These included natural history and the conservation of natural English flora and fauna, as well as classical, artistic and literary pursuits, but particularly the education and the moral well-being of his fellow countrymen and women. His volume of blank verse, *Walks in a Forest* (1794), dedicated to William Mason, does not merely describe Needwood Forest at different times of the day in different seasons, but, like his friend Erasmus Darwin's poem *The Botanic Garden* (1789, 1792) and Mason's own *English Garden* (1778–81), it also drew analogies between the harmony of nature and a divinely ordered human society. Its purpose, stated in the preface, was 'to inculcate, on every fit occasion, those moral truths, which contemplation of the works of God in the natural world suggests, and that reverence and love for the great Creator which it is adapted to inspire'.[48] Gisborne had earlier published a pamphlet on the abolition of the slave trade,[49] and he evoked its horrors again in the poem. He also possessed one of Wright of Derby's paintings of Vesuvius and had a keen interest in volcanoes, quoting from Hamilton's reports of the eruptions of both Vesuvius and Mount Etna in his poem, where his interests in geology and subterranean fires were reconciled with accepted theological beliefs in the Creation and the Creator.[50]

Long disguised for modern readers familiar with Gisborne's friendship with Gilpin as a journey through the picturesque, *Walks in a Forest*, a moralizing tome, had been preceded by one that was more overtly didactic, entitled *An Enquiry into the Duties of Man in the Higher and Middle Classes of Society in Great Britain* (1794). This was followed by *An Enquiry into the Duties of the Female Sex* (1796). In *Walks in a Forest* the forest was an analogy for a divinely ordered human society in which the harmonious though dissimilar elements 'all conspire to swell the sum of general bliss'; Gisborne's *Enquiries* advocated a moral reform of all levels of British society, which in fact served to reaffirm existing hierarchies of class and gender.[51] Reinforcing the ideals of his friends and fellow reformers Hannah More and William

Wilberforce, both volumes were widely read. Gisborne was patently no mere clergyman/amateur living quietly in the country pursuing painting as a pastime: landscape for him was part of his wider interests – another, if more pleasantly aesthetic, window on to a world of moral, social and national obligations and duties.

Like ministers who drew, drawing masters and, even less-studied, drawing mistresses of the eighteenth-century have been the subject of many misconceptions and misunderstandings, not least by their fellow artists and even their pupils.[52] When Lady Amabel Polwarth's sister Lady Mary Grantham was visiting neighbours near Newby, she sent her mother an account of one of the better-known women who earned their livings in this way:

Miss Black, the Drawings Mistress, who was come down to instruct Mrs W[eddell] in Oil painting which she has lately begun, having drawn before in Chalks & I should think well, by some heads I saw her doing: Miss Black having none of her own performances with her, I could not judge of her merit in that way, but her appearance & manner did not strike me as it was much more familiar & on equality than I think those sort of people should be allowed. she talked of Miss Egerton's paintings & indeed seemed to know the world.[53]

Mary Black, the daughter of a drapery painter, was a portraitist in oils and then pastels who gave lessons to earn additional income. Her pupils included the royal family, but her personal reputation and character rather than her skill dominated contemporary descriptions of her almost from her first commission in 1764 when her sitter, Thomas Monsey, was 'sorry to find Miss Black is grown so saucy, as it will only embarass, or stop the progress of her reputation and improvement...'.[54] Being judged on the basis, first, of being female, then by her character and social situation, before finally and condescendingly by her skill as an artist, was a fate Mary Black shared with all her fellow drawing mistresses, including Mary Smirke (cat. 147).

Lady Mary Grantham's encounter with Mary Black was after 1777, when she had inherited her father's equipment, kept her own servants and carriage and went 'about much in society', which she undoubtedly felt placed her, like Reynolds or Kauffman, on a level with her clients, although they clearly did not reciprocate this view. When successful artists such as Reynolds and Angelica Kauffman were cultivating the personas, cultural accomplishments and accoutrements of gentlemen or ladies in order to be accepted into 'polite society', despite their statuses as professional artists who laboured for their incomes, drawing mistresses and masters, no matter how often they exhibited with fellow professionals, suffered from their associations with amateurs as their tutors, and were looked upon as servants.

From the second half of the eighteenth century, Britain's prosperous mercantile economy, with many first- and second-generation families of wealth outside London, provided a means of income for drawing masters in centres other than such traditional ones as Bath and the university towns. The populations of Birmingham, Leeds, Norwich, Bristol and many other towns, were served by drawing masters whose reputations seem to have

suffered from having given up their aspirations to greatness in London. This is illustrated by Sir George Gilbert Scott's recollections that as a child in the 1810s, he had enjoyed visits from a 'Mr Jones of Buckingham', who had been a student at the Royal Academy, '& much noticed by Sir Joshua Reynolds ... Foolishly, however, he returned to his native town, and had consequently failed of reaching the eminence for which nature had fitted him. He supported himself as a drawing-master and occasional portrait painter.'[55]

By the early nineteenth century, as we have seen, the reputations of Gainsborough, Cozens and others had suffered through their association with amateurs, and even with 'the picturesque' (Chapter 5). The history of the concomitant fall into disrepute of drawing masters and amateurs is documented elsewhere,[56] but it is worth recalling here that Francis Towne (cat. 135) took care to exhibit only oil paintings, to live principally in London and to only 'visit' Exeter in order to avoid the appellation of 'provincial drawing master'. Similarly, when Constable was offered a lucrative position as drawing master to a military academy in 1802, he turned it down, perceiving that it would be 'a death blow to all my prospects of perfection in the Art I love'.[57]

NOTES

1 Our expectations arise from a spate of recent literature on the Grand Tour including: Jeremy Black, *The British Abroad*, Stroud 1992, and *The Grand Tour in the Eighteenth Century*, New York 1992; Jenkins and Sloan; Bignamini and Wilton; Ingamells; and French 2000.

2 Buckinghamshire Record Office, Lee of Hartwell Papers, E.2.16.

3 Ingamells, 704–5, and M.J. McCarthy, 'Sir Roger Newdigate and John Breval: drawings of the grand tour', *Apollo*, (August 1992), 100–4. Newdigate was an instrumental figure in the eighteenth-century Gothic Revival, a benefactor of Oxford, and early patron of Piranesi. His drawings remain in the hands of his descendants.

4 See Ingamells, *sub* Parker and Newdigate.

5 Warwickshire Record Office, Newdigate Papers, CR 136/B 2105 (Charles Parker to Sir Roger Newdigate from Rome 18 Feb. 1784), from photocopies provided by Michael McCarthy in the Brinsley Ford Archive, PMC.

6 Taken from the lines of a poem by Joseph Addison, 1701. For a brief introduction to this way of seeing Italy, see Peter Nisbet's essay, '"Poetick Fields": The Grand Tourists' view of Italy in the eighteenth century', in Duncan Bull, *Classic Ground: British Artists and the Landscape of Italy 1740–1830*, exh. YCBA, 1981, 10–16.

7 Henry Swinburne, *The Courts of Europe* I, 1841, p. 144.

8 See n.1 above, especially Ingamells and the most extensive and up-to-date bibliography in Bignamini and Wilton.

9 See Errington and Holloway for Scotland; Andrews for the picturesque tour; Ian Ousby, *The Englishman's England: Taste, Travel, and the Rise of Tourism*, Cambridge 1990; and most recently, Marcia Pointon, 'Abundant Leisure and Extensive Knowledge: Dorothy Richardson Delineates', chap. 3 in Pointon 1997, especially 104, and Chloe Chard, *Pleasure and Guilt in the Grand Tour: Travel writing and imaginative geography 1600–1830*, Manchester 1999.

10 For example, an album of sixty atmospheric watercolour landscapes dated 1791–4 mainly of the area around Turin by the English

envoy Thomas Jackson (1758–1829), son of Gainsborough's friend William Jackson, gradually lost pages of drawings as it passed through the hands of several dealers over three decades before finally being sold at Christie's, 19 July 1988.

11 Preface to BL MSS Stowe 791.

12 Ingamells, 1037.

13 Quoted in ibid. The original manuscript with Young's own and Brown's illustrations remained in his family's hands, but the copy he presented to the Marquis of Buckingham in 1787 is now in the British Library (Stowe 791), accompanied by several pen and ink sketches and watercolour drawings of antiquities in Sicily, as well as an 'essay relative to Posidonia, the remains of which are yet visible in the Gulf of Salerno', illustrated with seven watercolours.

14 See Jenkins and Sloan, 41–5, 66–8, 165–70.

15 Most of these watercolours came to the BM as part of Payne Knight's bequest.

16 Stumpf, 12, 15–18.

17 See Jenkins and Sloan, 149–55.

18 A. W. Thibaudeau, *The Hamilton and Nelson Papers* (from the A. Morrison collection) I, (1893–4), no. 102. In 1798, the Earl of Bristol wrote to Hamilton of his own attempt to collect works by 'that old pedantry of painting which seemed to show the progress of art at its resurrection' (quoted in Francis Haskell, *Rediscoveries in Art*, Oxford 1976, 108).

19 Townley MSS, BM Archives, letter of 2 November.

20 Christie's, 31 March 1810, quotation conflated from I, 5.

21 Beginning with *The Italian School of Design* in 1808.

22 Quoted in J. A. Gere, 'William Young Ottley as a collector of drawings', *British Museum Quarterly* (1953), 44–53.

23 His collection is listed in E. K. Waterhouse, 'Some notes on William Young Ottley's collection of Italian primitives', *Italian Studies* (1962), 272–80.

24 *A Series of Plates Engraved After the Paintings and Sculptures of the Most Eminent Masters of the Early Florentine School.*

25 See Griffiths 1996, 93–6, 99–100, and David Rogers's entry on Ottley in Turner, 634.

26 See Piggott, 124–9, and especially Sam Smiles's excellent study, *The Image of Antiquity*, and David Haydock, "A small journey into the country": William Stukeley and the formal landscapes of Stonehenge and Avebury', in Myrone and Peltz, 67–82.

27 See Piggott, 177–9, 187–8, and Smiles, chaps 5 and 9.

28 Smiles, 197–200.

29 Piggott, 142, 149, and Ray Desmond, *Kew, The History of the Royal Botanic Gardens*, 1995, pp. 11ff.

30 *Wal. Corr.*, XXXIX, 460.

31 John Cornforth, 'Swinton-Yorkshire-III: The home of the Earl and Countess of Swinton', *Country Life* (21 April 1966), 944–8.

32 Edward King, retiring president of the Society of Antiquaries, 1784, quoted on p. 84 of Stephen Bending, 'The true rust of the Barons' Wars: gardens, ruins and the national landscape', in Myrone and Peltz, 83–93.

33 See Clarke, 33–5 in chap. 2, 'Travellers at Home', and Parris, 124; for an extensive discussion of the history of these aids, see Kemp, 190–9, and John Hammond, *The Camera Obscura: a Chronicle*, Bristol 1981.

34 YCBA, reproduced on cover of Rosenthal, Payne and Wilcox and 286.

35 Hammond (n. 33 above), 22–3.

36 Ibid., 43–79, Parris, 124, and Kemp, 196–9.

37 See Ford (literature in cat. 63), and for Brown, see Ingamells, 137.

38 For Downman, see Williams, fig. 143.

39 For Lusieri, see Jenkins and Sloan, 112–14 and Carlo Knight, 'Lusieri, Hamilton and the Palazzo Sessa', *Burlington Magazine* CXXXV (August 1993), 536–8.

40 Wilton, 21; the sale after his death included a Claude glass.

41 Bedfordshire RO, Lucas (Wrest Park) papers, L30/9/60/4: Taymouth, September 1772.

42 Kemp, 199. For a recent discussion, of its history, use and the different varieties of mirrors and glasses, see Arnauld Maillet, *Miroir de Claude: l'Art de L'Enfance*, Marcellaz-Albanais 1999.

43 See Parris, 124, and Andrews, 67–73.

44 Quoted in Andrews, 69.

45 Benedict Nicolson, 'Thomas Gisborne and Wright of Derby', *Burlington Magazine* CVII, no. 743 (February 1965), 58–62, on 60.

46 Williams, 230–48; see Mallalieu for brief information on each.

47 Sir James Stephen, in *Essays in Ecclestiastical Biography* II, 1849, 305, quoted in Egerton, Wright of Derby, exh. Tate, 1990, 224.

48 4th edn. 1799, v, vi.

49 *Remarks on the Decision of the House of Commons on 2 April 1792, respecting the Abolition of the Slave Trade* (1792).

50 Egerton, 225–6.

51 *Forest*, 10, and for *Enquiries*, see Kriz, 151, no. 49.

52 See the chapter on drawing masters by Fleming-Williams in Hardie III, Clarke, chaps 5 and 6, and Sloan, 1982.

53 Bedfordshire RO, Lucas (Wrest Park) Papers, L30/9/81/6, 29 September, 1780: Miss Egerton was related to both the family at Wrest Park and to Amelia Hume, later Long (see cats 31, 110).

54 Frances Harris, 'Mary Black and the portrait of Dr Monsey', *Burlington Magazine* CXXXV (August 1993), 534–6.

55 G. Gilbert Scott, ed., *Personal and Professional Recollections by the late Sir George Gilbert Scott*, 1879, 24–5.

56 See essay by Greg Smith, in Fenwick and Smith, and Smith 2001

57 Fleming-Williams, in Hardie III, 218.

122

THE REVD CHARLES CORDINER
(?1746–94)

122

An album of watercolours including a group for 'Antiquities and Scenery of the North of Scotland, in a series of Letters to Thomas Pennant' (London, 1780)

Open to: *A Briton mourning over a Cromlech in sight of the Eifl Hills above Clynnog*

Watercolour over pencil sketch, on card, 84 × 135 mm; mounted on album leaf

Inscribed on verso as in title above, and *14*

Provenance: Purchased from Appleby Brothers

1943-7-7-1 to 133(13)

The Revd Charles Cordiner became the episcopalian minister of St Andrew's Chapel, Banff, in 1769. His name does not appear in Mallalieu, and if he is known in British art, it is mainly as the supplier to Pennant (see cat. 87) of numerous drawings made in the north-east for Pennant's published tour of Scotland, as well as his *Arctic Zoology*. His view of Duff House was engraved by Sandby for the *Virtuosi Museum* (1778–9, pl. 66). Cordiner himself, however, was the heir of Stukeley's Roman Knights (cat. 85), an antiquarian who employed Druids and Scotland's own ancient bard Ossian as symbols of Scotland's ancient poetry and heritage. They ran as heroes and leitmotifs through the landscapes and views of Scottish antiquities in his own publications: *Antiquities and Scenery of the North*

of Scotland, in a series of Letters to Thomas Pennant* (London 1780) and *Remarkable Ruins and Romantic Prospects of North Britain, with Ancient Monuments and singular subjects of Natural History* (2 vols, published in parts, London 1788–95, engravings by Peter Mazell). Not only did he supply other antiquarians with views, but they in turn sent some to him: several by Moses Griffith and others, and one by Mary Delany, are included in the album, along with a series of letters to Cordiner from fellow antiquaries and copies of his replies.

The ancient Caledonian epics, *The Works of Ossian*, which James MacPherson claimed to have translated, aroused a tremor of excitement throughout Britain from the 1760s onwards; surprisingly, they did not inspire many professional Scottish artists, but they clearly formed an undercurrent in the approach to the antiquarian interests of Scots such as John Clerk (cat. 94) and the Revd Charles Cordiner. Debate raged over whether the poems were genuine or fakes, but Stukeley wrote publicly to MacPherson, congratulating him on his further publications of *Fingal* and *Temora*. The truth was probably that they were a combination of both, but for the Scots their veracity became almost a patriotic cause. John Clerk found it difficult to reconcile the sense of pride in Scotland's beauty and heritage that the poems aroused in him with his encouragement, as an enlightened Scot, of the attempt to improve the country's culture and language, among other things, through support for the Act of Union. His confusion was reflected in the paintings of the poems

his brother Sir James Clerk commissioned for Penicuik in which the heroes were divorced, as indeed they are in the poems, from their native landscape. The antiquary in Cordiner caused him similar doubts: Walpole noted that in his text Cordiner had queried Fingal's possession of armour and swords of steel when the material was not yet known in Scotland (*Wal. Corr.*, XXIX, 37). Nevertheless, Cordiner embraced Ossian and the image of the bard as the source of Scottish culture, along with the Druids as the seat of ancient philosophy and learning, and he had no compunctions about placing their figures in real landscapes. In his view of a cascade near Carrol, Sutherland, for example, a bard with his harp fills the lower right corner, accompanied by the text: 'Here, perhaps, has Carril, whose name is still preserved in these scenes, nursed his wild and desultory strains: here, "amidst the voices of rocks, and bright tumblings of waters, he might pour the sound of his trembling harp"' (*Temora*, Book VI). Similarly in the present view of a cromlech, an ancient 'Briton' laments his loss in the mountains of Wales, a bard's harp leaning against the cromlech on the right.

This watercolour and a number of others in the album were not intended for Cordiner's works on Scotland and were never published. In 1791 he sent a pair of views of the cliffs and caves on the coast of Moray to the Society of Artists as an honorary exhibitor, and the following year sent a framed group of six drawings of marine animals and several other views of waterfalls and lochs. This presumably served as publicity for Cordiner's second publication, which he had originally advertised in the *Scots Magazine* (LVI, 735). He died shortly afterwards, in November 1794, at the age of forty-eight, just before the final part was published.

Literature: Errington and Holloway, 59–61, nos 6.4, 6.15; Smiles, 42, 62–75.

123(a)

123(b)

ROBERT ADAM (1728–92) and GEORGE KEATE (1729–97)

123

An album: Views Of several places and of Several peices of Antiquity In different parts of France, Italy and Savoy Switzerland Taken in a Tour made thro' those Countries In the years 1754, 1755, and 1756. Together with some Sketches of The Antiquities of Pola … by George Keate, 1754–6

(a) *Title page*

(b) *Note to the reader*
Pen, ink and wash drawings with decorated borders, by Adam, 440×315 mm
Inscribed in image
LB I (2) (1)

(c) *Different Head dresses worn by the Swiss Women in the small cantons of Lucerne and Shaffhausen, 1756*

(d) *Decorative tailpiece with Author's acknowledgment to his implements, 1756*

Pen, ink and wash drawings with decorated borders, by Keate, 145×260 mm, 180×230 mm

Inscribed with title and in image and numbered *211* and *231*

LB I (113) (122b)

Provenance: John Henderson, by whom bequeathed

1878-2-9-106, 107, 318, 336 (201.c.4)

This album has been exhibited many times in the last few years, always open to *A Manner of Passing Mt Cenis*, a striking image of Keate being transported over the Alps in an open chair carried by two bearers. Because he was an amateur, the rest of his drawings in the album have been dismissed as 'pedestrian', and the exhibitions have paid little attention to the man himself or his place in British society and culture, which was not an insignificant one.

Keate was the heir of George Keate of Isleworth and a descendant of Catherine Seymour, sister of Lady Jane Grey. He was called to the Bar in 1753 but never practised. He made his grand tour, which the drawings in this album illustrate, from 1754 to 1756, and afterwards settled for some time in Geneva where he became an intimate of Voltaire. A miscellaneous writer who, like many gentlemen 'wrote for pleasure, not for profit' (*DNB*), he began to publish in 1760, with a poem on ancient and modern Rome written in that city in 1755, and followed the next year by a history of Geneva. He knew most of the artists and writers in London, and in 1760 commissioned for Sir Adam Fergusson, whom he had met on the Grand Tour, a painting by Francesco Zuccarelli of *Et in Arcadia ego*, which he later celebrated in a dramatic poem, *The Monument in Arcadia* (1773).

Keate was also an antiquarian and natural historian: his *Account of the Pelew Islands* of 1787 was reprinted and translated often, and his private museum, which Mrs

Different Head dresses worn by the SWISS Women in the small Cantons of LUCERNE and SHAFFHAUSEN. 1756.

123(c)

THE AUTHOR
OF THESE DRAWINGS
ACKNOWLEDGING THE
ASSISTANCE OF THE
LITTLE IMPLEMENTS
HERE DELINEATED

INSCRIBES THIS LAST
TO THEIR MEMORY.

123(d)

the antiquities of Pola indicate Keate's own interest in classical antiquities. A portrait of Baron Stosch, one of the greatest coin and gem collectors of the age, is also in the album, along with several costume studies and views of religious customs; but it mainly contains small landscapes, views with or without ruins or buildings, arranged in ten 'classes', in chronological order. The drawing of Mont Cénis is unusually large compared to the rest of the drawings, most of which are small, fairly detailed landscapes in a rather stippled style very reminiscent of the works of the Lens family, but also of the watercolours produced by Sir Roger Newdigate and Henry Swinburne on their travels (see cat. 131). The final drawing, illustrated here (d), is typical of these works and strongly reinforces Keate's statement that this collection was 'begun by accident, and compleated without any knowledge of the rules of the art'. Nevertheless, he continued to draw and learned to paint in watercolours on his return to England, exhibiting six pictures at the Society of Artists and thirty at the Royal Academy between 1766 and 1789. His daughter Georgiana (1770–1850) was also an amateur and married John Henderson (cat. 154) in 1796. It was their son who bequeathed to the Museum not only this album but the many works by his father and various members of the Monro school with whom he studied.

Literature: K. G. Dapp, *George Keate Esq.: An eighteenth-century English gentleman*, Philadelphia 1939; *DNB*; Ingamells; Clive Wainwright, 'The "Distressed Poet" and his architect', *Apollo* CXLIII (January 1996), 39–43.

JOHN SKIPPE (1743–1812)

124

Album of studies after frescoes by Mantegna in the Eremitani Chapel and Giotto in the Arena Chapel, Padua
1773
Open to *The Lamentation*, after Giotto

Brown wash and pen heightened with white bodycolour, on blue paper, 201 × 305 mm; mounted on album leaf with ink wash border, 345 × 455 mm

LB 1

Provenance: Purchased from Dr Granville

1859-12-10-941 to 972 (open to 971, f. 31) (198.c.13)

Delany recorded seeing in 1779, included shells, minerals, gems, insects and coins. The sale of its contents lasted for eleven days (King's, 5–16 April 1802), the coins for two (Sotheby's, 14–15 January 1801) and his library three (King's, 23–5 June 1800). It was housed in his home in the present Bloomsbury Street, off Bedford Square, in an octagonal room designed for him by Robert Adam in 1777. Adam also designed the furniture, but the 'Etruscan' ceiling collapsed and Keate sued Adam, losing the case in 1786. When the museum was sold in

1802, *The Times* lamented that although it would 'enrich the cabinets of the first collectors of Europe, it certainly ought to have become a national purchase' (quoted in Wainwright, p. 43).

The drawings in the present album reflect Keate's many interests. The album is beautifully and expensively bound, with a frontispiece and title-page drawn by Robert Adam, whom he had met in Rome in 1755. They are similar to but pre-date the architect's drawings for his publication on *Spalatro* (1764), and the inclusion of views of

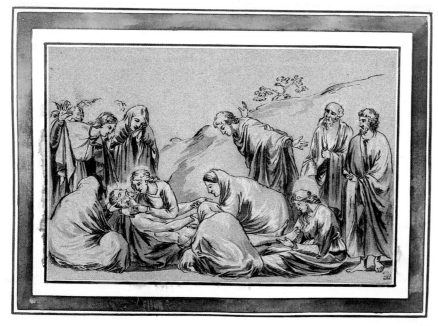

124

A Latin inscription in a cartouche on the title-page explains that the album contains twenty-eight drawings of Sts James and Christopher after Mantegna's paintings of 1444 in the church of the Augustinian fathers at Padua. The last three drawings in the album were added after the title-page had been written: a portrait of Giotto in a decorated frame, the present study of the lower part of Giotto's *Lamentation* and a study of the whole composition of Mantegna's *Trial of St James*. They are mannered simplifications of the original paintings, focusing on the outlines of the figures, the chiaroscuro and the composition, with no attempt to record the colours of the originals.

Skippe came from an old-established family at Upper Hall in Ledbury, Hertfordshire, and went up to Merton College, Oxford, in 1760. Malchair (cat.115) had arrived in the city only shortly before and Skippe was one of his first pupils. The novice drawing master set his pupil to copying prints after the Carracci and these first lessons seem to have given Skippe a taste for Bolognese drawings, paintings and prints, which he not only followed up by collecting on his grand tour, but also by making his own drawings in this manner long after his return: the mount on one is inscribed: *Designs by John Skippe, in the composing of hundreds of which he amused himself in his winter nights* (Fleming-Williams, in Hardie III, 264). Malchair's drawings

record a visit to Upper Hall in 1760, and Skippe probably continued his lessons through his time at Merton. He made his first visit to Italy in 1766–7, and renewed his contact with Malchair on his return, touring the West Country with him in 1768. Malchair visited him at Ledbury in 1772 on the eve of Skippe's departure for his second tour, to Italy and Egypt, from which he did not return until 1778, when he settled at Overbury. Their correspondence and visits continued through the 1780s.

Skippe's interest in Mantegna was unusual for the time; it should not be seen, however, as a forerunner of the taste for Italian 'primitives' demonstrated by William Young Ottley (cat. 162), but rather as an antiquarian interest, an aspect of his work not previously commented upon. It is also indicated by his surviving drawings of Alexandria and Egypt (private collection). Skippe's well-known collection of old master drawings was arranged by him in two albums in such a way as to provide an illustrated history of art, although his attributions were much derided by recent cataloguers (dispersed Christie's, 20–1 November 1958).

A dispute with his family, which had resulted in the move to Overbury, must have led to a shortage of funds, as Skippe tried to sell his collection of old masters at Christie's in 1779, apparently without much success. In a more unusual attempt to gain public notice (and presumably

income), from 1781 to 1783 he made a series of forty chiaroscuro woodcuts after his old master drawings, probably in imitation of J. B. Jackson's woodcuts of three decades earlier. Jackson had considered the technique to be more effective than the 'little Exactness' of engraving on copper for conveying the qualities of freedom, boldness and spirit found in drawings. But the technique was already more of interest to print historians than the general print buying public who perceived it as 'archaic' and associated it with the beginnings of printmaking. Jackson failed to make a financial success of his own series, and Skippe seems to have been his only follower.

Many of Skippe's notebooks and letters survive, including notes from various artists of their recipes for painting and a manuscript list of 'Pictures painted at Ledbury & elsewhere', which gives the titles of portraits and history paintings Skippe executed and presented to friends. These included a classical composition presented to Malchair in 1784 and another to Reynolds the following year, as well as the *Baptism of our Saviour … in a landscape* presented to the Revd Cracherode in 1780, with whom Skippe had corresponded about printmaking techniques, and a portrait of Miss Price sent to Foxley (cat. 117)

Literature: Fleming-Williams, in Hardie III, 264; Harrison, 14, 17–19, 30–1, 71; Brenda Rix, *John Baptist Jackson, the Venetian Set*, exh. Art Gallery of Ontario, Toronto, 1983–4, n. p.; notes on Skippe's papers in the Brinsley Ford Archive, PMC.

JOHN ROBERT COZENS (1752–97)

125
Lake of Lucerne

Pen and ink and watercolour over pencil sketch, 234×355 mm

Inscribed on verso: *Lake of Lucerne* and *No. 19*

B&G 33

Provenance: ?Richard Payne Knight; John Towneley, sale 1–15 May 1816 (394), bt Woodburn (15 *g.*); Molteno (dealer), from whom purchased by Hon. Rowland Allison-Winn (in album of fifty-six drawings), from whom purchased by the Museum

1900-4-11-27

The young connoisseur Richard Payne Knight arrived in Italy in November 1776 after a tour through the Alps with John

Robert Cozens, who had been commissioned to record their travels. The album of Swiss drawings made on this journey, broken up by Allison-Winn in the late nineteenth century, was said to have come from Payne Knight's collection, and they have always been known as the Payne Knight series. But it has never been firmly established that these drawings ever belonged to Payne Knight, and they certainly did not, as has often been stated, come to the Museum with Payne Knight's bequest. The Museum purchased the remaining drawings from the album (1900-4-11-9 to 32) from Allison-Winn in 1900. This series of pen and ink sketches with pale grey, brown and blue washes has been credited with a tremendous influence upon the development of the 'national' school of British watercolour painting, but it is a reputation that also bears closer examination. The main argument put forward for their influence is that Turner and Girtin were employed in the 1790s to copy them and other watercolours by Cozens for Dr Monro, who had access to these works while Cozens was under

his care at Bethlem Hospital. The facts, however, are more complicated than this simple explanation, as many of the works Turner and Girtin are said to have copied belonged neither to Cozens nor Monro at the time, but to patrons such as Payne Knight, William Beckford and George Beaumont. Certainly, Monro may have borrowed a number of works or even albums from these men, but it is more likely that Turner and Girtin were actually copying Cozens's now lost original sketches for Payne Knight's set. Significant differences in details of composition and colouring between the 'Payne Knight' versions in the British Museum and the Monro school copies seem to underline this possibility; indeed, when Cozens travelled with Beckford in 1782, he filled seven sketchbooks with pencil and wash sketches that were the basis for the ninety larger finished watercolours he later painted for Beckford. The dates and subjects recorded in the seven sketchbooks (now in the Whitworth Art Gallery) make it clear that a number of other drawings are also now missing.

John Robert's father Alexander was a prolific teacher, but he himself had no documented pupils. Thomas Sunderland has been described as one but there is no concrete evidence (see cat. 146). Charles Gore's daugher Eliza produced watercolour sketches during her lessons with Philipp Hackert in Rome, when various artists, possibly including William Pars, Cozens, and her father, sketched in the evenings at the German artist's home. One of Eliza's drawings of cedars has been published as evidence of Cozens's tutelage because it so closely resembles one of his own compositions. However, it rather underlines the point that searching for stylistic influences as evidence of lessons is to misunderstand the eclectic approach of such amateurs, who took part in an exchange amounting to the absorption of a *zeitgeist* and a way of seeing, in much the same way as professional artists.

Literature: Oppé 1952, 127; Mallalieu, 130–3; Sloan 1986, *Cozens*, 113–25; Sloan 1995, 90–1.

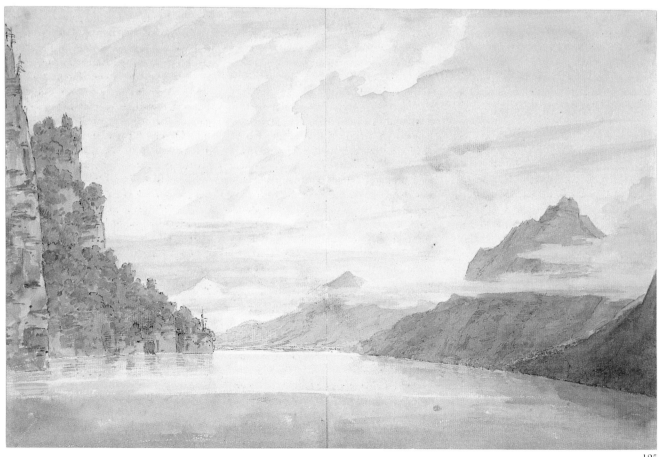

125

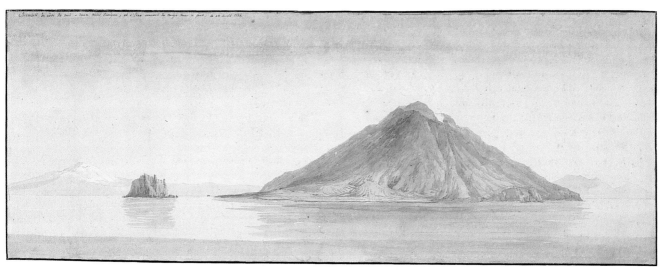

126

CHARLES GORE (1729–1807)

126

View of Stromboli from the north with snow-covered Etna in the distance, 1777

Watercolour and white bodycolour over pencil, 175×462 mm; mounted on separate sheet with black ink border, 215×500 mm

Inscribed by J. P. Hackert: *Stromboli du côte du nord à deux miles eloigne, et l'Etna couvert du neige dans le fond. Le 23 Avril 1777*

Provenance: ? Richard Payne Knight; Folio Society (as French School, stock no. D3069); Andrew Skirving of Bonfiglioli Gallery; Alan D. Guest, from whom purchased

1994-5-14-2

When Charles Gore, Richard Payne Knight and Philipp Hackert left Naples for Sicily on 12 April 1777, they planned to stop and visit Paestum and the volcanic Lipari Islands *en route*. Payne Knight and Hackert both knew Sir William Hamilton, the British envoy to the Kingdom of Naples and the Two Sicilies, who was, however, visiting England when they were in Naples. Hamilton had employed Hackert to make drawings of *montagnuoli* thrown up by Vesuvius as early as 1770. Hamilton's lavishly illustrated *Campi Phlegraei*, a close study of the volcanic area around Naples, had been published in 1776, less than a year before they set off on their trip to Sicily, and he had already established a reputation as a modern Pliny whose careful observations might help to reveal the ancient history of the earth. Even in Hamilton's absence, the three men would undoubtedly have

had access to or already have known the images of volcanoes that lined the walls of his residence, the Palazzo Sessa, particularly the views of the volcanoes of the Lipari Islands and Sicily that Pietro Fabris (*fl.* 1756–84) had drawn when he accompanied Hamilton in his examination of the area in 1768. A guided ascent of Vesuvius and a collection of volcanic minerals were standard elements of any visit to Naples, and Payne Knight is known to have partaken of both.

Payne Knight and Gore saw their expedition as a scholarly investigation of ancient history and modern manners, and they intended to publish their findings as an illustrated diary written by Payne Knight. Paestum would provide them with an introduction to the massive Doric architecture that was evidence of the ancient culture they would find in Sicily, and the Lipari Islands provided the perfect introduction to a chain of volcanoes that ended with Mount Etna. Payne Knight sought to learn moral lessons from history, and volcanoes not only provided some of the most sublime visions in nature, including an opportunity literally to look into the mouth of hell, but from ancient times had been thought to be part of God's punishment of sinful mankind. Hamilton's and other recent studies had indicated that they also provided an opportunity to understand how the earth was actually formed.

Charles Gore already had more experience of marine views than Hackert (see cat. 79), and his two views of the islands are among the few in the Payne Knight series at the British Museum that were not worked

up into finished drawings by Hackert, Cozens or Hearne. There are twelve more views of the islands among the Gore drawings at Weimar, which show how carefully prepared were the two final versions in the Payne Knight bequest. They were inscribed by Hackert in French as in the present drawing, which is of the same quality as the other two; in fact, it is the nearest to Stromboli and most clearly shows the shape and nature of the volcano. But Stromboli was the only active volcano in the chain apart from Etna, and this view may have been rejected by Payne Knight because, unlike the other two, it does not show smoke coming from the summit, which he had made a point of describing in his text. In addition, his commentary mentions that Mount Etna was not visible, due to certain atmospheric effects; it is, however, seen clearly on the left of this view. Payne Knight wanted to land on the island and examine the crater, but was prevented by an ordinance from the King of Naples that visitors submit to a period of quarantine before landing.

Literature: Stumpf, 30–1; Jenkins and Sloan, 65, 165–8.

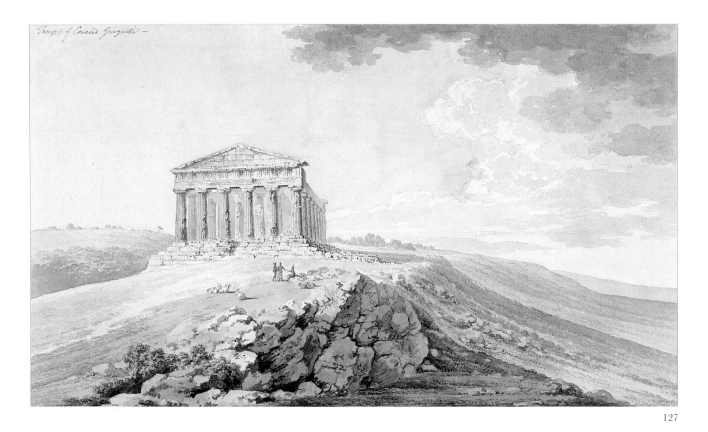

127

127

The Temple of Concord at Agrigentum, 1777

Watercolour and bodycolour over pencil, 248 × 434 mm

Inscribed: *Temple of Concord Girgenti -*

LB 9

Provenance: Bequeathed by Richard Payne Knight

Oo.4-26

The thirty-nine works in the British Museum that were Payne Knight's collection from the expedition to Sicily include Hearne's watercolours worked up in England from those that Payne Knight had brought back. Gore's drawings include loosely washed sketches from nature in blue and grey and in Hackert's favourite brown washes, but most of the drawings were detailed and highly finished in watercolour with bodycolour, as here. Both techniques were in use by English and German artists. Unfortunately, the white bodycolour in the sky oxidized, and in many recent publications has given a false impression of a dark stormy sky; the oxidization has now, however, been reversed and the effect is closer to Gore's original intention.

Like many Englishmen who intended to publish their tours, Payne Knight was keen to describe the current manners and morals of the inhabitants as a reflection of ancient customs, but also in order to point out lessons that might be learned from past history. Agrigentum, for example, was said to have been the largest city in Sicily in ancient times, with slaves swelling the number of inhabitants, who were famed for their luxury and refinement, which 'soon proved their destruction'. They fell to the Carthaginians under whom the city 'regained its liberty but never again its ancient Splendor'. In the eighteenth century Payne Knight pointed out that the Catholic Church was responsible for the modern city of Agrigento's poverty; further, the pride the inhabitants took in continuing the reputation for hospitality of their ancient forebears merely rendered them 'busy & inquisitive, & thro' a want of education, they become rude and impertinent'.

Although Payne Knight's manuscript was completed and most of the drawings taken to a sufficient stage to serve as the basis for illustrations, he never published it. Claudia Stumpf has speculated that this may have been because a number of other publications on Sicily, by Vivant Denon,

Jean Houel, Swinburne and the Prince of Biscari had appeared in the meantime. However, the last section of the manuscript, which dealt with the customs and problems of the present inhabitants of the island, was highly critical of Christianity and advocated no less than a general revolution in Europe to effect a return to its ancient pure state. Anxious to establish a reputation as a scholar and connoisseur, Payne Knight may have feared, in the period between 1777 and 1783, during the American War of Independence, that the manuscript might instead gain him too public a reputation as a rebel. In 1780 he was returned as a Whig member of parliament, and in 1781 he and Gore were elected to the Society of Dilettanti. In the following decades, however, he was less circumspect about what he published, and frequently came under criticism for the signs of 'Jacobinism' detected in his work.

Literature: Penny and Clarke, 20–31, nos 97–113; Stumpf, *passim*; Sloan 1986, *Cozens,* 113–25.

128

Temple said to be of Juno Lacinia at Agrigentum

Watercolour over pencil, 226 × 421 mm

LB 7

Provenance: Bequeathed by Richard Payne Knight

Oo.4-31

The serious intentions of the expedition to record unusual ancient remains and natural occurrences was evident in the careful measurements recorded in Payne Knight's written account. Like earlier antiquarians in Britain, he was anxious to record his expedition's findings for posterity, but although the drawings are in perspective and drawn to scale, there is no evidence of measurements on those now in the British Museum. C. F. Bell's recently discovered notes on the Gore drawings at Weimar indicate that there were measurements on some of his drawings of Segesta and Seliunte, which were clearly left out of the finished watercolours. The largest temples were at Segesta, and a few measurements are mentioned in the text, but the majority of such details are provided in the descriptions of the temples near modern Agrigento. There were remains of about fourteen temples on the citadel of the ancient city,

now planted with Olives & other trees, interspersed with Ruins, of which here are in greater quantities & better preserved than any where else in Sicily … The present appearance of the Temple of Juno is the most pictoresque that can be imagined. It is situated upon a small Hill cover'd with trees, among which lie the broken Columns etc. that have fallen down.

In keeping with their desire to make accurate visual records, Gore employed a camera obscura; many of his drawings in the collection at Weimar, particularly panoramic views of coastlines, harbours and ships, are inscribed with notes indicating the use of one. Here the unfinished foreground and 'wide-angled' view, and in others the empty expanses of bare rock that fill the lower part of the sheet, seem to provide clues that he used one in Sicily as well, and Bell's notes indicate that some of the drawings of Agrigentum at Weimar are inscribed: *taken with the camera obscura.* Gore was the prototype for the English lord in Goethe's *Wahlverwandtschaften*, who 'occupied most of the day by taking picturesque views of the park with the help of a dark box, a practice he had followed for several years on his extensive travels' (quoted in Penny and Clarke, 154).

Literature: Stumpf, 15, 42–7, 63–6; Bell; and see previous entry.

MICHEL-VINCENT 'CHARLES' BRANDOIN (1733–90)

129

The Nant D'Arpenaz

Pen and grey ink and watercolour over pencil, 270 × 435 mm; on original grey mount with pen and ink border, 354 × 513 mm

Inscribed on verso of mount: *Le Nant D'Arpenaz, rocher de 800 pieds de haut dans la valée de Salenche, en Savoye. / The Nant d'Arpenaz–a rock 800 feet of perpendicular hight, in the Valley of Salenches, in Savoy* and *No. 107*

Provenance: Sir William Forbes of Pitsligo; by descent, sale, Sotheby's, 15 July 1999, lot 74 (purchased with lot 70)

1999-9-25-2

The son of Protestant refugees, Michel-Vincent Brandoin was born in Vevey, Switzerland, apprenticed to an uncle in textiles in Amsterdam and visited London in 1757 and Paris and Italy the following year. He settled in Church Street, Chelsea, in 1762, taking lessons in watercolours from Sandby, as well as undertaking commissions for views and teaching privately. As 'Charles' Brandoin, he exhibited a watercolour and a 'tinted' drawing, a view of Lake Geneva, at the Society of Artists in 1768 and 1769. Like Sandby, he was as interested in figures as in landscape and enrolled

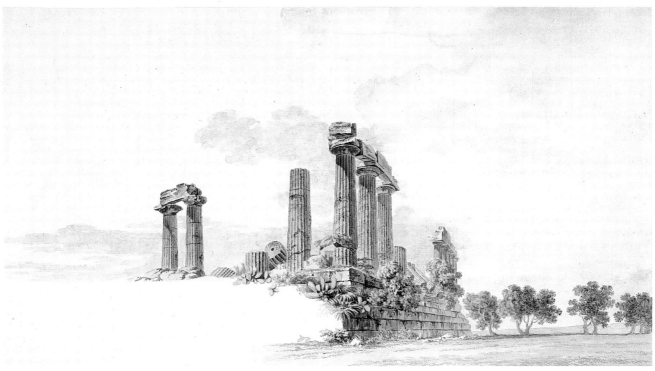

128

129

at the Royal Academy in 1770, depicting the crowds at its early exhibitions and making watercolour copies of the paintings shown. He also executed a series of caricatures published between 1771 and 1772.

Brandoin returned to Vevey in 1773 and spent the rest of his life painting watercolour views for the increasing number of grand tourists passing through Switzerland, based on his own compositions and those by others. The present view shows the Cascade d'Arpenaz on the Arve river just north of Sallanches. In spite of its similarity to Mary Mitford's view (cat. 130), it does not depict the same falls, but indicates the popularity of such views, both then and now. Some of Brandoin's views were published in aquatint in the 1790s. In 1771 William Pars had exhibited at the Royal Academy the magnificent watercolours he had made on his journey in Switzerland with Lord Palmerston the previous year. The works Brandoin showed at the Society of Artists and the Royal Academy included Swiss views, which should now be taken into account when considering the British visual

response to the Alps, together with the watercolours of Pars and John Robert Cozens a few years later. Brandoin's pupils in London in the 1760s and early 1770s presumably benefited from his own vision of the landscape combined with the British topographical tradition that he was taught by Sandby; his later watercolours painted in Switzerland continued to enter British collections for the rest of the century.

Sir William Forbes of Pitsligo, the 6th baronet (1739–1806), travelled to Italy in 1792 for his wife's health, and may well have visited the Continent earlier. He had resolved not to purchase paintings or antiquities while abroad, but once in Rome and Naples, he frequently visited the studios of all the artists in residence, and amassed a collection to which he added after his return to Edinburgh. His son William Forbes, the 7th baronet (1773–1828), was an amateur artist, and was depicted by Henri-Pierre Danloux (1753–1809) in 1801, kneeling by a rock, sketching from nature. He also collected, and either he or his father might have commissioned this large group of

Grand Tour views from Brandoin, or purchased them from an earlier collector such as William Beckford, for whom Brandoin worked in the 1780s.

Literature: William Hauptman, 'Beckford, Brandoin, and the "Rajah"', *Apollo* CXLIII, 41 (1996), 30–9, and forthcoming articles on Brandoin's role as an eyewitness to the London art scene of the 1760s.

Attributed to MARY MITFORD (b. *c.*1742, *fl.* to 1774)

130

Falls of the Pissevache in the Pays de Valais, Switzerland

Watercolours over slight graphite sketch, with some pen and brown and grey ink, 296 × 445 mm

Inscribed faintly on verso with title and *33*

Provenance: Abbott and Holder, from whom purchased

1995-7-22-1

130

The attribution of this watercolour to Mary Mitford is based on its similarity to a group of six drawings signed by her that was sold by Abbott and Holder in July 1989, and a few others that have appeared at various times, signed *M. M.*. In 1989 Mary Mitford was not identified, but it seems certain that she was the elder sister of two of William Gilpin's pupils and later friends, Colonel William Mitford (1744–1827) and his brother John, later 1st Baron Redesdale (1748–1830). Along with two other sisters, these were the children of John Mitford (m. 1740, d. 1761) of Newton House and Exbury, Hampshire, a barrister of Lincoln's Inn. Mitford's sons followed his profession, William becoming a MP and author of *A History of Greece*, which he was encouraged to write by Edward Gibbon (cats 180–2), and John eventually becoming attorney-general and speaker of the House. In 1776 Gilpin proudly described them, like William Lock of Norbury (cat. 161), as being educated 'only at Cheam'. John Mitford's travel journals and sketchbooks are in the Gloucester Record Office. Some of the pencil sketches were made on his grand tour in 1776–7, but the rest are nearly all local views in pen and ink, dated to the late 1770s and all showing a debt to Gilpin's method of composing landscapes. William Mitford was also a draughtsman, although none of his works appears to have survived. Gilpin took particular note of his talents as 'a soldier, a country-gentleman, a farmer, a sportsman, very musical, well skilled in painting, at the head of a family of six children and not yet thirty years of age' (Bodleian, MSS Eng. Misc. d. 570, f. 54). It was William who offered him the living at Boldre in Hampshire when Gilpin retired from Cheam in 1778.

Nothing, however, is known of Mary except her watercolours. They include views in Italy and France (dated 1770 and 1774), Nottingham (1774), Southampton, Fowey, in Cornwall, and Holland. Many are Alpine views, such as the present work, especially of the Apennines; some are signed in full and some only with her initials. It seems certain, however, that Mary Mitford did not travel abroad and that her watercolours must have been copied from the works of her drawing master or masters. William Marlow's (1740–1813) name has been suggested, and certainly her manner of drawing trees and buildings is very close; but similar views by him have not been identified, and he was not known to have taken pupils. The view of Nottingham is close to Paul Sandby's work, while the present view is similar in colour, style and approach to Michel-Vincent Brandoin (see cat. 129). The last two artists were taking private pupils in London in the 1760s and early 1770s, and either might have taught this very talented amateur.

Literature: Barbier, 49–55, 173; Ingamells for John Mitford.

131

EDWARD SWINBURNE
(1765–1847)

131

Tasso's House, Sorrento, 1797

Watercolour over graphite, 381 × 523 mm
Verso: sketch of an antique arch, on right half
of sheet, pencil

Inscribed: *Taso's house Sorrento*; inscribed on
verso: *House of Tasso the poet, at Sorrento 1797
E[?] S.*; and on left side: *Porta [Capena?]*,
referring to the pencil sketch on verso

Provenance: Sir John Swinburne of
Capheaton Hall, by descent, sale, Sotheby's,
22 October 1979, lot 69 (with three others of
Ischia and Livorno, as by Henry Swinburne);
bt Abbott and Holder, from whom purchased

1980-2-23-15

This watercolour and another in the col-
lection (*A view of Subiaco*; 1980-2-23-16)
were purchased as the work of Henry

Swinburne (1743–1803), the younger
brother of Sir Edward Swinburne (1733–
86), 5th baronet, of Capheaton, North-
umberland. Their sister Isabel married
Thomas Crathorne of Ness, Yorkshire, and
was painted by Francis Cotes as a muse of
Art, holding a *porte-crayon* and a drawing
of a cupid, a tribute to her husband depict-
ed with her posthumously (Huntington
Collection, San Marino (Calif.)). Henry
Swinburne was a writer, traveller and
diplomat, the author of *Travels through Spain
1775–1776* (1779) and *Travels in the two Sicilies*
(1783) and *The Courts of Europe* (published
posthumously, 1841). He did indeed make
the original drawings used to illustrate his
book on Sicily, but they were tight, detailed
views, drawn in pen and ink with a little
wash, focusing mainly on architecture, and
very similar to the types of drawing found
in George Keate's album (cat. 123). In the
family sale in 1979, four and a half lots of

Italian watercolours, all inscribed with
locations, but apparently only one signed,
were attributed to Henry Swinburne (65–7,
69, 70). Another lot and a half (68, 70) were
attributed in the catalogue to a mistaken
conflation of his nephew and great-nephew,
both called Edward Swinburne.

Henry Swinburne had two nephews who
were closely involved in the arts: Sir John
Swinburne, 6th baronet (1762–1860), a
long-lived patron of many artists, and Sir
John's younger brother Edward (1765–
1847), a noted nineteenth-century amateur
about whose early life little is known.
However, the accounts of other travellers to
Italy indicated that he drew and painted
landscapes in watercolour on two visits in
1792–3 and 1797. He is now thought by
the present writer to be the artist of this
work and the other purchased by the
Museum, as well as several others given to
his uncle Henry in the sale, and now widely

dispersed. Any attributions of these works to Sir John's son Edward (1788–1855) can be discounted.

John Carr, also from Northumberland, and his sister Harriet, another amateur artist, met Edward Swinburne in Rome in 1792 and found him of 'great use' as he was personally known to all the English artists. Dated drawings place him in the Abruzzo and Sicily in 1792 and again in Rome in 1793. In Naples in 1797, on his second trip, he met the artist William Artaud (1763–1823), who described him as 'a most able designer of landscape', and went on a sketching tour with him and three fellow artists around the gulfs of Naples and Salerno and on to Paestum. It must have been on this tour, described in Artaud's letters, that Swinburne made the present watercolour. Sorrento, just south of Naples, is a town of beautiful gardens and sunsets, and traditionally identified as the place where Ulysses resisted the call of the sirens. It was also the birthplace of the great Renaissance poet Torquato Tasso, author of *Gerusalemme Liberata* (1581). The town is placed on the 'very brink of the steep rocks that overhang the bay, in a most enchanting situation (*Two Sicilies* I, 133), and its terraces overlook the Gulf of Sorrento and the Bay of Naples, with views of Vesuvius, Procida, Cape Miseno and, nearer, Capri.

Undoubtedly painted directly from nature, this watercolour is bright and fresh and might show the influence of any number of English or Italian artists in Rome and Naples during that time. Indeed, Edward Swinburne had clearly studied watercolours long before he came to Italy, as his handling and use of colours is confident. After his return he told Farington that 'reckoning from the Alps, – [Italy] included every character of Landscape in the highest perfection' (*Diary*, 12 June 1804). He continued to study with numerous other artists and to paint watercolours, often of Italian scenes, and to exhibit them for the rest of his life. Many of his watercolours done in Italy are still in the family collection and show him to be a competent landscapist, in watercolour and in monochromatic wash, comfortable with sketching from nature, painting figures or composing more finished landscapes on a large scale. Swinburne was president of at least two northern institutions for the promotion of the fine arts and in 1831 was president of the Northern Society for Painters in Watercolour.

132

Swinburne lived with his brother Sir John at Capheaton, and presumably shared his London house in Grosvenor Place almost next door to their friend Walter Fawkes of Farnley's London home. All three collected watercolours by contemporary artists such as Cotman, Varley and Girtin, and all were patrons of Turner. Swinburne's name appears on the flyleaf of a Turner sketchbook dating from 1799, and he subscribed to the engraving of *The Shipwreck* in 1806, purchasing a watercolour of *Grenoble* in 1809, and the same year either he or his brother bought the watercolours of *Brienz* and *Chillon* now in the British Museum. The Swinburnes also owned three other large Turner watercolours now in the Museum.

Literature: David Hill, 'A newly discovered letter by Turner', *Turner Society News* 23 (1981/2), 2; Paul Usherwood, *Art for Newcastle, Thomas Miles Richardson and the Newcastle Exhibitions 1822–1843*, exh. Laing Art Gallery, Newcastle, 1984, 81; Ingamells; Anne French, *Art Treasures in the North: Northern Families on the Grand Tour*, exh. Laing Art Gallery, Newcastle, 1999–2000 (catalogue forthcoming). (I am very grateful to Anne French for her assistance with this entry.)

ELLIS CORNELIA KNIGHT (1757–1837)

132

Theatre at the Palace of the Prince at Palestrina

Pen and grey ink with brown wash, 221 x 285 mm

Inscribed on verso with title and *No 48*

Provenance: Place purchased not recorded in register (possibly Abbott and Holder), through the H. L. Florence Fund

1971-9-18-5

The daughter of Admiral Sir Joseph Knight, Cornelia was well educated in the classics and several modern languages at a school in London. Most academies provided the services of a drawing master by this date and she probably received her first lessons there. Her mother was a friend of the sister of Joshua Reynolds and their circle was therefore his, and included Samuel Johnson, Oliver Goldsmith, Edmund Burke and the young Angelica Kauffman. On the admiral's death Lady Knight, his second wife, did not receive a pension and hearing that Rome was 'the cheapest city in the world and the most beautiful', she arrived there with her nineteen-year-old daughter in 1778. They remained in Italy, residing in various cities,

until the French invaded Rome, and were then pushed from Naples to Sicily in 1799, where Lady Knight died. Under the protection of Sir William and Lady Hamilton, Cornelia travelled with them and Nelson back to England in 1800. Five years later she was appointed companion to Queen Charlotte, and took up the same position with Princess Charlotte in 1809. From 1816, through the connections she had made at court and the grand tourists she and her mother had encountered in Italy, she was able to spend the remainder of her life visiting various courts throughout Europe.

During their twenty years in Italy, with brief sojourns in France, Cornelia seems to have spent her time paying and receiving visits, reading, writing and drawing. Her *Autobiography* was in fact compiled long after her death from her journals and other papers, and describes all the events and people they met, but contains very little personal information and does not mention her own writing, drawings or published work. Her mother's letters are more informative. They indicate that Cornelia was an accomplished linguist (in 1790 she was learning Swedish as a tenth language), classicist and poet, writing sonnets and verses to celebrate important events. She published *Dinarbus*, a continuation of Johnson's *Rasselas*, in 1793. The previous year she had published *Marcus Flaminius, a View of the Military, Social and Political Life of the Romans*, a didactic romance in the form of letters, which Fanny Burney regarded as a work of great merit, which 'to Italian travellers, who are classical readers, [she imagined] it must be extremely welcome, in reviving images of all they have seen, well combined and contrasted with former times of which they have read' (quoted in Knight, 100).

Cornelia's principal work, however, was *A description of Latium, or La Campagna di Roma* (1805), which she illustrated with etchings after her own work. Many of these were drawn while she and her mother were staying in the palace of the Prince of Palestrina, near the city built on the site of a great Roman temple dedicated to Fortune, in Latium, to the east of Rome. The area was dense with antiquities, which provided evidence of a people to whose arms and arts 'this Island in particular are indebted for the chief advantages and blessings of their social and political existence' (p. xi). In her discussion of Palestrina, Cornelia quoted Pliny's description of an antique mosaic still

to be seen. Only one of her etchings in the volume depicted Palestrina, but she wrote: 'Near the armory is a theatre, capable of holding two hundred spectators, and there is a wardrobe and scenery belonging to it' (p. 198). Like most antiquarians, she took pains to describe the contemporary way of life and customs in the hope that they would also provide clues to the past.

Cornelia's mother recorded that her daughter had made 550 drawings and paintings by 1781, a number that had risen to 1,800 nine years later – some in pen, drawn from the imagination, but mostly in wash, drawn from nature, some with colour. The drawings that survive are scattered, but seem mainly to depict views and especially Roman ruins and buildings, with an attempt at accurate perspective and remarks on the versos that indicate that she paid particular attention to the original function of the buildings and sites. Her manner of depicting landscape is very close to that of Mary Mitford (cat. 130), and is more probably the result of early lessons in London than any serious study undertaken with drawing masters in Rome. Although they are often attractively coloured, their focus is always the historical content rather than the creation of a picturesque or romantic image. Her portrait by Angelica Kauffman (1791; Manchester City Art Gallery) was painted out of friendship and depicts her holding a pen, her elbow resting on a table bearing a roll of papers, a drawing of a naval rostrum and several books, including *Flaminius*, indicating that her reputation was as much as an author as an amateur artist.

Literature: Lady Eliott-Drake, *Lady Knight's Letters from France and Italy 1776–1795*, 1805; E. C. Knight, *Autobiography of Miss Cornelia Knight*, 2 vols, 1861; Ingamells.

WILLIAM YOUNG OTTLEY (1771–1836)

133
Study of trees and rocks in the Chigi Park at Ariccia

Pen and brown ink, with brown-grey wash, over graphite, 301 × 421 mm

Inscribed: *[C]higi Park Ariccia*

Provenance: George Clulow, from whom purchased

1904-4-14-4

Every summer, when the danger from malaria and the heat in Rome became unbearable, most of the wealthier inhabitants and visitors decamped to the Alban Hills, where the cascades and temples of Tivoli, the pope's residence Castel Gandolfo on Lake Albano, and the cool, wooded slopes of Lake Nemi provided welcome relief and diversion. Poussin, Claude and Salvator Rosa had all sketched in the area and British artists followed in their steps. The gnarled roots and twisted trunks of the chestnut groves around the Rocca di Papa, the oaks of the Galleria di Sopra and the Chigi Park near Ariccia provided perfect locations for artists to take panoramic views of the Campagna or to make sketches and studies from nature in the shady woods. Alexander Cozens in the 1740s, Richard Wilson in the 1750s, John Downman and John Robert Cozens in the 1770s and Francis Towne in the 1780s found these wooded groves rich sources of unusual textures, colours, light and shade. They all made sketches similar to this work, in which Ottley focused on the twisted roots snaking along the rocky crevices; in many of the sketches, as in the present work, any suggestion of the horizon is omitted, as are a distant view or even the tops of trees. Two close studies of ivy and ferns in pen and ink over pencil sketches are signed and dated *L'Arriccia June 1797* (in a Berlin collection in 1996), as is another similar drawing of the wood near Ariccia in the Museum (1970-5-30-1).

William Young Ottley was the grandson of Sir William Young, a 'roaring rich West Indian' whose income from sugar plantations enabled him to make a grand tour and collect old master paintings in the 1750s. Sir William's eldest son, also William, made his own grand tour in the 1770s, travelling with Charles Townley (see cat. 167), and employing the Scottish artist John Brown (1749–87) on their tour of Sicily. This William Young, Ottley's uncle, was a talented amateur, whose own watercolours illustrated his manuscript account of the tour (British Library, MSS Stowe 791). John Brown worked in Rome with Henry Fuseli and Alexander Runciman for several years, returning to London in 1780. He taught William Young Ottley before leaving for Edinburgh where he died in 1787 from recurring malaria. Ottley purchased over 200 of his Italian drawings in sketchbooks from Brown's widow, and later broke them up for various sales, including one at

133

Phillips, 6 June 1814, where several were purchased by Sir Thomas Lawrence (they reappeared in his sale in 1830).

Because of his connection with Brown and through him the Fuseli circle, as well as his own friendship in Rome with John Flaxman and his engraver Tommaso Piroli, most writers concentrate on Ottley's figure drawings (see cats 162–3) and connoisseurship. The handful of landscape drawings and studies from nature that survives indicates that he was aware of its traditional role and importance for British artists in Italy. Nevertheless, he approaches the trees here as if they were figures and invests them with an almost anthropomorphic quality.

Literature: Nancy L. Pressly, *The Fuseli Circle in Rome*, exh. YCBA, 1979, 54–63, 141–4; Wilcox, 73–4; Ingamells.

EDWARD DODWELL (1767–1832)

134

A Katabathra of Lake Copais, 1805

Watercolour over pencil, 335 × 448 mm

Inscribed on the verso of mount: *Co.* and *View taken from the bottom of a Katabathra of Lake Copais between Acrophia & [space] Drawn by ED [monogram] 21 of May 1805*

Provenance: By descent from the artist's sister; sale, Ritchie's, Toronto, 3 December 1996, lot 183, bt Martyn Gregory, from whom purchased with the assistance of the National Art Collections Fund

1997-6-7-12

One of Sir William Hamilton's favourite artists was the topographical watercolourist, Giovanni Battista Lusieri (1755–1821), whom he employed to draw the panoramic view from the window of his residence in Naples, the Palazzo Sessa, in 1791. The artist used a camera obscura for most of his work, in order to record the exact details of buildings and the landscape from such a wide and distant viewpoint. Lusieri met Lord Elgin in Sicily when Hamilton and the Neapolitan court were exiled there in 1799. The young ambassador was *en route* to Constantinople from where he also hoped to visit Athens, and he secured the artist's services for £200 per year. Elgin's embassy was the beginning of a flood of British visitors to Greece, many, like him, eager to discover what they believed to be the origins of classical culture and history. Only two years later, not only Lord Elgin, but Lord Carlisle, W. R. Hamilton, Thomas Hope and James Dallaway were all touring Greece and studying its antiquities.

Edward Dodwell was the descendant of the classical scholar Henry Dodwell; well-educated with an inherited income, he also visited Greece in 1801, travelling with William Gell (1777–1836). An antiquarian,

134

Dodwell was studying, measuring and recording early Greek monuments as well as vases. He formed a substantial collection of the latter (now in Munich) and, like Gell, his recording required some skill at drawing, for which, also like Gell, he frequently employed a camera obscura. Gell's sketchbooks are in the Department of Greek and Roman Antiquities in the British Museum, but apart from records of early Pelasgic remains in the Soane Museum, Dodwell's drawings and watercolours nearly all remain in the hands of his descendants. Five of his finest watercolours were recently sold in Toronto, and the British Museum was fortunate to acquire two of them: the present watercolour and a *View of Temple of Apollo Epikourios at Bassae*, inscribed as taken with a camera obscura (Department of Greek and Roman Antiquities). The original sketches for these watercolours were made on his second tour of Greece in 1805–6, the main purpose of which was to explore and record for future publication. For this he employed the assistance of a professional artist, Simone Pomardi (1760–1830), who, like Elgin's artist Lusieri, also used a camera obscura.

On their tour Dodwell himself produced 400 drawings and Pomardi 600. Most of them are inscribed with the locations and date and annotated *E D, P, Cam.O.* or *Orig.* It is clear that they worked closely together, both of them sketching and drawing landscapes and monuments, working up each other's drawings, often working together on the same watercolour, Dodwell drawing and Pomardi colouring. The meaning of *Co* on the present work is unclear – it might mean that it is a copy. However, it is unusual in that it does not represent a temple or view, but rather reflects Dodwell's particular interest in finding support in nature for the origins of Greek myths. He also hoped that his descriptions and quotations from ancient Greece would illustrate the present and 'add new interest to modern localities and customs' (preface, p. iv). In this case the *katabathra*, which were underground rivers and caverns, were said to have been opened or blocked by Hercules as passages to the infernal regions. But Dodwell also observed that the lakes flooded regularly and that the caverns and underground rivers, probably created by earthquakes, served a useful purpose in permitting the lakes to drain. He seems to have been familiar with the eighteenth-century artistic formula for the sublime favoured by Wright of Derby, John Robert Cozens and others who depicted such caverns looking out of the mouth from the dark depths; he also stated in his preface his intention in the drawings to show every locality 'with scrupulous fidelity' (p. viii). The description of the *katabathra* was

included in the first publication of his tours illustrated with small engravings, but in 1821 he published *Views in Greece, from drawings by Edward Dodwell*, a lavish folio volume with hand-coloured aquatint plates by T. Medland and a brief text to supplement the 1819 volumes.

Literature: Edward Dodwell, *A Classical and Topographical Tour Through Greece, during the years 1801, 1805, and 1806* (2 vols, 1819), I, 236–40; Hugh Tregaskis, *Beyond the Grand Tour*, 1979, *passim*.

FRANCIS TOWNE (1739–1816)

135

A Road and Villa near the Arco Oscuro, 1781

Pen and grey ink and watercolour, 227 × 322 mm; on artist's mount with wash border, 332 × 430 mm

Inscribed: *F. Towne del.t Rome May 7th 1781*; and on mount: *No 38*; and on verso of mount: *No 38 Near the Arco scuro Francis Towne del.t. May 7th. 1781 from 11 till 1 o'clock*

LB 2(11a)

Provenance: One of a group of watercolours bequeathed by the artist to James White of Exeter and his residuary legatee, J. H. Merivale, executors of Francis Towne, and presented by them according to Towne's wish, in two groups in 1816 and 1818

Nn.1-11 (1972,U.630)

135

William Pars, who was Francis Towne's friend from his days as a student at Shipley's drawing school in London in the late 1750s, lived in Rome from 1775, painting in watercolours and oils and giving lessons to British grand tourists, including Charles Gore (cat. 126) and his daughters. He knew Sir William Hamilton in Naples, and copied old masters and painted portraits in oils for other patrons, and sketched with Thomas Jones, John 'Warwick' Smith, and from 1780 with Francis Towne. Pars died in Italy shortly after Towne returned to England. On 10 June 1809 Towne was given permission to make copies of three of Pars's Athenian watercolours in the Museum and in the following decade asked his executors to ensure his own Italian drawings were presented to the British Museum where they might join Pars's work. From the inscriptions on their works, it is clear that they sometimes sketched together, occasionally with the other artists mentioned above. Most artists in Rome at the time sketched directly from nature out of doors. Towne does not seem to have done preparatory sketches, but instead drew directly on the sheet for the final work, adding finishing touches and further colours back in his studio. Throughout his career he emphasized his reliance on nature by inscribing his drawings with the date and place, often including notes about the light and, almost as if it was part of his signature, the words, *Drawn on the Spot by Francis Towne*.

Towne's colours and method of colouring changed through different periods of his career, lightening perceptibly in tone while he was in Italy; but the pen and ink outlines, emphasizing the drawing itself, always remained the most essential element of his work. Where other artists used the brush and colours to build up parts of the composition or allowed the distance to fade away in brush and wash, he employed pen and ink outlines to give form to even the furthest mountains, imparting a crispness that no doubt appeared old-fashioned to his contemporaries, who valued chiaroscuro and atmosphere and consistently refused to elect him to the Royal Academy. Towne's reliance on outline drawing with pen and ink can be traced to examples of earlier Dutch and Flemish masters whose work he had studied and copied while a student in London at St Martin's Lane and Shipley's.

Copying and studying old masters was also the foundation of his own teaching methods.

Born and educated in London, Towne first went to Exeter in 1763 as a coach painter, but soon recognized that he could find regular employment as a drawing master, and continued to do so for the rest of his life, basing himself in London and exhibiting oils there but staying in Exeter for periods every year to earn a regular income from teaching (up to £1,000 per year). He taught members of the Courtenay, Clifford and Fulford families, painted views of their houses, and toured North Wales before travelling to Italy to further his career as a landscape painter, which he considered to be his true profession; he was deeply offended and felt it was a negation of his life's work to be described by an old friend as a 'provincial drawing master'.

Literature: Wilcox, *passim*

JULIUS CAESAR IBBETSON
(1759–1817)

136

Cattle on an upland

Watercolour, with pen and grey ink,
196 × 295 mm

LB 4

Provenance: Purchased from Edward Daniell

1877-10-13-959

Ibbetson was trained as a ship's painter but came to London as a picture cleaner in 1777, painting in his spare time and exhibiting at the Royal Academy from 1785. Charles Greville (cat. 141) suggested Ibbetson accompany his cousin Colonel Charles Cathcart's 1788 mission to Peking, and he travelled as far as Java, painting watercolours that recorded views accurately. His subsequent work, although overlaid with picturesque compositional elements and done in a decorative style, remained faithful as records of costumes, buildings, landscapes and, particularly, local industry. He toured Wales several times with patrons, including, in 1792, Robert Fulke Greville who, like his siblings, was also an amateur. Ibbetson was also adept at drawings animals and illustrated John Church's *Cabinet of Quadrupeds* in 1805.

The Beaumonts (cat. 149), Lord Mansfield of Kenwood (married to Cathcart's sister) and Lord Bute were also Ibbetson's patrons, and in 1798 he left London,

residing in various towns where he had commissions from such patrons, staying for some time in the Lake District and finally settling in Masham, near his patron William Danby, the brother of Mary Harcourt (cat. 108). He painted in watercolour and oils and his penchant and skill for painting cows led Benjamin West to describe him as 'the Berghem of England'. Lord Mansfield had pedigree Warwickshire cattle, which Ibbetson recorded for him at Kenwood.

Teaching was clearly a significant portion of Ibbetson's activity as an artist, and he was the first drawing master to issue a 'progressive' drawing manual, *Ibbetson's Process of Tinted Drawing* (1794), which took the form of nine aquatints, consisting of one hand-coloured colour chart and two views, each in four progressive stages from outline through built-up layers of wash. In 1803 he published *An Accidence, or Gamut, of Painting in Oil, for Beginners; in which is shewn the most easy way of imitating Nature*. The text was mainly anecdotal and technical, and included his recipe for 'gumption' used by Beaumont; it contained little actual instruction, but had plates of colour specimens, and one original circular oil painting signed by Ibbetson mounted on a prepared aquatint frame and inserted in each copy as an example to follow.

Many artists took the opportunity while on sketching tours to give drawing lessons to the local gentry, or arranged their tours to incorporate stays at country houses where they had been requested to give lessons.

In the summer of 1800 Ibbetson was staying in Roslin, no doubt not only for the opportunity of drawing in the famously picturesque North Esk, but also to take advantage of the presence of many amateurs who were drawn there to sketch from nature (see cat. 174). Lady Balcarres and her daughters had been receiving lessons in Edinburgh from Mrs Schetky (Maria Reinagle) and her son from the early 1790s, and in 1800 she took lodgings in the village of Roslin so that they might take instruction from Ibbetson in painting in oil from nature. He painted himself and his pupils sketching by a waterfall (Irwin, pl. 2,), and dedicated his *Accidence* to Lady Elizabeth who had made the original suggestion that he produce it. Shortly afterwards he wrote to Lady Balcarres that he could make good money from painting pictures in the manner of the Dutch and Flemish masters, but complained that it 'is not wholesome, because one gets no honour by imitation – except in the affair of imitating Nature of which I am proud whenever I am so much as suspected' (Clay, 134).

Sketching in oils from nature was a more common activity amongst amateurs than has generally been recognized. There are well-known drawings of Sir George Beaumont and Thomas Hearne with large canvases set up by a waterfall in Wales, and Kerrich (cat. 156) and Sir William Elford (cat. 119) also undertook smaller sketches in oils out of doors.

Literature: Rotha Mary Clay, *Julius Caesar Ibbetson*, 1948, 66–73, 86–7, 134–6; Irwin, 232–3; Luke Herrmann, *British Landscape Painting*, 1973, 119–22; Bicknell and Munro, 50–1, 69, pl. IX.

JOHN WHITE ABBOTT
(1763–1851)

137

Cattle in a landscape, 1796

Watercolour with pen and grey and brown ink, 248 × 332 mm

LB 1

Provenance: Presented by F. A. Abbott

1880-3-13-22

Whereas Towne, the professional landscapist who drew all his works 'on the spot, from nature', did not really allow the subject matter of the Dutch old master drawings he studied to filter through into his

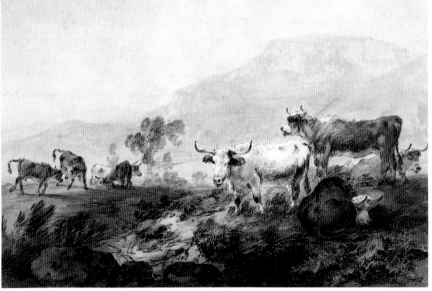

136

own landscapes, the amateur John White Abbott frequently staffed his views with figures and animals reminiscent of the works of others. He produced dozens of copies of old masters in pen and ink and brown wash; some are in the Museum's collection, but many have appeared recently in the sale rooms. Here Berchem or Bloemaert's cattle, freely interpreted with Abbott's distinctive lively penwork, are grafted on to an English view, perhaps

the mouth of the Exe. Ibbetson's open-mouthed cattle, bellowing, chewing and charging, have all the appearance of being sketched and drawn from nature, and are as lively as the local inhabitants with whom he peopled his landscapes. Abbott's figures are usually classical or rustic and his works carefully composed, signs of his connoisseurship and reminders of his status as a gentleman amateur, rather than a professional landscapist.

Abbott knew Towne from an early age through his uncle John White, whose estate Abbott eventually inherited. An apothecary and surgeon, he stopped practising when he came into his inheritance and devoted himself completely to painting. Like Towne, he never exhibited a drawing, always showing oils at the Royal Academy, and in 1794, after tours of Scotland and the Lake District, at least one critic felt that his painting was the best in the exhibition. He did not travel abroad, but copied Towne's views of Italy and the Alps, noting particularly their attention to the light. He has always been thought to be imitative rather than innovative in his style, which was extremely close to Towne's, especially in his best-known and most admired works, which are large, often monochromatic, drawings of rocks and trees drawn at Cantoneign in Devon. However, apart from colour and the distinctive tree silhouetted on the left, the present work shows how independent he could be of this one drawing master, and how his work was the product of many masters whose work he had studied.

Literature: A. P. Oppé, 'John White Abbott', *Walpole Society* XIII, Oxford 1925, 67–84.

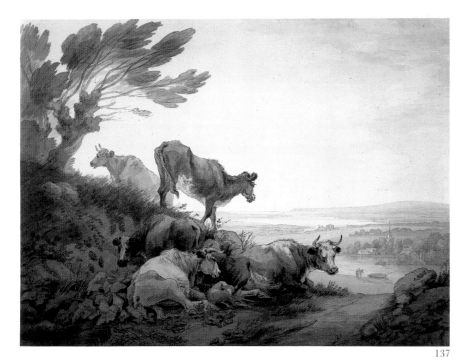

137

SIR GEORGE BULTEEL FISHER (1764–1834)

138

Near Charlton, Kent, overlooking the Thames

Watercolour, with pencil sketch of trees to right on verso, 292 × 420 mm

Inscribed on verso: *Near Charlton*

Provenance: Walker's Galleries, from whom purchased through the H. L. Florence Fund

1943-2-13-1

One of nine sons of the Revd John Fisher, Fisher was a cadet at Woolwich in the late 1770s when Sandby was teaching there. He has been described as a pupil of Towne, and certainly there are stylistic affinities; there does not, however, seem to be any documentary evidence for this, apart from the fact that his brother John was the Bishop of Exeter from 1803 to 1807. At this time, however, George Fisher was serving in Spain.

The bishop, known as 'the King's Fisher' because of his great friendship with George III, was also an amateur, and a great friend and patron of John Constable to whom he

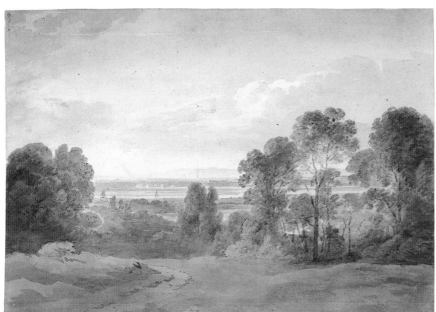

138

introduced Colonel George Fisher in 1814. Constable described George Fisher as 'an excellent artist. Many years ago he made some beautiful drawings in America, which were engraved. The Colonel is just returned from Spain, and was very interesting in his accounts of it – which part of his conversation I preferred to his telling me how Rubens made his pictures, for that I thought was a waste of time.' Ten years later the colonel was commandant of Woolwich, living at Charlton, and Constable's presence was requested. The artist, however, was disinclined, 'as I begin to tire of going to school'. Two years later, he was to describe Fisher's works as 'heartless atrocious landscapes'.

There is a very similar view to the present watercolour in the Victoria and Albert Museum, but a number of views of Charlton have been attributed to Fisher that are probably by other pupils of Sandby, especially George Heriot (1766–1844). They are difficult to date, but this version, with its delicate, pale washes arranged in screens, seems to show that Fisher had been looking carefully at Constable's work; it may therefore be of as late a date as the 1810s or even 1820s. Clearly he had found a successful formula and varied it little.

Another side of Fisher's work is revealed by *Six Views of North America, made on the Spot by Lieut. Fisher of the Royal Artillery*, a series of aquatints by John William Edy, published in London in 1796 (British Library, Map Library). The large watercolour for *The Montmorency Falls near Quebec* (1792) is in the Victoria and Albert Museum (P. 3-1913, 492 × 657 mm). Much as Sandby had done in the 1770s (see cat. 99), Edy seems to have made a speciality of engraving views taken by military gentlemen while serving abroad, and no doubt was selected for his ability to improve their original drawings. A commentary by Fisher was issued to accompany these large prints, suitable for the portfolio or framing, and the text indicates that Fisher, unlike Governor Pownall (cat. 99), was more interested in conveying the picturesque and sublime qualities of the landscape than its historical or political potential. His attempts to bring some known context to such striking and overwhelming scenery resulted in the awkward imposition of trees and lawns from an English park on to the Isle d'Orléans, the wooded slopes of the Bristol Gorge on to the Hudson, or Tivoli on to the Falls of Montmorency. On the whole, however, he succeeded in conveying the grandeur and sublimity of a landscape that could not be contained or explained by known pictorial conventions, and could never be mistaken for an English or European landscape.

Literature: Fleming-Williams, in Hardie III, 264.

THE REVD THOMAS GISBORNE (1758–1846)

139
View of Snowdon and Lake of Llanberis, 1789

Watercolour over pencil sketch with scraping out, 290 × 415 mm

Inscribed on verso with title and dated

Provenance: Mrs P. Chaplin from whom purchased

1969-6-14-5

The eldest son and heir of John Gisborne of Yoxall Lodge, in Needwood Forest, Thomas Gisborne was educated at Harrow from 1773 to 1776, where John Spilsbury taught drawing. At Cambridge, Gisborne was a prize-winning classical scholar, expected to take a seat in parliament, but instead he chose the church. He was

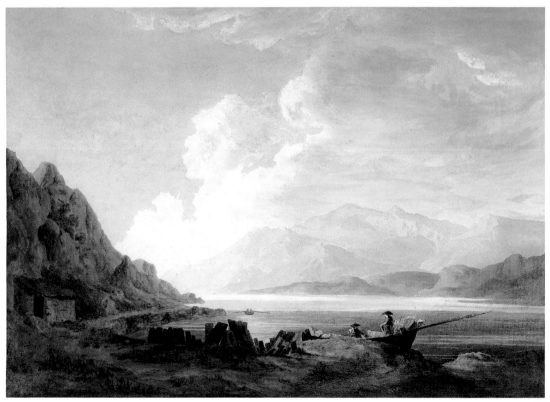

139

ordained priest in 1783 and given the curacy of Barton-under-Needwood, going north to live the rest of his life at Yoxall Lodge, near Derby, which he had inherited on his father's death. He became prebend of Durham Cathedral, but never aspired any higher, content with being known for his sermons, and as a man of letters, writing on moral philosophy, divinity and poetry. An amateur botanist, he was related to Erasmus Darwin through his brother's wife and, a close friend of William Wilberforce since Cambridge, he was a supporter of the abolition of slavery.

Joseph Wright of Derby's (1734–97) well-known portrait of the young curate and his wife (Yale Center for British Art, New Haven (Conn.)), depicts them doubly sheltered, seated under a large green umbrella under an oak and a fir, his dog by his side, his wife leaning on his shoulder, his portfolio under his arm and his hand with a *porte-crayon* pointing to Needwood Forest below. It is dated 1786, two years after their marriage, when Gisborne was already a keen amateur draughtsman, but had not yet begun to publish his writings. The same year he bought paintings of Dovedale and Italy from Wright, who had long been a friend and was a frequent visitor to Yoxall. In 1793 the artist presented his friend with his self-portrait and they toured the Lake District together in 1794, five years after this watercolour view of Snowdon.

Gisborne undoubtedly sketched with Wright, but he had lessons and sketched with other artists as well, including John 'Warwick' Smith, whose secret of washing with watercolours Gisborne knew by 1792, but had promised not to share with any other artists. Smith was one of the first watercolourists to abandon the use of grey washes for undertones, and his blues and greens are brighter as a result. This may have been the secret he imparted to Gisborne. The sky here is certainly bright and parts of the paper have been left blank; there is evidence of scraping out in the foreground figures, an unusually early example of this technique, which Turner was to use to such effect.

Gisborne first met William Gilpin (cat. 111) in the summer of 1792, on common ground not as amateurs, but as fellow divines and philanthropists. Gilpin described Gisborne to Mary Hartley in September that year as 'an ingenious man; & of so much simplicity of character, that he takes with me exceedingly. You can enter

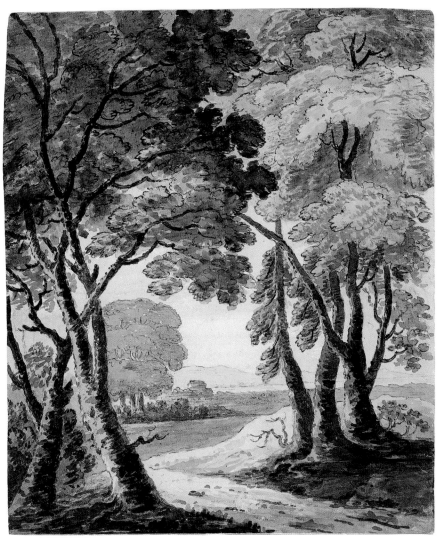

140

his mind without lock or key. He is a man of considerable fortune; but went into orders, not with any view of preferment, but merely, as it appears to me, to have a better pretence to be serious …' In October he wrote again: 'Mr Gisborne and I unite not only in our love of painting, (to which he is pure devotee) but in all other subjects.' They continued to correspond regularly: in 1795 Gisborne gave lessons in landscape to a young artist protégé of Gilpin's friend the Revd William Mason, and in 1800, when Gilpin was experiencing a brief enthusiasm for bodycolours, Gisborne experimented with its relative merits in comparison to watercolour.

Literature: Barbier,163, 169–70; Benedict Nicolson, 'Thomas Gisborne and Wright of Derby', *Burlington Magazine* CVII, no. 743 (February 1965), 58–62; Egerton, 223–4.

GEORGE GREVILLE, 2ND EARL OF WARWICK (1746–1816)

140

Classical landscape seen through a group of trees

Watercolour over pencil sketch,
304 × 255 mm

Provenance: By descent to 8th Earl of Warwick, his sale, Sotheby's, 17 June 1936, lot 165, 'Seven old Volumes containing Sketches by George Earl of Warwick, Etchings by Lady Louisa Greville, etc.', bt (£3) Louis Meier, bookseller, Cecil Court, from whom purchased with a large group of works by this artist by Cyril Fry; presented by Cyril and Shirley Fry

1998-4-25-7

The 2nd Earl of Warwick is best known for

his patronage of John 'Warwick' Smith. In 1775 he enabled Smith (1749–1831), who had received lessons from William Gilpin's father and then brother, to travel to Italy to study for a period of five years. Some of the artist's largest and finest Italian and Alpine watercolours were once in the collection at Warwick Castle. While in Naples, Smith's funds were provided through Greville's uncle, Sir William Hamilton, who in the 1790s found himself waiting years for repayment of £500 he had given to the artist George Wallis on his nephew's behalf. Like the rest of his family, the 2nd Earl of Warwick was the patron, pupil and friend of a number of artists.

Greville's sister Lady Louisa Greville was one of the finest etchers represented in Richard Bull's album (see cat. 110), and like George and their brother Charles, probably had lessons from Paul Sandby and Alexander Cozens. The family had many close contacts with the court, and Lady Louisa was a great friend of Lady Diana Beauclerk (cat. 176) from 1760. The family collection has been slowly dispersed, beginning in 1936 when parcels of unidentified unframed works of English watercolours and drawings, many of them landscapes, were sold at Sotheby's, 17 June (lots 154–65). More recently a number of Alexander Cozens's oils on paper, part of his series of circumstances of landscape, have been discovered in the collection and sold; the earl and his brother Charles each subscribed to six copies of Cozens's *Principles of Beauty* (1778).

From 1775, when he read the manuscript of William Gilpin's *Tour of the Lakes*, Lord Warwick corresponded with Gilpin about ideas of picturesque beauty. Gilpin described the earl's taste as 'wholly of the sublime kind, formed upon the mountains & lakes of Switzerland, & Cumberland', and noted that the changes he planned for the grounds of Warwick Castle 'will out-Brown any thing that is done there' (quoted in Barbier, 68). Gilpin had hoped to have the secret of aquatint from the earl in order to illustrate his tours with prints done in this manner, but as his brother Charles Greville (see cat. 141) had given the secret to Sandby with a promise he would not divulge it, the earl was unable to oblige.

Most of Lord Warwick's own watercolours have been scattered. He was said to have been a prolific painter of Alpine landscapes, but the few surviving examples of his work seen recently are imaginary, vaguely

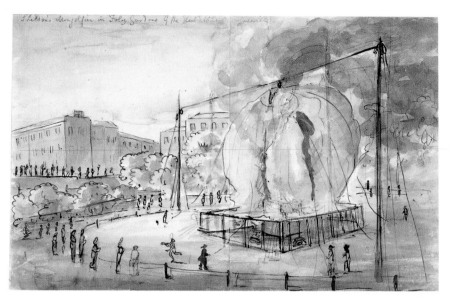

141(a)

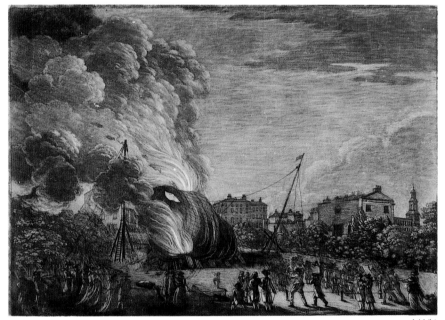

141(b)

Italianate compositions in grey or blue wash over pencil sketches, reminiscent of the work of the Italian artist Carlo Labruzzi rather than of any British artists. The present work is quite different, but its provenance seems to bear out its attribution to the earl; it is remarkably close in style to an early experimental aquatint by Sandby in the Museum's collection (1904-8-19-730).

Literature: Barbier, 68; Williams, 83–5; Jenkins and Sloan, 170–1.

The Hon. CHARLES GREVILLE (1749–1809)

141

(a) *View of the garden of Foley House, with Mr. Sheldon's Balloon on fire, 1784*

Pen and brown ink and watercolour over pencil sketch, 225 × 360 mm

Inscribed: *Sheldon's Mongolfier in Foley Gardens by the Honble. Charles Grenville*; and on mount below: *Drawing by the Honb.e. Charles Grenville of Sheldon's Mongolfier Baloon – in Garden of Foley House – View in Garden Foley House*

(b) *View of the Garden of Foley House with Sheldon's Balloon*

Etching and mezzotint probably on an aquatint base, 254 × 356 mm

Inscribed on mount below: *Balloon on fire in Garden of Foley House Portland Place*

Provenance: Frederick Crace collection of London topography; his son, J. G. Crace, from whom purchased

1880-11-13-4515, 4516 (Crace, XXIX, 54–5)

On 15 September 1784 Vincenzo Lunardi made the first balloon ascent in England, from the artillery ground in front of Bethlem Hospital (Bedlam). It was one of the most spectacular and celebrated events of the century, recorded and satirized in numerous prints, several of them by Paul Sandby, whose print *An English Balloon* (DG 6700) depicted the balloon as a grinning face wearing a fool's cap with the ears of an ass projecting from it. Ten days later the English aeronaut Keegan and his pilot Dr Sheldon gained permission to attempt to launch their own balloon in the gardens of Foley House. Charles Greville (incorrectly inscribed as Grenville (of Stowe) by Crace), the brother of the 2nd Earl of Warwick, lived in Portland Square, which overlooked the scene, and took the opportunity to record the occasion. The balloon was three times the size of Lunardi's, and the attempt ended in disaster when it caught fire. Men with faggots to heat the balloon from below were seen running from it, while two men with trumpets tried to direct the efforts to contain it and spectators watched from a distance.

Like his brother, Charles was a friend of Sandby, and has traditionally been credited with passing on to the artist the secret of making aquatints Greville had learned while abroad. In the 1770s Sandby made a series of aquatints of views in Naples after drawings by Pietro Fabris, who worked for Greville's uncle, Sir William Hamilton. Greville accompanied Sandby on his second tour of Wales, providing the artist with views of the area around Sir William's property near Milford Haven, before returning suddenly to London on the death of his father. Greville himself experimented with aquatint in the early 1770s, and the example attributed to him here, which seems to be an etching and mezzotint over an aquatint base, was produced in 1784; two years later he set up his own printing press in his new house in

Paddington in order to print Bartolozzi's engravings of the Portland Vase. The frontispiece was designed and probably aquatinted by Greville himself to commemorate his uncle's role in bringing the vase to England.

Sandby issued a number of satirical prints of the balloon ascents in 1784, including one titled *Caelum ipsum petimus stultitia* (DG 6702), which was based on Greville's own drawing and print, but he exaggerated the resemblance of the balloon to human posteriors and added the small image of his own *English Balloon* of 1784 with asses' ears to the resulting explosion.

Literature: A. Griffiths, 'Notes on early aquatint in England and France', *Print Quarterly* IV, no. 3 (1987), 263–4; Jenkins and Sloan, 190–1.

JOHN NIXON (*c.*1750–1818)

142

(a) *The Sailing Club, on board the Phoenix to the Hope*, 1801

Pen and grey ink and watercolour, 160 × 222 mm

Inscribed: *JN 1801.* and *Messrs Clarks Lang Barnard & Bolland, on board the Phoenix to the Hope* and *the Sailing Club*

(b) *On board the Phoenix near the Hope below Gravesend*, 1801

Pen and grey ink and watercolour, 161 x 222 mm

Inscribed: *JN 1801.* and *Rt. Lang, B: Barnard. S Woodyere (J Bolland Drawing) Mr Gibson. E Browne. Mr Townsend. T Forster. (2 Mr Clarkes) Mr Ellis. & J Nixon. on Board the Phoenix, near the Hope below Gravesend NB: some of the Gentlemen in the Cabin*

Provenance: Mrs F. B. Haines, by whom bequeathed

1923-7-14-7, 8

In January 1735 William Hogarth, the lawyer Ebenezer Forrest and John Rich, manager of the Covent Garden Theatre, met George Lambert (cat. 61) in the latter's painting room at the theatre, and established the Sublime Society of Beefsteaks. The society met regularly and wore a ribbon badge shaped like a silver gridiron with their motto 'Beef and Liberty'. They ate and drank, and the president sang the song of the day, some-

times 'O the Roast Beef of Old England', an anti-French song written by Theodosius Forrest, son of Ebenezer. A month later, Hogarth's Engraver's Copyright Act was presented to the House of Commons. The two events were not unconnected. The Beef Steak Club was not merely a convivial society, but had an underlying agenda of defending British theatre, literature, art and culture from foreign invasion; the Copyright Act protected engravers from unauthorized copying of their work for fourteen years from the date inscribed on their prints, which helped to modify market prices in favour of prints produced in England.

Ebenezer Forrest, a lawyer, was the author of *Five Days Peregrination*, a sketching expedition down the Thames with Hogarth, Samuel Scott and John Thornhill in 1732 (British Museum, 201.a.6). His son Theodosius (1728–84), a lawyer like his father, was also involved in the theatre and music and was a talented amateur artist. A friend of Paul and Thomas Sandby, he sketched from nature, exhibited at the Royal Academy and undertook several peregrinations with Thomas Sandby and other friends, which were copied in manuscript and illustrated for the various participants. A manuscript copy of their tour of Flanders and Holland in 1769 is also in the Museum (198.a.44) and other tours are in the British Library (Manuscripts).

John Nixon was a successful merchant with a large establishment shared with his brother in Basinghall Street. Also an amateur, he toured extensively, particularly through Britain, supplying views for Grose and Pennant (cats 87–9), travelling with them, and following his friends Rowlandson and Grose in the production of caricatures and satires; at least eighty of the latter were engraved. He was a captain in the Guildhall volunteers, an amateur actor and a convivial host who surrounded himself with actors and wits as well as artists, and was secretary of the Sublime Society of Beefsteaks.

Although none of the figures, some of whom are sketching, has been identified, it is tempting to see the present watercolours as records of the continuation, in deed and spirit, of the peregrinations of the original members, lawyers, businessmen, actors and artists, of the Beefsteak Club.

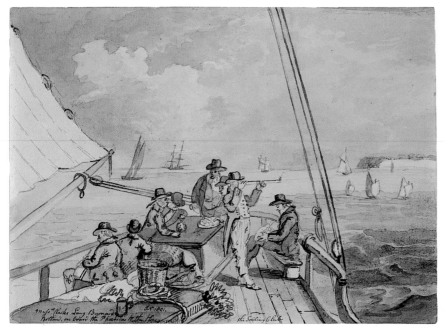

142(a)

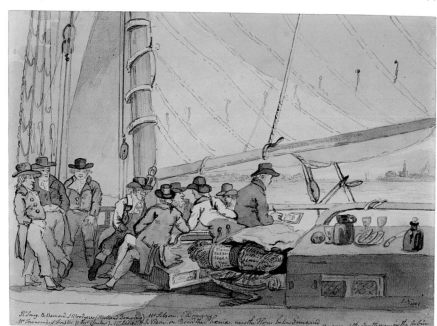

142(b)

Literature: Charles Mitchell, *Hogarth's Peregrination*, 1952; Huon Mallalieu, 'John Nixon and his circle', *Country Life* (12 May 1977), 1260–1; I. Bignamini, 'George Vertue, art historian, and art institutions in London, 1689–1768', *Walpole Society* LIV (1988), 95–8, 109 n. 4.

WILLIAM PARSONS (1736–95)

143
London from Hampstead, 1776

Pen and brown ink with watercolour with pen and ink border, 150 × 188 mm

Inscribed: *near the Spaniards Hampstead* and *by William Parsons. Comedian*

Provenance: Parsons and Sons, bt Tom Girtin 1926, by whom presented

1936-12-2-2

WILLIAM WOOLLETT (1735–85)

144
London from Hampstead, 1776

Pencil, 199 × 254 mm; on mount, 323 × 412 mm

Inscribed on mount: *A Sketch by W. Woollett, done at the Spaniards, Hampstead Heath, 1776. present, Sir Geo: Beaumont Bart: Will: Parsons, Comedian, & T. Hearne.*

LB 2(b)

Provenance: Purchased from Evans

1853-12-10-659

THOMAS HEARNE (1744–1817)

145
London, from the Spaniard's Inn, Hampstead

Pencil, 200 × 287; on artist's mount with wash border, 323 × 410 mm

Inscribed on verso of mount: *from the Spaniard at Hampstead*

Provenance: Presented by Edward Croft-Murray

1936-12-2-1

In 1776 William Woollett, engraver to the king, Thomas Hearne, watercolourist, Sir George Beaumont, collector and patron, and William Parsons, actor and comedian, went on a sketching expedition to Spaniard's Inn above Hampstead Heath.

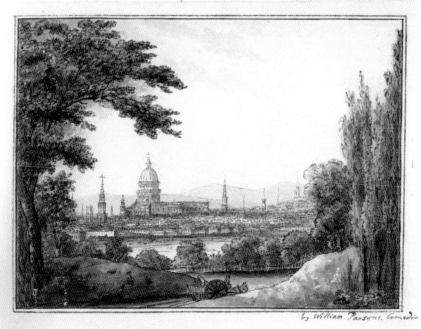

near the Spaniards Hampstead.

by William Parsons, Comedia.

143

A Sketch by W. Woollett, done at the Spaniards, Hampstead Heath, 1776.
present, Sir Geo: Beaumont Bart. Will: Parsons, Comedian, & T. Hearne.

144

Three of their resulting drawings are now in the British Museum.

Woollett was one of a group of engravers who built their reputations on engraving the best works by the best masters (he earned £7,000–£8,000 from his print after Benjamin West's *Death of Wolfe*). They were visited by wealthy connoisseurs who watched them work and to whom they sold their prints. Their shops bore select addresses and they dressed themselves well and 'cultivated an urbanity of manners' that permitted them to associate freely with their clients. Woollett received his royal appointment in 1775, which ensured his success, and he was able to issue proofs before letters and proofs on India paper for print connoisseurs at three times the price of ordinary impressions. His income was high, which was just as well, as his wife bore him at least five sets of twins and one set of triplets before his early death in 1785. He was successful enough not to need to sell the works of other engravers and he had a large number of pupils, including Thomas Hearne.

Woollett seems to have formed a particular friendship with the Revd Charles Davy (1722–97) of Henstead in Suffolk, tutor to Sir George Beaumont. Davy was the friend of a number of artists, including Beaumont's drawing master at Eton, Alexander Cozens. In the spring of 1771 Davy took his pupil to London for six weeks, and nearly every day was spent in Woollett's shop, watching Hearne and Woollett engrave and discussing paintings. Beaumont later claimed that this was when his 'love for painting was completely confirmed'. Farington later recorded: 'Sir George, who was then a pupil to Mr Davy then sketched Heads only, but being pleased with the sketches of Landscape made by Woollett and Hearne, he became their imitator' (*Diary*, 5 July 1809). The two engravers were invited to Henstead for the summer, passed 'in perfect happiness sketching all day and talking of paintings all night'.

Hearne went off the Leeward Islands afterwards and Beaumont to Oxford, where he entered the circle of Malchair and the Bowles family and joined their amateur dramatics at North Aston, which included the company of Thomas Jones and George Dance. He took every opportunity to perform himself and to see his favourite actors, particularly Garrick, at Drury Lane, and became friendly with several of them, especially William Parsons. Apprenticed to a surveyor, Parsons had begun to play

as an amateur in theatrical productions and, encouraged by his success, he took it up professionally, intending to fall back on his ability to paint fruit and landscapes for additional income if necessary. He exhibited paintings at the Free Society of Artists and Society of Artists in 1765 and 1773 respectively as an honorary exhibitor, but by this time he had a prolific career as an actor. The present drawing is his only known surviving work, but the *DNB* (1895) records that John Bannister, a fellow actor and comedian, owned a view by Parsons 'the details of which are admirable, of the city and St. Pauls from the Spaniards Inn, Hampstead', then in a private collection at Ware Priory, Hertfordshire. The earlier provenance of the present work is not known and it is impossible to say whether the *DNB* was describing a watercolour or oil. Nevertheless, this small drawing was clearly the result of the sketching expedition made with Woollett, Hearne and Beaumont in 1776. Hearne's drawing is unfinished, but was obviously treasured for another purpose, perhaps the memory of this occasion, as it has been carefully mounted, a treatment normally reserved for finished works.

Literature: Hardie I, 174–6; Sloan 1986, *Cozens*, 57–8; Brown and Owen, 10–12, 22–3, 28; David Morris, *Thomas Hearne and his Landscape*,1989, 6–7; Clayton, 210, 229.

THOMAS SUNDERLAND
(1744–1828)

146

*The Mill at Ambleside, c.*1795–9

Pen and brown ink and watercolour, over graphite, 326 × 236 mm; on mount with wash border, 470 × 340 mm

Provenance: Purchased from P & D Colnaghi through the H. L. Florence Fund

1940-7-13-22

Thomas Sunderland's drawings and watercolours, most of them mounted and many in albums, were released on the market by his descendant at a sale at Sotheby's on 14 July 1919. An unscrupulous dealer inscribed many of them with the purported signatures of Paul Sandby and D. M. Serres, but most of these are now recognized again as Sunderland's work. Some of the albums have remained intact and occasionally appear in the sale rooms (fifty-one views of

145

Ireland were sold at Sotheby's, 16 July 1992, lot 52). The British Museum has an album of sixty-four views in the Lake District drawn in 1800 (1941-2-8-126 to 190; 200*.b.2), which does not appear to have come from this sale, but contains versions of watercolours that were in the sale and are now in various collections (e.g. Leeds City Art Gallery).

Like Richard Payne Knight and Charles Gore, Sunderland's family, originally from Yorkshire, had regenerated their income through marriage and industry, in this case ironworks, near their home at Ulverston. Sunderland's sale included a large collection of prints, amongst them Earlom's after Claude and Charles Rogers's *Century of Drawings*, as well as a group of landscape drawings, with a signed and dated one of 1766 by Alexander Cozens. Sunderland filled albums with his own copies after old masters, the Antique and after Lavater's drawings of heads and figures. There were groups of drawings and albums of his own landscapes drawn in Switzerland, Wales, Italy, Ireland, Scotland and Spain. But the best were mainly of the Lake District and mounted on his characteristic mounts, signed and dated 1791–8 (lots 192–4).

Sunderland has always been described as a pupil of John Robert Cozens (cat.125) because his drawings of the Lake District

were so similar to Cozens's and because Cozens was said to have based his late watercolour of *Lodore Falls* (B&G 442, now Abbot Hall Art Gallery, Kendal) on a sketch by Sunderland (now BM 1941-2-8-136). Sunderland's manuscript record of Cozens's 'method of tinting landscapes' (B&G Appendix) has also been seen as proof that he was a pupil, but such 'recipes' circulated extensively amongst amateurs and professionals and it merely indicates that he managed to obtain a copy, much as Sawrey Gilpin and Ozias Humphry had done with Alexander Cozens's recipes in the 1760s and 1770s.

Sunderland's watercolours are superficially as close to those of Edward Dayes, Joseph Farington and especially Sir George Beaumont, as they are to those of John Robert Cozens. This is a clear indication that it was not Cozens's stylistic approach that an amateur would be hoping to learn from him, but rather his unique attitude towards composition, which could be learned more by studying his works than from actually taking lessons from him. In fact it was precisely this aspect of his work, his way of looking at a landscape, that was of the greatest benefit to the later work of Turner and Girtin, who had been employed to copy hundreds of Cozens's sketches for Dr Monro (cats 151–3).

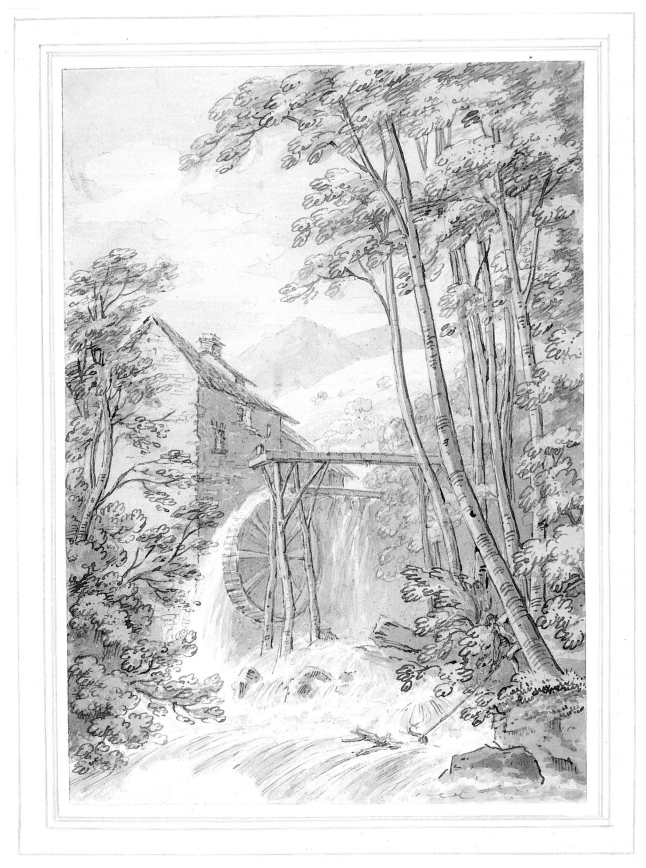

Literature: Randall Davies, 'Thomas Sunderland (1744–1823): Some family notes', *Old Watercolour Society's Club* XX (1942), 31–9; Bell and Girtin, 'Some additions and notes to vol. XXIII of *Walpole Society*', 3–6; Wilton 1980, 59.

MARY SMIRKE (1779–1853)

147

(a) *The Grove at Stanmore, Middlesex*

Watercolour and white bodycolour over graphite sketch, 250 × 190 mm; mounted on trimmed album page with gold border, 296 × 235 mm

Inscribed: *The Grove Stanmore*; and on verso: *84*

(b) *Glen, near The Grove, Stanmore, Middlesex*

Watercolour and white bodycolour over graphite sketch, 190 × 254 mm; mounted on trimmed album page with gold border, 251 × 309 mm

Inscribed: *Grove's Glen Twilight*[?], and on verso: *72*

Provenance: Cyril Fry, his sale, Sotheby's, 28 May 1998, lot 507, purchased by the Museum with funds from an anonymous donor

1998-7-11-17, 18

Robert Smirke (1752–1845) exhibited at the Society of Artists from 1775 to 1778, mainly history paintings and portraits. He is often discussed as an illustrator with Thomas Stothard, Richard Corbould and Edward Francis Burney, and he exhibited paintings the subjects of which were taken from Milton, Shakespeare or Thomson's *Seasons* at the Royal Academy from 1786 to 1813. He is also said to have added figures to Farington's landscapes. The two men were great friends and, after receiving a good classical education and excelling in languages, his daughter Mary used to accompany them on sketching tours. She thus learned from her father and Farington, but also from her brothers, Robert, the architect of the British Museum, and Richard and Edward, both antiquaries, with whom she sketched in Wales and in the summers in Richmond and Hampstead. Smirke resolved to give her 'as strong an education in drawing as would enable her to practise any branch of the Art she may be inclined to' (Egerton, 1348).

Mary Smirke was a skilled copyist, from manuscripts in the British Museum and

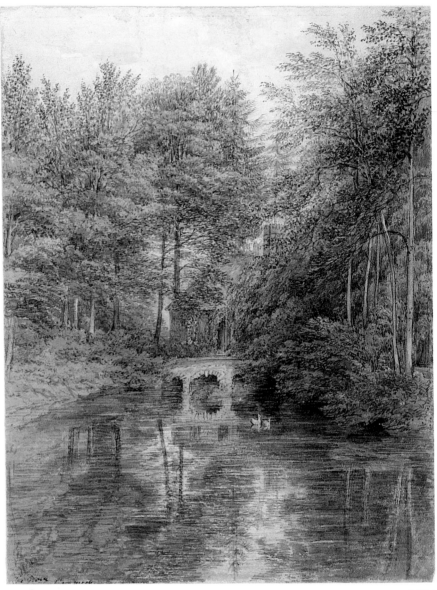

147(a)

on commission from George Dance and Thomas Lawrence. Farington passed to her some of his pupils and she gave drawing lessons, exhibiting at the Royal Academy from 1809 to 1814. She made a series of finished watercolours of views in Wales from drawings by the Duchess of Rutland so that they could be engraved and presented to the duchess's friends (*Valle Crucis* is now in the Victoria and Albert Museum). Afterwards her time was increasingly taken up with household duties, but in 1818 her translation of *Don Quixote*, which she had begun in 1810, was published with illustrations by her father. During the 1790s he had exhibited a number of paintings depicting passages from Cervantes's novel.

These views of the Grove were in a beautiful embossed leatherbound album containing twelve similar works by Mary Smirke, which was acquired by Cyril Fry in the 1970s. They illustrate her training not only in landscape, but particularly as a copyist, in her use of bodycolour and the miniature quality of her approach to the subject and small brushstrokes. The Grove and the Glen were presumably in the wooded stretches that still remain on the high ground of Stanmore Common; a church or large house is just visible in the background of the view of the Grove. This may be Bentley Priory, also called Stanmore Priory, enlarged for the Marquess of Abercorn between 1815 and

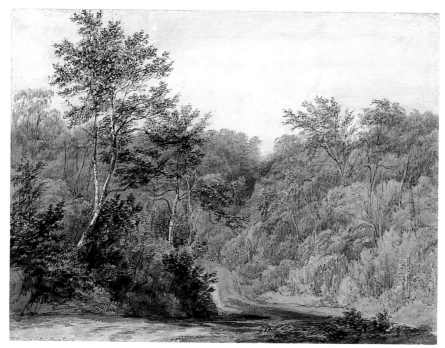

147(b)

and connoisseur with a particular fondness for Dutch painting. Beaumont's wedding present to the couple in 1793 was an oil painting by himself of a very Dutch-like scene of a cottage at Dedham, in Suffolk. Amelia made copies from many of the old masters in their various collections. But Charles Long was also keen to support contemporary British artists and, like the others, regularly attended the annual Royal Academy dinners; he subscribed towards the upkeep of John Robert Cozens's family and helped to fund Girtin's trip to Paris.

In the 1790s Amelia became a pupil of Girtin and Henry Edridge, with whom she had probably come into contact through Dr Monro. No details of her lessons are known, but it must have been through them that she learned to draw and paint in watercolours from nature. First, however, like many of their other pupils, including Dr Monro and John Henderson, she probably learned to handle her pencil by copying Edridge's detailed drawings and to paint in water-colours by copying Girtin's own (her copy of his *Kirkstall Abbey* is now in the Yale Center for British Art, New Haven (Conn.)). By the time she drew the present view in the gardens at Bromley, where she and her husband had moved in 1801, and which they had designed, she had a confident hand that had absorbed lessons from drawings she had seen by other artists as well, particularly the Gainsboroughs in the collections of Dr Monro and Beaumont. She painted in watercolour and oil, but she was most accomplished as a draughtsman

1818 by Mary's brother Robert Smirke. His own Jacobean-style house, Warren House, was nearby (now Springbok House).

Literature: Judy Egerton, 'An artist of little leisure: Mary Smirke, 1779–1853', *Country Life* (20 November 1969), 1348–9.

AMELIA LONG (1772–1837), *née* HUME, after 1820 LADY FARNBOROUGH

148

Bromley Hill, 1805

Pencil, 248 × 389 mm

Inscribed: *Bromley Hill Amelia Long 1805*

LB 1

Provenance: Bequeathed by Richard Payne Knight

Oo.5-55

Amelia Hume's earliest work in the Museum (cat. 31) is firmly in the tradition of young lady amateurs being taught to make small copies of oils using a miniaturist's technique. Although both her parents were amateur artists, as well as connoisseurs, there is no evidence of where or from whom she received her early training. Even in that earliest work, however, it is clear that her skill was formidable and it is not surprising

to learn that she was later said to be Girtin's favourite pupil. Shortly after painting the *Madonna and Child*, she married Charles Long (1761–1838), a great friend of William Pitt, who held a succession of government positions, advised the monarch and spoke frequently in parliament on the arts. Like his father-in-law Sir Abraham Hume and his friends Sir George Beaumont and Richard Payne Knight (who once owned the present drawing), Long was a collector

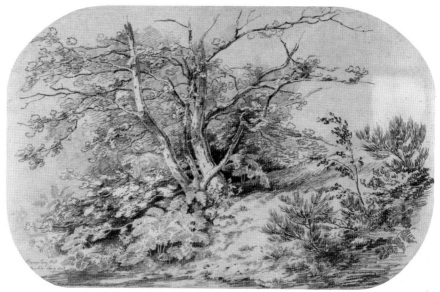

148

and produced soft-ground etchings for distribution among her friends. She was also one of the first in England to experiment with lithography.

Literature: Tessa Sidey, *Amelia Long, Lady Farnborough*, exh. Dundee Art Gallery, 1980; Clarke and Penny, no. 147; Brown and Owen, 82–3, 86.

SIR GEORGE BEAUMONT (1753–1827)

149
Landscape with waterfall, 1802

Black and white chalk on blue paper, 233 × 330 mm

Signed and dated: *Sept 15 1802*; and inscribed on verso: *near Coleorton* Wednesday Sept. *15. 1802*

LB 1 (incorrectly as 1818)

Provenance: Richard Payne Knight by whom bequeathed

Oo.05-56

In 1784 Sir George Beaumont was elected to the Society of Dilettanti. He already knew some of his fellow members, including Uvedale Price, who had inherited his father's collection at Foxley (see cat. 117), which included a number of works by Gainsborough, an old acquaintance of the family. Price had, like Beaumont, also been a pupil of Malchair at Oxford. Charles Gore, Charles Townley and, later, the Revd Cracherode were fellow members and collectors, as was Richard Payne Knight, who shared with Beaumont his taste for Dutch painting and had also recently begun to collect old master drawings. He, too, was a patron of Cozens and of Hearne, who was currently engaged in painting views of Knight's seat at Downton.

Another taste Beaumont and Payne Knight shared was for Gainsborough's drawings, although this was several years later, after the artist's death. Both purchased important groups of drawings after Gainsborough's daughter's sale at Christie's, 11 May 1799, when several sketchbooks were bought in. Payne Knight acquired one, now in the British Museum, which contained several early studies from nature, including a drawing of an artist using a Claude glass (Oo.2-27, fig. 4), while Beaumont shared the contents of a second group with another collector. During the 1790s and early 1800s Gainsborough's unfinished drawings and sketches thus

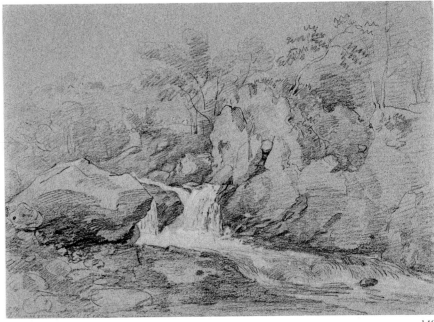

149

entered the collections of many amateurs and connoisseurs (Dr Monro was another admirer and imitator of his work). These were the beginnings of a taste for a type of drawing that had never been collected or valued during the artist's lifetime, but which 'spoke' to collectors and amateurs who had recently begun to look at nature in a new way, and who were also very concerned with the establishment and consolidation of a national British school of art.

The present drawing, although strongly influenced by Gainsborough, was drawn from nature at Coleorton, in Leicestershire, to which Beaumont had finally won full title in 1802 after a long legal process in which he was assisted by John Mitford (see cat. 130). Two other close friends at the time were William Mitford and Uvedale Price, who were advising him on the house and gardens he was planning to build at Coleorton, next to the forest of Charnwood.

Literature: Clarke and Penny, no. 138; Brown and Owen, 59–60, 148.

150
Framlingham Castle, Suffolk, 1783

Black chalk and grey wash, with part of a landscape on verso, 186 × 241 mm

Inscribed on verso: *Framlingham Castle Thursday Septr 11th 1783*

Provenance: by descent to Sir George Beaumont, from whom purchased through Felicity Owen

1973-6-16-11

Sir George Beaumont's first lessons in drawing were at Eton where he was taught by Alexander Cozens. Although Henry Angelo in his *Reminiscences* recalled being taught to invent landscapes from sketches created by pressing paper on a series of accidental blots, and that Beaumont was the 'only disciple who could make anything of the matter', Cozens also taught his pupils by more traditional methods. Beaumont's Eton sketchbook (private collection) indicates that he copied from drawing manuals and outline etchings of Cozens's own landscapes, as well as from simple watercolour landscapes with only one or two elements, as preparation for learning to draw from nature. Even though Cozens's method of inventing landscapes from blots did not require one to be in front of nature, the ability to work up the blot with invention into a landscape did require a knowledge of the elements of landscape, which could only be learned by studying from nature itself.

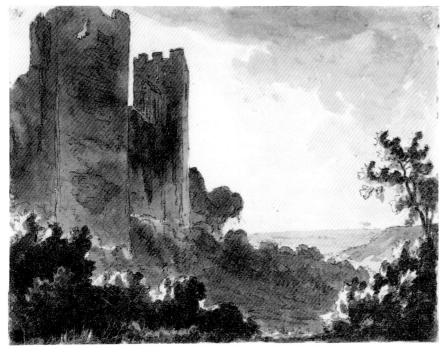

150

151

Portrait of Dr Thomas Monro

Pen and grey ink, 175 mm × 129 mm

LB 1

Provenance: Bequeathed by Colonel Kennett Henderson

1893·7·17·2

Dr Thomas Monro (1759–1833), the third generation of physicians to Bethlem Hospital, was educated at Harrow and Oxford. His name, however, is never mentioned in connection with Malchair, and very little is known about his artistic education before 1794 when he moved into 8 Adelphi Terrace, London. But his interest in and patronage of art must have begun much earlier as he was one of the subscribers to Alexander Cozens's *Principles of Beauty* (1778), for which subscriptions were taken from 1776. When Monro moved into Adelphi Terrace, John Robert Cozens was already in his care and shortly afterwards Payne Knight and Beaumont raised a subscription to help pay for his care. On 9–10 July 1794, the contents of Cozens's studio, including many works by his father, were auctioned by Greenwood's, and although no buyers' names are recorded in the only copy (National Art Library, Victoria and Albert Museum), the later contents of their collections indicate that Beaumont, Payne Knight, Harcourt and Monro were amongst the purchasers.

Because the contents of this sale were not known to earlier writers, it has always been assumed that John Robert's drawings were in the care of Dr Monro and used as the models to copy when the doctor held his 'academy' in the evenings at the Adelphi from 1794 to 1797. Instead, the Cozens outlines that Turner and Girtin copied and washed into 'finished' drawings for Monro were only those works that the doctor had managed to purchase at Cozens's sale or borrow from his friends. Turner and Girtin were given a half-crown and their supper, but they were not the only artists who attended this informal academy, and Cozens's were not the only works that were copied. Farington recorded that Monro 'has young men employed in tracing outlines made by his friends &c. – Henderson, Hearne &c. lend him their outlines for this purpose' (*Diary*, 30 December 1794).

This view in Suffolk was drawn by Beaumont very soon after his return from his grand tour with his wife, who was also a skilled amateur and copyist of old master drawings. The entire journey can be followed through Beaumont's drawings, many of which remain with his descendants. Most are in a similar medium, grey or blue monochromatic washes over pencil drawings, usually mounted and inscribed with a title and date. Although he already knew how to draw landscapes, having admired and copied the works of Richard Wilson for years and having had lessons during the 1770s from various artists, including Thomas Hearne and Malchair, Beaumont's drawings from his Italian tour of 1782–3 are closest to the work of John Robert Cozens.

Cozens had accompanied William Beckford to Rome and Naples in 1782, and at the end of the year returned to Rome to study without his patron. He spent his time in Rome drawing with fellow artists and visiting Allan Ramsay and his family, where he frequently met the Beaumonts and other grand tourists who commissioned watercolours from him, based on the sketchbooks he was filling with grey wash drawings (now Whitworth Art Gallery, University of Manchester). Occasionally the dates on Beaumont and Cozens's drawings coincide, and it seems likely that they sketched together. These drawings and those like the present work that Beaumont made on his return to England are less laboured than most of his work, and they were to prove a strong inspiration for John Constable's own style when he was permitted to study them in 1799 and again in 1823. As Malchair remarked in a letter to Skippe when he saw these drawings at Christmas 1783, Sir George was now 'a very capital drawer of Landskipp'. Beaumont purchased a number of both Cozenses' works at the younger's sale in 1794, owned copies of their publications and helped to support John Robert's family financially during his illness (see cat. 151). When Constable carefully studied and copied Beaumont's watercolours and writings by Alexander and John Robert Cozens in 1823, they had a profound effect on his own approach to landscape.

Literature: Sloan, 150–5; Brown and Owen, 48–56.

John Henderson was a near neighbour of Monro at the Adelphi; but apart from his collections, which were extensive and left to the nation on the death of his son, very little is known about his early activities. He was a talented amateur and took a series of views of the harbour at Dover with a camera obscura sometime before 1795. But most of his drawings were copies of the works of other artists, many of them traced by the method employed by Monro and the young artists in his 'academy', which was to place the original drawing and a sheet of paper over it on a glass, with a light behind it. Most of his drawings of this type in the British Museum came in his son's bequest of 1878, and include competent and well-coloured copies of watercolours by Cozens and Girtin amongst others; they still cause a great deal of confusion regarding attribution, as they often record originals that are now lost (see cat. 154).

Literature: Fleming-Williams, in Hardie III, 278 ff.; Andrew Wilton, 'The Monro School question: Some answers', *Turner Studies* IV, no. 2 (1984), 8–23.

DR THOMAS MONRO
(1759–1833)

152

(a) *A rocky pinnacle*

Black chalk, with grey wash, 188 × 120 mm

Provenance: Presented by Mrs Athelstan Coode

1904-6-27-3

(b) *A pond under a dark sky*

Black chalk, with grey wash, 148 × 215 mm

Provenance: Presented by F. R. Meatyard

1939-7-4-6

The present drawings are two examples of the most common type of drawing by Dr Monro that survive in hundreds of collections, as they remained in albums in the hands of his descendants, and were given away or sold throughout the twentieth century. They are usually said to have been drawn out of doors from nature in Payne's grey or ink wash and worked up at home with crayon, pen and ink or, most commonly, as here, with a stick of dry Indian ink while the paper was still wet. Monro's grandson recorded that the doctor kept drawing paper in a pan of water, taking sheets as required and placing them on a pad of blotting paper to draw on with the stick of ink and sometimes a brush. Other drawings were made on dry paper with a stick of ink dipped in water. Clearly, not all these drawings were made from nature: the present *Rocky pinnacle* is actually an interpretation of John Robert Cozens's watercolour of *Schloss Hadernburg between Brixen and Bolzano* (B&G 209), one of the views taken on his second trip through the Alps with William Beckford in 1782. A 'Monro School' copy of this composition was known to exist, but the present drawing is clearly inspired by Cozens's work, rather than copied directly, reflecting the family tradition that Monro called his drawings his 'imaginings' – a clue to the type of drawing he collected and admired, which was not related to those of the 'Monro School' with which he is usually associated.

151

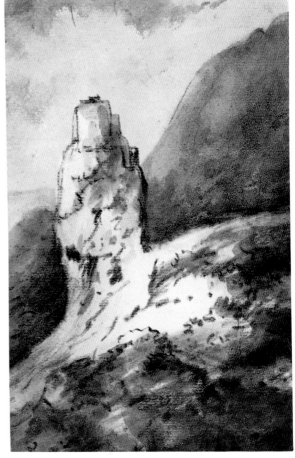

152(a)

152 (b)

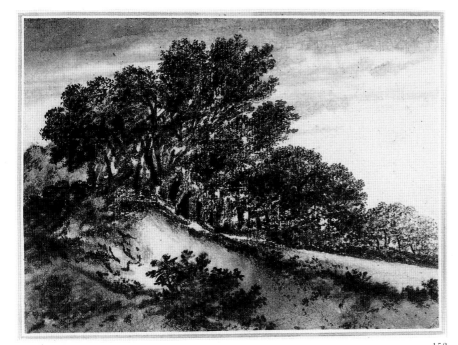

153

In his own drawings, Dr Monro shows a debt to earlier artists, rather than the contemporaries who worked for him or whose works he purchased. On his father's death in 1791, he inherited his extensive collection of drawings by old and modern masters, keeping a few but selling most of them through Greenwood's over six days in April 1792. The collection included large numbers of works by Wilson and especially Gainsborough. Dr Monro himself was to form a large collection of the latter's work in particular, buying heavily at his sale, including Gainsborough's 'camera' and its transparencies on glass (now Victoria and Albert Museum). The British Museum contains at least one direct copy of a Gainsborough drawing by Dr Monro, and his admiration for this artist is significant in the light of J. L. Roget's later statement that 'As a leader of connoisseurship, he [Dr Monro] was looked upon in his day much in the same light as Sir George Beaumont and Mr Payne Knight ...' (quoted in F. J. G. Jefferiss). After his death the sale of his collection of drawings by modern and old masters took five days (Christie's, 26–30 June 1833).

Literature: F. J. G. Jefferiss, *Dr Thomas Monro and the Monro Academy*, exh. Victoria and Albert Museum, 1976 (n.p.).

153

Landscape

Black chalk, with grey wash, 172 × 233 mm

Inscribed on verso: *To Campbell Dodgson on his retirement as Keeper of the Prints and Drawings at the British Museum and in affectionate admiration from his friends Robert & Mary Witt 13 August 1932* and *The book from which this drawing is taken is inscribed on the cover: – These drawings were executed and presented to Lord Essex by his much esteemed friend Dr. Monro A.D. 1814*

Provenance: Presented by the artist to Lord Essex; Robert and Mary Witt, presented to Campbell Dodgson, by whom bequeathed

1949-4-11-30

George Capel-Coningsby (1752–1839), the 5th Earl of Essex, was a descendant of Lady Carnarvon's brother (cat. 24). He made his grand tour with his wife in 1791–2 as Viscount Malden. He himself was not an amateur, but Lady Malden, like the young Amelia Hume (cat. 31), was a talented copyist of old masters in miniature. According to Walpole's notice of her in his *Anecdotes* (V, 239), her painting improved

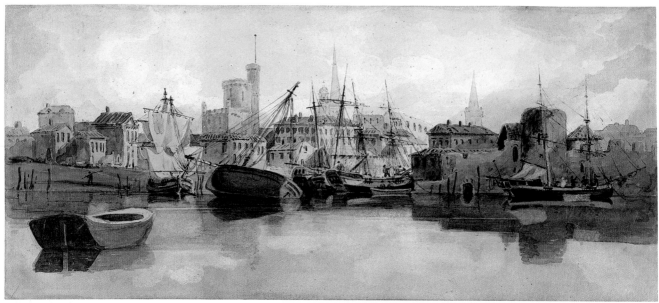

154

greatly during her time in Italy, and she applied several times to make copies of paintings in the Uffizi.

Although this drawing is reminiscent of a composition of Alexander Cozens, an imaginative landscape rather than a study of nature, it is included here as much for its status as a social document as a work of art. Its history detailed in the inscription on the verso is a vivid reminder of the role that the creation, giving as gifts and collecting of amateur drawings has played in 300 years of British culture and society.

JOHN HENDERSON (1764–1843) ? after THOMAS GIRTIN (1775–1802)

154
Southampton

Watercolour, 188 × 430 mm

Provenance: Bequeathed by P. C. Manuk and Miss G. M. Coles through the National Art Collections Fund

1948-10-9-15

In late 1795 John Henderson showed Dr Monro the group of outline drawings he had made at Dover with the assistance of a camera obscura. At least one of these was later turned into a 'Monro School' drawing by Girtin, with grey and blue wash; the existence of several copies of the outlines also indicates that they were probably traced by Girtin and/or Turner. The problem of attribution has exercised many writers since the arrival of a group with the Henderson bequest in 1878, which was complicated by a further series that came through a descendant of Monro; this was presented to the Museum by C. F. Bell in 1935.

The present watercolour came into the Museum simply as a watercolour of Southampton by Henderson. Two views of Southampton that Girtin is known to have painted are now lost, and this has been assumed to be a copy of one of them (G&L, 210), although no documentation for this has been found. It has been assumed to have been copied from Girtin because of its similarity to his work, especially in colour, although a closer examination shows it does not have his crispness of touch in drawing or finish. The Museum has a full-size copy of Girtin's watercolour of Durham Cathedral, which came in the Henderson bequest (LB 7: 1878-12-28-36, G&L 236).

It has often been questioned whether Monro's or other patrons' collections of drawings by earlier British masters such as Wilson or Gainsborough affected the work of Girtin or Turner. The presence in the Museum of a watercolour copy by Girtin, dated 1794, of Richard Wilson's *Villa Adriana* (1878-12-28-356), as well as copies by him of works by Canaletto in the Henderson bequest and of copies after Sebastiano Ricci and prints by Piranesi and Dutch artists in other collections, indicates that the young artists did indeed learn a great deal from their patrons' collections. Copying was as important a method of learning for professionals as it was for amateurs.

Literature: Thomas Girtin and David Loshak, (G&L) *The Art of Thomas Girtin*, 1954; Susan Morris, *Thomas Girtin*, exh. Yale Center for British Art, New Haven (Conn.), 1986, 14, 18.

PRINCESS ELIZABETH (1770–1840) after MARCO RICCI (1676–1730)

155
Pastoral scene with a youth climbing a tree

Pen and ink with black and grey wash, on three joined pieces of varnished paper, 370 × 542 mm

Inscribed: *right*

Oppé 1950, 157

Lent by Her Majesty The Queen (RL 17354)

In 1946, when Oppé found this drawing in Queen Charlotte's portfolio of drawings by the princes and princesses, he firmly attributed it to Alexander Cozens on grounds of style; he accounted for its presence in the portfolio by stating that it must have been connected with their instruction, as Cozens had been their drawing master from at least 1778 until his death. In fact, the royal

accounts indicate that Cozens taught the princes Edward and William from the autumn of 1778 until William joined his ship the following year, after which he taught Edward alone (Oppé 1952, 39–40). A watercolour of ships at sea dated 1781 by Prince Edward (RL K308) indicates that this was the type of instruction he and his brother were receiving from Cozens. Amongst many other drawing masters, John Alexander Gresse and possibly Richard Cooper, as well as the children's tutor Dr John Fisher, were also giving them lessons in landscape at this time.

Clearly, the use of varnished paper (the varnish contained oil, which made the paper more translucent for tracing at the time, but has since gone yellow), the monochromatic use of wash and the manner in which the drawing was mounted led Oppé to his conclusion that Cozens copied this drawing by Marco Ricci. However, comparison of Cozens's work of this date (see

cat. 107), and the fact that a teacher who set his pupils the task of copying a drawing by another artist would assist them in copying, rather than by making a copy himself, point to this being the work of a pupil rather than of Cozens. Despite its accomplishment, the handling is not as good as Cozens's. It was, however, Jane Roberts's discovery of the existence of another copy of the same work by Princess Elizabeth at Bad Homburg (Gotisches Haus, E125) that led her to the conclusion that the present work is also by the princess. The fact that the paper was oiled indicates that she traced Ricci's original drawing of golden brown ink (RL 0115; A. Blunt, *Venetian Drawings … at Windsor*, no. 144), one of a large group purchased by George III from Consul Smith, before she added the ink wash. Marco Ricci was the nephew of Sebastiano Ricci and had been brought to England in 1708 to paint scenery. In 1712 he in turn brought his uncle to England where they worked together before

returning to Venice. His drawings were made as finished works in their own right, not as preparatory sketches for oils and, unlike his uncle, few of his works in the Royal Collection contained bodycolour.

Queen Charlotte and her daughters anticipated the later taste for Gainsborough's drawings demonstrated by Dr Monro and Sir George Beaumont by several decades. When the artist was painting portraits of the individual members of the royal family in the 1780s, he gave lessons to some of the children, which seem to have taken the form of giving them drawings to copy. He apparently took special trouble with Princess Mary, later Duchess of Gloucester, whose portrait of 1797 by Sir William Beechey shows her holding a sketchbook with a drawing of a bust of a child similar to one found in some of Gainsborough's portraits. In their companion portraits, her sister Princess Elizabeth draws a vase of flowers, while Princess Augusta (see cat. 173) holds a sketchbook with a drawing remarkably like one of the figures in Gainsborough's late 'fancy pictures'. According to Whitley, a dealer's exhibition some years after Gainsborough's death included drawings and sketches in oil of landscapes and cattle, which the artist 'had made expressly for Princess Mary to copy' (p. 74). He also stated that Charlotte, the Princess Royal, 'formed a class for drawing and painting' for her sisters and friends at Buckingham House in the winter of 1786–7.

Literature: Oppé 1947, 37; Whitley II, 74; Oliver Millar, *Later Georgian Pictures in the Royal Collection*, 1979, 8–9, pls 163–6; Roberts 1987,

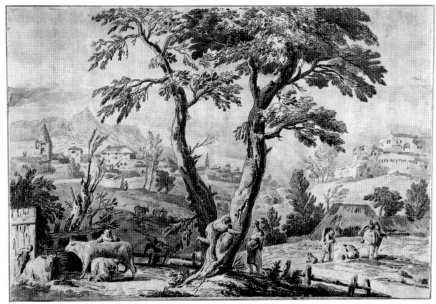

155

7

Muses and Sibyls

Shortly after the death of Sir George Beaumont (cat. 149), the artist Benjamin Robert Haydon (1786–1846) wrote:

Sir George was an extraordinary man, one of the old school formed by Sir Joshua – a link between the artist and the nobleman, elevating the one by an intimacy which did not depress the other. Born a painter, his fortune prevented the necessity of application for subsistence, and of course he did not apply … Painting was his great delight. He talked of nothing else. His ambition was to connect himself with the art of the country and he has done it forever.[1]

From the earlier discussion of the seventeenth-century *virtuosi* and Sir Nathaniel Bacon, who was praised by Peacham and Norgate as the exemplar of a gentleman-painter, we are more aware than Haydon that the 'old school' was not formed by Joshua Reynolds and that Beaumont was one of the last of a much older link between the artist and the nobleman. Two hundred years earlier, Norgate had observed that as in poetry where *Orator fit, Poeta nascitur* (an orator is made, a poet born), so in art:

in whome soever there appeares a naturall inclination propensity or love to this Art, he cannot but become excellent, if he meete with sutable meanes, Leasure, and opportunities, that may be assistant to that naturall inclination. But where that is wanting, and noe other use to be made of this, but as a Get Penny, a drudge for profitt, and a mecanique trade to live by, without the Company or Conversation of the Graces, or the *Muses*, I thinke it impossible for such an one, though *Vandike* were his Tutor, ever to become other then a *Nonproficient*.[2]

Thus a gentleman could be an 'excellent' artist, but anyone who laboured for profit alone could only be 'nonproficient'. In the seventeenth and eighteenth centuries professional artists were often perceived as mere artificers who worked for money rather than love, their work created by mechanical processes rather than informed by the gentlemanly qualities of virtue, taste, reason and even genius. This is the reverse of today's attitudes towards professionals and amateurs: as good as they often were, Bacon, Prince Rupert, Marshal and others throughout this study never produced works that modern critics might consider the equal of those painted, drawn or engraved by professionals. We understand now, however, that they did not wish to: even at the beginning of the nineteenth century, John Nixon (cat. 142) was praised for maintaining 'that gentlemanly independence which enables him to set all the laws of drawing at defiance', which preserved him to his 'legitimate ranks as an *honorary exhibitor*'.[3]

At the same time, however, Sir George Beaumont, Lady Long (cat. 148), John White Abbott (cat. 137) and others were publicly exhibiting drawings, watercolours and oils that some critics felt were equal to or even surpassed the work of professionals on the walls next to them. To display such superior technical skill in public was to demonstrate a preference for execution over genius and to forego a gentleman's innate superiority of mind over professional artifice. The reactions to these crossings of boundaries were to completely alter the relations between professional and non-professional artists in the nineteenth century. Our concern in the present chapter is to examine the last of Haydon's 'old school'.

One final indication that the boundaries between the professional and amateur were in a constant state of flux at the time, retaining seventeenth-century attitudes alongside more modern ones, is provided by William Gilpin's attempts to assist the young William Lock (cats 160–1) in pursuit of his muse. From the beginning of their association, Gilpin noticed that Lock could not be induced to draw 'if the fit was not on him', commenting that 'It is a happy thing for him however, that he has not his bread to get by his art.' In despair at his lethargy in 1787, Gilpin sent Lock's father a mock obituary notice, which concluded:

The fact is, he was born a gentleman; & lay under the misfortune of not being obliged to use his pencil for maintenance. If his father had been so kind as to have disinherited him; & bequeathed him only a pot of oil – a few bladders of paint – a pallet, & a dozen brushes, it is thought he would have made one of the greatest masters in the art of painting, the world ever saw.[4]

William Young Ottley (cats 162–3) was not obliged to earn his living either, but instead of being discouraged by any inability to compete with real artists, he continued to study with them and employ the knowledge he gained in an occupation that was worthy of a gentleman – as a collector and a connoisseur. The difference between them in approach and application and what they chose to do with their art was not due to age or wealth, but to the difference in the way they were encouraged to pursue their accomplishments. The ten-year-old Lock was pushed because of his natural abilities at sketching to produce larger, more finished compositions, the type attempted by professional artists, without attaining an appropriate age or being given sufficient training. Ottley, on the other hand, was provided with professional training, but was given a free hand to use or follow it as he wished, as a gentleman and an amateur.

Life Drawings, Bluestockings and Separate Spheres

Although many factors in the relationship between professional and non-professional artists had remained the same throughout the seventeenth and eighteenth centuries, there were of course many changes in education, economics and society that affected cultural perceptions of their activities. Some were as subtle as changes in the use of certain words while others amounted to an almost complete division of some of the activities that men and women had once shared into those considered appropriate to their respective public and domestic domains.

One element of the study of art by non-professional gentlemen that had not altered was their ability to study alongside professionals in the life academy, which remained closed to all women. It was expected that women would learn to draw figures by studying and copying their drawing masters' drawings or prints, or the cold white marble sculptures of 'the Antique'. Despite Chambers's image of a young lady drawing from the Antique in Townley's collection (cat.167), and Bartolozzi's serious young woman copying a life drawing (fig.5), relatively few drawings resulting from such studies by female amateurs exist and almost none of these women attempted serious historical figure compositions along the lines of the examples by Byron, Lock and Ottley that follow this essay. Where men such as Jane Austen's Edward Ferrars could comfortably claim ignorance of the niceties and jargon of the 'picturesque', expressing only a preference for a landscape that 'unites beauty with utility',[5] their expected role in the creation and improvement of a national school of art dictated a keener taste for and knowledge of the higher realm of history painting.

From Norgate's time, a knowledge of artists and schools was understood to be as much a part of the pursuit of art for men as learning to draw. Jonathan Richardson's collection of drawings, which included Prince Rupert's *Landscape* (cat.1), and the aristocratic collections he helped to shape were meant to be comprehensive illustrations of the 'progress' of design,[6] an intention echoed at the end of the century not only by Ottley's collection of the works of artists before Raphael, but his lavishly illustrated catalogues of the collections of others.

Few women collected: their roles as connoisseurs were instead limited to the works they chose to copy, present as gifts, and exhibit at the Society of Arts and Royal Academy, and their visits to exhibitions, museums and private collections. We have already seen that the wives of seventeenth-century courtiers and *virtuosi* were educated not only in the womanly arts of needlework, dancing, singing and enough mathematics to keep household accounts, but that they also often shared their husbands' or brothers' studies in the classics and poetry, as well as botany, geography, astronomy and other sciences; they were permitted and even encouraged to attend public lectures at some academies. They were lent and copied old masters, the results gracing the closets of kings and of their friends, and both they and their husbands commissioned and used such copies to demonstrate their taste and knowledge of the arts.

This situation did not suddenly cease to be true in the first half of the eighteenth century: Augusta, Princess of Wales, lined her closet with copies by Joseph Goupy, to whom the Duke of Chandos had earlier paid £50 for each of his twenty-inch copies of the Raphael Cartoons.[7] His duchess, Cassandra Willoughby (1670–173?, m. 1713), was herself a 'great painter', according to Walpole, painting copies like Goupy as well as flowers and birds and 'lead-coloured' portraits from the life. She was shown at her easel painting the duke in a double portrait, of which, unfortunately, only the duke's half was presented to the British Museum in 1762.[8] It is lamentable that none of her work survives, since her letter-book indicates that she led a life both before and after her marriage that must have been typical of many women whose lives are less well documented. Cassandra spent her days at Wollaton before her marriage overseeing the running of the household, embroidering to mend the various household textiles, and in the evenings she took exercise with her brother out of doors or sewed, painted, cut paper or played the spinet. She and her brother organized and catalogued her father's large collection of natural history and, when in London, she indulged in her taste for 'curiosities' by visiting the collection William Courten had left to Sir Hans Sloane, and 'Mr Flamstead and his astronomical instruments' at Greenwich.[9] This passion for curiosities was one apparently shared by many women before and after her time: in December 1686 Evelyn took the Countess of Sunderland to see Courten's collection, and in 1695 Ralph Thoresby complained that his own visit was interrupted when 'an unfortunate visit from the Countess of Pembroke and other ladies from the Court prevented further queries'.[10] Sarah Stone (cats 164–5) was only one of many women who frequented and drew in Sir Ashton Lever's and other museums later in the eighteenth century.

It has sometimes been noted that women's freedom to pursue their cultural activities was the result of their social or familial positions – that wealth and leisure were prerequisites, which was certainly true throughout the seventeenth and eighteenth centuries, but that marriage meant constraint so that married women were less able to follow these inclinations than young women or widows.[11] Sarah Stone gave up drawing at museums after she married, but other examples from the present study indicate that this was certainly not always the case. The Countess of Burlington, the Countess of Oxford and her daughter the Duchess of Portland, her friend Mary Delany, the Marchioness Grey and Rhoda Delaval all carried on with their amateur activities before, during and after their marriages, with the full support of their husbands who took some pride in their work. Rather than a single status, what seems common to them was a number of other factors: in part the court circle in which they moved, in which various members of the royal family received lessons in drawing and painting; the more liberal educations they and their husbands had received (including Greek, Latin and the classics); parents or husbands who were unusually active as patrons or collectors; and finally a desire to be seen to be occupying their time usefully and virtuously, and not in idle pursuits.[12]

These women did not, however, describe their activities in the cultural sphere as accomplishments: they grew aware as

the century progressed, and attitudes towards the appropriate activities for women altered, that their abilities in these fields might be thought to have been acquired at the expense of others more appropriate to their sex; they consequently only broadcast their learning and achievements in these fields within their own circles. The Marchioness Grey, for example, stated that she was wary of giving 'the Character of *Preçieuse*, *Femme Savante*, Linguist, Poetess, Mathematician, & any other name that any Art can be distinguished by'.[13] These were pleasures she had shared with her husband and their great friend Catherine Talbot (1721–70), who had enjoyed a classical education that she had put to public use as a contributor to the *Athenian Letters* with the marchioness's husband, Lord Hardwicke. Catherine Talbot later came to regret her earlier fame,[14] but passed on her passion for these subjects to the marchioness's daughters, Amabel (cat.110) and Mary, and she recommended them for study in the essays on moral subjects published after her death.[15]

This group of women and their friends have been seen as the precursors of the later 'Bluestockings', a term originally applied to their regular guest the eccentric scholar and botanist Benjamin Stillingfleet, but gradually adopted by another circle of women in the second half of the century who pursued intellectual companionship. As attitudes towards appropriate pursuits for women changed, 'bluestocking' gradually became a term of ridicule and derision.[16] Conduct books and published ideas on education in the later eighteenth century promoted a model 'domestic' woman to replace the old courtly or aristocratic model of accomplishment promoted in earlier courtesy literature. Catherine Talbot's friend Susanna Highmore (1725–1812), the daughter of a portrait painter and herself an accomplished artist and poet, married John Duncombe, the author of one such courtesy book, *The Feminiad. A Poem* (1754). Although Duncombe proclaimed championship of the female cause, describing learned British women from the past two centuries, he warned that women had to alter their priorities when they married: a husband dreaded 'a genius that transcends his own' and, further, 'husbands oft experience to their cost/ The prudent housewife in the scholar lost'.[17] Soon after her marriage in 1761, Susanna wrote a poem explaining that she had given up poetry and painting in favour of motherhood.[18] By 1780, instead of admiring Lady Amabel Polwarth for her classical learning, and other virtuous accomplishments passed on to her by her mother and Catherine Talbot, Horace Walpole criticized her for behaving like a 'college tutor' instead of 'like a human creature'.[19]

Recreation versus Amusement; Creation versus Imitation

By 1770 the restrictions of this 'renovated cult of female propriety and domesticity',[20] were beginning to extend even to the types of artistic activity in which women might participate and the language used to describe them. Men followed a 'pursuit' – a profession, employment or recreation, this last word bearing the root 'create', which was associated with genius and invention. Women, on the other hand, undertook 'amusements', pleasant diversions from serious business, ways of passing time. Their elegant presence as spectators at exhibitions and as visitors to private collections is recorded in numerous images, indicating that in some ways they became part of the exhibits themselves. The types of work they showed as 'honorary exhibitors' is also an indicator of what was socially permissible. Historical compositions requiring large numbers of figures were the prerogative of men, as their invention required skill in drawing figures, intellect and an accumulation of knowledge that were by this time inappropriate for women to show. Imitation and decoration, rather than creation, were considered female fortes, and thus copying and decorative works and those closely tied to the imitation of nature, such as flower painting, landscape or portraits, made up the majority of their exhibits.[21]

The difference between the encouragement of women who cultivated and displayed reason, sense and taste in the first half of the century and the restrictive attitudes later, is manifested by Alexander Pope's comparison of his friend Lady Burlington to Pallas Athena, the goddess of wisdom, and his disappointment when she not only took up the art of cut paper, but even tried to teach her husband.

> Pallas grew vapourish once, and odd,
> She would not do the least right thing,
> Either for goddess, or for god,
> Nor Work, nor Play, nor Paint, nor Sing.
>
> Jove frown'd and 'Use' he cried 'those eyes
> So skilful and those hands so taper,
> Do something exquisite and wise' –
> She bow'd, obey'd him – and cut paper....
>
> Alas! One bad example shown;
> How quickly all the sex pursue!
> See, Madam, see the arts all o'erthrown
> Between John Overton and you![22]

Pope's underlying message was that paper cutting was a minor and feminine art that diverted patrons and amateurs from more serious and tasteful pursuits, and printmakers such as Overton, who made a fortune supplying patterns for such work, were equally culpable.

Pope owned one of Lady Burlington's painted copies of an old master, claiming that the name of the painter of his own version was more important to him than the original.[23] Lady Burlington's finest achievements, however, were her portraits in crayon (pastel): less messy and easier to master than oils, they had been recommended for gentlemen from the early seventeenth century,[24] and continued to be a popular medium for women during the eighteenth (see cats 169, 177).[25]

In the highly commercial world of eighteenth-century Britain, the growing wealthy middle classes imitated the accomplishments of the earlier courtly aristocrats and landed gentry in order to demonstrate their own gentility and politeness – but they were careful to keep within the new boundaries set on what was appropriate to their genders and on the degree of skill to be

shown. A woman's ability to draw should signal gentility, not genius.[26] The female members of the royal family, with their legion of drawing masters, provided exemplary models, but like the aristocratic women who attended their court, they were also restricted by the new boundaries. Fan-painting, paper cutting and particularly flower painting were amongst their achievements, but the last was also linked with instruction in botany from Ehret (see cats 40, 51). Many women, including Lady Aylesford (cat. 166), who painted not only flowers, but also kept a very careful sixteen-year-long visual record of mosses,[27] learned to disguise their serious horticultural studies under the umbrella of the genre of flower painting.[28]

Drawing was the handmaiden of the most appropriate of all the arts, needlework, and Horace Walpole included the names of several women known for their pictures in needlework in his anecdotes of painters of the reign of George III.[29] Although their works were soon banned from the Royal Academy, along with cut paper, shell-work or 'any such Baubles',[30] Walpole considered that they 'maintained a rank amongst the works of genius' exhibited at the Society of Arts, and claimed that they were the revival of a most ancient art, older even than drawing.

Two other amateur pursuits marginalized from the 'ranks of genius' – caricatures and fancy pictures – were practised by both men and women. Exposure to the work of great Italian caricaturists encountered on the Grand Tour made these visual social satires a favourite pastime for eighteenth-century collectors and amateurs. At Chatsworth there is a group of thirty outline, mainly profile, caricature sketches made by Lady Burlington and various family and friends in the 1730s and 1740s, drawn on any pieces of paper that came to hand, including scraps of broadsheets and the backs of playing cards. In 1731 Lady Burlington organized the composition and text for a caricature of the castrato Farinelli and the Swiss impresario Heidegger with figures originally drawn by Marco Ricci and Joseph Goupy, and had it etched by the latter.[31]

Many amateur caricatures were etched by the amateurs themselves for private distribution among friends, but others such as George Townshend sent them to publishers for printing and wider distribution. Printmakers realized that there was a market in these 'parlour tricks', and what had begun as sophisticated private amusement was converted into a rancorous public activity.[32] The print publisher Matthew Darly and his wife Mary were to a large extent responsible for the great vogue for caricature prints by offering lessons and manuals on how to draw them, by soliciting them through advertising that 'Sketches or Hints sent post paid will have due Honour shown them', and printing them mounted on paste-card to be sent easily through the post.[33] Most printsellers followed suit, and viewing the newly issued prints in their windows was a popular London entertainment. One reason that caricatures remained popular was the belief that the art was accessible to all without professional training,[34] and an inside knowledge of the politics or social peccadilloes of their subjects gave amateurs an advantage over the professional satirists. Some later amateurs, however, sent their work to professionals for re-drawing as well

as engraving – what Rowlandson came to describe as 'taking in other men's washing'.[35]

It was through the work of William Henry Bunbury (cats 178–9) that purely social caricature became so popular. Collectors were reassured that they were being satirized by one of their own and not by a professional, a reassurance underlined by the naïve quality of his drawing. Although frequently in financial difficulties, Bunbury went to great lengths not to compromise his amateur status.[36] But his reputation as a caricaturist has overshadowed his equally prolific output of drawings of 'fancy subjects' for another popular genre of print production in the last quarter of the century – the so-called 'furniture prints' (see cats 161, 178).

Stipple engraving was the most popular medium for reproducing such prints. A technique mastered by W. W. Ryland and Francesco Bartolozzi, it effectively imitated a red or sepia chalk drawing, and intricate details of drapery and hair. Easier to produce and more durable than other forms of engraving, these prints began to appear in increasing numbers from the mid-1770s, most often in oval or circular forms and by the end of the decade in colour. They were the perfect size, subject and medium for decorating the more intimate spaces of neo-classical interiors.

Although the prints often depicted women and children, it is simplifying matters too much to say they pandered to women's tastes or were hung in women's spaces in homes. Angelica Kauffman's inspiration for many of these works were the same seventeenth-century French and Italian drawings or reliefs from classical antiquity that inspired contemporaries such as J. B. Cipriani and Bartolozzi. The technique of stipple was a new one and fed a taste for this type of print among print collectors not only in England but also abroad, especially in Germany.[37] The Revd Cracherode, from whose wide-ranging collection most of the British Museum's stipple prints of this type originated, was one of many collectors who sought out proofs and fine impressions, states before letters, or etchings before the aquatint was added.

Engravers and printsellers were always ready to produce prints on commission for private individuals from designs provided by them: many women, including Lady Diana Beauclerk and Lavinia, Countess Spencer, had prints published in this way, paid for by their relatives (see cats 176–7, 182). But just as Wedgwood received unsolicited designs from men and women amateurs at this time for use on his pottery, so engravers such as Bartolozzi (1727–1815) received the same for their prints, and actively encouraged such submissions by dedicating other prints to these women and their friends. Engravers recognized the obvious commercial advantages to making these prints part of their stock, and it was not only female amateurs who sent their designs. Prints after William Henry Bunbury's compositions were issued in the hundreds and admired for their quality of spontaneity and naïvety, which was felt to convey their underlying sentiment more sincerely than a professional artist might manage. Bartolozzi's pupil, Mariano Bovi (c.1740–1805), retained some of the drawings sent to him by amateurs such as Lady Diana Beauclerk and Lady Templetown,

and others that headed the list of works exhibited for sale when he sold his stock from his premises in Piccadilly in 1802.[38] Inevitably commercialization led to proliferation and saturation, to the point where these so-called 'sentimental' prints became so associated with the perceived feminine capacity for feeling that there was a reaction against it.[39]

Mnemonics of Muses and Sibyls' Leaves

The 'cult of sensibility' that surfaced for a variety of reasons in the second half of the eighteenth century helps us to understand the admiration that serious collectors such as Horace Walpole and Sir William Hamilton could express for works that possess an awkwardness and lack of skill, not only to our eyes, but also, we suspect, even to theirs. This is demonstrated clearly in the German artist Wilhelm Tischbein's (1751–1829) description of Sir William's private study overlooking the Bay of Naples:

The paintings on the walls were of little importance, but they all had a meaning and content that he enjoyed, and recalled things to his mind in the most pleasant way. Thus there was among them a pen-drawing scribbled by a lady-friend [Lady Diana Beauclerk] who had shown her children in a nice group as they tumbled about together on the ground. Many people would not have kept this sort of drawing, but [he] respected it for the naive way in which the figures were caught, and which a painter concerned with the rules of art would never have been lucky enough to capture.[40]

But the 'cult of sensibility' and admiration based on social rather than aesthetic values are not sufficient reasons to explain what might seem to modern readers excessive praise lavished upon the works of amateurs by their contemporaries.[41] The most remarkable examples of such praise throughout this book have been quoted from Horace Walpole's correspondence or his *Anecdotes of Painting in England*,[42] and he provides the key to understanding the purpose of such praise in his claim that British art is 'verbally formed before visually real'.[43]

In his preface to the *Anecdotes* Walpole noted that many books had been written on the lives of painters of Italy and France, but none on English artists. A reader would be forgiven for being prejudiced against 'a work, the chief business of which must be to celebrate the arts of a country which has produced so few good artists. This objection is so striking, that instead of calling it *The Lives of English Painters*, I have simply given it the title of *Anecdotes of Painting in England*.' The forty volumes of notes taken by the artist, antiquarian and engraver George Vertue (1684–1756), on which Walpole based his anecdotes, had been exhaustive, as Walpole remarked: 'nor would I advise any man, who is not fond of curious trifles, to take the pains of turning over these leaves'.[44] Like Norgate and Peacham before him, George Vertue had praised the work of contemporary gentlemen amateurs as well as professionals, noting for example that Taverner's 'extraordinary Genius' was 'equal if not superior in some degree to any painter in England' (see cat. 56).

Retaining Vertue's notice of amateurs as well as professionals, great patrons as well as artists, and his notes on privately established academies and societies, Walpole arranged his edition of the *Anecdotes* by reign. In the account under William III, he included Vertue's notices of the work of so many seventeenth-century non-professional artists that at one point, the Revd James Dallaway, editor of the 1826 edition of the *Anecdotes*, was to interject: 'Several of the before-mentioned artists seem to have been unnecessarily introduced, and are not to be ranked above mere amateurs.'[45] Even in the fifty years since Walpole's own edition, the perception of the worth of the activity of amateurs had been reduced to the point where they were perceived to play no role at all in the history of an English school.

There had been no mistake, however: by including their work, Vertue and Walpole underlined a role encouraged for English gentlemen since the time of Peacham in the seventeenth century and re-enforced by Locke and Shaftesbury in the eighteenth – as men of taste, collectors and connoisseurs, who provided a cultural foundation upon which the arts and nation as a whole must build. In this Walpole himself led by example: his own collection at Strawberry Hill was not only 'made out of the spoils of many renowned cabinets',[46] but he also added to it ancient and modern works, by both artists and amateurs, either purchased or commissioned by him or presented to him. He built for them special cabinets, even entire rooms, had them carefully framed, mounted and placed in appropriate settings, and commissioned and published views of the rooms housing them. He himself compiled the two volumes of *A Collection of Prints engraved by various persons of quality*, and had them lavishly bound with printed title-pages.[47]

Through his voluminous and wide correspondence, and his creation of Strawberry Hill (brought to the public through its press, published catalogue and thousands of visitors), Walpole provided a microcosm of how a gentleman might encourage the advancement of the arts in Britain, and cultivated a public perception of himself as the epitome of a 'man of taste'. By personal association with him, or by presenting him with their work for his collection, men and women could acquire not only his stamp of approval, but also some of his reputation through association.

Like Vertue, Walpole kept notebooks, which he called his 'Books of Materials', and which contained mnemonics of events and things he had read; these he used as the basis for his fourth volume of the *Anecdotes*, written by 1771, but not published until 1780. In the preface, he expressed the wish that a future writer would pick up his and Vertue's torch and carry on their anecdotes to include the artists of the present day, and he described the works of a number of amateurs, among them Lady Bingham, Lady Diana Beauclerk and Mrs Damer, whose work was not to be excluded. He continued to add to his 'Books of Materials', and in 1937 a 'fifth' volume of the *Anecdotes* was published, edited from their contents.[48] Literary, historical, political and artistic scraps are intermingled in the originals, but also included was a group of notes titled 'Ladies and Gentlemen Distinguished by Their Artistic Talents'.[49]

The men and women described were what Walpole, like Haydon and Hamilton, might have described as of the 'old

school', whose intentions in following these pursuits were virtuous, inspired by reason and taste, such as Mrs Damer's search for a simple Grecian style to exemplify Athenian ideals. Contemporary reviewers of the work of honorary artists, especially women, were inclined to concentrate as much on their lineages and personalities as on their work, but Walpole's notices confined themselves to the last. The amateurs he discussed did not draw, paint or sculpt for self-advertisement, to imitate the gentry, to place themselves in competition with professional artists or simply to pass time. When he took notice in 1786 in his 'Books of Materials' of 'The poetry, paintings, novels, singing and playing of several young women, though cried up, may properly be called, *Miss-doings*', he indicated his contempt for those who did and the misplaced exaggeration of those who praised them.

The amateurs of the 'old school' whose work Walpole described were men and women whom he himself had often guided and advised, and to some extent his praise of their work was a paean to his own achievements as a patron of British art. Next to Lady Diana Beauclerk and Mrs Damer, Lady Bingham was to receive the greatest encomium in the preface to the fourth volume of the *Anecdotes*, where Walple claimed the credit for turning her from pastels to miniature copies, (see cat.186). Her understanding of his purposes and ultimate audience was made clear when she thanked him for his praise, writing:

some future writer of anecdotes may say that you only praise your own gift, as you have given me that merit which you now reward; … I hold my art by a sort of *copyhold* right under you. Pray then let me keep it as long as possible, that my collection may increase, to which you have not given intrinsic value, for posterity will always believe *you* more than they will their own eyes, and your mentioning my performances would certainly render them forever valuable, if my colour could last as long as your book is certain of being read.[50]

The attributes of the 'old school' versus the new – drawing for virtuous rather than frivolous reasons – is also documented by changes in portraits of amateurs, perhaps even more indicative of their public intentions than the works they themselves produced. We thus find Lady Bingham portrayed by Kauffman in an imitation of Reynolds's grand formal style, seated in a pose and costume reminiscent of Michelangelo and Guercino's sibyls rather than in the more common trope of a Muse of Art.

The nine Muses of the classical world provided passive sources of inspiration to the arts of literature, poetry, dance and music. Although there was no specific muse of art, an allegorical image of Painting was often conflated with references to the muses to create a 'Muse of Art'. Late seventeenth- and early eighteenth-century women who were accomplished amateur artists were shown seated at their easels, brush and palette in hand, as the Duchess of Chandos had been.[51] These images of amateurs actively engaged in their work moved perceptibly towards the image of the amateur as a 'Muse of Art' in Thomas Hudson's 1746 portrait of Lady Andover (see cat.118), and several of Reynolds and Gainsborough's portraits of the 1760s

where the amateurs were shown standing, one arm leaning on a classical altar or pedestal, a *porte-crayon* rather than a paint brush in hand, and drawings and small busts or books of drawings displayed, rather than easels or oils.[52] Their clothes and attitudes became gradually more reminiscent of classical sources and their engagement with their art more removed, referred to rather than portrayed, passive rather than active. It is to this tradition that Reynolds's portrait of Lady Broughton belongs (cat.185), while Kauffman's prtrait of Lady Bingham is quite different.

Muses were most frequently referred to in poetry, but also appeared in connection with most cultural activities. In 1773, busy with Lord Harcourt's garden and his wife's drawings, Mason was prompted to write to Walpole: 'Did you know that the Muses have a little cabinet at Nuneham?'[53] Although they are less remarked upon, sibyls, too, were a popular currency in artistic references, particularly amongst those with classical educations, typically in Lady Amabel Polwarth's description of her drawings of Wrest and Wimpole as 'Sybil's leaves' in 1774, a direct reference to Virgil's account of the visit of Aeneas to the Cumaean sibyl. For her to equate her drawings with the sibyl's written oracles, the words of the gods and the Romans' source of ancient history, and for Lady Bingham to see herself as the gods' prophet and scribe rather than their passive inspiration (the muses), was for these amateurs of the 'old school' to stake a reasoned and intellectual claim for their art.

Lady Bingham's turban is not merely a symbol of the exotic oriental origin of the sibyls: it is also a symbol of her intellectual pursuits. For the young daughters of Sir Thomas Frankland, however, whose identities are subsumed by that of their father, and their characters revealed through comparison with their dog and nature, their turbans and closed portfolio signify their feminine accomplishments and modesty.

Fig. 5 Francesco Bartolozzi after F. Vieira Portuensis, *Young woman copying a life drawing*, from *Elements of Drawing*, 1799. Stipple engraving, 350 × 475mm (Prints and Drawings, British Museum)

NOTES

1 B. R. Haydon, *The Autobiography and Memoirs of Benjamin Robert Haydon*, ed. T. Taylor, revised A. Huxley, I, 1926, 405–6; Beaumont had bequeathed his paintings to the nation and played an important role in the foundation of the National Gallery.

2 Muller and Murrell, III.

3 *London Chronicle*, 31 May 1807, 523, quoted in Smith 2001, chap. 3, which studies the writings of these critics and the relationship between artist and amateur *c*.1790–1830.

4 Barbier, 159–60.

5 *Sense and Sensibility* (written 1790s, first published 1811), Oxford, World Classics, 1998, 66.

6 See Gibson-Wood 1989, *passim*.

7 Whitley II, 80.

8 See John Kerslake, 'The Duke of Chandos' missing Duchess', in *National Trust Studies 1981*, ed. G. Jackson-Stops (Sotheby's 1980), 139–49; the portrait by Herman van der Mijn is now in the National Portrait Gallery.

9 Joan Johnson, *Excellent Cassandra: The Life and Times of the Duchess of Chandos*, Gloucester 1981, 39–45.

10 See Gibson-Wood 1997, 63–4.

11 Yarrington, 39.

12 For a discussion of this circle, see Sloan 1997, 291–4.

13 Quoted in ibid., 294.

14 Myers, 213.

15 Ibid., 224.

16 See ibid., 6–12.

17 Quoted in Marjorie Reeves, *Pursuing the Muses: Female Education and Nonconformist Culture 1700–1900*, Leicester University Press, London and Washington 1997, 50. This is an interesting study of a group of women from a different social circle, mainly non-conformists, whose education and interests were comparable with the Bluestockings but who on the whole were more concerned with literary than pictorial arts.

18 Myers, 120; for Susanna Duncombe, see entry on her by Jacqueline Riding in Gaze, 473–5, which indicates that she did not completely abandon drawing as she produced illustrations for the literary works of friends, now mainly in the collection at the Tate Gallery.

19 *Wal. Corr.*, XXXIII, 242.

20 See Colley, 262–73.

21 See Graves for lists of exhibitors at the Society of Artists and the Royal Academy and the titles of their works, and see Smith 2001, appendix to chap. 3 for percentages of women to men and honorary to professional artists.

22 *On the Countess of Burlington Cutting Paper*, quoted in De Novellis, 17.

23 Ibid.

24 Muller and Murrell, 102–3.

25 See Jacob Simon's article cited in Literature to cat. 169; susceptible to rubbing and damage from dampness, few examples of pastels by amateurs survive.

26 Bermingham 1992, 156.

27 1799–1815, now in the Natural History Museum, see Jordan, 153.

28 For further examples see Shteir, *passim*.

29 *Anecdotes* III, 335–6; see for example his passage on Worlidge for a poem on the needlework pictures of the artist's wife, 335.

30 Smith 2001, chap. 3, n. 6.

31 De Novellis, 22–4.

32 Richard Godfrey, *English Caricature 1620 to the present*, exh. V&A, 1984, 15.

33 See ibid., no. 18: Mary Darly, *A Book of Caricatures...With ye Principles of Designing in that Droll and Pleasing Manner*, 1762.

34 Ibid., 68.

35 Quoted in William Feaver, *Masters of Caricature*, 1981, 45.

36 J. Riely, *Henry William Bunbury*, exh. Gainsborough's House, Sudbury, 1983, 4–6.

37 See Tim Clayton, 'Reviews of English prints in German journals 1750–1800', *Print Quarterly* X (1993), 123–37.

38 Mariano Bovi, *Catalogue of Prints*, 1802. Many of the prints were after drawings by William Lock, Lady Bessborough, Lady Wortley and Countess Spencer.

39 See Clayton, 245–6.

40 Translated and quoted by John Gage in 'Lusieri, Hamilton and the Palazzo Sessa', *Burlington Magazine*, (November 1993), 766.

41 For the most extensive examination of reviews covering the late eighteenth and early nineteenth centuries, see Smith 2001, chap. 3.

42 Walpole's correspondence, edited by Wilmarth Sheldon Lewis, was published in forty-eight volumes by Yale University Press (1937–83), and the *Anecdotes* appeared originally in 1762–71, with a fourth volume added to the 1780 edition, and a fifth, edited by Hilles and Daghlian, published in 1937. References here are to the Wornum edition, covering the original four volumes in three, and to Hilles and Daghlian's edition of vol. V (see bibliography)

43 Quoted without source by T. Standring in K. Baetjer, ed., *Glorious Nature: British Landscape Painting 1750–1850*, exh. Denver Art Museum, published London 1993, 73.

44 Walpole, *Anecdotes* I, x.

45 Ibid., II, 239.

46 Quoted in Clive Wainwright, *Romantic Interiors*, New Haven and London 1989, 71; see this chapter for the most detailed description of his collection and the building that housed it; see also Peter Hill, *Walpole's Collection*, Twickenham 1997, extracted from a manuscript catalogue of *c*.1800.

47 See Peltz, 389–401.

48 *Anecdotes* V, Hilles and Daghlian. The three manuscript 'Books of Materials' (1759, 1771, 1786) are now in the Lewis Walpole Library, Farmington (Conn.), (refs 49.2615. I, II, III). They were purchased by W.S.Lewis from the Folger Library in 1950. The Department of Prints and Drawings has a set of photographs of the 'Books of Materials' taken from a microfilm provided by Mr Lewis in 1958.

49 Hilles and Daghlian, chap VIII, 228–40.

50 *Wal Corr.*, XLI, 418–19.

51 Also Anne Wentworth, Countess Fitzwilliam, by Mercier in 1741, for which see John Ingamells, *Philip Mercier*, exh. York City Art Gallery and Kenwood, 1969, no. 40 (private collection). Women who limned or painted miniatures were shown standing by tables holding their materials and displaying one of their works, as Susanna Highmore was in her father's portrait of her (Victoria Art Gallery, Melbourne). The earliest example of this type seen by the present writer was mistakenly attributed to Lely; clearly dating from *c*.1690, it was said to be of Mrs Penruddock, and was sold Sotheby's, New York, 15 January 1993 (lot 221).

52 See Bennett, *passim*, where several are reproduced. Richard Samuel exhibited his painting of *Nine Living Muses of Great Britain* at the Royal Academy in 1779.

53 Quoted in *A Candidate for Praise: William Mason 1725–97, Precentor of York*, exh. York Art Gallery, 1973; Ingamells, 33.

THOMAS KERRICH (1748–1828)

156

Portrait of the Revd William Cole

Black and red chalks with stump,
453×302 mm

Engraved by Facius in stipple, 1809

LB 1

Provenance: Acquired before 1837,
possibly with the papers Kerrich bequeathed
to BL MSS (Add. 6728–6776), from where
transferred to Prints and Drawings
Department

1972-U-536

Thomas Kerrich was the son of the Revd Samuel Kerrich, DD, of Norfolk. On his graduation from Cambridge in 1771, Kerrich was awarded a travelling scholarship and spent several months in Antwerp and Paris before going on to Italy. Although he was not training formally as a professional artist, like many young men, he attended various academies and universities for brief periods while abroad, and in Antwerp was awarded a silver medal for drawing. His surviving drawings indicate that he drew from drawing manuals, made academic studies and sketched figures, sometimes caricatures, from life. He came into contact with the Fuseli circle while in Rome and his series of portraits of himself and his Cambridge associates are of a scale, texture and intensity unlike any work by his British contemporaries (Christie's, 21 March 1989 (81–9) and Sotheby's, 22 March 2000 (128–43)). Many were engraved by the brothers Facius, including the present portrait of the Revd William Cole (1714–82), a close friend and correspondent of Walpole, with whom the latter had attended Eton. Cole shared Kerrich's strong ties with Cambridge and his passion for recording antiquities, and left his notes and drawings to the British Museum where they were later joined by those of Kerrich.

While abroad Kerrich was frequently in the company of a Norfolk friend, Thomas Coke (1754–1842) of Holkham, who collected antiquities, including gems and casts, and brought home a mosaic from the floor of Hadrian's villa. From 1775 Kerrich lived in Cambridge, taking over his father's parishes in Norfolk, and in 1797 was appointed Cambridge University librarian and elected a Fellow of the Society of Antiquaries. He had spent most of his

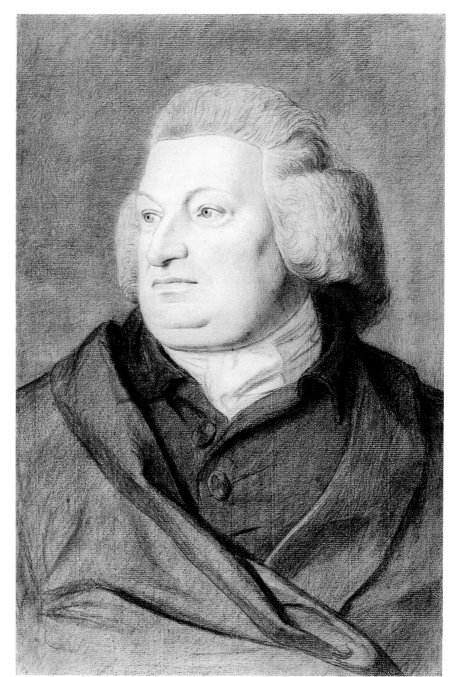

156

life making drawings and plans of early ecclesiastical and military architecture, as well as drawings and limnings of ancient costumes and armour from church monuments throughout Britain; he bequeathed forty-eight volumes of these to the British Museum (now the Department of Manuscripts, British Library). He was also an important print collector, and published one of the earliest catalogues, of the work of Martin van Heemskerck (1498–1574) in 1829, as well as forming a collection of early royal portraits, which he bequeathed to the Society of Antiquaries.

As an antiquarian and not a professional artist, Kerrich was not confined to contemporary formulae in his drawings, whether portraits, antiquities or landscapes. A group of the last category, mainly views around Lowestoft and the Suffolk coast drawn in the 1790s, including one oil on panel (Gere collection, on loan to the National Gallery), demonstrates a topographical approach that is so direct and natural that the landscapes are more reminiscent of the work of artists a century earlier than the more contrived compositions of his contemporaries such as George Beaumont or Dr Monro.

Literature: *DNB*; Ingamells, 573–4; Christopher Riopelle and Xavier Bray, *A Brush with Nature: The Gere Collection of Landscape Oil Sketches*, exh. National Gallery, 1999, no. 45.

Robert Ker Porter (1777–1842)

157

Academic study of a nude male figure,
c.1795

Pencil and coloured chalks on grey paper, 450 × 285 mm

Inscribed: *12*

Provenance: Collection of Morden College, Blackheath, sale Sotheby's, April 1958 (album); bt L. G. Duke; presented by him to Dudley Snelgrove; his sale, Sotheby's, 19 November 1992 (lot not known), bt Abbott and Holder, from whom purchased and presented by the British Museum Society

1999-6-26-21

When he acquired the album from which this drawing was removed, the collector L. G. Duke also removed two further academic studies, and five loose signed watercolour landscapes, drawn from nature in Wales and at Warwick Castle. He gave the

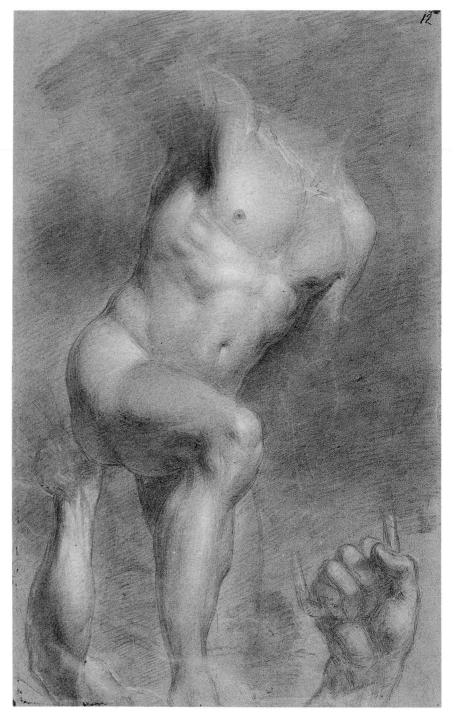

157

present drawing to a friend and the album with its remaining figure studies to the British Museum (c. 204), where it joined a large group of drawings by the artist.

Robert Ker Porter was the son of an army surgeon. His elder brothers entered the army and the medical profession, but Robert and his two sisters were brought up by their mother in Edinburgh where they knew Walter Scott. Jane and Anna Maria Porter both became well-known historical novelists, but when Robert demonstrated a talent for drawing, his mother showed his work to Benjamin West who obtained him a place at the Royal Academy. He won a prize at the Society of Arts for an historical painting of *The Witch of Endor* in 1792. He made several sketching tours, including one with François-Louis Francia, and received several commissions for church paintings. In his rooms in Great Newport Street in 1799, he was one of the founders of 'the Brothers' who 'met for the purpose of establishing by practice a school of Historic Landscape, the subjects being designs from poetick passages'. The membership included Francia and Girtin and was later better known as the Sketching Society, when it included Cotman and the Varleys.

Robert Ker Porter was a professional painter, exhibiting several panoramic battle paintings after making his name with *The Storming of Seringapatam*, exhibited at the Lyceum when he was twenty-three. He had not severed all his family's military connections and was a captain in the Westminster militia. He issued several propaganda prints advertised as 'Boney's Cruelties', which Ernst Gombrich has suggested may have influenced Goya when they were both in Saragossa a few years later. His battle paintings gained the attention of Alexander I, and in 1805 he was invited to St Petersburg to paint the murals in the Admiralty. From that date onwards his connections at the Russian court and his own published observations of his travels ensured him a series of positions as a military, diplomatic and cultural attaché in Sweden, Spain, Georgia and Persia, where he made careful records of Assyrian antiquities and inscriptions. His last posting was as British consul at Caracas where he took a keen interest in recording the flora and fauna of the country and negotiated a treaty for abolishing the slave trade.

Neither strictly an amateur at the beginning of his career, nor a professional artist at its end, Ker Porter's drawing is included here as an example of the type of life study

undertaken at the Royal Academy by both amateur and professional artists who worked side by side in the life classes. Gentlemen's sons such as Lock and Ottley (see cats 160–3) were as welcome to attend as they had been since the beginning of the century, if not earlier, in the academies at Dublin, Edinburgh and London, where the names of gentlemen could be found alongside those of professional artists in the lists for Thornhill's, Louis Chéron's and the St Martin's Lane academies.

Literature: 'Sir Robert Ker Porter', British Library, Departments of Manuscripts and Printed Books, exh. leaflet, 1977, 4pp.

The Hon. Revd Richard Byron (1724–1811)

158
Belshazzar's feast

Pen and brown ink with grey wash, 310 × 425 mm

Signed on the drawing: *R Byron Inv & fect* and monogram lower right; on the mount below: *Honble Richard Byron invenit & fecit.*

Provenance: Probably bequeathed by Richard Payne Knight

BM Crown Stamp 1950 and 1972 U 525

This drawing and three others in the Museum are the only known drawings by Richard Byron who was, however, a prolific etcher (cat. 159). A younger son of William, 4th Lord Byron (cat. 55), he was educated at Christ Church, Oxford, from 1743 to 1750, and was later rector of Haughton le Skerne, Durham. His sister Isabella took lessons from Joseph Goupy, and she also etched (see cat. 159). Many of the next generation of Byrons were also amateurs, including John and Frederick George Byron, who were both talented caricaturists.

Byron's three other drawings in the Museum came from the same source: two are landscapes of picturesque thatched mills and barns in hilly landscapes with figures on the road or working nearby. They are drawn with brush and wash, and one has the details picked out in pen and ink, in a manner reminiscent of seventeenth-century Dutch and Flemish artists, and may be related to works by Tillemans that Byron's father commissioned for Newstead Abbey, or drawings by Tillemans or his father in the collection there. The third drawing is a pen and ink and wash copy of an allegorical

drawing or painting by Carlo Maratta inscribed: *iacentem picturam annibal carraccius e. tenebris suo lumine restituit et ad apollinis ac pallidis aedem perduxit.* It depicts the artist Annibale Carracci bringing the art of painting (represented as a female figure) out of the darkness and restoring her to Apollo's temple. No reference to such a painting has been found. In the seventeenth and eighteenth centuries Annibale's Farnese ceiling was considered an artistic achievement equal to Michelangelo's Sistine ceiling and Raphael's frescoes in the Vatican Stanze.

Joseph Goupy, who gave lessons to Byron's sister Isabella, Countess of Carlisle, painted mainly in oils and gouache and also etched and taught Isabella by setting her to copy the works of Italian old masters. The Revd Byron appears to have mainly learned to draw by studying paintings, drawings and prints by Italian and Dutch old masters. The composition of the *Belshazzar's feast* demonstrates a very ambitious attempt to paint an historical subject of a complexity that few contemporary professional artists endeavoured. Rembrandt's well-known painting of this subject (National Gallery) was in the collection of the Earl of Derby by 1736 where it was copied by Tillemans, and a different composition of the same subject, also then attributed to Rembrandt, passed through several English collections in the second half of the century, and was issued as a mezzotint by Henry Hudson in 1785. The subject of Belshazzar's Feast may have been inspired by Rembrandt, but Byron's composition appears to be his own interpretation, with dozens of figures praising their pagan gods and drinking from the golden vessels pillaged from the temple in Jerusalem. It depicts the moment when writing appeared on the wall with the message that the king had been weighed in the balances and found wanting: Babylonia fell the next day and Belshazzar was slain.

The Byron family's admiration for Rembrandt was particularly evident in Richard and Isabella's etchings and it was a taste shared by many of their contemporaries, including the collectors Cracherode and Payne Knight. The latter probably owned the four works by Byron in the collection: he may have acquired them from Byron himself or possibly from his great-nephew the poet, who became friendly with Payne Knight on realizing that they shared their unpopular criticism of Lord Elgin's removal of the Parthenon marbles. In 1814 Payne Knight was made a trustee of the

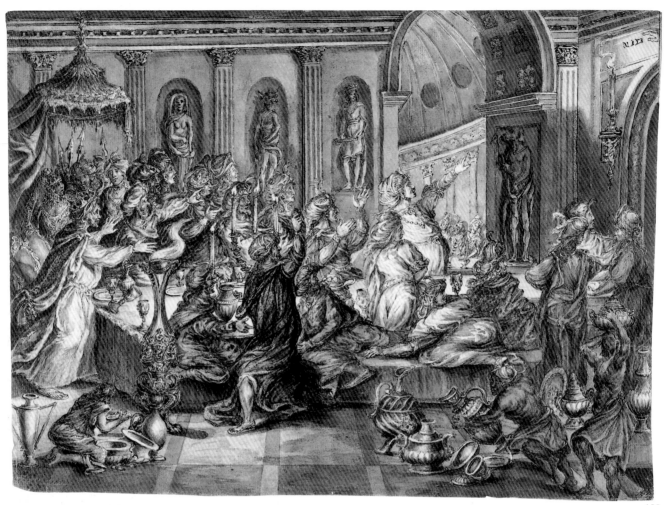

158

British Museum and shortly afterwards made a new will leaving his collection to the Museum, where it would join those of his late friends Charles Townley and the Revd Clayton Mordaunt Cracherode (d. 1799). Payne Knight not only admired Rembrandt and other Dutch old masters: he was also a promoter of history painting amongst contemporary British artists, particularly Benjamin West and Richard Westall. The Payne Knight provenance of Byron's drawings has not been recognized until now. Regarded as minor works by an unknown and obviously unskilled artist, they had probably been weeded out from the more important works in Payne Knight's 1824 bequest of nine volumes containing 1,144 drawings. No inventory was made of them until 1845, by which time considerable sorting and reattributions had taken place.

Literature: Raines, 'Tillemans', 28 n. 44; Clarke and Penny, for Payne Knight's collection of drawings.

THE HON. REVD RICHARD BYRON (1724–1811) after REMBRANDT

159

Album of etchings, open to *Landscape with a cottage and large tree*, 1776

Etching on yellow paper, 100 × 195 mm

Album inscribed on cover: *Etchings by R Byron*; and on first page: *Given to me by the Honble. and reverend Richard Byron, March 19, 1799 CMC*

Provenance: Bequeathed by the Revd Clayton Mordaunt Cracherode

BM Crown Stamp (188.c.1)

Byron's father, the 4th Lord Byron (cat. 55), not only drew and painted in oils, but also, like most amateurs, tried his hand at etching. Three by him are in the Museum: two Dutch landscapes and one after Guercino. At least two of his children were

prolific etchers, his daughter Isabella (1721–95) and son Richard. He held a position at court and it is not surprising to find that Isabella learned to paint and probably to etch from Joseph Goupy who had several pupils in the royal circles. She mainly copied Italian old master prints, but also etched at least one Dutch-style landscape of her own composing and she made several copies of Rembrandt's etchings. Most of her signed works date from after her marriage in 1743 to Henry Howard, 4th Earl of Carlisle (d. 1758), and before her subsequent marriage, in 1759, to Sir William Musgrave a leading print collector. There are examples of her work in Richard Bull's album in the British Museum and in Walpole's album at Farmington.

Richard Byron was also probably taught to etch by Goupy. In 1795 he is said to have published for his friends an album of his prints, many copied from Italian and Dutch masters, others etched in their manner.

Four years later he presented this album to a well-known and respected collector who shared his passion for Rembrandt, the Revd Cracherode, who died only two weeks later. Byron's copies of Rembrandt show great talent, with drypoints rich in burr, and are sometimes deceptive, including Rembrandt's signature in the plate. This etching copies one by Rembrandt dated 1641 (Bartsch 226), but in reverse, with Byron's signature and date etched over a previous inscription in the lower right. Walpole owned ten of Byron's etchings before 1775, which are now in his album at Farmington, together with other examples after Rembrandt by Isabella Byron and William Hamilton (see cat. 93). James Chelsum, who was at Oxford shortly after Byron, included the latter's work in two albums he put together around 1780 of 'Prints by Notable Dilettanti' (now Yale Center for British Art, New Haven (Conn.)), which also contained other copies of Rembrandt by the Earl of Aylesford (cat. 120) and several Cambridge amateurs. Chelsum was ordained in 1773 and in 1786 wrote a history of mezzotint.

Literature: E. D'Oench, 84–6, 150–1; Alexander, 11, 29.

WILLIAM LOCK (1767–1847)

160

Two studies of Dido, 1781

Verso: Profile of a long-haired man, a veiled head and other details of heads

Pen and brown ink over pencil, 224 × 270 mm

Inscribed: *W. Lock. May. 1781. another design for the figure of Dido.*

Provenance: Christie's, 10 July 1990, lot 3 (album), bt Christopher Powney, from whom purchased

1991-10-5-3

Lock's father, William Lock (1732–1810) of Norbury Park, Surrey, was named by Sir William Hamilton in 1787 as one of three 'true Connoisseurs of the arts in England' (with Charles Townley and Charles Greville), but by that date he had already disposed of a large part of his collection (Christie's, 16 April 1785). He had visited Italy several times, the first occasion with Richard Wilson, whom he had encouraged to take up landscape painting. He collected, at home and abroad, old master paintings and drawings as well as sculpture, contem-

porary and antique, and he was friend and patron to countless artists, including George Barrett who painted murals for his home, Henry Fuseli who visited Norbury and advised on the younger Lock's drawings in 1787, Lawrence who was the family's portraitist and, in 1797, J. M. W. Turner. The elder Lock was himself an amateur, and in 1784 wrote to John Strange, the English resident in Venice, requesting that he procure for him '300 sheets of the Grey Paper which Piazzetta used for his Drawings. The Coloured paper here has not got grain enough to bite the chalk'

(British Library, Egerton MSS, 1970.f. 168, quoted in Sir Brinsley Ford's archive, Paul Mellon Centre for Studies in British Art).

The younger Lock did not owe his own ability to draw solely to his father's example. From the age of ten, he was a pupil of William Gilpin at the preparatory school at Cheam before Gilpin left and the school was taken over by his son in 1778. Gilpin had always believed strongly that drawing should be part of a boy's education, and undoubtedly William Lock received both lessons and encouragement while there. In 1781 he and his father played an instrumen-

159

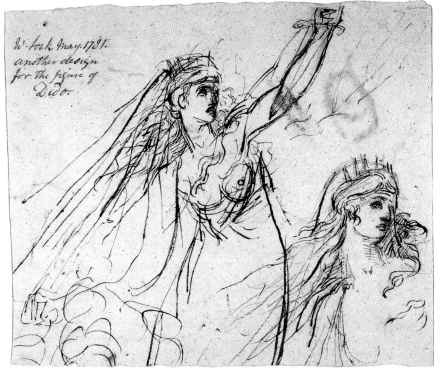

160

tal role in acquiring from Lord Harcourt (cat. 96) the recipe for aquatint in order for Gilpin to illustrate the tours he had been circulating in manuscript. The previous year, when Lock was thirteen, he had himself drawn and etched the portraits of two schoolfellows. His mother sent two examples of his printmaking to Richard Bull for his album of works by amateurs: an angel, etched on a sword blade, and a seated woman engraved in a manner to imitate a crayon drawing.

William Lock was encouraged as a young prodigy, with Gilpin setting him tasks, one of which was a painting of the death of Cardinal Wolsey. Lock produced numerous drawings over the next two years: the present work is from an album containing twenty-eight figure studies, five of them dated between 1780 and 1782. Two sheets of sketches related to the present study were acquired by the Victoria and Albert Museum and the British Museum in 1947. Lock's father and Gilpin had entered into a regular correspondence debating the qualities and limitations of the picturesque and the sources of the sublime, in both land-scape and figural compositions, and the younger Lock's drawings passed back and forth in the post, both men commenting on his efforts.

Literature: Duchess of Sermonetta (Vittoria Caetani), *The Locks of Norbury*, 1940; Barbier, 68, 124–5, 129–31, 158–61.

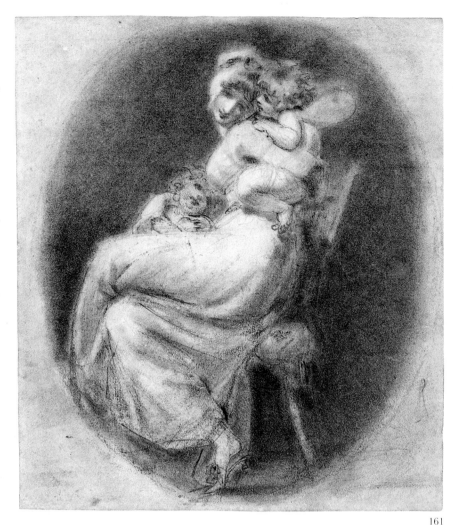

161

161

Belinda, from 'The Rape of the Lock', 1783

Verso: academic sketch of naked woman holding child

Coloured chalks, stump and graphite, 231 × 203 mm

Inscribed on verso: *W L 1783–*

Provenance: Stanhope Shelton Pictures, from whom purchased

1977-11-5-1

Remarkably little is known of the details of William Lock's education after he left Cheam. He continued to work periodically on larger compositions of subjects that Gilpin set for him, and there are many sketches illustrating themes from classical mythology, Shakespeare and the Bible. The present drawing illustrates Alexander Pope's well-known poem, first published in 1712, commemorating a battle between the families of Lord Petre and Arabella Fermor, after Petre had cut off a lock of Arabella's hair. Belinda was the central figure of the poem, here seen attended by 'denizens of air' with 'insect-wings'. There is a similar subject in a sketch in the Museum's collection, showing her in a bower (1947-10-105).

In 1786, however, Gilpin noted a particular refusal on his pupil's part to become inspired by any serious subject, and Lock continued to sketch but do little else for several years, apparently losing all confidence in his work and refusing to show it to anyone but his father. Fuseli was brought to Norbury Park in 1789 for his opinion, which appeared to echo Gilpin's:

[Fuseli] cou'd not otherwise account for the disgust which now seems to stop him [Lock] in his progress if it did not arise from the few who understand him – That he considers it is not worth while and contents himself with feeling that he can do any thing he pleases [Fuseli] added that William was certainly guilty of 'laying his Talent upon a Napkin' and that it was a Misfortune to the Art that he was born in a situation not to be obliged to paint.

Clearly, Gilpin, Fuseli and Lock's parents all thought that he had been born with a gift, and were disappointed that he did not fulfil it for the greater benefit of the arts in England simply because he was not obliged to. By this date another young man with a prodigious talent, but who had to earn a living from it, Thomas Lawrence, had been taken up as a protégé of Mary Hartley (cat. 112) in Bath, and had begun to paint the Locks's portraits (William's portrait in oiled charcoal was sold at Christie's, 17 November 1992, lot 28).

After a spell in Rome for Lock to decide whether to take up his art more seriously, he chose not to pursue the idea of becoming a painter. After his return, he continued to draw, often in Lawrence's manner. In 1795 Fuseli described his drawings to Farington,

saying that they were 'unrivalled by any man of this day' for 'invention, taste & spirit; and for the execution which is neither too much or too little'. These and a number of his earlier drawings of pretty subjects rather like the present one were engraved by Bartolozzi and Charles Knight as decorative stipple prints, issued more for the engraver's benefit than Lock's own. It was as if by agreeing to the publication of sketches of his sisters and other fashionable subjects, Lock was foregoing all claims to becoming a serious (although never 'professional') artist and, indeed, several years later when he was asked for some sketches for a similar purpose, he recommended 'an artist of the name of Stothard whose labours in that way are pre-eminently successful tho his circumstances I fear bear no proportion to them'. The founders of the Society of Painters in Water Colours, who objected so strenuously to the type of serious amateur his father and Gilpin wanted him to become, would have approved.

Literature: Barbier, 160–1; David H. Weinglass, ed., *The Collected Letters of Henry Fuseli*, 1982, 49; *Farington Diary* II, 16–17; Jenkins and Sloan, 254–7; Ingamells 608–9.

WILLIAM YOUNG OTTLEY
(1771–1836)

162

Angels of the Revelation (8:13)

Pen and brown ink, with brown wash, over pencil, 326 × 236 mm

LB 2

Provenance: Francis Du Roveray, his sale, Christie's, 22 February 1850, lot 820, purchased by Evans for the Museum

1850-3-9-18

Ottley was educated in Richmond, Yorkshire, and took lessons from the local drawing master, George Cuitt, before attending Winchester. The frontispiece of the first of Walpole's albums of amateur prints at Farmington is an imaginary landscape with trees, a rocky arch and a bridge, drawn in black wash with some pen and ink, and inscribed: *Drawn by W. Y. Ottley when a boy at Winchester school.* His master at Winchester is not known. He studied with the Scottish artist John Brown *c.*1786–7, and then at the Royal Academy from 1788 to 1791, when he left for Italy. He enjoyed a substantial income from family plantations in the West

Indies (see cat. 133), and described himself as an amateur. Certainly, there was never any question of him needing to earn a living as an artist, and during his seven years in Italy he helped others who found themselves in financial difficulties. Although he travelled and studied with many artists, amongst them John Flaxman, the engraver Tommaso Piroli and the Dutchman Humbert de Superville, Ottley devoted as much time to the collection and connoisseurship of old master prints, drawings and paintings and the study of the art of the early Renaissance. He exhibited at the Royal Academy once, in 1833, the year he became keeper of the Department of Prints and Drawings in the British Museum. He had sold parts of his collection as a *marchand-amateur*, but much was bought in and remained with him. His reputation was built on his connoisseurship, expressed publicly in his numerous writings on art, particularly a history of engraving on copper and wood (1816) and *The Most Eminent Masters of the Early Florentine School* (1826; with plates by Piroli).

The Museum has many drawings by Ottley, in a variety of media, from illustrations to Shakespeare and Dante to scenes from the Old and New Testaments, as well as several images of mothers and children. They echo the occupation of his friend in Rome, John Flaxman, whose illustrations to Homer and Dante were engraved by Piroli before he returned to England in 1794. Piroli engraved Ottley's own set of *Twelve Stories of the Life of Christ* in 1796, in aquatint rather than outline as Flaxman's were: Ottley's preparatory drawings show, like the present example, that he conceived his work in light and shade. He continued to produce drawings of this type after his return to England, and it is difficult to say for certain that this drawing was made in Italy. What is clear, however, is that he spent much of his time in Italy studying and copying the work of the early Italian masters from the Trecento onwards, including works he saw in Pisa, Florence and Assisi with Piroli. There are copies after Signorelli and Raphael in the Museum and many after Michelangelo in collections elsewhere.

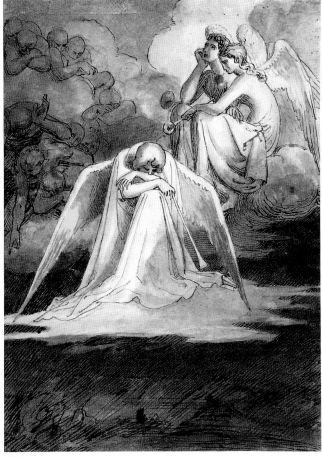

162

Ottley used these as a foundation, like the prints, drawings and paintings he acquired throughout his stay in Italy (to which he continued to add after his return), for his later authoritative writings on the history of engraving, *The Italian School of Design* (1805–23), and the catalogues he wrote of his own and other collections, including that of the National Gallery (1826).

Literature: J. A. Gere, 'William Young Ottley as a collector of drawings', *British Museum Quarterly* XVIII, 2 (1953), 44–53; Pressly, 141–4; Ingamells, 728–9.

163
Unidentified composition

Pen and black ink, over black chalk, 278 × 199 mm

Provenance: F. A. Driver, from whom purchased

1965-2-13-5

John Brown had been part of Fuseli's circle in Rome in the 1770s and acted as Charles Townley's draughtsman on a tour of Sicily. He made drawings of Townley's marbles in Park Place in 1786 (see cat. 167), the year he taught Ottley in London. Many of Brown's fluid mannerisms so reminiscent of Fuseli are evident in Ottley's drawings, but they also show that he was aware of the work of other members of the cosmopolitan circle in Rome in the 1770s, as well as friends such as Humbert de Superville or George Wallis who was illustrating Ossian when Ottley

163

himself met them in Rome during his long sojourn in 1790s.

The subject of the present drawing is not known, but may bear some relationship to the equally obscure drawings of giants amongst rocks by 'The Master of the Giants', an unidentified artist working with Brown and the others in Rome in the 1770s. Translated by Ottley through the medium of Flaxman's Neo-classical outline, and combined with his knowledge of the early prints of the Renaissance by Pollaiuolo and Mantegna, the resulting compositions were strange images quite different from those being produced by his contemporaries.

This drawing may have been a preparatory sketch for the series of illustrations to the Old Testament that Ottley was working on in the mid-1790s. The images were much more bleak in this second series: a study for warriors on horseback from Genesis 14:15 in the Museum's collection employs his characteristic repetition of gestures, particularly outstretched arms with swords in hand, underlining his study of the images of battling nudes and gods by the early printmakers mentioned above. The plates were engraved as aquatints by Piroli and published in 1797 in a small edition. The thirteen original copper plates were acquired by the Huntington Library, San Marino (Calif.), in 1993.

After SARAH STONE
(*c*.1760–1844)

164
Interior of Sir Ashton Lever's Museum, Leicester House, Leicester Square, c.1835

Watercolour with black ink, some bodycolour and gum arabic, 450 × 425 mm

Inscribed on verso: *Sir Ashton Lever's Museum: – (Leicester House, Leicester Square) (From a Drawing made on the Spot.)*

Provenance: Purchased 1994 from Andrew Edmunds, with assistance from Professor Michael Crawford

Department of Ethnography, Library

In 1786 Sarah Stone exhibited the original of this *Perspective view of Sir Ashton Lever's Museum* at the Royal Academy. The watermark on this copy is dated 1835, but it is unlikely that she painted it. As we have seen, the polite recreation of copying paintings in

various media and sizes dated back to drawn and limned copies in the seventeenth century; in the next century many amateurs not only copied paintings and drawings in private collections, but also began to copy those on public display. It was not only works of art, however, that were copied in private collections: the British Museum permitted artists and amateurs to draw and paint objects in its collections, and many private museums, such as that set up by Sir Ashton Lever in 1775, also permitted, even encouraged, drawing and painting, by providing 'Good Fires in all in the Galleries' and by displaying their work.

Sarah Stone was the daughter of a fan painter, and in the manner of early limners such as Alexander Marshal, she was used to working in bodycolour as well as watercolour and able to mix her own colours. She was undoubtedly trained by her father and assisted him in his work, as her earliest surviving drawings are on smooth, sized paper and rarely have any indication of background in the images. Her usual practice was to sketch the object first in pencil on thin paper and then paint the final version on sized sheets in albums or with more bodycolour and detailed work for framing. Her earliest drawings are of objects in the Leverian Museum and are dated 1777, two years after it opened; by 1784, she had painted over a thousand. It is not clear whether she first asked permission to draw in the Museum and was then commissioned by Lever or whether she earned her living from this type of work from the beginning; she is said to have been commissioned, but documentation is sparse and there are no records of payment. The drawings apparently belonged to Lever, as in 1784 he advertised in the *Morning Post* the addition to the Museum of a large room of 'Transparent Drawings in Water Colours, from the most curious specimens in the Collection, consisting of above one thousand different articles, executed by Miss Stone, a young lady, who is allowed by all Artists to have succeeded in the effort beyond all imagination.'

When the Leverian Museum was sold by lottery in 1786, the year Sarah Stone made her record of its interior, Lever retained her watercolours and, on his death two years later, some were sold. In 1791 Joseph Banks was offered nearly 800 of her drawings of birds, shells, fossils, and other subjects, although he does not seem to have purchased them (her works now in the Natural

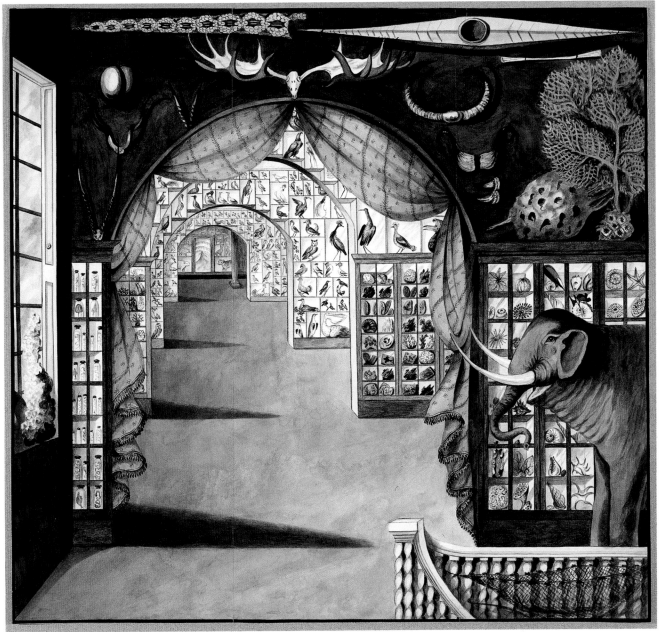

164

History Museum have been acquired since 1930). Her original watercolour of the interior of the museum remained with the contents of the museum itself, which was dispersed by sale in 1806 when it was sold to Mrs Oliphant for £2.10.0. (now private collection). The museum had be moved after the lottery, but continued to have objects added to it. Sarah Stone was to paint there throughout the 1780s. In 1789 she married John Langdale Smith, a midshipman who shared her interest in painting and exhibited a portrait at the Royal Academy

in 1791 when she exhibited paintings of birds at the Society of Artists. She contributed a view of the interior of the museum in its new location in the Rotunda to a published companion to the museum; this showed some of her framed drawings of birds, shells and flowers, etcetera, hanging on the entrance arch. She painted little after her marriage, apart from live birds brought back by her husband from his voyages. Following a pattern that seems to have been typical for young women who gained reputations as artists, she exhibited at the

Royal Academy before her marriage as 'Miss Stone', when she was described as a 'Painter', but afterwards, as 'Mrs Smith', she was an 'Honorary Exhibitor'. There is no doubt that her watercolours, whether she was paid for them or not, served the owners of the museum as an additional exhibit or attraction, their 'curiosity' value due to the fact that they were produced by a young woman perhaps underlined by her lack of skill in comparison to works produced by her professional male contemporaries.

Literature: Jonathan King, 'Woodlands art as depicted by Sarah Stone in the collection of Sir Ashton Lever', *American Indian Art Magazine* 18 (2) (1993), 32–45; King, 'New evidence for the contents of the Leverian Museum', *Journal of the History of Collections* 8 (2) (1996), 167–86; Christine E. Jackson, *Sarah Stone: Natural Curiosities from the New Worlds*, 1998, passim. (I am grateful to Jonathan King and Harry Persaud for their generous assistance with this entry and the following one.)

SARAH STONE (*c*.1760–1844)

165

Volume of forty drawings of objects in the Leverian Museum, open to Woodlands black-dyed skin pouch decorated with thunder birds

Pen and ink and watercolour, 335 × 210 mm

Provenance: Provincial auction, 1991, where purchased by the Museum

Department of Ethnography, Library, M23270C

The Leverian Museum contained around 26,000 items, mostly natural history objects, but also objects brought back to England from two of Captain Cook's voyages (1768–80), Asian musical instruments, antiquities and North American materials, several of which are included in the present volume. It continued to grow under new

165

ownership through the 1780s and 1790s. Some of the objects Sarah Stone painted were not in the Leverian Museum, but in other private museum collections and the British Museum. Visiting museums was as popular a pastime as it is now, although it was certainly confined to those who could afford it, as admissions were frequently charged. Lever's tickets were half a guinea, and 'the tutor and governess' were included in the 5-guinea family ticket. Artists and amateurs were encouraged because of the advertisement their works provided.

On the collection's dispersal, some items came to the British Museum, while others went to 'travelling museums' and collections abroad. The purse represented here came to the British Museum only in 1937 (6-17.1), and an Hiberno-Viking silver penannular brooch found in 1785, also represented in this album, came to the Museum in 1909 (6-24.2). Sarah Stone's watercolours are often the only visual record of many of the objects, but other artists also recorded items, among them Lady Eleanor Fenn (*née* Eleanor Frere, m. 1788, d. 1813), who drew insects in the museum, which she later included in two small guides to particular sections of the museum. Many of Sarah Stone's drawings and watercolours were engraved for books such as John White's *Journal of a Voyage to New South Wales*, with objects from the Leverian Museum and Thomas Pennant's four-volume *View of Hindoostan*, (1798–1800), where the plates were made from copies Pennant had his 'paintress, Miss Stone' take from the drawings in their collection.

COUNTESS OF AYLESFORD (1760–1832)

166

Touch me Not, 1792

Watercolour over pencil, 350 × 238 mm; on mount with wash border, 495 × 370 mm

Inscribed on mount: *XIX.6.* and *Impatiens Noli me Tangere TB. 243.V.I.EB Touch me not*; and below the border: *Packington July 30. 1792. Garden.*

Provenance: Sale, Sotheby's, 1 November 1973, One of sixty-three drawings; purchased from Abbott and Holder

1978-4-15-6

Louisa Thynne married Heneage Finch, 4th Earl of Aylesford, in 1781. Her father,

the Marquess of Bath, was a lord of the bedchamber to George III and her mother, the daughter of the Duchess of Portland, was a lady-in-waiting. At Longleat her parents employed 'Capability' Brown to replace the Dutch gardens with lawns and a serpentine river. Works by members of the Thynne family were included in a group of drawings of *c*.1770 by the Finch family sold at Sotheby's, 16 July 1992 (lot 20). Lady Aylesford's collection of nearly 3,000 botanical drawings passed to the Countess of Dartmouth, but the present drawing is from two albums of the countess's botanical watercolours at Packington, which was sold and broken up in 1973.

Similar albums were produced in great numbers in the eighteenth century, just as they had been in the seventeenth (see Ellen Powers and Lady Carnarvon (cats 24, 36). Mrs Delany's *hortus siccus* was unusual in being made of cut paper; more commonly they were compiled from dried examples, such as Joseph Banks's (now Natural History Museum) or professional artists were employed to create florilegia like those painted for the duchesses of Beaufort and Portland. In the eighteenth century, the women of the family generally painted their own florilegia in watercolour, carefully labelling the plants by the Linnaean system and showing leaf, stem, petals, flowers and their parts, with seeds. Similar albums to Lady Aylesford's were produced by several generations of Conyers women at Copt Hall, in Essex. Most of Matilda Conyers's (1753–1803) watercolours were painted on vellum, and the album containing watercolours by an older Matilda (d. 1793) and Henrietta (1727–93) included drawings by Ehret who clearly influenced their work, if they did not actually receive lessons from him. Sophia (d. 1774) married Sir Roger Newdigate, whose own watercolour views of Italy, ruins and antiquities produced on his grand tours in 1739–40 and 1774–5 remain with his descendants. The later tour was undertaken after his wife's death with his sister-in-law Mary Conyers, who while in Rome, took lessons from 'Fabrini' (see p.171). Given the courtesy title of Mrs Conyers, her works also appear in the Suffolk albums (see cat. 118).

Literature: Matilda and Henrietta Conyers at Abbott and Holder, London, June 1996; Thomas Williams Fine Art, *A Georgian Garden: Botanical Studies … by Matilda Conyers (d. 1803)*, exh. and sale, New York, 1997; Ingamells, 704–5.

166

W.(?) CHAMBERS (*fl.* 1794–5)

167

*The Townley Collection in the Dining Room at Park Street, Westminster, c.*1794–5

Pen and ink with watercolour and touches of bodycolour, with gum arabic, 390 × 530 mm

Provenance: Charles Townley; by descent to Lord O'Hagan, his sale (with the Townley papers), Sotheby's Book Department, 22 July 1985, lot 559, bt private owner; his sale, Sotheby's, 12 April 1995, lot 90 (with *The Townley Collection in the Entrance Hall at Park Street*), purchased by Christopher Gibbs for the Museum

1995-5-6-8

With his friends Sir William Hamilton and Richard Payne Knight, Charles Townley (1737–1805) was one of the most distinguished collectors of his day. One of the main purposes of collecting was to improve public taste at the same time as displaying one's own taste and connoisseurship. Many collectors did so in their country houses, to which the gentry 'on tour' around Britain were generally admitted. In 1758 the Duke of Richmond had opened his gallery of sculpture in Whitehall where artists as well as others were encouraged to visit and draw under the resident artist J. B. Cipriani's guidance. Charles Townley similarly encouraged visitors, even providing a guide to his collection, which became one of the sights of London. Visitors are seen consulting the guide in the view of the entrance hall, the pair to this watercolour.

Sir William Hamilton, whose collections of paintings, sculpture, antiquities and especially vases were displayed in his residence in Naples, where Townley had seen them in 1772, also wanted his reputation as a connoisseur to be recognized in London during his absence. He published his first collection of vases and antiquities, and sold it (at a loss) to the British Museum where, again, artists and other visitors were encouraged to study it and improve their own taste and ultimately British design in general. Like Hamilton and Payne Knight, Charles Townley was a trustee of the British

Museum and also wanted the nation to benefit from his collection. He originally planned to bequeath it to the Museum, as Payne Knight was to do, but instead he left it to his family on condition that they built a suitable gallery. When they could not meet the condition, the collection, like that of Sir Hans Sloane, was purchased for the nation by an act of parliament.

On his return from his final trip to Italy in 1777, Townley bought the house at 7 Park Street (now 14 Queen Anne's Gate) and adapted it for the optimum display of his collection, to which he continued to add. One of his last major purchases was the *Discobolus*, excavated in 1791 and seen as the main focus of the room in this record in watercolour, which he seems to have commissioned in 1794 or 1795. The same sculpture is the distant focal point of the companion view of the hall, for which he paid Chambers £5.5.0. on 21 October 1795. For comparison of contemporary values, the following month he paid £3.3.0. for the second volume of the Hamilton vases illustrated by Tischbein. In February that year he had paid Chambers £2.2.0. for some unspecified drawings, and in August £1.1.0. for 'drawing gems'. Apart from these payments and the pair of watercolours of Park Street, Chambers is unknown. It is possible that he may be the W. A. Chalmers who exhibited interiors at the Royal Academy from 1790 to 1794.

It is clear from the way the interior was laid out that Townley intended these rooms of his home to be more for public than private benefit: admission to his collection was free and the decorations were designed to set off the sculptures. Colours were chosen to enhance them and the columns installed to separate them visually from each other. The three sculptures across the foreground in this view usually rested against the wall and window behind the viewer. Women artists, whether amateur or professional, were not permitted to draw the nude from life, but it was acceptable to learn from casts or the acknowledged perfection of antiquity. The pose of the fallen athlete being studied here would demand advanced skills in foreshortening; it is doubtful that a drawing master would have been permitted to advise as closely as shown here, but a father or spouse might demonstrate his accomplishment and skills as an amateur and a connoisseur, by publicly encouraging his daughter or wife in this fashionable pursuit.

167

Literature: British Museum Archive, Charles Townley papers, 'Abstract of Payments 1795' (I am grateful to Gerard Vaughan for pointing out the existence of these accounts and to Christoper Date for finding them); B. E. Cook, *The Townley Marbles*, 1981; Ingamells, 946–8; I. Jenkins in Bignamini and Wilton, no. 214.

DOROTHY BOYLE, COUNTESS OF BURLINGTON (1699–1758), *née* SAVILE

168

Study of a woman wearing a cap [not illustrated] and *Study of a bust of a young woman*

Red chalk; 146 × 115 mm, 223 × 162 mm

Both inscribed: *Lady Burlington*

ECM II, 1,2

Provenance: Iolo Williams, by whom bequeathed

1962-7-14-15, 16

The eldest daughter and co-heiress with her sister of the 2nd Marquess of Halifax, Lady Dorothy Savile brought a fortune of £30,000 and an annual income of £1,600 to her marriage in 1721 to Richard Boyle, 3rd Earl of Burlington. Their marriage was a compatible one of shared interests, particularly as patrons of music and the arts. Both were at court, she as a lady of the bedchamber and he as a privy councillor. Lord Burlington encouraged various artists and designed architecture in the 'Bagnio' at Chiswick that he used as a drawing office. He had first met the artist William Kent in 1714 and over the next three decades encouraged him in his various careers as architect and garden designer, finding him patronage at court. Drawings of Lady Burlington at her easel by Kent indicate

168

that she often used the drawing office as a studio, and his presence undoubtedly shows that he gave advice and tuition. Having trained as a painter in Rome, Kent would have been qualified to advise the countess on painting in oils, as would the king's portrait painter, Charles Jervas, who at one point was teaching her friend Alexander Pope daily. The poet owned one of her copies of an old master, which he stated that he valued more for the artist who had executed it than for its subject. He encouraged her painting in oils, and wrote a satirical verse when at one point she diverted herself with cutting paper (see p. 214).

Although Lady Burlington eventually became an accomplished portraitist in oils (one of her best portraits is of the Duchess of Portland (see cat. 40) before her marriage), like all amateurs at the time, she began by copying works by other artists in chalks. The largest surviving collection of her *oeuvre* is at Chatsworth, the home of her daughter's descendants. It includes chalk drawings after paintings by Van Dyck in the Royal Collection, as well as numerous caricatures, at which she was adept, and pen and ink sketches of figures and landscapes so close in manner to Kent's style that their hands are difficult to distinguish. The drawings shown here appear to be exercises in drawing from life, with a pedestal added playfully to give the bust of a young woman the appearance of having been drawn from the Antique. Lady Burlington was best known, however, for her portraits in pastel, at which she excelled. George Vertue recorded seeing a room hung with great numbers of them at Burlington House. Walpole, who was waspish about her personally, felt that she dashed them off too quickly and 'never took any pains to improve her genius'; her surviving works in this manner, many of them portraits of her daughters, certainly vary in quality, and it is likely that a master such as Jervas or Louis Goupy, her daughter's drawing master in the late 1730s, had a hand in some of the better ones.

Literature: Mark De Novellis, *Pallas Unveil'd – The Life and Art of Lady Dorothy Savile, Countess of Burlington*, exh. Orleans House Gallery, 1999.

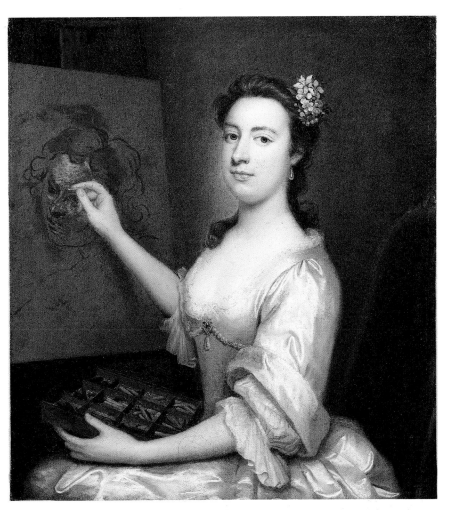

169

Attributed to ARTHUR POND (1701–58)

169

*Rhoda Delaval, c.*1750

Oil on canvas, 768 × 686 mm

Provenance: Presented by Montagu Bernard in 1979

National Portrait Gallery, London 5253

In 1734 Arthur Pond began to give drawing lessons to Grace, Countess Dysart, whose quick progress to drawing portraits in crayons (pastels), so impressed a fellow member of the court circle, Mary Pendarves (later Delany, cat. 40), that she also wished to learn to draw this way. She in turn recommended him to her fellow lady of the bedchamber, Catherine Dashwood, whose entire family then commissioned their portraits from Pond. The lessons proved a remarkably astute move on the part

of the artist as a way into royal patronage, and his sitters soon included various young members and friends of the royal family, among them many of Bernard Lens's pupils, the princesses Mary and Louisa, the Duke of Cumberland, Duchess of Portland, Helena Percival (cat. 44) and her sister-in-law. The husbands and brothers of many of his pupils and sitters were patrons and collectors who employed Pond in his capacity as a dealer and provided him with an introduction to their clubs and societies.

Arthur Pond began to give lessons to Rhoda Delaval (1731–57) in 1747. She did not come from the circle of ladies at court, but from a newly wealthy Northumberland family. Her parents, brothers and eventually her husband Edward Astley all took lessons, sat for their portraits, or employed Pond as a dealer. Astley purchased nearly the whole of Pond's personal collection of prints for £1,500, and one of Rhoda's

younger brothers was so good at his lessons that he was apprenticed to the artist.

Although Pond certainly helped to popularize the practice among amateurs, drawing in crayons was not introduced into England by him: several seventeenth-century drawing manuals recommended it, although only a few examples from that century survive. Rosalba Carriera and other Italian and French pastellists began to portray young men on their grand tours in the 1710s, and the resulting portraits helped to establish a market in Britain for this smaller, more affordable and portable type of portrait in contrast to the usual oil. The Countess of Burlington (cat. 168) had lessons from William Kent and possibly Charles Jervas in this medium in the 1710s and 1720s, and filled a room at Burlington House with portraits in crayon. The greatest vogue for lessons was in the 1730s to 1740s: George Knapton, William Hoare, Catherine Read and Francis Cotes all specialized in this type of drawing before the middle of the century, and the taste for drawing in crayons did not abate in the second half. George, Viscount Nuneham (cat. 96), and his sister Elizabeth Harcourt (cat. 109) took lessons from Knapton in the 1750s, and Ozias Humphry, Hugh Douglas Hamilton and John Russell were all highly talented pastellists with numerous pupils. In 1772 Russell produced a manual on the subject, *Elements of Painting with Crayons*, where he noted: 'The Student will find the sitting posture, with the box of Crayons on the lap, the most useful method for him to paint' (p. 21). The portrait of Rhoda Delaval also demonstrates that it was common to use blue paper to provide a background tone, and that one proceeded from an outline to flesh colours, learning by copying drawings by other masters first, before drawing *ad vivum*. Unfortunately, the medium is very vulnerable, and although some works survive in the hands of descendants of artists such as Rhoda Delaval, there are few examples by amateurs in public collections. Lady Diana Beauclerk was one of the few amateurs to practise this type of portraiture successfully in the second half of the century. Her portrait of her daughters was recently acquired by the Lewis Walpole Library (see fig. 7 on p. 239).

Literature: Lippincott, 38–47; Jacob Simon, 'The production, framing and care of English pastel portraits in the eighteenth century', *Paper Conservator* 22 (1998), 10–12.

PAUL SANDBY (1730–1809)

170

*A young lady painting, c.*1770

Pencil and watercolour, 195 × 152 mm

Oppé 1947, 259

Lent by Her Majesty The Queen (RL 14377)

A very similar drawing in pencil and red and black chalk of the same young woman, from a viewpoint slightly further to the left, is in the collection at the Yale Center for British Art (New Haven (Conn.)), and has been dated to the 1760s. Her costume and general appearance are very close to a series of drawings Sandby made around this time of his wife Anne, Lady Maynard, and Lady Elizabeth Harcourt (cat. 109). In the drawing at Yale, the young woman holds a *porte-crayon* and is clearly copying a chalk drawing of a head pinned to the wall in front of her, the little round palette attached to the table leg is folded in and the drawer with disks or shells of colours is not pulled out. In this watercolour, a tartan curtain has been added, and the view across a river to ware-house-type buildings on the far bank is clear. Her 'sack' dress with its folds at the back and wide stomacher embroidered with flowers is datable to the mid-1760s. She is painting with watercolours, all her necessary equipment clearly visible in the ingenious table, and there is no evidence that she is copying from another drawing. In the mid-1760s Sandby lived near Carnaby Market, so although tartan curtains appear regularly in interiors of his own rooms, it seems doubtful that he could see the river from there. The house may have been his pupil's, who has not been identified.

Although she is seated by a window, it is for the light it provides rather than the view. Many of the surviving works by Sandby's pupils are not sketches from nature, but imaginary Italianate compositions drawn in chalk, with pen and brown and black ink, washed with ink and some watercolour. There are drawings of this type of composition by Sir William Hamilton (see cat. 93), Robert Adam, who may have had lessons from Sandby, and others, including two by Sir Frederick Stephenson, Queen Charlotte's comptrol-

170

ler of the household. Stephenson's drawings (Yale Center for British Art) exemplify one of Sandby's favourite teaching techniques, similar to that employing outline etchings described in cat. 100: he would draw an outline in black chalk, which he offset on to other sheets, finishing the original in watercolour and having his students finish the offsets. Lady Louisa Greville (see cat. 140) and Lord Nuneham (cat. 96) both produced several etchings of these Italianate compositions, in the manner of Salvator Rosa, Marco Ricci and Sandby himself.

The surviving works of another Scottish pupil, Lady Frances Scott (1750–1817), who married Lord Douglas in 1783, are also of this type and include a copy of a landscape by Robert Adam (Oppé collection, Tate Gallery). Horace Walpole recorded in his *Anecdotes* that Lady Scott 'draws, paints, and writes verses' (v, 236). Other members of her family were said to have taken lessons from Alexander Cozens, whose pupils produced similar Italianate imaginary compositions, but the only evidence of her being taught by Sandby is the well-known view by him of *Roslin Castle* (c.1780), a favourite spot on the picturesque Esk river within easy reach of Edinburgh. This shows Lady Scott drawing the view from a camera obscura while her companion, Lady Elliott, looks on

(Yale Center for British Art; with a preparatory sketch of the two women). The use of the camera obscura, by professionals and amateurs, particularly military amateurs, was far more common than is generally acknowledged (see p. 174), although the resultant works are not always easy to spot as they look like straightforward topographical views.

Literature: Robertson 1985, 51–3, 60, 80–4, 89, 103.

JOHN HODGES BENWELL (1764– 85)

171

A woman mourning beside an urn in a wood, 1783

Watercolour, with pen and grey and brown ink, over graphite, 148×138 mm; on mount with gilt and wash border, 180×165 mm

Inscribed on mount: *J. H. Benwell invt & Pinxt. – 1783.–*

Provenance: Purchased from Arthur Churchill

1912-4-16-207

Several members of the Lens family visited Bath in the first half of the eighteenth

century and may have given lessons there, but apart from the deaf and dumb artist William Mayo, who was a copyist and portrait painter in pastels, there are few records of drawing masters in the city before 1750. However, throughout the second half of the century and into the nineteenth, Bath was visited in season not only by the *haute-ton* who came there to take the waters, but also by those who might serve them: dancing and music masters, portrait painters and drawing masters. Among these were not only Gainsborough, William Hoare and Wright of Derby, but also lesser-known artists who advertised their arrival, residence and what they might teach. Limners, miniaturists, pastellists, fruit and flower painters and drawing masters were the most numerous, while others promised 'velvet painting, varnishing, etc. taught as usual'; occasionally, a teacher of painting in oils, bodycolours and tinted drawings (Thomas Hulley Sr, 1797–9) or etching and aquatinting (Mr Stuart, 1796) would appear.

Benwell was born at Blenheim, the son of the under-steward to the Duke of Marlborough, where his precocious talents were recognized early, and he was sent to the Royal Academy. He gained a silver medal at the age of eighteen in 1782 when he produced two very attractive fancy subjects in pastel on grey paper of a *St James's Beauty* (Manchester City Art Gallery) and *St Giles's Beauty*, engraved as oval-shaped popular stipple prints by Bartolozzi. The same year he appeared in Bath as a teacher of watercolours, crayons and pastels and his popular drawings of cupids and illustrations to such sentimental works as Sterne's *Maria* or Lady Anne Lindsay's ballad 'Auld Robin Gray' were variously engraved by Bartolozzi and Charles Knight. All were still 'fabulously expensive and extremely collectable' at the beginning of this century. He exhibited a classical subject at the Royal Academy in 1784, but died of consumption the following year. His watercolours were heightened with crayon in a manner that he seems to have invented, and, unfortunately, many have been rubbed. This example, however, provides a good indication of why his work had such a wide public, and how the vogue for producing figure subjects on a small scale, whether a continuation of the old limning tradition in bodycolour, or in heightened watercolour, continued to be favoured by amateurs during the eighteenth century.

In the nineteenth century miniature

171

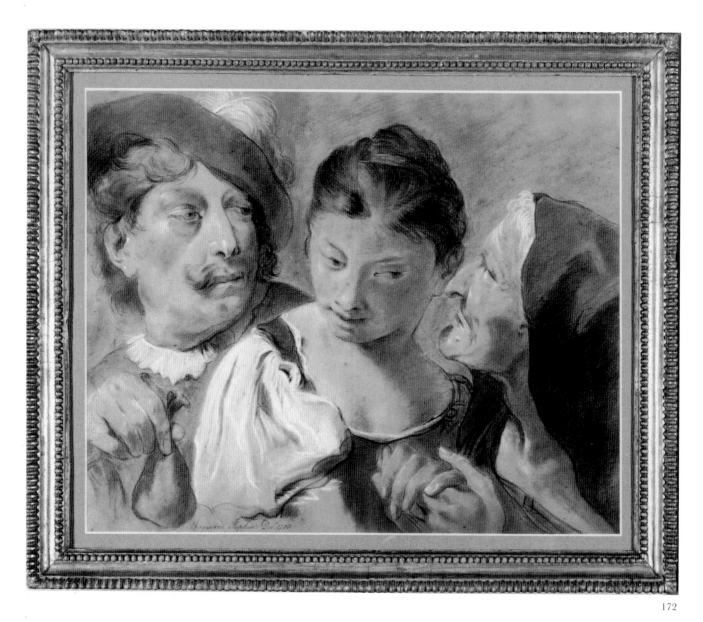

172

painting by amateurs became almost exclusively limited to portraiture. Already in 1804 in Bath, Joseph Hutchison (1747–1830), 'Portrait and Animal Painter to the Duke and Duchess of York', who taught head, figure and historical subjects, advertised particularly that 'eight lessons are sufficient for a portrait'.

Literature: Manuscript 'Index of Bath Artists', Victoria Art Gallery, Bath; 'Notes: John Hodges Benwell – A St James's Beauty', *Connoisseur* V (March 1903), 154, 279.

PRINCESS AUGUSTA SOPHIA (1768–1840) after GIOVANNI BATTISTA PIAZZETTA (1682–1754)

172

The Procuress, 1782

Black and white chalk on brownish paper, 405 × 505 mm; in original frame

Inscribed: *Augusta Sophia Decr. 1782*

Lent by Her Majesty The Queen (RL K 515)

The group of thirty-six drawings by Piazzetta acquired with seven of his paintings by George III from Consul Smith's collection is 'one of the finest groups to come from his hand', although it hung for

many years at Buckingham Palace under the name of Sebastiano Ricci (A. Blunt, *Venetian Drawings ... at Windsor*, 1957, 27). With its wonderful depiction of contrasting expressions and ages, the original of the present drawing (RL 01251), was engraved by Giovanni Cattini for *Icones ad vivum expressae* (1754). There are often several versions of one composition, apparently all by Piazzetta himself and executed at different dates. The Windsor group is from *c*.1730, and there is another version of this composition in a private collection at Padua. They are all on blue-grey or brownish paper, like the present work, but the paper has undoubtedly faded. Like Marco Ricci's landscapes copied by Princess Elizabeth (cat. 155), these drawings

by Piazzetta were works of art in their own right, intended by the artist to be sold or presented to friends, and they were much sought after by collectors and engravers during and after his lifetime, as they are now.

The Royal Collection has three drawings after Piazzetta by Princess Augusta, but only two (*A peasant girl and a boy* and *A geometer* (RL K 315, 316)) were known to Oppé when he catalogued the English drawings. They were drawn by Princess Augusta four years after the present work. All three hung in Buckingham House in the nineteenth century, but the other two were removed from their frames and placed in Queen Charlotte's portfolio in the Royal Library in 1903. Like her sisters, the princesses Charlotte and Elizabeth, Augusta also copied and etched old master drawings by Leonardo and Stefano della Bella in the Royal Collection. A number of artists were acting as drawing masters to the royal family at this date; but copying was a common undertaking, and making a copy did not have to be instigated by a drawing master, especially when a collection was as rich in examples to choose from as the Royal Collection. Like the present work and the dozens of copies by Princess

Charlotte after etchings by Ridinger, Berchem and Mortimer, which were deliberately drawn in such a way as to look like etchings and elaborately framed to hang at Frogmore, copies were made as gifts and decorations, to be framed and displayed in the same way as the originals, but with an additional element of innocent deception that we have already noted was felt to be particularly appropriate for the work of female amateurs.

Literature: Roberts, 75–7; Cornforth 1991, 46–9.

PRINCESS AUGUSTA SOPHIA (1768–1840)

173
Head of a girl, 1788

Pen and ink and watercolour, 202 × 210 mm

Inscribed: *Augusta Sophia 1788*

LB 1

Provenance: One of a group of works by amateurs purchased by Evans for the Museum at the McIntosh sale, Christie's, 16, 18–20 May 1857 (lots 731–54)

1857-5-20-77

Apart from copies of drawings by other masters in the Royal Collection, the Royal Library also has a number of oval landscapes by Princess Augusta in pen and ink and grey wash and dated 1778. During the 1780s, however, most of her work was figural.

In the 1770s and 1780s Benjamin West rented a house in Park Street, Windsor, in order to attend the royal family while they were in residence. While he was painting their portraits, like Gainsborough, West appears to have given the occasional lesson or made drawings specifically for them to copy or etch. In 1784 Charlotte Augusta Matilda, the Princess Royal, made etchings of the drawings of *The Five Senses* he made specifically for this purpose and in 1787, the Earl of Ailesbury noted: 'Princess Mary has taken to drawing heads, West giving her one to copy, she used to draw only landscapes.' Princess Augusta's drawing is very much in West's manner, but West himself was taking his inspiration in these works from the prints of another artist, Francesco Bartolozzi.

A proof of a stipple print from the Lucas collection (1917-12-8-940), another family of amateurs at Wrest Park (see cat. 110), is remarkably similar to the present drawing, in reverse. The catalogue of Bartolozzi's prints stated that it was after a drawing by Cipriani, published in 1790 (De Vesme and Calabri, 1228.1). The bowed head of a young girl with closed eyes is there framed by slightly tighter long curls, and the dress was added by Bartolozzi in pencil, but the print begs the question of which came first – Cipriani's drawing, Bartolozzi's half-made print or Princess Augusta's drawing.

Princess Augusta, who never married, seems to have given up drawing in the following decade. When she visited her sister Elizabeth, who had married the Prince of Hesse-Homburg in 1818, she took up the pen again to draw a series of caricatures of the court (now Staatliche Museum, Greiz, Germany).

Literature: Historical Manuscript Commission, 15th Report, *Somerset and Ailesbury MSS*, 'Diary of Thomas Earl of Ailesbury', I, 279; Roberts, 72; Jane Roberts, 'Royal Watercolourists', *Watercolours and Drawings* III, no. 3 (1989), 8–9; *Elizabeth, englischen Prinzessin und Langrafen von Hessen-Homburg (1770–1840) als Kunstlerin und Sammlerin*, exh. Hole Museum im Gotischen Haus, Bad Homburg, Greiz, 1990.

173

PRINCESS ELIZABETH
(1770–1840)

174 (a)
Commemorative Fan, 1789

Watercolour, pen and ink, with bodycolour and gilding on vellum, on ivory supports, 262 × 465 mm

Inscribed: *Health is restored to ONE and Happiness to Millions*, and below crown: *GR*

Lent by Her Majesty The Queen (RCIN 25087)

PRINCESS CHARLOTTE
(1766–1828)

174 (b)
Cupids with an hourglass and *A group of women and children*

Graphite and black chalk on orange and blue paper, scraped, 65 × 78 mm, 88 × 155 mm

Inscribed on sheet acquired with them: *Cuttings out of HRH. the princess Royal given to L J E. Waldegrave at Windsor Jany 1788*

Provenance: as for cat. 173

1857-5-20-75, 76

Princess Elizabeth, the third daughter of George III and Queen Charlotte, was the most active artistically of all the royal children. She engaged in every type of amateur practice taken up by her contemporaries in the royal circle and outside it. We have already seen her as an accomplished flower painter (cat. 51) and, like her eldest sister, she copied landscapes by

174 (b)

Gainsborough in the 1780s. The Royal Library has examples of grey washed landscapes and fifty-one vignettes in the same medium mounted on cards very reminiscent of the work of Alexander Cozens and William Gilpin (Oppé 1950, no. 15). She also sketched figural compositions and made several copies of prints. On a visit to her brother the Duke of Cambridge in Hanover in 1837, the princess completed an extra-illustrated manuscript of the *Histoire de la Duchesse d'Ahlden*, the life of George I's estranged wife imprisoned for infidelity, which she compiled and transcribed in French and illuminated with calligraphy and flowers. The fan illustrated here is an earlier example of her skill at limning, with delicate swags of flowers, decorative cameos

and gilding. Hand-painted fans were appropriate commemorative gifts for birthdays, or in this case, to celebrate the king's recovery in 1789 from his first serious illness. This fan is one of a group of similar examples in various collections (including one in the Schreiber collection in the British Museum), which may have been distributed at a 'Gala' at Windsor Castle on 1 May 1789. Elizabeth also made rolled-paper firescreens as gifts, painted velvet for chairs and decorated several panels in imitation of red and gold lacquer, which were installed in rooms at Frogmore and Bad Homburg.

Princess Elizabeth learned to etch from Biagio Rebecca (1735–1808) when she was quite young, and later from Peltro William Tomkins; a drawing by the princess in the British Museum, of a young girl with a bunch of faggots in the manner of Gainsborough, was engraved as a stipple print by Tomkins (1890-5-12-68). He was also the engraver of two volumes of figures based on Princess Elizabeth's cut-paper silhouettes, *The Birth and Triumph of Cupid* (1795) (under the name of Lady Dashwood, later reissued as *The Birth and Triumph of Love*, 1796, 1822, 1823). At Frogmore in the 1790s they were coloured in a manner similar to Sir William Hamilton's vase publications and inserted into medallions in the tall Pompeiian pilaster panels in the Cross Gallery. They were placed to separate Princess Elizabeth's larger wall panels of swags and trellises of flowers set against a blue sky in a style she had learned from Lady Diana Beauclerk and Mary Moser. In the following decade she cut silhouettes of

174 (a)

similar figures out of black paper for her friend Sarah Sophia Banks.

The examples of silhouettes exhibited here are by Elizabeth's eldest sister Princess Charlotte. They were not cut in black but in paper that was painted blue or brown. They are remarkably close to another publication issued by Tomkins in 1790: not titled, the first page bore his dedication: *To the Queen This Book of Etchings, from Papers cut by The Right Honourable Lady Templeton, In the Collection of Her Majesty*.... It contained twelve plates on blue or orange paper showing women and children, sometimes accompanied by cherubs, spinning, reading or dancing, and taking the shapes from paper silhouettes, but with the details of costume and faces etched in. They have been incorrectly described as another series after Princess Elizabeth's paper cuts, under another pseudonym, Lady Templeton; however, they are similar to a series of designs titled 'Domestic Employments' and 'Maternity' made for Wedgwood in the 1780s by the amateur modeller, Elizabeth, Lady Templetown (1747–1823) (see cat. 108). Lady Templetown had been lady of the bedchamber to Princess Amelia. In 1785 she lent Wedgwood a group of cut Indian paper designs, which became the source of fourteen 'sentimental, morally didactic and uplifting subjects' modelled for Wedgwood's jasper ware series, 'Domestic Employments' (Young, 41). This connection between Wedgwood's single-colour relief designs and cut paper is one that would reward further study and help to elucidate whether the 1790 series was by the Princess Royal (Charlotte), Princess Elizabeth or Lady Templetown.

Literature: Roberts, 71–86; Reilly 1, 604–5; Cornforth 1990, 48–50; Dawson 1995, 51–62; Young, 41–2; Jane Roberts *et al.*, *Fans from the Royal Collection*, forthcoming exh. (2001–3).

GEORGE, PRINCE OF WALES (1762–1830), later GEORGE IV

175
Sketch for a costume

Watercolour and grey ink, touched with white, 245 × 145 mm

Inscribed on mount: *Given to me August 1783. by J. Newnham. A drawing made by the Prince of Wales as a pattern for a masquerade dress in which he intended to have appeared on his Birthday.*

LB 1

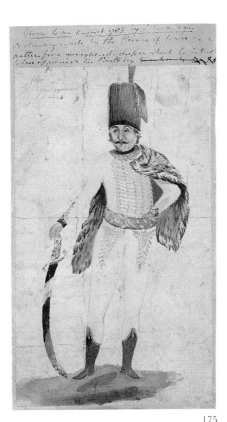

175

Provenance: One of a group of works by amateurs purchased by Evans for the Museum at the McIntosh sale, Christie's, 16, 18–20 May 1857 (lots 731–54)

1857-5-20-87

Of all the royal children who received lessons in drawing, the least is known about George, Prince of Wales. His father had received lessons in landscape, military and architectural drawing (see cats 67–8), and of his brothers, the princes William and Edward received lessons in landscape from Alexander Cozens, while Augustus and Ernest may have been taught by Paul Sandby (cats 100–1). No doubt the Prince of Wales participated in drawing exercises such as copying from prints by old masters: the British Museum has his sister Princess Charlotte's copy of a plate from the same drawing book by Bloemaert that Sandby had used for admission to the Board of Ordnance in 1747 (1857-5-20-65).

The few drawings that survive from the Prince of Wales's hand are, perhaps characteristically, sketches of designs for furniture, a fountain and for the decoration of the panels of the New Music Room at Brighton Pavilion in 1818 (1962-7-14-34). The prince's interest in design and his own clothes manifested itself in his earliest drawings:

that of 1780 for a tripod made up for him by a cabinet maker, and the present elaborate hussar's uniform with a jewelled sword and flowered blue sash, which he evidently intended to wear to a masquerade celebrating his twenty-first birthday.

Literature: Roberts, 86.

LADY DIANA BEAUCLERK (1734–1808), *née* Spencer

176
Cupid with a bow and *Cupid with a mirror*

Pen and grey ink with watercolour, 147 × 129 mm and 185 × 124 mm

Verso: study of a cupid with an arrow; brush drawing in grey wash

Inscribed in Italian verse: *Chiara & puro / Come mostra lo specchio un viso tale / Quale è, cosi dovrebbe l'amatore / Mostrar di fuori, com è dentro, il core, / Convien che al detto sia la voglia uguale*

Provenance: Bequeathed by Iolo Williams

1962-7-14-9

Lady Diana Spencer was the eldest daughter of Charles Spencer, the 2nd Duke of Marlborough. She grew up at Blenheim, where from the age of eleven she made pastel studies of children from the duke's paintings by Rubens and Van Dyck. She married the 2nd Viscount Bolingbroke in 1757, but divorced him in 1768 and married Topham Beauclerk two days later. Although both husbands moved in court and social circles in which she found many compatible friends, including Charles James Fox and George Selwyn, Bolingbroke was by all accounts a drunk and a rake, and Beauclerk, a friend of Johnson, Burke, Garrick and Reynolds, was a hypochondriac, addicted to laudanum. Lady Diana's most active support came from a family circle that included the countesses of Pembroke and Spencer, the Duchess of Devonshire and her brother Robert Spencer, all of whom were amateurs and active patrons of the arts. She lived at times in Little Marble Hill, which she decorated by painting the walls with flowers and infant bacchantes in watercolour, and after Beauclerk's death she moved into Devonshire Cottage, in Richmond. Both homes were near Horace Walpole, one of her most sympathetic and supportive admirers.

Walpole so admired Lady Diana's 1776 series of 'soot-water' drawings illustrating

his gothic romance *The Mysterious Mother* (1768) that he planned to have them engraved in aquatint, and built a special room at Strawberry Hill to house them. There is a large example of her work in this manner, the *Gypsies and Female Rustics* in the Victoria and Albert Museum, and her work in this style, sometimes with touches of watercolour, has frequently been confused with drawings by another amateur whose work Walpole also admired, William Henry Bunbury (cat. 178).

Lady Diana was better known amongst her contemporaries, however, for her drawings of children and especially infant bacchantes and cupids. An album once in the collection of her descendants contained several pretty wash drawings of this type of subject, as well as studies of her children and figural compositions in landscape. The present drawings of cupids reflecting on love and renouncing it may have come from this album. Through the 1770s and 1780s, Francesco Bartolozzi and other engravers produced countless stipple engravings of these playful cherubic infants after their own or J. B. Cipriani's designs, inspired by artists such as Guercino or by classical motifs. Unlike Cipriani or Bunbury, Lady Diana's drawings relied almost entirely on an effective use of the brush with little or no pen work. These popular designs found their way on to all forms of decorative arts, including decorative panels on furniture (some of Lady Diana's are now at Farmington and Lydiard House, near Swindon) and on Wedgwood's pottery.

After her friend Charles James Fox apparently sent one of her sketches to Wedgwood, Lady Diana supplied the potter with about four designs of infant bacchantes and cupids, which appeared on wares as varied as wine coolers, teapots and marble clocks from 1776 and during the 1780s. Her example was followed by Lady Templetown and Miss Crewe whose designs of 'maternal affection' and 'domestic employments' appeared not only on Wedgwood's wares, but were also issued as prints (see cat. 174). Lady Diana's biographer in 1903 listed five bas-reliefs executed by Lady Diana herself in wax: two pairs were in Walpole's collection at Strawberry Hill, carefully set in frames with the Beauclerk arms and cameos by Wedgwood and James Tassie, and the fifth, a group of cupids, was in the Earl of Pembroke's collection at Wilton House.

A large ewer based on a design by Jacques Stella is silhouetted in the window behind Lady Diana in her portrait painted by Reynolds in 1763–5, which shows her as a Muse of Art, seated, holding a portfolio in one hand and a *porte-crayon* in the other (Iveagh Bequest, Kenwood). The vase has frequently been described as being by Wedgwood, and assumed to allude to her work for him. Wedgwood did not, however, begin to produce this type of vase until the end of the 1760s, and Lady Diana had not yet started to provide him with designs when the portrait was painted. In fact, Wedgwood's production of black basalt and agateware vases begun in 1769 was inspired by the Antique vases that had been appearing in collections and fashionable portraits such as Lady Diana's from the mid-century.

Lady Diana's designs employed by Wedgwood were engraved in stipple by Bartolozzi in 1791 (V&C 1252-3 and 400), ensuring them even wider distribution. Their success may have inspired her to illustrate William Spencer's translation of

G. A. Bürger's ballad 'Leonora', engraved by Bartolozzi in 1796, and John Dryden's *Fables ancient and modern* the following year. She was short of money at this time and may have been paid, although there is no firm evidence for this, and the drawings were probably executed earlier in the decade since she had become ill and drew very little by this time. Her name featured prominently on the title-pages.

Literature: Mrs Steuart Erskine, 'A scrapbook belonging to Lady Diana Beauclerk', *Connoisseur* VII (September–December 1903), 33–7, 92–8; Mrs Steuart Erskine, *Lady Diana Beauclerk, her life and work*, 1903; Hanns Hammelmann and T. S. R. Boase, *Book Illustrators in Eighteenth-Century England*, New Haven and London 1975, 14; Williams, 231–2; Reilly I, 605–7; Young, nos B27, C21, E12; Dawson, 59–60, 127.

Chiaro & puro
Come mostra lo specchio un viso tale
Qual è, così dovrebbe l'amatore
Mostrar di fuori, com'è dentro, il core.
Convien che al detto sia la voglia uguale

176 (a) 176 (b)

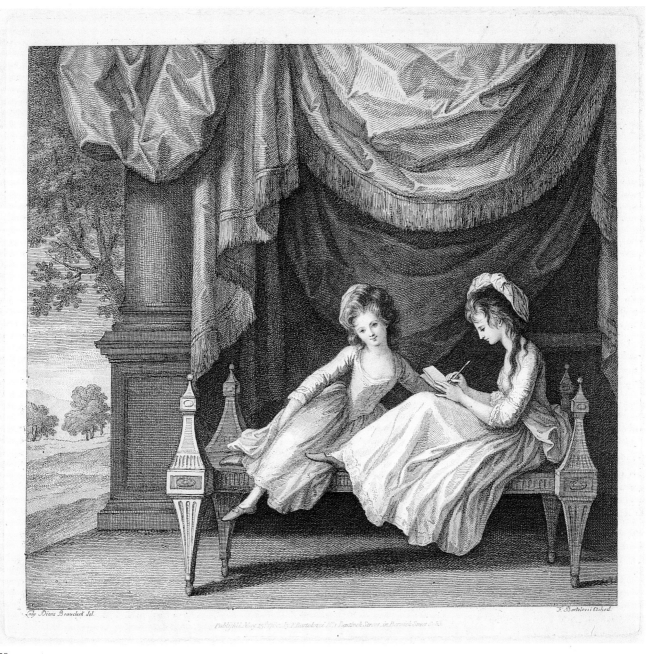

177

(*Left*) Fig. 6 Josiah Wedgwood, *Pair of wine coolers*,
blue and white jasper ware with figures based on
designs by Lady Diana Beauclerk. Ht 730 mm
(Department of Medieval and Later Antiquities,
British Museum)

(*Right*) Fig. 7 Lady Diana Beauclerk,
The daughters of the artist, pastel, 610×835 mm
(Lewis Walpole Library, Farmington (Conn.))

FRANCESCO BARTOLOZZI (1727–1815) after LADY DIANA BEAUCLERK (1734–1808)

177

The daughters of Lady Diana Beauclerk: Elizabeth (c.1765–93), later Countess of Pembroke, and Mary (1766–1851), later Countess Jenison Walworth, 1780

Etching and aquatint, 288 × 305 mm

De Vesme and Calabri 1212

Provenance: Bequeathed by the Revd Clayton Mordaunt Cracherode

S7-77

In 1778, several years before his numerous stipple engravings after her infant bacchantes and cupids, Bartolozzi engraved Lady Diana's portrait of Georgiana, the Duchess of Devonshire, in the form of an etching with aquatint (V&C 1066). The original drawing is now in the Royal Collection; the plate was a private commission from Lady Diana's brother, the Duke of Marlborough. This print of Elizabeth Beauclerk, shown drawing, and her younger sister Mary, was published two years later in a first state of pure etching, followed by a second with the publication line, and a third and final state aquatinted. Topham Beauclerk died in March 1780, and the print was published in May that year. Lady Diana had drawn in crayons (pastels) from the age of eleven and became an accomplished portraitist in pastels. Two bust-length portraits of her young sons were sold at Sotheby's, 19 November 1970 (lot 63), and what appears to be the pastel on which the present etching was based has recently been acquired by the Lewis Walpole Library in Farmington (Conn.) (see fig. 7). Bartolozzi's interpretation resolves the awkward position of Elizabeth's arm, gesturing while she reads to her younger sister, by placing the figures full-length on a couch and showing her drawing her sister's portrait instead. There is a liveliness and realism to the original, however, which is lost in the print, much as the figures themselves are diminished by their grand setting.

Sir William Hamilton had been an admirer of Lady Diana in 1757, not long before her sister married his friend the Earl of Pembroke. When Walpole told him of his new room to house her drawings in 1776, Hamilton replied: 'L[ady] D[iana] B[eau-clerk]'s merit, – talents – graces – alas! I know but too well – I am sure take her all in all there never was so clever a creature, & in good hands would be an angel – but I must hurry from this subject – the only one on which I am really tender' (transcript courtesy of Donald A. Heald, New York). In August 1780, after a visit to Sir William Hamilton in Naples, by way of a thank-you, Pembroke's son Lord Herbert sent Hamilton a copy of this print 'lately published'. Hamilton thanked him in December: 'the Etching does ones heart good to look at it. I always thought Lady Di. had more true taste than any creature living and I defy any artist in Europe to compose two figures with more grace and elegant simplicity than these two delightfull little girls. Do kiss the hand that produced them … and tell her Ladyship that I can never cease being her admirer, as I was long before you was born.' Hearing of Hamilton's admiration of Lady Diana's work, the Earl of Pembroke wrote shortly afterwards: 'If you was to see six pieces of Ly Di's from a story in Ossian, you would fall down & worship her more than ever. She lives totally at Richmond with her Children, & paints all day long.' In the 1780s Lady Diana relied heavily on her sister, the Countess of Pembroke, and in 1787 their children, Elizabeth Beauclerk and George, Lord Herbert, were married.

Literature: Arthur Oswald, 'Woolbeding, Sussex – II', *Country Life* (15 August 1947), 329–31; *Pembroke Papers (1780–1794)*, ed. Lord Herbert 1950, 27, 76, 86; D. Alexander, in Gaze, 226–8.

WILLIAM HENRY BUNBURY (1750–1811)

178

Girl of Dauphiny

Watercolour, with pen and red-brown ink, over graphite, 232 × 191 mm

Inscribed on mount with title

Provenance: William Esdaile; purchased from Lauser

1900-7-17-59

Bunbury was the best-known and certainly most prolifically published amateur artist of his day. His reputation as a charming and humorous social satirist now dominates discussion of his work, but his 'fancy subjects' were equally admired among his contemporaries. These pretty, 'sentimental' subjects have not appealed to later twentieth-century taste; frequently described as

GIRL OF DAUPHINY.

178

'insipid', they and their counterparts by professional artists such as Francis Wheatley and George Moreland have been largely ignored. But like novels, the prints after these drawings appealed 'To the Fashionable World and Polite circles' (*The World*, 3 January 1787) and frequently bore dedications to well-known aristocratic women who had been presented with the original drawings. Like Lady Diana Beauclerk, whose style Bunbury's drawings of this type most closely resembled, Countess Spencer, Miss Crewe and Mrs Damer (cat. 184), his status as an amateur was enhanced by his status as someone who moved in court circles. His subjects were most often taken from contemporary novels or plays, or depicted popular genres similar to those by Kauffman or Cipriani of *The Song*, *The Dance*, or *Morning Employments*.

One of Bunbury's series consisted of various types of female beauty, including *The Girl of Modena*, *The Girl of Snowdon* and *Lucy of Leinster*. It was probably to this

series that the present drawing belonged. Bunbury had returned from his grand tour in 1770, and many of his publicly exhibited works at the Royal Academy the following decade had been non-comic genre subjects of this type, depicting Italian and French peasants, and young women and families he had sketched on the Continent. In spite of its looseness, this present work is not a sketch, but a finished drawing, and is typical of the output of Bunbury's amateur contemporaries. Drawn with a wet brush loaded with sepia ink, details have been touched in with the tip of a brush and some pen and ink and then varnished. This was frequently done to preserve the surface of drawings, which were then mounted on card and stored in portfolios, pinned on walls or framed, but not glazed. The varnish discolours with time, darkening to a deep yellow-brown that often lessens a drawing's appeal to modern taste.

Literature: Clayton, 245–6, 307 n. 54.

179
The Water Sprite, 1793

Watercolour, with pen and red-brown ink, over graphite, 278 × 395 mm

Inscribed: *The Wat[er] Sprite HWBunbury1793*; and on the verso: *–Believe not every handsome Knight/ and dance not with the Water Sprite –* and *See the Ballad of the Water King 3ʳᵈ vol. of The Monk*

LB 1

Provenance: Purchased through J. Hogarth & Sons from Dr John Percy's sale, Christie's, 12 May 1890, lot 145

1890-5-12-18

Although many of the popular stipple prints issued during these decades illustrated novels or plays and were published in pairs or as a series, the most popular subject for singly issued prints was poetry. Bunbury's watercolour illustrates lines from a cautionary ballad, 'The Water King', transcribed in the novel *The Monk*:

179

Warned by this tale, ye damsels fair
To whom ye give your love beware;
Believe not every handsome Knight
And dance not with the Water Sprite

Matthew Gregory Lewis's gothic novel was not published until the year after this drawing was made (1794), and Bunbury's relationship to the author and the publication is not clear. A stipple print after the design was produced by Isaac Taylor Jr in Colchester in 1798, underlining the fact that Bunbury did not produce his drawings purely for publication. This is one of his finest watercolours, more highly coloured and finished than most, and the prominence of his signature and the title is an unusual feature (although his family frequently added inscriptions to his work after his death). It may be an indication that he was applying himself more seriously to his art at this time – during the 1790s he was working on a series of illustrations of Shakespeare for the publisher Macklin and produced fewer caricatures. His wife died in 1799, and shortly afterwards he moved to Keswick where, during the last decade of his life, he began to paint realistic genre subjects in oil. These were exhibited at the Royal Academy in 1806 and 1808, where Bunbury had not exhibited for twenty years.

Literature: David Alexander, *Affecting Moments: Prints of English Literature made in the Age of Romantic Sensibility 1775–1800*, exh. University of York, 1993, no. 28; Williams, 230–1; J. C. Riely, *Henry William Bunbury*, exh. Gainsborough House, Sudbury, 1983.

THE HON. GEORGE TOWNSHEND (1724–1807), 4th Viscount, 1st Marquess

180

Portrait of Edward Gibbon [?], *c*.1775

Pen and brown ink, over graphite, 230 × 134 mm

Inscribed: *Gibbon ? 1775*, and on verso: *? Edward Gibbon, about 40 years / of life. i.e. c.1775*

Provenance: Purchased from Edward Hawkins

1868-8-8-13152

The Hon. George Townshend was an officer in the army, serving through most of the 1740s as aide-de-camp to William, Duke of Cumberland, at Culloden and in Flanders. He learned to draw caricatures while on the Grand Tour in 1749, using

180

his talent at first for private amusement, but later as a political weapon against Cumberland and later against Charles James Fox. He was also a talented portraitist – his watercolour sketch of James Wolfe, with whom he did not always get on, is not only a sensitive but a skilled likeness (McCord Museum, Montreal, which also contains his caricatures of Wolfe). Townshend received the surrender of Quebec after the death of General Wolfe in 1759, and while serving in North America made numerous pen and ink and watercolour sketches of the local inhabitants, mainly from the Ottawa and other Algonquin tribes. At first they appear to be caricatures, but in fact convey a great deal of information about their ways of life, as well as providing insight into how the British perceived the native inhabitants, one of whom Townshend brought back with him to England.

Many of Townshend's political caricatures were published as satirical prints by Matthew Darly on pasteboard cards and then later in small volumes. These prints began to appear in 1756, shortly after Walpole reported that Townshend 'adorns the shutters, walls, and napkins of every tavern in Pall Mall with caricatures of the Duke [of Cumberland] and Sir George Lyttelton, the Duke of Newcastle and Mr

[Henry] Fox'. A year later Walpole wrote that Townshend's genius for likenesses in caricature was astonishing (*Wal. Corr.*, XXXVII, 445; XXI, 77). The original drawings for many of those done between 1756 and 1761 were in an album at Felbrigg, collected by his friend William Windham (now National Portrait Gallery), while another album with caricatures by his brother-in-law and sons remains with his descendants at Raynham. Nothing is known of Townshend's connection with the historian Edward Gibbon, which may have been through parliament or their roles in local militia, but the features and attributes of the present work are consistent with caricatures of Gibbon by other amateurs.

Hogarth was frequently mistaken as the artist of these productions, and felt obliged to defend himself in his print *The Bench*, 'Addressed to the Honble. Col. T-s-d', in which he defined the difference between caricature and character. But it did little to stem the tide of taste for this popular form of print, whether personally humorous or political. In 1762–3 Mary Darly published *A Book of Caricature*, a manual compiled from examples by many of her pupils and patrons, including several examples by Townshend, and his work exerted a strong influence on the next generation, particularly Bunbury and many amateurs whose work was less public.

Literature: R. W. Ketton-Cremer, 'An early political caricaturist', *Country Life* (3 January 1964), 214–16; Eileen Harris, *The Townshend Album*, 1974.

LADY DIANA BEAUCLERK (1734–1808), *née* SPENCER

181

Caricature portrait of Edward Gibbon wearing a laurel wreath

Pen and brown ink over graphite, 120 × 90 mm

Inscribed on verso by Horace Walpole: *Mr Edw. Gibbon, by Lady Diana Beauclerc*

Provenance: E. Daniell, purchased by Dr John Percy; his sale, Christie's, 15–18, 22–4 April and 12 May 1890, lot 85, where purchased for the Museum by J. Hogarth & Sons

1890-5-12-10

The historian Edward Gibbon (1737–94) lived in Lausanne during most of the 1750s

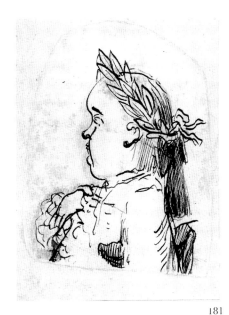

181

182

and from 1783 to 1793, but it was his visit to Italy in 1764–5 that led to his great work, the *Decline and Fall of the Roman Empire* (1776–88). He had known Lady Diana during her marriage to Lord Bolingbroke, and when a reconciliation could not be effected between them, he wrote that it was 'a great pity. She is handsome and agreeable and ingenious far beyond the ordinary rate' (Erskine, p. 63). Her second husband, Topham Beauclerk, was a great friend of Gibbon and in 1776 they arranged to visit Bath together. In the end, Gibbon was unable to accompany them, but wrote to his mother that she would find Lady Diana 'one of the most accomplished women in the world'. His correspondence does not mention the present caricature: he certainly became very overweight in later life, but this image is affectionate rather than mocking.

Literature: Erskine, 63; Norton II, 141.

LAVINIA, COUNTESS SPENCER (1762–1831), *née* Bingham

182
Caricature studies of Edward Gibbon, c.1785

Pen and brown ink over graphite, 287 × 186 mm

Inscribed on verso: *Mr E. Gibbon by Mr J. Walpole. 1782*

Provenance: Purchased by Dr John Percy; his sale (where attributed to J. Walpole), Christie's, 12 May 1890, lot 1329; bt for the Museum by J. Hogarth & Sons 1890-5-12-148

Lavinia Bingham, the daughter of Lord and Lady Lucan (cat. 186), toured Italy with her family for nearly two years from the age of sixteen. Horace Mann wrote to Walpole from Florence that Lady Lucan 'is very clever and has many accomplishments, and is teaching them to her daughters, who by their judgement of the pictures and all the collection in the Gallery are looked upon as prodigies at their age here'.

In 1780, thanking Walpole for his notice of her work in his *Anecdotes* (see p. 217), Lady Lucan requested that he 'grant my daughter Lavinia the same protection you have afforded me, as *she* has an original genius; and if you will scold and encourage her, make her wish to see you, and at the same time dread it, I am certain that she will become upon some future day … worthy

of being mentioned by you in another volume'. Encouraged by her mother, Lavinia showed her drawings to Walpole, who later added a note about her in his manuscript 'Books of Materials': 'Lavinia Bingham, Countess Spencer, daughter of the celebrated copyist Lady Lucan, drew only in bistre, and was happy in expression, but for some time very incorrect in drawing, but improved much and succeeded particularly in the characters of children.'

Lavinia Bingham married the 2nd Earl Spencer in 1781 and thus became the sister-in-law of the Duchess of Devonshire and Viscountess Duncannon (both amateurs), as well as being related through marriage to the Countess of Pembroke and her sister Lady Diana Beauclerk. Her portrait of Lady Duncannon was etched by Bartolozzi in 1787 (V&C 1068). A folio of her drawings from before and after her marriage survives at Althorp; on their original eighteenth-century mounts, they are all figural subjects and include portraits of her family, and nymphs, cupids and bacchantes later engraved in stipple by Bartolozzi and Bovi.

According to the *DNB*, Lavinia, Countess Spencer, ' was a woman of great beauty and intelligence, brilliancy of conversation and charm of character. For many years … she was well-nigh the most prominent lady in London society, and was remarkable for having been the friend of a singularly large number of men of eminence, literary, naval and political.' She knew Samuel Johnson as a girl, and her father moved in the same Whig circles as Lady Diana Beauclerk's husbands, who were friends of Johnson, Reynolds, Burke and Fox. She and Lord Spencer went abroad for her health in 1785, and they visited Gibbon daily during their stay in Lausanne. He described her as 'a charming woman, who with sense and spirit, has the simplicity and playfulness of a child. You [Lord Sheffield] are not ignorant of her talents, of which she has left me an agreable specimen, a drawing of the Historic muse sitting in a thoughtful posture to compose.' These sketches of Gibbon were acquired as by a J. Walpole, who has not been identified, but have since, very plausibly, been attributed to Lady Spencer. There is a slightly more finished version of the larger figure in a private collection (National Portrait Gallery Archives).

Literature: Hilles and Daghlian, 234–5; *Wal. Corr.*, XLI, 419; Norton III, 33–4; Ingamells, 614–15.

RICHARD BENTLEY (1708–82)

183

Sheet from a letter containing vignettes of pagoda and rocks

Pen and brown ink and wash, similar design on verso, 310 × 193 mm

Inscribed with letter from artist and signed

Provenance: Bequeathed by Iolo Williams

1962-7-14-8

Bentley was the son of the master of Trinity College, Cambridge, and succeeded his father as keeper of the King's Libraries in 1725. In the late 1730s, however, his father was still soliciting 'some place or other for his son'. Bentley became a friend of Walpole in 1750 when the latter described him as having 'more sense, judgement, and wit, more taste, and more misfortunes, that sure ever met in any man'. He soon joined Walpole and John Chute's 'Committee of Taste', which resulted in many of the Gothic Revival elements at Strawberry Hill.

Walpole kept a scrapbook of Bentley's drawings and designs (Lewis Walpole Library, Farmington (Conn.)), which included pen and ink drawings very similar to this one of a chinoiserie-type pagoda, on a letter that has always been assumed to have been addressed to him. One of the designs in the album was for a garden seat in the shape of a shell, which was actually executed in oak for the garden at Strawberry Hill. Bentley probably took his inspiration from one of the French *rocaille* designs that had been flooding the English market from the 1730s: in the 1740s and 1750s dozens of printsellers issued collections of these designs for furniture or ornament, adapted and interpreted by English designers and engravers. In 1753 Walpole paid for the publication of an edition of six poems by Thomas Gray, beautifully illustrated by Bentley in a clever, intricate and particularly English rococo style that moved away from the contrived elegance of the French tradition. The result is now generally agreed to be one of the best of all eighteenth-century illustrated books. It has been suggested that the present design was related to the illustration for Gray's *Ode on the Death of a Favourite Cat*, which included pagodas in the image. But the designs of the pagodas there are much less rococo than in the present drawings, which seem to be for a three-dimensional object, perhaps a garden

ornament, as it is shown from the front and the back. There are other chinoiserie designs in the Bentley album at Farmington, including a design for a garden building at Strawberry Hill that was never executed and a frame for butterflies for their friend Trevor Hampden.

Walpole's taste for chinoiserie was short-lived, lasting only until 1754 when he turned more single-mindedly to 'Gothick'. He frequently asked Bentley to illustrate his whims for Strawberry Hill or for other friends. Not all of them came to fruition and many of those that did were reinterpreted by other artists and designers. Bentley's most important designs included many of the chimneypieces, some ceilings and the staircase balustrade at Strawberry Hill. In 1753, for financial and domestic reasons, Bentley fled to Jersey from where he continued to send Walpole designs, as well as oil paintings, plants and shells. But Walpole was highly critical of the oils, writing: 'Have you no Indian ink, no soot-water, no snuff, no coat of onion, no juice of anything? If you love me, draw: you would, if you knew the real pleasure you can give me.' After Bentley's return in 1756, they fell out, apparently because Walpole felt Bentley was getting above his station, 'being forward to introduce his wife at Walpole's House when People of the first Fashion were there'.

Literature: ECM II; *Wal. Corr.*, IX, 301–2; XXXV, 131, 243, 644; Michael Snodin, ed., *Rococo Art and Design in Hogarth's England*, exh. Victoria and Albert Museum, 1984, nos D25, 26, R3; Loftus Jestin, *The Answer to the Lyre: Richard Bentley's Illustrations for Thomas Gray's Poems*, Pennsylvania 1990.

ANNE SEYMOUR DAMER (1749–1828)

184

Sir Joseph Banks (1743–1820), exhibited at the Royal Academy 1813

Bronze, ht 560 mm (without socle)

Inscribed in Greek: *ANNA EMOPIE DAMER ET* (Anna Seymour Damer fecit)

Provenance: Presented by the artist

Department of Medieval and Later Antiquities 1814,3-12,1

Anne Seymour was the daughter of two of Walpole's greatest friends, his cousin Field Marshal Henry Seymour Conway and his

183

wife Caroline, Countess of Ailesbury. Anne inherited Strawberry Hill on Walpole's death in 1797. She married John Damer in 1767, but nine years later he committed suicide after running up gambling debts. She had drawn since childhood, frequently sending Walpole sketches on cards much like those done by Lady Burlington (see p. 215). She began modelling in wax in her early teens, first a dog in bas-relief and then heads 'in the manner of [Isaac] Gosset'. Gosset (1713–99) was a Huguenot wax-modeller of profile reliefs, which were sold in oval frames and much copied and reproduced by Wedgwood and Tassie.

In 1778–9 Anne Damer was sent to Italy for her health and presented a self-portrait in marble to the Uffizi. When she set out again in 1781, Walpole wrote to Horace Mann in Florence that she was so reserved and modest that

We have by accident discovered that she writes Latin like Pliny, and is learning Greek. In Italy she will be a prodigy; she models like Bernini, has excelled the moderns in the similitudes of her busts and has lately begun one in marble. You must keep all knowledge of these talents and acquisitions to yourself; she would never forgive my mentioning them, at least her mental qualities – you may hint that I have talked of her statuary, as you may assist her if she has a mind to borrow anything to copy from the Great Duke's collection.

Anne had lessons in anatomy and studied with John Bacon the Elder (1740–99) and Giuseppe Cerrachi (1751–1801), whose full-length marble statue of her is in the British Museum. She exhibited as a Visitor at the Royal Academy from 1784 to 1818, presenting her work to family, friends and public institutions. A Whig and a Foxite, like Diana Beauclerk and the Duchess of Devonshire, she made a bust of Charles James Fox and in 1823 presented her old friend Richard Payne Knight with a copy of her earlier self-portrait. It came to the Museum with his bequest, but was destroyed in 1941.

Anne Damer began to work in bronze around 1800 and this portrait of another friend, Sir Joseph Banks, botanist, president of the Royal Society and one of the Museum's greatest trustees and patrons, may be based on a terracotta model exhibited at the Royal Academy in 1806, now lost. The static herm-like form indicates a desire to imitate early Greek sculpture, echoed by her signature in Greek letters on the side. Anne Damer had made earlier gifts to the Museum, including a group of tiles from the Alhambra, and in 1814 she presented this bronze bust with instructions that it be placed on a pivot. Following her desire for it

184

to be set at a height, the Museum displayed it on the great staircase in Montagu House, but it was removed fifteen years later and around 1850 relegated to a basement where it remained for the next century.

Anne Damer's full-length statue of George III still graces the Edinburgh Register Office. She presented the bust of her friend Lord Nelson to the City of London, and her bust of Charles James Fox was sent to Napoleon at his own request. In return, she received from Napoleon an enamelled gold box set with brilliants, which she left to the British Museum.

Literature: *Wal. Corr.*, XXXVIII, 198; XXV, 184; Susan Benforado, 'Anne Seymour Damer, Sculptor', Ph. D thesis, University of New Mexico, Albuquerque, 1986; Yarrington, 32–44; Aileen Dawson, *Portrait Sculpture: a catalogue of the British Museum's collection c.1675–1975*, 2000, no. 2.

THOMAS WATSON (1741–81) after SIR JOSHUA REYNOLDS (1723–92)

185

Lady Broughton, 1770

Mezzotint, 615 × 380 mm

CS 8.II

Provenance: Purchased of Messrs Hodgson and Graves

1839-4-13-13

Maria Hill (d. 1813) was the daughter of Thomas Hill of Tern, Shropshire, and sister of the first Baron Berwick of Attingham, whose descendants owned the original painting by Reynolds in the nineteenth century (now Virginia Museum of Fine Arts). She married Sir Brian Broughton-Delves, 5th baronet, of Broughton Hall, Staffordshire, but was widowed in 1766. She had begun her sittings to Reynolds in 1765 and continued to sit after she was widowed. The painting was completed and paid for in 1769, the year she married Henry Errington (?1738–1819) of Sandhoe, Northumberland. Errington had already travelled in Italy with Laurence Sterne, but returned to Italy with Lady Broughton in 1774–5, visiting Florence, Rome, Venice and Milan. Although in her portrait Lady Broughton proudly displays a drawing of a cupid (either stringing or breaking a bow) copied from a print or a drawing manual, and a tree evidently drawn from nature, with a bust to indicate that she also drew from

casts or sculpture, nothing is known of her work.

No doubt she was an amateur artist to some extent, as most of Reynolds's sitters portrayed with *portes-crayons* and portfolios were (e.g. *Lady Diana Beauclerk* (English Heritage, Kenwood) and *Anne Hussey Delaval, Lady Stanhope* (Baltimore Museum of Art)). But there was a reason for portraying women with their drawings other than merely to indicate their personal accomplishments, and printsellers were able to exploit portraits such as this one that could be interpreted as allegories of the 'Muse of Art'. There was an enormous market for portrait prints in England but English printsellers found difficulty in selling these on the Continent where the interest was in historical, allegorical and mythological images. Another state of this print dated 1770 bears Lady Broughton's name on the flagstone above the publisher's line (Louvre, 26 531 LR). In the state shown here, her name has been erased. Portraits such as the present work, where the sitter is given specific attributes, found a ready market on the Continent if the name was removed. A further market is indicated by a later third state of this print with the date erased and a new title added: *Mrs Siddons, In the Character of the Artist's Bride*.

Literature: Ingamells, 136, 340; Olivier Meslay, *D'Outre-Manche: l'art britannique dans les collections publiques françaises*, exh. Louvre, 1994, 199; Clayton, 245.

JAMES WATSON (c.1740–80) after ANGELICA KAUFFMAN (1741–1807)

186

Lady Bingham, 1776

Mezzotint, 505 × 362 mm

CS 10.III

Provenance: Bequeathed by William, 2nd Baron Cheylesmore

1902-10-11-6378

Through the example of Arthur Pond (cat. 169), Rosalba Carriera and Catherine Read, pastel painting was still very popular with many amateurs in the 1760s and 1770s when Lady Bingham began to draw portraits in this medium. In his 'Books of Materials' Walpole recorded that Lady Bingham did not do very well as she had 'never seen any good pictures'. But in 1773

185

Angelica Kauffman pinx.￼ James Watson fecit

Lady Bingham

Printed and Published according to Act of Parliament 1st April 1778, by J. Brotherton, N. 132. New Bond Street

186

he lent her all his finest minatures, which she copied in watercolours 'at least equal to the originals', and claimed that this was where her greatest genius lay. Unfortunately, she also copied 'a vast number of very bad pictures, and copied them so exactly that she never made them better'. Similarly, when she drew from life they were not as well drawn. She made miniature copies of Reynolds's compositions, and was a great friend of Mrs Delany, Joseph Banks and his sister Sarah, copying Banks's portrait of Captain Cook by Dance. Around this time her own portrait was painted by Angelica Kauffman, seated full-length in flowing robes, wearing a headdress like a sibyl, leafing through a large volume of drawings of figures, presumably her own. They are not miniatures and must be her copies after old master drawings: later in life she filled five folio volumes with illustrations of Shakespeare's historical plays. The portrait by Kauffman was published as a mezzotint by James Watson in 1775, only a few years before stipple became the preferred medium for prints after her work. By 1778 when he retired, Watson had made as many as sixty plates after paintings by Reynolds, and the use of mezzotint for this portrait underlines Kauffman's attempts in this work to paint in the grand manner of Reynolds.

Sir Charles Bingham was created Baron Lucan in 1776, the year he took his family to the Continent for an extended tour. They remained for a while in Paris before touring the galleries of Italy in 1778–9, staying mainly in Florence. During the five months she spent in Rome, Lady Lucan studied painting in oil and was made an honorary member of the Accademia di S. Luca.

Literature: Ingamells, 614–15; Foskett, 389.

WILLIAM WARD (1762–1826) after JOHN HOPPNER (1758–1810)

187

Daughters of Sir Thomas Frankland Bart., 1797

Mezzotint, proof before letters, 582 × 454 mm

Inscribed: *Sir Thos Franklands Daughters / Published as the act directs*

CS 38.1

Provenance: Bequeathed by William, 2nd Baron Cheylesmore

1902-10-11-6228

For illustration, see frontispiece

In the late 1760s Malchair's sketching parties at Oxford included Heneage Finch, John Skippe, Robert Price, Luttrell Wynne, George Beaumont and Thomas Frankland (1750–1831) of Thirkleby, Yorkshire. The son of Admiral Sir Thomas Frankland, Frankland succeeded to the baronetcy on his father's death in 1784. His children were also amateur artists. Robert (1784–1849) drew sporting pictures, some of which were engraved, and a series of small, often slightly comical portraits of local Yorkshire characters and friends, including Turner's patrons, Lord Lascelles and Walter Fawkes of Farnley.

Four of Frankland's brothers and sisters are commemorated in a monument of 1803 by Flaxman in Thirkleby Church. Two are the sisters depicted here, Amelia (1777–1800) and Marianne (1778–95), on the left. Both were unmarried and died of consumption, the younger very shortly after their portrait was painted by Hoppner (National Gallery of Art, Washington). Described as one of the artist's masterpieces, it was exhibited at the Royal Academy in 1795, where it was paired with his painting of the *Douglas Children* (private collection). The *St James's Chronicle* noted that it 'does the Artist great credit: the Group is natural and graceful; the heads are sweetly painted; and there is a hue of colour and keeping in the effect that is charming'.

Literature: Mallalieu, 134; Selby Whittingham, 'Picture Notes' in *Turner Studies* IV, 2 (1983), 60, and V, 1 (1985), 59; John Hayes, *British Paintings in the National Gallery of Art, Washington*, Washington 1994, 134–6.

Bibliography

Abbreviations

B&G C. F. Bell and Thomas Girtin, 'The drawings and sketches of John Robert Cozens. A catalogue with an historical introduction', *Walpole Society* XXXIII (1934–5)

BL British Library

BM British Museum

CH MSS Christ's Hospital Archives *see* Manuscript Sources

CS Chaloner Smith, John, *British Mezzotint Portraits*, 4 vols, 1883

DG M. Dorothy George, *Catalogue of Political and Personal Satires in the Department of Prints and Drawings in the British Museum* VI, 1938

DNB *Dictionary of National Biography*

ECM II Edward Croft-Murray, typescript catalogue of British drawings by artists born 1665–1715, in the Department of Prints and Drawings, British Museum

ECM & PH Edward Croft-Murray and Paul Hulton, *Catalogue of British Drawings*, I, *XVI and XVII Centuries*, British Museum, 1960

exh. exhibition

L. Lugt, Frits, *Les Marques de Collections de Dessins et d'Estampes*, Amsterdam, 1921, *Supplément* 1956

LB Laurence Binyon, *Catalogue of Drawings by British Artists and Artists of Foreign Origin working in Great Britain in the Department of Prints and Drawings of the British Museum*, 4 vols, 1898–1907

MSS Manuscripts

NACF National Art Collections Fund

NLS National Library of Scotland, Edinburgh

NPG National Portrait Gallery, London

O'D Freeman O'Donoghue, *Catalogue of Engraved British Portraits in the Department of Prints and Drawings*, British Museum, 6 vols, 1908–22

OIOC Oriental and India Office Collections, British Library

P&D Department of Prints and Drawings, British Museum

PMC Paul Mellon Centre for Studies in British Art, London

RL Royal Library

V&A Victoria and Albert Museum

V&C *see below*, de Vesme and Calabri

Wal.Corr. W. S. Lewis, ed., *The Correspondence of Horace Walpole*, 48 vols, New Haven and London, 1937–83

YCBA Yale Center for British Art, New Haven (Conn.)

Manuscript Sources

Christ's Hospital Archives, Court and Committee Books, Guildhall Library, City of London

Graham Clarke (Hestercombe) Papers, DD/GC, Somerset County Record Office, Taunton

Gilpin Papers, MSS Eng. Misc. d. 570, Bodleian Library, Oxford

Tom Girtin Archive, C. F. Bell's notes on Charles Gore, taken at Weimar, 1933, Department of Prints and Drawings, British Museum

Grimston Family Papers, DDGR, Humberside County Record Office, Beverley

Knight Family Papers, Arch. 122, 125, Kidderminster Public Library

Lee (Harcourt and Hartwell) Papers, D/LE/E, AR, Buckinghamshire County Record Office, Aylesbury

Lucas (Wrest Park) Papers, L 30, Bedfordshire County Record Office, Bedford

Mitford and Freeman-Mitford Papers, Journal of John Mitford (later Baron Redesdale), MSS D 2002/F1-6, Gloucestershire County Record Office, Gloucester

Secondary Sources
(Published in London unless stated otherwise)

Alexander, David, *Amateurs and Printmaking in England*, exh. Wolfson College, Oxford, 1983

Alfrey, Nicholas and Stephen Daniels, eds, *Mapping the Landscape*, exh. University Art Gallery, Castle Museum, Nottingham, 1990

Andrews, Malcolm, *The Search for the Picturesque*, Aldershot and Stanford, 1989

Archer, Mildred, *British Drawings in the India Office Library*, I, *Amateur Artists*, 1969

Baetjer, Katharine, *Glorious Nature: British Landscape Painting, 1750–1850*, exh. Denver Art Gallery, 1993

Barber, Tabitha, *Mary Beale: Portrait of a Seventeenth-Century Painter, her Family and her Studio*, exh. Geffrye Museum, 1999

Barbier, Carl Paul, *William Gilpin*, Oxford, 1963

Barrell, John, ed., *Painting and the Politics of Culture: New Essays on British Art 1700–1850*, Oxford, 1992

Bartsch, Adam, *Catalogue Raisonné de toutes les Estampes … Rembrandt*, 2 vols, Vienna, 1797

Bell, Michael, *Painters in a New Land*, Toronto, 1973

Bennett, Shelley, 'A Muse of Art', in *British Art 1740–1820: Essays in Honor of Robert R.Wark*, ed. G. Sutherland, Huntington Library, Calif., 1992, 57–80

Bermingham, Ann, 'The origin of painting and the ends of art: Wright of Derby's *Corinthian Maid*', in Barrell, 135–66

Bermingham, Ann, '"An Exquisite Practise": The institution of drawing as a polite art in Britain', in Brian Allen, ed., *Towards a Modern Art World*, New Haven and London, 1995, 47–66

Bermingham, Ann, *Learning to Draw: Studies in the Cultural History of a Polite and Useful Art*, New Haven and London, 2000

Bicknell, Peter and Jane Munro, *Gilpin to Ruskin: Drawing Masters and their Manuals, 1800–1860*, exh. Fitzwilliam Museum, Cambridge, 1988

Bignamini, Ilaria, 'George Vertue, art historian, and art institutes in London, 1689–1761', *Walpole Society* LIV, 1988 (1991), 1–148

Bignamini, Ilaria and Andrew Wilton, *Grand Tour: The Lure of Italy in the Eighteenth Century*, exh. Tate Gallery, 1996

Blunt, Wilfred and William T. Stearn, *The Art of Botanical Illustration*, revised edn, Woodbridge, 1994

Brown, David Blayney and Felicity Owen, *Collector of Genius, A Life of Sir George Beaumont*, New Haven and London, 1988

Brown, Iain Gordon, *The Hobby-Horsical Antiquary*, National Library of Scotland, Edinburgh, 1980

Buchanan-Dunlop, H. D., ed., *Records of the Royal Military Academy 1741–1892*, 2nd edn, Woolwich, 1895

Carline, Richard, *Draw They Must: A History of the Teaching and Examining of Art*, 1968

Challoner Smith, John, *British Mezzotint Portraits, from the Introduction of the Art to the Early Part of the Present Century*, 4 vols, 1883

Christian, Jessica, 'Paul Sandby and the military survey of Scotland', in Alfrey and Daniels, 18–22

Clarke, Michael, *The Tempting Prospect: A Social History of English Watercolours*, BM, 1981

Clarke, Michael and Nicholas Penny, eds, *The Arrogant Connoisseur: Richard Payne Knight 1751–1824*, exh. Whitworth Art Gallery, Manchester University, 1982

Clayton, Tim, *The English Print 1688–1802*, New Haven and London, 1997

Colley, Linda, *Britons: Forging the Nation 1707–1837*, New Haven and London, 1992, Pimlico paperback edn, 1994

Coombs, Katherine, *The Portrait Miniature in England*, V&A, 1998

Cornforth, John, 'Frogmore House, Berkshire', *Country Life* (16 August 1990), 46–51; 'If objects could speak', *Country Life* (22 August 1991), 46–51

Cramer, Charles A., 'Alexander Cozens's *New Method*: The Blot and General Nature', *Art Bulletin* LXXIX, no. 1 (March 1997), 112–29

Croft-Murray *see* ECM & PH

Daghlian *see* Hilles

Dallaway, James *see* Walpole

Dawson, Aileen, *Masterpieces of Wedgwood*, BM, revised edn 1995

de Beer, E. S., ed., *The Diary of John Evelyn*, 6 vols, Oxford, 1955

De Novellis, Mark, *Pallas Unveil'd: The Life and Art of Lady Dorothy Saville, Countess of Burlington*, exh. Orleans House Gallery, 1999

de Vesme, A. and A. Calabri, *Francesco Bartolozzi: Catalogue des estampes*, Milan, 1928

Dobai, Johannes, *Die Kunstliteratur des Klassizismus und der Romantik in England [1700–1840]*, 3 vols, Bern, 1974–84

D'Oench, E., D. Alexander and C. White, *Rembrandt in 18th-Century England*, exh. YCBA, New Haven, 1983

Dolmetsch, Joan, ed., *Eighteenth-Century Prints in Colonial America*, Williamsburg, 1979

Egerton, Judy, *Wright of Derby*, exh. Tate Gallery, 1990

Einberg, Elizabeth, *George Lambert 1700–1765*, exh. Kenwood, Greater London Council, 1970

Einberg, Elizabeth, 'The perfect pupil: Richard Beauvoir (1730–80), painter in oils and water-colours', *British Art Journal* I, no. 1 (1999), 35–7

Errington, Lindsay and James Holloway, *Discovery of Scotland*, exh. National Gallery of Scotland, Edinburgh, 1978

Erskine, Mrs Steuart, *Lady Diana Beauclerk, Her Life and Work*, 1903

Evelyn, *Diary, see* de Beer

Farington, *Diary, see* Garlick

Fergusson, Bernard, *Rupert of the Rhine*, 1952

Fleming-Williams, Ian, 'Drawing-masters' and 'The amateur', Appendices in Hardie III, 1968, 212–44, 245–67

Fleming-Williams, Ian, 'The Finches of Packington', *Country Life* (15, 22 July 1971), 170–2, 229–31

Ford, Richard Brinsley, 'The letters of Jonathan Skelton from Rome and Tivoli in 1758', *Walpole Society* XXVI (1960), 23–84

Foskett, Daphne, *A Dictionary of British Miniature Painters*, 2 vols, 1972

French, Anne, *Gaspard Dughet called Gaspar Poussin 1615–75: A French Landscape Painter in Seventeenth-Century Rome and his Influence on British Art*, exh. Kenwood, Greater London Council, 1980

French, Anne, *Art Treasures in the North: Northern Families on the Grand Tour*, 2000

Friedman, Joan, '"Every Lady Her Own Drawing Master"', *Apollo* 105, no. 182 (April 1977), 262–7

Ganz, James A., *Fancy Pieces: Genre Mezzotints by Robert Robinson and His Contemporaries*, exh. YCBA, New Haven, 1994

Garlick, Kenneth, A. Mackintyre and K. Cave, eds, *The Diary of Joseph Farington*, 16 vols, New Haven and London, 1978–84, Index 1998

Gaze, Delia, ed., *A Dictionary of Women Artists*, London and Chicago, 1997

Gibson-Wood, Carol, 'Jonathan Richardson and the rationalizaton of connoisseurship', *Art History* 7, no. I (March 1984), 38–56

Gibson-Wood, Carol, 'Jonathan Richardson, Lord Somer's collection of drawings and early art historical writing in England', *Journal of the Warburg and Courtauld Institutes* 52 (1989), 167–87

Gibson-Wood, Carol, 'Classification and value: William Courten's collection', *Journal of the History of Collections* 9, no. I (1997), 61–77

Godfrey, Richard, *Wenceslaus Hollar: A Bohemian Artist in England*, exh. YCBA, New Haven, 1994

Goulding, Richard W., 'Welbeck Abbey miniatures', *Walpole Society* IV (1914–15)

Graves, Algernon, *The Society of Artists of Great Britain 1760–1791, The Free Society of Artists 1761–1783: A Complete Dictionary of Contributors and their Work*, 1907, reprint Bath, 1969

Griffiths, Antony, 'The etchings of John Evelyn', in Howarth, 51–67

Griffiths, Antony, ed., *Landmarks in Print Collecting: Connoisseurs and Donors at the British Museum since 1753*, exh. various venues from 1996, and British Museum, 1999

Griffiths, Antony, *The Print in Stuart Britain 1603–1689*, exh. British Museum, 1998

Hake, Henry M., 'Some contemporary records relating to Francis Place … with a catalogue of his engraved work', *Walpole Society* X (1922), 36–69

Hardie, Martin, *Watercolour Painting in Britain*, 3 vols, 1966–8

Harrison, Colin, *John Malchair of Oxford, Artist and Musician*, exh. Ashmolean Museum, Oxford, 1998

Hayden, Ruth, *Mrs Delany and her Flower Collages*, BM, 2nd edn, 1992

Hayes, John, *The Drawings of Thomas Gainsborough*, 2 vols, 1970

Hayes, John and Lindsay Stainton, *Gainsborough Drawings*, exh. International Exhibitions Foundation, Washington, 1983

Heal, Ambrose, *The English Writing-Masters and their Copy-Books 1570–1800. A Biographical Dictionary and a Bibliography*, Cambridge, 1931

Hearn, Karen, ed., *Dynasties: Painting in Tudor and Jacobean England 1530–1630*, exh. Tate Gallery, 1996

Herrmann, Luke, *Paul and Thomas Sandby*, exh. V&A, 1986

Hilles, Frederick W. and Philip Daghlian, eds, *Anecdotes of Painting in England; [1760–1795] … collected by Horace Walpole; and now digested and published from his original MSS.; Volume the Fifth and last [Anecdotes V]*, New Haven and Oxford, 1937

Hind, A. M., *A Catalogue of Drawings by Dutch and Flemish Artists in the Department of Prints and Drawings*, 3 vols, 1915–31

Hofmann, T., J. Winterkorn, F. Harris and H. Kelliher, 'John Evelyn's archive at the British Library', in *John Evelyn in the British Library*, British Library, 1995, 11–73

Hollstein, F. W. H., *Hollstein's German Engravings, Etchings and Woodcuts 1400–1700*, XXXVI, revised edn Tilman Falk, Roosendaal, The Netherlands, 1994

Houghton, Walter, 'The English virtuoso in the seventeenth century', *Journal of the History of Ideas* III (1942), pt 1, 51–73, pt 2, 190–217

Howarth, David, ed., *Art and Patronage in the Caroline Courts: Essays in Honour of Sir Oliver Millar*, Cambridge, 1993

Hunter, Michael, *John Aubrey and the Realm of Learning*, 1975

Hunter, Michael, *Establishing the New Science: The Experience of the Early Royal Society*, Woodbridge, 1989

Hunter, Michael, *Science and the Shape of Orthodoxy: Intellectual Change in Late Seventeenth-Century Britain*, 1995

Ingamells, John, ed., compiled from the Brinsley Ford Archive, *A Dictionary of British and Irish Travellers in Italy 1701–1800*, New Haven and London, 1997

Irwin, Francina, 'Lady amateurs and their masters in Scott's Edinburgh', *Connoisseur* 187 (1974), 232ff.

Jenkins, Ian and Kim Sloan, *Vases and Volcanoes: Sir William Hamilton and his Collection*, exh. British Museum, 1996

Jones, William D., *Records of the Royal Military Academy 1741–1840*, Woolwich, 1851

Jordan, Caroline, '"Pilgrims of the Picturesque": The amateur woman artist and British colonialism, c.1750–1850', PhD thesis, University of Melbourne, 1996

Joyner, Paul, 'Some Sandby drawings of Scotland', *National Library of Wales Journal*, Aberystwyth, XXIII (1983), 1–16

Kemp, Martin, *The Science of Art: Optical Themes in Western Art from Brunelleschi to Seurat*, New Haven and London, 1990

Kitson, Frank, *Prince Rupert: Portrait of a Soldier*, 1994

Kitson, Frank, *Prince Rupert: Admiral and General-at-Sea*, 1998

Kriz, K. Dian, *The Idea of the English Landscape Painter: Genius as Alibi in the Early Nineteenth Century*, New Haven and London, 1997

Latham, Robert and William Matthews, *The Diary of Samuel Pepys*, 11 vols, 1970–83

Leith-Ross, Prudence, with contributions by Henrietta McBurney, *The Florilegium of Alexander Marshal at Windsor Castle*, 2000

Lippincott, Louise, *Selling Art in Georgian London: The Rise of Arthur Pond*, New Haven and London, 1983

Llanover, A., ed., *Autobiography and Correspondence of Mary Granville, Mrs Delany*, 6 vols, 1st ser. 1861, 2nd ser. 1862

Macdonald, Stuart, *The History and Philosophy of Art Education*, 1970

MacGregor, Arthur, *Tradescant's Rarities*, Oxford, 1983

MacGregor, Arthur, ed., *The Late King's Goods*, London and Oxford, 1989

Mallalieu, Huon L., *The Dictionary of British Watercolour Artists up to 1920*, 3 vols, Woodbridge, 1976–90, 2nd edn of vol. I, 1986

Massey, William, *The Origin and Progress of Letters … An Account of English Penmen and their Books*, 1763

Muller, Jeffrey M. and Jim Murrell, eds, *Edward Norgate, 'Miniatura or the Art of Limning'*, New Haven and London, 1997

Murdoch, John, Jim Murrell and Patrick Noon, *The English Miniature*, New Haven and London, 1981

Murdoch, John, *Seventeenth-Century English Miniatures in the Collection of the Victoria and Albert Museum*, 1998

Myers, Syliva Harcstark, *The Bluestocking Circle: Women, Friendship and the Life of the Mind in Eighteenth-Century England*, Oxford, 1990

Myrone, Martin and Lucy Peltz, eds, *Producing the Past: Aspects of Antiquarian Culture and Practice 1700–1850*, Aldershot, 1999

Norton, J. E., ed., *The Letters of Edward Gibbon*, 3 vols, 1956

O'Connell, Sheila, *The Popular Print in England*, exh. British Museum, 1999

O'Donoghue, Yolande, *William Roy 1726–1790: Pioneer of the Ordnance Survey*, British Library, 1977

Ogden, Henry V. S. and Margaret S. Ogden, 'A bibliography of seventeenth-century writings on the pictorial arts in English', *Art Bulletin* 29 (1947), 196–201

Ogden, Henry V. S. and Margaret S. Ogden, *English Tate in Landscape in the Seventeenth Century*, Ann Arbor, 1955

Oppé, A. P., 'The Fourth Earl of Aylesford', *Print Quarterly* XI, 3 (1924), 263–92

Oppé, A. P. *The Drawings of Paul and Thomas Sandby in the Collection of His Majesty the King at Windsor Castle*, Oxford and London, 1947

Oppé, A. P. *English Drawings, Stuart and Georgian Periods, in the Collection of His Majesty the King at Windsor Castle*, Oxford and London, 1950

Oppé, A. P., *Alexander and John Robert Cozens*, 1952

Parris, Leslie, *Landscape in Britain c.1750–1850*, exh. Tate Gallery, 1974

Parry, Graham, 'The John Talman letter-book', *Walpole Society* LIX (1997), 1–173

Pears, Iain, *The Discovery of Painting: The Growth of Interest in the Arts in England 1680–1768*, New Haven and London, 1988

Peltz, Lucy, 'The extra-illustration of London: Leisure, sociability, and the antiquarian city in the late eighteenth century', PhD thesis, University of Manchester, 1997

Pepys, *Diary*, *see* Latham and Matthews

Piggott, Stuart, *William Stukeley: An Eighteenth-Century Antiquary*, revised edn, 1985

Pointon, Marcia, *Strategies for Showing*, Oxford, 1997

Pressly, Nancy, *The Fuseli Circle in Rome*, exh. YCBA, 1979

Raines, Robert, 'Peter Tillemans, life and work, with a list of representative paintings', *Walpole Society* XLVII (1980), 21–59

Reilly, Robin, *Wedgwood*, 2 vols, 1989

Riely, John, *Henry William Bunbury*, exh. Gainsborough's House, Sudbury, 1983

Roberts, Jane, *Royal Artists from Mary Queen of Scots to the Present Day* 1987 (= Roberts)

Roberts, Jane, *Views of Windsor, Watercolours by Thomas and Paul Sandby*, 1995 (= Roberts 1995)

Robertson, Bruce, *The Art of Paul Sandby*, exh. YCBA, New Haven, 1985

Robertson, Bruce, 'Joseph Goupy: Checklist of prints, drawings and paintings', *Bulletin of the Cleveland Museum of Art* LXXV (1988), 376–82

Rohatgi, Pauline and Pheroz Godrei, *Under the Indian Sun: British Landscape Artists*, Bombay, 1995

Rosenthal, Michael, *British Landscape Painting*, Oxford, 1982

Royalton-Kisch, Martin, *Adriaen van de Venne's Album*, 1988

Royalton-Kisch, Martin, *The Light of Nature: Van Dyck and his Contemporaries*, exh. British Museum, 1999

Saunders, Gill, *Picturing Plants: An Analytical History of Botanical Illustration*, Berkeley and Los Angeles and London, 1995

Scrase, David, *Fitzwilliam Museum Handbooks: Flower Drawings*, Cambridge, 1997

Shteir, Ann B., *Cultivating Women, Cultivating Science: Flora's Daughters and Botany in England 1760–1860*, Baltimore, 1996

Sloan, Kim, 'Drawing – a "polite recreation" in eighteenth-century England', in Harry C. Payne, ed., *Studies in Eighteenth-Century Culture* 11, Madison (Wisc.), 1982, 217–40

Sloan, Kim, 'Thomas Weston and the Academy at Greenwich', *Transactions of the Greenwich and Lewisham Antiquarian Society* IX, no. 6 (1984), 313–33

Sloan, Kim, 'A new chronology for Alexander Cozens', parts I, II, *Burlington Magazine* CXXVII, no. 983 (Feb. 1985), 70–5, no. 989 (June 1985), 355–63

Sloan, Kim, *Alexander and John Robert Cozens: The Poetry of Landscape*, New Haven and London, 1986 (= Sloan 1986, *Cozens*)

Sloan, Kim, 'The teaching of non-professional artists in 18th-century England', PhD thesis, Westfield College, University of London, 1986 (= Sloan 1986, 'Non-professionals')

Sloan, Kim, 'A Cozens album in the National Library of Wales, Aberystwyth', *Walpole Society* LVII (1995), 79–97

Sloan, Kim, 'Industry from idleness? The rise of the amateur in the eighteenth century', in M. Rosenthal, C. Payne and S. Wilcox, eds, *Prospects for the Nation: Recent Essays in British Landscape, 1750–1880*, Studies in British Art 4, New Haven and London, 1997, 285–306

Smiles, Sam, *Ancient Britain and the Romantic Imagination*, New Haven and London, 1994

Smith, Greg, 'Watercolour: Purpose and practice', in Simon Fenwick and Greg Smith, *The Business of Watercolour: A Guide to the Archives of the Royal Watercolour Society*, 1999, 1–33

Smith, Greg, *The Emergence of the Professional Watercolourist: Contentions and Alliances in the Artistic Domain, 1760–1824*, forthcoming, Ashgate, 2001

Stainton, Lindsay, *English Landscape Watercolours*, exh. British Museum, 1985

Stainton, Lindsay and Christopher White, *Drawing in England from Hilliard to Hogarth*, exh. British Museum, 1987

Stumpf, Claudia, *Richard Payne Knight: Expedition into Sicily*, 1986

Swain, Margaret, *Embroidered Stuart Pictures*, Shire Album 246, Princes Risborough, Bucks, 1990

Turner, Jane, ed., *The Dictionary of Art*, 34 vols, London and New York, 1996

Tyler, Richard, *Francis Place 1647–1723*, exh. York City Art Gallery, 1971

Ucko, P. J., M. Hunter, A. J. Clark and A. David, *Avebury Reconsidered from the 1660s to the 1990s*, Institute of Archaeology, University College London, 1991

Vertue, George, 'Notebooks', *Walpole Society*, 6 vols (XVIII, XX, XXIV, XXVI, XXIX, XXX) Oxford, 1930–55

Walpole, Horace, *Anecdotes of Painting in England; with some account of the Principal Artists*, with additions by the Revd James Dallaway, in new edn by Ralph N. Wornum, 3 vols, 1888

Walpole, Horace, 'Ladies and gentlemen distinguished by their artistic talents', based on Walpole's 'Books of Materials', 1759, 1771, 1786 (now Lewis Walpole Library, Farmington, Conn.) published in *Anecdotes* V (*see* Hilles and Daghlian)

Wark, Robert R., *Early British Drawings in the Huntington Collection 1600–1750*, Huntington Library, San Marino (Calif.), 1969

Waterhouse, Ellis K., *Painting in Britain 1530–1790*, 4th edn, Harmondsworth, 1978

Whinney, Margaret and Oliver Millar, *English Art 1625–1714*, Oxford, 1957

White, Philip, *A Gentleman of Fine Taste: The Watercolours of Coplestone Warre Bampfylde*, Taunton, 1995

Whitley, William T., *Artists and their Friends in England, 1700–99*, 2 vols, London and Boston, 1928

Wilcox, Timothy, *Francis Towne*, exh. Tate Gallery, 1997

Williams, Iolo, *Early English Watercolours*, 1952, reprint Bath, 1970

Wilton, Andrew, *The Art of Alexander and John Robert Cozens*, exh. YCBA, 1980

Wind, Edgar, *Hume and the Heroic Portrait: Studies in Eighteenth-Century Imagery*, ed. Jaynie Anderson, Oxford, 1986

Wornum, Ralph *see* Walpole, *Anecdotes*

Wuestman, Gerdien, 'The mezzotint in Holland: "easily learned, neat and convenient"', *Simiolus: Netherlands Quarterly for the History of Art* 23, no. 1 (1995), 63–89

Yarrington, Alison, 'The female Pygmalion. Anne Seymour Damer, Allan Cunningham and the writing of a woman sculptor's life', *Sculpture Journal* (1997), 32–44

Young, Hilary, ed., *The Genius of Wedgwood*, exh. V&A, 1995